Jacques Thuillier

HISTORY OF ART

Jacques Thuillier

HISTORY OF ART

translated from the French
by DEKE DUSINBERRE

Flammarion

Contents

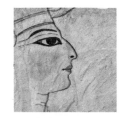

Introduction

Never before have we enjoyed such a vast artistic heritage. Excavations all over the world are revealing new aspects of vanished civilizations, new museums are opening, and historic monuments are being restored. Air travel has put the treasures of India and Bolivia within reach of every tourist. The "iron curtain" that once made access to an entire range of European and Asian art so difficult is now just a distant memory. The eternal obstacles erected by wars and religions are now fewer than ever, and even where they exist substantial documentation can be obtained through television, films, and photographs. Capital cities the world over strive to host major exhibitions—the average French schoolchild, for example, can now boast of having seen, with his or her own eyes, Chinese warriors from Qin Shi Huangdi's tomb, Turkish treasures from the Topkapi Palace, and equally inaccessible Cézannes and Matisses held by the Barnes Foundation.

Faced with this wealth of art from every land and period, it is hard not to feel lost. Worse still, it is difficult to retain a sense of curiosity and surprise. Numerous guidebooks, of course, provide the necessary details, as do scholarly exhibition catalogs and richly illustrated museum listings. Perhaps overabundance is the biggest threat, for our attention spans are limited. In the profusion still encountered in many sacred buildings, which things are important? In the overwhelming selection offered by museums, which works should be noted? Without some basic knowledge and experience, it is impossible to distinguish between an unusual item, a fascinating article typical of some civilization, and an individual masterpiece by a great artist.

This is where an encyclopedic approach should be abandoned in favor of a history of art. An encyclopedia attempts to maximize information of all kinds. A history of art, on the other hand, seeks to propose practical paths through the vast expanse of works and events.

It is a thankless task: the historian is obliged to endlessly sift and select; he is made to appear to neglect individuals and objects whose importance he is fully aware of; and he must over-simplify reality, fully aware of the risks of misleading. Yet it is an essential task, for only an overall perspective makes it possible to pinpoint major developments prior to recomposing reality in all its complexity.

I have accepted these limitations, though not without feeling pangs at every sacrifice. What, so little on Giotto? So little on Georges de La Tour? A mere sentence or two on the wonderful Corot, and nary a hint of Schönfeld's subtle genius? Nothing about Bolivia's warrior angels? I am aware, in advance, of all the criticism to which I am open. On four specific points, however, I would like to defend myself.

The rejection of borderline practices

First of all, the title *History of Art* was deliberately adopted to exclude those periods that are the domain of archaeology, namely prehistory and protohistory. Current fashion holds that art dates back to the earliest manifestations of humanity. Yet I feel that nothing justifies the use of the term "art" for the symbols or depictions encountered in those periods, unless people of those times are ascribed a psychology excessively modeled on our own. Only by freeing itself from this initial stage—after writing was developed—did art come into being. The specific nature of art, to use Henri Focillon's terms, is that it should not just *signifier* (signify) but actually *se signifier* (signify itself).

The same could be said for what has been called "primitive art." In fact, whether referring to Africa or Australia, the term almost always applies to works dating from the twentieth century—sometimes the second half of the nineteenth century—thereby cleverly sustaining confusion between art and anthropology. I am unwilling to play this double game, whose aesthetic consequences are quite serious. Obviously, the African heads discovered at Ife are not part of this confusion: whatever their date, these works clearly belong to the history of art, and even count among its masterpieces.

The rejection of historical conventions

Another comment might prove useful to readers surprised by the extreme caution with which I use established categories such as Romanesque, Gothic, Renaissance, Classicism, Baroque, and so on.

These distinctions often arose almost by chance, then were accredited by pedantic dispute and popularized by textbooks. Although convenient for everyday language, they have no solid basis. They often date from a time when photographs were rare or non-existent, and they gave rise to spurious issues of dating, influence, and primacy. Instead of examining the historical and geographical reality, scholars often prefer to play with abstract notions of this type. I feel it is wiser to forget them and to employ straightforward historical divisions devoid of rigid conceptual content, thereby underscoring the continuity of creative activity.

The rejection of old deterministic theories

A third comment is equally crucial: most histories of art written today, even the most concise, stress the economic, sociological, and religious circumstances that supposedly *explain* artistic creations. This is an old idea that Madame de Staël found inspiring, that Hegel and Taine developed, and that Marxism—until recently—turned into an unshakeable belief. Art was said be just an "epiphenomenon," totally conditioned by the artist's situation at the time. In short, art's only appeal was to reveal, through imagery, the dialectics of history.

The time has come, I think, for a "Copernican" revolution. In this book, art itself once again becomes central to all other issues. Experience shows that creativity—even when an artist is constrained by an extremely precise commission, even when an artist personally advocates a specific doctrine—is always unpredictable. An artist living amid war and wretchedness may adopt tragic overtones, yet more often will create works of peace and serenity. It is mistaken to assume that an admirable religious painting indicates profound faith, for it may be the work of a hard-core atheist. Iconography, by its very nature, is misleading—it reflects the work's maker much less than the work's purpose. The works of great artists significantly transcend the concepts they hoped to convey, as well as the concepts into which some people have tried to confine them.

That is why this book offers nothing in the way of political or religious history, nor the least hint of economic and social explanation. Obviously, every angle—even forced or false—can be useful in understanding a work and its purpose, and there can never be too many angles on art. But brevity was important here, and it seemed most important to indicate stylistic developments that make it possible to

understand a given period while leaving the path open to various interpretations. I know that I am hereby running counter to a tradition that, in the wake of Marxism, was very fashionable in Europe, especially Germany, and that is now resurfacing in the United States. But it is the nature of art to survive all fashions unscathed, at least intellectually.

The rejection of the myth of progress

One last comment should be added: readers often expect a history of art to be an edifying tale, the confirmation of age-old progress that culminates in the current "avant-garde." Even people who are unfamiliar with—or hostile to—Hegelian dialectics frequently cling to this reassuring idea. Alas, familiarity with art from many periods and many countries has never allowed me to embrace it.

The idea of progress in art already existed in ancient Greece, not without good reason. An increasing mastery of forms and techniques can be observed from archaic styles to the sculpture of Phidias. Subsequently, in the Roman era, the concept was apparently applied only to the past. It became meaningful once again with Giorgio Vasari, the Renaissance art historian who traced an evolution running from the barbarian period up to Raphael. But Vasari himself, by placing Raphael and Michelangelo at the summit of perfection—a level impossible to surpass—seems to have capped the idea of progress, consigning it to the past. It nevertheless emerged once again in Hegelian analyses. In step with the social utopias so dear to the nineteenth century, seemingly confirmed by wonderful developments in science and technology, the notion of progress often assumed the power of a credo.

Although usually a secular credo, it was carried to extremes of intolerance. Even beyond all Hegelianism there arose the notion of a "modern art" that was judged not on its merits but only on its "modernity," through the related notion of an "avant-garde" at the forefront of innovation. The fact that the "modern" quickly becomes passé and that the avant-garde slides ineluctably out of date hardly seemed to occur to people. This precisely betrays the illogic of all credos. We have now reached the stage where the "avant-gardes" of World War I are almost one hundred years old. But what is a one-hundred-year-old "avant-garde"? Does it still deserve preferential treatment?

It is possible, of course, to write a history of art based solely on the innovations that punctuated its evolution, one that would reveal

an effervescence of ideas and surprisingly precocious developments. That is not what I have written, however, because I feel that art's temporal dimension is infinitely more complex. It cannot be reduced to a series of "avant-gardes." Innovations merge with frequent returns to the past, periods of fermentation can be followed by lengthy stagnation, combinations constantly arise and dissolve, and geography can upset everything. It is this *multifarious temporal dimension* that I think it is most important to convey, even at the cost of much simplification and pruning.

I am trying to free our view of art from the abstractions arising from the preconceptions and pedantry of recent centuries. I want to return to the works themselves, and to our intuition when faced with them. I want to enable the works to speak directly. I am fully aware of the inadequacies of such a book, but will be satisfied if I manage, however slightly, to endow readers with a fresh eye once again.*

*Tradition calls for a bibliography to accompany such a book. But the subject stretches across almost five millennia, and the twentieth century has produced such a vast boom in art history that even citing only the most important books and articles would require at least another entire volume. For that matter, are there any "bad" books when it comes to art history? The most outdated and most tendentious usually demonstrate the approach typical of a given period and are for that reason worthy of interest, while recent, richly illustrated volumes contain so many new images that they are always fascinating.

I
ART'S EARLY MANIFESTATIONS

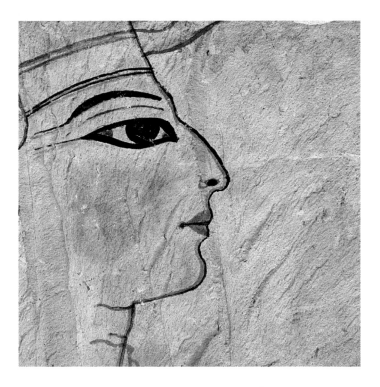

Egypt and the Near East

introduction

E gypt is one of the earliest civilizations known to us, for three specific reasons. Its hot, dry climate (now apparently drier than in antiquity) preserved what the dampness of other climates irrevocably destroyed. Its varieties of stone—sandstone, granite, porphyry—enabled ruins to survive to the present day, often with carvings and inscriptions nearly intact. And, above all, its religion assigned a key role to death. We remain ignorant of the long traditions, probably developed over many centuries of prehistory, that evolved into the complicated rites observed in pharaonic Egypt. Yet these rites fascinated all antiquity until they were eradicated by Islam, for they were organized not only around the problem of survival after death but also—what was rarer—the conservation of the body. The transformation of a body into a mummy and the care accorded to the tomb where it was laid to rest had no equivalent in other lands. Egyptian tombs thus became veritable Noah's arks. Despite all the pillaging, they have preserved objects, inscriptions, sculptures, and paintings that make Egyptian civilization seem very present, often leading us to believe—probably mistakenly—that we know it down to its tiniest details.

We should remain cautious: Egypt's large cities, prosperous and inhabited for millennia, were all destroyed along with their treasures, walls, ports, monuments, and everything related to daily life. We should not get carried away in our enthusiasm. The notorious pyramids, considered one of the seven wonders of the world even in ancient days, could be seen as a late expression of the prehistoric taste for everything colossal and outsized. While they might be masterpieces of architectural technology, the pyramids were never masterpieces of architecture. Egypt's true art must be sought in its temples, not one of which has survived intact. It must be sought among the thousands of statues and sculptures, most of them fragmentary. Paintings, meanwhile, are relatively rare and always subterranean, but their quality stirs the imagination as to what the secular painting of the day (now totally vanished) must have looked like. Egypt must nevertheless be credited with the enormous honor of having fascinated everyone for the past two hundred years—even today it remains the world's largest site of excavations. Egyptian writing, which had become unfathomable with the collapse of the ancient world, has now yielded up its secrets. The chronology and geography of Egyptian art has been reconstructed with ever-greater precision. And thanks to the discovery of royal tombs, we know that we possess some masterpieces of the highest quality, ones that have survived the millennia undamaged.

The Near East did not enjoy the fine unity that characterized Egypt and Egyptian history (one river, one ruler, one language, one religion). Archaeology has nevertheless brought to light traces of peoples no less ancient, and dynasties no less powerful, than those of the Nile Valley. It is now thought that the lands between the Tigris and the Euphrates emerged from the prehistoric period at about the same time as Egypt;

the discovery of some five thousand tablets in Uruk attests to the use of cuneiform writing in about 3300 B.C.E., roughly the same moment that Egypt mastered hieroglyphic writing (c. 3150 B.C.E.). The geographic isolation of the Nile Valley favored a relative cohesiveness, and thereby the swift rise of civilization and art. It would seem that the transition from prehistoric signs and symbols to distinct depiction occurred fairly quickly. In contrast, Mesopotamia was open on all sides, subjected to a turbulent history of constant invasions, rivalries, and quarrels that destroyed kingdom after kingdom. We have clues, and sometimes proof, of brilliant but often fleeting civilizations that predated the establishment of the Achaemenid Empire (550 B.C.E.).

It should also be noted that our knowledge of the Near East, during most of this period, remains dependent on excavated finds. Through tradition and necessity, however, builders in the Near East generally used simple mud bricks, so even when buildings were huge, they left few traces. Surviving vestiges of art are therefore few and far between. Would King Gudea seem such an important historical figure if he had had the idea of having his likeness sculpted in clay, rather than in blocks of diorite that easily survived the ages?

Hence there is little point in comparing the treasures of Egypt with what we know of Near Eastern art. Any parallel would be misleading due to problems of preservation and the limitations they place on our knowledge. Yet it is still worth taking a look at a bas-relief that shows King Sargon II conversing with a dignitary (page 17), which dates from a period for which we possess significant, well-preserved remains of illustrious origin. It adorned the Palace of Khorsabad and must therefore date from the late eighth century B.C.E. The relief, carved in alabaster, was probably once painted and displays great refinement by combining an overall sobriety with elaborate details. We might then turn to another large relief, a much earlier one from Egypt, found in the tomb of Seti I in Thebes (c. 1302–1290 B.C.E.). The beardless king, adorned with jewelry, is shown conversing with the goddess Hathor (page 16). The contrast is total. Obviously, images should not be over-interpreted, nor should symbols be exaggerated—the pharaohs, after all, were also formidable warriors, while Sargon had his own deities. Still, despite the two civilizations' shared conventions of artistic expression, it is hard not to feel that these were two totally opposed worlds.

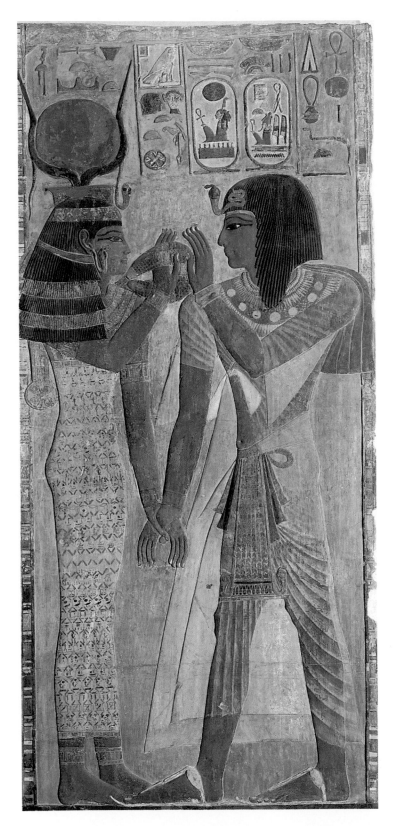

The goddess Hathor and King Seti I, bas-relief from the tomb of Seti I, Valley of the Kings, Thebes (Egypt), 19th Dynasty (c. 1303–1290 B.C.E.). Painted limestone, 7′4″ × 3′5″ (2.26 × 1.05 m). Musée du Louvre, Paris (France).

FACING PAGE
Sargon II and a high official, bas-relief from the palace of Sargon II, Khorsabad (Iraq), late eighth century B.C.E. Alabaster (gypsum). H: 10′9″ (3.3 m). Musée du Louvre, Paris (France).

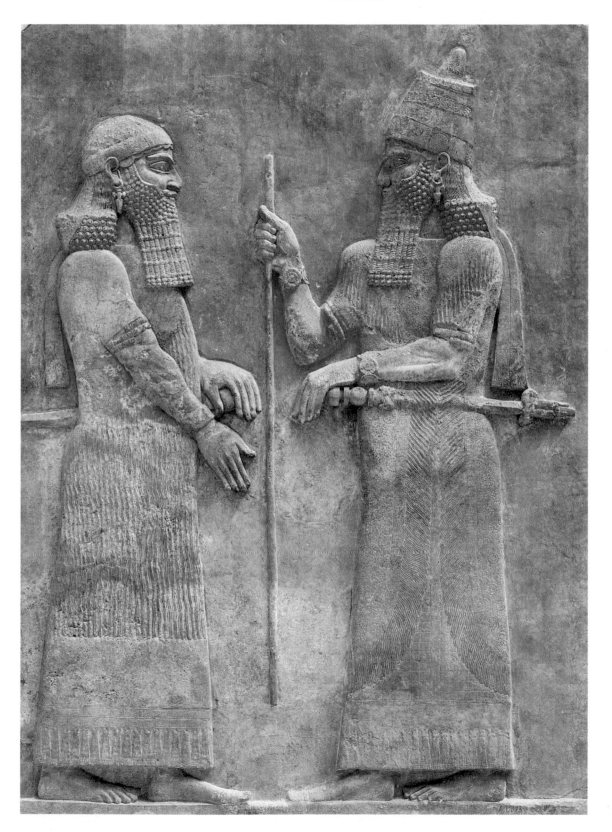

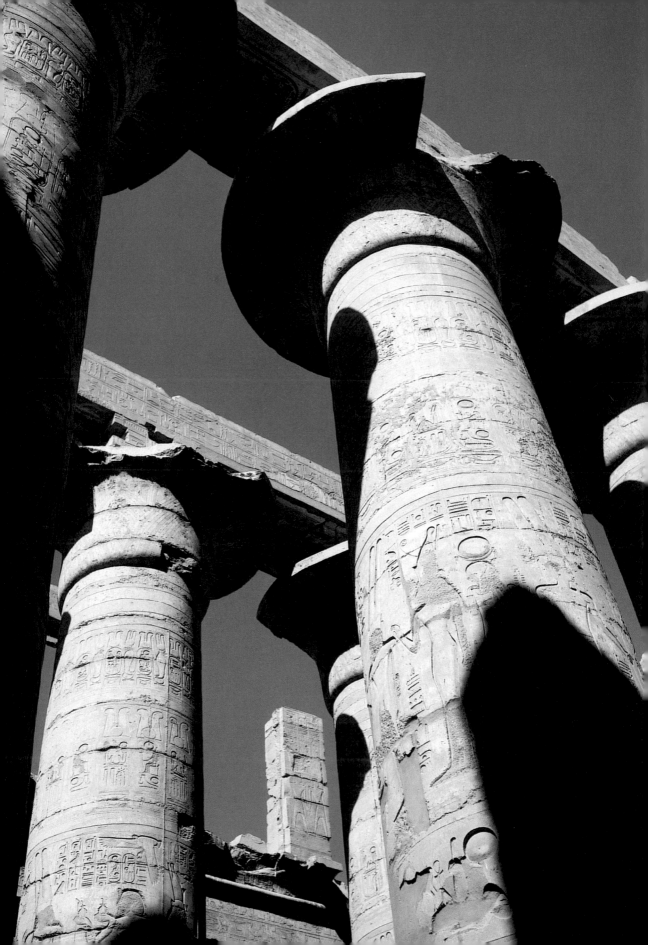

Architecture

EGYPT

The importance of religion in Egyptian life led to the construction of huge temples of stone. They were once so highly admired that the extraordinary monoliths of granite called obelisks, which stood at their gates, were sometimes transported to Rome—despite unsuitable religious inscriptions—to decorate the circuses there. Later, infinite care was expended in moving them to the main squares of the city. As late as the nineteenth century, when one of the finest obelisks was transferred to the Place de la Concorde in Paris, the task was still considered a technological feat.

Indeed, Egyptian temples belonged to the tradition of colossal architecture that included fields of monoliths and cyclopean walls of huge blocks. Soon, however, a feeling for art properly speaking emerged, evident in the proportions respected by architects and above all in the use of columns.

Ancient Egyptians frequently employed columns when building major edifices. Rarely made of a single piece of rock, each column would be composed of blocks of carefully cut stone, often carved with large figures or inscriptions. It was usually placed on a plinth that served as a base, and the upper part would be worked in such a way as to form a capital. Columns were theoretically designed to support the roof of the building, in which case, the shafts would be massive and arranged close together in order to bear safely the heavy loads of the stone lintels.

At an early stage, apparently, various types of column emerged. These were generally related to plants such as the lotus and papyrus, and it is tempting to view them as directly inspired by earlier constructions in wood. But we should be wary of all "evolutionary" doctrines (despite appearances, and despite eighteenth-century interpretations, Gothic columns were not derived from Druidic forests). It is by no means certain that the Egyptian columns that most resemble wooden architecture are the most archaic.

On the other hand, it is easy to believe that these columns reflected a desire to break with the crude massiveness displayed by pyramids and mastabas. Egyptian architects were seeking to impress the eye by a play of massive forms that subdivided the space and bore large figures and inscriptions to be glimpsed in the half-light that filtered through the shafts. This quest seems to have assumed various expressions. For example, the peristyle court of Ramses II at the

Columns with open-papyrus capitals, Hypostyle Hall, Great Temple of Amon, Karnak (Egypt), 19th Dynasty, reigns of Seti I and Ramesses II (1292–1213 B.C.E.).

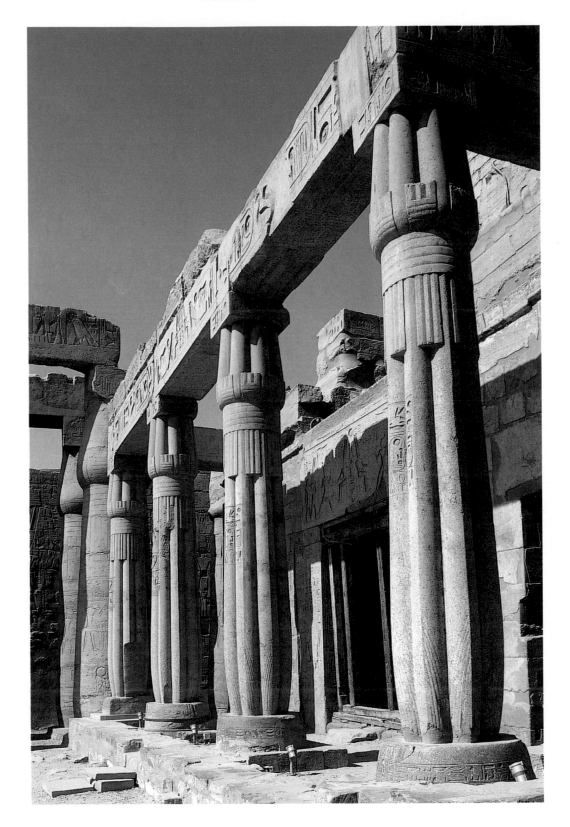

Temple of Luxor, founded in the reign of Amenhotep III (1390–1352 B.C.E.), is surrounded by rows of papyrus-bundle columns with bud capitals: the capital is formed of a closed bud and the shaft resembles a bundle of stems that bulge out from the base and are "tied" at the neck (page 20). These are the most elegant of all Egyptian columns, and the subtle design of the shaft, which simultaneously conveys weight and thrust, can be compared to the finest examples found in European Gothic art.

Adjoining the court is a colonnade, built by Amenhotep III, which consists of twin rows of powerful papyrus-bundle columns of the campaniform type, whose capitals imitate the open flower (page 21). A similar design can be seen in the large temple complex at Karnak, whose vast Hypostyle Hall, 338 by 170 ft. (104 by 52 m), dates back to Seti I, son of Ramses I, founder of the Nineteenth Dynasty (page 18). In the middle are two rows of papyrus columns some 73 ft. high (22.4 m.), also topped by open capitals. Along the sides, however, shorter columns bear closed capitals.

Egyptian columns could also take much simpler forms. Sometimes the round base, shaft, and flat capital were devoid of all molding, but the shafts would have fluted sides that lent them the name of proto-Doric (page 22). Such columns can be seen, for example,

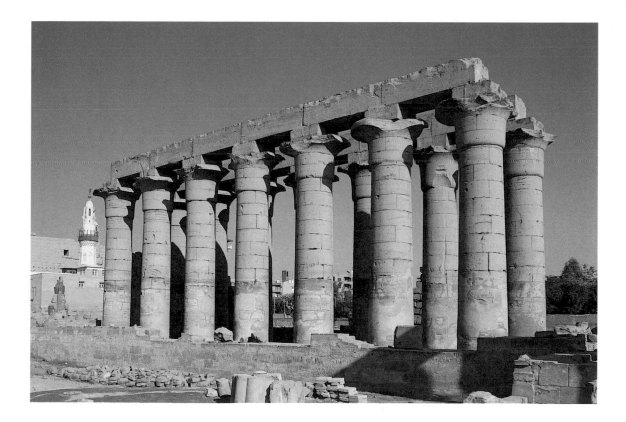

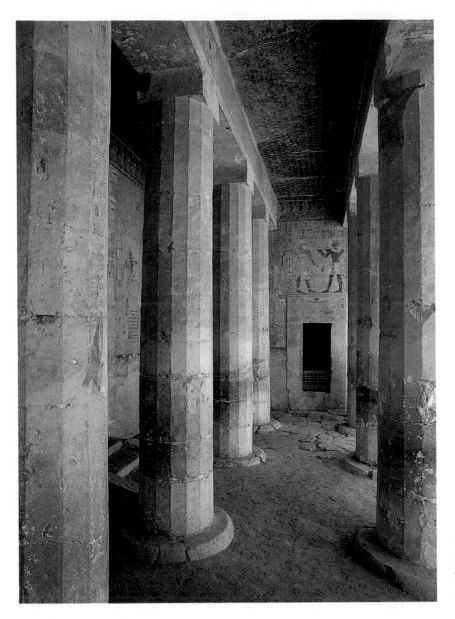

Faceted polygonal
columns, Anubis Chapel,
Temple of Hatshepsut,
Dayr al-Bahri (Egypt).

in tombs in the necropolis of Beni Hasan (Twelfth Dynasty, c. 1930 B.C.E.), both inside and out.

In contrast, other Egyptian columns frankly employ sculpture. On two or four sides of the upper section there may appear the face of the goddess Hathor, with her human face, cow's ears, and large wig (page 23). This approach was fairly common during the Middle Kingdom. To modern eyes, the presence of these faces disrupts the unity of the architecture, but it must not have done so in the eyes of the Egyptians, who often delighted in clothing bare columns with painted or carved decorations,

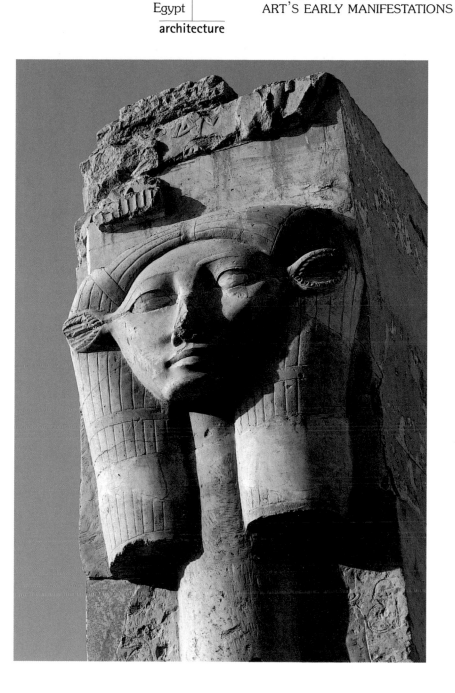

Hathor column, Temple of
Hatshepsut, Dayr al-Bahri
(Egypt), 18th Dynasty
(1478–1458 B.C.E.).

as seen in the Hypostyle Hall at Karnak (page 18).

Columns might also be employed for purely aesthetic reasons—in the necropolis at Amarna, for example, strange papyrus-bud columns with strongly bulging shafts were hewn straight from the rockface, and have no supporting function. Here we sense the creation of a "form" for the pure pleasure of playing with it. And this very form would play a capital role in all architecture down to the present day.

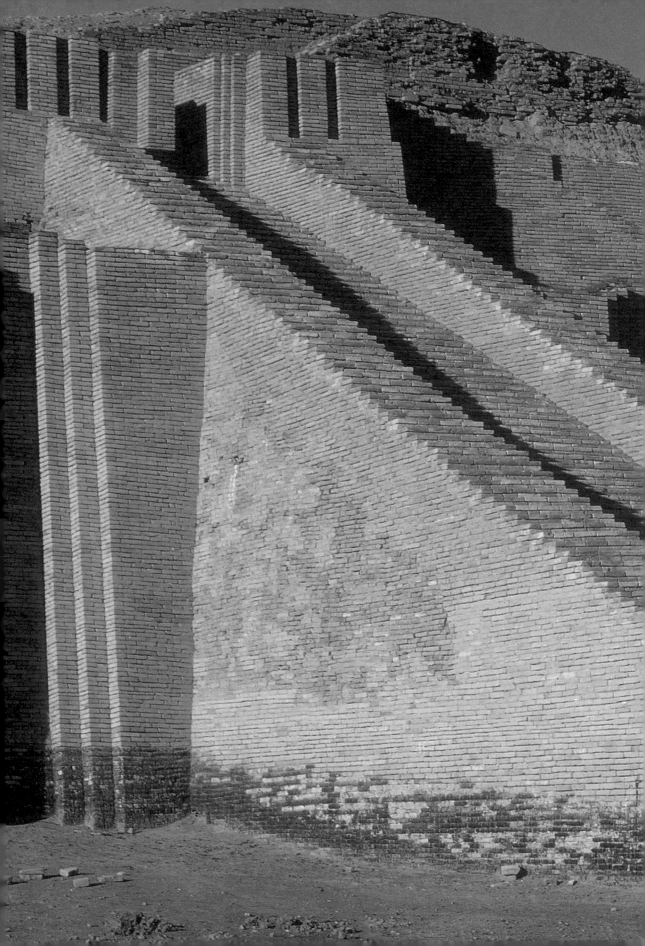

THE NEAR EAST

A proper discussion of Mesopo-
tamian architecture is scarcely
possible. Almost all ancient cities
there were razed several times, and
the actual locations of some of
them have not even been identified.
Others are known only through
excavations. Because buildings were
made of mud bricks or baked bricks,
the ruins could not withstand the
passing centuries. At best all that
remains is the ground plan, often
highly elaborate, and part of the
foundations; but our knowledge of
the elevations usually remains hypo-
thetical.

It can nevertheless be asserted
that the most distinctive innovation
was the ziggurat, as recorded in col-
lective memory in the form of the
biblical Tower of Babel. Unlike the
Egyptian pyramids, the ziggurat
was not a funeral monument, but
rather a stepped tower with a tem-
ple at the top. It represented one of
the last efforts, so typical of prehis-
tory and protohistory, to produce a
truly colossal construction.

One of the best-preserved ziggu-
rats, even though only the lower
level survives, is that of Ur, which
dates from the second millennium
B.C.E. Built of fired brick, its base
measures over 200 ft. long by
140 ft. wide (62 by 43 m), and it

probably had three levels. Access
was provided by three monumental
stairways that converge on a land-
ing located at the foot of the
second level. The central one, rela-
tively restored, is pictured here
(page 24). Nothing remains of the
second level except for remnants
of the brick mass. No trace
remains of the temple at the top,
dedicated to the god Sin. The pow-
erful, squat ziggurat at Ur is not
without similarities in spirit to the
Egyptian pyramids, although right
from the Babylonian period the
grand linear staircase was replaced
by a long, outer ramp that spiraled
up to the temple at the top.

Mesopotamian architecture also
placed great importance on fortifi-
cations, made indispensable by the
many battles and sieges that
occurred. Equally important were
the palaces, which from an early
date seem to have been vying with
each other to be the most magnifi-
cent. Those that have been exca-
vated—at Mari, Larsa, and Ashur—
suggest huge buildings designed to
host large events, yet their ground
plans also reveal a concern for a
certain level of comfort.

The aerial view of an excavation
site pictured here gives an idea of
the kinds of information that can

Ziggurat, Ur (Iraq),
second millennium B.C.E.

be gleaned from such sites (page 26). It shows the former city of Ugarit, which once thrived, thanks to its proximity to Cyprus and its location on the intersection of major trade routes. Excavated items have revealed the existence of eight different languages and five kinds of writing. Yet the site does not seem to have provided significant information about the city's art or architecture, despite the existence of a necropolis and a large royal palace.

What role could columns have really played in the development of architecture here, where they were so ill-adapted to local building materials? Later, columns would appear again, wonderfully developed, soaring some 65 ft. (20 m) high, topped by two levels of scrollwork and a large capital featuring two half-figures of bulls (page 27)—but this reappearance occurred at the palace in Susa at the time of Darius (522–468 B.C.E.), that is to say, during a period when syncretism made it possible to incorporate influences from Egypt and Greece into traditional methods.

FACING PAGE

Large capital with two half-figures of bulls, from the audience hall of the royal palace, Susa (Iran). Sixth-fifth century B.C.E. Gray limestone, 18′ (5.52 m). Musée du Louvre, Paris (France).

Ruins of royal palace and acropolis, former city of Ugarit (currently Ras Shamra, Syria). Fourteenth–thirteenth century B.C.E.

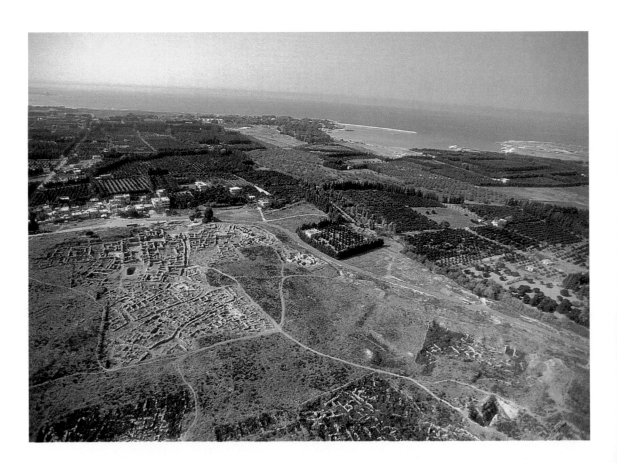

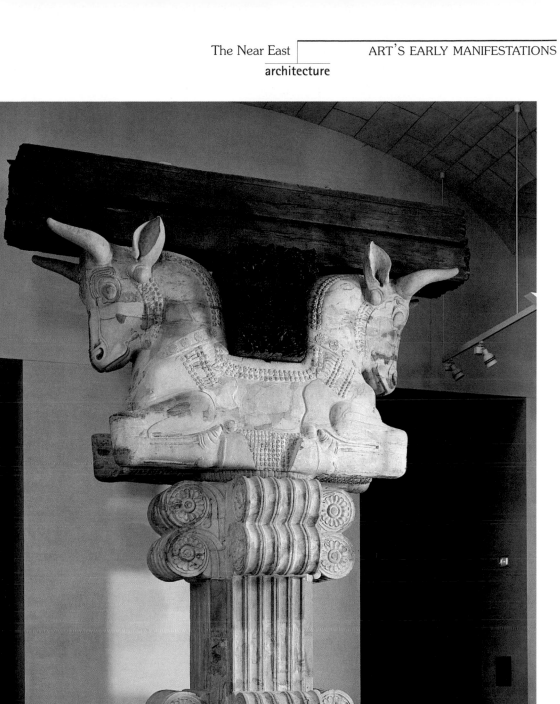

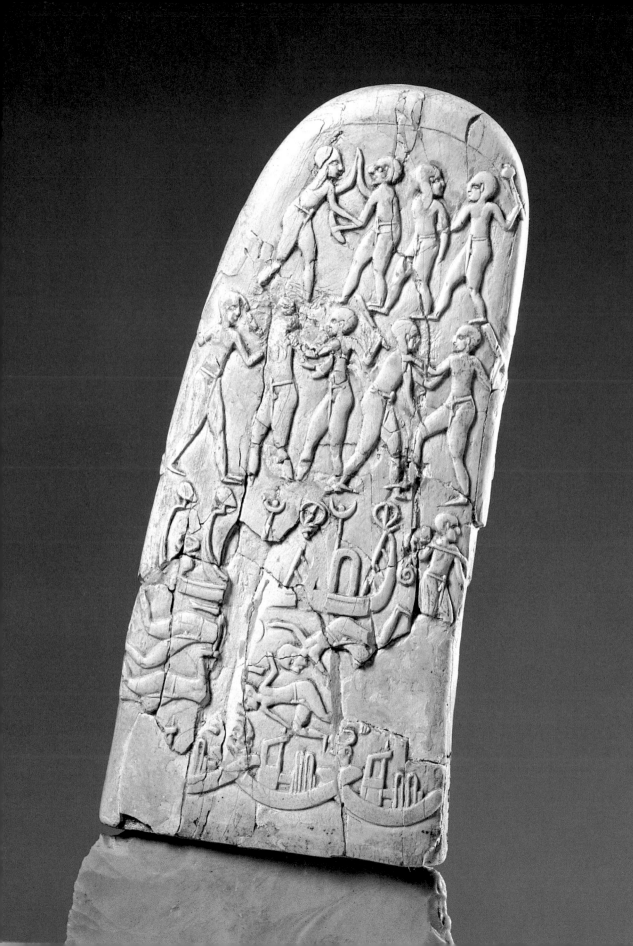

Sculpture

EGYPT

Sculpture is rightly considered to be the highest form of Egyptian art. Occasionally found intact in tombs, often highly mutilated when discovered in excavations, Egyptian sculpture, which ranges from fragile statuettes to colossi, from small freestanding figures to vast bas-reliefs, today represents one of the most astonishing riches to have survived. It includes items made not only out of durable materials such as pink granite and basalt, but also out of wood, terracotta, alabaster, sandstone, and even bronze.

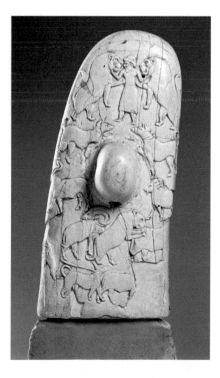

The two sides of the handle of the Gebel el-Arak dagger. Late predynastic period (c. 3150 B.C.E.). Blade of flint, handle of hippopotamus ivory, 10″ (25 cm). Musée du Louvre, Paris (France).

Not a single name of a famous sculptor has survived in written documentation; in any case, names without biographical details would be of little use. Egyptian sculpture has nevertheless been the object of enthusiastic study, and recent scholarship is now able to propose a plausible chronology. Describing all the stages of an anonymous art would be asking too much of this book, however, so emphasis will be placed instead on aspects that render Egyptian sculpture more than a mere object of archaeological scholarship, namely an art that speaks to all.

The earliest Egyptian sculpture to give the impression of being a work of art—rather than just a simple ritual depiction—is the Gebel el-Arak dagger handle (Louvre, Paris), which is dated to about 3150 B.C.E., toward the end of the predynastic period. The knife blade itself is a finely worked piece of flint, while the handle, carved in bas-relief from the ivory of a hippopotamus tooth, has the quality of great sculpture. The top of the front shows an "animal tamer," that is to say a man mastering two lions (page 29). It is quite similar to a motif often found in Mesopotamian art. The rest of the surface is covered with various, highly detailed animals whose proportions are

accurate and whose movements are remarkably expressive. The back shows an even more refined relief, depicting a battle that takes place on three levels (page 28). The sculptor's handling of the scene is surprisingly free and lively, and very different from the emblematic nature of most works from this period. This early, exemplary work is a foretaste of what Egyptian art would later become.

Age-old conventions

It would seem that a long evolution, highly specific to Egypt, slowly established and imposed precise conventions for statuary. A man had to be shown either standing, one leg slightly forward, or seated in a calm pose. He would be naked except for a simple loincloth knotted at the waist, and would wear a large wig. A woman would almost always be dressed from neck to calves in a close-fitting tunic that remains modest even as it reveals the body's curves; she, too, would wear a wig. These statues might be huge, life-size, or tiny. They were found in temples in large numbers. Furthermore, it would appear that individuals also adopted, at an early date, the habit of placing an image of the deceased person in tombs, even modest ones. The production of these statues, all different and yet based on a similar model, spanned a period of three millennia.

Fine examples can be seen in the three life-sized statues that have greeted visitors to the Egyptian rooms of the Louvre since 1837. Two almost identical ones show an Egyptian dignitary named Sepa, while the third is a woman called Nesa (page 31). The statues probably come from Saqqarah and date back to about 2670 B.C.E., during the Third Dynasty. The poses are very straightforward: the man takes a step with his left foot, as though walking. The woman, more reserved, stands still with her legs and feet together. The heads face forward, eyes wide open, mouths closed. The bodies are reduced to simple forms yet display supple modeling, except perhaps for the feet, lower legs, and the man's knee. These crude details in fact lend greater balance and power to the overall effect.

All these features can also be seen in a sculpted portrait of Ramesses II, which displays the additional refinement to be expected from an artist in royal service (page 33). Now in the Museo Egizio in Turin, Italy, it originally came from the temple at Karnak and must have been produced much later, around 1270 B.C.E. Here the black granite afforded the possibility of an artful sheen, while the hands and feet were treated with greater care. Ramesses is shown seated on his throne, wearing a pleated gown; the artist used the pleats to animate the surface of his sculpture, while managing to convey the modeling of the king's body beneath the fabric. Here there are effects that call to mind the art of metalworking (although nothing has survived, prior to this date, of Egyptian sculpture in

Statues of Sepa and Nesa, 3rd Dynasty (c. 2670 B.C.E.). Painted limestone, 5′ (1.54 m), 5′6″ (1.69 m), and 5′6″ (1.69 m), respectively. Musée du Louvre, Paris (France).

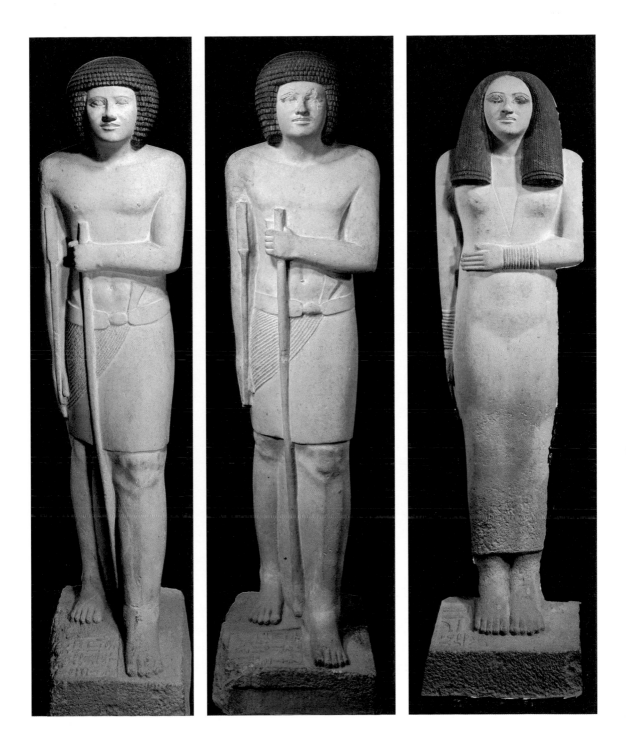

bronze). These differences aside, this work, despite being produced fourteen centuries later, differs little in spirit from the three statues in the Louvre.

The extent to which this art could combine simplified volumes and pure forms with a certain stiffness of pose and aloofness of feeling can be judged from the numerous heads now detached from their bodies and housed in museums. Their beauty lies in their ability to forge an alliance between divine radiance and a kind of humanist truth. The head of Amenotep III now in the British Museum (page 32) was probably sculpted around 1360 B.C.E. and once topped a colossus some 30 ft. high (9 m). The king has strikingly harmonious features—everything is serene and confident. His almond-shaped eyes match the slight smile on his lips, evoked in a refined yet unaffected manner. Here we already sense the mystical sweetness that would one day light up the features of certain statues of Buddha.

Realist inspiration

It would nevertheless be misleading to regard this hieratic quality as the defining feature of Egyptian statuary. Of course, this quality was indeed present, and the religious inspiration behind it lasted until Egypt succumbed to Islamic iconoclasm. Despite a common misconception, however, many works demonstrate that Egyptian sculptors could move comfortably from the divine to the real, yielding surprising changes in register. The same artist—or same team—often seems to have handled with equal ease lifelike portraiture, theological subject-matter, and traditional canons, descriptions of everyday life and evocations of the otherworld. Such versatility presupposes both a strong traditional training and an

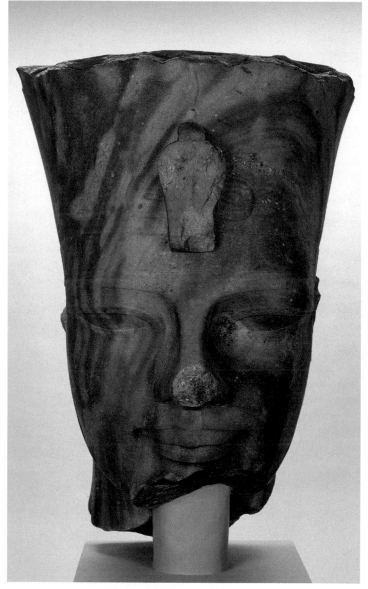

Head from a statue of Amenhotep III, 18th Dynasty (c. 1360 B.C.E.). Brown quartzite, 4'3" (1.31 m). British Museum, London (England).

Seated statue of Ramesses II,
Karnak (Egypt), 19th Dynasty
(c. 1270 B.C.E.). Granite,
6´4˝ (1.94 m).
Museo Egizio, Turin (Italy).

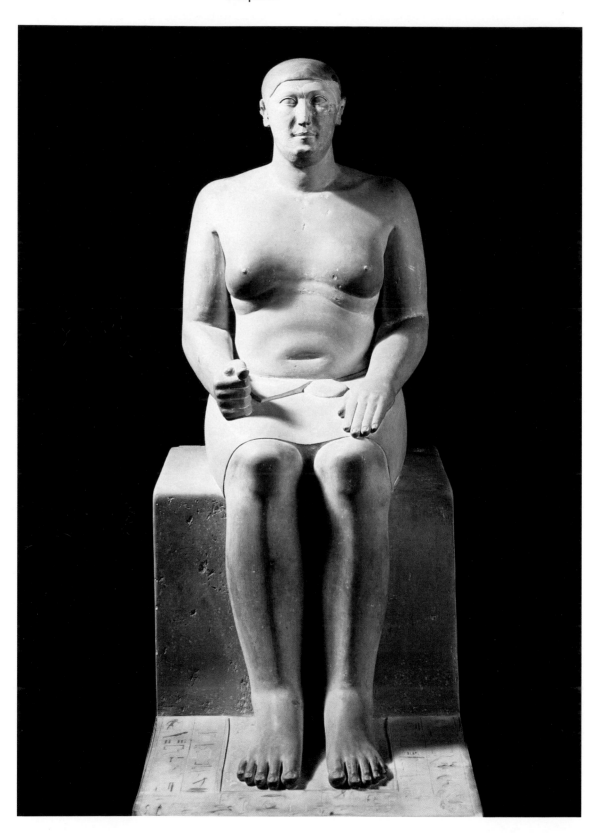

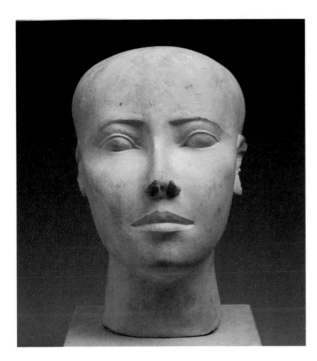

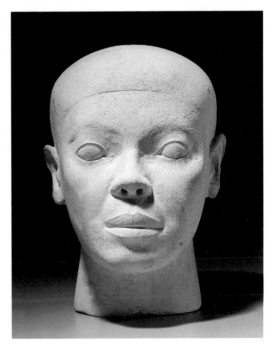

Reserve heads,
4th Dynasty, reign of Khufu
(c. 2585–2525 B.C.E.).
Limestone, H: 9″ and 12″
(23 and 30 cm). Museum
of Fine Arts, Boston
(Massachusetts).

FACING PAGE

Statue of Vizier Hemiunu,
4th Dynasty, late
in the reign of Khufu
(c. 2580 B.C.E.). Limestone,
H: 5′ (1.56 m). Roemer
und Pelizaeus-Museum,
Hildesheim (Germany).

agile eye, skilled at both direct observation and innovation. Few other periods of antiquity were able to unite these two facets of creativity, whereas Egyptian art displayed this freedom at an early date.

Indeed, it is hard to ignore the secular inspiration behind certain statues, even those that come from tombs. When artists were not faced with a monarch, but instead were depicting a civil servant, they could show sensitivity to his personality. This can be seen in a statue of the vizier Hemiunu, who oversaw the construction of Khufu's pyramid (page 34). The life-size portrait probably dates from around 2580 B.C.E., and was carved from limestone. The face was damaged prior to being rediscovered; it must once have been painted, its eyes set with crystal and gold. As usual, the volumes of

the sitter's body are strong and simple, yet the artist blithely depicted the obesity of this high court official, who was apparently charged with important duties. His thick, oily flesh, his swollen breasts, and his pleated navel are features that sculptors usually seek to disguise, at least when it comes to nudes.

Similarly, sculptors were often attentive to race. Egypt was composed of various peoples with diverse facial features, as interestingly exemplified by a set of sculptures called "reserve heads." The purpose of these heads, which date from the Fourth Dynasty during the reign of Khufu, has been extensively debated but remains uncertain. There is no room to go into details here, but what is important to note is the surprising spareness of these works (page 35). The head

on the left is a perfect oval with a long, straight nose and even lips. The head on the right, with its broad nose and thick lips, is certainly a Nubian subject, and remarkably is handled without the least hint of caricature (as frequently occurred in relief carvings of battle scenes), instead displaying the same idealized purity as the former.

As the statue of Hemiunu suggests, Egyptian sculpture, which seemed oblivious to the passing of time, was sensitive to the age of individuals. This is evident in the two statues of Tjeti, chancellor to the king of Lower Egypt, dating from the reign of Pepi I or Merenre, that is to say around 2339–2292 B.C.E. (page 36). Both statuettes are of wood, and are approximately 2½ ft. (75 cm) high. One is held by the British Museum and shows an erect, thin young man, head held high and completely nude (which proves that Egyptian sculpture was familiar with the heroic nude as later found in Greece). The other, in the Louvre, displays thicker forms, a face with rounded cheeks, and a thick neck; this time, the chancellor is wearing a long loincloth with belt and front panel.

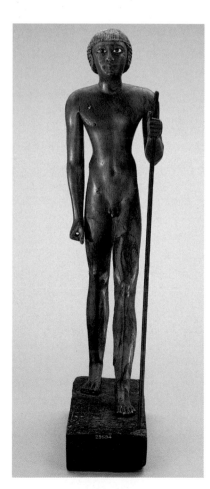

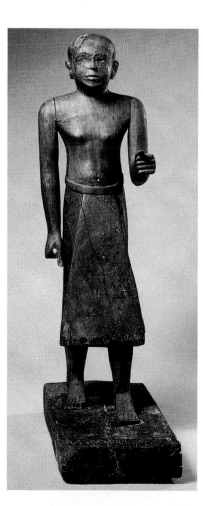

FAR LEFT
Statue of Tjeti as a young man, 6th Dynasty, reign of Pepi I or Merenre (2339–2292 B.C.E.). Wood, H: 2′5″ (75 cm). British Museum, London (England).

LEFT
Statue of Tjeti as an old man, 6th Dynasty, reign of Pepi I or Merenre (2339–2292 B.C.E.). Acacia wood with traces of painted stucco, H: 2′6″ (79 cm). Musée du Louvre, Paris (France).

FACING PAGE
Anonymous couple, perhaps from Saqqarah (Egypt), Old Kingdom (c. 2500–2350 B.C.E.). Acacia wood, H: 2′3″ (69 cm). Musée du Louvre, Paris (France).

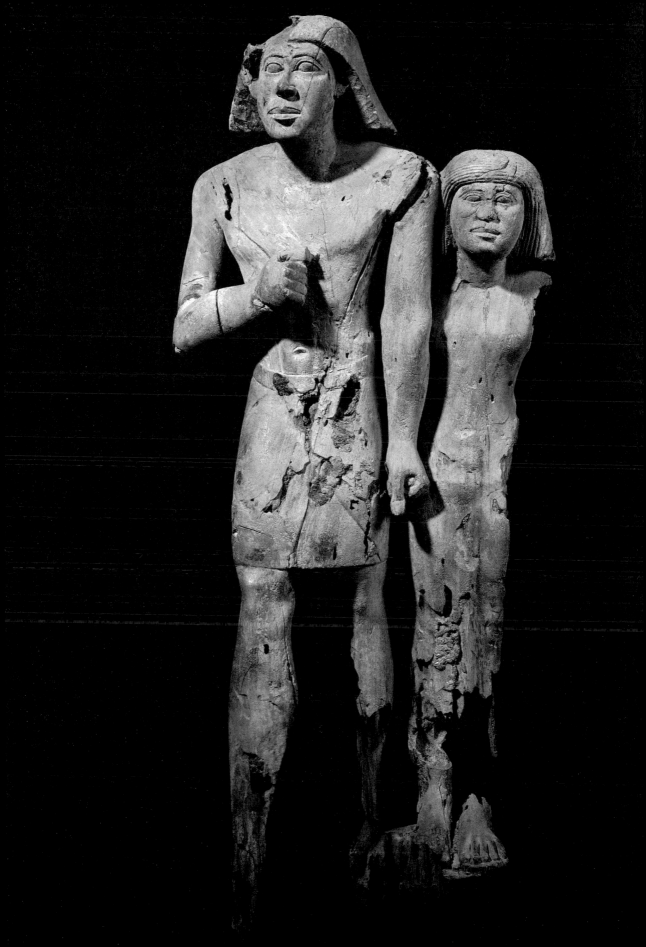

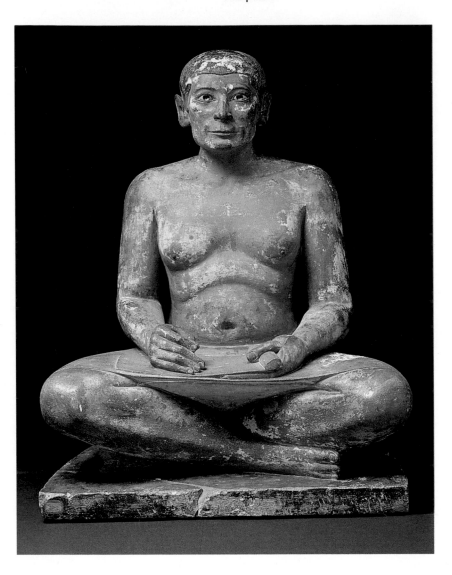

Clearly then, artists were able to feel and convey the inner life of a sitter and were able therefore, at an early date, to free themselves from restriction to a stereotype. A small *Couple* in the Louvre (c. 2500–2350 B.C.E.), also carved of wood, introduces a kind of dynamism and realism into the stereotypical image of a man and wife that completely breaks with convention (page 37).

The same is true of the famous *Seated Scribe* in the Louvre, discovered in 1850 by famous French Egyptologist Auguste Mariette (page 38). The sculpture has retained much of its original coloring, as well as the rock crystal set in its eyes. The lack of wig, the arms hanging free from the body, and the nudity interrupted only by the loincloth and papyrus scroll all lend this figure a singular presence.

Seated scribe, Saqqarah (Egypt), 4th or 5th Dynasty (c. 2620–2500 B.C.E.). Painted limestone, alabaster, and rock crystal, H: 1'9″ (53 cm). Musée du Louvre, Paris (France).

And it is immediately apparent that the sculptor deliberately opted for this realistic effect by stressing the scribe's somewhat sagging breasts, paunched belly, sunken navel, pronounced cheekbones, square chin, and thin lips. If this statue is correctly dated to the Fourth Dynasty (c. 2620–2500 B.C.E.), as has most recently been suggested, then it is clear that this interest in individual portraiture is not the product of later evolution but reaches back to the very roots of Egyptian art.

Interest in everyday life

To get a better idea of Egyptian artists' interest in the external world, we have to turn to the technique of bas-relief carving. The walls of tombs are often covered with scenes sculpted in very low relief, which may or may not be highlighted with paint. Stylistic conventions were maintained down through the centuries: figures were depicted in profile, their feet set along the same line; scenes were divided into several vertical registers; any sense of depth was banished. Yet within these narrow limitations there existed a striking curiosity about things that largely transcended religious concerns—or, rather, employed every excuse to escape those concerns. Everyday life acquired a right to exist here in

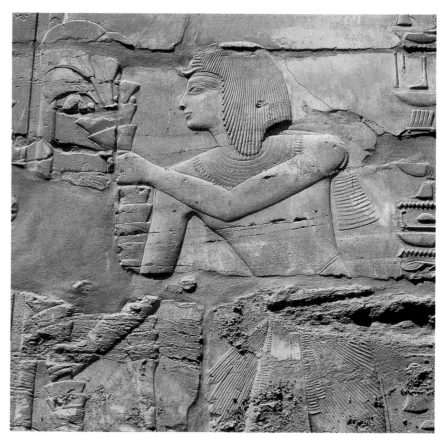

Seti I presenting an offering of flowers, bas-relief, Great Temple of Amon, Karnak (Egypt), 19th Dynasty (c. 1280 B.C.E.). H: approx. 6′ (2 m).

the form of farming scenes, sundry animals, and even vegetation. Everything was depicted with remarkably acute drawing.

A fragment such as *Seti Presenting an Offering of Flowers* illustrates the refined curves and precise chisel-work typical of these wall carvings (page 39). The viewer is no longer aware of conventions when admiring this sensitive profile and the skill with which the artist has conveyed the roundness of an arm or the hollow of an armpit while scarcely abandoning the flatness of the surface. Such dexterity made it possible to combine direct observation with traditional subject-matter, as seen in an early Sixth Dynasty panel of a cowherd crossing a ford while the new-born calf on his shoulder turns back toward its mother (page 40), or in a Fifth Dynasty scene of hunting ibex with a lasso (Metropolitan Museum of Art, New York). There is even a hint of humor in an early Sixth Dynasty fragment showing five donkeys near a field of wheat: one of them takes advantage of the halt to graze, while the others, all drawn from life, each wear a different expression (page 41). The work, etched in very light relief with a free point, is simply highlighted with subtle coloring that sets off the motif even as it artfully avoids areas such as the ears and noses of the donkeys and the tips of the stalks of wheat.

Such work can only be fully understood by studying ostraca: simple shards or flakes of stone that served as a kind of sketchbook for artists (both sculptors and painters). Ostraca display the same

Peasants driving cattle and fishing, tomb-chapel of Niankhnesut, Saqqarah (Egypt), early 6th Dynasty, reign of Teti (2350–2200 B.C.E.). Painted limestone, 19 × 30″ (48 × 78 cm). Detroit Institute of Arts, Detroit (Michigan).

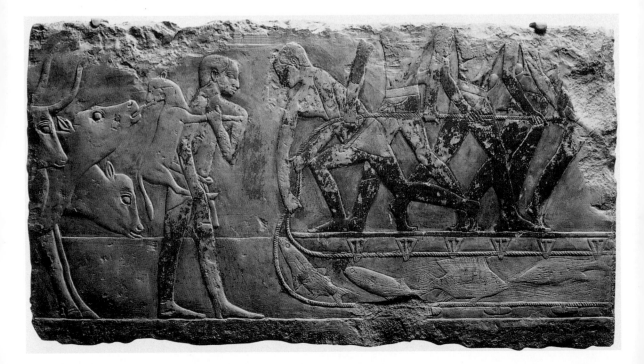

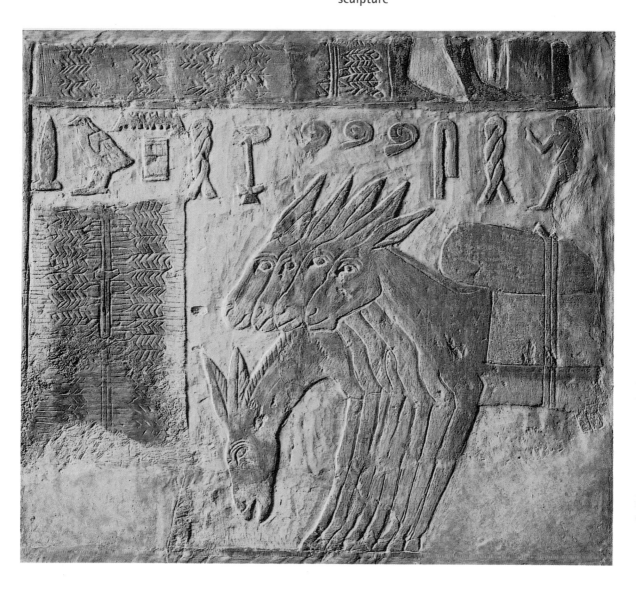

Donkeys in harvest scene,
Saqqarah (Egypt), late
5th– early 6th Dynasty
(c. 2350 B.C.E.). Painted
limestone, 17 × 19˝
(42 × 47 cm). The Ruben
Wells Leonard Fund,
Royal Ontario Museum,
Toronto (Canada).

mocking tone and free drawing seen in these reliefs. Above all, however, we must not overlook all the little statuettes placed in tombs, thereby bringing street life into sepulchers: a brewer glazing his earthenware jar, a butcher tying up his beasts, a miller grinding wheat. The modeling is often crude, the expression more or less caricatured—but here we are dealing with art for the common people.

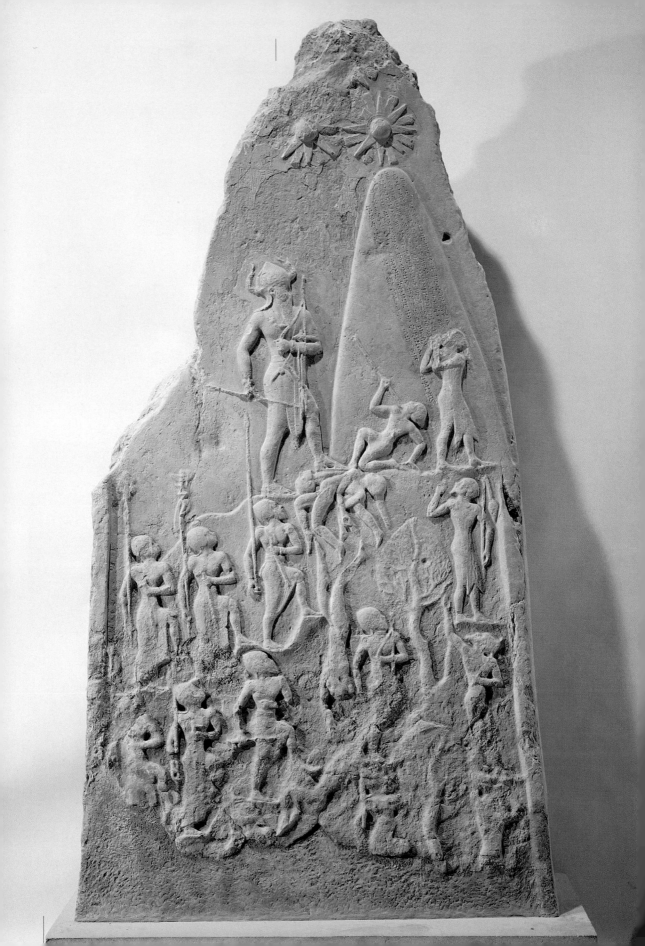

THE NEAR EAST

It should be acknowledged from the outset that Mesopotamian sculpture is disappointing. Compared to Egyptian sculpture, it seems to have been late in blossoming, monotonous in inspiration, and usually poor or awkward in execution. And yet for museum visitors it offers a fascinating glimpse of the early days of artistic expression, showing how art moved away from prehistoric and protohistoric depictions. It can stir the imagination concerning the various civilizations it represents and the bloody conflicts it records. Masterpieces, however, are few and far between.

From Mari to the Akkadian kingdom

True enough, an alabaster statuette of a high official named Ebih II (c. 2400 B.C.E., page 44), found in the excavations at Mari, is appealing for the delicate modeling of the arms, the decorative handling of the beard and the *kaunakes* (tufted sheepskin skirt), and debonair expression on the face, whose eyes are set with shell and lapis lazuli. Yet however outstanding this example may be, it remains very close to archaic idols.

The earliest surviving monument in which Mesopotamian sculpture seems to fully transcend the conventional ornamentation and depiction of deities is probably the large triumphal stele erected by Naramsin, who led the kingdom of Akkad to victory (page 42). Now in the Louvre, dated to around 2230 B.C.E., the stele was discovered at Susa, where it was probably taken as booty. Bearing a lengthy inscription, it shows the king climbing a mountain, accompanied by his soldiers on two sloping angles that suggest an ascent. He carries a bow and quiver, and his foot rests on a pile of naked corpses. In front of the king, one warrior has been felled by a spear while another, fleeing, turns back with a beseeching, terrified gesture. Everything points to a highly elaborate depiction in which authentic narrative gains ascendance over symbolism: the mountain and the tree flanked by soldiers suggesting a real landscape; the dying man in the middle falling headlong as though plunging into a ravine; the division of the composition into two zones, one full of movement and the other—against which the king is set—conveying calm.

The days of King Gudea

From the ruins of the veritable empire forged by Naramsin would rise the Sumerian state of Lagash,

Naramsin's victory stele, Susa (Iran), c. 2230 B.C.E. Pink sandstone, H: 6′10″ (2.1 m). Musée du Louvre, Paris (France).

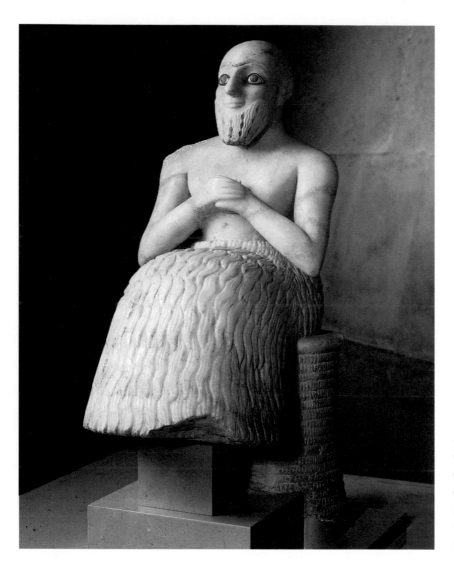

Statue of Ebih II, Temple of Ishtar, Mari (Syria), c. 2400 B.C.E. Alabaster, eyes of shell and lapis lazuli, H: 20" (52 cm). Musée du Louvre, Paris (France).

consolidated by King Gudea, who came to power around 2125 B.C.E. Gudea restored economic prosperity to the city, rebuilt temples, and had many statues made of himself. These surprising figures, with their squat dimensions and fixed expressions, are a long way from the refinement of Egyptian sculpture. They are nevertheless impressive for their simple forms and their volumes, which appear simultaneously crude and skillful. An example like the *Anepigraphic Gudea*, an inscriptionless standing figure of Gudea, was carved in polished diorite in such a way as to retain just the key aspects of the body's volumes, yielding a work that, despite its coldness, bears the hallmarks of a masterpiece (page 45).

The revival of Susa

Gudea died, the brilliance of Lagash faded, and a veritable empire began

FACING PAGE

Anepigraphic Gudea, Lagash, 2nd Dynasty (c. 2150 B.C.E.). Diorite, H: 3′6″ (1.07 m). Musée du Louvre, Paris (France).

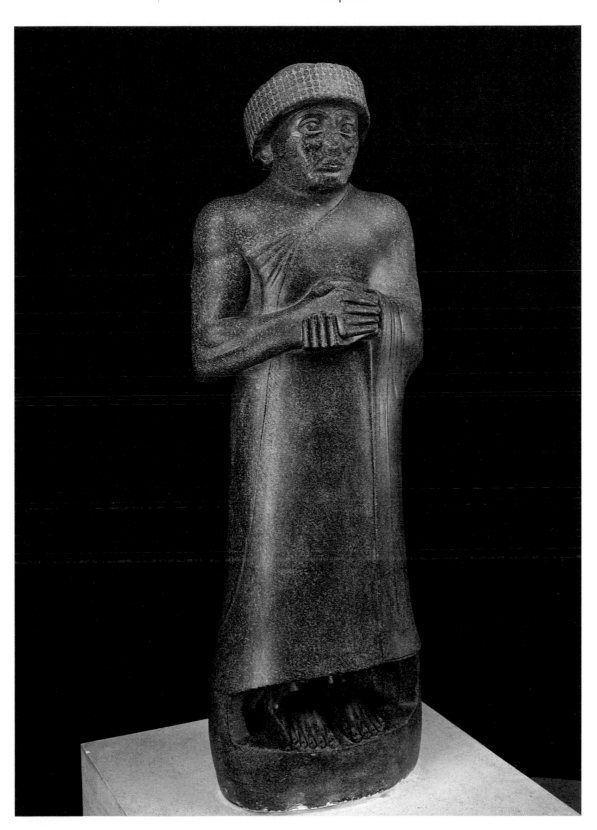

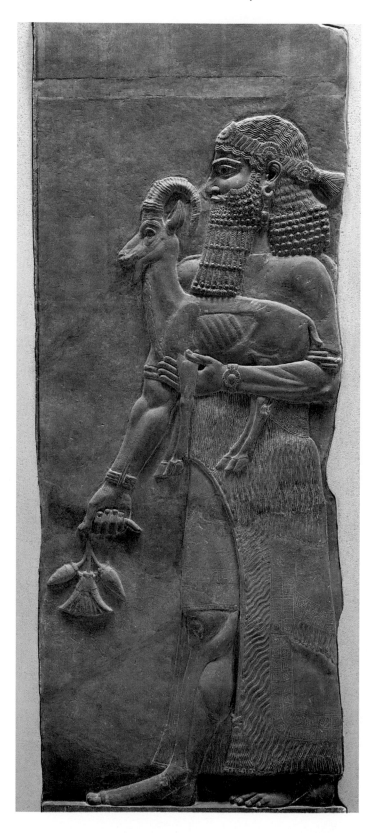

to form around the old city of Susa. But the crisis that historians believe afflicted the entire Near East around the end of the third millennium B.C.E.—invasions by new peoples, multiple wars, fragmentation of power—hardly seemed conducive to the emergence of a dazzling new art. It was only when Assyria had firmly established its military and economic power, when its monarchs reigned from the Persian Gulf to the shores of the Mediterranean, that a confident art could rise once again.

Times had changed. Repeated expeditions by pharaohs keen to lay their hands on the wealth of the East had brought familiarity with glamorous Egyptian art to Mesopotamia. Trade links had been established with Phoenician cities. Massive deportations of populations, spurred simultaneously by concerns for military security and a need for labor, supplied the Assyrian Empire with artists and craftsmen from highly varied backgrounds. Thus a kind of syncretism gave birth to a sculptural art that would cover palace walls with bas-reliefs, as seen successively in the palaces built in Nimrud by Ashurnasirpal (883–859 B.C.E.), in Khorsabad by Sargon II (721–705 B.C.E.), and in Nineveh by Sargon's son and successor, Sennacherib (704–681 B.C.E.).

Well-preserved and particularly imposing remnants of these decorative schemes have survived. The winged bulls with human heads (Louvre), positioned to guard the gates of the palace of Khorsabad, seem to reflect, on a giant scale,

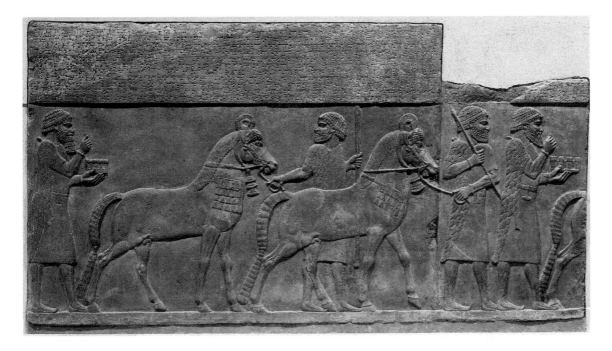

Procession of Median tribute-bearers, bas-relief from the palace of Sargon II, Khorsabad (Iraq), 721–705 B.C.E. Alabaster (gypsum), 5′3″ × 11′11″ (1.62 × 3.66 m). Musée du Louvre, Paris (France).

FACING PAGE

Man offering a ram, palace of Sargon II, Khorsabad (Iraq), eight century B.C.E. Alabaster (gypsum). Musée du Louvre, Paris (France).

motifs that were deeply rooted in Mesopotamian tradition. But the large alabaster panels on the walls, glorifying the military accomplishments of the Assyrian dynasty such as *Servants Bearing the Chariot of Sargon II* (Louvre) or the *Procession of Median Tribute-Bearers* (page 47)—clearly derive from Egyptian art: head and legs are shown in profile; the relief is low, but features detailed hair, beards, and dress in a decorative spirit that would have been heightened by the coloring that is not longer extant. There is also a comparably skillful accuracy in the rendering of animals, especially horses with their harnesses.

A slab showing a man with a young ram in his arms (page 46) artfully represents the old theme of making an offering. The artist displayed genuine sensitivity in his depiction of the alert young animal

with its dangling legs, and he varied the surface by means of the curls of the man's hair and beard, and the various pleats of his tunic. Although this courtly art displays a certain conventionality in its precise chronicling of events and its attentiveness to the tiniest details, it still manages to convey both grandeur and variety.

The decorative carving from Nineveh displays a very similar style, if less majestic and more picturesque. On one plaque in the Louvre showing King Ashurbanipal (668–629 B.C.E.) standing in his chariot, the sculptor attempted to suggest five successive planes within the flat bas-relief: a guard and an attendant, the wheels of the chariot, the body of the chariot with two servants in the rear, the man leading the chariot, and finally the king who dominates the entire group. The scenes of the deportation of the

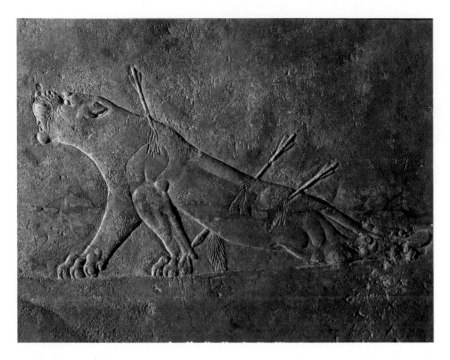

Wounded lioness, Nineveh (Assyria), seventh century B.C.E. Alabaster (gypsum), 3′11″ × 5′3″ (1.2 × 1.6 m). British Museum, London (England).

Elamites (Louvre) are perhaps less skillful, but display an unexpected vividness and sense of humanity. The images of unfortunate men setting off with wives and children, on foot or in carts, or eating in their camps seem to have a documentary quality of historic value.

And yet these figures' profiles are still ungainly, their arms thick, their hands stubby; on studying this art, the viewer begins to long for the incomparable elegance of Egyptian bas-reliefs. But we should be careful not to take such comparisons too far—even if Nineveh had bequeathed us only the famous *Wounded Lioness* now in the British Museum, it would still merit its place in the history of art. The lioness comes from one of the hunting scenes that, along with battle scenes, decorated the walls of the palace. She has just been hit, her hind legs paralyzed by two arrows in the lower spine (page 48). Never before had visual expressiveness been so well combined with observation. The artist gave higher relief to the motionless hind legs on the ground, as well as to the enormous, tense forelegs where all the great beast's impotent rage can be felt. The body is sketched in a long curving line that starts from the ground and climbs to the tip of the lion's muzzle with a firmness, precision, and sensitivity that only highly subtle modeling could impart.

From the Babylonian empire to the days of the Achaemenids

The vast Assyrian Empire, threatened from all sides, would collapse in the space of four years (616–162 B.C.E.). It was succeeded by the Babylonian Empire (612–539 B.C.E.),

itself swept away by the Achaemenids, who first chose as capital of their immense territory the ancient city of Susa and then moved to glittering Persepolis, built by Darius. Within all these political and economic upheavals, the Assyrian artistic heritage, far from being reduced, was carefully nurtured by magnificent monarchs and major builders. But it developed in an environment increasingly marked by syncretism, in which local traditions were more and more influenced by Greek and Egyptian models. One of the contributions of the Babylonian and Persian empires seems to have been the use of bricks glazed with permanent colors, replacing the alabaster reliefs whose coloring was obviously subject to much deterioration, especially the sections exposed outdoors. Fine remnants of these large brick decorations have survived, notably in museums in Berlin, London, and Paris (page 49). The use of glazed brick certainly rejuvenated the decorative effect, but it seems to have stiffened draftsmanship and induced a repetitiousness in which the inventive spirit of previous centuries was steadily lost.

The archers of Darius, bas-relief from the royal palace, Susa (Iran), c. 500 B.C.E. Glazed bricks, H: 6'6" (2 m). Musée du Louvre, Paris (France).

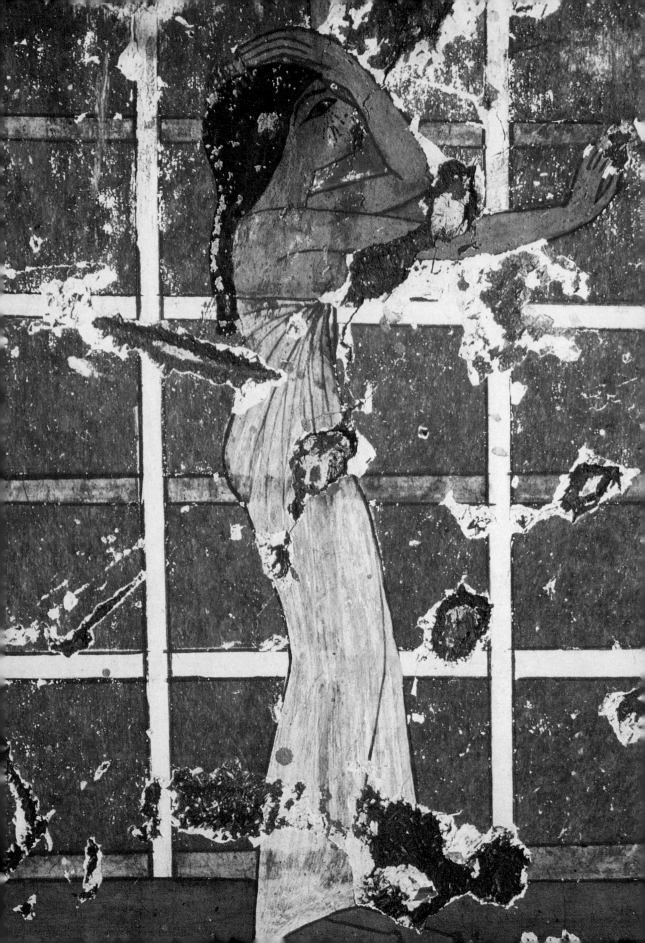

Painting

EGYPT

Less is known about Egypt's painting than its sculpture. Although painting must have played a crucial role in palace interiors, almost nothing has survived. It would certainly have featured in temples, too, but all vestiges have disappeared. In tombs, designed to remain sealed forever, painting was probably little more than a decorative feature, yet it is here, thanks to surviving fragments, that we can gain some idea of its qualities.

We can ignore the coloring of statues, which was done in a simple way that followed rather impoverished conventions. We can also ignore the painted highlights on bas-reliefs, which, though probably closely related to paintings, played a secondary role to the carving in such works. We are thus obliged to turn to the record left by tomb paintings, which are extensive in number and variety. Many evoke the mysteries of the afterlife, yet however interesting they may be, they are not always of great artistic quality. Here, too, Egyptian artists seemed more comfortable with scenes drawn from everyday life. Mention has already been made, in the context of sculpture, of the many ostraca—shards of stone on which artists made their sketches—found in large quantities, notably in the great pit at Dayr al-Madinah.

These ostraca display a surprising freedom of observation, which, of course, we would not expect to find in tombs. And yet painters, like sculptors, often seized any good opportunity. Consider the mourner painted on stucco (c. 1370 B.C.E.), in the tomb of Nebamun and Ipuky in al-Khukhah (page 50): dressed in gray, the figure stands out against a red ground, sectioned into large squares by alternating white and yellow-brown bands that fill the composition. The harmony of colors is both rich and subtle, while the curves of the body and clothing contrast skillfully with the straight horizontals and verticals of the background.

This painting might be compared with another scene of mourners found in Thebes (modern day Luxor), in the tomb-chapel of the vizier Ramose, dated to around 1360 B.C.E. (page 52). This time, color is secondary; the faces and flesh are painted in ochre, the wigs in black, and the dresses in the same white as the background. But the artist breaks the uniformity with surprising skill by placing an entirely naked little girl in front. Set against the curtain of white dresses, she stands out from the other, older women, which enabled the artist to arrange harmoniously the patches of black

Mourning before the coffin (detail), tomb of Nepamun and Ipuky, al-Khukhah (Egypt), 18th Dynasty (c. 1370 B.C.E.). Paint on stucco, 11 × 8″ (27 × 20 cm).

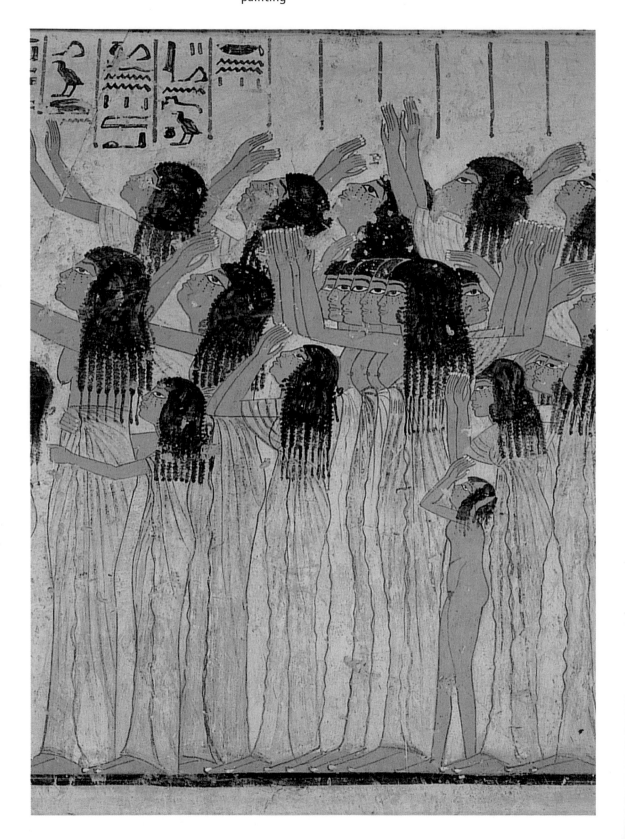

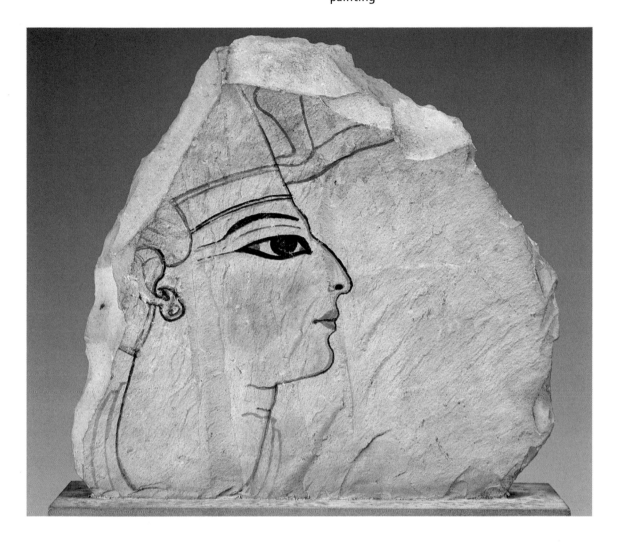

Sketch of a royal portrait on an ostracon, New Kingdom (c. 1555–1080 B.C.E.). Painted limestone flake, H: 8″ (21 cm). Musée du Louvre, Paris (France).

FACING PAGE

Funeral procession, tomb of Vizier Ramose, Thebes (Egypt), 18th Dynasty (c. 1360 B.C.E.). Paint on stucco.

hair along the upper part of the composition. Above all, the stiff and conflicting lines that represent the gesture of lamentation are brilliantly countered, in an ingenious touch, by the trembling black locks of hair and the shuddering verticals of the long white dresses.

Many other examples of Egyptian painters' decorative instincts can be found. Proof that their confident hands were equal to those of sculptors can be seen in an outstanding ostracon now in the Louvre (page 53). It contains a sketch of a

royal portrait, and would seem to have been done by an artist during the period of the New Kingdom. He used just one brush loaded with red pigment and one loaded with black. Sometimes the red line appears alone, sometimes it is reinforced by a black stroke that neither alters the underlying stroke nor overworks the drawing. A similar sensitivity to line would be found much later, in China.

As to the vast decorative schemes produced by artists for royal palaces, we can perhaps get some idea of

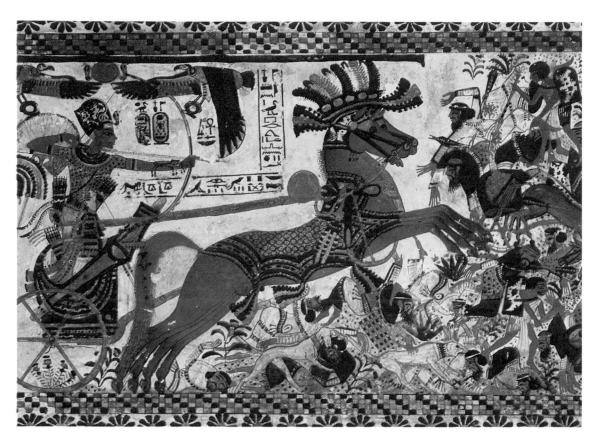

them from a painting on a large wood and stucco chest found in Tutankhamen's tomb, which dates back to c. 1325 B.C.E. (page 54). The two main panels of the chest show the king defeating the Nubians and the king defeating the Syrians. The palette is very limited—reddish brown, yellow, and black—and the figures are still shown in profile. The composition, although ambitious, is clear. The figure of the king and the charging horses harnessed to his chariot possess an almost mannerist elegance. In contrast, the battle itself surprises by its vividness, its ethnic characters with their carefully described dress, and its clearly distinguished incidents.

The same composition was handled in a similar way in several large bas-reliefs, notably those on the walls of the temple of Amon-Re in Karnak, depicting the military campaigns of Seti I, and those on the pylon of Ramesses III's tomb-chapel in Thebes, showing him on a hunt. It might be assumed that this was a kind of official scene, elaborated by a great court artist and then reproduced—not without variations—by painters and sculptors, and finally miniaturized with great skill by the royal artists who decorated chests.

These works seem all the more important in that secular paintings were naturally the Egyptian art

The king on his war chariot (detail), chest of Tutankhamen, tomb of Tutankhamen, Thebes (Egypt), 18th Dynasty (c. 1325 B.C.E.). Painted stucco on wood, 17 × 24″ (44 × 61 cm). Egyptian Museum, Cairo (Egypt).

to which foreigners would be exposed. Everything that survives today was deeply buried in tombs, whereas the work that is no longer extant must have had the greatest influence. According to Pliny, the Egyptians claimed to have invented painting six thousand years before it spread to Greece. The Roman writer assumed that the Egyptians were merely boasting but, exaggerated numbers apart, their claim must have reflected the truth. Ruins in Mari have revealed fragments of an eighteenth-century B.C.E. fresco which clearly respects conventions similar to those seen in Egyptian painting: head and feet in profile, shoulders shown frontally, limited range of colors (*Celebrant of Sacrifice*, Louvre).

Bust of woman, fresco (fragment) from the acropolis at Mycenae, thirteenth century B.C.E. National Archaeological Museum, Athens (Greece).

What may mislead us, however, is precisely the fact that secular painting in Egypt must have differed from tomb painting. Paintings discovered at Knossos in Crete, for example, executed around 1700–1400 B.C.E., show greater life and variety than Egyptian counterparts. A taste for decorative curves here enlivens the flat washes and the figures seen in profile. More recently, in 1970, a discovery on the acropolis of Mycenae revealed fragments of frescoes including the bust of a woman that would appear to date back to the thirteenth-century B.C.E. (page 55). It is hard not to see traces of an Egyptian tradition behind it, possibly transmitted through Crete.

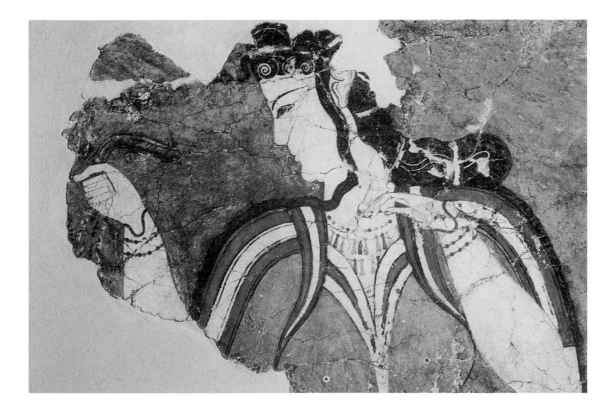

II
FROM "GREEK MIRACLE"
TO "PAX ROMANA"

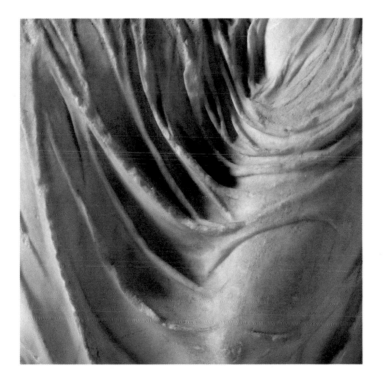

introduction

When leaving the realm of Egyptian and Mesopotamian art for that of Greek and Roman art, we seem to move from archaeological hypotheses to historical certainty. Written documents confirm the main developments. Painters and sculptors are given individual names— Myron, Scopas, Zeuxis, and Apelles. Writers of the day mentioned the artists' main works, provided anecdotes about their lives, and rendered judgment on their styles. Famous monuments are mentioned and sometimes described. A history can therefore be based on documentation bequeathed by antiquity itself.

These texts are accompanied by physical vestiges. Most of the major sites were excavated long ago, with even greater attention than that paid to the valleys of the Nile and Euphrates. Excavations brought to light a considerable number of statues, collected over the past five hundred years. Although examples of painting, being fragile, have almost completely vanished, a great number of painted vases have survived. The history of art gleaned from the written documents can thus be laid beside the one revealed by the visual remnants.

Unfortunately, the two histories do not always converge. Excavations have complicated the history of places of worship, generally simplified by written testimony. Vases constitute a specific type of production whose link to other kinds of painting is not at all straightforward. When it comes to sculpture, apart from a few instances in which bas-reliefs have remained in situ, matching ancient citations to surviving works is generally a hazardous business. Even the great number of copies made

Horsemen from the west frieze (fragment), bas-relief from the Parthenon, Athens. British Museum, London (England).

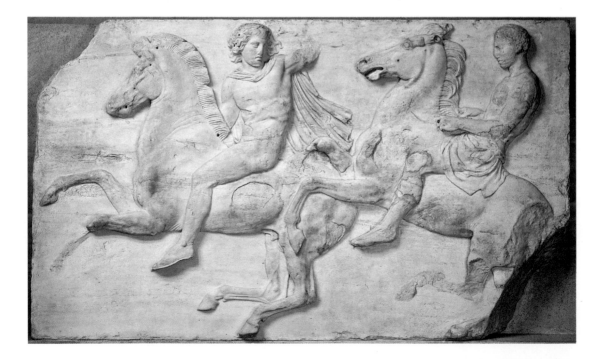

of certain works poses complex problems unknown during other periods. Paradoxically, study of the art of "classical antiquity"—to which we feel we are the direct heirs—entails a degree of probability that calls, more than ever, for caution and reappraisal.

This reappraisal might even call into question the tacit understanding we so easily sense when faced with Greek and Roman art. All feeling of strangeness vanishes when we view sculpture from the Parthenon, or a bust of an imperial ruler, or even a painted portrait from Fayum. This is perhaps because the Greek and Latin languages, with all the concepts they imply, have never ceased to hold—and must retain—a major place in our culture. Yet maybe we tend to oversimplify things in our minds.

Our conception of Greece is probably idealized, and our conception of Rome is too easily confused with the glorification of citizen and soldier. Surviving images seem to confirm these impressions: the frieze of naked horsemen on the Parthenon is not a lie, any more than is the stately procession of toga-garbed men on Rome's *Ara Pacis* (Altar of Peace). They possess symbolic value, but they should not lead us to overlook the vast dimensions of time (nearly ten centuries) and geography (wars took the Greeks as far as the Ganges in the days of Alexander, while Rome reached the limits of the civilized world in the days of Trajan). Throughout these adventures, art never ceased to record its own metamorphoses. The following account of them, necessarily cursory, will simply retrace the major stages.

Procession on the northern face of the *Ara Pacis Augustae* (Altar of Peace), 9 B.C.E. Marble, Rome (Italy).

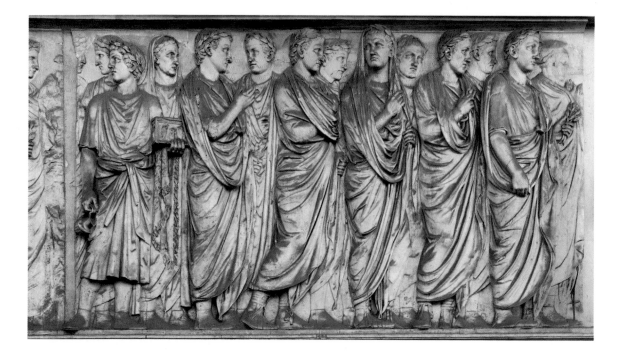

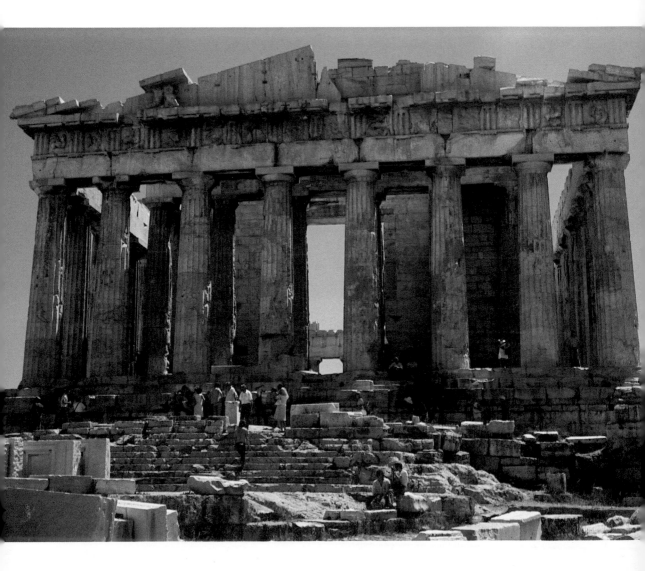

Architecture

If there is one sphere in which the entire world is indebted to Greece, it is architecture. The Greek temple, with its row of columns and triangular pediment, became one of the key landmarks of architecture. Beyond any religious significance, the model spread from Greek to Rome and from Rome to the rest of the world. "Greek temples"—in the form of churches, palaces, museums, town halls, and theaters—can be found in places as far apart as London, Dayton, and even Kyoto. This is not to suggest that the Greeks invented the architectural form from scratch, however. Similar approaches could be found all around the Mediterranean, and consideration of Etruscan temples with their decorated pediments and colonnaded façades is enough to suggest connections and mutual influences. But it was apparently thanks to the Greek spirit and Greek dynamism that the model was clearly conceived and universally disseminated.

Greek temples

Greek temples were usually rectangular, and were set on solid foundations. On the ground, a stepped base (crepidoma) was laid to take the columns that supported the ceiling structure and roof, with triangular pediments at each end (page 60). Many variations of this basic plan existed. The cella, or main body of the temple, was the true heart of the building and was usually windowless. It would be wrapped in freestanding or engaged columns, or sometimes plain walls. Similarly, distinctions were established between Doric, Ionic, and Corinthian columns, which left room for manifold variations depending on place, tradition, and taste. In contrast, increasing the number of stories was almost unthinkable: strict proportions were established between the length, width, and height of the temple, and also between the overall edifice and its most visible component, the column. From this arose the carefully calculated harmony—and beauty—of each building.

This form of Greek temple, almost always erected in the most visible spot in the city, was adopted by the Romans—the Forum in Rome wound up resembling a veritable swarm of temples of the prostyle type (one row of freestanding columns in front) or the peripteral type (surrounded on all sides by columns). The model thus spread to the entire Roman Empire, as exemplified by the excellently preserved Maison Carrée in Nîmes,

The Parthenon,
Athens (Greece),
438–431 B.C.E.

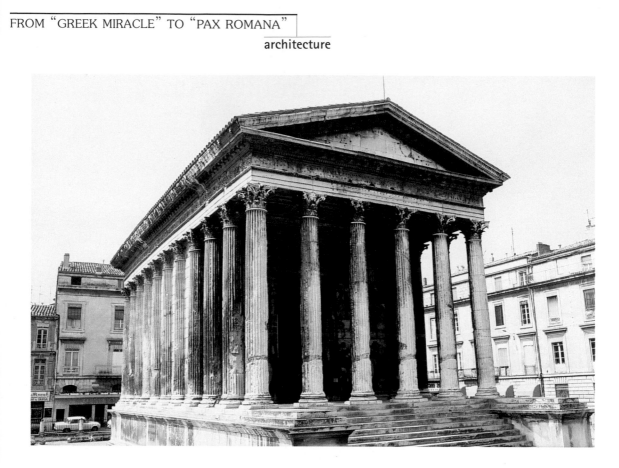

France (page 62), as well as by countless ruins found all around the Mediterranean. They explain how this form of Greek architecture managed to survive until it was revived during the Italian "Renaissance" and above all in the late eighteenth century.

Roman innovation

And yet Rome, master of the world, was not content merely to transmit and promote Greek art. It also added its own, sometimes contradictory, features. Such was the case with architecture. One of the great merits of Greek temples was their sturdy simplicity. Built of stone or marble, with minimal use of wood, they were not overly threatened by fire. Their rectangular construction did not require complicated calculations of thrust and weight loads. On the other hand, they could not incorporate innovations likely to surprise the eye, and above all they could not house a large crowd. More a sacred spot than a utilitarian building, the Greek temple was suited primarily to ceremonies that took place outdoors. It is easy to see why Rome turned toward methods of construction better suited to its needs as a vast capital. The innovation entailed the use of *opus caementicum,* that is to say various materials bound by an almost indestructible mortar, which effectively counteracted the thrust of arches, vaults, and cupolas. This building material made it possible to erect extremely ambitious edifices. The mortar, however, was gray and dull

The Maison Carrée,
early first century,
Nîmes (France).

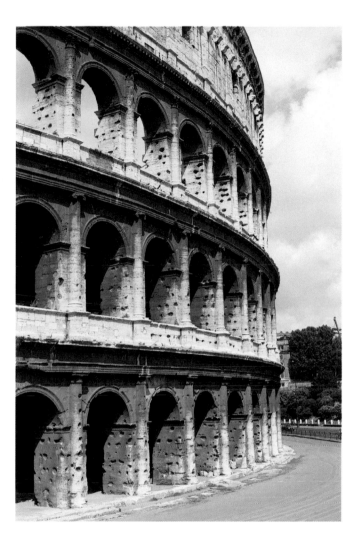

The Colosseum (originally
Flavian's Amphitheater),
dedicated by Titus in
the year 80, Rome (Italy).

in appearance, and Rome, with its taste for lavishness, could not bear such austerity. It therefore faced the walls with frescoes of plaster or slabs of marble (often colored), both inside and out. In recent decades, the reinforced concrete of our own era has raised the same problems and same reactions: after having advocated the use of raw concrete, we have returned to the use of facings once judged—not without reason—overly facile.

Thus Rome, thanks to its use of a sturdy, solid building material able to serve as the core of a building practically impervious to fire and weather, could erect edifices able to withstand the centuries—not least because the absorption of thrust made it possible to use round arches. Roman architecture favored the proliferation of arches, which were almost unknown to Greek architecture. Arches eliminated the serious problem of stress on lintels, which Egyptian architecture had solved only by narrowing doorways and employing enormous blocks of stone often weighing several tons.

In Mycenae, the Lioness Gate, still standing, is topped by a colossal block. In contrast, the arch makes it possible to spread the uprights, thereby making possible the rhythmic effect of the arcade, and accords with the stone vaults and pendentives inside, which were much less inflammable than wooden roofing. Thus were constructed vast amphitheaters, the most imposing being the Colosseum in Rome, begun under Vespasian in 72 C.E. and completed under Domitian (page 63). Measuring some 600 by 500 ft. (188 by 156 m), it could hold more than 50,000 spectators. Then there were gigantic baths such as those of Diocletian, also in Rome, a vast complex endowed with sophisticated technical facilities (its ruins were ample enough to house the later construction of a large church—Santa Maria dei Angeli—a chapel, a large museum, and an institute).

Among the innovations made by Rome—or credited to it thanks to its glamour—two architectural forms are worth stressing, and both can still be seen in situ. The first was the basilica. Initially, a basilica was an assembly hall, not a temple. Simple in construction, rectangular in plan, divided by two rows of columns, a basilica provided convenient shelter for all gatherings, whether political, judicial, or commercial in nature. The first basilica was allegedly built on the Forum by Cato the Elder in 184 B.C.E. Little by little, basilicas attained considerable size thanks to vaulting of *opus caementicum*; once Christianity triumphed, they were often turned into places of worship. They naturally offered a convenient plan for the earliest Christian churches, beginning with Constantine's basilica, which comprised a nave flanked by two pairs of aisles, all covered with a wooden roof structure, completed around the year 400 (and later to become Saint Peter's Basilica).

Although this architectural form is highly significant due to its future development, true admiration must be reserved for another Roman model, the temple now called the Pantheon, which, after two fires, was completely rebuilt under Hadrian between 118 and 120 C.E. (page 65). This building represented a total break with the Greek spirit and Greek forms. Beneath a porch with a traditional triangular pediment (but with powerful columns of porphyry), the doors opened not onto a cella but into a vast interior space that clearly retained the architect's full attention: the entirely round space is topped by a dome once decorated with bronze rosettes (only removed in the seventeenth century) and pierced in the middle by an open-air oculus. The excellent preservation of this building has made it an object of reflection for architects down through the centuries. It could be said without exaggeration that all the domes subsequently erected, in America as well as Europe—beginning with Brunelleschi's in Florence and Michelangelo's in the Vatican—were more or less inspired by the Pantheon, without ever being able to surpass it.

Interior of the Pantheon, 118–120, Rome (Italy).

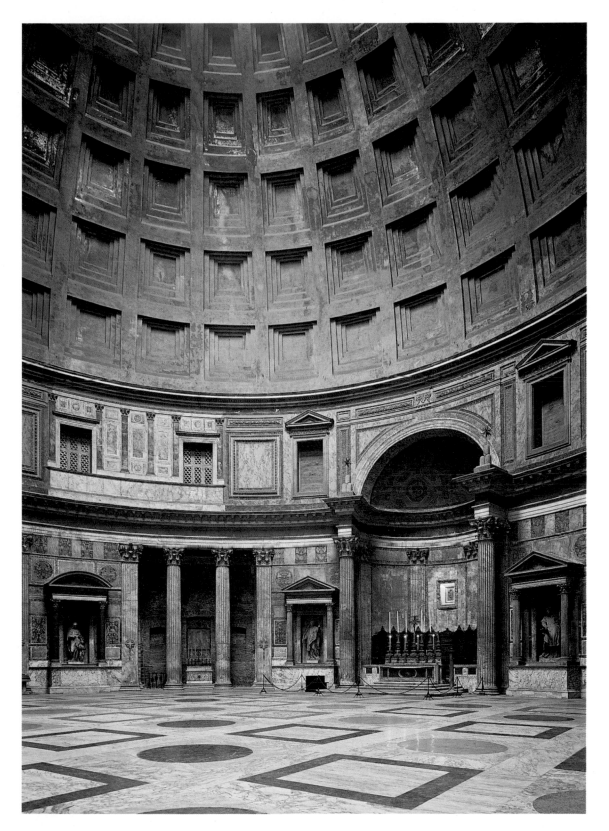

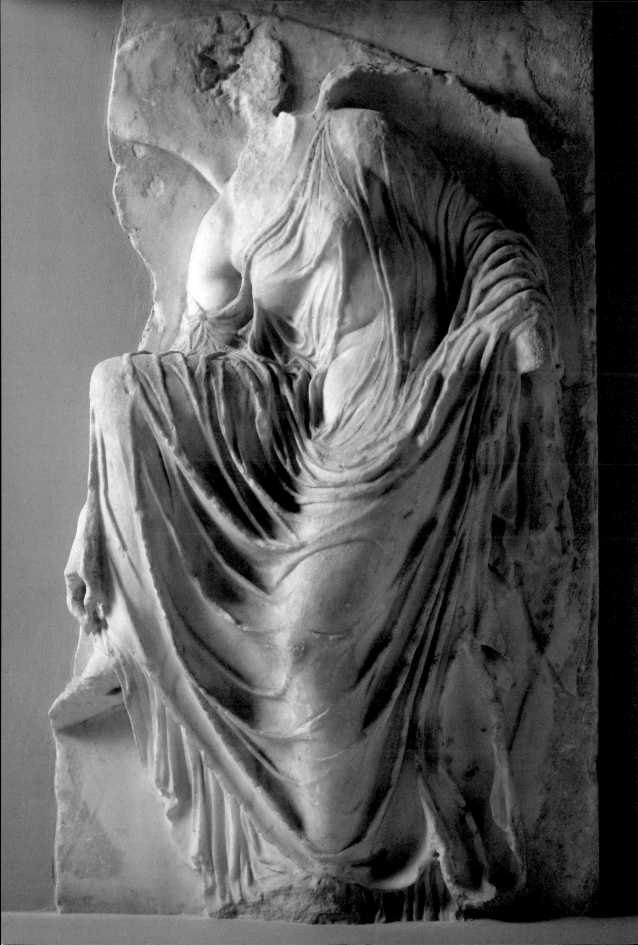

Sculpture

Ancient authors mention so many wonderful Greek sculptures that they hardly seem credible—yet there survive a few fragments, and these fragments alone suffice to fully justify their claims. There was indeed in Greece a swift and sudden evolution that completely transformed sculpture. This was part—and not the least part—of the "Greek miracle."

We should not be fooled by words, however: the "miracle" did not spring unannounced from the wilderness. All around the Mediterranean, things were beginning to change. Egyptian conventions had evolved little since 2500 B.C.E., but they cross-fertilized other traditions, some of which were more flexible, as in Crete, and some of which were more hieratic, as in Mesopotamia. Many centers of civilization vanished without leaving a trace, at least in terms of art. If Veii and Volterra had not been so close to Rome, so closely tied to Rome's fate (and if their tombs had not been so richly furnished), we might never have paid so much attention to Etruscan art.

Etruscan sculpture

It is worth dwelling for a moment on the Etruscan example. If Vitruvius is to be believed, the Etruscans were great architects. We now know that they were also great sculptors. Etruria rose toward the end of the seventh century B.C.E. and apparently its greatest expansion took place between the late seventh and mid sixth centuries, when Etruscans traded throughout a good part of the western Mediterranean. The great *Apollo of Veii,* now in the Etruscan Museum in the Villa Giulia in Rome, is generally assigned the date of 510–500 B.C.E. (page 68). It was an acroterion (ornamental statue on a pediment) on the temple at Portonaccio, and was part of a group showing Apollo and Hermes fighting over the Cerynean Hind. And it is an admirable statue with fine proportions that are simultaneously powerful and elegant. The smile is alive, the movement is expressed forcefully. The garments drape the body closely, enfolding it without weighing it down, animating it with skillfully decorative curves. We are a long way from the Egyptian canon, and at this early date Greece did not seem to have produced anything so accomplished. The Etruscan spark would die fairly quickly, however. The special privilege of the Greek miracle was its continuity, in which new stages followed one after another for three centuries, leading to a complete and irrevocable revolution in vision.

Nike [*Victory*] *Adjusting Her Sandal,* bas-relief from the balustrade of the Temple of Athena Nike, Athens, c. 408 B.C.E. Marble, H: 3′5″ (1.06 m). Acropolis Museum, Athens (Greece).

Apollo of Veii,
ornamental statue from
pediment, late sixth
century B.C.E. Terracotta,
H: 5′10″ (1.81 m).
Museo Nazionale
Etrusco, Villa Giulia,
Rome (Italy).

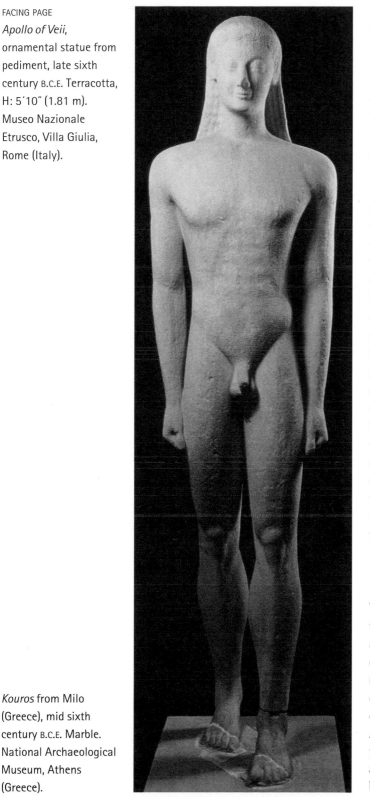

Kouros from Milo
(Greece), mid sixth
century B.C.E. Marble.
National Archaeological
Museum, Athens
(Greece).

Ancient writers themselves seem to have been aware of this. They left a whole series of names of sculptors, specifying the exact contribution of each one. Very few of the works they mention have survived (the bronze in which such works were cast, of course, was a highly prized metal during troubled times). Modern scholars have nevertheless classified the countless copies made in marble—often very incomplete today—and identified the contribution of each of the artists cited. These scholarly hypotheses are probably accurate for the most part, but it should be recognized that copies, executed in a different medium and reacting differently to light, can only offer an approximate idea of the vanished works. The subsequent replacement of heads, arms, legs, and even part of the body often lends the feeling that they relate more or less to the spirit of the Renaissance or the eighteenth century. In order to avoid such distortions, it is preferable to discuss the evolution of Greek art based on the few originals that have survived.

Early Greek sculpture

The first stage shows how the human body was steadily liberated from Egyptian and Eastern conventions. Thus the two *kouroi* (to use the Greek term for statues of naked youths) found in the ruins of Delphi and signed Polymedes of Argos display the conventional pose of one foot placed in front and the arms hanging gracelessly by the sides. They date from about

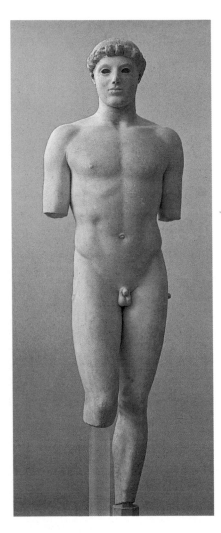

protruding kneecaps, and the less stylized *Volomandra Kouros*. Similar, if more relaxed in pose, is the *Actium Kouros* in the Louvre. Yet another stage was reached, however, with the *Kritios Boy* in Athens, which probably dates from the early fifth century B.C.E. and which gives an impression of ease that dictates the dropping of the term *kouros* in favor of "ephebe," or boy (page 70). The head has rid itself of the Egyptian-style coiffure that framed and supported it, and it has traded the conventional smile for a slightly pouting serenity. The contrast between very broad shoulders and narrow hips has vanished, the muscular masses are correctly positioned, and the head turns ever so slightly. When the statue was intact, the slight bend in the knee would have enlivened the body without violating the traditional pose. We are approaching the moment when sculptors would free themselves from acquired rules and would begin to study nature.

At the same time, the problems they set themselves became more complex. The mid fifth century B.C.E. is the date assigned to the *Rampin Horseman,* which is a long way from a simple *kouros.* The remnants of this piece, found in two stages on the Acropolis in Athens, are held by the Louvre in Paris and the Acropolis Museum in Athens, respectively. It displays clearly archaic features, yet the finely carved head seems to turn in a way that suggests a new, more supple pose.

The Kritios Boy, c. 480 B.C.E. Marble, H: 3′9″ (1.17 m). Acropolis Museum, Athens (Greece).

615–570 B.C.E. With the *Milo Kouros* (mid sixth century B.C.E.), the pose remains the same and the hair still frames the head in the Egyptian manner, but the volumes are becoming more supple and the body is handled more skillfully (page 69).

The same could be said of an entire series of more or less complete *kouroi* preserved at the National Museum in Athens. These include the *Sunion Kouros,* perhaps somewhat more archaic with his broad chest, thin hips, and

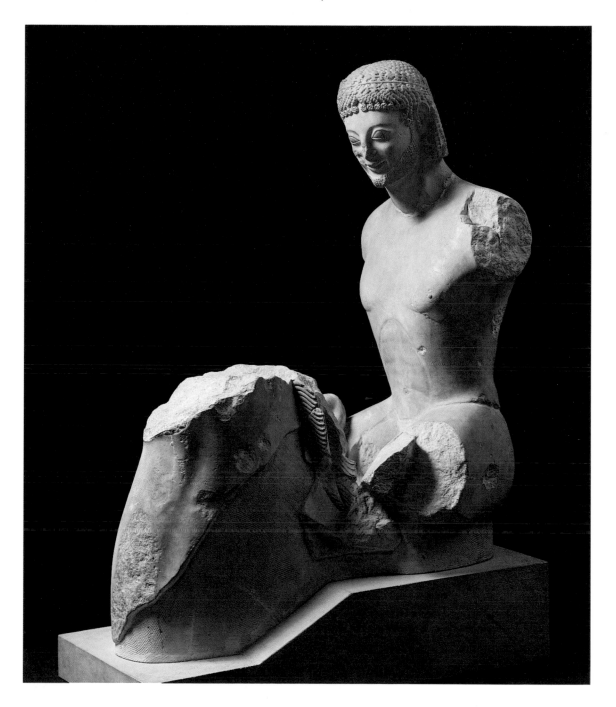

Rampin Horseman from the
Acropolis, Athens, c. 550 B.C.E.
Marble, reconstructed from
elements in the Louvre, Paris
(France), and Acropolis Museum,
Athens (Greece).

Another stage of evolution was marked by the famous *Auriga the Charioteer*, a large bronze found at Delphi dating from about 475 B.C.E. (page 72). It was probably buried under the rubble early enough to escape being melted down, and it appears to be well preserved, but is only part of a larger sculpture. The charioteer is missing an arm, his chariot, and his horses, which would have alleviated the stiffness of the surviving statue. We must imagine the original setting of the piece in order to appreciate fully the proud, firm modeling of the face (with encrusted eyes), the torso with its curving and artfully varied folds, and the bare feet rendered with perfect authenticity. Everything here points to the hand of a great sculptor.

The era of masterpieces

Around the middle of the fifth century B.C.E., Greek sculpture entered one of its finest periods, characterized by a sober style imbued with a kind of serene humanism. It was at this moment, between 472 and 457 B.C.E., that the sculptures on the temple of Zeus at Olympia were executed. Although the pediment still betrays a certain stiffness, the carving in the square panels on the frieze, called metopes, displays magisterial

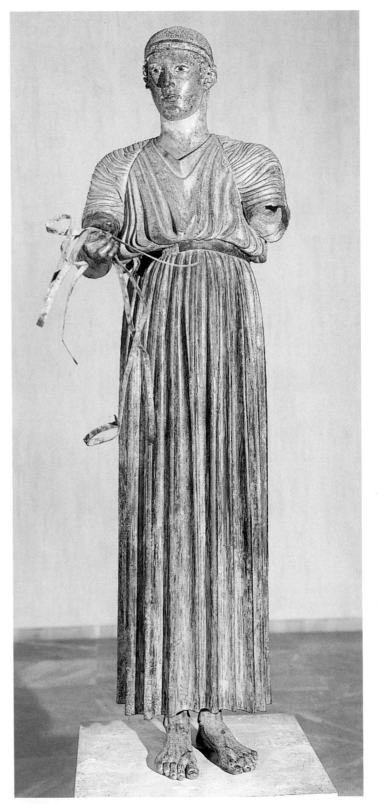

Auriga the Charioteer,
from Delphi, c. 475 B.C.E.
Bronze, H: 5′10″ (1.80 m).
Archaeological Museum,
Delphi (Greece).

simplicity. Some fragments from the temple are now housed in the Louvre, which received them as a gift from the Greek senate, while other remnants, found later, are still on the site. The story of Hercules is presented schematically, composing scenes easy to understand and monumental in impact despite their limited size. Thus *Hercules Wrestling with the Cretan Bull* depicts the intersecting postures of both hero and beast as they struggle—the muscles are accurate, the modeling full, the lines harmonious and effective.

Documents inform us that Phidias was in charge of construction of the Olympian temple, but do not say who carved the metopes. On the other hand, they explicitly attribute to Phidias the temple's huge chryselephantine *Zeus*, one of the seven wonders of the ancient world. The texts also say that Phidias sculpted the

The Cretan Bull, c. 460 B.C.E. Marble, 3′8″ × 4′11″ (1.14 × 1.52 m). Musée du Louvre, Paris (France).

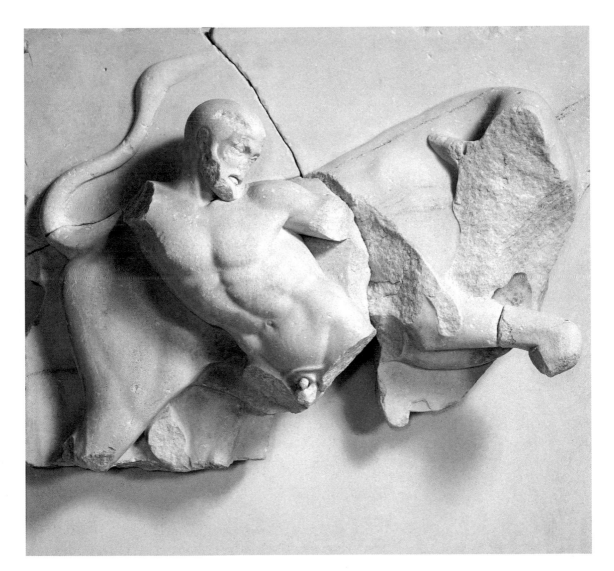

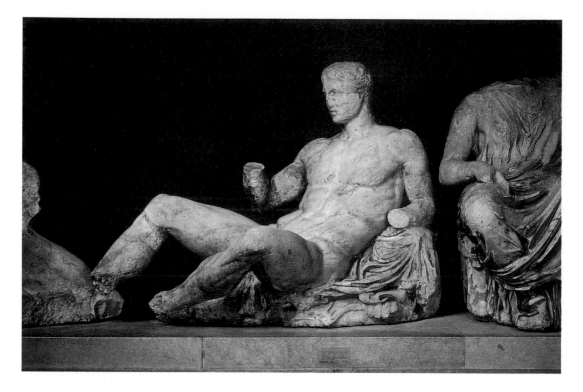

Dionysus from the east pediment of the Parthenon, Athens, 438–431 B.C.E. Marble. British Museum, London (England).

famous chryselephantine *Athena* on the Parthenon, made of wood, gold (*chrysos*), and ivory (*elephantinos*). If the small marble copies are to be believed (obviously, no trace of the originals survive), it was not so much a work of art as a last colossal idol, weighted with precious ornamentation that drowned all gracefulness. In contrast, the pediment, frieze, and metopes that are also usually ascribed to Phidias (despite a clear diversity of styles, which could be explained by the lengthy time span of the task) display the supple, sensitive art associated with Olympia.

Meanwhile, the two pediments of the Parthenon in Athens show *The Birth of Athena* (east façade) and *Athena and Poseidon's Contest for Possession of Attica* (west façade). The ninety-two metopes that, respecting the tradition of Ionic temples, ran around all four sides, depicted battles between the gods and giants, between the Lapiths and centaurs, between Greeks and Amazons, and between the Greeks and Trojans. An unusual Ionic frieze showed the Panathenaic Procession. Large parts of these decorative carvings vanished over the centuries, but other were saved, notably by being taken down and shipped to the British Museum in the early nineteenth century (page 58). The quality of all the surviving fragments is startling.

The representation of the figures on the pediment was governed more by their specific place within the architecture than by subject-matter, but the Dionysus on the eastern pediment provides a

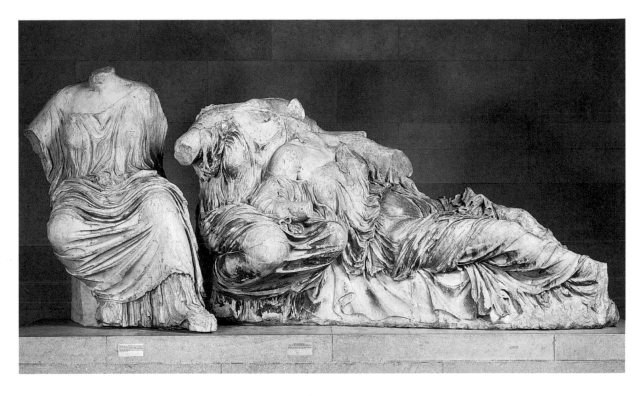

Hestia, Dione, and *Aphrodite* from the east pediment of the Parthenon, Athens, 438–431 B.C.F. Marble. British Museum, London (England).

magnificent study of the reclining male nude—its harmoniousness has never been surpassed (page 74). In the other section of that pediment, the goddesses Hestia, Dione, and Aphrodite, although now headless, remain models of melodious drapery (page 75). The poorly preserved metopes are similar to the ones in Olympia, although without the same visual power. Yet in the frieze of the Panathenaic Procession, the file of young women (Louvre) is orchestrated around their long, serenely vertical gowns, while the file of young men (British Museum) is paced by the diagonally trotting riders. Everything here, from the overall scheme (perfectly suited to the edifice) to the artful statues and bas-reliefs, seems to confirm not only the participation of Phidias

but also the esteem in which he was held in antiquity.

The sculpture on a temple like the Parthenon was not very conducive to the making of copies. The influence of Phidias must therefore have spread rather though his works cast in bronze, as cited in ancient texts. His calm expressions, balanced forms, and refined drapery nevertheless seem to have had a great impact. But we should not overlook his contemporaries and successors, of whom there were many. Most of them worked in bronze, and their famous statues were, once again, copied extensively, either in metal or marble (which seems to have been less costly). As already mentioned, however, almost all ancient bronzes have vanished, having been melted down for military

purposes, and this creates great difficulties when trying to identify the style of the most famous artists.

Antiquity particularly admired the art of Myron, who lived in the second half the fifth century B.C.E. His *Cow*, no longer extant, was highly praised, as was his *Discus Thrower*, which was probably the source for a whole series of extant copies, more or less faithful. Polyclitus was a contemporary of Phidias, and occasionally outshone him. Praxiteles, who flourished around 375 B.C.E. according to Pliny, was known for his quiet manner, his powerful yet supple male nudes, and his elegant female nudes. He would seem to be the

Poseidon (?) from Cape Artemision, c. 460 B.C.E. Bronze, H: 6´10˝ (2.09 m). National Archaeological Museum, Athens (Greece).

sculptor of the original *Apollo Sauroctonos*, several copies of which survive. Also specially praised was Lysippus, who was born late enough to have served as official sculptor to Alexander the Great.

Modern scholarship has tried on many occasions to reconstruct the oeuvres of these artists by studying extant copies. Yet despite all the affirmations, it is wiser—with per-haps two or three exceptions—to remain very circumspect.

Bronzes recently recovered from the ocean floor may provide some consolation, since they just might be originals (although they might also be fine ancient copies). None, however, corresponds to works described in ancient texts. There-fore we can date them solely on the basis of stylistic evidence. The National Museum in Athens houses a large bronze found off Cape Artemision, sometimes identified as Poseidon and sometimes identified as Zeus, depending on whether he is viewed as originally wielding a trident or a thunderbolt (page 76). Given his powerfully modeled mus-cles, together with his stiff pose, beard, and decoratively combed locks, we might be inclined to date the original to about 460 B.C.E. In contrast, the graceful movement and calm expression of *The Antikythera Boy* suggest a date in the fourth century B.C.E. (page 77), as does *The Marathon Boy*, whose jaunty pose and delicate propor-tions evoke the art of Praxiteles (page 78). Yet how can we be cer-tain? Given the considerable sculp-tural output of that period, we must

admit that the underwater finds remain minuscule in number, and are more likely to give an idea of the quality of all the lost originals rather than provide a reliable chronology. The same thing could perhaps be said, for that matter, of certain Greek marbles universally assumed to be originals, such as the Louvre's *Venus de Milo* and *Winged Victory of Samothrace*. Nowadays, scholars can no longer agree on a date for these works, even a probable date.

The Antikythera Boy,
fourth century B.C.E.
Bronze, H: 6´4″ (1.94 m).
National Archaeological
Museum, Athens (Greece).

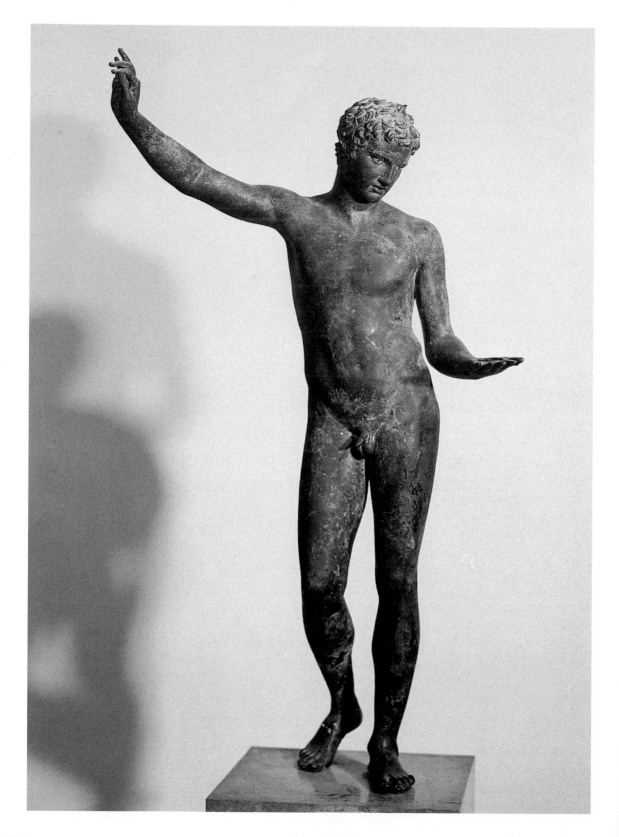

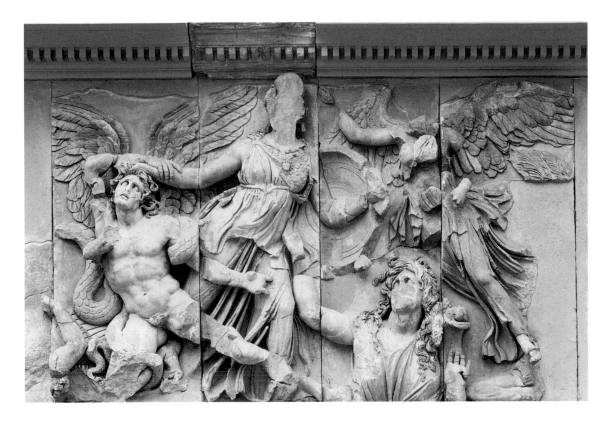

Large frieze, Great Altar
of Zeus from Pergamum,
c. 180 B.C.E. Marble.
Antikenmuseum,
Berlin (Germany).

FACING PAGE

The Marathon Boy,
fourth century B.C.E.
Bronze, H: 4′ (1.24 m).
National Archaeological
Museum, Athens (Greece).

It has already been pointed out that Alexander had the painter Apelles and the sculptor Lysippus in his employ. His death in 323 B.C.E. is generally considered to mark the end of the Classical period and the beginning of the Hellenistic one. This distinction is largely artificial, and is little more than wordplay, except for one crucial development: a major shift in geographical dimensions.

Greek tradition was suddenly absorbed by peoples hitherto considered barbarians. New capitals sprang up. Economic upheaval led to the revival of old centers of production and the creation of unexpected new markets. The swift spread of syncretism corresponded to a new taste and favored original subject-matter without fomenting a break with the past.

Although it would seem that major artists thrived during this period, it is very difficult to map in any detail the geography of Hellenistic centers. The vagaries of excavation, for instance, turned up the Great Altar of Zeus at Pergaum (first half of the second century B.C.E.), which was transported to Berlin's Antikenmuseum and reassembled there (page 79). The large frieze is carved in a violent, theatrical style in the spirit of Scopas, whereas the small frieze reflects a more sober, quieter art. Hence it would be pointless to continue assuming that each artistic center produced a unique style.

Roman art represented only one of these various centers, yet its fate would be linked to that of the city that came to dominate the entire Western world.

Roman sculpture

Roman sculpture raises problems quite different from those of Greek art. Rome and its environs still present tourists with statues and bas-reliefs that have never left the city's streets. Since the fifteenth century, Rome's foundations have been yielding a prodigious number of "antiquities" that can now be seen in the Vatican, in the Museo Nazionale Romano, and in the courtyards of palazzi, not to mention other museums throughout the world. Yet this very profusion has generated certain enigmas: it quickly becomes clear that Rome, in its heyday, was already a vast museum containing masterpieces gleaned from everywhere.

FROM HERITAGE TO SYNCRETISM

Rome directly inherited the traditions of nearby Etruria, and the famous *She-Wolf* in the Museo Capitolino for example, seems to be an Etruscan bronze dating back to the fifth or early fourth century B.C.E., traversing the centuries without anyone ever daring to challenge its origins. Similarly, the *Head of Brutus*, also in the Museo Capitolino, is probably a fragment of a full-length statue that dates back to the first quarter of the third century B.C.E. and is a masterpiece of striking realism (page 81). It is possible

that these traditions long prevailed in Rome, but it is clear that as Roman domination increased, syncretism spread. From Etruria to Greater Greece, it would extend all around the Mediterranean to include Athens, Alexandria, and Asia Minor.

Within this mix, Greek art enjoyed the highest rank and greatest reputation in every sphere, particularly in sculpture. Its workshops seem to have been particularly well organized, from the quarrying of marble and the establishment of bronze foundries to the training of teams of copyists able to sustain export markets. This system produced a steady stream of excellent artists capable of producing their own original creations and willing to move abroad, especially to Rome. It is therefore difficult to speak of purely Roman sculpture— even when monuments were erected to the glory of Rome, they may well have been the work of artists from Greece or Alexandria, or of their local disciples. Inversely, it is perhaps unfair to attribute to Roman artists any work smacking of the realist tradition or displaying signs of a clumsiness that Athenian art would have allegedly eschewed.

OFFICIAL SCULPTURE

It is not possible to put a name on the sculptor of the famous statue of Augustus, called the *Augustus of Prima Porta* (page 82). The original, probably a bronze, might be dated to 8 B.C.E. or shortly thereafter. The marble copy retains the trace of a masterpiece that combines aspects of Greek statuary

Head of Brutus (?), first quarter of third century B.C.E. (?). Bronze, H: 2′3″ (69 cm). Museo Capitolino, Rome (Italy).

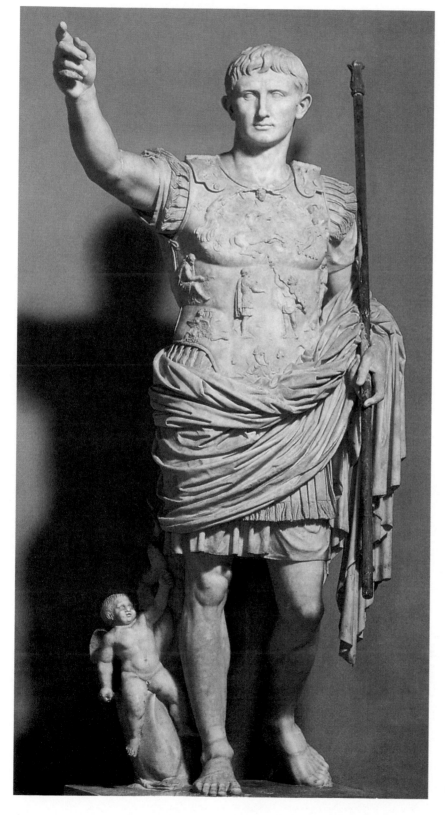

The Augustus of Prima Porta,
originally from Livia's Villa,
c. 17–10 B.C.E. Marble,
H: 6´9˝ (2.06 m). Museo
Vaticano, Rome (Italy).

from the days of Polyclitus with a delicately idealized portrait of the emperor. Nor is it possible to identify the artists behind a major work of Rome in the Augustan age, namely the *Ara Pacis Augustae* (Altar of Augustan Peace), whose erection on the Campus Martius was commissioned by the Senate on July 4, 13 B.C.E. Substantial surviving fragments made possible the reconstruction of the monument, enabling us to admire the calm procession of men, orchestrated around the varied drapery, and the noble yet understated portraits (page 59). The work of a specialized artist was perhaps behind the large ornamental panels that accompanied these bas-reliefs, so elegant and subtle is their handling. The *Ara Pacis* was certainly highly admired, and its influence can be noted in a bas-relief of the *Sacrifice* from the Flavian period (Uffizi, Florence), and in the scene of *Extispicium* originally from Trajan's Forum and apparently dating from the early part of Hadrian's reign (Louvre, Paris). Perhaps this official relief style also bears comparison with the nobly handled drapery on the reliefs on the Arch of Constantine in Rome, which were initially executed for a triumphal arch dedicated to Marcus Aurelius (page 83).

THE ROLE OF PORTRAITURE

One of the characteristics of Roman sculpture is the large number of

Reliefs originally carved for the Arch of Marcus Aurelius, c. 180. Marble, Arch of Constantine, Rome (Italy).

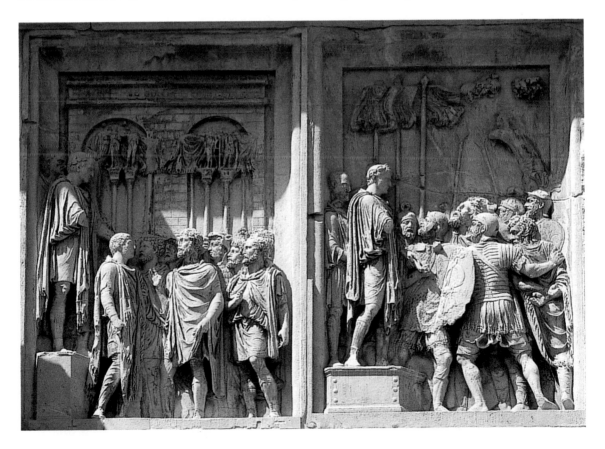

portraits it produced: emperors, leading citizens, great ladies, and even private individuals. Various fashions followed one another, and the variety of styles defies classification. There was a certain idealism in the days of Augustus (27 B.C.E.–14 C.E.), greater realism during the reign of Vespasian (69–79), a kind of balance of the two under Hadrian (117–138), and a concern for expressivity under Caracalla (211–217). Yet these tendencies apply to portraits of emperors, which are easily identifiable, and they are unlikely to have

constituted true styles. For the countless anonymous busts, we have few chronological reference points apart from beard and hairstyle.

It is nevertheless clear that the sculpture of the day produced an astonishing gallery of human faces that are handled with outstanding frankness. Nothing could be more authentic than the portrait of *Vespasian* (69–79) now in Copenhagen (page 84). Sometimes elegance and beauty predominated, as in a marble head called *Faustina Maggiore* (138–140) in Ostia, outside Rome (page 85). Beauty and elegance

FACING PAGE
Faustina Maggiore
[the Elder], 138–140.
Marble, H: 1´2˝ (36 cm).
Museo di Ostia,
Ostia (Italy).

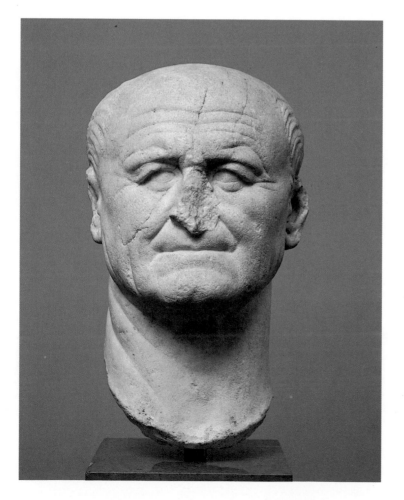

Portrait of Vespasian,
69–79. Marble,
H: 1´ (30 cm).
Ny Carlsberg Glyptotek,
Copenhagen (Denmark).

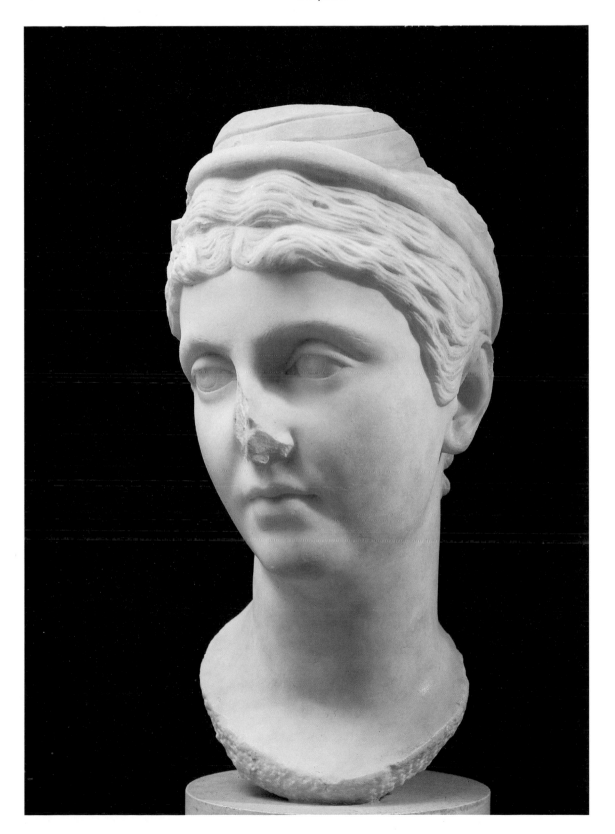

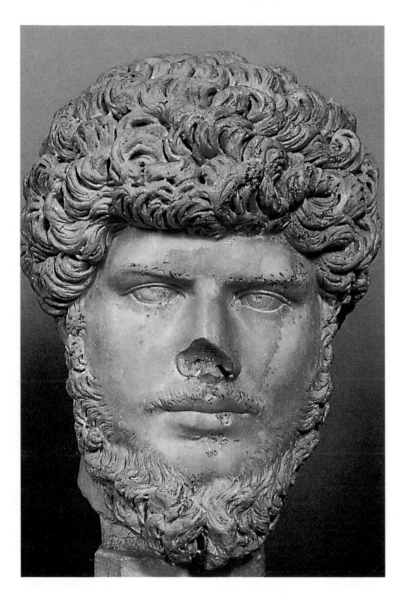

Portrait of Lucius Verus,
c. 130–169.
Saint-Raymond Museum,
Toulouse (France).

were not restricted to women, however, since even at a late date there were very fine heads of children, while the portrait of Lucius Verus, Marcus Aurelius's adopted brother, betrays a kind of dreamy, romantic beauty (page 86).

It is unfortunate that almost all of the many portraits cast in bronze have been melted down. A single one has survived, and by luck it is a major piece: the *Marcus Aurelius* (177–180), which is now in the Museo Capitolino (page 87). This large equestrian statue, 14 by 12½ ft. (4.24 by 3.87 m), was once thought to represent the Emperor Constantine, who had been chosen by God to convert the Roman empire to Christianity. That would explain why it was never melted down. The traces of gilding that have survived the ages reveal it to be almost intact. It is impossible

FACING PAGE
*Equestrian Statue
of Marcus Aurelius,*
c. 177–180. Bronze,
13'9" × 12'7"
(4.24 × 3.87 m).
Museo Capitolino, Rome
(Italy) shown here prior
to restoration, on the spot
in Piazza del Campidoglio
designed for it by
Michelangelo.

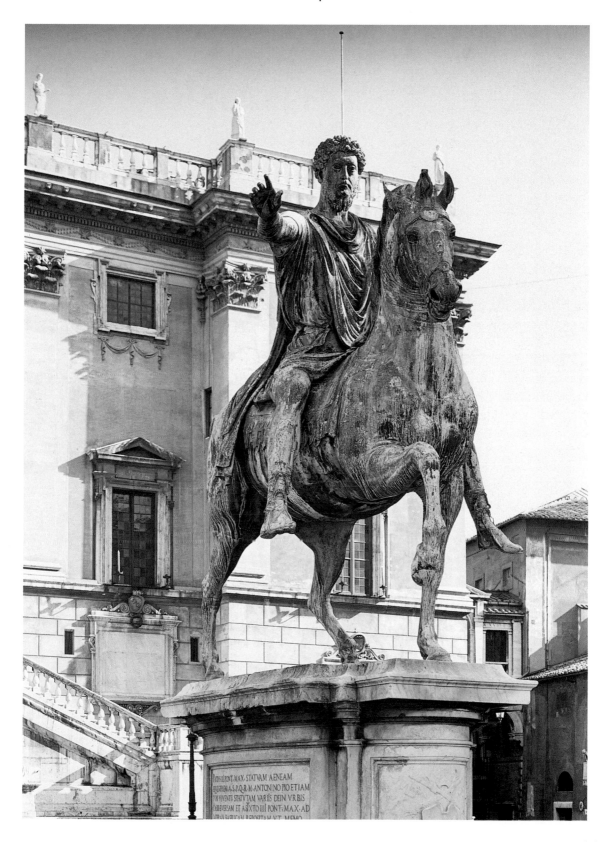

not to admire the powerful stance of the horse, the harmonious and subtle folds of the garment, the formal pose of the figure designed to convey majesty when viewed from below. Thanks to the survival of this work, the fifteenth century would rediscover, without too much difficulty, the secrets of casting an equestrian statue. Up to the eighteenth century, equestrian portraits were held to be the most prestigious form of sculptural art, one that enjoyed a particularly rich and abundant period between 1815 and 1940, only to die out by the late twentieth century.

"MUSEUM" SCULPTURE

Alongside official commissions, there naturally existed sculpture designed to decorate public and private buildings, dwellings, parks and gardens, or simply designed to please art lovers. Rome, it must be repeated, seems to have been the first capital city that aspired to be a museum. Previously, sculptures had already been treated as war booty, and Rome never hesitated to parade them in displays of the victor's spoils. But its attempt to assemble all the world's art treasures within its walls was much more than a simple question of military conquest.

Rome went to great expense to acquire obelisks from Egypt, which were considered inimitable wonders, just as it sought to obtain the most famous bronzes and marbles from Greece. But it often had to be content with copies, the best of which were executed by excellent Greek craftsmen. Hadrian provides an example of this predilection, for his vast villa in Tivoli included a replica of the Canopus, featuring a canal lined with copies of sculpture including four caryatids and their capitals from the Erechtheon in Athens, carefully reproduced in Pentelic marble. It is possible that some of these copies were sufficiently reconceived to become masterpieces in their own right, being adaptations of the originals rather than exact reproductions. For example, what are we to make of two *Centaurs,* also found in Hadrian's villa and now in the Museo Capitolino, made from gray marble from Tainaron and bearing the signature of two masters— Aristeas and Zapias—from the school of Aphrodisias? Then there are the two *Satyrs* done in *rosso antico* marble also from Tainaron, now divided between the Museo Capitolino and the Vatican Museums. The mere decision to produce these works in precious marble instead of bronze, combined with their refined execution, perhaps sufficed to breathe new life into an art that seems to hark back to the third century B.C.E. yet accorded so well with Hadrian's lavish palace in the second century C.E.

From syncretism to decadence

These links with artists and craftsmen from the eastern Mediterranean fueled a lively syncretism. For several hundred years, some—unlike Etruria—had shown scant concern for life in the afterworld. Toward the end of the

Centaur originally in Hadrian's collection in the Villa Hadriana. Gray marble, H: 5'1" (1.56 m). Museo Capitolino, Rome (Italy).

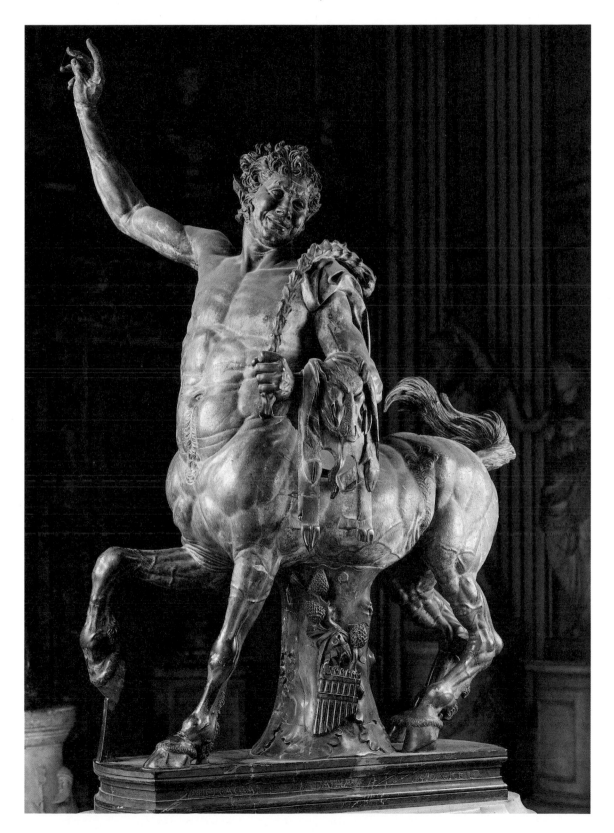

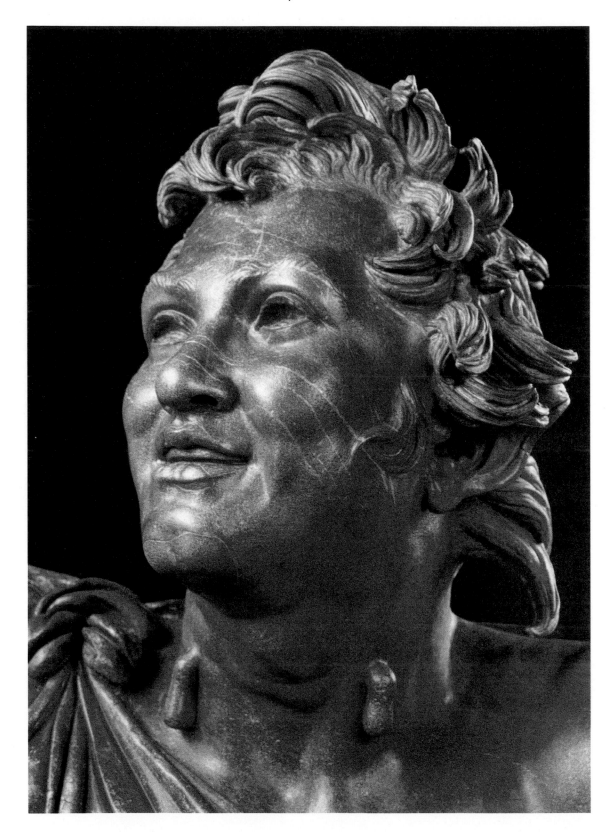

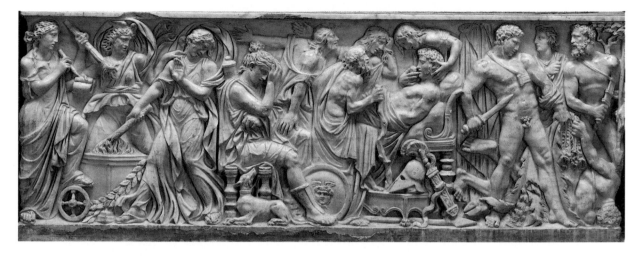

Sarcophagus depicting
The Death of Meleager,
c. 180. Marble, H: 2´4˝
(72 cm). Musée du Louvre,
Paris (France).

FACING PAGE

Drunken Faun originally
in Hadrian's collection.
Antique red marble,
H: 5´8˝ (1.75 m).
Museo Capitolino,
Rome (Italy).

first century C.E., however, when the practice of burial became common, there arose a fashion for large carved sarcophagi, for which Rome apparently turned toward Asia Minor. That is where the main themes (often highly complicated) originated, as did the materials (usually a very fine marble) and the style of carving (almost always in elaborately detailed high relief). What connections between Levantine craftsmen and maritime trade explain the perpetuation of these works? What symbolic concerns or workshop traditions sparked a fashion for such unlikely funeral subjects as *Bacchus and Ariadne* and *The Battle of the Galatians*? Alas, explaining such developments is harder than merely documenting them. These sarcophagi often startle us with their inextricably dense composition, their awkward jumble of figures of different scale, and their expressiveness that has little to do with artistry. Do they perhaps reflect the exaggeration typical of all "popular" art? Were there, at first, skillfully executed originals that were denatured as they were repeated? True enough, high-quality examples occur, notably toward the end of the second century, such as a sarcophagus depicting *Phaedra and Hippolytus* (Vatican) and above all one showing the *Death of Meleager* (page 91). But by the third century, the technique had become increasingly heavyhanded as proportions became less and less coherent, soon approaching the "naïve" art of the early Christian era. Clearly syncretism here favored, rather than forestalled, the swift decline of Roman art and its descent into barbarism.

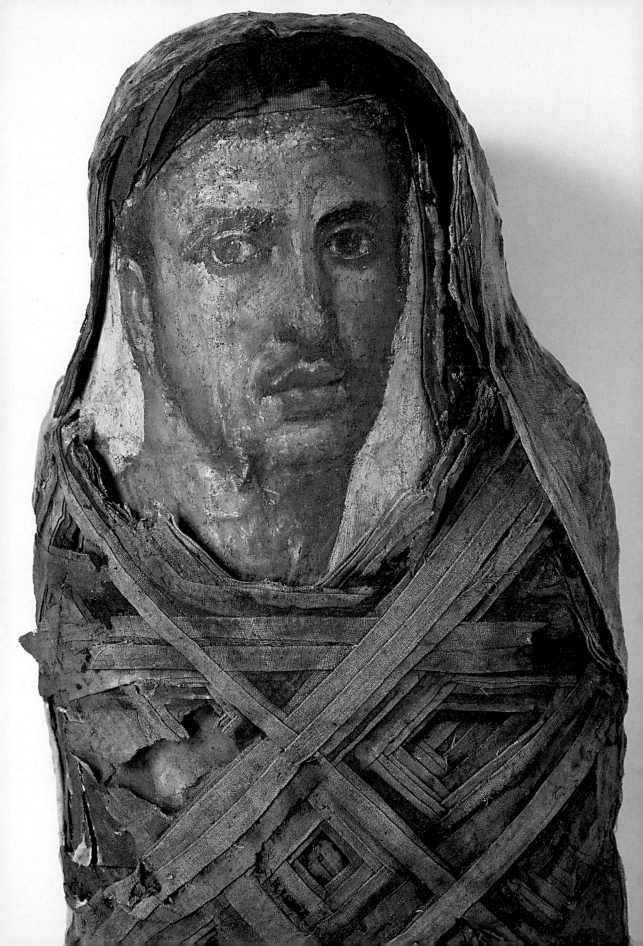

Painting

Ancient sculpture constitutes a vast realm in which the eye must always remain somewhat wary—there are very few true masterpieces sufficiently intact to be of more than purely archaeological interest. What, then, of ancient painting? It was unable to survive the centuries. Whereas Egyptian tombs preserved some very fine fragments of painting, neither the Greeks nor Romans took the same care with their dead. The ruins of temples and palaces from Mari to Crete may supply evidence of the importance of painted decoration, but the few items on display in museums are in fact merely puzzles pieced together in more or less arbitrary fashion. All the special qualities of the art of painting, from refined drawing and color to bold brushwork, have irrevocably vanished.

The glory of Greek painting

Thanks to ancient documents, of which there were many (Adolphe Reinmach compiled an anthology that ran to 433 pages), we know that Greek painting was dazzling. Artists such as Polygnotus, Zeuxis, Parrhasius, Timanthes, and Apelles enjoyed immense renown; their works, for perhaps the first time in history, attracted fabulous prices and were jealously guarded by cities, coveted by emperors, and admired by travelers. Not the slightest remnant survives, however. They disappeared in the turmoil of barbarian invasions and successive waves of iconoclasm. A fragment recently exhumed from a royal tomb in Vergina (northern Greece), showing *The Rape of Persephone,* raised hopes that one of these vanished masterpieces had finally surfaced. But as far as we can tell from the sad state in which the painting has survived, it is unlikely to have been executed by one of the great artists of the day.

At least it was probably an original work. Apart from this example, our knowledge of Greek painting is based on the frescoes found under the ashes of Herculaneum and Pompeii, and on a few mosaics. These are all clearly copies executed far from the originals, at best from cartoons made from those originals. They therefore offer only a poor reflection of the originals. They do provide information about composition, which can sometimes be linked to works cited in ancient texts, but they offer no idea of what sparked so much admiration in antiquity. Only the occasional harmoniousness of a nude or the sensitivity of an expression suggest that the inventiveness and color in a painting

Beardless Man, tempera on canvas on mummy case. Ny Carlsberg Glyptotek, Copenhagen (Denmark).

painting

by Timanthes or Apelles might have rivaled the beauty of the sculpture of Olympia and the Parthenon.

As to Greek skill in draftsmanship, we can at least gain an idea of it from a related field: pottery. Although just a modest reflection of the grand art of painting and frescoes, pottery nevertheless played an important role in the development of Greek art. Pottery decoration reached a kind of perfection around 500 B.C.E., as exemplified by a cup in Berlin attributed to Sosias. This piece is relatively undamaged and the scene showing Achilles tending the wounded Patrocles is complete (page 94). The two bodies are set in a circle in skillful harmony.

Achilles and Patrocles, interior of a dish signed Sosias, c. 500 B.C.E. Diam: 13″ (32 cm). Antikenmuseum, Berlin (Germany).

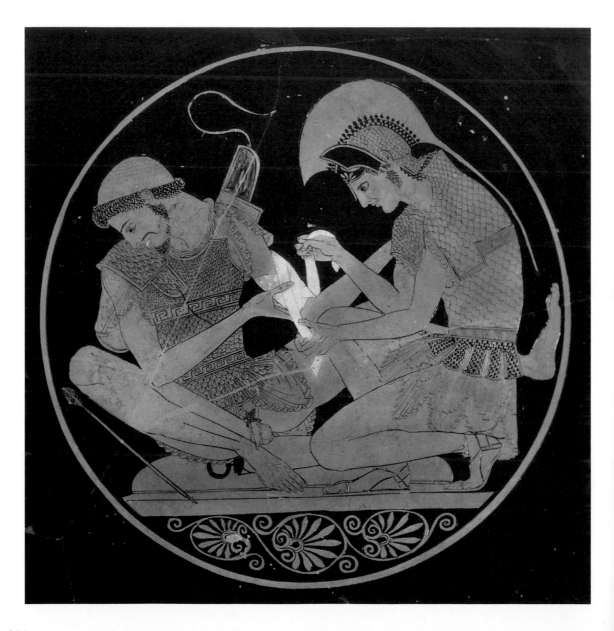

The eye is drawn to the center by the whiteness of the bandage and the white dot that underscores Patrocles' pained grimace. Every element is meticulously executed, from the delicate drawing of hands, arms, and legs, to the fine, carefully etched breastplates, the transparency of the pleated fabric, and the arrangement of reds and blacks. Faced with such artistry, it is hard not to believe that it was conceived by a great painter, then taken up by a decorator able to convey the spirit, respect the refinement, and adapt the subject in his own way with a marvelously subtle sense of line.

A work such as this might suggest the level of skill that Greek painting had already attained. Unfortunately, there is no way of tracing the rapid progress made in the fifth and fourth centuries B.C.E. In just a short period, all constraints—hieratic poses, single plane, limited palette, choice of subject matter—were overcome. We know of this only from the written documents. Polygnotus of Thasos, who arrived in Athens around 470 B.C.E., was praised for the complexity of the scenes he depicted and for his powerful expressiveness. Apollodorus (c. 430–400 B.C.E.) was said to have been the first to blend colors and use tonal shading. Zeuxis, apparently born around 455–450 B.C.E. (died prior to 394), was credited by Pliny with "taking the paintbrush to the heights of glory." Yet Pliny documented chiaroscuro effects only at a later date, when discussing a painting by

Aetion (c. 330–380 B.C.E.) of "an old woman bearing a torch" (probably in a wedding procession), and above all when praising Antiphilos (c. 310–280 B.C.E.) for his depiction of "a young lad blowing on the fire, illuminating both the dwelling… and the child's face."

Painting in Rome

Roman painting presents different problems. Once again the term syncretism must be employed. Rome does not seem to have drawn many major pictorial lessons from the Etruscans—paintings discovered to date in the tombs of Veii and nearby sites are rather poor. The same could be said of the few frescoes discovered on Roman territory. In contrast, once Rome imposed its authority on Greece, masterpieces by the greatest artists flowed into private and public collections in the capital. Furthermore, the interiors of Roman dwellings were henceforth covered with new paintings, as indicated by the House of Augustus and the House of Livia on the Palatine Hill (c. 30–20 B.C.E.), fully confirmed by the many paintings unearthed at Pompeii. For the most part, however, these were probably copies of Greek paintings done by artists who came from Greece. Was there a specifically Roman contribution to such work? It is possible, but for the moment making this distinction would be risky, and would have little significance given the extensiveness of the building and decorating campaigns undertaken in Rome in those days.

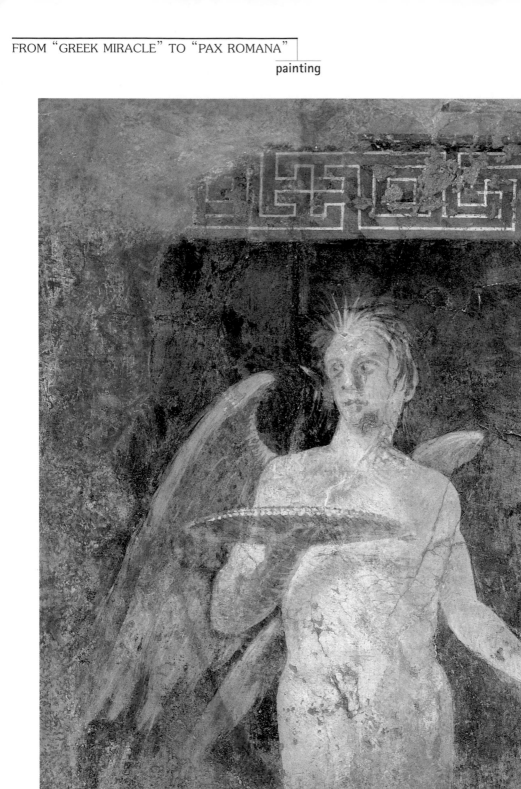

painting

Yet certain things might give us pause: take the *Winged Figure* in the Louvre, a large fragment originally from Boscoreale (page 96). The swift, confident brushwork hardly suggests the work of a copyist. Or look at the little *Harbor Landscape* and *Street Scene* (Museo Archeologico Nazionale, Naples; page 97), sketched with the tip of the brush in an allusive style, their lively vividness combined with a subtle skill in evoking backgrounds: it is hard not to see these as the inspired work of artists, perhaps from Alexandria, aimed at art lovers capable of appreciating their imaginative skills.

Portraits

If there is one realm in which the Roman spirit seems to have retained something of its sincerity, then that is portraiture, a discipline which consistently appealed to sculptors and could hardly rely on imported works. But what remains of painted portraits? Just a few bottoms of decorated glassware with portraits of high quality, usually dated to the mid third century, to which could be added an intriguing *Portrait of a Baker with his Wife* (page 98). Yet in an ironic twist that only underscores the admirable impact of Roman syncretism, the best examples of painted portraiture come from the sands of Fayum in Egypt.

It was an Egyptian tradition to decorate mummies with a portrait of the departed. In Fayum, carved masks were abandoned in favor of a panel bearing a portrait painted in encaustic (wax-based pigment).

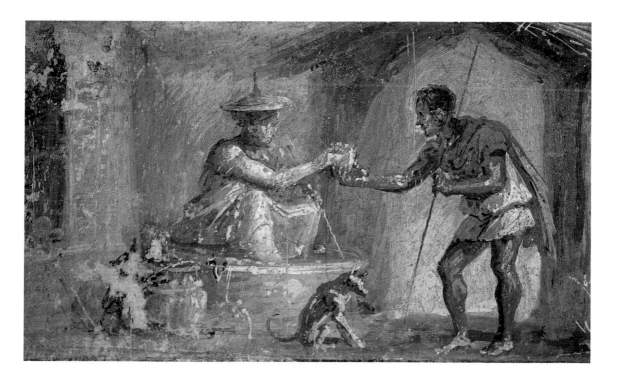

Portrait of a Baker and his Wife, prior to 79. Fresco, 25 × 22" (65 × 58 cm). Museo Archeologico Nazionale, Naples (Italy).

Nearly one hundred have survived, of uneven quality. The best of these provincial portraits, however, offer a better impression of ancient painting than do the ambitious copies found in Pompeii. The psychological subtlety conveyed by the artist who painted the woman dubbed *Aline*, now in Berlin (page 99), is admirable. Mature yet still flirtatious and fashion-conscious, she could have been painted yester-day. And the face of a *Beardless Man* (page 92), now in Copenhagen, displays unexpected freedom and energy of brushwork. With this gallery of portraits, more lifelike than the most realistically carved busts, Roman painting has at least left us—even in the absence of its finest masterpieces—an incomparable impression of everyday life, so alien and yet so familiar, back in the days of its empire.

FACING PAGE

Portrait of Aline from Fayum (Egypt), c. 24. Tempera on canvas, 16 × 13" (42 × 32 cm). Aegyptischesmuseum, Berlin (Germany).

THE FAR EAST

It is not the purpose of this brief history of art to offer a detailed description of the collapse of the Western world, which entailed the collapse of artistic creativity (regardless of what Austrian art historian Alois Riegl and his followers may have written). However, a twofold phenomenon can be observed: on the one hand, there was the rise of all-conquering religions such as Christianity, the Mithra cult, Manichaeism, and Islam, against which Greco-Latin ecumenism could not hold out; and on the other hand, there were invasions by barbarian peoples who brought with them extensive destruction and slaughter, simultaneously sweeping away human and technical capabilities, economic networks, and the vast infrastructure—aqueducts, roads, bridges, harbors, ships—on which the Roman world had rested. Once the first links were broken, the entire chain collapsed. Fortunately, these events occurred over time, and certain techniques could be handed down; but there would be no geographic exception. Rome itself fell prey to the barbarians on several occasions, while Alexandria, Byzantium, and Athens were sooner or later overwhelmed by the Arabs. Finally, it was descendents of the earliest invaders who perpetuated the few

remaining vestiges of the ancient civilizations. But nothing survived of the vast artistic heritage established over three millennia—apart from what would be found in tombs and ruins (or, much later, under volcanic ash).

The Far East: long memories

The same was not true of the other end of the civilized world, namely the Far East. Of course it might be pointed out that during the same period this region underwent violent struggles between kingdoms, experienced brutal changes of dynasty, and even carried out deportations of entire peoples; but none of these matched the total collapse of a grand civilization, the rupture in collective knowledge and memory that occurred all around the Mediterranean.

It will always be difficult for Western minds to imagine a continuous, cumulative history in which traditions stretch, unbroken, back to the mists of time; and it might be supposed that, conversely, it takes a certain effort for Eastern minds to grasp the total regression of an entire set of peoples who no longer understood the language spoken by their neighbors and who lived among the ruins they were no longer able to

Ascribed to Sekkyakushi, active in Japan in the late fourteenth–early fifteenth century, *Boy on Water Buffalo.* Freer Gallery of Art, Washington, D.C.

repair, and then who slowly and with sustained effort rediscovered the secrets of lost techniques and lapsed mental processes.

This divergence has left deep traces; it could hardly be otherwise. Westerners, given the vast effort of reconquest that occurred over a thousand-year period, have developed an irrepressible attraction to progress and novelty, which have acquired almost mystical value. In contrast, the treasure of an uninterrupted past has attuned Far Eastern minds to the respect for tradition. They do not seek invention for invention's sake, but prefer to find it within an enriched heritage.

This difference needs to be stressed from the outset, for it perhaps facilitates our understanding of the arts of the Far East. Even today, such understanding is not automatic; there is no point in pretending that all obstacles have vanished. We are talking about an immense region. Even though many people have visited Japan in the past thirty years, few of them speak the language. Few have traveled to China, a country that was almost completely closed until very recent times. Westerners have no familiarity with the actual location of the main geographic areas (whose names often vary), the identity of the various dynasties, religious beliefs, and social attitudes. As to writing and its refinements, they remain beyond the ken of anyone who has not undertaken a difficult apprenticeship, which renders somewhat suspect the admiration

occasionally expressed by Westerners for Chinese and Japanese calligraphy. Calligraphy's status as an art might even be challenged, not on the level of skill and elegance, obviously, but because, whatever the authority of oriental traditions, the international language of artworks belongs to the realm of forms and not of signs.

It is precisely in its wealth of forms that art from the Far East constitutes a priceless treasure. If we ignore the deeper content and concentrate on the image, it immediately becomes comprehensible. It captivates the eye and seduces the mind. Whatever the problems of spoken and written language, customs, and costumes, Eastern art is no less tangible or vital than any Western art.

In fact, this book should have accorded the same space to China, Korea, and Japan as it does to Western lands. Unfortunately, as mentioned above, the various periods of Far Eastern art in no way coincide with those of Western art (even if there are sometimes shared nuances). Either the chronology had to be abandoned, or two parallel books had to be written; instead, it was thought preferable to provide a brief glimpse of the East at the moment when the *pax romana* collapsed, when the two paths diverged. This glimpse is highly inadequate, of course, but will at least point to the paths not taken by Western art, as well as to some of the marvels produced by a world so distant, so different, and yet so near.

Hua Yan, *The Song of the Cithara and the Rustle of the Wind in the Pines*, China, 1743. Ink and color on paper, 5′9″ × 2′5″ (179 × 75 cm). Museum für Ostasiatische Kunst, Berlin (Germany).

Architecture

Architecture is obviously the most difficult sphere to analyze. The region is so vast, represents climatic differences so important, contains so many peoples with specific traditions, and has seen so many famous edifices built, demolished, and replaced, that one hesitates to make any assertion at all. For a long time yet, while a gigantic inventory is being undertaken, the focus will remain ethnological.

So only a few comments will be made here. The first concerns materials. Construction in stone or masonry played an important role in oriental architecture, as demonstrated by the Great Wall of China. It would seem that the walls that preceded it were built in northern China during the period of the Warring States (fifth to third centuries B.C.E.), then extended about 221–206 B.C.E., and pursued into the Ming period (1368–1644). The Great Wall comprised a stone exterior filled with rubble. Among other types of stone edifice in China, it is worth mentioning ramparts, monumental gates, and especially bridges, of which some fine old examples survive, such as the so-called Marco Polo Bridge with its eleven arches (built to the southwest of Beijing between 1189 and 1192 C.E.), and the seventeen-arch bridge at the Beijing Summer Palace.

Stone was also used for various tombs and certain pagodas.

Yet it would seem that wood was the favored building material for palaces and temples, as well as private homes. Tradition held that these relatively inexpensive constructions would be rebuilt, in identical form, periodically. Hence there was little concern to erect eternal monuments, since from the outset the materials were perishable and the building was destined to be replaced after a generation. This ran counter to the religious architecture not only of the Egyptians but also of the Greeks, Romans, and—later—European builders of cathedrals. At the same time, in a countervailing effect, this transitory aspect seems to have encouraged conservatism in Eastern architecture, based as it was on exact reproductions of earlier models.

Thus it could be argued that the Far East, despite its wealth and refinements, produced no architectural forms that long survived as models for the history of art. An exception could be made for the large round holes cut into walls to serve as doors (page 106), which were entirely alien to European architecture, although relatively recently Ieoh Ming Pei ingeniously adopted this idea for an interior wall of his Louvre project.

Wild Goose Pagoda,
Xi'an (China), 652–704.
H: 195´ (60 m).

Usually, the scale of buildings was relatively modest; elevation was limited to one story, capped by a roof but no ceiling. In contrast, great attention was paid to the form of the roof: whether saddleback, hipped, or tiered, it gave the building personality, and its upturned eaves would be seen in Europe as characteristic of the Chinese style. Yet the finest buildings were distinguished largely by the way they were laid out and set in the landscape, and by the play of terraces on which the temples were built.

One special type of edifice stands out, however: the pagoda.

A round doorway in China.

This could be considered a Chinese equivalent of the Mesopotamian ziggurat, yet it is said to be derived from Indian stupas following the introduction of Buddhism into China. Whether round or polygonal, a pagoda always has several stories whose width diminishes as the building rises. Each story is marked by a roof, sometimes with curved edges. The Wild Goose Pagoda (*Da Yan Ta*), built between 652 and 704, is nearly 200 ft. (60 m) tall and fairly simple in plan (page 104). Other pagodas stress the height and thrust of the edifice. The Sakyamuni Pagoda of the Fogong Temple in Yingxian, built by a Liao-dynasty emperor, was completed in 1056. Built of wood, it has five stories and six cornices (which seem to add up to nine stories when viewed from the interior), rising some 220 ft. (67 m). It thus towered over all the other buildings in the city. Pagodas are not linked to a single religion, because although associated with Buddhism they also exist as Taoist and Confucianist temples.

The most famous temple is the Temple of Heaven in Beijing, which in fact is an architectural complex begun in 1420 on a vast terrace. A wall excluded the people, ceremonies being reserved for the emperor and official celebrants. The round shape was chosen because it corresponded to the conception of the universe at the time: the earth was seen as a rectangular surface over which sat the heaven like a kind of round bell jar. Since 1420, the buildings have been restored or rebuilt to the same plan

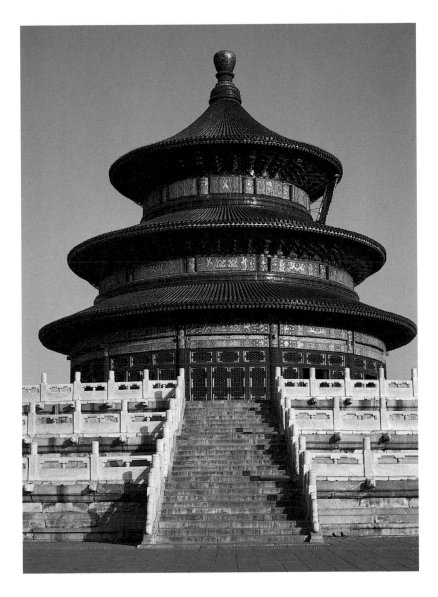

Hall of Annual Prayers,
Temple of Heaven,
original version from 1420,
Beijing (China).

several times, notably following an 1889 fire caused by a bolt of lightning that struck the Hall of Annual Prayers. As is often the case in China and Japan, what we see today are just nineteenth-century copies of the original fourteenth-century buildings (page 107).

The Chinese pagoda is probably the type of building that made the biggest impression on Europeans, for many relatively faithful copies were erected in the eighteenth century in France, England, and Germany as follies on the grounds of large estates.

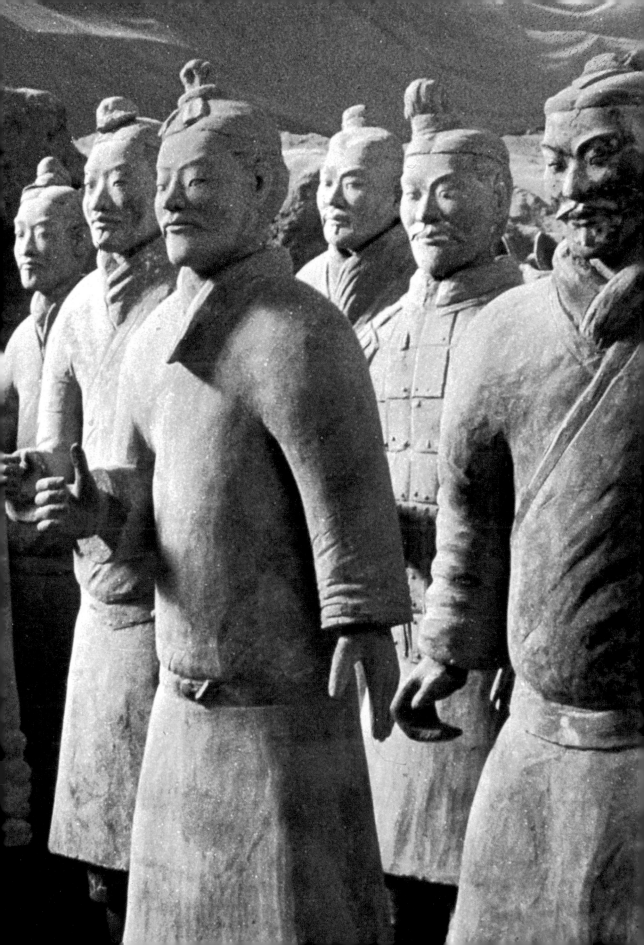

Sculpture

It is probable that forthcoming discoveries by experts in Chinese archaeology—which has only just begin to establish itself (and with what surprising results!)—will lead to a comparison of the dates for China's emergence from prehistory into early civilization with those currently proposed for the West. And yet the transition from reality to symbolic representation, which corresponds to the end of human sacrifice and, more or less, to the birth of art, may have occurred somewhat later there.

It is precisely a stage in this transition that was illustrated in an unexpected and striking fashion by the discovery in 1974 of a chamber near the tomb of the first emperor of China, Qin Shi Huangdi, the founder of the brief Qin Dynasty, who died in 210 B.C.E. (some one hundred years after the exploit that took Alexander the Great from Greece to Babylon). Ancient Chinese texts referred to the marvels of this mausoleum, excavation of which is far from completed. But none mentioned the chambers in which an army of eight thousand life-size terracotta soldiers had been buried. Everything suggests that they were designed to replace the leader's entourage, which was ritually sacrificed to accompany the deceased monarch in his tomb.

These statues of clay were cast from various molds, and each one was individualized. They were certainly painted at the time and constitute an ensemble of surprising vividness and variety (page 108). Life-size horses were also modeled, with considerable skill, in terracotta (in previous centuries live ones were harnessed to the leader's tomb chariot, as testified by the remains of skeletons). The extraordinary virtuosity of Chinese bronze-casters in the first millennium B.C.E. had already been recognized, yet the discovery of Qin Shi Huangdi's army suddenly revealed a mastery of human and equine figures that nothing had led us to expect. Accurate observation is wed to a powerful simplicity of form. The texts also say that, during his lifetime, the first emperor had giant statues of bronze cast in his image. Nothing more is known of them. But it is not impossible that the great conqueror's mausoleum holds further surprises.

The promise held out by these early works, however, does not seem to have been kept—Far Eastern art did not develop sculpted portraits of rulers or private individuals, as was the case in the West, nor give rise to decorative sculpture for interiors or gardens. It did not seek to exploit the respective

Army of 8,000 soldiers, tomb of Emperor Qin Shi Huangdi, third century B.C.E. Painted terracotta. Xianyang (China).

refinements of wood, stone, marble, and bronze, which had been so skillfully cultivated in Europe in the first millennium B.C.E. Nor did it explore the male and female nude the way Greek art did. In practice, the Far East favored objects—in jade, lacquer, and porcelain—over sculpture.

Yet it is impossible to overlook the appeal and quality of the many terracotta figurines produced over a thousand-year period: statuettes of young women, horses, and various animals. These have been found in tombs, where they were placed as offerings. Originally, as

we have seen, they served as replacements for human sacrifice. Relatively modest in size, they are carefully made and often retain their original, vivid colors.

Their execution initially betrayed a certain hieratic feel, but poses soon became less stiff. Rather than sliding into casual repetitiousness, this abundant output could often be remarkably rich. The statuettes of women display a wide variety of dress, as well as expressions that range from naïveté to disdain. The animals are even more fascinating. There are several figures of camels dating back to the Han period

Camel Rising from the Ground, Tang period (618–907), first half of the eighth century. Painted terracotta, H: 14˝ (37 cm). Jacques Polain Bequest, Musée des Arts Asiatiques-Guimet, Paris (France).

Horse in "Flying Gallop," Tang period (618–907), eighth century. Painted terracotta, H: 11″ (28 cm). Jacques Polain Bequest, Musée des Arts Asiatiques-Guimet, Paris (France).

(206 B.C.E.–220 C.E.), usually depicted standing. Illustrated here, however, is an unusual one from the Tang period (618–907) in which the animal is rising from its knees (page 110). This always entertaining and sometimes noisy sight is here rendered with witty realism. Finding a seventh-century Western artist equally skilled at organizing space and depicting a transitional movement would be no easy task.

Similarly, an admirable horse recently donated by Jacques Polain to the Musée Guimet in Paris is shown mouth open, mane waving in a "flying gallop" (page 111). The game of polo, of course, was very fashionable at the Chinese court in the early Tang Dynasty, and must have spurred artists to study horses in every pose. Yet it is still hard not to admire, in the mid seventh century, the impression of speed and effort, something not matched by Western antiquity.

To this series of statuettes should be added another, quite different chapter, one less known in Europe—namely, art inspired by religion. Indeed, the influence of Buddhism should not be overlooked. Buddhism is traditionally

held to have reached China in the year 65 C.E. and quickly spread across the country, only to decline after the persecutions of the ninth century (whereas, in Japan, Buddhism retained its predominance). Because Buddhism tolerates the worship of images, it gives great scope to the arts, notably sculpture. Chinese art does not rival the wealth and vitality of Indian or Khmer art in this sphere, not least because many works were destroyed during periods of persecution. Yet the few surviving works often display remarkable quality. Take, for example, the statues of a *luohan*, or disciple of Buddha, now in Paris (page 112) and the British Museum in London. These large, colored ceramics are almost life-size, and not only demonstrate surprising mastery of this technique during the Liao Dynasty, but also a

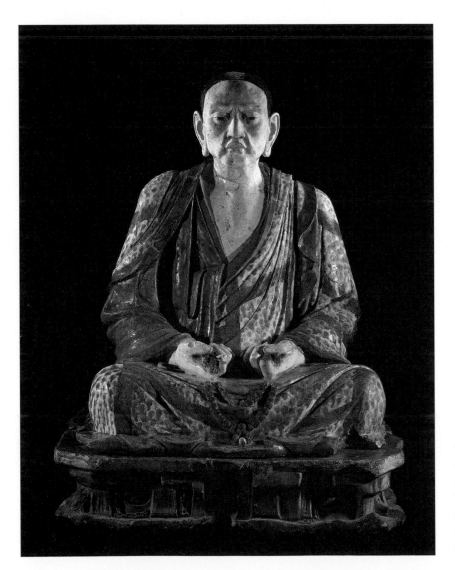

Statue of a Luohan (Danmoluobatuo, the Sixth Disciple of Buddha), China, tenth–thirteenth century. Ceramic, H: 3'2" (98 cm). Musée des Arts Asiatiques-Guimet, Paris (France).

realism and psychological expressiveness in the garments, hands, and faces that place them among the true masterpieces of sculpture.

Japanese sculpture, meanwhile, perhaps does not offer the same originality and mastery displayed by its painting. But mention should be made of often-overlooked statues of Buddhist inspiration, such as the *Seated Portrait of Tokiyori* (page 113), now in Paris, with its impressively austere volumes, lines, and expressivity.

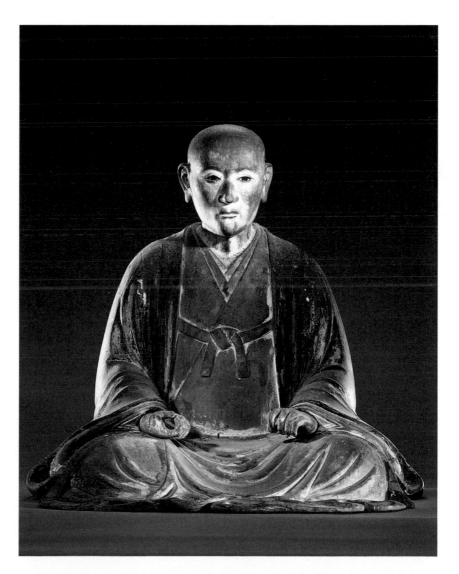

Seated Portrait of Tokiyori,
(Japan), wood.
Musée des Arts asiatiques–
Guimet, Paris (France).

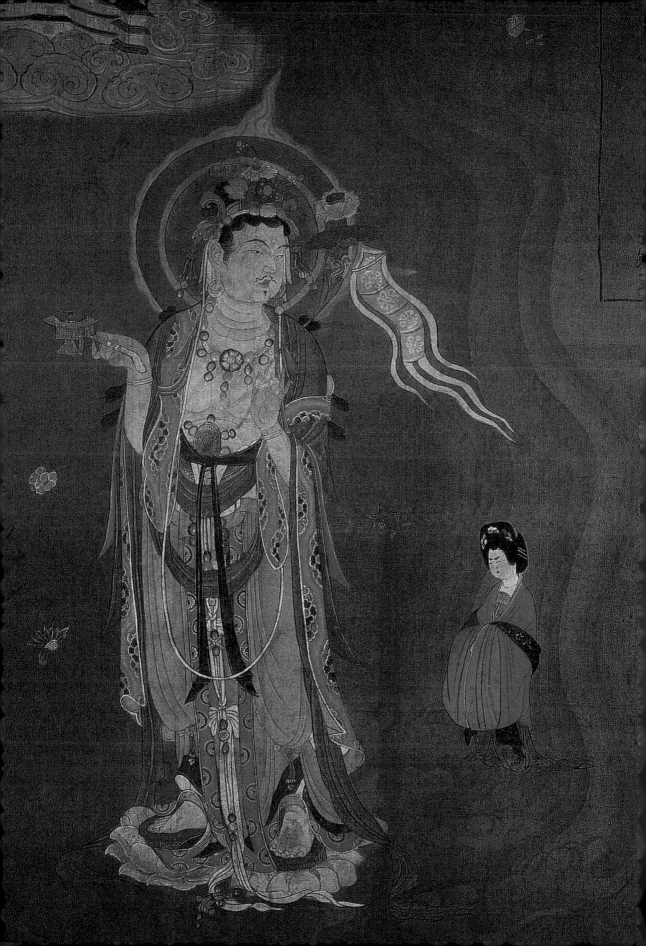

Painting

Far Eastern painting evolved completely isolated from the major developments in Western painting. It was practiced in highly specific contexts using supports that differed greatly from those used in the West. And the support, of course, has a considerable influence on inspiration. As mentioned above, architecture mostly involved wooden buildings designed from the start to be demolished and rebuilt. Hence in the Far East there was little call for frescoes, a major form of Western painting from ancient Greece through to the Renaissance and into the eighteenth century. The space of Oriental buildings also being limited, they were never adorned with large canvases of oil paintings—requiring a certain distance for appreciation, also difficult to move around—which represented the lion's share of the masterpieces preserved in Western homes and museums. Therefore, the three main supports for painting were vertical scrolls (called *kakemono* in Japanese), horizontal scrolls (*makimono,* often narrow but very long, able to accommodate complicated narratives, and easily stored in a modest wooden container), and finally multipaneled screens that offered a large surface yet could be easily folded and stored in closed position. All Eastern painting, then, was intended to be viewed at specific, brief moments. Screens and scrolls were usually painted on paper and silk, which were light, supple, fragile materials that needed to be protected from the light (the very light that enhances the effects of oil painting). Apparent differences in technique thus tend to narrow: many of the most famous Japanese "paintings" would pass for drawings in Europe. The ambiguity of these categories, in fact, explains the importance acquired by color prints starting in the eighteenth century.

It might be supposed that the art of painting would lose a great deal by limiting itself to light, foldaway forms. True enough, there is nothing to match the lyricism of a Titian or Rembrandt, nor the musical harmony between architecture and painting found in so many baroque churches. Nor will we find the forcefulness of, say, Veronese's *Marriage at Cana* or Delacroix's *Death of Sardanapalus.* Yet formal experimentation in the East was interiorized, so to speak, and painters, by reducing the image to the dimensions of the gaze—a skilled, attentive gaze—achieved a level of refinement that has never been surpassed.

It would be mistaken to assume, for that matter, that Far Eastern

Bodhisattva, Dunhaung (China), late ninth century. Ink and colors on silk, 31 × 21″ (80 × 53 cm). British Museum, London (England).

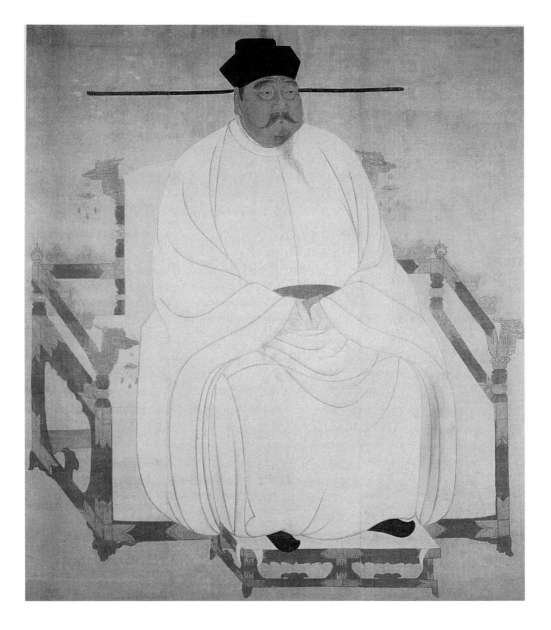

painting is monotonous. Portraits are much rarer there than in Europe, but are of outstanding quality, as demonstrated by the *Portrait of Song Taizu* in Taipei, apparently executed in the second half of the tenth century (page 116). A remarkable clarity and assurance are evident in the way the white mass is defined by just a few curving red lines, in the geometric structure of the red chair, in the dark patches of the hat and shoes, and in the pure horizontal line barring the background.

Horizontal scrolls featured, above all, a variety of tales, from adventurous voyages to more comic novels, never shrinking from caricature or burlesque effects.

Portrait of Song Taizu, China, second half of tenth century. Ink and colors on silk, 6′2″ × 5′5″ (1.91 × 1.69 m). National Palace Museum, Tapei (Taiwan).

Kshitigarbha Meditating on a Lotus, China, early tenth century. Ink and colors on silk, 21 × 15" (55 × 39 cm). British Museum, London (England).

Scenes of everyday life were often depicted, sometimes humorously, sometimes with poetic sensitivity, and women were often shown either in the role of a good housewife or of an elegant courtesan. Conversely, certain forms of painting were inspired by Buddhism, ranging from a refined, late ninth-century image of the *Bodhisattva* protecting a high-ranking lady (page 114) to mystical works such as *Kshitigarbha Meditating on a Lotus* (page 117) by an anonymous painter who probably lived in the early tenth century.

Sometimes moral lessons may be hidden behind invented scenes that are hard to fathom, notably in paintings inspired by Zen Buddhism

(see below). The scroll illustrated here (page 100) might pass for a simple rural scene of a boy riding a water buffalo, but the subject carries a symbolic meaning: nothing could be more difficult than mastering a buffalo, a strong, heavy animal that does what it wants; similarly, when it comes to meditation, nothing could be more difficult than to master one's thoughts and to concentrate on nothingness, as Zen practice requires. In fifteenth-century Japan, the image of a rebellious, awkward buffalo being harnessed by a small lad with a thin ribbon evoked the same eternal struggle and ultimate triumph seen in Michelangelo's sculpted *Victory* in sixteenth-century Florence (page 217) and Albert Pommier's monumental *Hercules* in twentieth-century Paris (page 530), even if the latter two replace religious asceticism with a generalized Western philosophy.

Nevertheless, we should not seek symbols in every image from the Far East. Such symbolism exists, but without lengthy initiation we cannot hope to follow the twists and turns of a philosophy belonging to other eras and other outlooks. In order to appreciate such art, it suffices to sense the painter's ambition, without necessarily understanding it all. China, Japan, and Korea would probably not have produced so many landscapes if they had not been stimulated by the simple pleasure of contemplating nature with its flora, fauna, and ever-surprising presence of humans. Landscape, the preferred realm of Far Eastern art, also represents

its outstanding accomplishment. Nothing in Western antiquity could have allowed us to predict the flowering of this genre.

The history of Eastern landscape art cannot be recounted here, for it would require as much space as an explanation of all Western art, and would be even more complex to present. Despite the enthusiasm of connoisseurs, vast periods remain obscure. Worth stressing, however, is the fact that right from the Sui and T'ang dynasties (sixth to tenth centuries), landscape images appeared alongside poetry. Fascinating traces of them have been uncovered in Chinese tombs (which remain underexplored). There also survive old copies of landscapes painted on silk. Some of these can be dated to the late sixth century, such as an *Outing in Springtime* (Palace Museum, Beijing), perhaps attributable to Zhan Ziqian, an artist favored by Emperor Wen Di (reigned 589–604). It shows the trees still bare from winter, hills rolling into the distance, and tiny figures on foot or on horseback in the countryside—the Chinese landscape was already fully formed.

A different stage was marked by the scroll painted by Dong Yuan (active c. 937–962), also in Beijing. It presents a horizontal view of a long hill with wooded slopes and the bay formed by the Xiao and Xiang rivers, where the wives of the legendary emperor Shun allegedly drowned themselves in sorrow. The space is harmoniously divided between land and water,

Guo Xi, *Early Spring*, China, 1072. Ink on silk, 5′2″ × 3′7″ (1.58 × 1.08 m). National Palace Museum, Tapei (Taiwan).

Lu Zhi, *Gathering Medicinal Plants in the Mountains*, China, 1547. Ink and colors on paper, 27 × 13″ (70 × 32 cm). Museum für Ostasiatische Kunst, Berlin (Germany).

Wang Hui, *Lu Mountain*,
China, 1692. Ink on paper,
3′3″ × 1′6″ (101 × 46 cm).
Museum für Ostasiatische
Kunst, Berlin (Germany).

the composition is simple, the human figures tiny. Not long afterward, however, during the Song dynasty in the North, a different sensibility could be seen in the work of artist Guo Xi. His *Early Spring* (1072; page 119) exploits a vertical scroll to multiply—in a thoroughly unrealistic if artfully studied way— what Guo Xi himself called, in the title of one of his theoretical treatises, "the sublime features of forests and springs." This was the tradition that would henceforth dominate Chinese landscape painting. Rocky cliffs, deep ravines, peaks rising in the distance, twisted trees, sometimes a house clinging to the slope—the formula scarcely evolved from Lu Zhi's 1547 *Gathering Medicinal Plants in the Mountains* (page 120) to Wang Hui's 1692 *Lu Mountain* (page 121). The only thing that changes is the handling of the brush, the addition of a shade of color here or there, or the introduction of clouds or wisps of mist that lend depth to the composition along with an unreal sense of lightness.

Japanese graphic art was closely linked to that of China. Major exchanges were already occurring in the sixth and seventh centuries, both in terms of techniques (notably the production of paper and ink) and religious concepts. In the thirteenth and fourteenth centuries, the influence of Zen Buddhism grew and the technique of painting with ink enjoyed a brilliant period. Then, toward the late seventeenth century, Chinese monks and artists, driven from their land during the fall of the Ming dynasty and the ensuing upheavals, moved to Japan and once again imported the tastes and developments of the continent. It is hardly surprising, then, that an artist such as Kao Sonen (died 1345) sketched his portrait of Kanzan, an eccentric character in Zen mythology, in such a lively manner (page 125). And it is natural that, around 1500, a work such as Gakuo Zokyu's *Landscape* (page 123) harks back to large Chinese scrolls, notably through its twisted trees, high cliffs rising above the mists, and distant background sketched with a light, quick brush.

Yet Japan's decorative spirit also asserted its own personality. This can be seen in the large historiated screens that became one of the most striking features of Japanese art. A pair of late sixteenth-century screens titled *Southern Barbarians* (Freer Gallery of Art, Washington, D.C.) are famous for the vivid way they show the Portuguese arriving in Japan and marching down a street. Even more remarkable, however, are works by Kano Eitoku (1543–90), such as his *Screen with Cypress Tree* (National Museum, Tokyo), set against a background of clouds done in gold leaf. The bold composition shows only a part of the trunk. This elliptical view, translated into prints, would make a strong impression on European painters in the late nineteenth century. Sixteenth-century Japan produced many screens with gold-leaf decoration of plants, flowers, and birds, sometimes very sober in design, other times wonderfully

Gakuo Zokyu (active
c. 1500), *Landscape*,
Japan. Ink and colors
on paper, 31 × 14″
(80 × 35 cm).
Freer Gallery of Art,
Washington, D.C.

Gyokuen Bompo
(1344–c. 1420),
Orchids and Rock, Japan.
Ink on paper, 33 × 14″
(84 × 35 cm). Freer Gallery
of Art, Washington, D.C.

opulent. It is very strange to realize that Japan, completely cut off from Europe at the time, developed an art so similar to the one produced in France in the seventeenth and eighteenth centuries.

Indeed, throughout its history Japanese painting was subject to "fashions" no less surprising than those in the West. One of the developments that most marked it was the importance assumed by Zen Buddhism in the late twelfth century (derived from the less enduring influence of Chan Buddhism on Chinese art). This version of the Buddhist religion, implying a highly disciplined lifestyle as well as a religious doctrine, turned artistic expression into the product of personal meditation. Stress was therefore placed on subjectivity, on free draftsmanship, and on reducing things to essentials. Ellipsis was sometimes taken to the point of enigma, and spontaneity led to a "splattered ink" technique that verged on abstraction. Thus the technical perfection of Japanese art was allied to a contrary principle of swiftness, emotion, and pure intuition. Zen art, in itself, has produced some surprising masterpieces. Above all, however, its influence ultimately meant that the concept of "imitating nature" never became an ideal for painting in the Far East (as it was for so long in Europe). Even when imitation was most vividly affirmed, Far Eastern art never abandoned a

Kao Sonen (?–1345), *Portrait of Kanzan*, Japan. Ink on paper, 3′4″ × 12″ (102 × 30 cm). Freer Gallery of Art, Washington, D.C.

concern for abstract form and subjective style. This profound difference has affected artists' very mentality, and has turned all Chinese and Japanese painting into an extraordinary lesson in art for Western artists and connoisseurs.

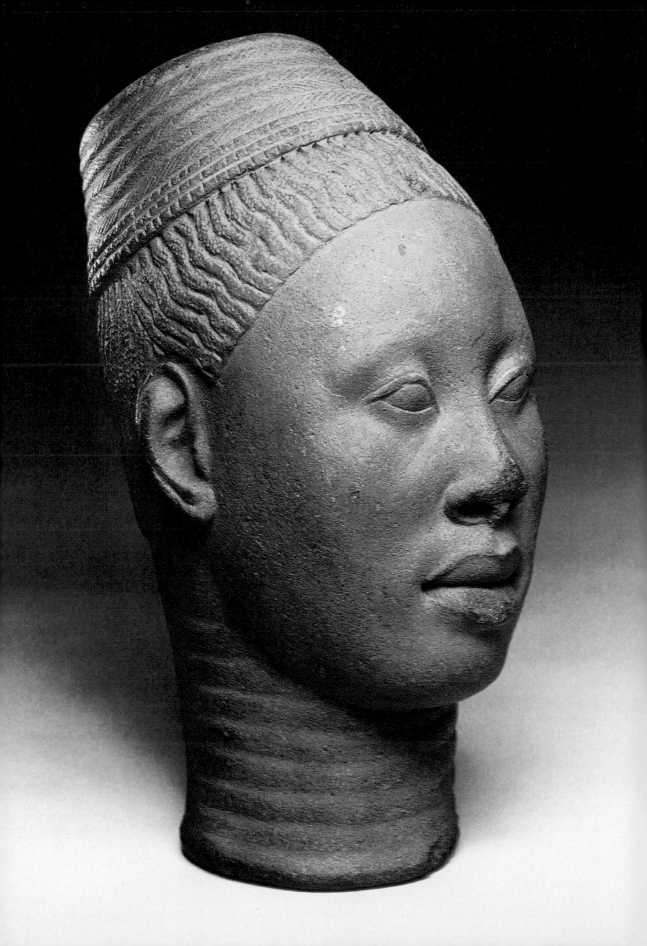

THE AFRICAN WORLD

In many regions of the world, at different moments, the prehistoric period represented a major formative stage for humanity. Religions became highly developed (even though their content remains a mystery to us) and a vast number of images were produced (even though only a tiny percentage has survived and their meanings are lost to us). The few clues that we possess were usually distorted by the religions that followed, starting in the third millennium B.C.E.

That is why sub-Saharan Africa is of particular interest to scholars. It long remained free of Christian and Islamic influence, retaining its animist traditions. Nigeria, in particular, has yielded up interesting vestiges. Although relatively recent in comparison to those of Upper Egypt and the Mediterranean sphere, these remnants, in the absence of any written culture, shed light on unknown developments.

Near the village of Nok, over 150 terracotta figurines have been discovered, simultaneously crude and expressive, some of which can be dated between 500 B.C.E. and 200 C.E. Other sets, apparently more recent, have also been uncovered, including a series of anthropomorphic monoliths at Ikom, and even a group of bronze statues of the so-called Tsoede

type. Perhaps the best-known relics are the bronze plaques now dispersed in ethnological museums the world over. They originally came from Benin, whose inhabitants had obtained a trading monopoly with the Portuguese. The plaques date from roughly 1550 to 1897. They display a certain technical skill combined with the vivid expressiveness often found in "zones of contact" with Western civilization.

This output, of more interest to ethnologists than to art historians, would not necessarily be discussed in this book were it not for an outstanding series of heads from Ife, an ancient city located on the banks of the Niger. Excavations seem to prove that it already existed in 800 C.E. The first heads came to light around 1910, but it was only after 1938 that they were systematically sought. The complete group, for the most part displayed in the Ife Museum in Nigeria, remains little known to most people. Yet these heads represent one of the most important discoveries of recent decades, for it is the one that raises the most complex issues.

The group includes a considerable number of heads, made either of terracotta or bronze. They are not fragments. Some rather clumsy statues in the same style

Head of man, Nigeria, twelfth–fifteenth century [?]. Terracotta, H: 13″ (32 cm). Museum of Ife Antiquities, Ife (Nigeria).

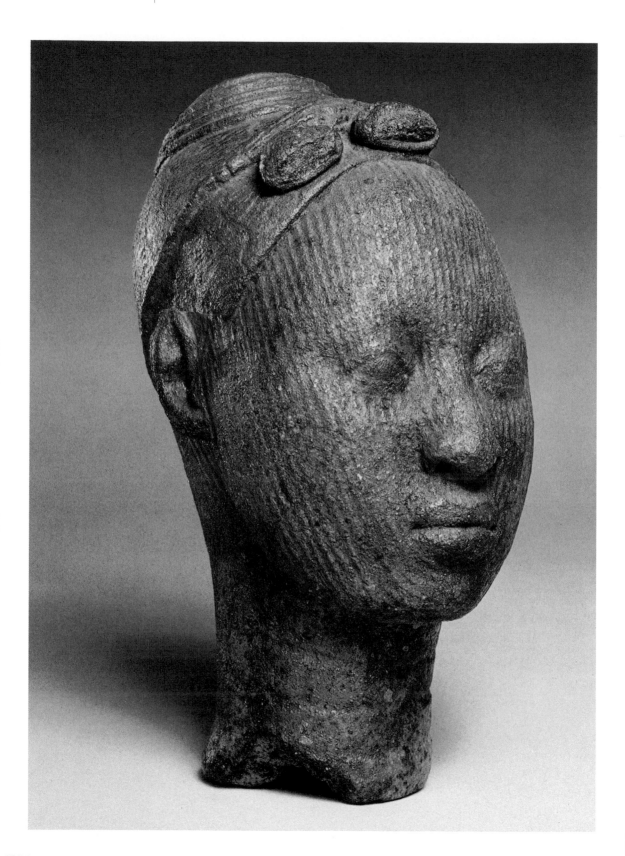

Head of man, Nigeria,
twelfth–fifteenth century [?].
Bronze, H: 11″ (29 cm).
Museum of Ife Antiquities,
Ife (Nigeria).

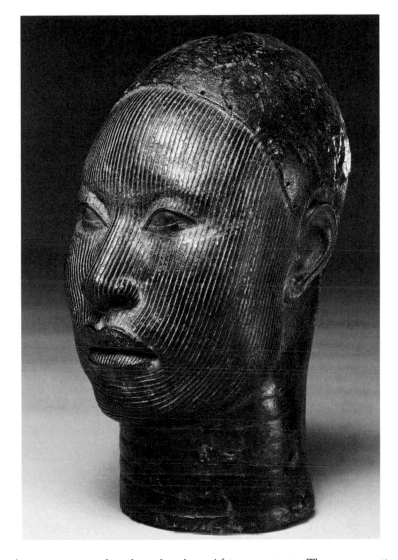

FACING PAGE
Head of man, Nigeria,
twelfth–fifteenth century.
Terracotta, H: 10″ (25 cm).
National Museum,
Lagos (Nigeria).

are known to exist, but these heads usually terminate at the base of the neck, with no mark of breakage. Carbon-14 methods have dated them all to the thirteenth to fifteenth centuries C.E. Oral tradition holds that they are portraits of local kings, *oni*, and they were usually buried at the foot of a tree as part of ceremonial ancestor worship.

The great surprise is that the Ife heads represent a break with everything previously known of African output. They are entirely realistic in appearance, with subtle modeling, accurate proportions, and a handling of eyes, lips, and ears that displays extreme care. Even Egyptian and Greek art took a long time to achieve such mastery, not to mention such indisputable beauty.

We still have no explanation for the emergence of these masterpieces in Ife. Nothing in the production of African masks—admittedly, rather late—points to their

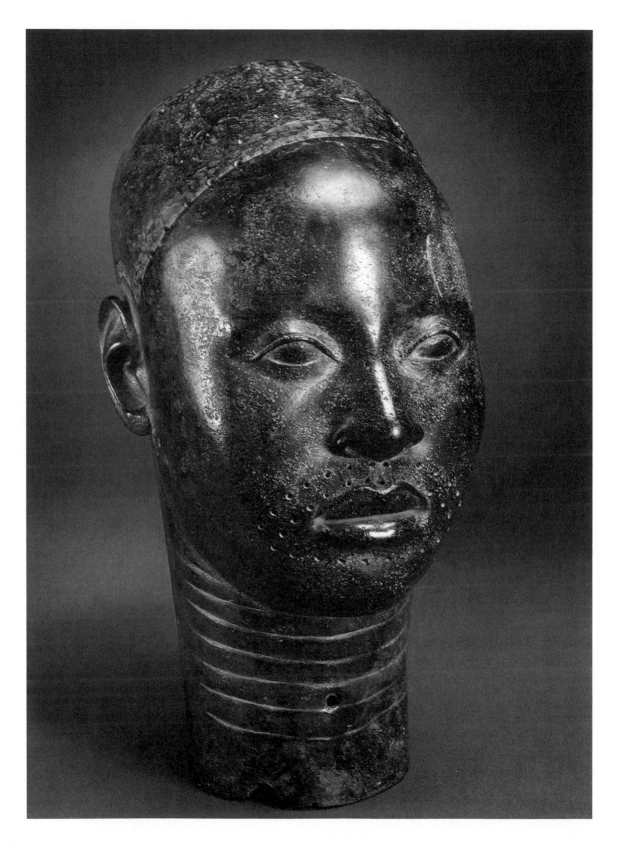

development. They remain unique in terms of craft and spirit. Yet in no other land at no other time did masterpieces of this caliber arise spontaneously. A long evolution, combined with propitious circumstances, is indispensable.

History is unlikely to unravel this mystery any time soon. Ife, located on a river, was not an isolated center. It was said to have been founded over a thousand years ago, but such ancient oral traditions are unlikely to be reliable. So where did its people come from? Did they already possess the skill of casting bronze? Where did they learn it? Art often travels with technology. Meanwhile, is the current dating of the heads, carried out under difficult conditions, truly reliable? If the dates are pushed forward or backward, certain explanations might suggest themselves.

Take the terracotta head depicting a man with short hair and a skull cap (page 126), which has survived in exceptionally good condition. Tradition holds that it represents a usurper named Lajuwa, who seized the throne of Ife on the death of the legitimate king, and that this portrait never left the royal palace. But tradition does not carry the authority of historical fact. Whatever the case, the artist who modeled this face had perfected time-honored skills. Whereas the masks and statues that are said to typify African art always involve *the addition of markers* for eyes, nose, teeth, and genitals—represented in an almost independent way—here the sculptor started from the overall synthesis of face and expression, and then drew from it all the features with a simplicity that triumphantly conveys inner life.

Another head of a man was cast in bronze with a high zinc content (page 130). The hair is not modeled, and it would seem that the upper head originally bore a complete diadem, worked separately (examples of which have been found on other pieces). The holes that ring the upper and lower lips might have held a beard and mustache of real whiskers, but it is remarkable that they in no way alter the underlying modeling of the face, which is handled no less sensitively than that of the terracotta head.

Two other heads are striped by unbroken grooves that run the length of the face (pages 128 and 129). These marks often appear on Ife heads, and would seem to represent ritual scarification. Yet here again, the lines are etched with such skill and refinement that, far from destroying the modeling and distorting facial features, they underscore the sensitive handling of volumes.

Faced with such works, it is impossible not to recognize that Ife sculptors *devised* an African ideal of beauty in the same way that Olympian sculptors *devised* a Greek ideal of beauty. And that this beauty, far from resembling the anecdotal expressionism of the masks formerly vaunted by the likes of André Derain and André Breton, possesses the same solemnity and universal appeal as Greek art of the fifth century B.C.E.

Head of a man, Nigeria, twelfth–fifteenth century. Bronze, H: 12″ (29 cm). Museum of Ife Antiquities, Ife (Nigeria).

III
THE HUMANIST RECOVERY
(8th–14th Centuries)

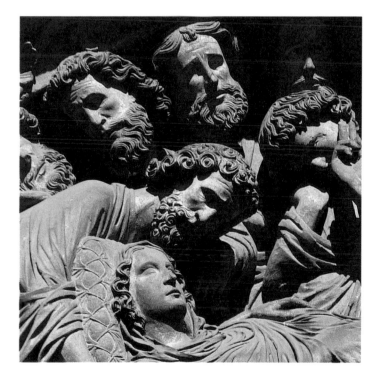

introduction

It matters little whether the end of the ancient world is assigned the symbolic date of 410, the year Rome was sacked by the Visigoth Alaric, or 726, the year Byzantium issued its first iconoclast decree, thereby outlawing images. The fact is that starting in the fifth century, a dark, troubled period descended on the West. Nearly a thousand years would pass before the ancient world's sense of harmony and splendor would be recovered. This period is usually called the Middle Ages.

This unfortunate label should be discarded, however, because no matter how it may be interpreted, it is inappropriate. A period that gave free rein to passions, from the most criminal to the most saintly, could hardly be called "middling." Nor does the term "middling" come to mind when standing before such bold architectural accomplishments as the Sainte-Chapelle in Paris or the cathedral of Bourges. If, on the other hand, "middle" is taken to mean a period *between* antiquity and modern times, taking the basilica of Saint-Denis as an intermediate stage between the Parthenon and the Château of Versailles, then debate might go on forever. But the point is not to quibble over a term accredited by long usage, whose original meaning escapes those who employ it; no, the important thing is to try to avoid preconceptions when confronting historical realities.

In the name of various forms of "primitivism" and in defense of "arts of the people," attempts are sometimes made to reassert the value of this period. Such attempts are misleading. For this period was, initially, a true return to barbarism: technical knowledge and extensive artistic experience were wiped out. The very idea of art even vanished from vast regions that had enjoyed centuries of booming creativity. Worse, works of art formerly prized and venerated henceforth inspired only hatred and destructive impulses.

Much could be said about this sudden decline. But what interests us here is just the opposite, namely the slow recovery that, after a period of slaughter and pillaging, would lead to a new flowering. This recovery, it should immediately be pointed out, never represented a reconstitution of the original. What would rise from the disaster was a new humanism, a humanism entirely different from the one associated with classical antiquity.

Geographical upheaval

This slow rise, or rather recommencement, was marked by major geographical upheavals, all linked to religious developments. Indeed, it was henceforth religion that would assume priority over other issues—and religion's attitude to art was unpredictable.

From today's standpoint, Christianity appears to have played the main role in the spiritual ferment that accompanied the collapse of the ancient world. Yet Christianity's fate was by no means certain, and it was surrounded by an entire range of more or less divergent cults and

persuasions. One of its staunchest rivals arose in the third century in the person of Mani, who used the message of Jesus in an attempt to establish his own church in the Sasanian world. Mani, who was very doctrinal, was apparently favorable to the use of sacred imagery, and tradition even holds that he was a great artist himself. Conversely, it would seem that Jewish hostility to the depiction of humans hardened as Christianity grew. Christians, meanwhile, had not necessarily rejected an alliance between art and religion. But subsequently, in Byzantium, scrupulous minds worried about the devotion people were displaying toward images, attributing miraculous powers to them. This concern led to the iconoclast movement, which arose first among the aristocracy of clergy and court, in opposition to the monasteries and to simpler minds contaminated by the survival of pagan practices. The upshot was the prohibition of images at the ecumenical councils of 730 and 753 in Constantinople. Religious images were authorized again under Empress Irene, then outlawed anew, and were only permanently restored to "orthodoxy" in March 843. In the intervening century, widespread destruction of images had taken place.

What was at stake was perhaps nothing less than the entire fate of art in the West. The Koran, meanwhile, had recently condemned all depiction of humans (Mohammed died in 632). The Arab conquest soon extended to all parts of the Mediterranean, suppressing every type of figurative image in Asia Minor, Egypt, the African coast, and Spain. The invasion was only halted at Poitiers, in central France, in 732. Byzantium, meanwhile, held out against the Turks until 1453. But what would have happened if the decisions of the iconoclast councils had been upheld, permanently excluding Christian countries from the world of art from 730 onward?

Intellectual change

It should not be forgotten that the Mediterranean tragedy took place against a backdrop of successive invasions of peoples from the east, peoples that overran the Roman *limes* (fortified borders) and advanced as far as Italy, Gaul, and Spain. They inflicted brutal destruction, and naturally the most Latinized regions had the most to lose. The invading nomads, however, were pagan, and although they leveled everything in their path they were not iconoclasts. And although they sacked and burned churches, it was not long before they began to convert. They wound up constituting a vast territory between Italy and Aquitaine and Spain. This territory was highly fragmented and always under threat, yet it energetically resisted Islam and would soon be a haven of artistic expression.

Haven? Indeed, although not a haven of freedom. In the ancient world, religion had granted great latitude to the arts. Henceforth, it would exercise more control than did political government. Constantine

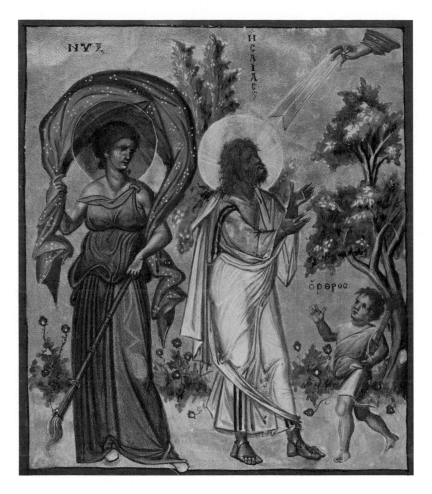

The Prayer of Isaiah, *Paris Psalter*, tenth century. Byzantine miniature, paint on parchment. Bibliothèque Nationale de France (ms. gr. 139, fol. 435v), Paris (France).

had grasped this when, even before paganism had been deprived of its official status, he favored the Christian religion and ultimately linked the fate of the empire to that of the Church. For several centuries, in art as in society, Christianity exercised what can only be called a kind of dictatorship. Artists were at the service of the Church, and it would be a long time before they regained the measure of freedom required for personal creativity.

The crucial point is that this subjugation concerned not only the craft, models, and iconography of art, but also the very way of thinking. Byzantium, probably inspired by religious theory, wound up favoring concepts over tangible appearances, even in the visual arts. This can be seen in a miniature illustrating Isaiah's prayer in the *Paris Psalter* (page 136). A large figure on the left, dressed in blue and holding a billowing blue shawl, symbolizes the fact that the scene takes place at night, while on the other side enters a scantily clad child suggesting that the scene lasts until the arrival of dawn. To insure that the symbols are understood, each figure is labeled above in Greek: "night," "Isaiah," and "dawn."

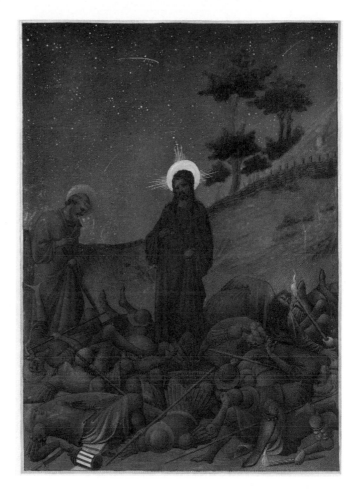

Limbourg brothers, Ego Sum,
Les Très Riches Heures
du duc de Berry, 1416.
Paint on parchment.
Musée Condé
(ms. 65, fol. 142v),
Chantilly (France).

Now if we compare a page illustrating the arrest of Christ in the famous book of hours known as the *Très Riches Heures du duc de Berry*, we see that the entire page is blue: a dark yet transparent blue for the sky dotted with shooting stars, and slate blue for the ground where the bodies lie piled in nocturnal gloom (page 137). Two glowing torches and a lantern are not sufficient to pierce the darkness—only the halo of Christ, in the middle, shines like a heavenly star. This, too, is symbolic, but it is developed throughout the entire page. By favoring tangible appearances—the pure clarity of the sky that contrasts with the chaos of the foreground, the harmonious tonal grading of blues, the dim features of Christ and Saint Peter who are barely visible in the dark—everything here manages to convey the first mystery of the Passion without recourse to symbolic expression.

The year was 1416, the artists were the Limbourg brothers. It was a time when artists reconquered their full artistic powers, when the first of Western art's grand revolutions had just occurred.

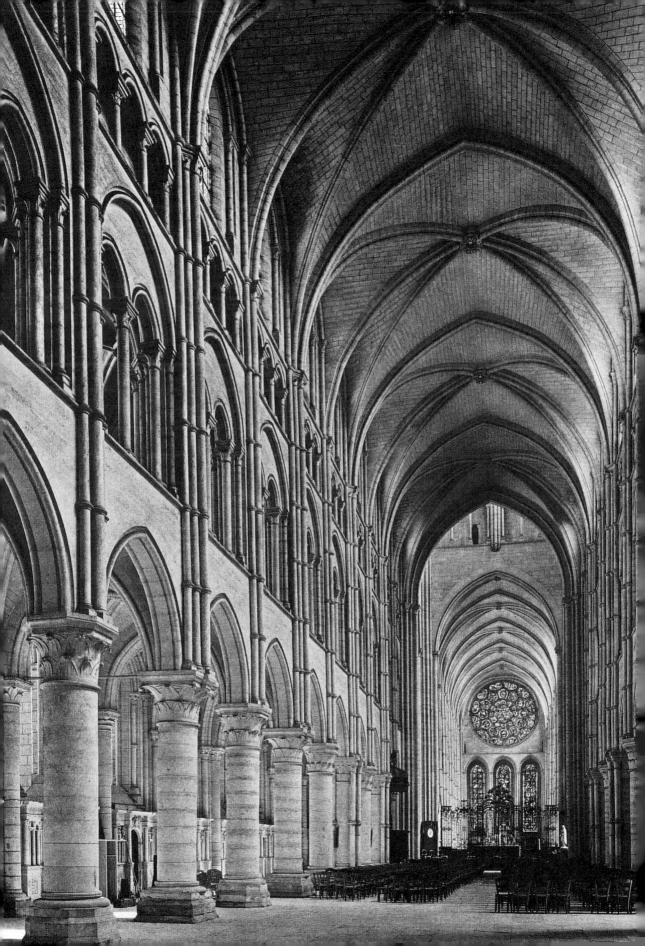

Architecture

Military architecture

The term "dictatorship" was used above to suggest that church authorities governed artistic creativity for centuries. When it comes to architecture, however, that idea might be misleading. We should not forget that the salvation of the body always comes before that of the soul. While it is true that modest towns spent incredible sums on their churches—building, enlarging, decorating, and renovating them in the latest fashion— and that cities always seemed to bristle with spires when seen from afar, when viewed close up these towns were girded by walls and towers. And on most heights there rose castles that dotted and shaped the countryside. So for many centuries, military architecture was even more present in Europe than ecclesiastical buildings.

It is important to keep this in mind and to examine differing attitudes to preservation, which have warped our perception. Few examples of military architecture survive prior to 1400, and those that remain are usually in ruins or, at best, incomplete. Religious architecture, in contrast, has changed little. The transition from Catholicism to Anglicanism in England, and to Lutheranism or Calvinism in northern Europe, obviously led to the destruction of great abbeys, yet it left most ecclesiastical architecture standing in a functional state. Most old fortifications, in comparison, were rendered completely pointless by the invention of artillery. Town ramparts were replaced by a bastion—the work of engineers more than architects— and even cities that remained strongholds no longer bear any traces of their former defenses.

Furthermore, civil government, long fragmented into rival powers, tended to become more centralized in most countries. Castles henceforth represented potential pockets of resistance to centralized rule. In France, for example, Louis XIII (reigned 1610–43) finally took the decision to dismantle large and small castles within his lands, producing all those ruins that can still be seen dotting French hilltops and valleys. In many instances, these strongholds, whether ancient or recent in origin, were quickly transformed into quarries—their stones then used elsewhere—or into nonmilitary châteaux of the type now seen along the Loire River.

Has much been lost, in terms of the art of architecture? Without a doubt. We need merely look at the calendar of months in the *Très Riches Heures du duc de Berry*,

dated 1416, which features illustrations of the duke of Berry's favorite "residences": Lusignan, Dourdan, Poitiers, Étampes, Saumur, and so on. The powerful volumes, varied designs, and rich details suffice to show that an essential aspect of French architecture vanished along with the old castles. Confirmation comes from the few Italian castles that have survived, such as the Rocca Scaligera in Sirmione, which dates back to the late thirteenth century, and the Castello di Fenis in Valle d'Aosta, built around 1340. But the most impressive set of castles is perhaps the series of fortresses built in Wales after it was conquered by England in 1283. For this program of castle building, King Edward I called on an architect from Savoy, James of Saint George. One of the most impressive is Caernarvon Castle, whose tall bare walls rise along the seafront, banded by strips of red sandstone and framed by five powerful octagonal towers (page 140). There is no attempt to decorate the upper sections, nor to soften the impression of a massive barrier through any play of asymmetry.

It was rare that castles were built in one go. One of the largest and best documented was the one built by the popes in Avignon, a building that suffered from neither wars nor demolition orders. In fact, it includes an Old Palace built from a former bishop's residence under Benedict XII (1334–42), then enlarged later under Clement VI (1342–52). The staggered façade and the tall, blind arches reinforcing the walls lend the edifice a

Caernarvon Castle, (Wales), thirteenth–fourteenth centuries.

Palace of the Popes,
Avignon (France),
fourteenth century.

more varied appearance (page 141). Similarly, despite terrible damage done to the interior, a few rooms still decorated in the original manner reveal how fortresses could often combine their defensive role with a decorative one: the frescoes in the Wardrobe Tower are certainly the finest secular paintings to survive in France from that period (1343).

Ecclesiastical architecture

Churches, of course, have suffered less from the ravages of time than have ramparts and castles. Yet here again it would be an illusion to think we know them fully—we have to beware of one obvious if often overlooked fact: of a series of buildings erected on a given site, only the most recent is known to us. Often enough, a thirteenth-century cathedral replaced one from the eleventh century, which itself succeeded a Carolingian church, which in turn masked all traces of an earlier Merovingian one. It sometimes happens that attentive excavations make it possible to reconstruct the ground plan of each stage, but when it comes to the art of architecture, what good is a plan without its elevation? And how can we describe and understand the art of France's provinces in the eleventh or thirteenth centuries when we

know so little about the main architectural models employed in Paris?

Therefore, we should not delude ourselves into thinking we can read the history of architecture like a well-organized picture album in which everything occurs in a cause-and-effect order, a delusion held by too many scholars in the past. Too unaware of inevitable gaps, and also perhaps of the extraordinary profusion of what remains, they divided this period into "Romanesque" art and "Gothic" art, two concepts adopted dogmatically, then deliberately endowed with a kind of organic life—birth, growth, peak, decline. Debate over the origin of these styles was once the object of national disputes. Today people are apparently more relaxed and above all more realistic about this question.

The term "Romanesque" makes little sense. It was proposed by a scholar for whom round arches recalled the Roman architecture of antiquity. The intention was probably to rehabilitate eleventh-century architecture in the face of the virtuoso accomplishments of the thirteenth and fourteenth. The term "Gothic" is much older but equally inappropriate. It was initially used in the seventeenth century to designate all architecture from the fall of Rome to the revival of "proper principles" in Italy in the sixteenth century. But when the habit of using the term "Romanesque" was adopted for architecture employing round arches, "Gothic" came to be used for the later period only; suddenly the relationship to the people called Goths became very fuzzy. Ordinarily, "Gothic architecture" is applied to buildings that use pointed arches and rib vaulting. There was indeed a more or less distinct progression from one method of architectural construction to the other, although in the other arts it is impossible to perceive a veritable rupture indicating the end of a "Romanesque" style and the start of a "Gothic" one.

This book will therefore try to avoid using these labels, which give rise to superfluous chronological divisions and artificial debates. On the contrary, stress will be placed on the continuity of this entire period. Only a broad overview such as this one can provide adequate appreciation of the wealth of invention at work.

Church issues

The main issue that Western architecture had to confront was the design of churches themselves. Secular architecture long remained fairly basic—this era of uncertainty and insecurity contented itself, when necessary, with models bequeathed by Rome to all the lands of the *pax romana*. In contrast, the need for churches became increasingly acute as urban populations grew and as the clergy asserted its preeminence. But no real precedent existed: ancient temples were never designed to house vast gatherings of people; the "mithraeum," or sanctuary devoted to the god Mithras, was entirely governed by an oriental rite that

was widespread among the Roman legions but was abhorred by Christianity; Byzantium, meanwhile, was Christian, but the amazing church of Hagia Sophia in Constantinople was too ambitious and too sophisticated. So a multitude of local architectural solutions arose, spreading sometimes within a given region, sometimes along certain special paths such as pilgrimage routes. Such solutions would then thrive or vanish depending on the genius of the architect and the need for new fashions. "Families" of architecture can therefore be clearly distinguished, but no attempt will be made to establish rigid "schools" or to draw up maps based on dates and characteristics. All kinds of hybrids were possible and, as pointed out above, gaps in the record would skew any conclusions right from the start.

Very quickly, churches were expected to satisfy needs that ancient edifices had never known, or had only sought to satisfy independently. The most sacred part of the church was obviously the choir, the spot where the sacrifice of the mass was performed. Particular attention was paid to the inside and outside of the choir, which could be quite lavish. At the other end of the church was a porch that called for special care: turned toward the exterior, visible to passersby, welcoming the faithful to a place removed from everyday life and cares, the porch had to clearly mark the boundary between the two worlds. It was where religious truths could be affirmed.

Between these two extremes, the nave had to provide a space as large as possible in order to host grand ceremonies; it also had to facilitate the circulation of people and create light effects. To all of this were added, externally, bell towers with their double signaling functions. The height of a tower soon became a question of prestige, and each church, especially in cities, did its best to outdo its neighbors. Above all, however, height was important to the function of watchtower. The bells that counted out the hours of daily life could also sound the alarm, an important role that survived into the late eighteenth century (during the French Revolution, this role saved the finest church towers from anticlerical demolition).

More than any other building of the period, a church therefore required an organic structure. Unlike most of the edifices left by antiquity, it was conducive to a series of interlocking architectural forms, both inside the building and out. Not surprisingly, then, churches gave birth to extreme diversity. Of the tens of thousands of churches surviving from that period, no two are exactly alike, either in overall form or in details, even though borrowings and explicit quotations frequently occurred, sometimes across long distances.

The reign of round arches

The articulation of architectural volumes reached an initial stage

Church, Saint-Nectaire
(France), first half
of twelfth century.

of perfection with so-called "Romanesque" art. The simple, necessarily repetitive module of the round arch produced a sober harmony that favored solids over voids. Take, for example, the church in Saint-Nectaire, France, which dates back to the first half of the twelfth century (page 144). Set in a dynamic landscape, it presents a sturdy profile with clear-cut lines. A polygonal, two-story bell tower rises above the cascade of roofs below, echoed in a minor key by the two square towers on the west façade. The bell tower is supported by the mass of the transept, which extends clearly beyond nave. The choir in particular is skillfully designed, presented as a cluster of round chapels, each topped by a triangular pediment that prevents the curves from dominating the composition. Windows are few

and narrow, but on the two façade towers and the bell tower they are twinned, which lends a kind of lightness to the powerful mass. The local volcanic stone has a fine pink color but a rather coarse outer surface, which is probably why a decorative band of rosettes runs just below the roof of the apse. Everything here is efficiently, knowingly orchestrated.

Exteriors organized around an arrangement of rounded arches were matched by clearly designed interiors usually dominated by a barrel vault (page 145). This vault over the nave would generally be made of masonry partly to prevent the fires that plagued traditional Roman timber roofs. The transverse arches supporting the vault underscored the division of the nave into bays (as well as masking inevitable irregularities in the surface finish). The walls, meanwhile, were strengthened by the columns or pillars that divided them into two or three stories, although the aim was more to create an effect of balance rather than one

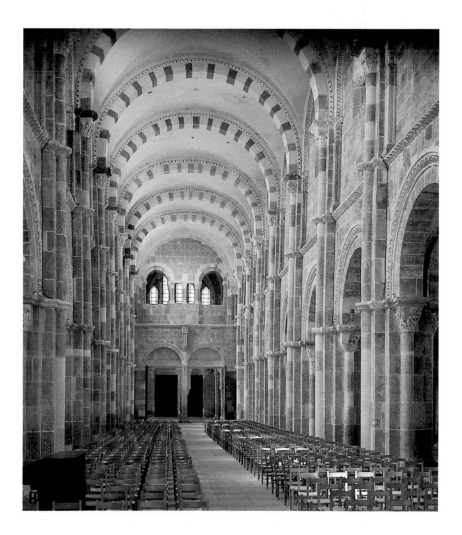

Vaulting in the nave,
basilica of La Madeleine,
Vézelay (France),
before 1135.

of thinness or upward thrust. The ground-level arcades of the aisles, which facilitated circulation, were echoed above by round bays that might be more or less narrow. It was only on rare occasions that the architect made so bold as to stack large upper galleries and tall windows above the nave, as seen in the church of Saint-Étienne in Nevers, France. The complex composition of choir with surrounding ambulatory and chapels usually produced a refined interplay of columns, vaults, and lighting, but in certain cases—such as the cathedrals in Strasbourg and in Nevers—the apse was closed with a vast half-dome, often decorated with a Christ in Majesty, thereby terminating the church in a strong, solemn fashion (page 146).

These skilled designs were all based on one grand model: the abbey church at Cluny founded in 910, whose rule was progressively imposed on all Benedictine abbeys. Or rather, the model was Cluny III,

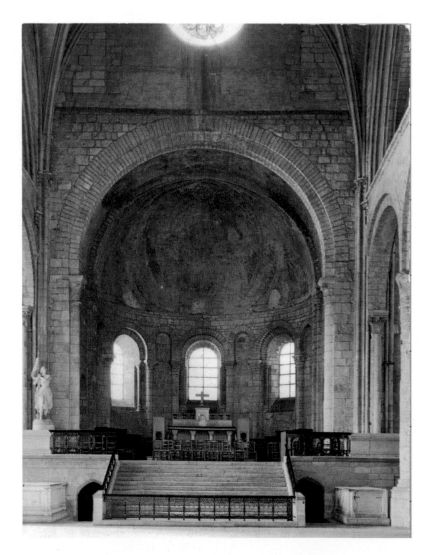

Romanesque choir, Saint-Cyr Cathedral, Nevers (France), eleventh century.

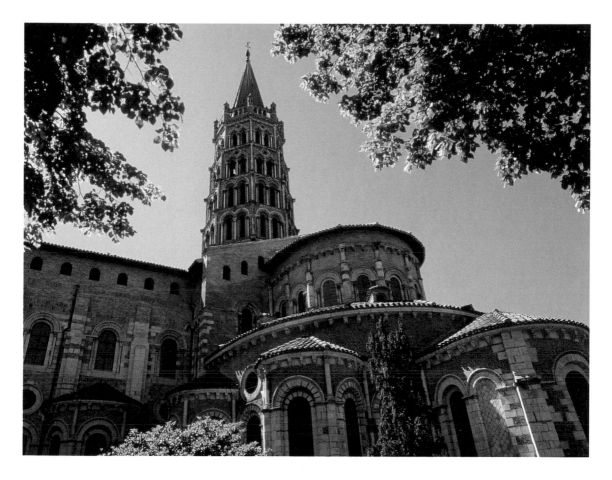

Apse and bell tower, basilica of Saint-Sernin, Toulouse (France), eleventh–twelfth centuries.

which Saint Hugh began building in 1088 to replace its tenth-century predecessor. Along with Saint Peter's in Rome, Cluny was the largest edifice in Christendom. Its narthex was topped by two square towers, its nave had twin aisles on each side and a double transept, and its ambulatory had five radial chapels. The whole thing rose to a height of three stories. This vast church was destroyed after the French Revolution, and only fragments remain. But at least we can still appreciate another great pilgrimage church, namely Saint-Sernin in Toulouse, France (page 147). It runs the length of eleven bays, has two aisles on each side of the nave, a vast transept, and a five-tiered bell tower that progressively narrows as it thrusts its spire heavenward. Nine projecting chapels are grafted onto the apse and the east side of the transept. Here the sober balance of forms is superseded by an ambitious design, already heralding the upward thrust and stress on voids that would typify the following period.

Understandably, each region retained its own traditions in terms of the external appearance and interior organization of churches. Thus in Germanic lands, development of the western entrance of

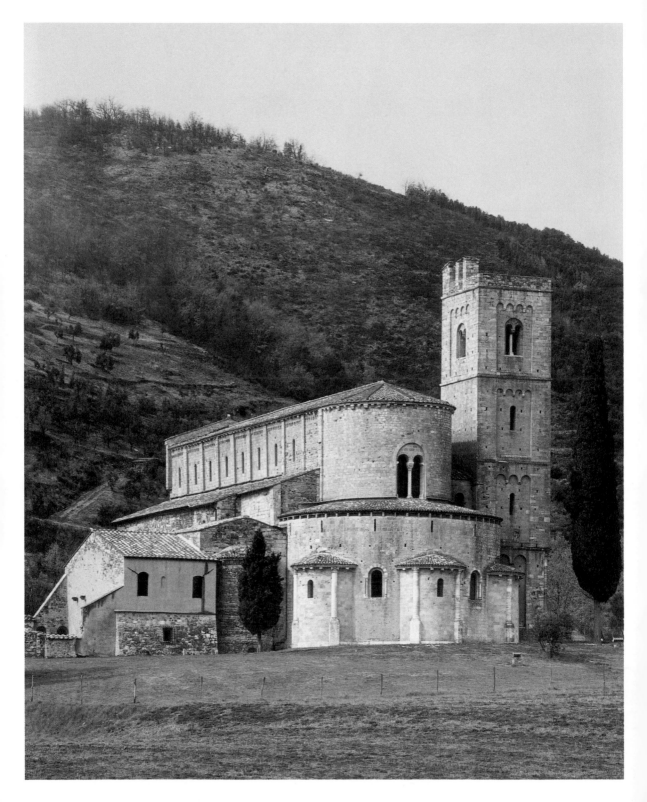

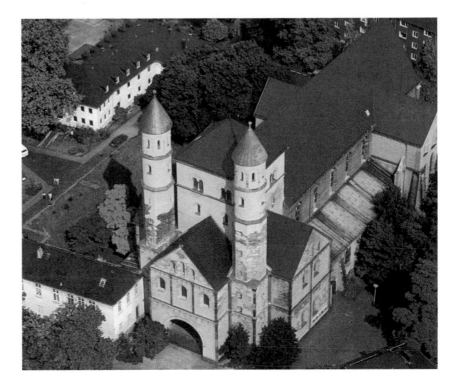

RIGHT
Church of Saint Pantaleon,
Cologne (Germany),
tenth century (in part).

FACING PAGE
Apse and bell tower,
Benedictine abbey of
Sant'Antimo, Montalcino
(Italy), twelfth century.

the church—known as the west-work (*Westwerk* in German), and typical of the architecture of the Ottonian period—ultimately led to a stress on the first bay, sometimes rising in a high wall flanked by two towers, as seen in the abbey church of Maria Loch in Eifel and the church of Saint Pantaleon in Cologne (page 149). Italy, meanwhile, renounced the central bell tower in favor of a tall, square tower detached from the main building. In Tuscany, for instance, the church of the Benedictine abbey of Sant'Antimo, founded in 1118, retains a Cluny-style design even more austere than the church of Saint-Nectaire: the chapels are endowed with just one narrow window, and the apse is pierced by a single large double window (page 148). The architect opted for round forms that are entirely bare of molding and decoration. Along the side, however, rises a sturdy tower, each of its four stories marked by a string course and "Lombard-style" blind arcading. Its top tier features another twin-arch window with fine central column, thereby reestablishing a certain balance and impression of verticality. The same refinement recurs inside, with an ambulatory that rings the choir supported by fine columns displaying perfect proportions (which, in Tuscany, is hardly surprising).

Rib vaulting

This arrangement of interlocking, hierarchical volumes would be overturned by the sudden rage for rib vaulting and the possibilities it afforded. The concern for

architects was that, once they attempted to roof a relatively large space in stone, the lateral thrust of the vaulted ceiling could push the walls outward and trigger a collapse. They therefore tried to make the vault as thin as possible, at the same time thickening the walls and limiting window space. Soon they were placing transversal arches at close intervals as reinforcement for the vault, while on the outside they added projecting buttresses to consolidate the walls. At both ends of the church, meanwhile, the heavy towers, the transept piers, and the chapels ringing the choir all helped to counteract the effect of thrust. Ultimately, however, it was the use of intersecting ribs on the vault that alleviated this grave threat. Such ribs carried the thrust down to the four corners of each bay, which meant that the vault could be made thinner without fear of fracture. The entire edifice henceforth rested on the skeletal structure of columns and intersecting ribs, so that the walls could either be reduced to mere infilling or be eliminated altogether.

However, the thrust borne by the columns now became considerable. Thickening them was not sufficient. Adding buttresses might work for a simple chapel, but if the buttresses were enlarged to become veritable supporting walls, then they would cut out most of the light. The safest solution, then, was to counteract the lateral thrust on the columns with solidly anchored, arched buttresses placed outside the building—the famous flying buttresses. Equilibrium was thus restored not within the structure of the building itself, but outside the edifice.

Sometimes architects sought to mask flying buttresses to a greater or lesser extent. But true genius, to the contrary, turned them into a strong aesthetic statement. This admirable technique produced highly poetic architecture (yet was rarely adopted in later architectural styles).

This permanent architectural scaffolding on the outside henceforth permitted the creation of dramatically bold spaces inside. Take, for example, the exterior of the apse of the cathedral of Reims, France, begun in 1211 (page 151). There is no question here of simple volumes with flat walls reinforced at the corners by buttresses; instead, the chapels around the ambulatory give rise to a double row of two-tiered flying buttresses. The pinnacles crowning the piers ring the church, while the arched supports themselves describe strong diagonals. The radiating chapels sit between the flying buttresses, masking the lower part of the buttresses while contributing to overall stability. It is worth noting that the pinnacles on the piers of the buttresses take the form of a tabernacle, or canopied recess for a statue, adding to the overall height. The architect could thereby increase verticals to a maximum, while horizontals were underscored by the balustrade above the first story and the blind arcading below the roof. This approach avoids the stacking effect

Flying buttresses around the apse, cathedral of Notre-Dame, Reims (France), thirteenth century.

LEFT
Nave, cathedral of
Notre-Dame,
Amiens (France),
thirteenth century.

seen in "Romanesque" churches, replacing it with a dynamic tension entirely ordered around the diagonals of the buttressing system.

A new aesthetic

This technical solution to the problem of lateral thrust arose at a time when cities were rich and populations high; as developed by a series of inspired architects, it soon became all the rage. It was a paradoxical style, because the outer envelope of a building no longer coincided—perhaps for the first time in history—with the interior volume. Exterior architecture took on its own aesthetic life, so to speak. In the twelfth and thirteenth centuries, churches played entirely on the effect of surprise: outside, a complex play of more or less small elements proliferated on all sides, drawing the gaze everywhere in an apparent jumble of gratuitous

FACING PAGE
Apse, cathedral
of Saint-Julien,
Le Mans (France),
thirteenth century.

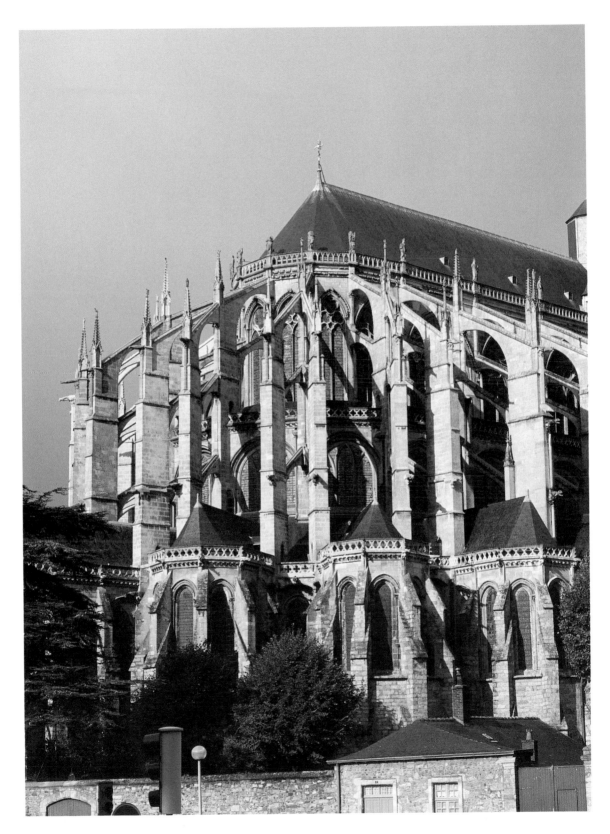

ornamentation; but once inside, the visitor would be struck by the unity of the powerfully orchestrated interior. This "split personality" allowed architects to come up with countless variations on basic themes.

And it led, above all, to a total transformation of interiors. All kinds of bold initiatives became possible, ranging from the sturdy equilibrium of the nave in Laon (page 138) to the risky elevation of the choir in Beauvais, where the keystone of the vault attains a height of 156 ft. (48 m) and the walls have been so hollowed that the upper gallery itself becomes transparent (page 154). The distribution of thrust had a similarly liberating effect on exterior façades, which were henceforth lit by a large rose window and decorated with fragile galleries. The architect in Laon opted for an effect of contrasting shadow and light (page 155), whereas that of Notre-Dame in Paris preferred a flatter surface enlivened by rows of statues.

Much has been written about the "extravagance" of "Gothic cathedrals." Jurgis Baltrusaitis recalled how the young Goethe, admiring Strasbourg Cathedral in 1772, "saw it rise like a tree with thousands of branches, millions of boughs, and leaves as numerous as the sands of the sea, spreading the glory of the Lord, his Creator," while Chateaubriand, in his *Génie du christianisme,* declared that "Everything in Gothic churches recalls the labyrinthine woods [of the Druids], everything evokes religious dread, divine mysteries."

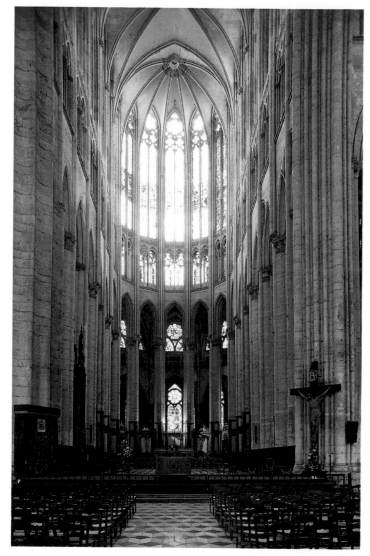

ABOVE
Choir, cathedral
of Saint-Pierrel,
Beauvais (France),
begun in 1226.

FACING PAGE
Façade, cathedral
of Notre-Dame,
Laon (France),
begun in 1160.

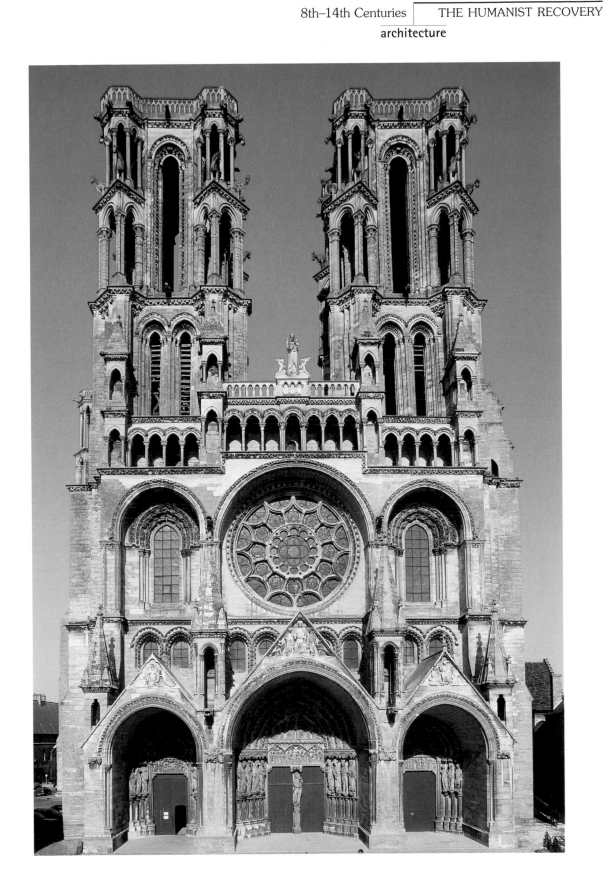

Today we are more attuned to the science and bold skill behind these immense buildings, rather than to the myth of a return to forests full of Druids. It is worth stressing the diversity deliberately cultivated by architects, which itself is a source of aesthetic pleasure. No one has ever really been able to deny this pleasure, even during periods when people were hostile, on the theoretical level, to this type of architecture. A striking fact, especially relevant to France, is that very few of these cathedrals have ever been deliberately demolished, even though they are expensive to maintain and far exceed the requirements of Christian worship.

A Europe-wide fashion

Historians have sought to categorize and classify this architectural diversity, although without much success despite the relationships that clearly exist between various churches. Sometimes the comparisons concern technical features, sometimes the effect thus obtained. A great architect's inspiration and genius appear nowhere in a better light than in these vast edifices. But only a few extreme examples can be mentioned here. First of all, the cathedral of Laon must be cited again for its powerful and skillful equilibrium; designed around 1160, it might well have been copied throughout the rest of France and Europe, yet it remained unique. Then there is Bourges Cathedral, begun in the late twelfth century, featuring a magnificent interior nave with double aisles made all the more impressive by the elimination of the transept, and all the more lyrical by the reach of its tall arches that put the elegant triforium and upper windows almost out of sight. Beauvais, meanwhile, begun in 1226, has the highest choir ever erected, while the cathedral at Le Mans boasts an apse, built on sloping ground in 1254, that unfolds outside like a splendid bouquet (page 153). The church of Saint-Urbain in Troyes, founded in 1262 by Pope Urban IV, represents the embodiment of a tricky equation formulated by an architect as lucid as he was bold, and the cathedral of Strasbourg has a disconcerting façade lined by a veritable lacework of small columns. This list would never end if it carried on—as it should—to embrace the rest of Europe, from Cologne to Wells via Vienna, Milan, Lübeck, Leon, and Palma de Mallorca. Photos might be better, but it must be stressed again that all pictures are misleading, since the façade gives no hint of the effect of interior volumes. Never had architecture been so fertile throughout all of Europe, nor more united in its principles even as it was varied in its output.

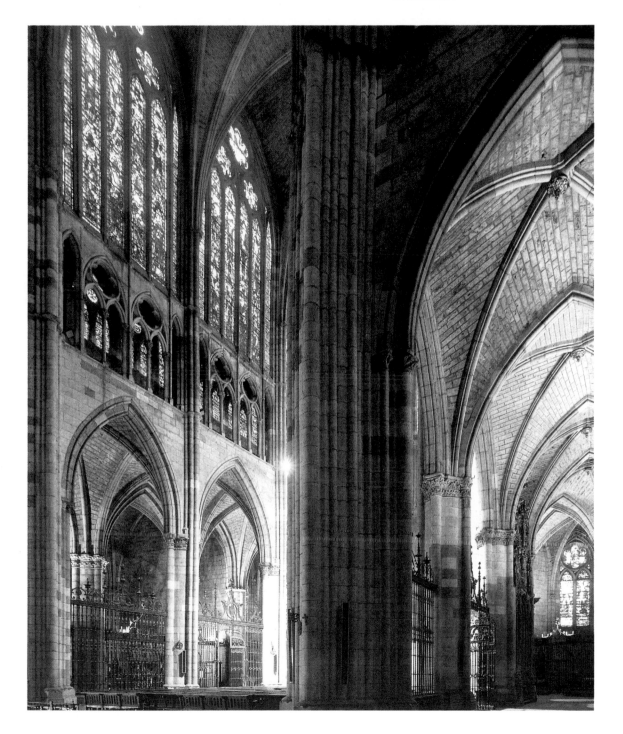

Interior view,
Leon Cathedral,
Leon (Spain),
begun 1255.

Sculpture

Surprisingly perhaps, the blossoming of architecture was not immediately accompanied by a blossoming of sculpture. It is true that primitive-style tympanums and capitals are today seen as masterpieces by specialists, who assign them an early date. Yet the main merit of such works may be that they marked a return to the lost art of depicting human figures.

This point calls for comment. During the period of barbarian invasions, most ancient buildings were destroyed, with the exception of a few amphitheaters and fortifications; similarly, few traces of monumental painting survived. But when it came to sculpture, so many examples were scattered throughout the lands of the *pax romana* that, despite the ravages, some fragments remained. The equestrian statue said to be of Constantine had always been on view in Rome. The same was true of the two large, completely nude figures of *Dioscuri* (Castor and Pollux) with their horses, which now adorn the Piazza del Quirinale. Other statues survived in Byzantium. Of course, all bronzes were melted down for their metal content sooner or later—apart from "Constantine" and the horses now on San Marco (the large rosettes decorating the dome of the Pantheon vanished as late as the seventeenth century). But in towns and rural areas from Provence in France to Tunisia in North Africa a number of marble works, more or less damaged, could still be seen. So the revival of great sculpture probably depended less on the availability of models than on motivation. Two conditions were required: techniques had to be rediscovered—or rather, reinvented—because sculpture is above all a technical craft; and the quest for tangible form had to be revived, because sculpture is a tactile art form par excellence and, contrary to common assertion, cannot rely solely on signs and symbols unless it is to function as a mere decorative device.

Bronze sculpture

Admittedly, very little is known about what happened to bronze sculpture over a period of many centuries. Long considered the first notable work of Western sculpture and proof of a Carolingian renaissance was a statuette allegedly of Charlemagne on horseback, long kept in the treasury of the cathedral of Metz, France. Today it is thought to be, at least in part, a work from the Byzantine period, probably predating the iconoclast

The Prophet Jeremiah, detail of trumeau of south portal, former abbey church of Saint-Pierre, Moissac (France), early twelfth century.

era and only later dubbed a portrait of Charlemagne—which perhaps saved it from being melted down.

But what did survive of ancient tradition was the idea that holy places should be fitted with bronze doors. Efforts were apparently made at an early date to endow churches and baptisteries with heavy doors bearing bronze plaques of historical scenes and carved decoration. But the recurring need for metal to make bells and cannon spared only a few examples, such as the double doors on the cathedral of Hildesheim, Germany, apparently completed in 1015. Figures in natural poses stand against an almost flat ground in twenty panels depicting episodes from the Old and New Testaments in a lively, expressive manner (page 161). In Verona, Italy, meanwhile, the western door of the church of San Zeno has bronze plaques, apparently dating from 1138, which feature sober scenes that underscore the decorative effect.

The most famous bronzesmith was Renier of Huy, who made the baptismal fonts in the church of Saint-Barthélemy in Liège (page 160). The high relief, elegant drapery, and decorative handling of the figures ringing the basin already hark back, in the early twelfth century, to ancient sculpture. Great technical skill is displayed by a figure shown from the back, wearing a clinging garment that simultaneously emphasizes his anatomy and his twisting motion. Since almost all works of this type have vanished, it would be foolhardy to discuss the history of European sculpture during these centuries.

FACING PAGE
The Story of Adam and Eve, bronze double door (detail), cathedral, Hildesheim, c. 1015.

Renier of Huy, *Saint John Baptizing Jesus*, bronze baptismal font, church of Saint-Barthélemy, Liege (Belgium), early twelfth century.

The reappearance of masterpieces in stone

Already, however, stone sculpture was discarding its archaic features. Two fragments comprising the figure of Eve have been identified as the lintel of a former portal on the cathedral of Saint-Lazare in Autun, France (there is still hope of recovering, someday, the figure of Adam that must have accompanied Eve). Foliage in thick, still stylized forms are harmoniously arranged, half-masking a young, completely nude woman (page 162). The old stylization here serves expressiveness more than hindering it. Eve's gaze is simultaneously alert yet dreamy, while admirable stress is placed on her hungering, sinning hand. This work has been dated to around 1130.

Around the same time, two other masterpieces were produced in France: the *Jeremiah* on the south portal of the abbey church of Saint-Pierre in Moissac (page 158) and the *Isaiah* of the Abbey of Sainte-Marie in Souillac (page 163). These startling figures must be by the same hand. Even more than the sculptor of *Eve*, this master was a virtuoso of curved forms, conveyed here through firm volumes with strict proportions and expressive movements. The figure's body can be sensed beneath the folds of cloth. A grand style was surfacing, apparently marking a new development: churches and cathedrals were about to become—to use an oft-repeated image—huge books of stone.

Large portals and their evolution

The three fragments just discussed came from church portals. As already mentioned, a church façade

The Temptation of Eve, stone lintel (fragment) originally from Saint-Lazare Cathedral, Autun (France), c. 1130. Musée Rolin, Autun.

The Prophet Isaiah, abbey
church of Sainte-Marie,
Souillac (France),
mid twelfth century.

was particularly suited to the "discourse" of sculpture, and door panels were just one aspect of this mute sermonizing. The entire framework of the portal offered a prime location for stone carving. In many regions, churches rivaled one another to produce the richest, most eloquent portal. In other areas, the stakes were upped to include the entire façade.

Here again, diversity and abundance were remarkable as early as the twelfth century. There is no point in trying to list and categorize everything. A series of tympanums found in Burgundy constitutes perhaps the most complete group; all are organized around a Christ, sometimes shown in Majesty (at Charlieu, Semur-en-Brionnais,

Saint-Julien de Jonzy, and elsewhere), sometimes appearing at Pentecost (Vézelay) or at the Last Judgment (Autun).

These tympanums strangely combine the grandest efforts of high sculpture with the vivid volubility of the carved capitals that enliven every nook of the churches. At Autun, Christ is handled in a solemn and somewhat stark way, and seems to have been carved from a separate slab of stone (page 164). The rest of the tympanum, divided between the elect and damned, presents a throng of figures carved in high relief. Everything here displays an anecdotal and naïve eloquence, from the winged profiles of angels to the voracious faces of cackling

Gislebertus, *The Last Judgment*, tympanum of west portal, Saint-Lazare Cathedral, Autun (France), c. 1130–40.

Pentecost, tympanum
of main portal,
La Madeleine Basilica,
Vézelay (France), c. 1130.

demons (with their skinny insect legs) and the long frieze of human figures along the lintel.

In contrast, Vézelay differs in inspiration (page 165). Here the sculptor displayed a more supple decorative sensibility. Christ, set in an oval mandorla, is clothed in drapery that reveals a remarkable sense of proportion and pattern, while the apostles are divided into two harmonious groups. Narrative sequences and allusions to distant peoples appear on the side panels, where the sculptor boldly evoked barbarian lands inhabited by men with furry bodies and elephant-like ears, only slightly less frightening than devils.

All these large "pages" of stone have been greatly admired since the nineteenth century either for their vivid handling or for their conceptual scope. Nevertheless, their decorative function encouraged artists to cling to hieratic forms. True innovation, therefore, would come from other quarters.

In western France, sculpture left tympanums (which contented themselves with lacelike carving on the individual stones of the archivolt) and migrated to friezes and statues on all levels of the façade. An excellent example of this can be seen on Notre-Dame-la-Grande in Poitiers. Another, more unusual, approach was adopted in southern France, where many Roman ruins were still to be found, serving as potential inspiration: church portals there featured scrollwork,

fluted pilasters, and Corinthian capitals. A single frieze would run across the entire façade, while alongside the doors stood large human figures, almost freestanding statues, draped in ancient dress. At the church of Saint-Trophime in Arles, dating from the second quarter of the twelfth century, this composition is strictly followed— saints are separated from one another by columns or pilasters in direct imitation of Roman antiquity (page 167). The proliferating sculpture is moderated by the perfect symmetry of the composition, by the ornamental stiffness of the friezes, and by the powerful, straightforward design of the porch. In contrast, the church of Saint-Gilles in Nîmes (page 166), of similar date, displays an almost overabundant decoration alongside the elaborately carved folds of the large statues, while a dramatic sense of movement animates the various episodes on the frieze, apparently harking back to ancient sarcophagi. Fortunately, the overall organization of columns and pilasters structures the façade and tames the profusion, making it possible to appreciate the details.

The transition to statuary

Ignoring the old distinction between "Romanesque" and "Gothic" art, we can now see that sculpture was ready to complete a smooth, steady transition to the masterpieces of the portals in Laon and Chartres. The twelfth and thirteenth centuries, it might be argued, simply followed a

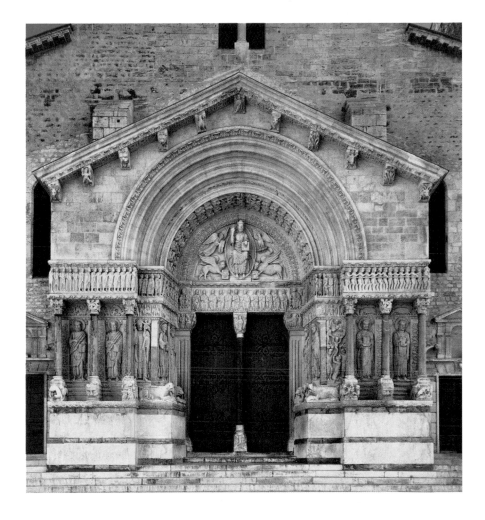

Portal, Saint-Trophime Cathedral, Arles (France), second quarter of twelfth century.

Façade (detail), former abbey church of Saint-Gilles, Nîmes (France), second half of twelfth century.

double evolution. On the one hand, the precise organization of façades became more rigid: portals were flanked by large figures; smaller, independent figures were carved on the voussoirs overhead; large, free-standing statues and carved pinnacles featured above the portal but below the large—and henceforth obligatory—rose window. On the other hand, a new suppleness in the handling of human figures could be seen more or less everywhere, combined with a variety of expression which was due either to the influence of ancient sculpture or, more frequently, to sculptors' renewed interest in observing natural forms.

By way of example, we may as well turn once again to Chartres Cathedral and its portals. The Royal Portal, dating from around 1145–55, crowned by Christ in Majesty, has splayed jambs featuring seven large statues. These statues are not set between columns and pilasters, as at Saint-Trophime, but are pushed forward, thereby acquiring added presence as they free themselves from the architecture (page 168). Their faces have regular features, sometimes with the

hint of a smile. The bodies, however, are exaggeratedly tall and are set in hieratic poses that hardly break the vertical structure of the overall unit. The portal on the north transept, dedicated to the Virgin, was probably begun around 1204–05, and manages to reduce the bodies of its Old Testament figures to normal dimensions by setting them between larger bases and higher canopies. The drapery remains fairly stiff, but poses are varied, heads turn, and connections are established between statues (page 169). The physicality of the figures is thus more pronounced, but without disrupting architectural harmony. This approach, developed at Chartres itself on the various portals of the transept, had already been initiated at Notre-Dame in Senlis (western portal, c. 1170), Notre-Dame in Laon (central portal of west façade, c. 1200), and Saint-Étienne in Sens (western portal, c. 1200). It reached a state of perfection with the portal of the Coronation of the Virgin at Notre-Dame in Paris (west façade, left-hand portal, c. 1210). These solemn gatherings of sacred figures who welcomed the faithful at the church door were long the pride of cathedrals, and they bore the brunt of iconoclastic attacks by Protestants in the sixteenth century and by French revolutionaries in the eighteenth. Few French cities were as lucky as Chartres, whose statues survived relatively unscathed.

Among the many construction projects launched in Europe, one of the most dazzling was certainly the

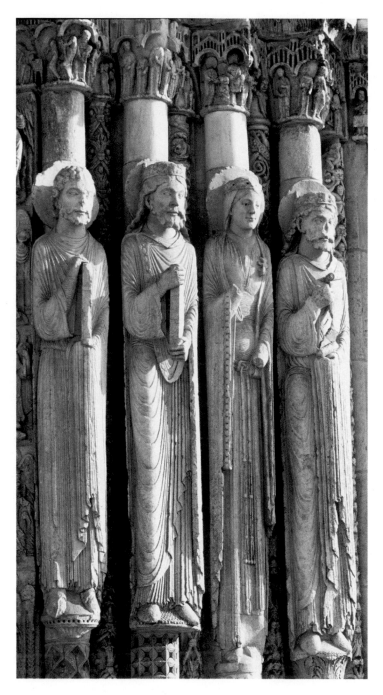

ABOVE
Statues on the Royal Portal, Notre-Dame Cathedral, Chartres (France), c. 1145–55.

FACING PAGE
Judith (?) north wing of transept, right portal, Notre-Dame cathedral, Chartres (France), c. 1220.

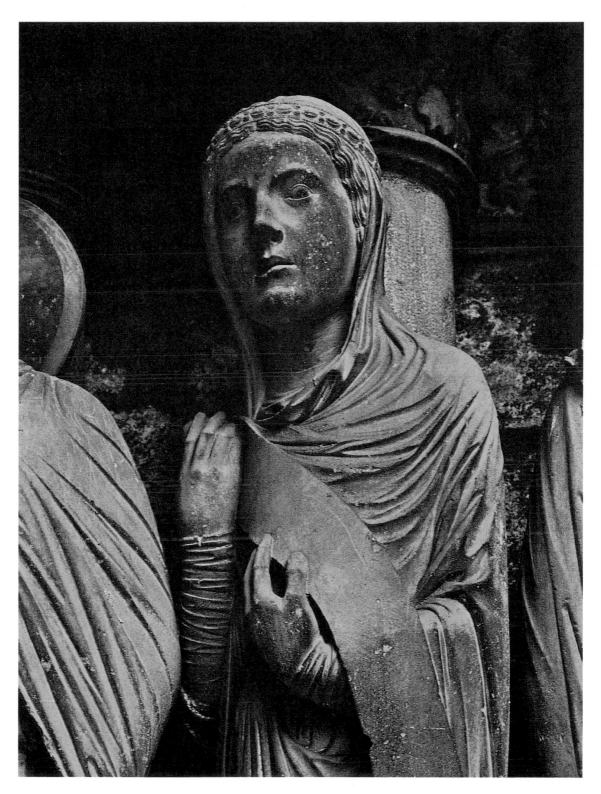

The Synagogue and
The Church, originally
on the portal of the south
transept, Notre-Dame
Cathedral, Strasbourg
(France), c. 1125.
Musée de l'Oeuvre de
Notre-Dame, Strasbourg.

cathedral of Strasbourg. Its façade, completely lined with slim little columns of pink sandstone, was as bold as it was original. The portal on the south transept, meanwhile, featured a series of famous sculptures, now removed but well preserved and generally dated to around 1225. Two allegorical statues, one representing the Synagogue (holding the tablets of the Law and a broken spear) and the other symbolizing the Church (with chalice and cross), display outstanding technique. The profiles are tall and thin, enlivened by elegant and expressive gestures, and the bodies can be sensed underneath the folds of the garments (page 170). Not since antiquity, it would seem, had a sculptor so successfully combined artfulness with authenticity.

Similarly, a tympanum on one of the transept's two portals

Death of the Virgin (detail), tympanum of the portal of the south transept, Notre-Dame Cathedral, Strasbourg (France), c. 1235.

depicts the Death of the Virgin. The iconography is thoroughly traditional, with a small statuette (probably restored) on the right symbolizing the Virgin's soul (page 171). But the overall expressiveness is novel, and stems not only from the contrasting play of poses and the soberly portrayed emotion on the faces, but also from the drapery itself: flowing and skillful, it is thickly folded yet allows the body of the Virgin to show beneath her shroud. Here we have a new visual language, which must have had an immediate impact. Something similar, if less inspired, can be seen in Germany at the cathedral of Bamberg and on the Gate of Paradise in Magdeburg Cathedral.

Major new projects were launched above all in France. In addition to Chartres, the most innovative sites in terms of sculpture were probably Bourges, Amiens, and, above all, Paris and Reims. In Paris, each portal of Notre-Dame seems to reflect new experiments. Other buildings should also be taken into account, including royal palaces and the Sainte-Chapelle, a chapel commissioned by King Louis IX and inaugurated in 1248. As befits a chapel, it only has one, rather modest, portal, but the upper level of the interior was decorated with twelve large statues of the Apostles, each attached to one of the piers supporting the vault. They can still be seen there, in all

their color, which perfectly matches the chapel's famous stained-glass windows.

We should not be deceived, however: most of the sculpture from that period, especially in France, only survived after suffering great tribulations. Of the statues in the Sainte-Chapelle, not a single one remained safely in place. It would require too much space here to recount their dreadful story, so suffice it to say that two were destroyed, four seriously damaged (and therefore deposited at the Musée National du Moyen Age in Paris), and six restored. Today, then, only six of the original statues are back in the Sainte-Chapelle. Although the skilled polychrome painting tends to mask the extent of the restorations, it is nevertheless preferable to turn to the unrestored originals, however damaged, now in the museum. Although these statues were designed to be attached to a column, they no longer have any direct relationship to architecture. Their drapery is rendered with perfect ease, suggesting the shape of the body without overly stressing it (page 172). They are animated by an imperceptible movement that successfully mitigates excessive symmetry, bringing the figures to life without making the viewer forget that sculpture is first of all an art of stable forms. The folds, meanwhile, are hollowed sufficiently deeply to remind us that sculpture is also an art of light and shadow.

Here, then, we have an instance of perfect equilibrium, which many writers have called a kind of "classicism." Others such as Cesare Gnudi, however, claim to detect in some of the Apostles a certain affectation of expression and vividness of drapery—perhaps due to an evolution in inspiration, or to the hand of a different artist—that heralds the more mannered style of decades to come. Sure enough, these features resurface on the portal of the Golden Virgin in

Statue of an apostle, originally in the Sainte Chapelle, c. 1245–48. Stone (formerly painted), Museé National du Moyen Age–Cluny, Paris (France).

Amiens and especially on Reims Cathedral. As appealing as it may be, the Smiling Angel (Amiens) has something mannered about it, while the famous Visitation (Reims, page 173), probably dating from between 1252 and 1275, with its antique-style drapery and its column-to-column conversation, seems to want to transform the "sacred portal" into the stage of a "mystery play."

Once the path had been indicated, the genius of Claus Sluter—who worked for the rich dukes of Burgundy—allowed him to take further decisive steps. His *Well of Moses* (Chartreuse de Champmol, Dijon, France)—which was not actually a well, but the base of a demolished crucifix—is striking less for its architectural presence than for the vehemence of the prophets depicted on it. Meanwhile, on the portal of this Carthusian monastery in Champmol, the

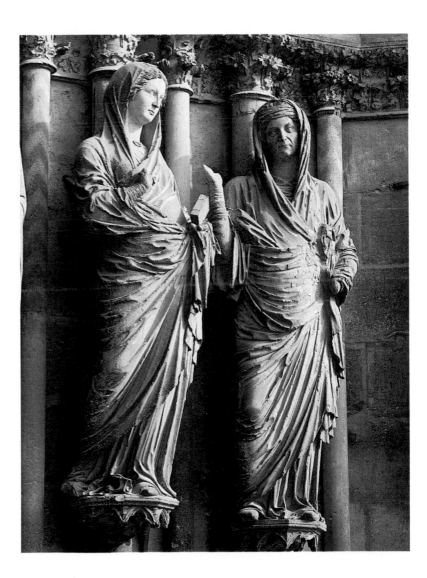

The Visitation, central portal, Notre-Dame Cathedral, Reims (France), between 1252 and 1275.

large and powerful plinths struggle to hold Sluter's statues of the donors and especially the patron saint who accompanies them (page 174). The drapery, the various details—each of which commands attention—and the precisely rendered expression bring the statue to life, yanking it free of the architecture. Artists henceforth stressed the human presence of the creatures they invented. A certain equilibrium had been broken. Some artists occasionally sought to reestablish the original balance, although without great success.

Italy's distinctive identity

Italy would later push these developments very far, even though they did not originate there. Sculpture of this kind did not initially find great favor, because Italy's old architectural traditions eschewed the deep portals populated with large-scale statues that had provided the favorite testing grounds for sculptors in Chartres, Paris, and Strasbourg. The commissions received by Italian artists such as Nicola Pisano (c. 1205–80) and his son Giovanni (c. 1240–c. 1314) were for high pulpits of marble, raised on columns and decorated with bas-reliefs (Pisa Baptistery, Sienna Cathedral). Furthermore, allusions to antiquity, which on occasion played a significant role in France, initially seem to have been a hindrance to Italian sculpture, which was perhaps too directly influenced by the great number of sarcophagi that had survived. For example, on

the pulpit in the Pisa Baptistery, Nicola Pisano chose to work in marble bas-relief, and when depicting the Crucifixion—the most commonly handled subject in Christendom—the influence of late antiquity is palpable (page 175). The great number of characters crowding the scene, the overly squat bodies, and the importance placed on the carefully handled faces and the heavy, complicated

Claus Sluter, *Portrait of Philip the Bold with a Saint*, chapel portal, Carthusian monastery of Champmol, Dijon (France), c. 1391–92.

Nicola Pisano, *Crucifixion*, marble panel on pulpit, Pisa Baptistery (Italy), 1260.

drapery all seem a long way from the explorations underway in thirteenth-century France.

Yet we are still very much on a path that would lead directly to the highly controlled art of Andrea Ugolino, sometimes known as Andrea Pisano (1290/1295–c. 1348). Andrea remains known for his bronze doors (1330–36) on the baptistery in Florence, still in situ. Here he was able to establish a remarkable balance between solids and voids and to develop elegant proportions (not without similarities to the manuscript illuminations of Jean Pucelle). In the scene of the Translation of the Body of John the Baptist, the six men seen from front and back form a perfectly flowing group, and their skillfully arranged antique-style drapery is a match for anything found in Paris or even in Rome's ruins. Subsequently, Andrea worked on the campanile of Florence Cathedral, whose main architect was none other than Giotto. It is hard to know to what extent Giotto dictated the designs for the surviving marble reliefs executed by Andrea, but a panel such as the *Creation of Adam and Eve* displays both a supple harmony in the two nudes and a sense of movement in the cloak of God the Father.

Secular sculpture

This elegance and harmony were part of a long tradition of

ecclesiastical art. It long seemed as though secular art was excluded from the main concerns of the day, but that impression was erroneous.

"Minor sculpture" confirms this fact. Ivory carvers, who were particularly active in Paris during that period, produced ivory plaques entirely worthy of "grand sculpture." Some of those plaques depicted scenes of hunting, gaming, and occasionally even episodes from courtly romances. Meanwhile, as mentioned above, castles lost the monumental sculpture they once had, although the ruins of a fortress built at La Ferté-Milon by Louis of Orléans between 1398 and 1407 still boasts a high relief in the *Coronation of the Virgin* over the doorway, while just to the side was a statue of a valiant knight. These enormous and costly castles often displayed figures of heroes from ancient history or courtly romances. Finally, it should be added that funeral sculpture was also evolving, little by little, from the tombstone or conventionalized recumbent figure to a real portrait of the deceased, even when children were involved.

Thus the distinction between religious and secular art seems to be a relatively late phenomenon. It is hard to believe that the sculptor who illustrated the agricultural scenes on the Portal of the Virgin at Notre-Dame de Paris felt as though he was changing register, or that Italian artist Benedetto Antelami, when he carved the month of February or November on the Parma Baptistery around

LEFT
Ascribed to Benedetto Antelami, *November*, Parma Baptistery (Italy), c. 1220.

1220, needed to adopt a different attitude (page 176).

Surprise has often been expressed at twelve large figures of secular lords and ladies in contemporary dress, carved by some of the best sculptors of the day and placed in the choir of the cathedral in Naumburg, Germany (page 177). These figures, in couples, stand full-length in front of engaged columns, yet cannot be apostles or saints. Tradition holds that they were the founders of the cathedral, which is perhaps plausible. Certain names can even read

FACING PAGE
Polychrome statues known as *Hermann and Regelindis*, Naumburg Cathedral (Germany), 1255–65.

on the scrolls. If this hypothesis is retained, then the sculptor executed these portraits of eleventh-century founders around 1250. Did he simply use his imagination, or did he apply more or less legendary names to portraits of people chosen from his entourage? In either case, these sculptures are certainly secular art.

And at least two of the couples in the Naumburg choir have always been considered masterpieces. One couple, *Eckehard and Uta*, combines a large, fat, and rather glum man with a young woman who half hides her face in timid modesty, as if amazed to find herself in this honored position. Almost better, perhaps, are *Hermann and Regelindis*: he looks dreamy and passionate while her face is gay, lively, and lit by an almost mocking, Reims-style smile.

Other examples of secular sculpture can be seen at Meissen in Germany, where the cathedral houses another pair of founders, namely Otto I and his wife, Adelaide. Husband and wife seem to be in conversation, the movement being more accentuated and the faces more expressive; but they lack the *style* that adds so much to the Naumburg statues. Is it accurate, then, to date these two figures to 1255–60? The same might be asked of a couple in Burgos Cathedral, Spain, who perhaps represent King Ferdinand II and wife (or else King Alfonso X and Queen Violane); characterized by a certain provincial stiffness, they too apparently date from the second half of

the thirteenth century. So it was only with the two statues of Charles V and Jeanne de Bourbon (Louvre, c. 1365–78), whose provenance is unfortunately still uncertain, that another great masterpiece of secular sculpture was produced.

The masterpieces in Naumburg Cathedral are echoed by another, equally exceptional and even more mysterious work in Bamberg Cathedral: the famous *Bamberg Rider*, set under a canopy and against a stone wall within the church itself. Long an object of great respect, it has suffered only relatively benign restoration. Countless hypotheses have been advanced as to the rider's identity (one going so far as to suggest Constantine) and the reason he merited this honor. Whatever the case, the beautiful handling of drapery, the rider's proud pose, and the simplicity of his steed make this statue, which may date from around 1235, one of the finest equestrian pieces since antiquity—or at least the finest that has survived in reasonable condition.

Indeed, since prehistoric times horses have played a key role in people's lives and imaginations. It would be strange if artists had failed to depict them during the heyday of "mounted knights." Painters and illuminators readily included horses in their narratives, as we shall see. But the secret of casting a horse in bronze was lost during the "barbarian" interlude, and carving from stone a standing horse with a rider on its back posed serious problems—even the

The Bamberg Rider, Bamberg Cathedral (Germany), c. 1235.

Bamberg sculptor decided to use two distinct blocks. In fact, artists were rarely asked to resolve the problem, since horses hardly figured in the Gospels or elsewhere in the Bible, and were therefore inappropriate to a church context. Yet horses can be found on church façades in central France, around both Poitiers and Angoulême, in acknowledgment of Saint Martin's charitable act—while on horseback—of tearing his cloak in half.

The *Bamberg Rider* seems to have triggered rivals fairly quickly: Notre-Dame in Paris had its own rider by 1304–8, in the form of a statue of King Philip the Fair, who came to the cathedral to thank God and the Virgin for his victory over the Flemish at Mons-en-Puelle. Philip wanted to be depicted inside the church "mounted, with helmet and gauntlets but not arm-guards," because that was how he had been dressed when nearly surprised by the enemy, and how he was dressed when he rode his war horse into the church to give thanks. This famous statue, restored in 1760, was destroyed during the French Revolution.

What might seem a royal whim was probably just a new fashion. A handsome rider, similar to the one at Bamberg but highly restored, long presided over the Old Market in Magdeburg. It allegedly represented Emperor Otto I, and perhaps dated from 1245–50. In thirteenth-century Italy, it became fashionable for aristocrats to top their tombs with an equestrian statue, as seen at Verona in the Scaliger family tombs and the extraordinary sculpture of Cangrande della Scala (1329) pulling up his mount sharply as the wind lifts the horse's embroidered padding. In Milan, meanwhile, behind the high altar of San Giovanni in Conca, Bernabò Visconti stands in his stirrups, commander's baton in one hand.

Going further, another idea that needs correcting claims that the true sign of secular sculpture is the nude figure, and that nude sculpture only reappeared with the Italian "Renaissance." But illustrations of the Old Testament often induced artists to discard modesty. The story of Adam and Eve was commonly depicted, while a concern for vividness in visions of the Last Judgment often led to caricature. Later, on tympanums such as the one in Bourges artists decided to translate the beauty of the soul—of the elect—by the beauty of the body.

Above all, it could be argued that the crucified Christ was shown practically naked, allowing sculptors to skillfully depict the human body at an early date. If we remain unaware of this today, that is because we underestimate the centuries-long obsession that tracked down and destroyed all nudity.

One little-known example concerns a statue from Notre-Dame Cathedral, now in a museum in Paris (page 181). This standing, larger-than-life-size figure is completely naked. Although restorations have been made to one arm,

Adam, c. 1260. Stone with remnants of paint, Musée National du Moyen Age–Cluny, Paris (France).

the hands, and the feet, they are minor and do not affect the overall appearance of the statue. Unlike the *Eve* at Autun, this nude is independent of any decorative scheme. Despite the calm, slightly angled pose, the fine body, and fair face, this *Adam* does not hark back to ancient sculpture. It seems to have been executed from life, and probably once had a partner statue of Eve, which prudishness long ago destroyed. If the two statues were indeed once placed in the south transept of Notre-Dame, they would have been contemporary with the inner and outer décor of that transept, the first stone of which was laid by Jean de Chelles in 1258. We should not be overly surprised, even though it would be some 170 years before two large nude figures of Adam and Eve, in Saint Bavo in Ghent, were even more meticulously depicted by van Eyck's paintbrush on the altarpiece known as *The Adoration of the Lamb*. To reiterate: back in those days, the revival of a new sensibility had already begun.

ELLVPIPORCVELEVS STA ETE EDVCT

Painting

Were buildings painted in those days, even on the outside? Were sculptures multicolored? The answer probably is yes, almost always. Careful restoration of architecture and statues often turns up traces of color that have survived the weathering, the washings, the scrapings. Color in all its forms was part of artistic expression at this time.

Unfortunately, except in unusual circumstances, architectural painting has not survived the ages. All exterior painting has vanished. We do have examples of a few large ensembles (in addition to more or less ruined fragments) that decorated the interiors of buildings, but these are usually works that had deteriorated or that displeased a later generation of worshipers, making them unsightly. These ensembles were therefore covered with a coating that masked them but also protected them from sundry vicissitudes. They should not be allowed to mislead us, for what was later uncovered in the nineteenth or twentieth century almost always lacks both freshness and finesse, and rarely conveys the impression of authentic touch and handling.

This shortcoming applies to the famous, extensive set of paintings in the church of Saint-Savin-sur-Gartempe in central France.

Despite its impressive scope and vitality, it does not feel like the work of great artists. The painters who executed it were perhaps good illustrators. A more skillful and subtle hand can be detected in the apse of another French church, the chapel in Berzé-la-Ville (page 182). This fresco has retained something of the richness of its original coloring, and makes it possible to imagine the beauty of vanished masterpieces such as the immense Christ in Majesty that overlooked the choir of the church at Cluny and must have served as the model for so many others.

To get a better feel for the true expressive forms and colors of those days it is perhaps best to turn to artworks other than frescoes. Mosaics, so appreciated in Byzantium, inspired some decorative ensembles in Rome, Sicily, and—around the year 800—the Carolingian church of Germigny-des-Prés. These works, however, remain too dispersed and often too restored (not to say revamped) to be of much use. Stained glass replaced mosaics by the late eleventh century, but the art of glass has its own rules, which are not exactly those of painting. There does remain, at least, the rich output of illuminated manuscripts. The finest manuscripts were extremely lavish objects, cost a great deal to

produce, and employed famous artists of the day. Because they have always been appreciated yet are opened only rarely, these books often preserve, intact, the original coloring and feeling intended by the artist. There are few other extant works from before the fourteenth century that make us feel so completely in the presence of true artists and authentic artistry.

The duality of traditions

These manuscripts contain an initial surprise: they reveal the extent to which figurative imagery was rejected—even outside of Byzantine iconoclasm—yet at the same time the extent to which a knowledge of antiquity survived despite all the destruction. The seventh-century Irish *Book of Durrow,* for example,

Book of Durrow,
seventh century.
Trinity College
(ms. 57 fol. 3v),
Dublin (Ireland).

Saint Mark, *Ebbo Gospels,*
originally from the abbey
of Hautvillers, c. 825.
Médiathèque (ms. 1),
Épernay (France).

unflinchingly referred to "barbarian abstraction." True enough, this approach long dominated the decoration of books, often obliging copyists, even at a relatively late date, to content themselves with large ornate capitals composed of tracery and arabesques devoid of meaning, however complicated. Sometimes, as in the case of certain Cistercian manuscripts, such decoration might employ small human figures, wittily caricatured, to form initial letters.

In contrast, the hieratic stiffness of Byzantine figures was absent from the figure illustrating the *Ebbo Gospels,* which dates from the first quarter of the ninth century and is part of a group of manuscripts usually called the "school of Reims." It is conceivable that the artist who painted Saint Mark had not only seen ancient figures but had also understood them: the saint is set in a specific space, even though there is no coordination of vanishing points (page 185). The artist refused to model shapes, leaving the brushwork visible, which gives an impression of movement and conveys a sense of the saint's own inspiration. Did this artist directly copy some ancient image or one derived from antiquity? We cannot be sure—other pages of other manuscripts display both the same skill and the same awkwardness. It nevertheless remains that the artist who depicted this Saint Mark possessed a tangible idea of forms.

In the *Utrecht Psalter,* a very special book also affiliated to the

is decorated with pages covered with pure ornamentation in the form of complex tracery of knots and rosettes (page 183). It has rightly been compared to the decorative wood carving on the prows of Viking ships. This tradition was related to the great monastic movement launched by Saint Colomba of Iona from Scotland and Ireland. The human figure, if it appeared at all, was reduced to a symbol. "Ornamentation was no longer at the service of man, man was at the service of ornamentation," commented French author André Malraux, who, in the twentieth century,

185

Illumination of Psalm 43,
The Utrecht Psalter, c. 820–25.
University Library (ms. 32. fol 25r),
Utrecht (Netherlands).

Fresco of *Christ's Entry into Jerusalem*, church of Saint-Martin, Nohant-Vicq (France), second quarter of twelfth century.

school of Reims, the use of ancient models is clearer (page 186). An agitated crowd of minuscule figures surges across the page, uncircumscribed by any frame, dispersed across a space that is not that of a book but is rather like the continuity of a Greek or Roman scroll (as also found in Chinese and Japanese

Frontispiece to *De Bello Judaico* by Flavius Josephus, late eleventh century. Bibliothèque Nationale de France (ms. lat. 5058, fol. 3), Paris (France).

traditions). Nor was this depiction of movement in all its diversity and its vividness an isolated phenomenon—several copies of the *Utrecht Psalter* have been found, notably in England, where the vivacious style was slowly overcome by the stiffness associated with British miniatures. Perhaps the influence of this model explains the mechanical thrust of the author presenting his book on the frontispiece of *De Bello Judaico*, an image that also contains a straining crowd on the right, conveying impatient curiosity (page 187). A trace of this staccato dynamism sometimes found its way into frescoes, such as the strange version of *Christ's Entry into Jerusalem* in a French church in Nohant-Vicq (page 187).

Redeveloping the human figure

It is easy to see why the art of miniatures, caught between two

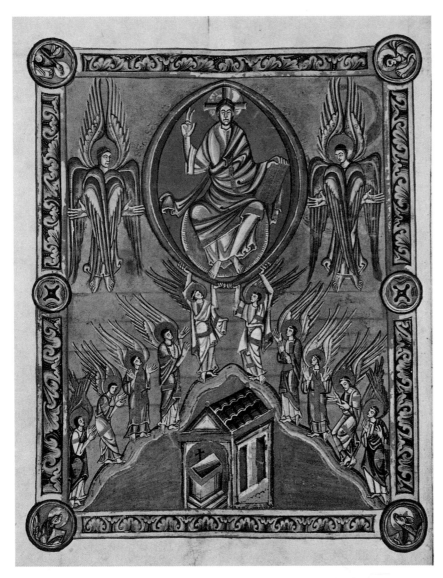

LEFT

Symbolic vision:
Christ in Majesty, *Missal
of Saint Denis*, c. 1050.
Bibliothèque Nationale
de France
(ms. lat. 9436, fol. 15v),
Paris (France).

profoundly different traditions, did not follow a straightforward path. It long vacillated between representations based on symbols and on conventions (*Christ in Majesty*, page 188) and more direct ones (*Mary and John at the Foot of the Cross*, page 189). The latter trend encouraged artists to respect human proportions and seek tangible expressiveness, even if tradition spurred them to add the symbols for the four evangelists and the sun and moon. Little by little, miniatures would evolve in the direction of this second path.

During the eleventh and twelfth centuries, however, miniatures were still dominated by a visionary approach and by allusions to the great mysteries of the Christian faith. Clearly, they were directly related to painted apses and carved portals: shapes are powerfully

FACING PAGE

Tangible vision:
Christ on the Cross,
*Psalter-Hymnal of
Saint-Germain-des-Près*,
c. 1050–80. Bibliothèque
Nationale de France
(ms. lat. 11550, fol. 6),
Paris (France).

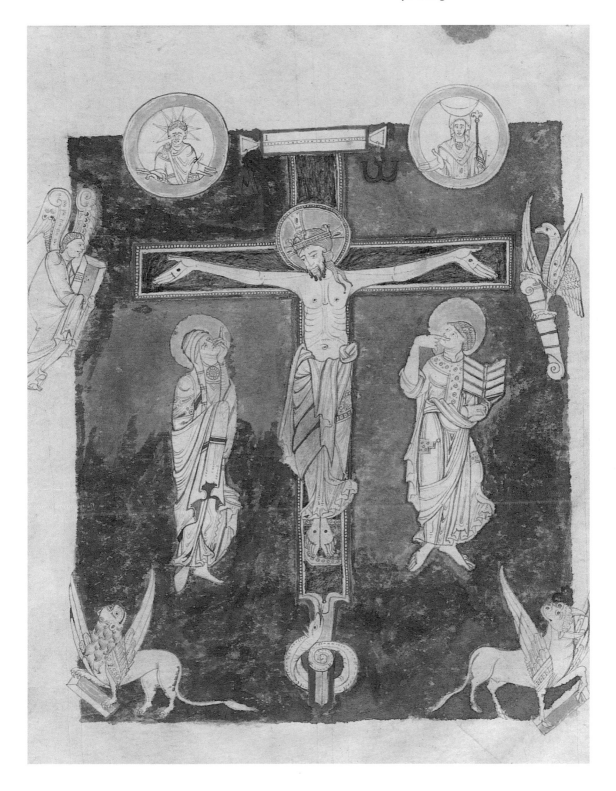

geometric, poses are hieratic, colors are often vivid and rich. Human figures usually occupy just one plane, and the often stiff drapery is not designed to model the body, but rather to modulate the vivid palette, to provide escape from the dullness of flat washes of color. There was no attempt at realism even when the imagery showed a specific saint (rather than one of many variations on Christ Pantocrator)—poses and expressions were still governed by symbolic significations.

It was notably in the late twelfth and early thirteenth centuries that these large, monumental illuminations began to vanish from ecclesiastical manuscripts such as lectionaries, sacramentaries, and evangelistaries. Their rigid formalism was being replaced by a more flexible art. This development is obvious if we look at the *Ingeborg Psalter*, painted between 1193 and 1214 for the wife of King Philip Augustus, probably at the court of France (Bibliothèque Nationale de France, Paris). The miniature is divided into two registers, the figures being harmoniously organized into clear and expressive scenes. The colors stand out from a plain background, and are limited to blues and orangey pinks. The subtle draftsmanship conveys accurate proportions, flowing folds, and noble, restrained expressiveness. Here we have a painter—or probably two painters—who could rival the best sculptors of the day.

The most refined, skillful, and delicately expressive art would emerge a little later, around 1255–70, as

seen in another royal manuscript, the *Saint Louis Psalter*, one of the greatest masterpieces of the art of illumination. This approach still clung to the flat plane even as it increased decorative density and unified the palette—subtly varied shades of red, blue, and gold—throughout the volume. The whole story is told through patterned curves. Take the page, for example, where Eliezer meets Rebecca at the well (page 191). We see the well, the watering trough, and seven camels. But the double scene, set against a gilded ground, is placed within a frame decorated with swirling ivy and dragons. The action takes place in front of a building with rose windows and gables shown straight on, thereby abolishing any sense of deep space. The camels on the right slide their necks into the scene, while the others in the middle are squeezed between the two episodes, set against what might be a sliding panel or even a sky. The folds of Rebecca's gown are clearly modeled in blue, while Eliezer's knee slightly lifts his cloak. Everything is a question of suggestion, of course—just a few details suffice to recount the story. Yet no other artist, not even Poussin, has lent Rebecca so much elegance and grace when offering water to Eliezer.

The master of the *Saint Louis Psalter* sought to depict figures who appeal to us through their harmonious proportions. This development would become even clearer in the work of Jean Pucelle, as seen in his little book of hours known as *The Hours of Jeanne d'Evreux*,

Eliezer Meeting Rebecca at the Well, *Psalter of Saint Louis*, c. 1255–70. Bibliothèque Nationale de France (ms. lat. 10525, fol. 11v), Paris (France).

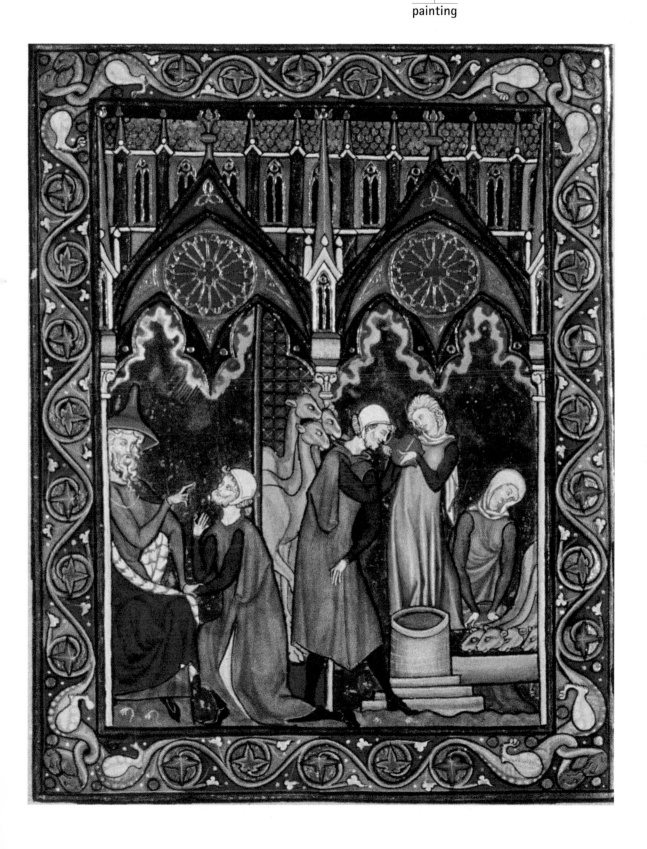

illuminated around 1325 (page 192). The verso of folio fifteen shows the betrayal and arrest of Christ. All ground has been eliminated—the entirely natural human forms are presented in a compact group linked by a single dramatic action, their reactions and expressions displaying a range of emotions that arouse the viewer's interest. In contrast, the recto of folio sixteen shows an Annunciation that is perhaps overly elegant and sophisticated. The scene is set in a room that, although open on one side by convention, creates a sense of deep space on the page thanks to a coherent vanishing point. Like

the group on the preceding folio, the imagery is then developed to its own ends, being accompanied, in the margins, by small-sized "grotesques" whose only role is to delight the eye and vaunt the artist's virtuosity. Devotional books of hours were thus already proclaiming themselves, explicitly, to be works of art.

This approach became more systematic in the opening pages of the *Psalter of the Duke of Berry*, usually ascribed to André Beauneveu and dated to around 1386–90. Beauneveu, a sculptor, was one of the most famous masters of his day. He worked for

Jean Pucelle, The Arrest of Christ and The Annunciation, *The Hours of Jeanne d'Évreux*, c. 1325–28. The Cloisters Collection (Acca. 54.1.2, fol. 15v and 16r), Metropolitan Museum of Art, New York (New York).

Attributed to André
Beaunevcu, Isaiah, *Psalter
of the Duc de Berry*,
c. 1386–90. Bibliothèque
Nationale de France
(ms. fr. 13091, fol. 11v),
Paris (France).

King Charles V of France and Jean, duke of Berry. He appears to have traveled a good deal, and displayed great talent as an illuminator as well as a sculptor. To judge from a few pages of the *Psalter of the duke of Berry*, Beauneveu was one of those artists who had acquired new mastery in the depiction of space. The perspective lines clearly hollow the surface, especially since the ground of the miniature is composed of a uniform, dark mosaic, whereas the colors of the subject have a light, watercolor feel. The cathedra, or episcopal throne, is constructed like a piece of architecture, solidly set on the ground; the prophet Isaiah occupies it with statuesque calm. In fact, the rich and powerful duke of Berry gathered around him an entire group of artists who made the city of Bourges one of the most fertile capitals of art until the duke's death in 1416. Chief among these artists were the three Limbourg brothers Pol, Jean, and Herman.

The Limbourgs had initially been recruited from their native land of Guelders by Philip the Bold, duke of Burgundy and great connoisseur of fine manuscripts. Nothing is known of their training. At most there is a mention of a first sojourn in Paris by Jean and Herman

around 1399, plus a plausible if hypothetical visit to Italy by Pol, the eldest brother, at about the same time. Early in 1402 Philip commissioned them to illuminate a very considerable work, a *Moralized Bible* that remained unfinished at his death (Bibliothèque Nationale de France, Paris). The Limbourgs' rich inventiveness, which would become their trademark style, was already evident here.

Jean, duke of Berry, apparently aware of their talent, engaged the brothers in his service around 1404–05, and showered them with attention. But Jean himself passed away in June 1416, and all three brothers died shortly afterward, probably carried off by an epidemic. They had only had time to complete one book of hours, the *Belles Heures* (presented to the duke late in 1409), and to begin a third manuscript, the *Très Riches Heures*, which promised to be the most ambitious masterpiece of manuscript illumination ever, but was left unfinished in the form of a series of quires.

Is it possible to identify the distinctive hand and inspiration of each of the three brothers? Scholar Millard Meiss attempted to do so, but their collaboration was so close that we will probably never be completely certain. On the other hand, we cannot help but admire the richness of their imagination, their delicate style, and the many visual inventions that they contributed to the art of their day.

The *Moralized Bible*—what the brothers managed to paint of it

between 1402 and 1404—demonstrated their innate sense of elegance, with slender figures and a discreet use of color in which mere highlights were added to the generally white garments. The *Belles Heures*, meanwhile, displays the Limbourgs' growing confidence. Color regained importance. Sometimes the ground is still filled with a dark mosaic pattern, as in the *Burial Scene* (fol. 76r), or with swirls of fronds, as in the *Procession of Saint Gregory* (fol. 72). However, in the *Lamentation over the Dead Christ* (fol. 142), the cross is set against a blue sky that pales into the horizon, while heavy clouds gather around *Saint Nicholas Saving Sailors in a Storm* (fol. 168). Indeed, scenes are often composed around the contrast of juxtaposed patches of bright colors—yellow, red, green, pink, and purple—and in this regard a composition such as the *Lamentation* already prefigures the art of Fra Angelico. Henceforth the Limbourgs enjoyed making their compositions more complex. Thus in the *Procession of Saint Gregory* two actions are combined: in the foreground is shown the effects of the plague, while in the middle ground Pope Gregory prays for salvation (page 195). The skillfully composed procession across the middle ground contrasts with the victim and mourners, who occupy the foreground at a weighty angle, in the manner of Giotto.

By now we have reached the threshold of the fifteenth century, and large-scale painting was

Limbourg Brothers, The Procession of Saint Gregory, *Les Belles Heures du duc de Berry*, c. 1404–08. The Cloisters Collection (Acca. 54.1.1, fol. 72), Metropolitan Museum of Art, New York (New York).

Tam leua auk illa peftis fuille fertur q̃ lṽies ĩ uia ĩ
menla in ludis lubito ſternuntando moreĩetur
Vnde cum aliquis ſternutante audiebat uix iei
auxilium dicebat adiuuet te d̃s et ſp̃m exalabat.

FACING PAGE

Simone Martini,
frontispiece to the works
of Virgil, c. 1340. Biblioteca
Ambrosiana (fol. 1v),
Milan (Italy).

BELOW

Master of the Saint George
Codex, *Saint George
Slaying the Dragon* (detail),
c. 1320–25. Biblioteca
Apostolica Vaticana
(Arch. Cap. S. Pietro C 129),
The Vatican, Rome (Italy).

evolving swiftly in the wake of Giotto (1267–1337), who was certainly one of the most remarkable figures of his day. Giotto was apparently familiar with French sculpture of the thirteenth century, and the human figures in the frescoes he painted in the Upper Church at Assisi (1297–99) already displayed an impressive density and solidity. Giotto's discoveries were inevitably integrated into the art of miniatures.

Other Italian artists also merit mention. Thus a master whose identity remains uncertain, but who belonged to the entourage of Cardinal Jacopo Stefaneschi, painted a *Saint George Slaying the Dragon* in the lower part of one page of a manuscript (page 197). The keen attention and anxiety of a group of onlookers to one side tell the real "story," but of more interest here is the pond from which the dragon emerges. It is bordered by rushes, and its transparent surface reflects some light

yet still affords a glimpse of fish threatened by waterfowl. This little fragment interprets nature in a new way. It may perhaps have been inspired by a fresco by Simone Martini in the church of Notre Dame des Doms in Avignon, France. It was in any case Simone himself who, around 1340, painted the frontispiece of an anthology of Virgil owned by Petrarch, which presents an even more surprising picture (page 196). It shows Virgil in the act of writing, seated beneath an olive grove, shielded by a semi-transparent curtain, while a commentator points out his presence to Aeneas, hero of Virgil's own *Aeneid*, and to two peasants from his *Bucolics*. There are no decorative additions this time, and everything now seems alien to the traditions of manuscript painting: the size of the figures, the quality of the drapery, the facial expressions, the realistic poses, the authentic animals. The only miniature conventions that

survive are a high-angle viewpoint and an inversion of proportions that favors the middle ground.

Rediscovering tangible landscape

Landscape suddenly assumed a new importance. In the *Works of Guillaume de Machaut*, dated approximately 1375, an allegorical figure of Nature presents Wit, Rhetoric, and Music to the poet on his doorstep (page 198). The buildings are depicted in a conventionalized way, but the rest of the page extends into a vast landscape. The sky and pond are blue, while the earth is beige. Plants drawn in profile "signify" grass, but the little mushroomlike canopies provide a fairly good image of trees, and the figures are no longer distinctly set against a colored ground but now occupy the background as they go about their business (a shepherd guards his flock,

Anonymous French Master, "Nature Presenting Wit, Rhetoric, and Music to the Poet," *The Works of Guillaume de Machaut*, c. 1375. Bibliothèque Nationale de France (ms. fr. 1584, fol. E), Paris (France).

villagers head for the mill, everyone adding to the overall color). The figure of the blind Guillaume de Machaut might even be a more or less realistic portrait. The accuracy of the poses and the eloquence of the tale encourage us to overlook the fact that the picture still clings to the flatness of the page, the birds are almost bigger than the bushes, and the rabbits leaving their holes look as though they could swallow the shepherd's flock.

Although such works evoked the general atmosphere of a landscape, they still failed to express the passing of time and seasons, a task that would be accomplished by illuminators of the early fifteenth century. One anonymous artist who certainly worked in Paris had a highly recognizable style apparent in several manuscripts datable to the beginning of the fifteenth century. He is *known* simply as the Master of the *Boucicaut Hours*, in reference to his greatest book, illuminated around 1412–16. His taste is sober yet displays outstanding ease and clarity; above all, he was perhaps one of the most remarkable colorists of the day. The Master of the *Boucicaut Hours* managed to push reds, blues, and greens to their limit, yet with such aptness and with such a subtle use of white that instead of seeming vulgar they produce a unique kind of gaiety. On several occasions, he decided to depict the rising or setting sun, and he was able to bathe the surrounding landscape in a delicate light that kissed the peaks while leaving valleys in a shadow softened by distance. The day the Master of the *Boucicaut Hours* painted the *Visitation* and the *Flight into Egypt* (page 200), the technique of aerial perspective began reclaiming its role in the art of landscape.

At the same time, the Limbourgs were making even bolder moves. As mentioned above, they did not hesitate to paint nocturnal scenes (page 137). In their calendar for the *Très Riches Heures du duc de Berry*, which must have been painted around 1412–16, instead of following the tradition of allegorical figures, they directly depicted the seasons through a sequence of landscapes that no other painters had ever conjugated so fully: snowy landscape, springtime blossoms, summer pastimes, poetic images of autumn. Each of these subjects would almost become its own genre. The works are so well known and so often reproduced that it almost seems superfluous to mention them. But then we might forget to *look* at them: smudged footprints in the snow, frozen tufts of grass at the base of trees, a group of birds drawn to the sheepfold in *February* (page 201); a cart laden with sheaves in the wheat field and the little bather leaving the water in *August*; the scarecrow in the sown field, the strollers and little dogs on the quay with reflections of water and even a shadow on the wall in *October* (so startling that some scholars claim to detect here a hand posterior to the Limbourg brothers.) In any case, it is impossible not to be amazed by the

PAGE 200
Boucicault Master,
The Flight into Egypt,
The Boucicault Hours,
c. 1412–16. Musée
Jacquemart-André (ms. 2),
Paris (France).

PAGE 201
Limbourg brothers,
The Month of February,
*Les Très Riches Heures du
duc de Berry,* c. 1412–16.
Musée Condé,
Chantilly (France).

diversity and accuracy of these details, by this sudden emergence of tangible presence—the entire poetic wealth of the universe was henceforth available to artists.

The metamorphosis of painting

Art's new alliance with physical appearances was sealed, as large-scale paintings would henceforth demonstrate. Already in 1337–40, Ambrogio Lorenzetti had boldly painted, for the Town Hall in Siena, Italy, a vast panorama of hills and fields, where only the disproportionate size of the lords violated scientific perspective (page 202). But it was in the north that sensibilities changed most quickly, notably in the lands of the dukes of Burgundy, which stretched from Dijon (in modern France) to Antwerp (Belgium). Art historians often fail to appreciate the crucial importance of this artistic center sustained by the tastes and ambitions of lavish dukes. In the nineteenth century, those historians

concerned with consolidating modern "Belgium" tried to consign to oblivion the sprawling geographical entity created by the Burgundian lords, which only waned with the tragic death of Charles the Bold and subsequent rivalries with the kings of France and the Habsburgs. Burgundy's historic center was Dijon, where the Carthusian monastery of Champmol played the same role as the Abbey of Saint-Denis in Paris, even if the wealth of Flanders induced many artists to remain in the duchy's northern provinces. Dijon boasts an altarpiece carved in wood by Jacques de Baerze, the back panels of which feature paintings by an artist from Ypres, Melchior Broederlam. The altarpiece was installed in Champmol in 1399, and although the delicate architectural features that host an *Annunciation* and a *Presentation at the Temple* are not very innovative in themselves, the scenes are set in landscapes that combine the same realism and delicacy as is seen in

ABOVE

Abrogio Lorenzetti, *Good and Bad Government*, c. 1338–40. Fresco, Town Hall, Siena (Italy).

FACING PAGE

Melchior Broederlam, *The Flight into Egypt*, right panel of polyptych, Carthusian Monastery of Champmol, c. 1396–99. Oil on wood, 4′5″ × 1′6″ (1.35 × 1.08 m). Musée des Beaux-Arts, Dijon (France).

manuscript miniatures. The paths may still lead to rocky outcrops, but the group setting out on *The Flight into Egypt* passes a rustic little fountain with narrow neck, set in the green grass, that already represents an instance of poetic naturalism (page 203).

The Master of Flémalle is the name usually given to an artist whose total oeuvre has not yet been conclusively established. But it is hard not to ascribe to him major paintings in the former possessions of the dukes of Burgundy. These paintings include a *Nativity* that was also originally one of the great treasures of the Carthusian monastery of Champmol and is generally dated to around 1415–20 (page 205). The Master of Flémalle made a major leap forward here: the conventionalized buildings are gone, the figures are plunged into crystal-clear air, and the landscape is not set against a gold ground but rather extends far into the pale horizon and clear sky.

This is not to say that no traditional features remain, such as the many long scrolls in the painting that spell out each detail. The artist might have worried that his approach to the birth of Christ would be misunderstood, since the stable was not an ancient ruin but a mud-and-straw hut topped by a thatched roof, open to the elements (harking back perhaps to the even simpler wooden framework of Giotto in the Arena Chapel in Padua). The ox and ass can be seen through holes in the slats. The shepherds, alerted by the angels,

have already arrived. It would seem as though the artist wanted to underscore three ideas: Mary's virginity (as confirmed by two midwives summoned by Joseph, Zabel, and the disbelieving Salomé, who displays her withered wrist, as recounted in the *Golden Legend*); the humbleness of Christ, who lies completely naked on the bare earth; and the spiritual glory of the Virgin, as proclaimed by her white gown and gold-embroidered cloak. Joseph still protects the thin flame of a lighted candle, just as he will protect the child lying at his feet. But the night of the Birth is already over, and the first rays of the sun can be seen on the hills as a crystalline light begins to blue the horizon and invade a wintry landscape with bare trees. In the far distance there appear a rider on the road, houses, a fortified town with ramparts reflected in the water, and a lake with a sailboat.

This extreme attention to religious content, combined with a visual sensibility that enjoys conveying the plastic and almost tactile reality of every last detail, was most certainly one of the major accomplishments of Burgundian artists in those days. It should not be forgotten that one artist who enjoyed the full favor of Philip the Good— probably the most refined of all the dukes of Burgundy—was Jan van Eyck, who successfully crossed another, final threshold: an acute vision would henceforth be combined with a consummate skill in both linear and aerial perspective, and freely handled forms would

Master of Flémalle, *Nativity*, c. 1415–20. Oil on wood, 33 × 28″ (85 × 72 cm). Musée des Beaux-Arts, Dijon (France).

now be imbued with great psychological intuition.

History, partly guided by sixteenth-century art historian Giorgio Vasari, has taken van Eyck to be the inventor of oil painting. His very large altarpiece, *The Adoration of the Lamb*, completed in 1432, is still viewed as a kind of inaugural event. Much could be said about this attitude, and it would be more accurate to see the painting as the culmination of a long tradition, although that should in no way diminish the admiration that has always surrounded this artwork. Its very size indicates that, right from the start, the altarpiece was conceived as a major undertaking, almost a manifesto. Straight away, the viewer is struck by two large nudes, male and female. They ostensibly represent the original sin of Adam and Eve, but one wonders whether van Eyck used them as an excuse to demonstrate his outstanding skill at depicting the human body (page 206). Artists had long mastered this skill, sculpture having solved the problem as early as the thirteenth century and the Limbourg brothers having blithely incorporated nudes into their books of hours. However, the scale of van Eyck's panels, along with their accuracy and realism, inevitably provoke admiration.

Another feature worthy of interest is the luminous and tangible aura in which all the scenes are enveloped. This is evident in the large, juxtaposed elements of *The Adoration of the Lamb*, but it is

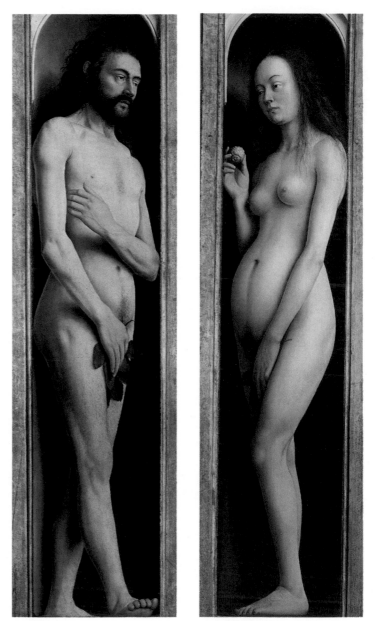

even more striking in the smaller *The Madonna of Chancellor Rolin*, executed around 1435. The objects and figures in the foreground are analyzed with an acuity that seems miraculous, but more miraculous still is the stunning view through the triple arcade of the

Jan van Eyck, *Adam and Eve*, panels from the *Adoration of the Lamb*, c. 1432. Oil on wood, Saint Bavo Cathedral, Ghent (Belgium).

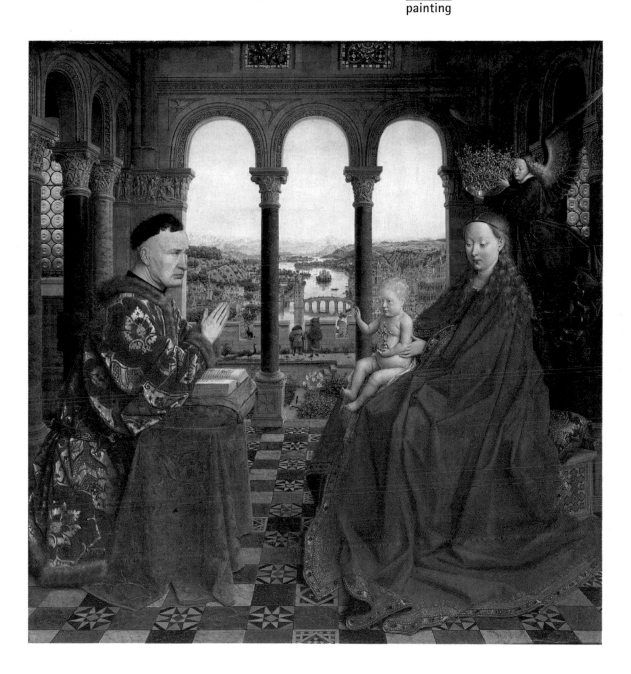

Jan van Eyck, *The Madonna with Chancellor Rolin*, c. 1435. Oil on wood, 26 × 24″ (66 × 62 cm). Musée du Louvre, Paris (France).

loggia. The landscape commences with a garden complete with a couple of magpies, two peacocks, and a bunch of white lilies. Beyond this can be seen an entire town with its cathedral and various churches, then a bridge crossed by a throng of pedestrians, an island, and finally rural riverbanks and a distant chain of mountains. Everything is handled with such polished care that it is clear the artist not only sought to produce a masterpiece that would amaze and spellbind, but also wanted to capture and immortalize a fragment and a moment of life in

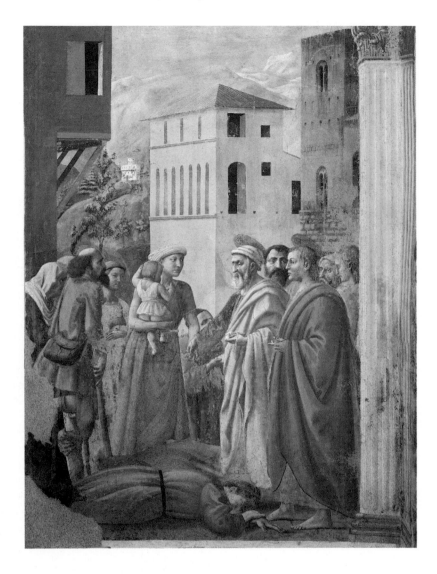

Masaccio, *Saint Peter Distributing Alms and the Death of Ananias*, c. 1426–27. Brancacci Chapel, Santa Maria del Carmine, Florence (Italy).

their perfect uniqueness, down to the tiniest detail.

Italy would not remain impervious to this acute skill and vision. In the early fifteenth century, however, it vacillated between two trends. In Florence, Masaccio (1401–28) was painting the Brancacci Chapel in Santa Maria del Carmine in a manner diametrically opposed to van Eyck: monumental figures executed in a fresco technique, with great attention to perspective but no concern for meticulous details (page 208). Masaccio explicitly harked back to the great Italian tradition of Giotto. The other major trend was the pursuit and development of the "international Gothic" style—elegantly mannered, colorful, gilded—the masterpiece of which was probably *The Adoration of the Magi* altarpiece painted by Gentile da Fabriano for the Florentine church of Santa Trinità in 1423 in

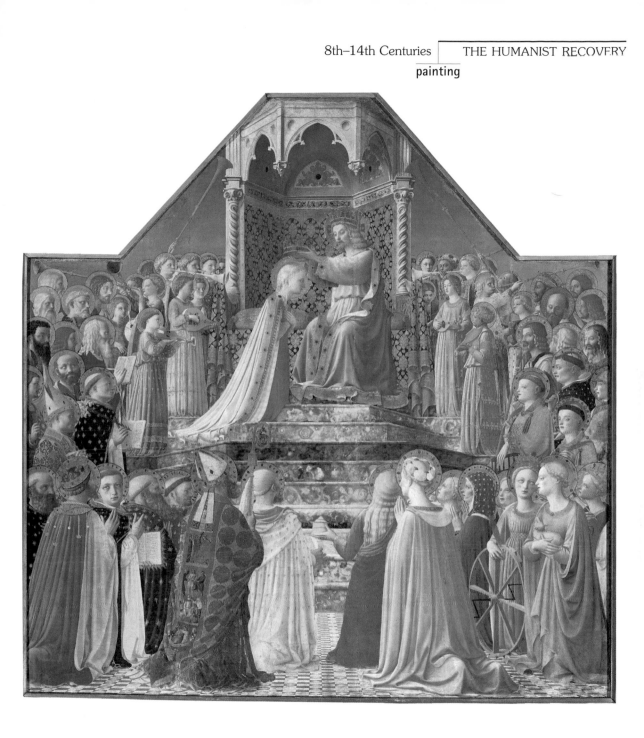

Fra Angelico, *The Coronation of the Virgin*, 1434–35. Tempera on wood, 7´9˝ × 6´10˝ (2.4 × 2.11 m). Musée du Louvre, Paris (France).

Uffizi, Florence. The same spirit can be seen, with renewed power, in paintings such as Fra Angelico's *Coronation of the Virgin*—pink, blue, and gold, heavenly colors and harmony (page 209).

It is no longer fashionable to include Fra Angelico among the

great painters. The nineteenth century over-praised him for his fine sentiments, which are no longer valued. Critics have so dissected his oeuvre that almost all of Fra Angelico's paintings, including *The Coronation of the Virgin*, are now largely attributed to assistants.

And these days, the concept of "progress" in art honors only "forerunners." As a result, Masaccio is acclaimed while Fra Angelico is seen as backward, stubbornly prolonging "Gothic" art.

False reasoning: although Fra Angelico had assistants, he had fewer than any other painter of his day, for he was a monk passionately attached to his task. It is even said that he refused all personal gain. Furthermore, it is Masaccio who could be considered to have been a young "reactionary" who looked back to Giotto, whereas Fra Angelico represented the culmination of an "international" trend developed by the Limbourg brothers and Gentile.

We would therefore do better to look squarely at the evidence, starting with the outstanding set of frescoes by Fra Angelico, entirely of his own inspiration (even if the presence of several assistants is obvious), in an excellent state of conservation in the monastery of San Marco in Florence. To this set can be added the Niccolina Chapel in the Vatican, painted in the artist's mature years (1447–50), as well an entire series of large altarpieces. Few other oeuvres of the day seem stronger, more complete, or more inspired.

His art seems easy to define, but we should be wary of the apparent ingenuousness of this "angelic" artist (who was in fact baptized Guido di Pietro and took Fra Giovanni as his monastic name). He was a highly skilled painter. In *The Coronation of the Virgin*, for example, primacy is given to color. In spite of a few dark patches, the panel plays on a bright, light palette of blues, yellows, reds, and pinks arranged in sequences that structure the painting. But Fra Angelico also excelled at draftsmanship. Usually, his lines closely defined color, but they could also model volumes. In the overall composition, lines establish alternating rhythms; it was precisely on the opposition between the free play of color and the firmness of line that Fra Angelico constructed his painting—in this instance by subjecting the entire scene to the demanding constraints of linear perspective.

All these features rejuvenated the glamorous elegance of the "international style." Nor was Fra Angelico alone. Pisanello, for instance, capped his career in 1441–45 with a singular masterpiece, *The Virgin and Child with Saint George and Anthony Abbott* (page 211). The latter is shown as a dark, bearded old hermit facing a young knight in white armor with shaven neck and large straw hat to shade his face. Does this symbolize age confronted by youth? A hermit by a lord? Meditation by bravery? Or was it simply a commissioned subject? The meeting takes place on the edge of a dark wood, below a vision of the Madonna and Child, silent and affecting. It just shows how painters, having abandoned symbolic signs in favor of the physical appearances of people and things, did not impoverish their art but rather enriched the vast realm of formal precision with artistic ambiguity.

Antonio Pisanello,
The Virgin and Child with Saint George and Anthony Abbott, 1441–45.
Oil on wood, 18 × 11″ (47 × 29 cm),
National Gallery,
London (England).

IV
THE AGE OF REFINEMENT
(Late 14th–Late 16th Centuries)

O ne long stretch of this history came to a close sometime in the 1430s, when the van Eycks painted the Ghent altarpiece. The die was cast—there could be no turning back.

The route had been unpredictable, dotted by many chance occurrences, constantly altered by ethnic expansions, military interventions, and changing religious attitudes. It would be naïve to speak of *predestination*. Islam's victories had sufficed to radically suppress the extensive Alexandrian heritage, just as a decision by a church council sufficed to revive the moribund Greco-Roman tradition. No dialectical imperative can explain the development of rib-vaulted architecture, nor the enthusiasm that greeted this method of construction so contrary to everything the world had known up until then.

Hindsight can merely identify the final destination: after roughly ten centuries, people displayed a revived interest in the tangible forms engendered by the visible world, while artists, for their part, recovered their means of expression. The terms *revived* and *recovered* converge with the term "Renaissance," employed by Vasari as early as 1550. Yet they should not mislead us. It was never a question of returning to a point of departure, to the art of the ancient world. Everything had changed— geography above all.

The divide of the Western world was complete. The Mediterranean Sea, which had formerly served to link its various shores—thereby generating wealth—became an insurmountable barrier: Islam occupied one side, Christendom the other. The crusades and ephemeral Christian settlements in Asia only exacerbated religious differences. Byzantium had long held out against both Bulgars and Arabs, only to fall to the Christians themselves when crusaders invaded and sacked the city in 1204, setting up an eastern Latin empire that survived until 1261. Once Michael VIII Palaeologus reestablished the Byzantine Empire, it glittered anew. By 1365, however, the Turks had gained a foothold in Europe. Byzantium held out until May 1453; Mistra, the last pocket of Byzantine civilization, finally fell in 1460. In Spain, on the other hand, Granada was captured by the Catholic kings in 1492, putting a definitive end to the Islamic invasion. The Turks looked toward Budapest and central Hungary (annexed in 1541), attempting above all to reach Vienna, the key to western Europe—this time, however, they would have no luck.

By the eleventh century, much of the trade with the Orient had already passed from the hands of the Byzantines to the Venetians and Genoese, who profited greatly from it. During the fifteenth century, commerce grew apace in the Baltic and Flemish lands of northern Europe. Large towns in Germany and France enjoyed a veritable golden age that occasionally enabled them to rival major Italian centers. When combined with the presence of enlightened, cultivated princes, this part of Europe projected the image of a wealthy, enterprising era

that patronized the arts. Yet it should not be forgotten that this period of flourishing expansion was also wracked by terrible misfortunes.

In the political sphere, first of all, the house of Burgundy was tempted to restore a kind of Lotharingian kingdom between France and the Holy Roman Empire by uniting traditional Burgundian lands with the rich Flemish provinces. These dreams were dashed by the death of Charles the Bold at the Battle of Nancy. But the split between "Burgundians" and "Armagnacs" would degenerate into a war between the king of France and the king of England, the so-called Hundred Years' War that devastated entire regions.

Even more disasterous were the religious troubles of the following century. The Anglican schism led to the confiscation of wealthy English monasteries, of which only majestic ruins remain. The spread of Luther's doctrines (not to mention Calvin's even stricter ones) and the violent civil wars that ensued were—to speak only of art—the worst catastrophe to occur since the Islamic conquests. Monasteries completely vanished in certain parts of Europe, as did the entire contents of many churches, including not only precious metalwork and stained glass but also all the painting and sculpture of previous centuries. Almost no Dutch "primitives" survived; as to German "primitives," Jean Bialostocki has estimated that no more than two percent now exist. In a country such as France, where the Reformation failed to impose itself, constant battles between the two sides led to vast destruction—stained-glass windows were shattered, altarpieces burned, porch sculpture smashed. People began destroying numerous churches and even cathedrals, including the one in Orléans. When Henry IV of France managed to restore order, the extent of the disaster was summed up in the harsh comment made by a contemporary, Étienne Pasquier: anyone who had slept through the previous forty years would think he had awakened to find not France, but the corpse of France.

It was nothing short of miraculous that these trying times could produce an art so brilliant, although it is worth noting that Italy, the country least ravaged by war and sundry disasters, was the one that led all other regions of Europe. Artists of the fifteenth and sixteenth centuries had no qualms about evoking suffering, death, and spiritual distress, of course, and yet in every land they preferred to celebrate physical beauty and to counter reality with a harmonious, happy world. A similar reaction often occurs during dramatic periods of history. It would be mistaken to view this as a lack of interest in reality; in fact, at that time, art was first and foremost a mental realm, for architects as well as for sculptors and painters. Proud of their new dominion, creative artists exploited their recovered powers with a kind of joy, despite all the calamities around them.

One example should suffice to stress the uniformity of inspiration behind the highly diverse expressiveness of this period. The church of Saint-Étienne in Bar-le-Duc in the Lorraine region of France now houses a

tomb sculpture called *Le Transi,* or "Tomb Figure," by Ligier Richier (page 216). The tomb holds the heart of René de Chalon, prince of Orange and son-in-law of Antoine, duke of Lorraine. The young man died in 1544, aged twenty-five, at the siege of Saint-Dizier. Tradition holds that, at his own request, his tomb portrait was not a standard recumbent figure but a standing, life-size skeleton with strips of dried skin flapping over a hollow carcass, whose right hand clutches at the empty rib cage while the left hand holds high his heart in a grand gesture. Toward whom is he brandishing it? To God? To an afterlife? To hope? The toothy skull with hollow eyes seems driven by a strange passion.

The contrast could not be greater with Michelangelo's *Victory,* now in the Palazzo Vecchio in Florence, and usually dated to around 1534 (page 217). This statue also depicts a young man, although larger than life and flawlessly handsome. He rises over a squatting hulk that has the lifeless face of an old man. The young man gazes into the distance, proud of his nudity and strength, confident of his victory. But victory over what? Right from his apprenticeship, Michelangelo, that tormented genius, had learned the great lesson of antiquity, which associated bodily perfection with a spiritual ideal. Like Michelangelo's *David*—a handsome athlete chosen by God and heading into combat—this allegory also speaks of a triumph over old age and death, of a victory over the darkness.

Ligier Richier, *Le Transi*
("Tomb Figure"), tomb
of René of Chalon, 1547.
Polychrome stone,
H: 5´8″ (1.75 m).
Church of Saint-Étienne,
Bar-le-Duc (France).

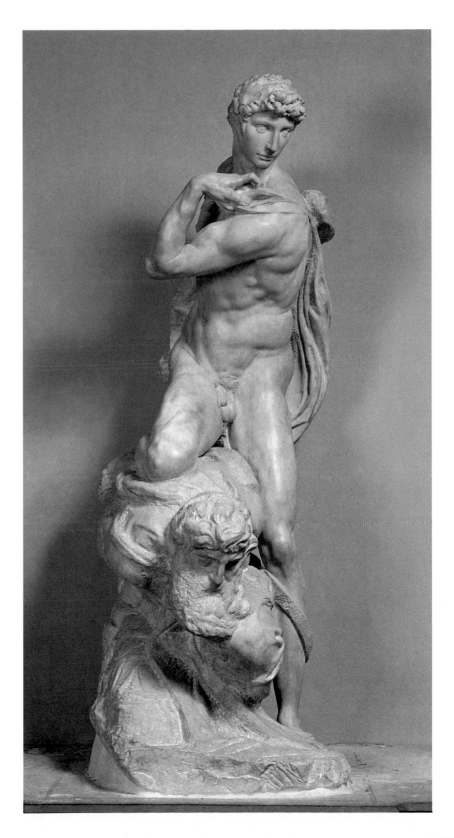

Michelangelo, *Victory*,
c. 1534. Marble,
H: 8´6˝ (2.61 m).
Palazzo Vecchio,
Florence (Italy).

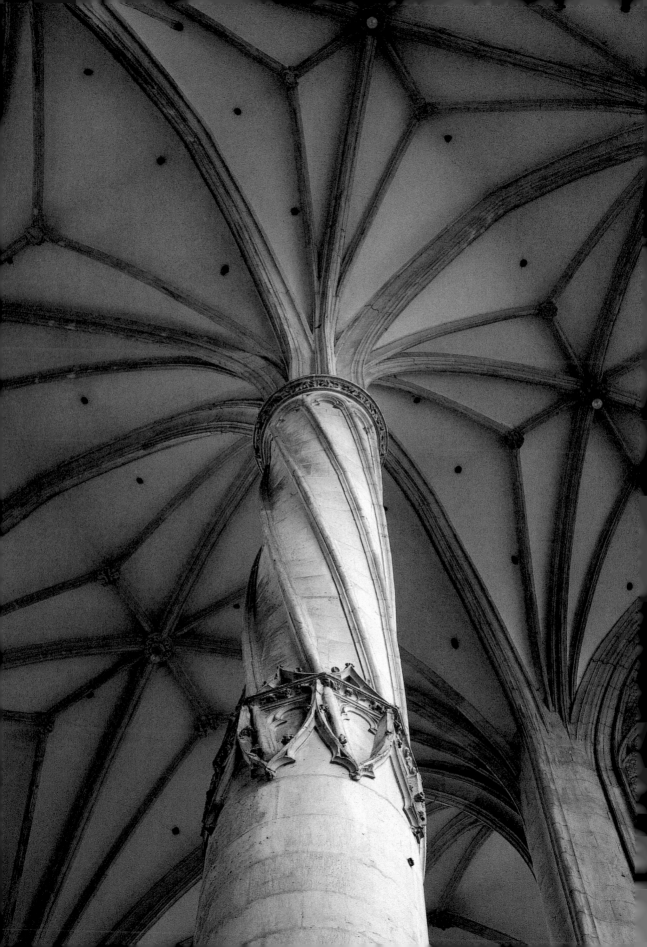

Architecture

Ogival (or pointed) architecture swept across all of Europe in the fourteenth century. This style lasted all the longer in that many of the vast construction projects remained unfinished—a porch was lacking here, an entire façade was incomplete there (Bologna), a nave needed finishing (Beauvais), or, most often, two or three towers were still going up (Chartres). Completing the construction program under a different architectural system would have threatened the equilibrium of the entire edifice, so builders usually decided to follow the old plans (in Milan and Cologne construction was only completed in the nineteenth century). In other, more common cases, the system of rib vaulting was retained even as new fashions were more or less adopted, even at the cost of giving the impression of a composite building.

The times were not very conducive to planning and executing buildings that could rival the cathedrals of Paris or Chartres in terms of height, length, and overall layout. Nevertheless, in France itself some new building projects of considerable scope were launched in places such as Toul, Notre-Dame-de-l'Épine, Paris (Saint-Gervais and Saint-Séverin), and Rouen (Saint-Maclou). However, architects were usually commissioned to complete churches that were already standing, and so they were inclined to outdo each other in terms of subtle touches, refining each of the various structural elements.

Flamboyant art

Stonecutters' workshops henceforth demonstrated surprising skill, which architects exploited by filling windows with increasingly complex tracery. Instead of respecting the harmonious design of the thirteenth century, when a simple rose window would be set above pointed equilateral arches (as at Paris, Reims, and elsewhere), windows grew larger and invaded the walls as their upper tracery branched into capricious, dynamic offshoots. Curves and countercurves suggested the shape of hearts or flames, hence the use in France of the term "Flamboyant" (for this style). The tooled effect did not stop with windows, but spread to the exterior, where it transformed gables into a lacework of stone topped by crockets and finials delicately shaped by the sculptor's whimsy. A good example can be seen on the royal portal of the church of Notre-Dame in Louviers, France (page 220). More especially, however, this

Pier and rib vaulting, basilica of Saint-Nicolas, Saint-Nicolas-de-Port (France).

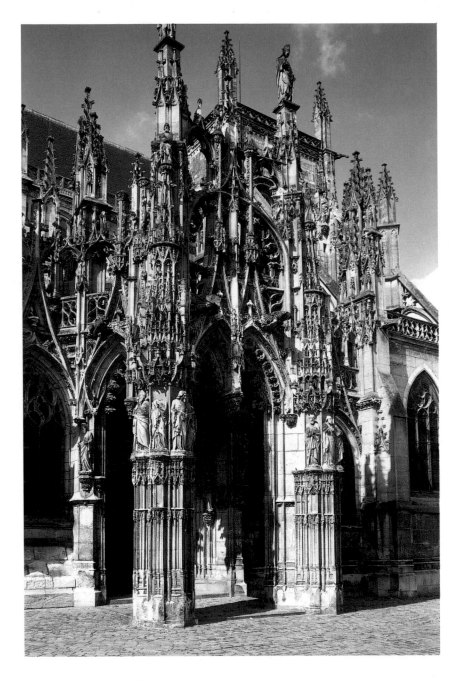

embroidered effect spread to rood screens, which swiftly became an essential and fashionable feature of church interiors. A masterful example of such work is the rood loft in the church of Sainte-Madeleine in Troyes (page 221).

At first sight, the three arches seem to be so finely hollowed that they span the nave with no support from below; in fact, these openwork arches, pinnacles, and balustrade hang from a large, carefully masked arch. Sculptural

South portal, church of Notre-Dame, Louviers (France), late fifteenth century.

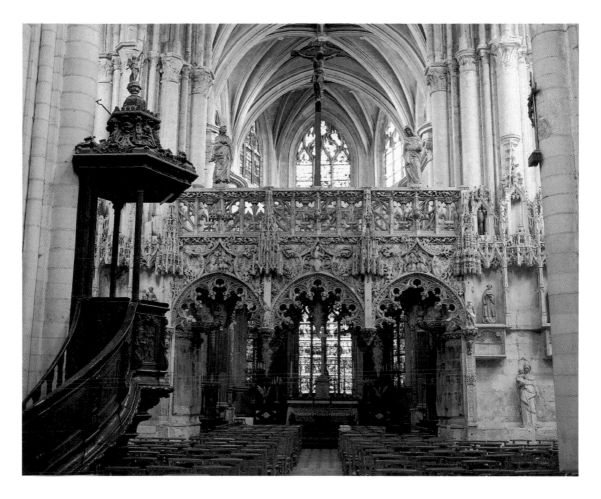

Rood loft, church
of Sainte-Madeleine,
Troyes (France), 1508–17.

exuberance is therefore accompanied by an architectural tour de force.

Such virtuoso effects might be seen as gratuitous, as a decadent phase of an art concerned only with details. This opinion is widespread, but means acknowledging only one of the aspects of an architectural approach that, in point of fact, sought to wed increasingly rich and complicated decoration to increasingly simpler structures, thus combining expressive refinement with a taste for a spare layout.

The reduction of wall surface and its replacement with stained glass windows—as boldly done by the architect of the upper chapel of the Sainte-Chapelle in Paris—led in the fifteenth century to the simplification of the elevation of an edifice. The upper gallery had already given way to the arched triforium, which, once reduced to a simple clerestory of high windows, itself gradually became superfluous. Henceforth churches were reduced to two stories: tall arcades topped by large, tall windows whose stained glass produced a play of color inside the building. And since there was no longer any need to emphasize the details of

the layout visually, architects could do away with the engaged columns marking the bays and the more or less figurative capitals, as demonstrated by churches such as Saint-Séverin in Paris, Saint-Maclou in Rouen, and Saint-Nicholas-de-Port in Lorraine (page 218). The ribbing of the vaults ran directly into the walls and the columns, and the formerly complicated vertical orchestration was reduced to bundles of slender columns, which became more and more discreet. Sections of flat walling thus appeared while, in contrast, the vault was filled with secondary and tertiary ribs known as liernes and tiercerons, dividing the ceiling into multiple compartments that draw the gaze upward, sometimes reinforcing the impression of boldness,

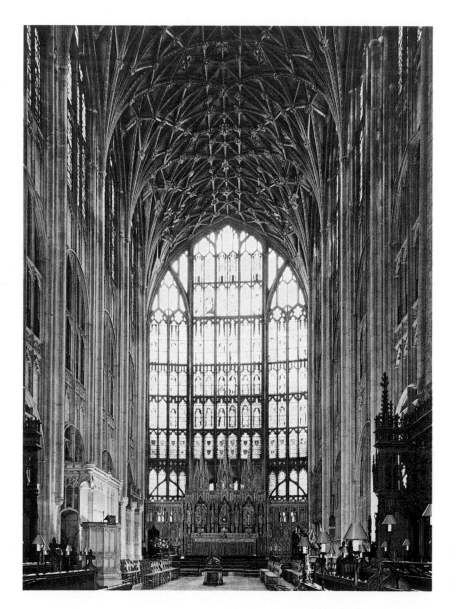

Choir, Gloucester Cathedral, Gloucester (England), 1337–60.

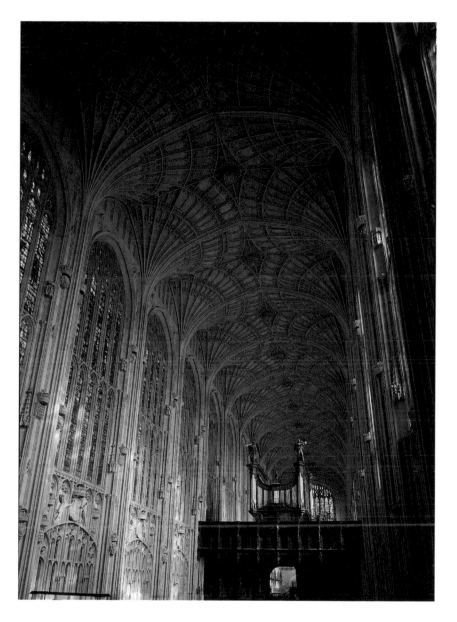

King's College Chapel,
Cambridge (England),
1441–1515.

other times reinforcing the idea of a "cap." Indeed, the great vertical thrust sought in Chartres and Bourges seemed less and less called for—occasionally the profile of the vault might even be lowered as tall, pointed arches were replaced by basket arches, while doorways often took the form of an ogee arch (a suddenly fashionable design whose origins remain obscure).

This trend first emerged in England, although in an independent manner. Liernes and tiercerons were already used in the vaulting of Lincoln Cathedral in the thirteenth century, while Gloucester Cathedral epitomized the "perpendicular style" around 1337–60, which divided

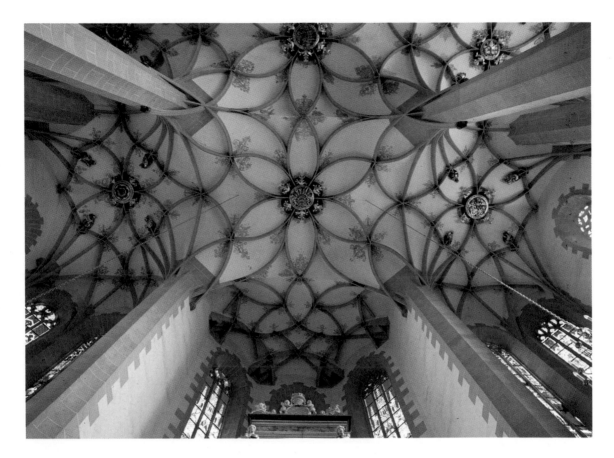

surfaces into a network of panels with vast windows and a vault dense with lavish liernes that meet in flowery bosses (page 222). Thus fifteenth-century English architecture produced a few buildings that, even if they seem very different from those on the continent, carried certain "Flamboyant" features to perfection. King's College Chapel in Cambridge, built from 1441 to 1515, perhaps represents the finest masterpiece, with its simplified elevation, its walls transformed into windows, and its low-pointed arches invaded by a rich web of fan vaulting. The decorative effect is so impressive here that we almost forget we are looking at architecture.

The same virtuosity can be found in the lands of the Holy Roman Empire. We need merely look to the church of Saint Anne in Annaberg, Germany (1499–1525), where the play of ribbing that springs from the tall, plain pillars, snaking across the entire ceiling in curves and countercurves, proves that here, too, a taste for spareness can be wed to subtle, refined skills (page 224). Then there is Vladislav Hall in Prague Castle, Czech Republic. Here the ribs seem to detach themselves from the arches and flow freely, intertwining, never letting the eye rest for a moment on a straight line (page 225). Independent of specific divisions of volumes, they lend a kind of

Vault above choir, church of Saint Anne, Annaberg (Germany), 1499–1525.

Vladislav Hall,
Prague Castle,
Prague (Czech Republic),
1493–1515.

perpetual movement to the space they traverse—a deliberate demonstration of skill and power on the part of the architect. It was hardly surprising, then, that an architect such as Anton Pilgram from Moravia set his self-portrait, compass and square in hand, in the cathedral in Vienna, below the highly complex organ foot that he created there. His gesture perhaps reflected not so much personal vanity as legitimate pride at being the successor to five centuries of builders who covered

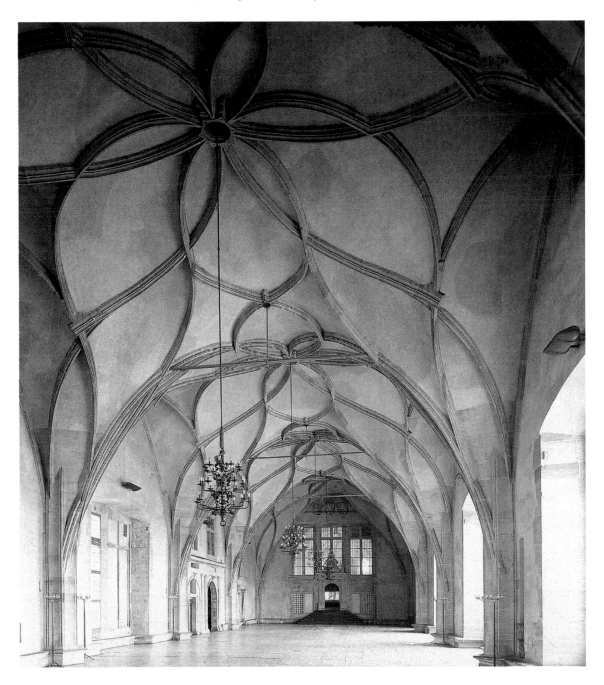

Europe with "a white mantle of cathedrals," and at being an heir to such incomparable knowledge.

Italian variance

Italy had never been profoundly marked by ogival architecture. The example of great ecclesiastical edifices in France, Germany, and Spain obviously inspired ambitious undertakings such as the cathedrals in Milan and Bologna, the church of San Francesco in Assisi, and Santa Maria sopra Minerva in Rome. But this enthusiasm was never unrivaled—in Venice, San Marco descended directly from domed

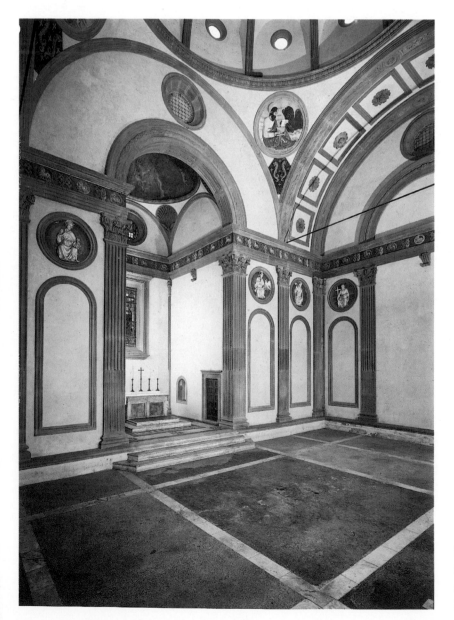

Filippo Brunelleschi, Pazzi Chapel, church of Santa Croce, Florence (Italy), 1433.

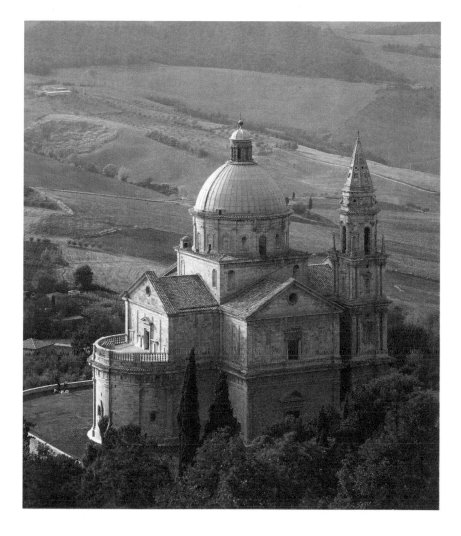

Antonio da Sangallo,
church of Madonna
di San Biagio,
Montepulciano (Italy),
1518–45.

Byzantine architecture, while Rome and many other places often adopted the wooden-roofed basilica design inherited from antiquity. Furthermore, the numerous Roman ruins provided examples of an entirely different decorative approach, while interest in ancient texts continued to grow (the ancient Roman architect Vitruvius was translated into Italian and discussed). Thus a scholarly milieu sprang up, based more on speculation than on the experience of long practice. During the fifteenth century, this situation gave birth to a veritable architectural revolution that occurred under the aegis of antiquity. It brought an abrupt halt to the ongoing transformation of rib-vaulted architecture, which was widely practiced and at the height of its technical and expressive potential. Rarely in the history of the arts has it been possible to witness, so clearly and independently of any political or ethnic upheaval, the sudden death of a great tradition.

Take, almost at random, the example of a church such as

the Madonna di San Biagio in Montepulciano, built by Antonio da Sangallo from 1581 to 1545 (page 227). It represents an Italian equivalent—if a century later—of Notre-Dame de l'Épine (1410–1524), one of the masterpieces of French Flamboyant architecture. A more complete contrast is hard to imagine. Italy was returning to an architecture that no longer entailed an analysis of thrusts, but rather an embedding of shapes, as employed back in the eleventh and twelfth centuries by the so-called "Romanesque" system. Yet these shapes were not the product of a long tradition, but instead reflected the architect's intellectual philosophy. The building was given the form of a Greek cross, with each of the four arms ending in a triangular pediment, each corner underscored by a pilaster. Above the crossing was set a massive cube on which sits a round drum topped by a dome. The only concession to the old ecclesiastical tradition was the external addition of an apse (which in fact served only to house the sacristy). Doors and windows were reduced to a minimum and devoid of tracery. All decoration was banished, apart from triangular or rounded pediments over doors and windows, and a frieze of ancient-style triglyphs that subtly divided the first story from the second. The whole thing would be austere were it not for a few refinements, such as the terrace and above all the campanile with four stacked decorative tiers (only completed in 1564 and initially planned as two towers). Clearly, Sangallo was striving to

reconceive the very idea of church architecture independently of the European context of the day.

The reformulation entailed a set of innovations based on ancient models or the ancient spirit. Thus, vestiges of art from the days of Augustus inspired a type of decorative carving that suited flat pilasters, and no longer had anything to do with pinnacles with their foliate crockets and finials. This type of ornamentation became highly popular. The flat yet heavily worked façade of the Carthusian monastery of Pavia (built entirely according to the rib-vault system) fascinated the French when they discovered it during the Italian wars of the early sixteenth century. Meanwhile, Italian architect Filippo Brunelleschi (1377–1446) revived the prestige of round columns aligned in a portico (Ospedale degli Innocenti, Florence, 1421–44) or topped by an entablature to create a basilica-style space (Santo Spirito, Florence, 1444–87). Architectural experimentation therefore often concerned structure as well as decorative idiom.

The quality of a building no longer rested on its audacious scope or the power of its rhythmic elements, but rather on its harmonious proportions. A kind of modular grid was applied to both floor plan and elevation, governing a design that did not have to reflect internal requirements. Thus, in the Pazzi Chapel (c. 1433) of the cloister of Santa Croce in Florence, Brunelleschi employed local, gray *pietra serena* stone to underscore

Filippo Brunelleschi, church of Santo Spirito, Florence (Italy), 1444–87.

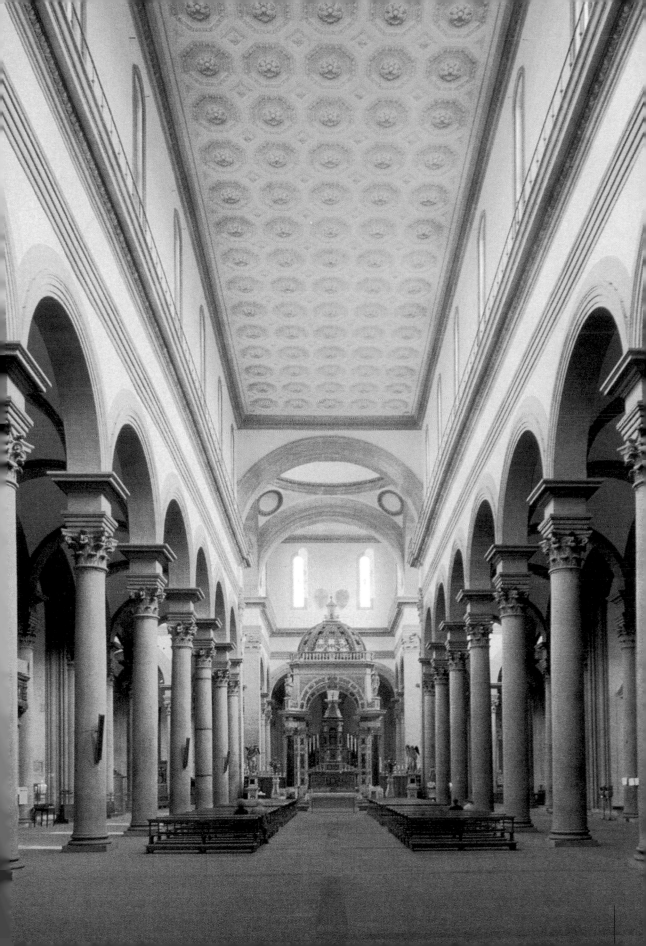

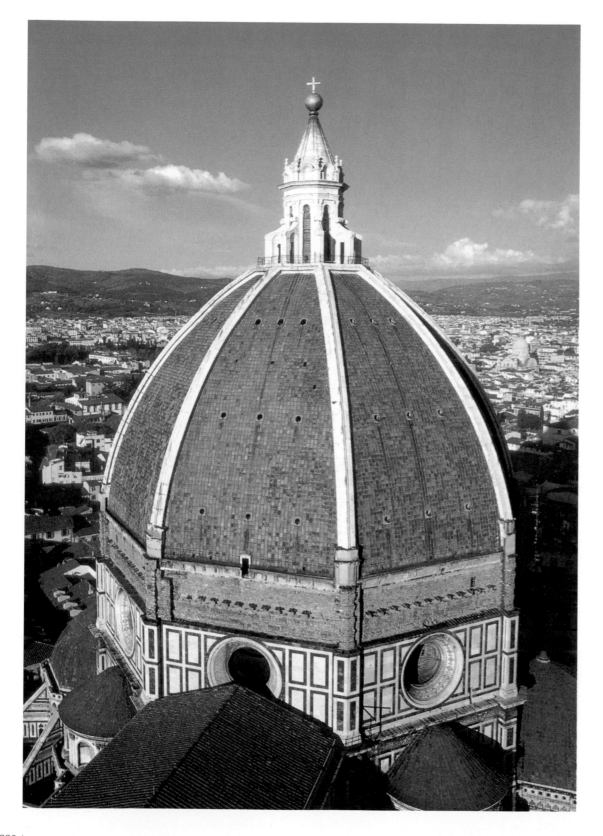

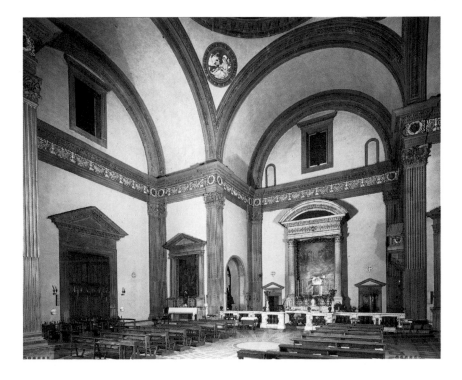

RIGHT
Giuliano da Sangallo,
interior of church of Santa
Maria delle Carceri,
Prato (Italy), 1484–91.

FACING PAGE
Filippo Brunelleschi,
dome of the church
of Santa Maria del Fiore,
Florence (Italy), 1446.

corners and cornices, and to divide the walls into sections that lent the interior space its own rhythm independently of architectonic requirements (page 226). More rigorous still was Santa Maria delle Carceri (1484–91) in Prato, by Giuliano da Sangallo (1443–1516), in which the use of *pietra serena* reflects perfectly the building's Greek cross configuration (page 231). This straightforward approach, however, almost devoid of decoration, can seem a little cold.

The quest for harmony led to simplified plans. Thus another Florentine architect, Leon Battista Alberti (1404–72) avoided complicating interior space by using a simple nave, without aisles, lined by chapels (Sant'Andrea in Mantua). The architectural features of aisles and ambulatory, once considered essential to every church of any importance, would not completely vanish, but architects were increasingly inclined to close off the choir and to delimit the aisle space by just a few massive piers that provided structural stability. In Santo Spirito, Brunelleschi had rejected a vault in favor of a coffered ceiling, which produced a rectangular volume dominated by horizontals (page 229).

But Brunelleschi's most brilliant accomplishment was the successful completion before his death in 1446 of the enormous dome on Santa Maria del Fiore. The impact of the dome would far exceed expectations, for two main reasons. In the first place, Brunelleschi's success relegated to second rank the problem of towers, steeples, and campaniles that had so preoccupied

architects from all over Europe since the eleventh century and that had spawned hundreds of domed masterpieces in places like Cluny, Chartres, Toulouse, Strasbourg, Laon, Antwerp, Freiburg, Ulm, Vienna, and Burgos. His dome on Santa Maria del Fiore was not only very imposing when seen close up, thanks to its massive power, but also dominated the landscape by almost completely effacing the presence of the famous "Giotto" campanile and the tower of the Palazzo Vecchio, some 300 ft. (94 m) high. It was the dome that henceforth defined the cityscape of Florence. This lesson was quickly grasped, so when it came to the plans for rebuilding Saint Peter's in Rome, everything focused on the dome.

When it came to bell towers, modest turrets henceforth sufficed. In the sixteenth and more especially seventeenth and eighteenth centuries, the issue of the exterior profile of a church—once a crucial question—was almost entirely limited to the design of the façade. The loss of interest in towers was easier to accept given the increasing numbers of urban monastic churches; people rarely wanted their towns to be invaded by towers, which were costly to build and to maintain. Soon enough, the center of Paris would host a church, La Madeleine, designed like an ancient temple with no tower at all (nor, for that matter, a visible dome). It was only with nineteenth-century revival architecture that people once again became interested, with a marked

passion, in façades with towers and steeples.

In the second place, Brunelleschi's dome represented a new architectural form. It was not like the one seen on the Pantheon in Rome, an immense space that completely covered the building from the second story upward. Nor was it like the dome of Hagia Sophia in Constantinople, which also crowned the entire church and was flanked by half-domes, creating a relatively squat profile. Brunelleschi's dome, in contrast, rose above the choir, at the end of a long nave, like the cupolas of certain Eastern churches yet with curved lines and an oval silhouette that created a large interior volume while projecting, externally, a solidly seated mass that soared skyward. In this respect, it was perceived as a new architectural form.

The new form was not only bold, but also difficult to master. In fact, the dome on Santa Maria del Fiore was never truly imitated. The type of dome that spread across the world from Washington, D.C. to Saint Petersburg first had to be modified—tamed, in a way—by a series of architects working on Saint Peter's in Rome. We know that Michelangelo, who began work on the church after 1546, first thought of a central plan dominated by a dome, but he did not have the time to complete his plans, and his successors refined the shape. Ultimately, the dome of Saint Peter's, with paired columns orchestrating the drum and outer ribs creating a sense of harmony, provided a model so perfect that it

Michelangelo, dome of Saint Peter's Basilica, Rome (Italy).

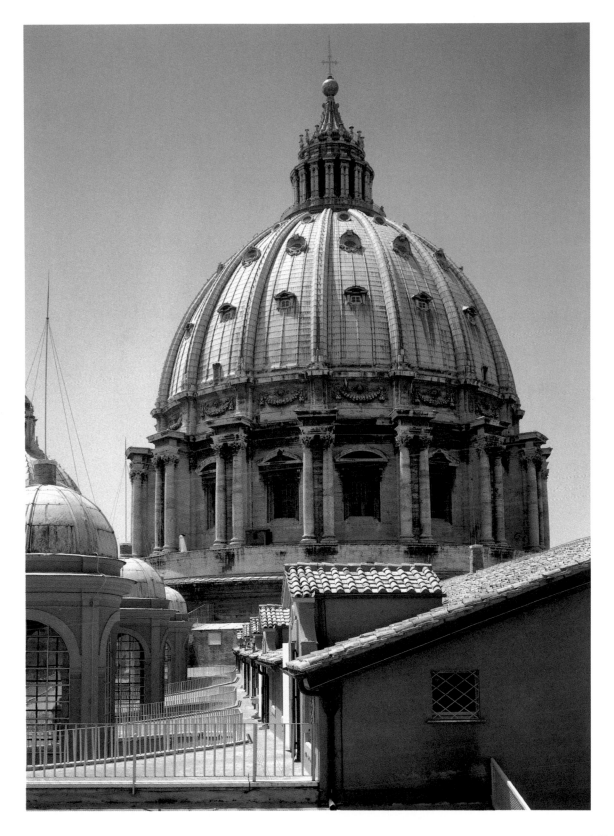

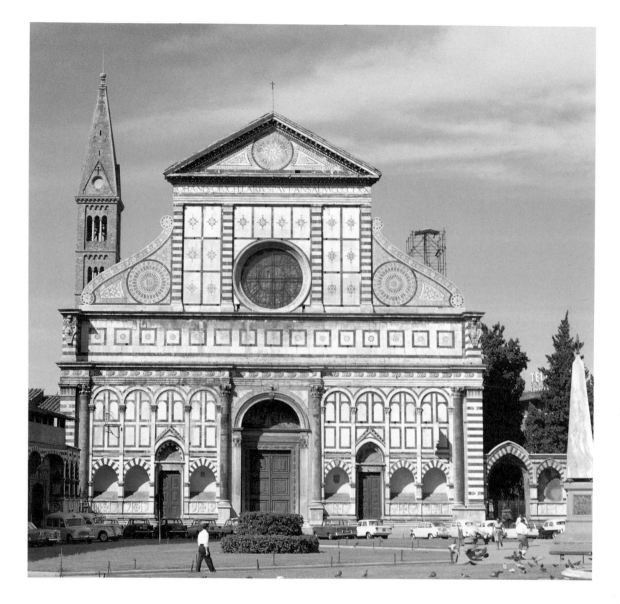

guaranteed the popularity of this new form for centuries to come (page 233).

Another revolution took place, however. The principle of harmony led to an assault on façades. The logical breakdown of a façade into nine sections, though hard to discard when it came to large buildings, was also abandoned. In Florence, Alberti designed Santa Maria Novella (1470) as two distinct stories, the upper one being narrower but linked to the lower story by large volutes and topped by triangular pediment (page 234). This flat surface—which rejected the interplay of substantial volumes, and instead created fine effects of shadow and light through the slight recesses of doors, niches, and windows—was surprisingly

Leon Battista Alberti, façade of Santa Maria Novella, Florence (Italy), 1470.

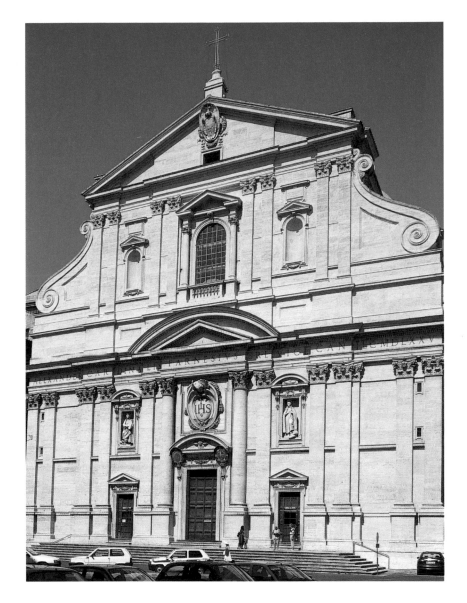

Giacomo Barozzi
da Vignola and Giacomo
della Porta, façade of
the Gesù, Rome (Italy),
1568–84.

successful. Giacomo Barozzi da Vignola and Giacomo della Porta would produce a more refined version of this concept in the church of Gesù in Rome (1568–84), thanks to the subtle use of classical orders (page 235). Acclaim was swift and universal. Here again, learned speculation had given birth to a new *form*, but one that was infinitely less rich than those developed since the eleventh century, as well as technically less clever. One look at Alberti's façade in Florence reveals it to be more of an architect's drawing than a living, breathing work. Gone was the wealth of sculpture—for a Gesù-style façade, two or four statues suffice. Yet the ease with which these flat façades could be set in the streets of urban neighborhoods, combined with

their reasonable cost, probably explains why they continued to proliferate until the end of the eighteenth century.

As we have seen, the innovations of Italian genius occurred at a time when "Flamboyant" architecture was still flourishing in Europe, produced by architects at the height of their experience. To a certain extent, the attitude of the likes of Brunelleschi and Alberti, based as it was on allusions to— and remnants of—antiquity, might seem somewhat reactionary from today's perspective. So how did it come to be adopted, if not by central and northern Europe, at least by France and Spain, which were in direct contact with Italian architecture? How did the latter wind up killing off age-old traditions that seemed more appropriate than ever to the vicissitudes of the day?

Here we must make a distinction between ecclesiastical and secular architecture. As already mentioned, plans drawn up in the ogival spirit were difficult to change. In Spain, buildings such as the Royal Chapel in Granada (begun 1504) and Salamanca Cathedral (begun 1513) retained their vaulted structure in its entirety, sometimes even increasing the ribbing in the vaults. In Portugal, the early sixteenth-century monastery of the Knights of Christ in Tomar displayed a strange abundance of carved decoration—ropework, shellwork, algae, and coral motifs—that ran totally counter to Italian austerity. In contrast, the vast monastic palace of Escorial,

built outside Madrid by King Philip II of Spain, was the work of Juan Bautista de Toledo, Giovanni Battista Castello, and Juan de Herrera between 1563 and 1582, and is probably the most severe edifice built during the entire period.

In France, the taste for soaring structures in the ogival tradition only slowly gave way to more calculated proportions. Often, prevailing fashion was reflected only in decoration. A church such as Saint-Pierre in Caen (1528–45) retained the traditional rib vaulting inside with flying buttresses outside, but windows became more rounded, sculpture became more Italianate, and pinnacles became candlesticks. In Dijon, the grand façade of Saint-Michel (1537–40) abandoned Flamboyant effusion for the greater serenity of rounded bays, and marked a return to traditional cathedral porches that are deeply and richly carved.

The most interesting churches in Paris were probably Saint-Eustache and Saint-Étienne-du-Mont. Begun in 1532, Saint-Eustache is a major church in terms of size, height, and overall harmony, thereby perpetuating the tradition of the fourteenth and fifteenth centuries. Historians have criticized the architect for decorating the powerful, soaring pillars with outsized pilasters and with fluted columns beneath the vault. Such grammatical slips should not be allowed to blind us to the success of the overall statement. Saint-Étienne-du-Mont, meanwhile, located on the edge of the Latin

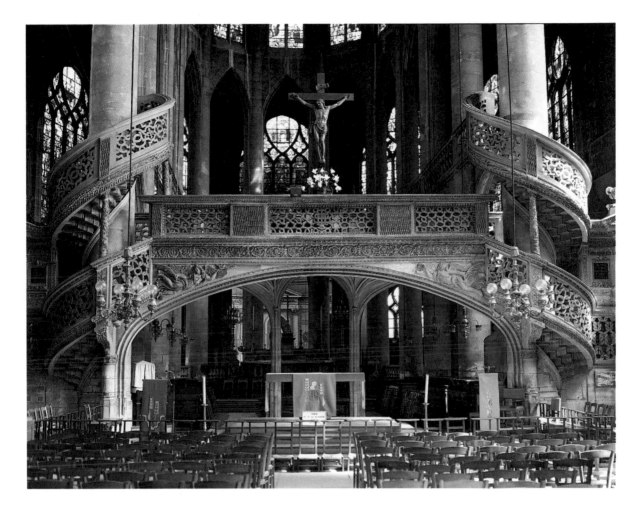

Rood loft, church of
Saint-Étienne-du-Mont,
Paris (France), 1492–1626.

Quarter, right next to the ancient monastic church of Sainte-Geneviève, was built between 1492 and 1626. Hindered by the narrow, sloping plot, as well as by the monks' right to insist that any bell tower be lower than the existing Clovis tower, the architect rejected all the standard approaches then common. For the choir, he adopted the simplest of Flamboyant styles: round, smooth pillars, and discreet ribs that blend into the springing. The only ornate—and highly refined—tracery appeared on the rood loft, which respected the geo-

metric rigor of the central arch, and on the twin spiral staircases that lend a delightful dynamism to an otherwise dry composition (page 237). The string course running along at mid height serves to recall the missing story. A whole series of builders thereby reconceived the entire design of the church, arriving at a model of perfect elegance.

The rood loft, for that matter, has been tentatively ascribed to the architect Philibert de l'Orme (c. 1510–70), perhaps the greatest French architect of his generation. Most of his work has disappeared,

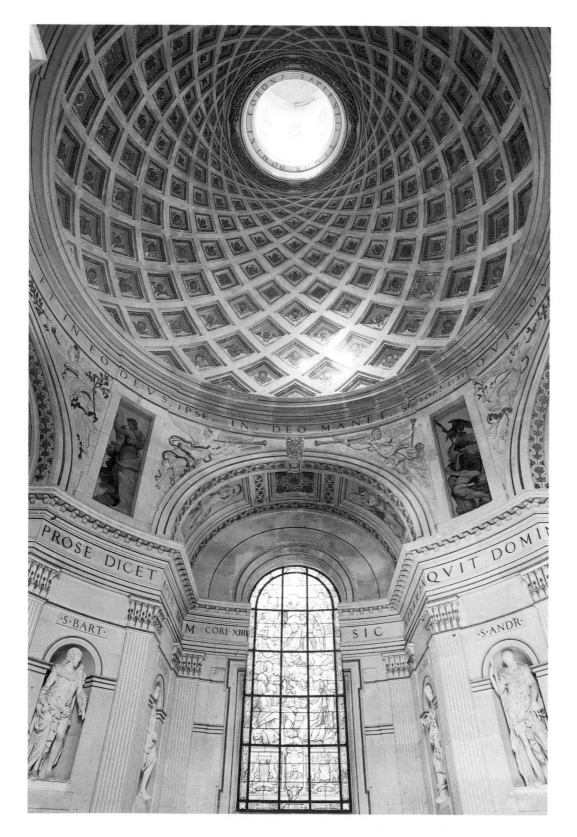

yet one surviving religious edifice reflects the triumph of Italian ideas along with the originality of the French reaction: the chapel in the château at Anet (1549–52). This chapel is of modest dimensions but boasts highly refined details. The insistence on correct proportions is rendered less cold and ostentatious through the use of fluted columns and the lively role of sculpture (page 238). The dome is enlivened by the diagonal uplift of the coffering, echoed on the black-and-white floor paving. De l'Orme may display less erudition and monumen-

tality here than Antonio da Sangallo, but his elegant harmony was specific to the French court.

True enough, in secular architecture Italian ideas were adopted more swiftly. French patrons called upon Italian architects such as Vignola and Sebastiano Serlio (who designed the château at Ancy-le-Franc). By 1540, the shift was complete, although Pierre Lescot's courtyard for the Louvre, begun in 1546, indicates that French taste tended to favor the pleasant over the grandiose (page 239).

Sculpture

The contrast between Ligier Richier and Michelangelo highlighted in the introduction to this chapter perhaps sums up the accomplishment of sculpture during these two centuries. Yet we could hardly overlook the fact that this great period produced many strong artistic personalities and highly expressive works. As already mentioned, Claus Sluter helped ecclesiastical sculpture to begin breaking its age-old links to architecture in order to become freestanding statuary once again, while retaining its sacred function. Suddenly sources of inspiration became more varied, and artists' names were more likely to be recorded. Sculpture, whether of stone or bronze, recovered roles and privileges it had lost since antiquity. It is hardly surprising, then, that the evolution of sculpture, like that of architecture, followed a complex path and was swiftly transformed by Italy's rapid rise to preeminence.

While Sluter indeed represented a crucial new threshold in European sculpture, he also played a part in extending the spirit of the Flamboyant style. After Sluter, sculpture would reflect that art's two contradictory yet complementary aspects: a virtuosity pushed to the point of lyricism on the one hand, and a solemn, profoundly spiritual realism on the other. The former aspect is well represented by large altarpieces of carved wood found throughout Germanic lands; the latter is expressed in the little-studied and often-dismissed series of "Entombments" sculpted in France, Italy, and the Iberian peninsula.

Germanic masterpieces

By the fourteenth century, fashion dictated that high altars in Flanders and Germany be backed by large altarpieces of carved wood, featuring painted and gilded statues, sometimes life-size, usually set beneath a pointed canopy of lacy woodwork. The quest for lifelike authenticity was sometimes taken to extremes of narrative, indeed anecdotal, vividness. Folds of drapery were carved deeply, breaking at sharp angles; hair and beards, hollowed by a chisel that reveled in its virtuosity, were given curls so thick they seem frizzy. The most famous example of such work was Veit Stoss's high altar (1477–89) for the church of Saint Mary in Cracow (page 240), but there were many masterpieces in this vein. Michael and Gregor Erhart's work for the church in Blaubeuren (1493–94), for example, and Tilman Riemanschnieder's Altar of the Holy Blood in Rothenberg have bequeathed us magnificent, complex imagery. Although it nearly falls into the

Veit Stoss, *Death of the Virgin* (detail), 1477–89. Painted wood, overall height of high altar: 45′ (13.95 m). Church of Saint Mary, Cracow (Poland).

extreme form of realism known as verism, their work remains restrained by a taste for fine craftsmanship.

Entombments

Even more than altarpieces, it was perhaps a series of sculptures depicting the Entombment of Christ that best illustrate the efforts to resolve the problems arising from the arrangement of a group of life-size figures. These problems have always surfaced at various times in the history of sculpture, but had not been addressed in the West since Greco-Roman art, except perhaps for some unusual cases such as a mid twelfth-century *Tomb of Lazarus* in Autun, France, of which only fragments remain. In the fifteenth century, sculptors began to face the issue when depicting scenes from the life of Christ—the Last Supper, Crucifixion, Resurrection, and most especially the Entombment. Among the oldest surviving examples of Entombments are two in northeastern France, one in the church of Saint-Martin in Pont-à-Mousson (perhaps dating from the first quarter of the fifteenth century) and another, well-preserved one in a chapel in Tonnerre (1454). The fashion soon spread far afield. This subject stimulated, two centuries in advance, keen artistic study of the expression of "passions." Here it involved the reactions of eight to ten people to the drama of burying Jesus, each reacting according to his or her gender, age, and psychology. This subject—which also enabled artists to depict men and women

confronting the mystery of death, a theme that gripped the entire period—produced many masterpieces, only a few of which can be mentioned here: the *Entombment* in the church of Notre-Dame in Semur-en-Auxois (originally from the Carmelite convent, attributed to Antoine Le Moiturier, 1490), the *Sepulcher* in the abbey church of Saint-Pierre in Solesmes (1496), another in the collegiate church of Notre-Dame in Les Andelys (originally from the Carthusian monastery of Gaillon), one in the church of Chaource (c. 1515), another in the church of Notre-Dame in Villeneuve l'Archevêque (originally from the Abbey of Vauluisant, 1528), and finally one in Pontoise (c. 1560). In the region of Lorraine alone, it is said that some forty groups of this type survive in good condition, despite all the destruction associated with the French Revolution, the most famous of which is the *Entombment* in Saint-Mihiel, sculpted by Ligier Richier prior to 1564.

Unfortunately, the Tonnerre *Entombment has* lost its original coloring, but all eight of its figures survive intact (page 243). In the foreground, around the prone body of Christ, are two old men, Nicodemus (who lightly supports the shoulders of Jesus) and Joseph of Arimathea (with his hand underneath one leg). Behind them are the Virgin (almost invisible beneath her veil) who discreetly leans on Saint John, plus the three Marys holding jars of ointments. Mouths are closed, drapery is still, and the forms, underscored by the whiteness of the stone, are

Entombment, 1454.
Chapel of former hospital,
Tonnerre (France).

powerful. Everything here is quiet and rigorous.

One hundred years later, this grand style evolved into a virtuoso performance, without undermining emotional impact. Ligier Richier departed markedly from the traditional alignment of vertical statues around a horizontal corpse. He tightened the group around the Virgin, supported by John and one of the Marys, as well as the two men lifting Christ's body, which is bent in such as way as to suggest a Pietà (page 244). At the same time, however, Richier skillfully extended this central group by adding, on the left, a large angel with half-open wings, a kneeling Mary Magdalene, and, on the right, another standing female figure (perhaps Veronica) who holds the crown of thorns. The sculptor creates a middle ground through the inclusion of three soldiers gambling with dice on a drum and another woman preparing the tomb. The handling of drapery and hair is remarkably varied, and the expressions on the faces reflect inner emotions.

Richier's group might simply be viewed as a sculpted tableau, or a skillful staging of thirteen life-size figures, or a theme related to all the

contemporary Pietàs (the subject most often depicted in stone and wood throughout this period). And yet, the more these Entombments are studied, the more they reveal an emotion often lacking in funerary works of the day, and the more they seem to convey the sincerest religious conviction. When it comes to Richier himself, a few surviving documents shed light on the artist. He was highly esteemed both for his artistic and civic work, having been elected to a municipal office in Saint-Mihiel in 1543. He leaned distinctly toward the Protestant Reformation, and when measures were taken to halt the spread of Protestantism, Richier abandoned his home and his masterpiece (perhaps not entirely finished) in order to settle in Geneva. It would seem that he poured all his faith into sculpting this *Entombment.*

In contrast to these grave, meditative works, it is worth mentioning Niccolò dell'Arca's *Lamentation Over the Body of Christ* (1464 or 1485), executed for the church of Santa Maria della Vita in Bologna. Dell'Arca's sculpture is an extravagant, theatrical, resounding piece that pushes the paroxysm of sorrow and vitality to breaking point. Yet it, too, is a masterpiece. All these groups reveal that, at a time when fashion was favoring new approaches, the grand art of cathedrals, an art that was profoundly emotional and—we should not be afraid to admit—spiritual, continued to grow and develop, with no loss of skill.

ABOVE
Ligier Richier, *Entombment,* prior to 1564. Stone, church of Saint-Étienne, Saint-Mihiel (France).

FACING PAGE
Niccolò dell'Arca, *Lamentation Over the Body of Christ* (detail, former arrangement), 1464 or 1485 [?]. Church of Santa Maria della Vita, Bologna (Italy).

Italian bronzes

When speculating about the arts of antiquity, Italy could hardly ignore sculpture. Let us turn to the famous *David* sculpted by Donatello around 1440, which has often been described as the first freestanding nude sculpture since the fall of the Roman Empire (page 246). This book has already demonstrated the contrary; at most, it might be argued that *David* is the first nude bronze. Interestingly, although Donatello took a major biblical figure as his subject, he clearly decided to handle it in a secular way. There is no quest for majesty. David is portrayed as a "weakling," and his body, angled in a stance seen in certain antique torsos, seems very juvenile—he is a teenager, almost a child. The soft modeling underscores the graceful pose. But this statue does not represent the full range of Donatello's genius, for a look at his equestrian statue of *Gattamelata* in Padua (page 248), based on the ancient statue of "Constantine," displays a frank, accurate realism that legitimately restored Italy's taste for large riders cast in bronze.

Remarkably, the next generation felt the need to offer a reply to Donatello, via the versatile artist Andrea del Verrocchio (1435–88). Verrocchio's *David* (1476) rejected the total nudity of the original for a close-fitting breastplate that better suits a biblical hero while displaying the artist's anatomical skills. Verrocchio also added the expressive effect of Goliath's head placed ostentatiously at the youth's feet.

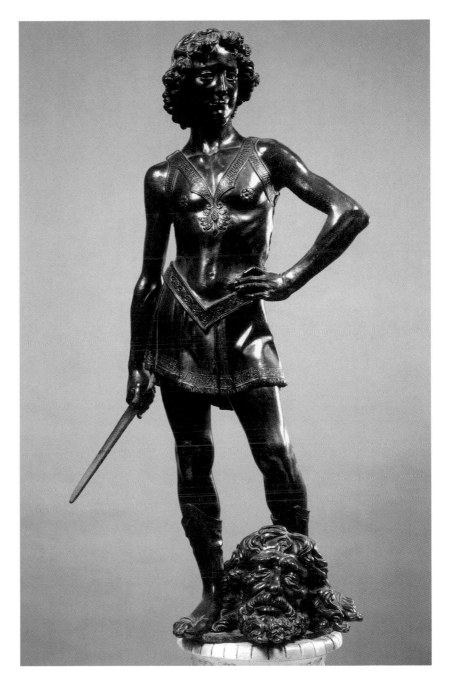

David's curly hair and confident, almost mocking, smile—based on some Florentine street urchin rather than copied from an ancient model—offer a discreet critique of the dreamy, languid expression on the face of Donatello's boy.

Verrocchio replied to Donatello's *Gattamelata* with his own equestrian statue of *Bartolomeo Colleoni*, commissioned in 1479. He left the statue unfinished at his death, but it was later cast by Alessandro Leopardi in Venice

LEFT

Donatello, *Equestrian statue of Erasmo da Narni*, known as *Gattamelata*, 1446–50. Bronze, 11 × 12′6″ (3.4 × 3.9 m). Piazza del Santo, Padua (Italy).

(1490–95). Whereas Donatello's strong, calm bare-headed rider is shown astride a horse seen in profile, Verrocchio's horseman rises on his spurs, turns one shoulder to the rear as he thrusts the other forward, and casts a contemptuous look at the crowd below (page 249). The horse turns its head slightly and lifts one hoof high—these asymmetries, though minor, suffice to breathe life into the statue.

As previously mentioned, earlier centuries produced numerous equestrian statues, although always of stone or wood. The successful casting in bronze of these two large statues by Donatello and Verrocchio represented a breakthrough. When set up on public squares in Padua and Venice, they inspired other monarchs and warriors to glorify themselves by commissioning these "monuments to lasting memory."

On several occasions Leonardo da Vinci had hoped to cast a rider on a rearing horse, first to honor the Sforza family, then for a statue of Giangiacomo Trivulzio. But his plans came to naught. They required the combined art of a great sculptor, the technique of a bronze-founder, and significant funds. It was only at the very end of the sixteenth century (1581–94) that a new bronze equestrian statue—of Cosimo I de' Medici—conceived byGiambologna, was erected on the Piazza della Signoria in Florence. From this point onward, however, a whole series of mounted portraits of monarchs and famous warriors (including the likes of Joan of Arc), often of very high quality, would be produced, their number continuing to grow into the mid-twentieth century, when this art was abandoned.

Michelangelo's unique accomplishment

It was in this complex, stimulating environment that the great figure of

FACING PAGE

Andrea del Verrochio, *Equestrian Statue of Bartolomeo Colleoni*, 1480–88. Bronze, Campo Santi Giovanni e Paolo, Venice (Italy).

Michelangelo emerged. His career as a sculptor unfolded around grandiose projects of which none came to total fruition, but from which he would elaborate an aesthetic principle of *non finito* that, although inimitable, would fascinate contemporaries and later generations alike.

Michelangelo first displayed total mastery of the male nude in a series of increasingly powerful pieces: *The Battle of the Centaurs* (c. 1492, Casa Buonarroti, Florence), *Bacchus* (c. 1496–97, Bargello, Florence), and the 12-foot-high (4 m) *David* (1501, Galleria dell' Accademia, Florence). And he proved his skill at handling ancient-style drapery in

Michelangelo, *Night*, c. 1526–34. Marble, church of San Lorenzo, Florence (Italy).

the Vatican *Pietà* (begun 1499, Michelangelo's only signed work) and also in the *Bruges Madonna* (1498–1501, church of Notre-Dame, Bruges). But he only attained a balance between virtuosity and spirituality through the turbulent unleashing of his imagination in the vast projects of Pope Julius II in Rome and the Medicis in Florence: the gigantic tomb of Julius II, commissioned as early as 1505, of which only one statue—*Moses*—would ever be completed; and the Medici tomb planned for the new sacristy of San Lorenzo, whose marble statuary, never finished, was only installed after Michelangelo's death.

Michelangelo, *Day*, c. 1526–34. Marble, church of San Lorenzo, Florence (Italy).

The enormous capital of fame that the sculptor Michelangelo has amassed over the centuries makes it impossible to speak of him in terms other than "sublime" and "grandiose." True enough, his work makes criticism seem silly and categorization small-minded, but that is no reason for refusing to analyze it. Take, for instance, the two statues at the foot of the energetic tomb figure of Giuliano de' Medici, generally interpreted as allegories of *Day* and *Night* (pages 250–251) It is worth noting, first of all, that the male nude is accompanied by a large female nude, which—apart from certain subjects (notably Eve)—was rare in Italian sculpture of the time. And neither of the nudes attempts to express ideal beauty; although their anatomy is carefully rendered, neither their appearances nor their proportions belong to the ideal canon. The body of the male figure of *Day*, still wrapped up in himself, is knotty with heavy lumps of muscle. *Night*, meanwhile, rejects any idea of grace, her belly striped by four thick folds and her widely separated breasts swollen with milk. Michelangelo was fully aware of the *Aphrodite Anadyomene* of antiquity, with her adolescent breasts, as well as the elegant *Belvedere Apollo*. But here he preferred to look to the famous *Belvedere Torso* and the *Laocoön*. In other words, he was guided neither by the ancient canons of beauty nor by direct observation of nature. Rather, he sought expressiveness—but an expressiveness not based on

gestures (the arms of his statues are rarely eloquent, and often one arm is hidden), nor on facial features (sometimes left unfinished). In fact, the effect achieved by Michelangelo derived above all from the contrast between the inert mass of marble and live forms he extracted from it.

But what did Michelangelo want to express here? This key question has generated endless speculation. The course of a day seems to be a rather thin subject-matter. This work has also been interpreted as the hold of time over human life, a reminder of the brevity of earthly existence, and then ultimately, the immortality of the soul. *Night* allegedly symbolizes fertility, and perhaps the blindness of an enslaved, abandoned soul. *Day*, in contrast, might represent rebellion, a struggle for liberty, or even the soul awakening to Christ's call. Other interpretations see these figures as the personification of the elements or four temperaments. But must we attribute discursive themes and rational creativity to Michelangelo? The job of a sculptor, who wrestles with mute material, is precisely to extract from stone a work that will seem all the more "poetic" for being able to entertain a series of explanations without being limited to them. Michelangelo was playing on the tangible appearance of his creatures, which he himself nevertheless critiqued—through his *non finito* aesthetic—as ideas never pushed to the reductive clarity of the "life-like."

Bronze sculpture

Michelangelo's long career—despite his turbulent nature, constant disputes and disruptions, and even failures—was one of the most glorious ever enjoyed by an artist. Yet fame did not increase his influence on other artists. Devout respect for antiquity, so proudly proclaimed by rivals such as Baccio Bandinelli and Bartolomeo Ammanati, was

Benvenuto Cellini,
Perseus, completed 1554.
Bronze, H: 16'10" (5.19 m).
Loggia dei Lanzi,
Piazza della Signoria,
Florence (Italy).

somewhat undermined by the indomitable originality of Michelangelo's work. It is hard to overstate his desire to be a carver of marble who sought to cut free the "idea" from the mass. Michelangelo rejected the art of modelers who little by little *constructed* a plaster model designed to be cast by a founder. So he left the field open to the many sculptors who worked in bronze.

Thus Benvenuto Cellini (1500–71), after an adventurous life that took him as far as the court of France (1540–45), produced a bronze *Perseus* for the Loggia dei Lanzi in Florence (page 253). Already a jeweler, goldsmith, and medalist, Cellini also wanted to be sculptor and founder. In Paris, he had worked on a large semicircular lunette designed to grace the portal of the Château of Fontainebleau, showing Diana as a nymph stretched out—one long curve of polished bronze—on the mossy floor of the forest. Despite its beauty, this piece was never installed at Fontainebleau, and was placed instead over the entrance to the Château of Anet (now in the Louvre, Paris).

Perseus was thus Cellini's second attempt at bronze sculpture. Commissioned by Cosimo de' Medici in 1545, it was only cast in 1553 and placed in the Loggia dei Lanzi within sight of Michelangelo's *David*, where it still stands. It displays an elegance that contrasts with the strength of its powerful neighbor; the pose is skillfully conceived, the body delicately modeled, and light drenches the bronze without sabotaging the effects of the volume.

The outlines suffice to suggest a multiplicity of viewpoints. Here metal sculpture felicitously explores some of its new possibilities.

Also in Florence—for a fountain in the Piazza della Signoria—Ammanati boldly surrounded the huge marble statue of Neptune on his chariot (as conceived by Bandinelli before his death, and unveiled in 1565) with a series of bronze nudes that wreathe the edge of the fountain. Their brash and cold beauty mingles calmly with passersby, scarcely shielded by the complex spray of water (page 255).

Thus the ideal urban fountain began to emerge as a theatrical combination of marble, bronze, and splashing water. In Rome, for instance, the Fontana delle Tartarughe (Tortoise Fountain) was erected in the Piazza Mattei as a discreet yet exquisite answer to the Neptune fountain in Florence. Four large, powerfully curved shells constitute four basins that catch the water tumbling from a bowl where four tortoises drink. But Taddeo Landini (c. 1550–96), who sculpted the fine statue of Sixtus V on the Capitoline Hill, placed below the bowl four graceful, nude youths, each with one foot on a dolphin. These bronze silhouettes appear exceptionally elegant underneath the thin curtain of trickling water.

The boldest and most prolific sculptor was certainly Giambologna (1529–1608, also known as Jean Boulogne), born in Flanders but a Florentine by adoption and sensibility. Whereas Michelangelo—a prisoner of his block of marble—tended to confine the figure or even group of figures to a simple geometric volume, Giambologna sought not only to fully occupy the volume but also to open it in every direction: spiral movements seem to extend infinitely, forms are exceptionally attenuated, sweeping gestures generate opposing diagonals. With Giambologna, life does not spring from the projection of an inner expressiveness, but rather from the construction of forms in space. Frank sensuality is accompanied by a quest for an ideal beauty—underscored, where appropriate, by a bronze patina (one inevitably thinks of the art of Parmigianino, who earlier in the century had himself sought to combine a seductive gaze with cool lines).

Giambologna enjoyed a long life and became a versatile artist able to fully express himself in marble (*Venus After the Bath*, Boboli Gardens, Florence; *The Rape of a Sabine*, page 256) and in bronze (*Mercury,* Bargello, Florence; *Apollo*, Palazzo Vecchio, Florence), and he even took up the challenge of equestrian statuary (*Cosimo I de' Medici*, Piazza della Signoria, Florence). The most important and most faithful of his disciples was Adriaen de Vries (1545–1626), who worked at the court of Rudolf II in Prague, producing some fine masterpieces of bronze sculpture (page 257).

The originality of French sculpture

Italy's supremacy in the realm of sculpture, from Michelangelo onward, is indisputable. It should not,

Bartolomeo Ammanati, detail of a sea nymph, *Neptune* (or *Il Biancone*) *Fountain*, 1560–75. Bronze and marble, Piazza della Signoria, Florence (Italy).

Giambologna,
Rape of a Sabine, 1583.
Marble, H: 13′4″ (4.1 m).
Loggia dei Lanzi,
Piazza della Signoria,
Florence (Italy).

Adrian de Vries,
Mercury and Psyche,
c. 1593. Bronze,
H: 8′1″ (2.5 m). Musée
du Louvre, Paris (France).

however, be allowed to overshadow artists elsewhere. In France, as we have seen, the old tradition of cathedral stone-carvers remained strong. More than elsewhere, the French tradition displayed a willingness to accept Italian initiatives, as proven by the popularity of Francesco Laurana's marble masks at the court of King René I of Anjou. These gentle if somewhat monotonous portrait busts seem to have contributed to the "sweet style" that flourished along the banks of the Loire in the late fifteenth century. In Troyes, one of the capitals of sixteenth-century sculpture, Domenico Fiorentino also merged Italian taste with French traditions, as can still be seen in his *Charity* in the church of Saint-Pantaléon. This alliance was even more crucial when it came to the artistic center that was created around the French court at Fontainebleau. Cellini was received there and attempted to cast several large pieces in bronze, but the artists who best succeeded in establishing their authority in France were Rosso and Primaticcio. The stucco-work that

they designed to frame their painted compositions made a profound impression on French sculptors. Indeed, the art of Jean Goujon (c. 1510–65) found its prime expression in bas-reliefs, which is unusual for sculptors. The five panels that survive from the rood screen in Saint-Germain-l'Auxerrois (demolished in 1745) were executed in 1544–45. The subject of the central panel is a variation on the traditional Entombment. It is treated with traditional respect, but here the refined lines of the chisel profoundly transform the overall emotional register (page 258). Goujon's other set of bas-reliefs, a famous series that can still be seen on the fountain at the Place des Innocents in central Paris, was sculpted around 1547 (page 259). Here there is no attempt to establish a sense of space: light, almost transparent drapery contrasts with the sheen of exposed flesh, delicate musical harmonies are created, the canon of elegance does not slide into extravagance. Goujon's oeuvre bequeathed French sculpture a style that was neither Roman nor Attic,

but rather represented an inspired intuition of the manner later identified with Alexandria.

Goujon's delicate if somewhat cold elegance was never attained by Germain Pilon (before 1540–90). In contrast, Pilon's powerful genius was best expressed through deeply carved drapery and the orchestration of figures in space. He has become known as one of the most inspired sculptors in the history of French art. He, too, executed a bas-relief of an *Entombment* for the tomb of Chancellor René de Biraguein the Paris church of Saint-Catherine-du-Val-des-Écoliers (now in the Louvre), a bronze work that features tortuous drapery and a Christ sharply modeled by a shaft of light. The chancellor's funerary statue, commissioned in February 1584, with a cloak whose train falls some 6 ft. (2 m), is a magisterial work whose severity is tempered by a kind of lyricism (Louvre, Paris). It was perhaps outdone by Pilon's double funeral effigy of Birague's wife, Valentine Balbiani, commissioned in 1573. She is sculpted not only in the round, propped up on one elbow while reading a book, but also in bas-relief, deceased. Pilon's portrait is one of the most expressive recumbent death figures ever sculpted, surpassed only by his great royal commissions. Still in the church of Saint-Denis are the large tomb statues of Henry II and Catherine de' Medici, shown kneeling in prayer (bronze) as well as lying dead and naked (marble), the latter representing perhaps the most daring images of monarchs ever carved.

LEFT
Germain Pilon,
Virgin of Pity,
c. 1585. Marble,
5′4″ × 3′5″ × 2′9″
(165 × 104 × 79 cm).
Church of Saint-Paul-
Saint-Louis, Paris (France).

Still more moving, however, are Pilon's works designed for the Valois chapel in the abbey, commissioned in 1580–86 but left more or less unfinished. His *Christ Resurrected* (Louvre, Paris) is a serene nude who delivers a blessing before leaving this earth, and may be one of the most moving religious works of the late sixteenth century (page 261). Pilon's masterpiece is perhaps the *Virgin of Pity*, wrapped in her vast cloak of mourning (page 260). It is a surprising synthesis of the old French tradition of "mourners" with Italian lyricism. These were the days when the Wars of Religion were leaving France littered with ravaged buildings and dead bodies—it perhaps took the genius of an aging sculptor to find the right language to express such tragedy.

FACING PAGE
Germain Pilon, *Christ Resurrected*, c. 1583, incomplete. Marble,
7′ × 6′1″ × 2′5″
(215 × 188 × 74 cm).
Musée du Louvre,
Paris (France).

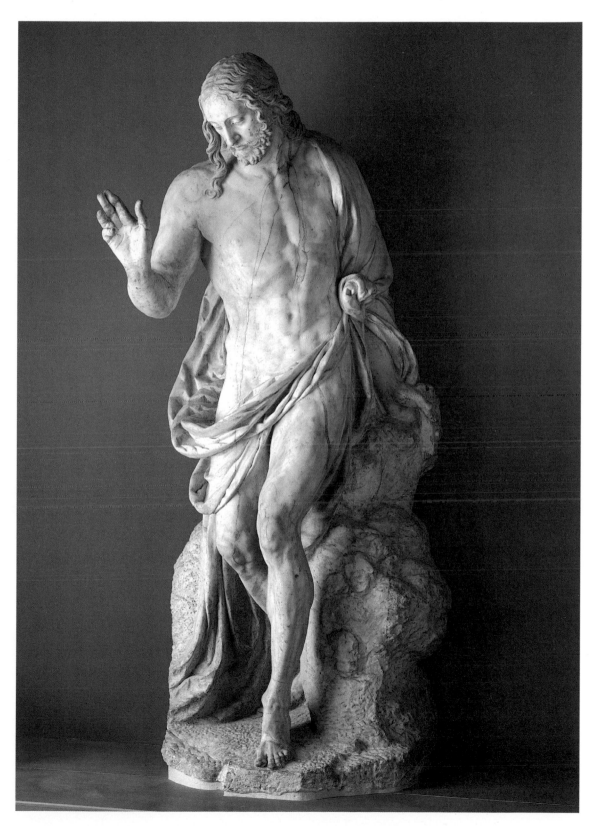

Painting

For the first time, discussion will now focus on a period for which many frescoes and paintings exist. But we should not draw the hasty conclusion that this situation reflects a change in attitudes. It relates first of all to the question of conservation. A carefully executed painting will last for five hundred years if not subjected to too many ordeals. Beyond that time, constant attention is required. Consequently, it would be rash to attribute the "miracle of the Renaissance" to a sudden change in the conditions of artistic creation. Granted, in the fifteenth century the number of pictures increased, for the number of patrons henceforth included burghers who had amassed considerable fortunes, leading to a shift toward secular commissions. But the Church maintained, directly or indirectly, a major role in commissioning works of art, and it was still aristocratic courts that supported artists and constituted the major art centers.

This very abundance of surviving works renders all the sharper losses due to religious wars and iconoclasm, which in certain countries wiped out entire sections of artistic output at a very early date. The resulting geographical inequalities disarmed many historians. Usually, they prudently followed the account

handed down by Giorgio Vasari in 1550—but Vasari never left his native Italy. Efforts in the last century have therefore tended to relativize his account and to reveal the wealth of inspiration that could be found all across Europe during this period, at least until the effects of Lutheranism—and especially Calvinism—were felt.

The reverberations of van Eyck's art

It has already been described how Burgundian lands nurtured artists such as the Master of Flémalle and the van Eyck brothers, who pioneered brilliant developments in painting. These developments were immediately exploited by an entire group of highly talented artists. Jan van Eyck's own genius could never be imitated—his vision of the minute, his conception of the monumental, and his intuited, aerial perspective were all his own—but soon all of his lessons had been learned by others. The realism of his work led to many quiet, accurate, uncompromising portraits; landscapes were enlivened by glimpses of towns and distant fields; familiar objects such as books and flowers nourished the genre of the still life, which had disappeared since antiquity.

Albrecht Altdorfer,
Saint George in the Forest,
1510. Parchment on wood,
11 × 9″ (28 × 22 cm).
Alte Pinakothek,
Munich (Germany).

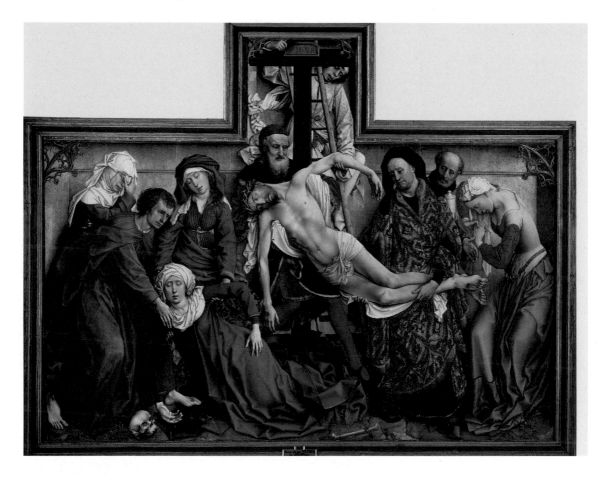

Suffice it to mention here Rogier van der Weyden, who in 1436 painted a dramatic *Descent from the Cross* (page 264), Hans Memling (c. 1435/1440–94), initially lauded but then overly deprecated, whose softness should be interpreted not as a sickly sweetness but as a deliberate reaction against a "sharp" style, and Hugo van der Goes (c. 1433/1440–82), whose admirable *Portinari Altarpiece* (c. 1475, Uffizi, Florence) rivals the greatest Italian masterpieces. The same trend would surface in Iberia or "the Iberian peninsula", in a somewhat drier form, as is demonstrated by Salamanca-based Fernando Gallego's *Christ Enthroned* (c. 1466–67, Prado, Madrid), which still displays Eyckian influence, and Barcelona artist Lluis Dalmau's *Virgin of the Councilors* (1445, Museu de Arte de Catalunja, Barcelona). Meanwhile, Bartolomé Bermejo's *Pietà* (1490), still in the sacristy of Barcelona Cathedral, is set in a landscape of clouds and mountains. In Portugal, there was Nuño Gonçalves's relatively late masterpiece known as the *Saint Vincent Polyptych* (after 1470–before 1481), an obsessive gallery of individual portraits and the only surviving work by a painter who was famous in his day (page 265).

ABOVE
Rogier van der Weyden, *Descent from the Cross*, 1435. Oil on wood, 7′2″ × 8′6″ (2.20 × 2.62 m). Museo del Prado, Madrid (Spain).

FACING PAGE
Nuño Gonçalves, large right panel, *Saint Vincent Polyptych*, c. 1470–81. Oil on wood, H: 6′9″ (2.07 m). Museu Nacional de Arte Antiga, Lisbon (Portugal).

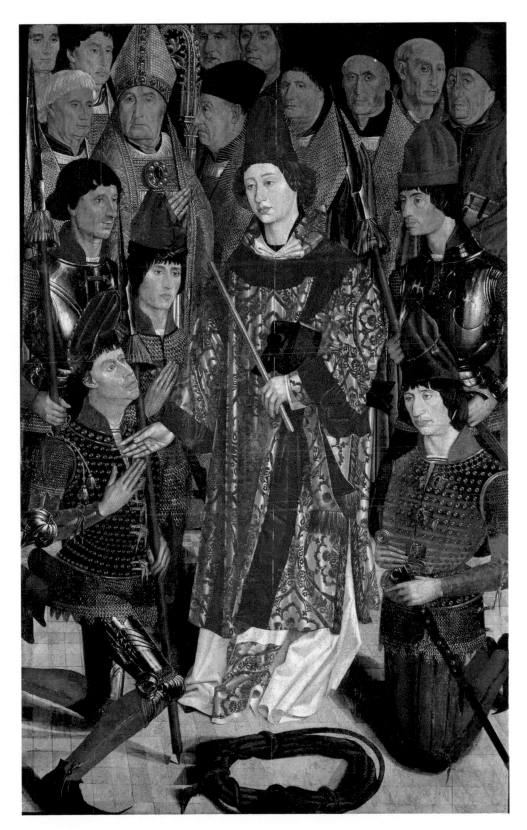

Yet it was perhaps in Provence, in the South of France, that the most original response arose. *The Coronation of the Virgin* (page 266), as well as being one of the finest paintings conserved in the region, is also one of the best documented—a surviving contract gives the date, 1453, and the name of the artist, Enguerrand Quarton. In this work, the eye is immediately drawn to the large, red zone created by the two cloaks of God the Father and Christ, flowing over the Virgin's cloak and occupying one third of the painting.

It contrasts with another large patch of color, this time deep blue. Nothing could be further from van Eyck and van der Weyden than this contrived staging based on color. And yet the presence of many highly individualized figures shows that the Flemish approach had been assimilated. The landscape underneath, meanwhile, opens onto the sea and chalky Provençal hills, meticulously showing buildings and streets in a surprisingly studied perspective technique as geometric as it is aerial. Clearly, Quarton far transcended the

Enguerrand Quarton,
The Coronation of the Virgin, 1453. Oil on wood, 5′11″ × 7′2″ (1.83 × 2.2 m). Musée Municipal, Villeneuve-lès-Avignon (France).

simple play of influences between North and South.

In recent years, Quarton has been credited with another masterpiece of Provençal painting, a *Pietà* executed for the Carthusian monastery of Villeneuve-lès-Avignon around 1455 (page 267). The attribution is improbable—apart from their high quality, everything separates these two paintings. The *Coronation* is like stained glass, so to speak, carved from color; the *Pietà* is carved from wood. There is not a single bright color in the latter, just dark against gold and the light of a white surplice. Instead of the teeming heavens and thronged underworld, the *Pietà* includes just five large figures in a sober, clear design. All the shapes—bodies, faces, hands, garments—have been simplified, almost frozen, unable to break free of the geometric scheme that unites them. The same goes for the gazes—although the eyes are open, the figures seem to be looking inward. Only Christ's lifeless body is delicately modeled through distinct outer contours and a subtle monochromic surface. This rigorous approach yields a kind of icon that seems aloof from prevailing fashions in painting and even in mystical thought. That the same monastery at Villeneuve could receive two so dissimilar masterpieces at roughly the same date says a great deal about

Anonymous, *Pietà*,
c. 1455. Oil on wood,
5´4" × 7´ (1.63 × 2.18 m).
Musée du Louvre,
Paris (France).

the fragility of any concept of "school."

Predictably, two other first-rate artists will be added to this list of Provençal painters: the Master of the Annunciation of Aix, who around 1443–44 executed a large triptych for Saint-Sauveur Cathedral in Aix (central panel now in the church of the Madeleine, Aix), and above all the Master of Le Cuer d'Amour Espris. Certain documents suggested that the latter might be none other than King René—duke of Anjou, Bar, and Lorraine, and king of Naples and Jerusalem—making him not just a collector and patron, but also an artist. Although this theory was recently defended by scholar Otto Pächt, most people find it hard to

believe that a king so clumsy at politics could have been so gifted at painting. They therefore feel it necessary to attribute to some master in René's entourage the art works illuminating the Vienna manuscript of *Cuer d'Amour Espris* (The Heart Smitten by Love), a poem indeed written by René himself, along with a directly related set of watercolors on paper that display great freedom in handling. But the actual name of the artist perhaps matters less than the visual boldness of these works, which deal once more with the subject of time over the course of a day, yet with even more boldness than the Limbourg brothers: when the allegorical figure of Heart reads the inscription on the magic wall, the

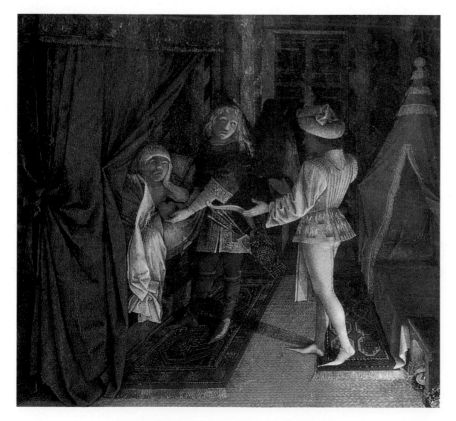

Master of Cuer d'Amour Espris, *Love Coming to Take the King's Heart*, c. 1457. Manuscript illumination (Cod. 2597, fol. 2), Osterreichische Nationalbibliothek, Vienna (Austria).

Jean Fouquet, *Self-Portrait*, c. 1450–60. Enamel, diam: 2 ¹/₃″ (6 cm). Musée du Louvre, Paris (France).

rising sun drenches the meadow in pure yellow; when Love comes to take René's own heart, the nocturnal room and faces are lit only by a night lamp placed on the floor (page 268). For perhaps the first time, an interior scene was treated with the vividness of a "night piece." Few painters were subsequently able to surpass this subtle chiaroscuro effect.

Another illuminated manuscript based on a text by King René, *Le Traité de la Forme et Devis d'un Tournois* (Treatise on the Form and Scheme of a Tournament), dated to around 1456, is now held by the Bibliothèque Nationale de France. It is composed of large sheets of paper that describe the ways and customs of chivalry. The scenes are depicted in bright watercolor highlights against pale, lightly washed grounds. They do not display the same subtle effects seen in *Le Cuer d'Amour Espris*, but the often complex perspective is handled carefully and the shadows of figures cast silhouettes on the walls. The groups appear to be arranged with ease and skill, poses and faces being discreetly expressive (especially in "Presenting the Banners," a double-page illumination on fol. 67v–68). This work displays a confidence, almost a "modernity," rarely found elsewhere.

The genius of Jean Fouquet

Jean Fouquet (c. 1415/1420–80), from Tours, was no less complex an artist, even though he was quite clearly inspired by Italy. A small enamel medallion now housed in the Louvre, boldly inscribed with his name, is obviously a self-portrait (page 269), making Fouquet the earliest French painter of whom we have a reliable self-portrait. His youthful face is beardless, while his clear and attentive gaze is directed straight at the viewer. His lips are very slightly parted, as well as slightly glum and sorrowful. Hardly any other painter in French history has left us such a spare, frank self-portrait.

It therefore constitutes a worthy introduction to the rest of Fouquet's oeuvre, of which, alas, only remnants survive. He must have been famous in his own lifetime, appreciated by the wealthy and powerful, for we know that he painted, in Rome, a portrait of Pope Eugenius IV (between 1443 and 1447, now lost) and, in France, portraits of King Charles VII (Louvre), of the king's mistress Agnès

269

Sorel (as the *Virgin*, Musée Royal des Beaux-Arts, Antwerp), of the royal treasurer Étienne Chevalier (Staatliche Museen, Berlin) and little of Chancellor Juvénal des Ursins (Louvre). But we know nothing else about him. After he died, Fouquet completely disappeared from the history of French art, and it was only in the nineteenth century that scholars were finally able to glean a few details about him, notably his birth around 1420, probably in Tours, and his death around 1481. The features of his style, on the other hand, are sufficiently distinctive to credit him with a relatively large number of illuminated manuscripts. One of the most remarkable, the *Hours of Étienne Chevalier*, was dismembered, probably as early as the seventeenth century, but forty-seven illustrations from it have been recovered, forty of them now at the Musée Condé in Chantilly, France. Another manuscript can be found at the Bayerische Staatsbibliothek in Munich. This is a richly illustrated *Boccaccio*, probably executed with studio assistants, yet bearing a frontispiece titled the *Vendôme Bed of Justice*, depicting a contemporary event). Yet another—*Les Grandes Chroniques de France*—comprising fifty-one miniatures, is now in the Bibliothèque Nationale de France. Fouquet's inspiration was even richer in the volume *Antiquités Judaïques* (Bibliothèque Nationale de France, Paris) and in the few surviving pages of *Faits des Romains*, where landscape plays an outstanding role. All of these miniatures were conceived as individual paintings—the compositional scheme, range of colors, visual effects, and even artistic inspiration vary with each page. Turning to one of the illuminations in the *Hours of Étienne Chevalier* (page 271), it is surprising to note a distinct trace of humor, for it is the patron's funeral that is being depicted even though Chevalier was still alive, and it may be Fouquet himself who is pictured leading the cortege. The humor stops there, however. The cortege advances slowly inside a small cloister, probably a familiar one. Everything conveys an impression of meditative solemnity, and the repetitive verticals seem to visually echo the tolling of the bell. It is only on further study that we notice the highly skilled perspective, the accuracy of poses and expressions, the clever suggestion of a crowd that is not actually depicted, and the noble dignity of the overall tone.

Germanic sparkle

The situation in Germanic lands initially appears more inconsistent. An artist such as Konrad Witz, for example, who worked in Basel and Geneva and died around 1446, remained profoundly rooted in cathedral-style art. His paintings show saints lost in the folds of their gowns, while his perspective still lacks confidence, although he has learned from van Eyck to populate his city streets with vivid little figures. A large landscape such as his *Miraculous Draft of Fishes* (1444) seems unusually straightforward and modern (page 272). As recent

Jean Fouquet, *The Funeral of Étienne Chevalier*, *Hours of Étienne Chevalier*, c. 1452–60. Musée Condé (ms. 71, fol. 46r), Chantilly (France).

as some conventions may have been, they were already being abandoned: no more paths weaving into the distance, no more snowy mountaintops, no special motif to draw the eye, just simple fields bordered by hedges. It almost seems as though landscape was at last becoming independent of the subject.

In contrast, Swabian-born Stefan Lochner, who worked in Cologne from 1442 until his death in 1451, perpetuated the charms of

"International Gothic" with subtle refinement in his masterpiece *The Adoration of the Magi* (c. 1442, Cologne Cathedral). Its gilded ground seems to take little heed of recent Flemish innovations. Still less heed, perhaps, was taken by Lochner's delightful *Madonna in the Rose Arbor* (c. 1450, page 273). The same could be said of Martin Schongauer's *Madonna in the Rose Garden*, painted in 1473 (Colmar, France). Schongauer also retained the traditional gold ground

Konrad Witz, *The Miraculous Draft of Fishes*, 1444. Oil on wood, 4'3" × 5' (1.32 × 1.54 m). Musée d'Art et d'Histoire, Geneva (Switzerland).

Stefan Lochner, *Madonna in the Rose Arbor*, c. 1450. Oil on wood, 20 × 16″ (51 × 40 cm). Wallraf-Richartz-Museum, Cologne (Germany).

and frontal position, although his overall handling displayed a new sense of ease. Schongauer's crucial influence rested on his engravings, for the prints he published were clearly indebted to van Eyck and van der Weyden in their subject-matter, spirit, and motifs. They nevertheless continued to feature heavy drapery and to combine vividly picturesque elements with emotional ones (in the manner of Sluter and masters earlier in the century), but without the gentle harmony that the Italians had discovered. In this respect, Schongauer tended to fossilize developments rather than to extend them.

It was the following generation that would yield a new vision and truly great masters.

First among those masters was Albrecht Dürer (1471–1528), the Nuremberg-born artist whom Germans have always revered. Dürer himself entrusted his fame to the new art of engraving, which indeed made him known and admired in all lands and all periods. Yet he was also an accomplished painter, and knew it. Or rather, he was one of those artists who thought universal knowledge was part of their art. By nature curious about everything, Dürer traveled to Holland, to Colmar (in hopes of meeting the

famous engraver Schongauer), and to Venice (to gain a better understanding of Italian art). He did not remain aloof from the drama of the early days of the Lutheran Reformation, but at the same time he was disposed toward introspective analysis. Right from his youth, he produced a variety of admirable self-portraits, all presenting himself in a flattering light.

It is worth studying one of Dürer's finest self-portraits, done in his twenty-seventh year, signed and dated 1498 (page 275). How very different this is from Fouquet's self-portrait, which projected rigor, simplicity, and earnest solemnity. Dürer put a good deal of vanity into his finely pleated, embroidered shirt, his pale outfit with broad black trimming, and his curly hair and sensuous lips. Yet if we continue to look further, we begin to sense a profound psychological analysis. Dürer had an unrivaled eye for scrutinizing nature, as seen in his watercolors showing a hare or a tuft of wild grasses (page 277), masterpieces that are veritable studies in natural history. Dürer examined himself in a similar way, curious about his own inner life and dreams as well as his body. As far as we know, he was the first artist to push self-awareness to the extent of drawing his own body completely naked (page 276). This bold, admirable drawing seems to have been done some fifteen years after the self-portrait discussed above, and it displays a quest for self-knowledge matched only, in literature, in the early sixteenth century, with Montaigne's *Essays*.

Dürer's reputation as one of Germany's greatest artists is based on a variety of factors: his rich inner life; his large output of drawings executed in a confident, accurate hand; the series of watercolors painted during his travels (revealing him to be a great landscape artist); and his engravings, which are among the most brilliant ever produced by a painter and which spread his fame far and wide. All that, however, somewhat obscures the few large paintings that have survived: the *Paumgärtner Altar* (Alte Pinakotek, Munich), *The Adoration of the Magi* (Uffizi, Florence), *The Madonna of the Rose Garden* (National Gallery, Prague), *Adam and Eve* (Prado, Madrid), and the *Four Apostles* (Alte Pinakotek, Munich), together with his self-portraits and portraits of friends, form a body of paintings of outstanding quality.

German art historians have a tendency to place the abundant—if more or less mediocre and mechanical—output of the elder and younger Cranachs as a pendant to Dürer's small painted oeuvre. For truly inspired genius, however, we have to turn elsewhere, namely to the "Danube school," where there briefly flourished a painting of a strange, indeed fantastic, kind. This fantasy was highly poetic, far superior to the "bizarreness" of Hieronymous Bosch (1453?–1516). The most inspired of the Danube painters was most probably Albrecht Altdorfer (1482/1485—1538). A small painting such as his *Saint George in the Forest*

Albrecht Dürer, *Self-Portrait*, 1498. Oil on wood. 20 × 16″ (52 × 41 cm). Museo del Prado, Madrid (Spain).

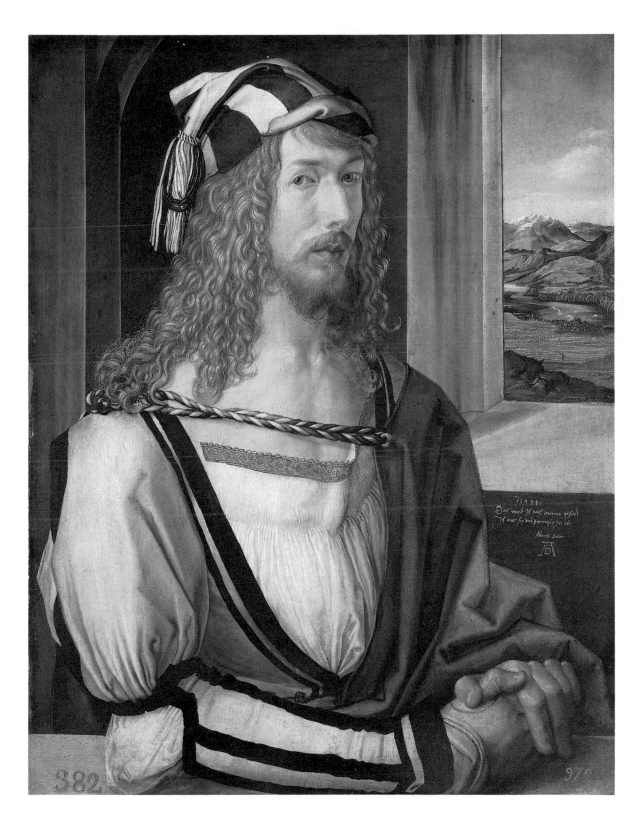

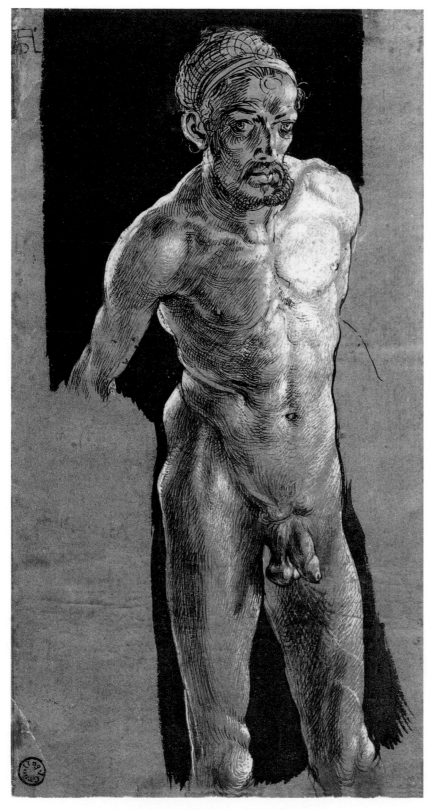

LEFT
Albrecht Dürer,
Self-Portrait, c. 1513–15 [?].
Pen, brush, and chalk,
11 × 6″ (29 × 15 cm).
Graphische
Kunstsammlungen,
Weimar (Germany).

FACING PAGE
Albrecht Dürer, *Tuft of Wild Grasses*, 1503.
Pen and watercolor,
16 × 12″ (40 × 31 cm).
Graphische Sammlung
Albertina, Vienna (Austria).

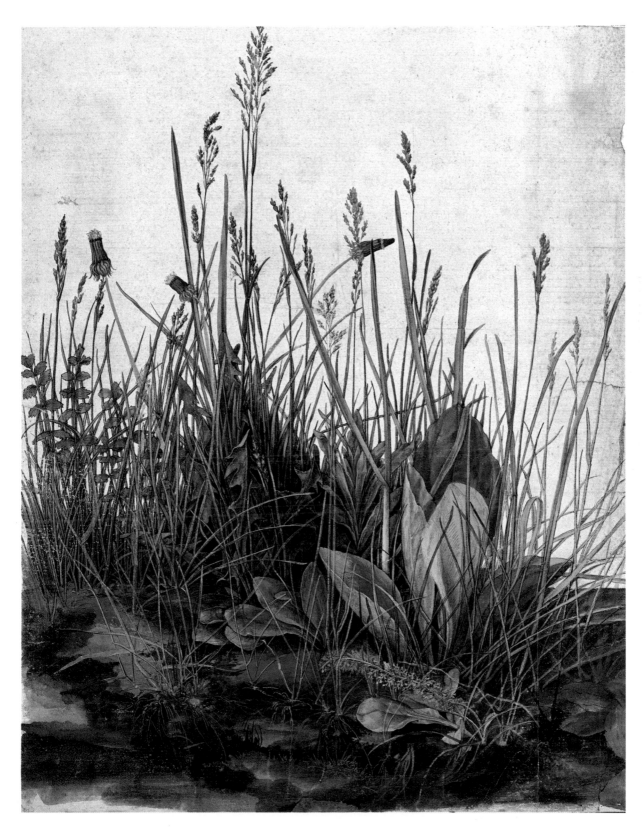

(1510, page 262) displays an inventiveness not found in Flanders, Italy, or France at that time. Through a simple play of scale, the stand of tall trees into which the knight ventures alone is transformed into a darkly dangerous, primal forest. This was perhaps one of the first paintings to display and define what would become one of the major creative motifs specific to the mentality of a country.

Saint George in the Forest was no fluke, nor simply a rendering of the legend of Saint George. The Alte Pinakotek in Munich, where it hangs, possesses another landscape bearing Altdorfer's monogram. This work seems to depict the Danube valley, thereby conveying a feeling of nature close at hand. Furthermore, Altdorfer's major works are distinctive for their unexpectedly poetic settings: the biblical *Susanna* bathes in the moat of a fabulous palace whose marble arches rise to the heavens (1526, Alte Pinakotek), while the monogrammed *Birth of the Virgin* (Alte Pinakotek) is set inside a church whose vaulted ceiling hosts a group of cherubs in brightly colored shirts performing a round dance.

This sensibility could also assume epic form. Wilhelm IV, the duke of Bavaria, decided to commission an entire set of paintings of fairly modest size (5 by 4 ft., 1.58 by 1.20 m) illustrating great battles of antiquity. The cycle was executed between 1529 and 1540, and has been carefully conserved in Munich, first in the treasury and now in the Alte Pinakotek. Six painters contributed to the cycle: Altdorfer, Hans Burgkmair, Jörg Breu, Melchior Feselen, Abraham Schöpfer, and Ludwig Refinger. It would seem that they were instructed to depict the entire battle rather than just one incident, as was the custom at the time. Altdorfer went one step further in *The Battle of Alexander and Darius on the Issus*, for he painted a sprawling fray that transcends any individual fate. Furthermore, the mountains, sky, and sea seem to participate in the clash, which suddenly assumes cosmic dimensions. Man is henceforth just a speck of dust in the whirlwind that is shaping the future of the world. Comparison with the two canvases that Feselen painted for the series—*The Siege of Rome by Porsenna, King of the Etruscans* (1529) and *Caesar's Victory at Alesia* (1533)—reveals the difference between the truly lyrical inspiration of a genius and the sophisticated skill of a painter who is merely good.

Something of this grand lyricism that sought to transcend the human condition can also be detected in a mysterious artist whose masterpiece, by an exceptional stroke of luck, has survived intact in Colmar, France. It was not until the seventeenth century that artist and scholar Joachim von Sandrart assembled some information on this master, who thereupon fell into oblivion once again. For once, however, the French revolutionaries saved a work from probable destruction and drew attention to the arts by transporting a large altarpiece to Colmar from an Anthonite abbey in Isenheim, Alsace

Albrecht Altdorfer, *Battle of Alexander and Darius at Issus,* 1529. Oil on wood, 5′2″ × 3′11″ (1.58 × 1.2 m). Alte Pinakothek, Munich (Germany).

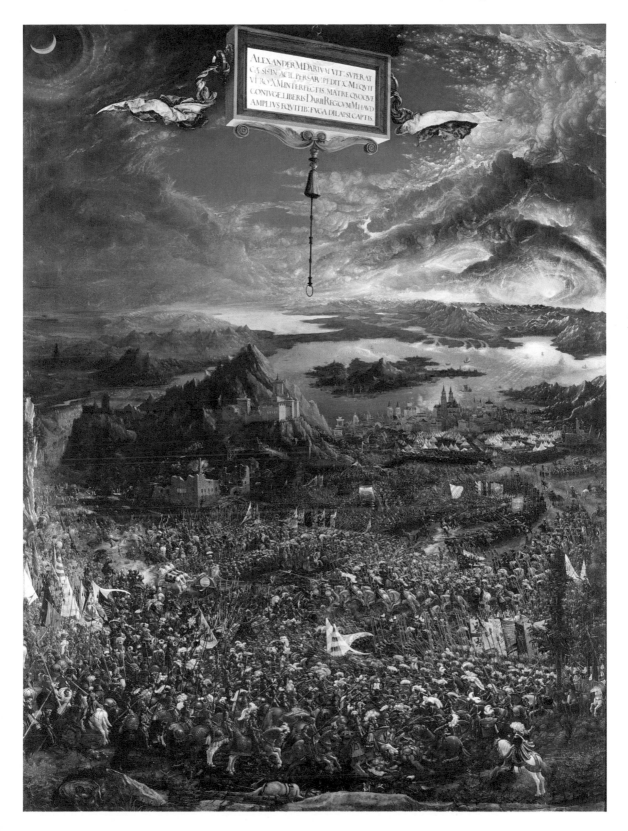

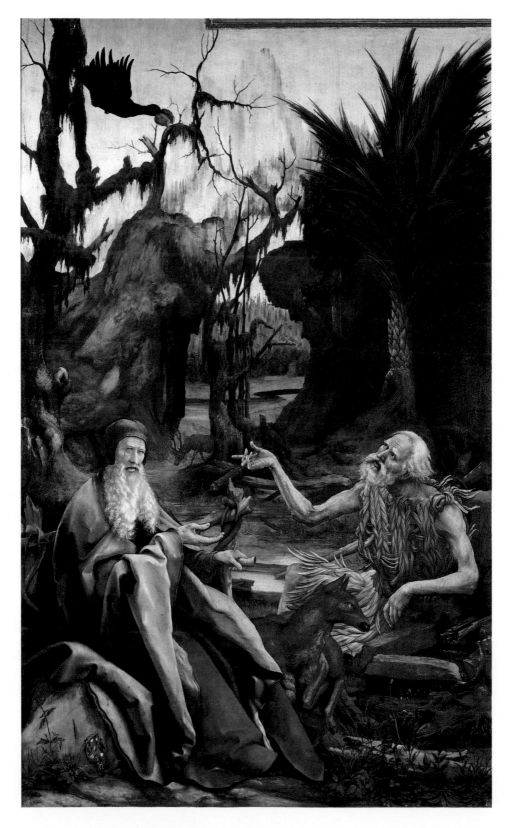

(where it had been greatly admired since the sixteenth century, and ascribed to various artists including Dürer). Subsequent research in the nineteenth and twentieth centuries still left much doubt. Sandrart had written of a "Matthaeus Grünewald" and "Matthaeus von Aschaffenburg," but who *was* he? The first name of Matteus or Mathis was very common in Germanic lands in the fifteenth century; research turned up a sculptor named Mathis Grün, who died in 1532, but general consensus now seems to fall on Mathis Neithardt (or Gothardt), although no decisive document has been produced despite extensive archival searches.

Nevertheless, the more uncertain the identity of this artist, the greater his fame became. He was once considered the equal, indeed the superior, of Dürer. "From an artistic standpoint, Grünewald represents the highest expression of the purely German spirit," wrote F. Knapp in 1935. Despite this infatuation, discovery of other works by Grünewald remain few or unconvincing, and apart from four grisailles on the Haller Altarpiece (Städelsches Kunstinstitut, Frankfurt; Staatliche Kunsthalle, Karlsruhe) and a *Madonna and Child* (Stuppach church, Würtemburg) his Isenheim Altarpiece remains the crucial point of reference.

This altarpiece, a *Wandelaltar*, or modulable retable, is one of the most important non-Italian paintings to survive. It features nine complete compositions, including a large-size *Crucifixion* and a large *Incarnation*

Grünewald, *Saint Anthony Visiting Saint Paul the Hermit*, Isenheim Altarpiece (detail), c. 1512–16. Oil on wood. 8′7″ × 4′7″ (2.65 × 1.41 m). Musée d'Unterlinden, Colmar (France).

of the Son of God, each measuring over 10 ft. high.

The most beautiful panel—though neither the strangest nor the most complex—shows *Saint Anthony Visiting Saint Paul the Hermit* in the wilderness (page 280). Paul looks up at the raven who is bringing two half loaves of bread, rather than the single half usually received by Paul, a sign that God himself has blessed this meeting. The two men sit in a wild landscape strewn with rocks and dead, mossy trees. Nature is nevertheless benevolent, and a deer peacefully lies between the two saints, one who lives in the world to care for his neighbor, the other who has chosen extreme solitude and asceticism. The scene only assumes its full meaning as a pendant to the intense violence of *The Temptation of Saint Anthony*, indicating that any spiritual life must be allied with nature, with the wilderness where God resides—another major theme that would long continue to inspire German art and poetry.

Italian primacy

As with architecture and sculpture, when it comes to painting Italy represents a different world. But was it fundamentally different? That is less certain. Italian art remained unscathed by the major tragedies that ruined the rest of Europe, such as the Hundred Years' War between England and France and the religious struggles that struck at the very roots of artistic creativity. Although Saint Bernardino tried to

impose his moral dictatorship in Siena, it collapsed with his death in 1444; Savonarola's puritanical preaching ended when he was burned at the stake in 1498. Meanwhile, the permanent return of the papacy to Rome in 1417 lent prestige to all of Italy, and not just to the capital of the ancient world, which, more than ever, considered itself to be the hub of the Christian world. At the same time, the division of political and economic power between small principalities and flourishing city-states favored an increase in the number of patrons and stimulated both parallel developments and fertile interaction.

Furthermore, the fact that more works of art survived in Italy than anywhere else in Europe was not solely due to a lack of long civil or foreign wars and serious campaigns of iconoclasm. Vasari's *Lives of the Artists*, published in 1550 and 1568, immediately established the reputation of Italian artists and publicly identified works to be admired and protected. A type of collective memory was thereby forged, which had not existed since antiquity and which—unfortunately—would long be limited to Italy. We need merely think of the deep and often permanent obscurity, in other lands, into which so many great artists fell upon their death: cathedral architects, master glass-workers, royal painters and sculptors. Even today, we are not sure who painted the Avignon *Pietà* or whether the poet and writer King René himself or one of his entourage illustrated *Cuer d'Amour Espris*. How the

history recounted here would be different if Vasari had traveled to France and Germany. Lucky Italy: it is natural that its heritage has been enhanced by this enormous privilege, that its heritage now appears far superior to all others.

Natural, too, that it must be dealt with differently here. From the fifteenth century onward, a veritable plethora of names and works survive. The variety of talent and innovation is obvious. A historian inevitably has to choose between pioneering geniuses and masters who may appear second-rate but nevertheless display appealing originality or inventive charm. Describing things in too much detail would distract attention; tracing too many intersecting paths would lead to the often random exercise of criticism. So, at the risk of seeming unscholarly, the following passages will be limited to luminous, moving works that have etched themselves into one's memory.

The "hard" style

It has already been pointed out that, prior to 1435, an "International style" had produced some great masterpieces that were delicate in spirit, notably by Gentile da Fabriano, Fra Angelico, and Pisanello. But Italy soon wearied of sophisticated softness, light, and appealing colors; as already discussed, in the Brancacci Chapel in Florence, Masaccio was already producing examples of a robust, simple style that seemed somewhat indebted to the great tradition of

Giotto. But it was only in the following generation that a reaction to "sweetness" would fully emerge, inspiring several great artists.

The most convincing representative of the new trend was Andrea Mantegna (1430/1431–1506), born in what was then the dependent territory of Vicenza. Right from his first masterpieces, Mantegna's work was marked by a taste for strongly drawn volumes and a passion for perspective. At around the age of twenty, he collaborated on the decoration of the Ovetari Chapel in the Eremitani Church in Padua, illustrating the lives of Saints James and Christopher, depicting severe figures dressed or draped in antique garments, set in the constraining framework of Roman architecture. In the scene of Saint James being led to martyrdom he employed a complex type of foreshortened perspective that recurred, in 1473, in a form called *sotto in sù,* for his decoration of the Camera degli Sposi (marital chamber) in the ducal palace of Mantua: Mantegna painted an illusory circular window in the ceiling, through which peer dramatically foreshortened servants and cherubs. His foreshortening attained an almost paradoxical quality in 1480 in the famous *Lamentation over the Dead Christ* (Pinacoteca di Brera, Milan), where the corpse is viewed from the soles of the feet.

Take, for example, Mantegna's *Saint Sebastian* now in the Louvre (page 284). It was originally from the church of Notre-Dame in Aigueperse, central France, where it was probably donated as early as 1481. The nude figure is solidly anchored to ancient ruins that certainly have a symbolic significance yet that endow the painting with the rigor of a blueprint. There is almost no difference between the foot of the saint and the foot of the broken statue in the lower left corner. Sebastian's body, evoking all the power of Roman sculpture, is etched by relentlessly precise outlines, while his face is massive and rugged. The scene is set within a deep landscape, but that landscape is composed of stones and buildings. In the distance can be seen tiny figures, noted with a precision worthy of van Eyck. Firmly drawn clouds fill the blue sky. The overall tone is uniform, there is no play of light to disrupt what André Chastel termed a "dry, echoing space." There is little bloodshed and the wounds are clean, leaving unmarred the beauty of the body and the stoic serenity of the martyr (whose squarish face actually bears a certain resemblance to Mantegna's own).

The same concern for precise geometry and restful forms can be found in the work of Piero della Francesca (before 1420–92), whose skillful simplicity fascinates many people today. Not many paintings by him survive, but a relatively well-preserved cycle of frescoes can still be seen in the church of San Francesco in Arezzo, which features episodes from the legend of the True Cross. His *Madonna of Senigallia* (Urbino) and *Madonna with Child* (Pinacoteca di Brera, Milan)

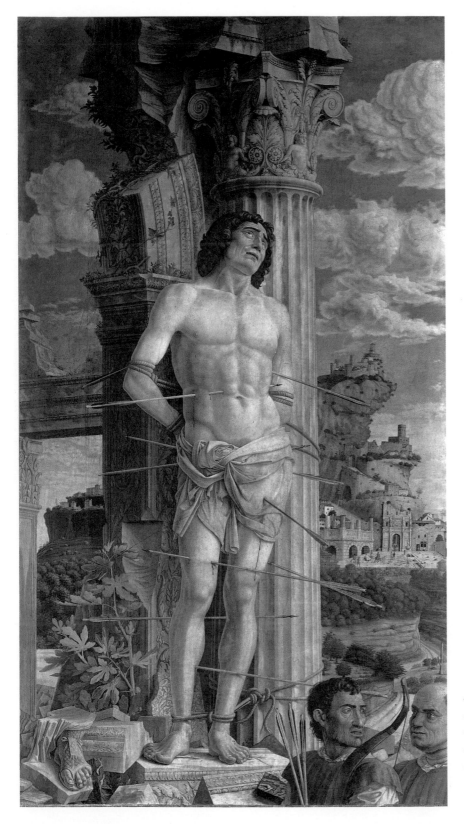

Andreas Mantegna,
Saint Sebastian,
c. 1480 [?]. Tempera
on canvas, 8′11″ × 4′7″
(2.75 × 1.42 m).
Musée du Louvre,
Paris (France).

Piero della Francesca, *Salomon Meeting the Queen of Sheba, Legend of the True Cross,* c. 1452–59. Fresco, church of San Francesco, Arezzo (Italy).

also display Piero's unusual combination of poetic sensibility and theoretical skill. As Chastel has written, "geometric intuition and intense colors are also carried to the highest degree of efficiency, transforming the world into a luminous cage with no fissures, into which humanity cannot wander." The same feeling often occurs in the next generation with Luca Signorelli (c. 1445–1523), who continued to use sharply delineated forms, though in a more dramatic vision.

The artist closest to Mantegna seems to have been a Venetian, Giovanni Bellini (1430–1516). He

was close personally, because his sister Nicolosia married Mantegna in 1514, and also close artistically, thanks to his crisp draftsmanship, geometrical forms, and taste for rocky landscapes. But Bellini brought light back into this cold, precise world. Take, for example, his admirable *Saint Francis in Ecstasy,* one of the most perfect paintings ever done (page 286). The saint stands out sharply, of course, against a steep pile of rocks, but the highly delicate setting—the shadow of the cave where he lives, the vine climbing up the entranceway, the everyday objects lying

around, the landscape to the left—vanquish the impression of a wild landscape. Above all, light invades the space, illuminating a section of the rock above the saint's head, casting his shadow on the ground, striping the bench from which he has just risen with the shadow of the trellis. A new softness thus envelops the painting, which does not—despite all claims—represent the standard scene of Saint Francis receiving the stigmata. Instead, it shows Saint Francis rising one fine morning from his crude desk and his meditation on death in order to praise God and all His creatures. Few painters, including Angelico, would dare to express this, and to express it so straightforwardly.

Easing up

It was around 1480, apparently, that growing signs everywhere suggested an "easing" of the sharp, dry style. A good example can be seen in the work of Sandro Botticelli, a young Florentine born in 1445 who soon became very well known. Around 1477–78 he painted his famous *Primavera* (Spring). This very large painting, over 6 by 9 ft. (2 by 3 m), was designed to decorate one of the Medici villas. It is clearly an allegory, although its exact interpretation is still difficult; the left part, shown here, nevertheless clearly depicts the three Graces

Giovanni Bellini, *Saint Francis in Ecstasy*, c. 1480–85. Oil on wood, 4´4″ × 4´7″ (1.24 × 1.41 m). The Frick Collection, New York (New York).

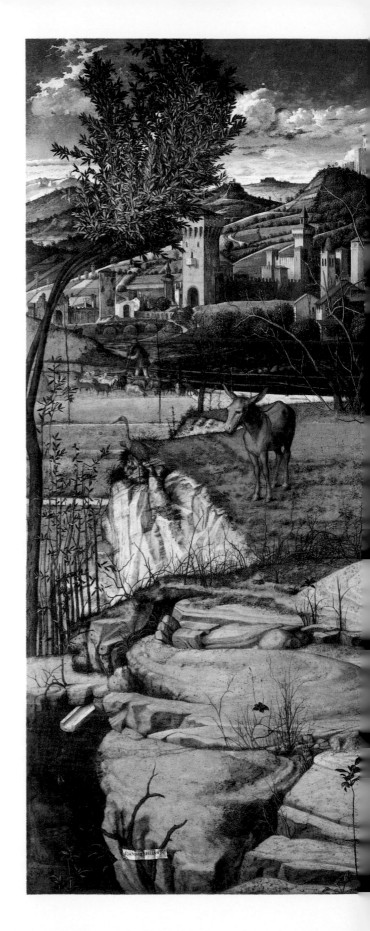

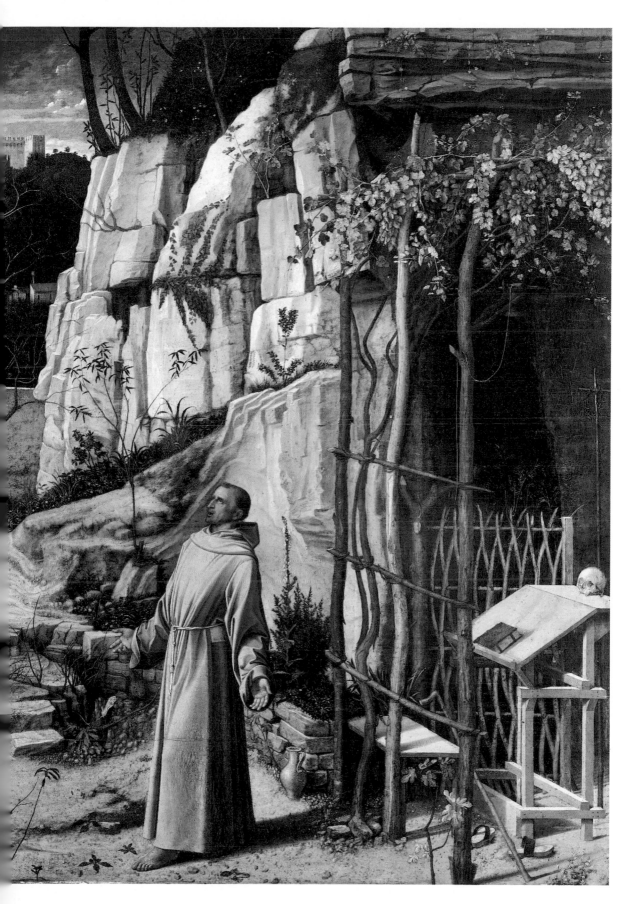

and Mercury (page 289). The eye is immediately caught by the musical play of curves against the counterpoint of the regular alignment of the trunks of the orange trees. Everything hinges on Botticelli's draftsmanship, and everything from the overall subject to the tiniest detail is rendered with sufficient grace and sensuality to make us forget that we are verging on the edge of "decorative" art. Volume, perspective, the weightiness of forms, and atmospheric presence—that is to say, the hard-won gains of van Eyck and, to some extent, Masaccio—are ultimately blended here into a diaphanous sense of poetry.

Through one of those constant swings of the pendulum that occurs so frequently in art history, here we return to the delicate refinements of the "International Style" that Florence had never completely abandoned since the days of Gentile da Fabriano. Here, however, they resurface with new skill and confidence.

It is probably necessary to forget the opinions of John Ruskin and the Pre-Raphaelites—their admiration for the languorous poses, the earnest gazes, the parted lips—in order to assess Botticelli's art without preconceptions. It was much more complex and bolder than generally believed. "International Gothic" concerned above all ecclesiastical art, and although he was a great painter of pious subjects, as seen in The Adoration of the Magi (c. 1475–77, Uffizi, Florence) and numerous tondi, or circular paintings, of the Madonna and Child,

Botticelli tended to stress the secular side of art. That was certainly true, at least, during the first part of his life, for later he seems to have been affected by Savonarola's sermons. He became interested in antiquity, reproducing the Arch of Constatine in the middle of his depiction of the Punishment of the Rebels on the Sistine Chapel and reconstituting Apelles's Calumny as described by Lucian and Alberti (c. 1495, Uffizi, Florence). Nor did he hesitate to paint both female nudes, as demonstrated by Primavera and above all The Birth of Venus (Uffizi), and male nudes, as seen in Mars and Venus (National Gallery, London). With Botticelli, then, a painting seemed to be less and less a representation, either religious or secular, and more a visual poem that involved mythology, allegory, allusions, and commentaries, while seeking to seduce rather than to deceive the eye. Hence his clear, colorful art full of curves and curls seems to avoid overly realistic details.

A no less gentle and graceful art emerges from paintings by Perugino (1448–1523), although in no way based on the power of curves. Perugino preferred steady compositions, symmetry, and juxtaposed figures. By placing his figures and landscapes in a fine, luminous atmosphere, he endowed them with the pleasant stillness now associated with Umbria.

This feeling of space, which, in a certain subtle way, converged with the concerns of Leonardo da Vinci, might be viewed as the very

Sandro Botticelli, Primavera (detail), c. 1477–78. Tempera on wood, 6′7″ × 10′2″ (2.03 × 3.14 m). Galleria degli Uffizi, Florence (Italy).

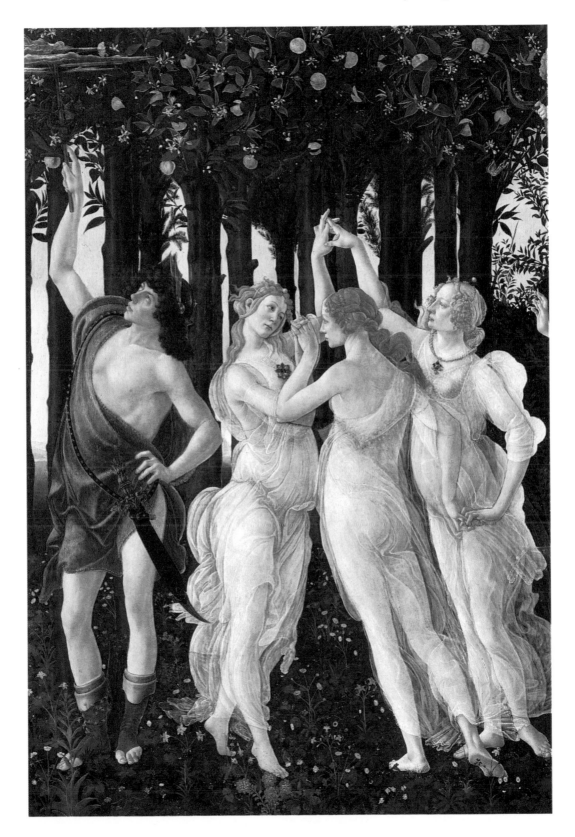

foundation of Perugino's art. There is no finer light than that which floods the quiet portico where Saint Bernard sees an apparition of the Virgin (c. 1493, Alte Pinakotek, Munich), or the one that presides over the wedding of Joseph and Mary in front of the vast esplanade with the three porticos of the Temple (c. 1500–4, Musée des Beaux-Arts, Caen). It has been said that Perugino's poetic effect resides entirely in the choice of an "exquisite moment"; true enough, in almost all his paintings it seems as though poses and expressions were captured in a moment of perfect harmony.

We should not forget, however, that at the same time—the closing decades of the fifteenth century—Perugino was reaffirming the primacy of religious art. Little is known of his life or personality, apart from the fact that in 1493 he married Luca Fancelli, the daughter of an architect, and had seven children by her. Yet his oeuvre could be taken for that of a monk or priest. He handled the nude with perfect mastery, but reserved nudity for Christ (*The Baptism of Christ*, Kunsthistorisches Museum, Vienna) and Saint Sebastian. The only painting of his to deviate somewhat from religious iconography is his *Battle between Love and Chastity* (Louvre), painted for Isabella Gonzaga's *studiolo* in 1505—though this is one of his lesser compositions. And yet Vasari asserted that Perugino "was a person of very little religion, and he could never be brought to believe in the immortality of the soul." So perhaps his immense oeuvre was a purely artistic exercise rather than an act of faith, as was the use of mythology by other artists at other times.

If so, his art is all the more admirable. Compare his *Saint Sebastian* of 1497–1500 (page 291) with the one by Mantegna (page 284). The latter's contrived antiquity is here replaced by a harmonious portico with finely carved pilaster; instead of the surprising vividness of the clouds and landscape, a clear sky bathes a peaceful, empty valley populated only by slender trees. Space is suggested simultaneously by the perspective of the paving on the floor and by the light that softens the muscles of the body. The many shafts that riddle Mantegna's Sebastian are here reduced to two, and the wounds are almost invisible on this perfect, still, slightly angled nude—a Christian Apollo. The face has a hint of delicacy and chubbiness. We are moving toward the highly artificial world—one full of grace and perfection—that would be developed by Perugino's pupil Raffaello Sanzio, better known as Raphael.

Five great painters

Although the coincidence may be hard to explain economically or sociologically, the fact is that Italy gave birth, in a period of only four decades, to five superlative painters. Their respective genius varied greatly and their styles were very different, yet all five were universally admired, protected by

Perugino, *Saint Sebastian*, c. 1497–1500.
Oil on wood, 5′6″ × 3′10″ (1.7 × 1.17 m). Musée du Louvre, Paris (France).

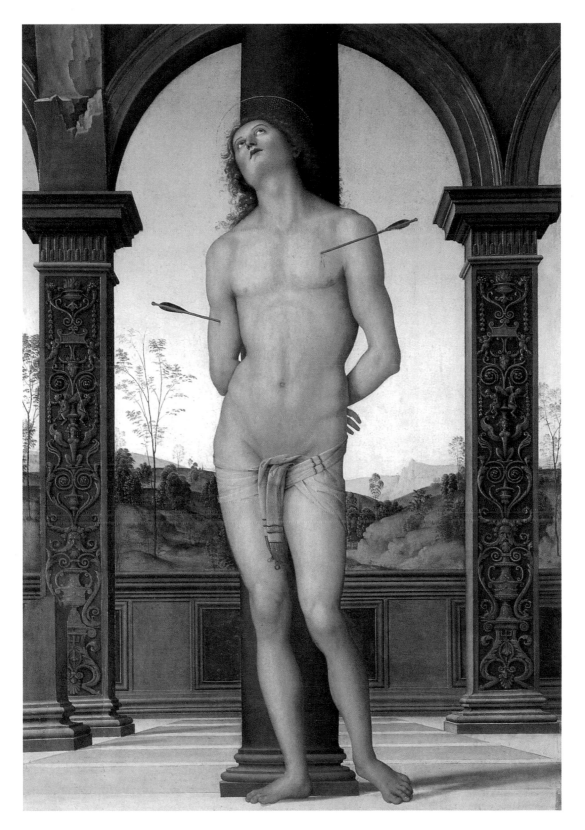

aristocratic patrons, and practically deified during their lifetimes. What is more, their fame has continued to grow over the centuries, surpassing all other artists on the planet.

Leonardo da Vinci

The first was Leonardo da Vinci (1452–1519). Leonardo symbolizes the Renaissance man who was interested in every subject, from physiology to ballistics, as well as in every field of art. His troubled life led him to change cities and patrons numerous times, and his imagination so outstripped the resources of the day that almost none of his plans came to fruition. The one large sculpture he attempted, an equestrian statue of Francesco Sforza, was destroyed when still a model. Of his paintings, his masterpiece of the *Battle of Anghiari* had vanished by the sixteenth century, while his major fresco, *The Last Supper* in Milan, on which Leonardo tested new techniques, began to deteriorate during his own lifetime—despite repeated efforts at conservation, it is now little more than a wonderful ruin. Yet one of his simplest and smallest paintings, the portrait of *Mona Lisa* (Louvre, Paris), has obtained the fabulous—and probably undeserved—glory of being considered the greatest masterpiece of all time.

In order to fathom Leonardo's art, we should probably turn to another painting, one with a more unusual subject-matter and a more complex technique. *The Virgin and Child with Saint Anne,* also in the Louvre,

might be seen as a charming and somewhat anecdotal maternity scene, but Leonardo almost certainly put more into it—a reminder of the calling of Christ who, even as an infant, tries to flee his mother's arms in order to grasp the lamb, that symbol of his future sacrifice and of the Eucharist (page 293). As Mary tries to restrain him, sadness can already be seen in her eyes because she is aware of her child's fate. The older and wiser Anne, on whose lap Mary sits, watches her little family slip away, her eyes lowered and her expression wavering between tears and a smile. It is worth taking a long look at the expressions on these faces, in which Leonardo managed to convey—even better than in Mona Lisa's smile—a state of fluid uncertainty. The triumphant achievement of this great draftsman was to eliminate lines that do not exist in nature, to depict volumes in all the fluidity of the ambient atmosphere, even if it meant clouding his colors by using only pale blues and traces of pinks blended into the brown undercoat. This technique yielded subtle modeling and the intense expressions that are rendered fascinatingly mysterious by shade and light.

Michelangelo the painter

Michelangelo obviously represents a complete contrast. During his lifetime (1475–1564), he was even more renowned for his painting than for his sculpture. In short, his oeuvre can be limited to three sets of paintings in the Vatican: the ceiling of the Sistine Chapel, the end wall of this same chapel, and two

Leonardo da Vinci, *Virgin and Child with Saint Anne,* 1510. Oil on wood, 5′6″ × 4′3″ (1.68 × 1.3 m). Musée du Louvre, Paris (France).

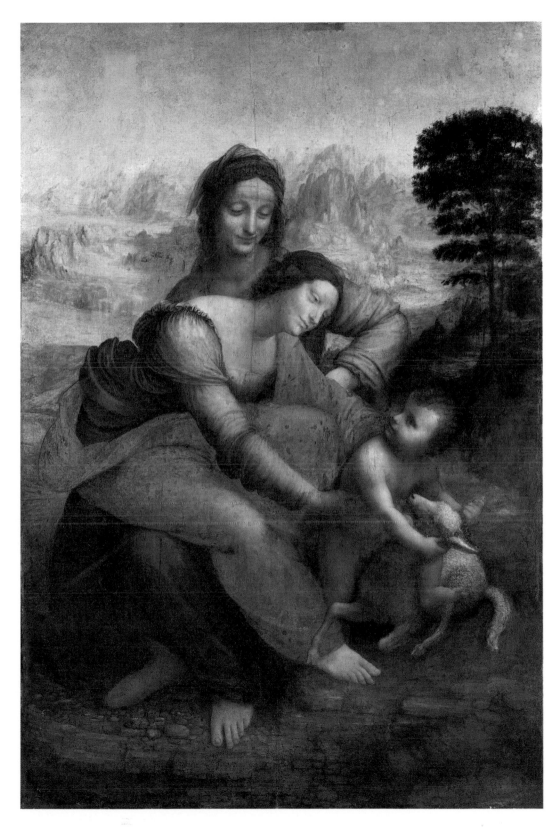

lesser known compositions in the Cappella Paolina. On the Sistine ceiling, Michelangelo succeeded in staying true to his energetic genius, while respecting the demands of imagery viewed from a great distance. The work is a triumph of vivid draftsmanship and also of color, the vividness and variety of which was revealed with startling impact by the careful and respectful cleaning that was completed recently. Michelangelo's wealth of invention, powerful forms, and beautiful nudes, combined with a grandiose simplicity,

have always fascinated artists and the general public alike. Taking a figure a random, the Cumean Sibyl is perhaps one of the least attractive of all, for Michelangelo wanted to weigh her down with the ravages of time (page 294). Her skin is leathery, her mouth almost toothless, her breasts pendulous, and her scanty hair is hidden beneath a kind of pauper's scarf—and yet despite all this, the Cumean Sibyl is one of Michelangelo's most powerful creations, a close relative of his sculpted figure of *Moses*.

Michelangelo, *The Cumean Sibyl*, c. 1510. Ceiling of the Sistine Chapel, The Vatican, Rome (Italy).

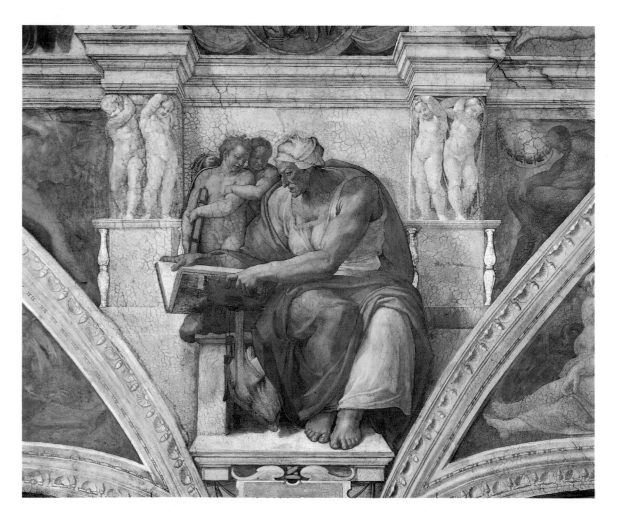

If we looked only at the ceiling of the Sistine Chapel, we would have a very mistaken picture of Michelangelo the painter. The vast ceiling was just a first step. Michelangelo had successfully devised a gigantic architectural décor, covering over 10,000 sq. ft. (1,000 m²), that incorporated several hundred figures, singly or in groups, set in every nook, on every illusory spandrel, imitation lunette, and false pendentive. It was a veritable summa of Christian theology, visually inscribed in the very heart of Christendom. But this attentively orchestrated wealth of detail had just one drawback: like most works prior to the sixteenth century, it failed to take into account the viewer's standpoint. Seen from the ground far below, the art was hard to make out, and it was even harder to appreciate the moving beauty of the brushwork. That was probably why, some twenty-five years later (around 1535), when Michelangelo was commissioned to paint the end wall of the chapel with a *Last Judgment* (unveiled on October 31, 1541), instead of pursuing the same decorative technique, he completely changed his approach and refused to subdivide the considerable surface area (45 by 40 ft., 13.7 by 12.2 m). Instead, he handled it like one vast painting even as he increased the number of figures, this time totaling some four hundred.

It is worth noting, however, that Michelangelo did not attempt to set this horde in real space—there is no real landscape, barely any clouds or sky. The celestial group in the middle, thanks to the enlarged size of its figures, appears closer than the earthly group, and yet ultimately it is the psychological effect that takes precedence over visual effect: the impression of a giant curtain closing all perspective, just as the Last Judgment will ring down the curtain on time.

The frescoes in the Cappella Paolina, or Pauline Chapel, are rarely visible and therefore less well known, but are even more unique. Begun in 1542, interrupted several times by incidents or by the aging painter's failing health, they were only completed in 1550. In these two compositions Michelangelo sought to produce a vivid sense of space not by extending linear perspective but by frankly contradicting it. In *The Conversion of Saint Paul* he established two different dynamic centers, one around the saint and the other around the divine vision; in the *Crucifixion of Saint Peter*, the play of perspective revolves around the church's founding saint. These are surprising visual experiments for an old man: they ran counter to those of the entire century, and no one ever seems to have discussed them, or even to have taken them up.

Raphael

Raphael (1483–1520) was the third of this remarkable quartet of artists. His career was brief, unlike those of Leonardo and Michelangelo, but he acquired legendary status: he was the artist of unsurpassable grace, he who "seemed to combine in one person all the

good qualities of the ancients" (Giovanni Pietro Bellori, 1695), he who had "a natural taste for choosing the beautiful" (Luigi Lanzi, 1795). Raphael was the infallible artist who carried painting to its zenith, and who alone merited burial in the Pantheon in Rome. Yet we must try to free ourselves from these platitudes, in imitation of Renoir who, around 1881–82, wrote to a friend concerning Raphael's *Madonna of the Chair* in Florence: "I went to look at this painting simply to satisfy a desire see it; but suddenly I found myself confronting the most free, most solid, most wonderfully true and simple painting imaginable."

Raphael had had the luck to inherit some important things from Perugino, which he never forgot. He was able to retain his master's soft style as well as his perfect balance between a harmonious human figure and an authentic sense of space. Let us consider, for example, one of the gems now in Chantilly, France, namely the *Three Graces* painted around 1504–5 (page 296). It was the work of a young man of twenty-one, and it refers directly or indirectly to an ancient sculpted group known at the time only from a rather poor version dating from the late Roman Empire.

FACING PAGE
Raphael, *La Belle Jardinière*, 1507.
Oil on wood, 4´ × 2´7˝
(122 × 80 cm).
Musée du Louvre,
Paris (France).

BELOW
Raphael, *The Three Graces*,
c. 1504–5. Oil on wood.
7 × 7˝ (17 × 17 cm).
Musée Condé,
Chantilly (France).

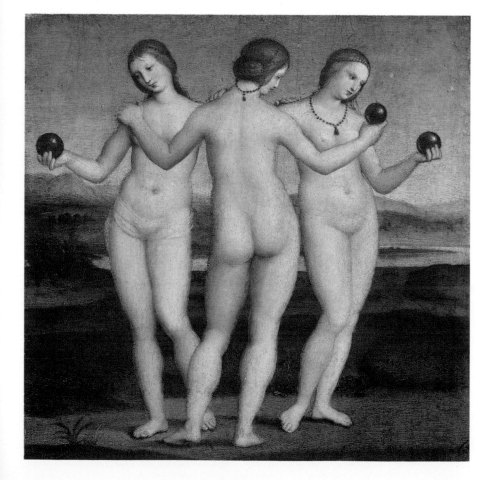

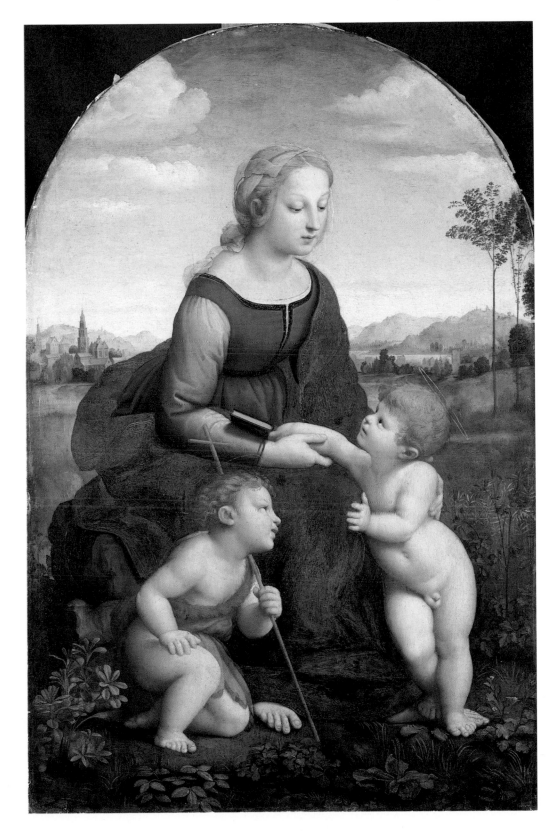

Raphael retained the symmetry, emphasized the *contrapposto* (curve of the bodies), and underscored the harmonious wavy rhythm suggested by the arms. A simultaneously open and discreet sensuality emerges from the very subtle blending of tones, known as *sfumato*, that softens the outlines of bodies even as it lends all volumes their full weight and presence. This effect is a long way from the wiry, mannered movement that is suggested by the Three Graces in Botticelli's *Primavera* (page 289).

The same equilibrium can be found in Raphael's famous Madonnas, such as *The Madonna with Goldfinch* (Palazzo Pitti, Florence), *La Belle Jardinière* (page 297), and *The Canigiani Madonna* (Alte Pinakothek, Munich). But the popularity of these works should not mislead us into thinking that Raphael remained a prisoner of his "sweet" style. He was able to study Michelangelo and assimilate something of Michelangelo's *terribilità,* or awesomeness (*The Prophet Isaiah*, Sant'Agostino, Rome). His work increasingly played on intense coloring and effects of light (*The Liberation of Saint Peter*, Vatican). Raphael was commissioned, in turn, to decorate vast spaces in the Vatican (the Loggie and the Stanze), which inspired him to use new themes and to alter his pictorial approach. Take, for example, *The Expulsion of Heliodorus from the Temple*, generally thought to have been executed between 1511 and 1514 (pages 298–99). This composition some 25 ft. (7.5 m) across has a complex

and ambitious thematic program. It tells the story of Heliodorus, who looted the Temple in Jerusalem and then was suddenly expulsed by a divine rider with two companions—an incident that was also seen as an allegorical affirmation of the inviolability of the Papal States. Raphael boldly decided to juxtapose both levels of interpretation on the same wall, which dictated his compositional gambit—in the middle he left a large

Raphael, *The Expulsion of Heliodorus from the Temple*, c. 1511–14. Fresco, approx. 25′ (7.5 m) at the base. Stanza Eliodore, The Vatican, Rome (Italy).

void with a double perspective (the arched ceiling of the Temple and the marble paving on the floor), while on the right he depicted the punishment of Heliodorus in ancient dress while placing on the left, in contemporary dress, Pope Julius II on the *sedia gestatoria*, flanked by courtiers. The calm scene on the left contrasts with the chaos on the right, marked by the diagonal thrust of the divine envoys, the rearing horse,

and the body on the ground; Raphael thus passed effortlessly from serene meditation to dramatic effect. The unmatched ease and naturalness of Raphael's art would drive other great painters to despair for centuries to come.

Titian

It is hard to know what date to assign to the birth of Titian, who

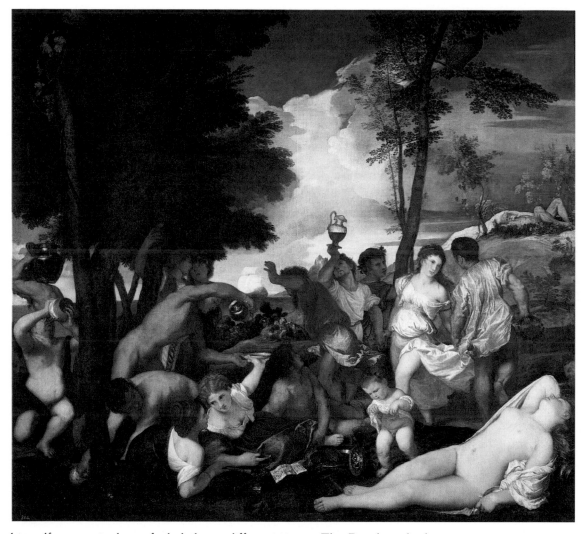

himself seems to have fueled the legend of his very long life. He is generally thought to have been born around 1488 and, whatever the case, he managed to accumulate substantial success, money, and honors by the time he died in 1576. In his own lifetime—and still today—he was held to be the painter most skilled in the use of color, outstripping even Leonardo, Michelangelo, and Raphael. The two paintings reproduced here are particularly famous for their use of color, although painted at very different times: *The Bacchanal of the Andrians* was painted for Alfonso d'Este's *studiolo* around 1518–19 (page 300), while *Diana and Actaeon* was begun in 1556 and dispatched to King Philip II of Spain in 1559 (page 301). A comparison between the two affords a better understanding of Titian's basic approach to color.

Titian was heir to the tradition of Giovanni Bellini (c. 1430–1516) and Giorgione (1477–1510), the latter an inspired painter who died at the youthful age of thirty-three.

Titian (Tiziano Vecelli), *The Bacchanal of the Andrians*, c. 1518–19. Oil on canvas, 5′8″ × 6′3″ (1.75 × 1.93 m). Museo del Prado, Madrid (Spain).

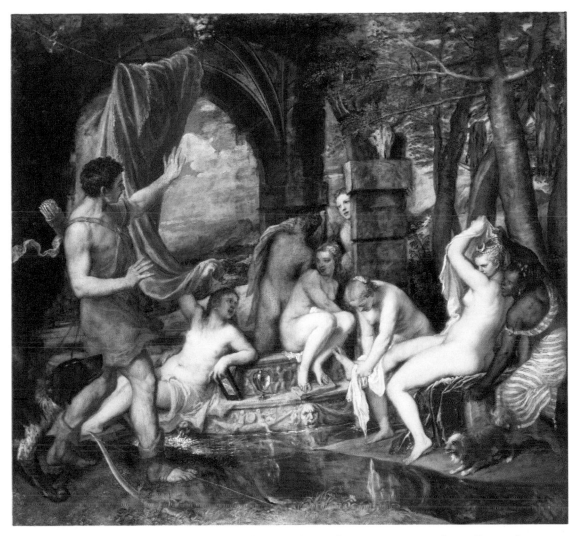

Titian (Tiziano Vecelli),
Diana and Actaeon,
c. 1556–59. Oil on canvas,
6′2″ × 6′8″ (1.90 × 2.07 m).
Ellesmere Collection,
National Gallery
of Scotland, Edinburgh.

Both paintings here make it clear that Titian was less interested in color itself than in a colored atmosphere where—as with Leonardo—hard outlines, with all their advantages and drawbacks, wind up disappearing. In the *Bacchanal*, he still exploits large patches of contrasting values of light and dark, while in *Diana and Actaeon* the coloring wins out. In the left part of this latter painting, he juxtaposed a fine touch of yellowy-orange, a patch of scarlet red, and a blue sky, approximating the three

primary colors. Even if it meant sacrificing the solidity of antique sculptural forms, Titian transformed painting into a harmony of tones that resolved themselves beautifully, sensually, felicitously.

Correggio

It may seem surprising to include Correggio (1489–1534) among this group of great painters. He is usually credited only with a certain gracefulness marked by languid gazes, but this view overlooks

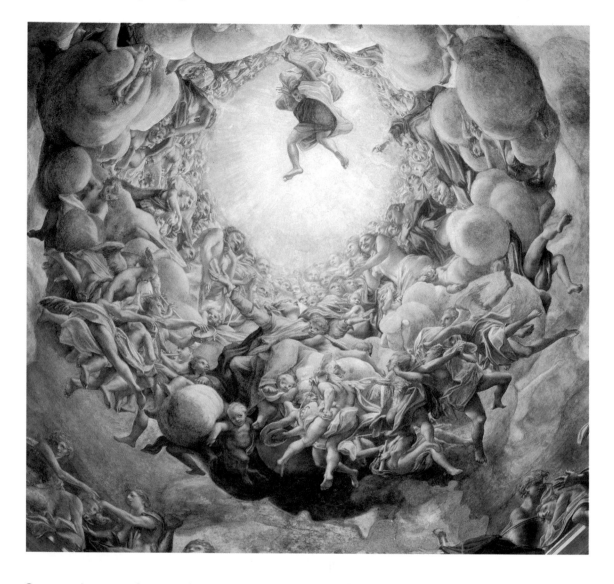

Correggio's extraordinary audacity. First of all, he discreetly destabilized the picture: prior to Correggio, most painters sought to ground their figures solidly, whereas he, on the contrary, favored diagonal lines and swirling fabrics, played on curving gestures, and masked the ground. His works thereby produced a simultaneous impression of liveliness and ambiguity.

He went even further, evolving from instability to levitation. With astonishing skills of foreshortening, he painted the inner dome of San Giovanni Evangelista in Parma with a Christ descending from heaven among apostles seated on clouds (1520–21). Then, with even greater confidence, in 1526–28 he filled the dome of Parma Cathedral with an *Assumption of the Virgin* amid a swirl of naked angels (page 302). Such "heavenly scenes" would be endlessly imitated by other artists up to the late

Antonio Correggio, *The Assumption of the Virgin* (detail), 1526–30. Inner dome of the cathedral, Parma (Italy).

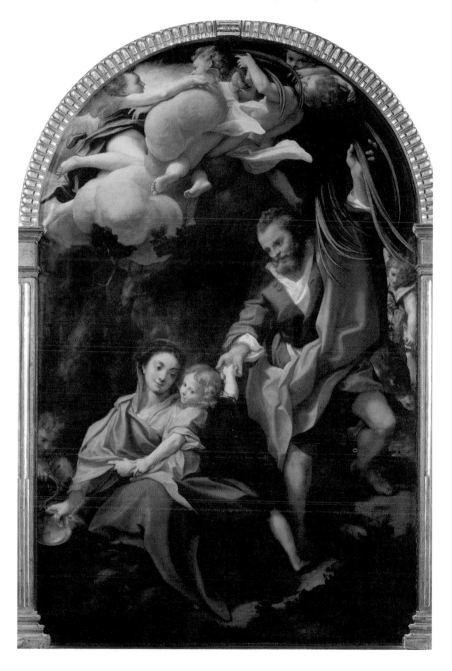

Antonio Correggio,
Madonna of the Bowl,
c. 1530. Oil on wood,
7′1″ × 4′6″ (2.18 × 1.37 m).
Galleria Nazionale,
Parma (Italy).

nineteenth century. Correggio thus devised something neither antiquity nor the Orient had ever produced, what neither Michelangelo nor Raphael dared do. He has thereby earned a place as one of painting's greatest "inventors."

It would obviously be naïve to think that five individuals from a single generation provide an accurate idea of sixteenth-century Italian painting in its entirety. Great masters sometimes leave deserts in their wake, sometimes they trigger great

flowerings. It is impossible to dismiss as mere epigones the likes of Andrea Solario (c. 1460–1524), Bernardino Luini (c. 1485–1532), and Il Sodoma (1477–1549). Beccafumi (1486–1551) lent sparkle to Siena, while Fra Bartolomeo (1472–1517) and Andrea del Sarto (1486–1530) brought glory to Florence. Lorenzo Lotto (c. 1490–1557), who left masterpieces in various churches scattered across Bergamo and the Marche region, painted like no one else. Nor could we overlook the trio of Venetian geniuses who lived in the same century as Titian: Jacopo Bassano (c. 1510–92), Tintoretto (1518–94), and Paolo Veronese (1528–88). And somewhat later there followed, from Umbria, Federico Barocci (1528/1535–1612), one of the finest painters—and I am weighing my words—that Italy ever produced.

All this artistic wealth long remained more or less disparaged—it was embarrassing to compare it with works by Raphael and Titian. Then a term was invented to describe it: "Mannerism."

The terms "manner" and "mannered" were frequent in both Italian and French Renaissance criticism, and referred to a repetitive output in a fixed style. They therefore carried a pejorative connotation, which they retained into the first half of the twentieth century, when people began referring to "Mannerism." At that point, in fact, it seemed crucial to define an intermediate period between the "High Renaissance" of the early sixteenth century and the

"Baroque" era that began in the seventeenth; this period seemed to be one of imitation rather than of creation, so the concept was accepted little by little, especially within German criticism, which was very concerned to establish basic principles and categories. In France, the term maniérisme only won acceptance after 1956, with the publication of André Chastel's book on Italian art. Meanwhile, the pejorative connotations of the term had greatly diminished. Far from designating a period of laxness and uniformity, this definition of Mannerism opened an exciting field of research.

This book will nevertheless avoid using the ambiguous term. A serious look at European art from 1510 to 1610 reveals a very rich output that cannot be reduced to any single model. Several generations of painters undertook lively initiatives, spurred to boldness by the greatness of their immediate predecessors.

The Madonna of the Long Neck by Parmigianino (1503–40), for instance, represents a rejection of the insistence on correct proportions, and seeks instead to combine gracefulness with a sense of monumentality (page 305). This was a difficult challenge, and Parmigianino never finished this painting, begun in 1535. He was apparently never able to develop the background, which leaves a dangerous void behind the large seated figure and her tight cluster of admirers. The use of the skin-hugging pleats and nudity underscore the beauty of human forms, but this is a "cold" beauty that seems

FOLLOWING PAGES
PAGE 306
Giovanni Battista Rosso,
Descent from the Cross,
1520–21. Paint on wood,
10′10″ × 6′4″
(3.33 × 1.96 m).
Galleria Pittorica,
Volterra (Italy).
PAGE 307
Jacopo Pontormo,
Deposition, 1526–28.
Oil on wood, 10′6″ × 5′10″
(3.13 × 1.82 m).
Capponi Chapel,
church of Santa Felicità,
Florence (Italy).

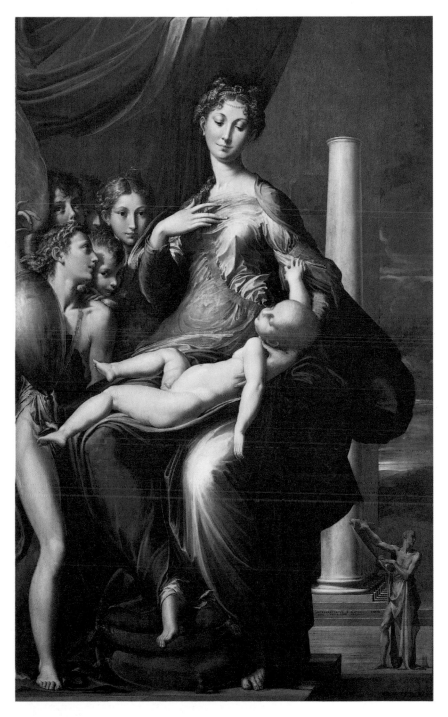

RIGHT
Parmigianino, *Madonna
and Child*, known
as *Madonna with
the Long Neck*, c. 1535.
Galleria degli Uffizi,
Florence (Italy).

more intellectual than sensual.

At an even earlier date, around 1520–21, Giovanni Battista Rosso (1495–1540) composed his large *Descent from the Cross* in purely geometric terms (page 306). There are neither beautiful bodies nor appealing faces here—the entire

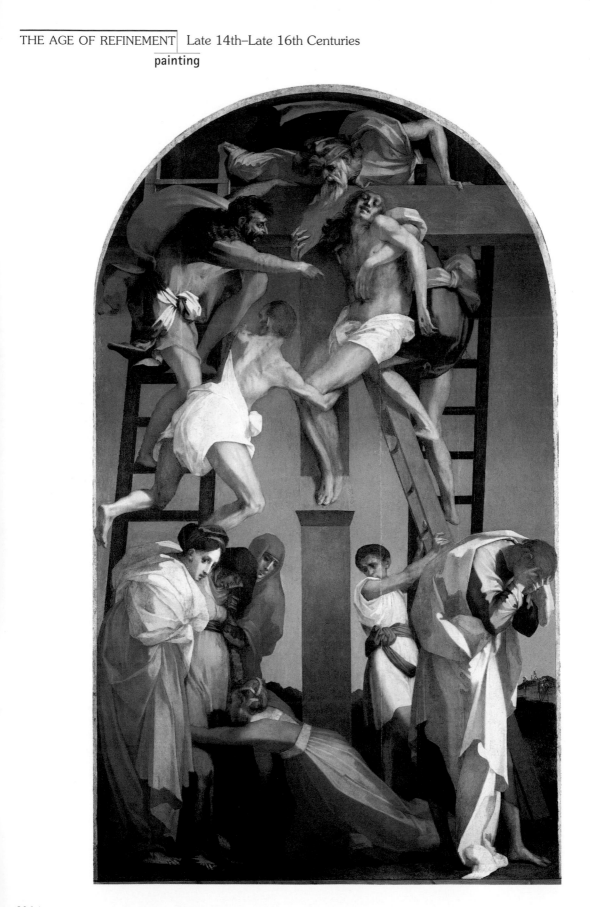

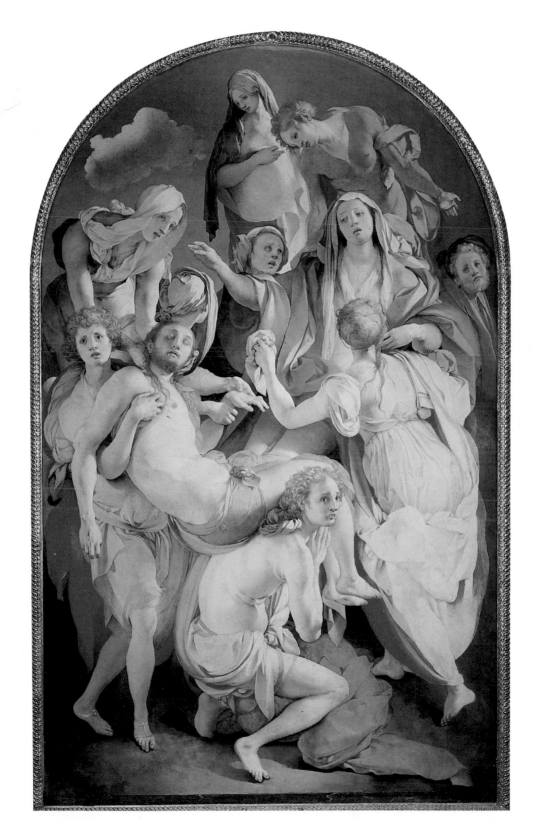

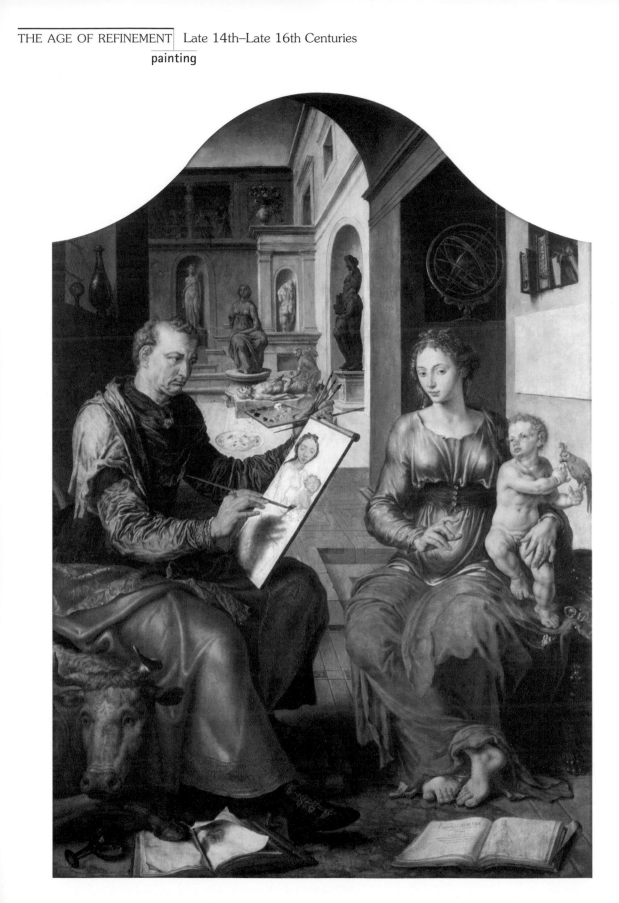

Abraham Bloemaert, *The Death of Niobe's Children*, 1591. Oil on canvas, 6′7″ × 8′1″ (2.03 × 2.49 m). Statens Museum for Kunst, Copenhagen (Denmark).

Maerten van Heemskerck, *Saint Luke Painting the Virgin*, c. 1545. Oil on wood, 6′8″ × 4′8″ (2.05 × 1.43 m). Musée des Beaux-Arts, Rennes (France).

painting is treated in cubic volumes that seem to be hewn from wood. Rosso almost always sought to fill his canvases with dense piles of bodies that left as little empty space as possible, as can be seen in his *Pietà* of 1537–40 (Musée d'Écouen, France).

Equally full is the *Deposition* painted by Jacopo Pontormo (1494–1557) for the church of Santa Felicità in Florence around 1526–28 (page 307). But it has nothing in common with Rosso's painting. The entire dense group is painted in "pastel" tones of pink, violet, straw yellow, and hyacinth blue with only a few touches of vermilion, while at the same time all the lines curl into a sinuous swirl. Pontormo sought the same curvilinear clarity as Botticelli, yet with unrivaled boldness.

Moving to northern lands, every-

thing shifts once again. Maerten von Heemskerck (1498–1574) traveled to Italy in 1536, and it was after this voyage that he painted *Saint Luke*, probably around 1545 (page 308). This is an art that refuses to abandon the glamour associated with carefully observed perspective and allusions to antiquity (as suggested by the statues in the background). Van Heemskerck also respected the tradition of fine brushwork that accurately rendered the texture of fabrics and the flesh tones of faces. This large painting—over 6 ft. (2 m) high—represents a summing up of the grand humanist culture of the sixteenth century.

An entirely different atmosphere is created by *The Death of Niobe's Children* (page 309), painted in 1591 by Abraham Bloemaert (1564–1651), who enjoyed a long career. The point of

this painting is clearly the depiction of the human nude, which is based on a tragic subject here, but which with only minor changes could become a bacchanal or divine banquet. In the last third of the sixteenth century, there was a great revival of interest in the study of the human body, which was rendered with increasing freedom not only in Italy but also in northern countries. Of particular note in this respect are the bold works of Bartholomeus Spranger (1546–1617), Hans von Aachen (c. 1552–1615), and also Joseph Heinz (1564–1609), all of whom gravitated to Prague, where Rudolf II of Habsburg, king of Hungary and Bohemia and Holy Roman Emperor from 1576 to 1612, was a particularly enthusiastic patron of the arts. Although Bloemaert was not part of Rudolf's small group of painters, justly called the "school of Prague," we know that the emperor particularly admired Bloemaert's painting of *The Death of Niobe's Children*.

This painting does not quite display the cold beauty attributed to Parmigianino and Jean Goujon, because the stylized nudes are still imbued with a certain realism, and mythological tales often encourage lascivious poses (which do not seem to have particularly shocked Rudolf II). Such works nevertheless avoid any hint of vulgarity through the artist's accomplished skill and "grand style."

One event illustrates better than any other the rich diversity of painting in the second half of the

sixteenth century, thanks to the initiatives and liberties taken by artists: namely, the success encountered in Toledo of a young man probably born in 1541 at Candia, on the island of Crete (then a Venetian colony). His name was Domenikos Theotokopoulos, but he became known as El Greco. He may have initially trained as an artist in Crete, and he may also have studied under Titian when he arrived in Venice (he certainly made a documented journey to Rome). What is certain, in any case, is that his art was Venetian.

Around 1575–76, El Greco moved to Toledo in Spain, and swiftly developed a highly personal style. He won major commissions in Toledo, such as *El Espolio* (Christ Stripped of His Garments) for the cathedral (1577–79) and *The Burial of Count Orgaz* for the church of San Tomé (1586–88), as well as royal commissions from King Philip II, notably the *Martyrdom of Saint Maurice* (1580–82, page 311). Yet El Greco's art is not easy to appreciate. He seems to ignore deep space; although familiar with perspective, he rarely used it. Like Rosso, he liked to fill the entire field of the canvas, even introducing heavenly scenes in the upper registers. Not even in his rare landscapes did he tolerate a quiet, atmospheric patch of emptiness; the sky would be handled like an object, striped with contrasting values, deliberately kept dark all the way to the horizon. El Greco was remarkably familiar with the

El Greco (Domenikos Theotokopoulos), *The Martyrdom of Saint Maurice*, 1580–82. Oil on canvas, 14′6″ × 9′9″ (4.48 × 3.01 m). Escorial, Madrid (Spain).

human nude and employed it boldly in his *Resurrection* of 1605–10 (Prado, Madrid), but his drapery was so heavy and vague that it masked the bodies underneath. His human figures vacillate between nearly accurate proportions and improbable attenuation.

No previous painter had followed his fancy in such a capricious way—freely transforming the world he claimed to depict into a pure interplay of visual relationships—even as he retained the admiration (if not always the understanding) of his contemporaries.

V
THE POWERS OF RHETORIC
(17th–18th Centuries)

introduction

There is nothing particularly special about the year 1600 from the standpoint of either history or art. During this rich and complex period, art appeared to be moving in contradictory directions if we compare developments in various countries. Yet with a little bit of distance we can see that a profound evolution was occurring, one that would govern two grand centuries of artistic creativity.

Europe was undergoing a metamorphosis. Soon it would take the form that it has largely retained up to the present day. Conflict with the Islamic world continued, but the threat was no longer so pressing. In the late sixteenth century, around 1570, the Turks had besieged Malta (1564–65), and taken Chios (1566) and Cyprus (1570), while in Spain the Moriscos in Granada rose up against the king (1568–71); but the Turkish armada was destroyed at Lepanto (1571) and the Moriscos were permanently expulsed in 1609. To the east, the threat still loomed, and Vienna was even dangerously besieged in 1683, being saved by the intervention of the king of Poland, John III Sobieski. Buda was then liberated in 1686 and the brilliant victory of Prince Eugene of Savoy at Zenta put an end to the Turkish threat in 1697.

Meanwhile, the terrible internal struggle triggered by the Reformation slowly subsided. It briefly looked as though Protestantism would triumph everywhere, or would at least consign Catholicism to the Italian and Iberian peninsulas, but the riposte organized by the Council of Trent proved effective. In France, where Calvinism seemed on the verge of victory, Henry IV's reconquest of the kingdom and the resounding failures of separatist uprisings in Montpellier (1621) and La Rochelle (1627) returned the country to the Catholic fold. Elsewhere, religious intolerance—reinforced by economic interests—usually led to separation, as when the United Provinces (Amsterdam) split from the Low Countries (Brussels and Antwerp). At the same time, Catholicism was gaining a foothold in the western hemisphere, from Mexico to Chile; Spanish and Portuguese dominion forged a powerful Latin America where original art forms soon arose, based on models imported from Europe.

These religious issues remained extremely important throughout the two centuries under discussion. They governed Europe's political geography and, in part, its artistic life. Hostility between Lutherans and Catholics in Germanic lands led to the appalling conflict known as the Thirty Years' War. Destruction, though less extensive than the damage to sixteenth-century France, was so widespread it is hardly surprising that these lands, despite their very old traditions, played only a secondary role in the history of art throughout most of the seventeenth century. Once the lines were finally drawn, Catholic Europe found itself further reduced, yet it was in Italy, Spain, Bavaria, and Austria that architecture, sculpture, and painting were able to find fullest expression. In Protestant countries these arts—unlike music—had no specific

religious role, nor were they driven by vast ecclesiastical construction sites, large altarpieces, and sacred subject matter. Pictorial accomplishment in Protestant lands primarily concerned the perfection of landscape, portraiture, and genre scenes, which could not fully compensate for a certain rejection of lyricism.

This assertion nevertheless requires qualification: Rembrandt, in Amsterdam, produced an art every bit as rich as, if very different from, the one produced by Rubens in Antwerp; furthermore, the eighteenth-century "Enlightenment" significantly reduced the importance of religion in artistic creativity even in Catholic countries. By the early seventeenth century, in fact, there were perhaps few painters and sculptors for whom art was primarily a quest for God. When looking at a religious painting—not even one by Boucher or Fragonard, but simply by Guido Reni, Pietro da Cortona, Poussin, Velasquez, or Maulbertsch—we do not really sense a desire to encourage spiritual meditation, to convey something that approaches a divine presence. Rather, knowledge of mankind is what interested artists and gave meaning to their work. Exploration of the wellsprings of human feeling inspired visual artists just as it spurred the imagination of playwrights such as Corneille and Racine.

An interest in "human passions" always entails—for artists as well as writers—learning how to stir emotions, how to be expressive. A poet like Racine seeks the right words to express the complex passions of Hermione or Phaedra in order to *move* the audience. Similarly, an artist tries to convey a figure's fear or love with just a few strokes of the brush in order to *communicate* those feelings to the viewer. Painters therefore have their own rhetoric, as do playwrights. And a rhetoric also exists for sculpture and architecture.

Architecture may not be an art of mimesis, being more closely related to music. But, like music, architecture's range of notes, registers, and vocabulary endows it with expressive powers. By way of example, let us consider two buildings with similar function: the Colonnade of the Louvre in Paris, designed by Claude Perrault and built in 1667–68, and the Zwinger in Dresden, built between 1697 and 1716 to plans by Matthäus Daniel Pöppelmann.

The façade of the Louvre is the expression of elegant, austere architecture (page 316). The ground plan is emphasized by the sober base, on which rises a uniform set of fluted columns arranged in pairs, topped by an unbroken cornice. The uniformity is interrupted only by the central pavilion (capped by a strict ancient-style pediment) and by the two corner pavilions, giving the overall composition a solid feel. Nothing could be clearer and firmer than this architectural idiom, although it would be monotonous were it not for the Corinthian capitals and, above all, for the presence of the recessed, two-story façade of the palace, underscoring

the colossal order of the colonnade—which, of course, was designed to adorn a building that had been a royal palace for centuries.

What could be more different than the Zwinger? Taking the Rampart Pavilion, this edifice has two clearly distinguished floors but the architecture is invaded by sculpture, which tends to create an indivisible whole (page 317). On the ground level, atlantes (i.e., bust figures) are grouped in threes and enlivened by the various poses they adopt; above them are three vase-like braziers. On the upper floor, the plain pilasters might provide a sense of calm were they not heavily laden with dangling foliage and crowned by statues and broken pediments. Viewed from afar, everything seems clearly organized; viewed close up, a dense complexity resounds like the finale of a symphony. Here we can hardly fail to recognize the variety of rhetorical powers available to architects, and the sway that an architect's bold vocabulary can exercise over the "soul of the beholder."

FACING PAGE
Matthäus Daniel Pöppelmann, Rampart Pavilion, Zwinger, Dresden (Germany), 1697–1716.

BELOW
Claude Perrault, Colonnade, Louvre, Paris (France), 1667–68.

Architecture

The foregoing comments shed some light on the issues facing architecture during this period. By 1600 or so, architecture had discarded most of the heritage of previous centuries and had acquired, thanks to a vocabulary borrowed from Roman antiquity, all the features required of a grand artistic language. The problem was no longer one of forging a new language. It was a question of knowing whether—and to what extent—the language needed refining in order to underscore its most sober and most perfect harmonies, or whether, on the contrary, it could be varied according to circumstances, whether sometimes even the best-established rules could be broken in order to present beholders with ingenious or delightful innovations, perhaps at the cost of flagrant violations of grammar.

As luck would have it, the early seventeenth century boasted two architects of genius who clearly understood this dilemma. One was the famous, multi-talented Gianlorenzo Bernini (1598–1680), whose many virtues did not include modesty. His architectural career was dotted with brilliant successes, but also a few errors, namely the two lateral towers that he built for Saint Peter's Basilica (later demolished), the bell towers framing the ancient façade of the Pantheon in Rome (also demolished), and various proposals for the Louvre, drawn up at the request of Louis XIV (none of which were adopted). Yet no one would deny that Bernini was capable of inspired genius, as testified by the colonnade in front of Saint Peter's. Bernini understood and respected the grandeur of ancient models, without slavishly copying them. Furthermore, the church of Sant'Andrea al Quirinale is a highly original creation (page 318), not just a smaller version of the Pantheon, which he was then restoring.

Opposite Bernini was his colleague and rival, Francesco Borromini (1599–1667). This skillful architect's masterpiece is certainly Sant'Agnese in Agone in Rome's Piazza Navona (1653–57). However, elsewhere—San Carlo alle Quattro Fontane (1638–41), the façade of San Filippo Neri (1637–50), and Sant' Ivo alla Sapienza (1646–65)—Borromini tended merely to animate façades with curves and countercurves, to open and swell pediments, to endow doors and windows with complicated architraves, and to design cupolas and lanterns so complex that initial admiration gives way to an impression of anecdotal detail rather than harmony (page 320). Borromini's clear mastery of the

Bernini, façade of Sant'Andrea al Quirinale, Rome (Italy), 1658–70.

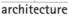

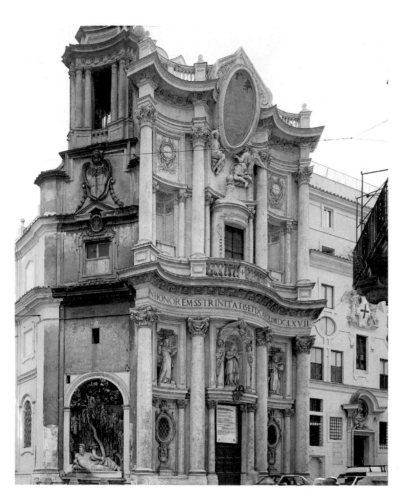

vocabulary was combined with a somewhat casual sense of liberty, an approach soon perceived as "taking liberties" even though, willy-nilly, his basic point was acknowledged.

It is worth noting here that the model of church design that slowly emerged and triumphed was not a simple edifice harmonious in its proportions and easy to grasp (as proposed in Florence by Brunelleschi's San Lorenzo sacristy and by Giuliano da Sangallo's church of Santa Maria delle Carceri); only in rare cases was a set of volumes personally conceived from scratch and a decorative idiom adapted to fit

that original concept. Instead, architects almost always preferred to vary and elaborate tried-and-tested elements. In fact, even when construction was supervised from beginning to end by the same architect, major features were usually handled in isolation: the façade, always elaborately designed yet based on an almost mandatory model; the upper part, preferably endowed with a dome; and the interior, arranged more freely but often less imaginatively (although, to be fair, it was usually the job of sculptors and painters to provide interiors with a sense of lyrical imagination).

Francesco Borromini, church of San Carlo alle Quattro Fontane, Rome (Italy), 1638–41.

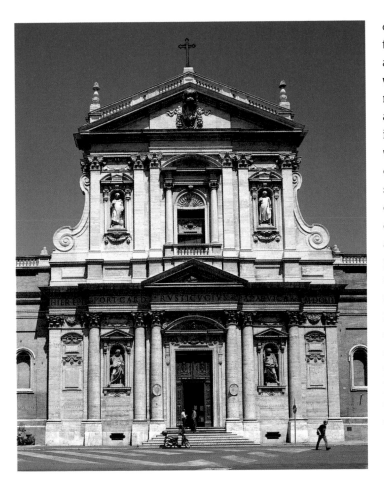

Carlo Maderno, church
of Santa Susanna,
Rome (Italy), 1603.

only its triangular pediment, this type of façade offered the notable advantage of setting a church flush with the street or square while masking the roofing of nave and aisles. The results often created the impression of a phony façade—which was sometimes true. On the other hand, such façades presented, even before the church was entered, a noble language that echoed the triumphal arches of antiquity: engaged columns and pilasters (usually twinned), powerful cornices, a play of pediments, and so on. Seeing these features on the façade of the Gesù must have made quite an impact, despite a certain dryness. Yet by 1603, with his façade for Santa Susanna, Carlo Maderno was able to show that it was possible to soften the impact of this vocabulary—without adulterating it—by playing on light and shadow and by placing statues in the niches (page 321).

Architects subsequently rivaled one another in putting their personal stamp on this basic plan. Usually, changes involved altering the plane of the façade through a more complex composition. Pietro da Cortona's façade on Santi Luca e Martina (Rome, 1635–50) discarded the overly rigid pediment and then curved in the middle between its two austere lateral buttresses. On Santa Maria della Pace (Rome, 1656–57), Cortona placed a semicircular porch before the door. Borromini, in typically bizarre fashion, tortured the antique-style pediment on San Filippo Neri and broke the façade

Façades

During the two centuries under discussion, it was the façades of churches that most exercised an architect's subtlety. As mentioned earlier, the two-level façade with pediment—as proposed in 1537 by Sebastiano Serlio in book IV of his *L'Architettura* and executed in 1584, with lateral volutes, by Giacomo della Porta in the church of Gesù in Rome—served as the starting point for countless Catholic churches. Having no link to the grand tradition of cathedrals, directly borrowing from antiquity

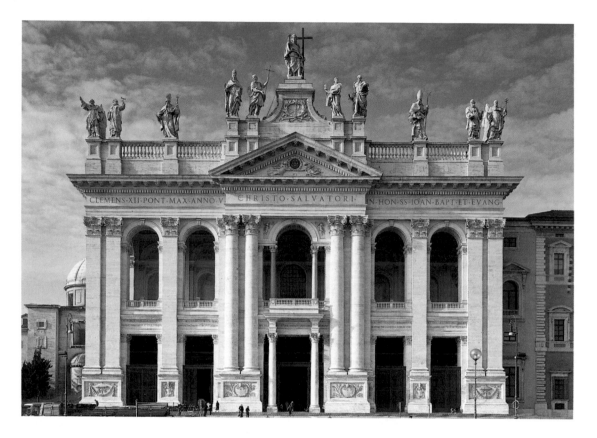

CLEMENS·XII·PONT·MAX·ANNO·V · CHRISTO·SALVATORI · IN·HON·SS·IOAN·BAPT·ET·EVANG·

of San Carlo alle Quattro Fontane with a play of convex and concave surfaces.

Meanwhile, Martino Longhi the Younger (1602–60) preferred to use round columns that were clearly detached from the wall for the façade of Santi Vicenzo ed Anastasio, in Rome, accompanied by a slightly staggered cornice and a series of three broken pediments. In fact, if we were to trace the subtle variations in this architectural rhetoric from church to church and from country to country, we might learn to appreciate one of the most refined and least-known developments in the history of architecture. The untutored eye today sees just a "Baroque façade" where people

once perceived endless inventiveness. It is hard today to know which innovations were admired as bold moves and which were rejected as intolerably licentious. Afterall, as early as 1732, for the façade of San Giovanni in Laterano, Alessandro Galilei was proposing to insert a delicate Serlian archway into a colossal-order façade (page 322).

Often, for example, despite the absence of any precedent in antiquity, architects would restore the twin-towered façade derived from medieval Christian churches. On Sant'Agnese in Rome, Rainaldi and Borromini set the towers far apart, allowing the dome to appear between them, limiting the façade to

Alessandro Galilei, façade of San Giovanni in Laterano, Rome (Italy), 1732–35.

a single story. Outside Italy, towers often returned more forcefully: the façade of Santiago de Compostela, Spain (1738–50) by Fernando de Casas y Novoa is dominated by two large towers that almost efface the Baroque design, already overwhelmed by the general exuber-ance of this ancient pilgrimage church (page 323). Similarly strange compromises can be found in Sankt Gallen, Salzburg, and Vienna.

Domes

Another major feature of churches

Fernando de Casas y Novoa, façade of Santiago de Compostela, Compostela (Spain), 1738–50.

was the dome, an architectural form that reached its peak at this time. Here again, there was no direct reliance on antiquity, because the Pantheon in Rome did not really serve as a model. The idea in fact evolved from Brunelleschi, although it was obviously Michelangelo's glorious dome on Saint Peter's in Rome that everyone wanted to imitate or at least echo.

Domes were costly, tricky to design, and difficult to build. Yet they were soon sprouting up not just in Italy but everywhere in Europe. The sudden rage for domes among French architects, for example, can be measured by counting the examples, both big and small, that dot the Paris skyline. Three masterpieces date from this period: the church of Val-de-Grâce (begun 1645, page 325), Les Invalides (1677–1706), and the Pantheon (begun 1756). But there are also many others that should not be overlooked, such as the chapel of Saint-Joseph-des-Carmes (1613–20), the Sorbonne (1635–60), the Collège des Quatre-Nations (1662–72, now the Institut de France), and the churches of the Assumption (1670–76), Oratory (after 1611), and Pentémont (1747–56), plus the Theatine Chapel (now demolished).

A dome was not only costly, however, it was tyrannical, dictating the overall plan of the church. At Saint Peter's, the authorities long hesitated over whether to add a nave, which risked ruining the view of the dome. Conversely, on Sant'Agnese in the Piazza Navona, the mere sight of the dome gave

the impression of an imposing church and enabled a large volume to be squeezed into a narrow plot. The truth, however, is that a dome only produces its full effect when set on a circular plan and allotted an unhindered view. Thus, Baldassare Longhena's Santa Maria della Salute (begun c. 1630), set at the entrance to the Grand Canal in Venice, fully asserts its powerful mass, echoed in a minor key by a second, simpler and lower

Baldassare Longhena, façade and main dome, church of Santa Maria della Salute, Venice (Italy), begun c. 1630.

dome (page 324). In Turin, meanwhile, Filippo Juvarra's Superga (1717–31) overlooks the entire city from its hill and, from a distance, flaunts its balanced volumes even if, close up, its design perhaps seems thin and its austerity somewhat disappointing.

Relatively often, architects had to abandon the rules governing façades if they wanted to lend a dome its full effect. At the Collège des Quatre-Nations in Paris, where Le Vau and

d'Orbay could profit from the vast perspective afforded by the banks of the Seine, the façade was reduced to a simple triangular pediment set on four columns and two corner piers. At Les Invalides, Bruant and Hardouin-Mansart built an edifice of much greater scope, yet they opted for a very simple design (page 326): the base was divided into two stories, one decorated with Doric columns, the other with Corinthian, while the central pediment, resting on just four columns, is simpler than the one at the Collège des Quatre-Nations. In fact, the design was clearly handled entirely as a function of the dome, to provide a base for its thrust; the façade therefore seeks not to retain the eye but to guide it toward the dome. The trophies festooning the dome have recently been regilded, confirming the impression that rarely has architecture achieved such masterful harmony and powerful overtones. If we forget for a moment that Les Invalides was given a new sepulchral function when it received Napoleon's ashes in the nineteenth century, its lyrical triumph and glory bears comparison with a great *Te Deum* composed by the likes of Gilles or Charpentier.

When it came to Saint Paul's Cathedral in London, Christopher Wren also devised a simplified façade: a simple triangular pediment set on eight fluted columns. Following many modifications, however, the main façade was raised to two stories and, above all, in 1706–08 it was given two high towers that significantly altered the overall

Mansart, Le Duc, and Le Muet, façade and dome, church of Val-de-Grâce, Paris (France), 1645–1710.

profile. Fortunately, neither these changes nor the Latin cross plan manage to destroy the effect of the huge dome, which rises over 300 ft. high (100 m) and is ringed by a magnificent colonnade of Corinthian columns (page 327).

Half a century later, Jacques Soufflot would attempt to rethink the whole problem of domes in an effort to combine "Greek sublimeness with Gothic lightness." He might be said to have failed, not only because his quest for lightness compromised the solidity of the church of Sainte-Geneviève even prior to its completion, but also because, with his ignorance of Greek architecture, Soufflot in fact turned to Roman antiquity. And yet his undeniable success merits admiration: the location, atop Sainte-Geneviève hill in the Latin Quarter of Paris, was particularly well chosen; the cross plan displayed the dome in all directions, lending full power to the crown of columns inspired by Wren (page 419). Soufflot reduced the complexity of the façade still further by setting the pediment on six equidistant, rather than twinned, columns. Without intending to do so, he thereby endowed Paris with an austere building that set a precedent and provided a pretext for rejecting the prevailing idiom.

FACING PAGE
Christopher Wren,
Saint Paul's Cathedral,
London (England),
1675–1711.

LEFT
Jules Hardouin-Mansart,
façade and dome,
church of Les Invalides,
Paris (France), 1679–91.

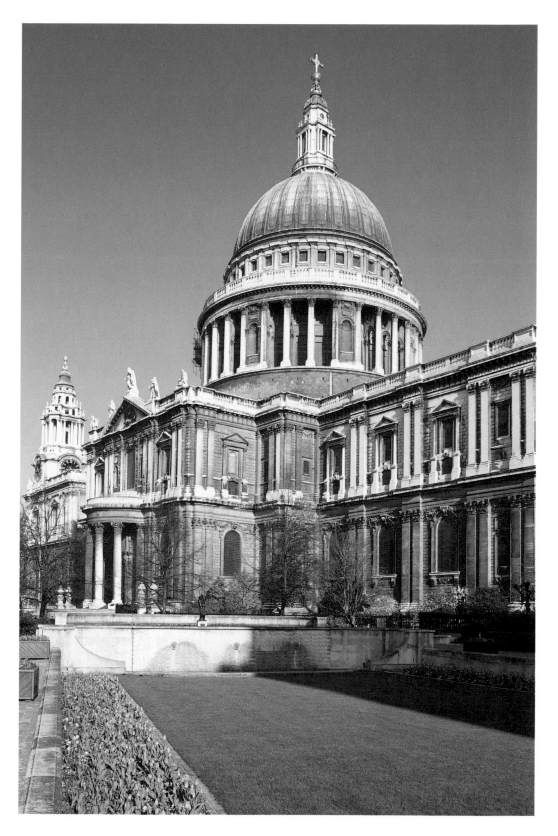

Interior volumes

Compared to other features, interior volumes presented architects with few constraints. Over these two centuries, almost every possible approach was tried. The Latin cross plan remained common, although the basilical form also inspired certain architects. The elevation of the nave tended to stop at two stories—tall arches below, high windows above. To provide greater unity and additional light, aisles were eliminated and side chapels often deliberately gave straight onto the nave. Powerful piers guaranteed the solidity of the building and columns only rarely played their traditional role. One of the finest exceptions is the church of Saint-Jacques in Lunéville, France, which is perfectly orchestrated around fine, round columns with slightly convex shafts (page 329); it was built in Lorraine, a region that retained the tradition of building in stone. In most cases, the taste for noble building materials had given way to brick and mortar coated with plaster, colorful stucco-work, or the special materials required for fresco painting.

In fact, the real novelty was no longer to be found in the architectural elements properly speaking. Novelty came from the birth of a new conception—that of mobilizing the various arts to contribute to an interior decoration conceived as a whole right from the start. The architectural support was devised in advance (often right from the maquette stage) as a function of the contributions of polychrome sculpture, painting (frescoes and altarpieces), stucco and gilding (columns, architraves, sundry ornamentation), and furnishings (altars, chairs, etc.), not to mention lighting (often conceived with "special effects" in mind). Only the art of stained glass was, as a rule, excluded, because it tended to reduce the light required by all the other arts; stained glass went into such a steep decline that certain traditional skills were soon extinct.

The idea that a masterpiece was no longer an isolated painting or statue in which a genius sought to condense and contain all his skill, but rather a symphonic space where the eye could wander from object to object to appreciate underlying harmony even as it enjoyed inexhaustible diversity, represented one of the high points in the history of art. This concept has surfaced at various periods, but was never so openly asserted—nor so frequently successful—as during these two centuries. It even led to a phenomenon rare in history: often, instead of demolishing a building that no longer corresponded to reigning fashion, the structure would be retained and, if judged still solid, would be completely fitted with a modern décor that left no hint of the old forms. This practice occurred often in Germany and above all in Italy.

The interiors of a certain number of Spanish and Portuguese churches also stemmed from this approach— lavish, profuse, mind-boggling to the extent of making people wonder whether they reflect refined luxury

Germain Boffrand and Emmanuel Héré de Corny, church of Saint-Jacques, Lunéville (France), 1730–47.

Francisco Hurtado
Izquierdo, detail of sacristy,
Carthusian monastery,
Granada (Spain),
begun 1732.

or carry vulgar taste to an extreme. Such interiors have been described as "miraculous grottoes." At Seville, for instance, in the church of Santa Maria la Bianca (1659), master-pieces by Murillo (now replaced by copies) were set in an inextricable jumble of ornamentation painted in white. Then there is the sacristy of the Carthusian monastery in Granada (1732–45), a sturdy architectural structure contradicted by a welter of surprising decoration that the eye registers without being able to decipher (page 330); or, in Malaga, the *camarín* (altar chapel) of the Virgin of Victory (1694), a large octagonal chapel topped by a dome whose drum, pierced with large windows, sheds light on a teeming cluster of palm fronds and feathers. All these decorative

ensembles, which so fascinated art historians such as Georg Kubler and Antonio Bonet Correa, spawned comparable efforts in Portugal and Latin America, beginning with the *sagrario* (parish chapel) attached to the cathedral of Mexico City.

A similar exuberance, if more controlled and calculated in its effects, can be found in churches in the Danube valley and Bavaria, where ornamentation is of less importance and a large role is played by highly skilled painting. Just fifty years ago, expressing admiration for such churches was considered a sign of poor taste. Nowadays, expertly restored and lovingly maintained, they are the

pride of German art and attract thousands of visitors. It would be pointless even to attempt to list all the most famous, so mention will be made only of the Munich church of Saint John Nepomuk (also known as the Asamkirche, 1733–34), the work of the Asam brothers, who jointly supplied all the skills of architect, sculptor, and painter. The ground floor is a teeming maze of colored marble, polychrome statues, and gilded garlands. On the upper level, despite large, twisting columns, the organization becomes more legible; the entire edifice is capped by a pale ceiling whose trompe-l'oeil frescoes seem to condense

Cupola, church of Santa Maria Tonantzintla, Mexico, eighteenth century.

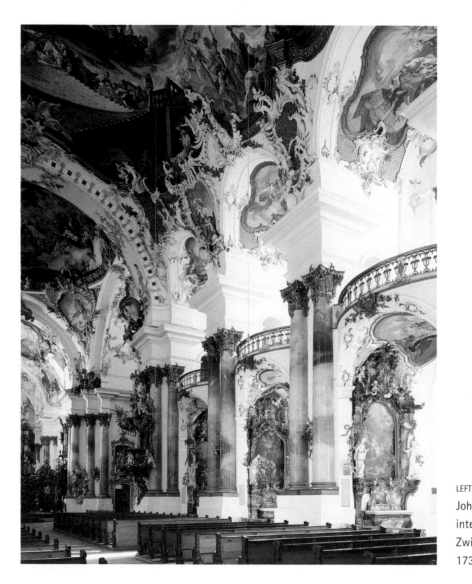

LEFT

Johann Michael Fischer,
interior, abbey church,
Zwiefalten (Germany),
1738–65.

all the light. More subtle is the Benedictine abbey at Zwiefalten (1738–65), designed by Johann Michael Fischer (page 332). The white interior is drenched in a fine light and is strongly orchestrated by large columns of colorful stucco-work with gilded capitals and bases. The side chapels are adorned with painted altarpieces surrounded by ornate frames of statues, putti, and strapwork, while above the entablature are large white stucco ornaments in the most extreme Rococo style, which invade the trompe-l'oeil painting. The overall effect has a splendor that is both dynamic and serene, creating a musical feeling combined with dreamlike illusion. Meanwhile, the Benedictine church in Ottobeuren (begun 1737) displays exterior architecture that is sober and rather uninteresting, leaving visitors unprepared for the dazzling, powerfully organized

FACING PAGE

Dominikus Zimmermann,
interior, Wieskirche,
Steingaden (Germany),
begun 1743.

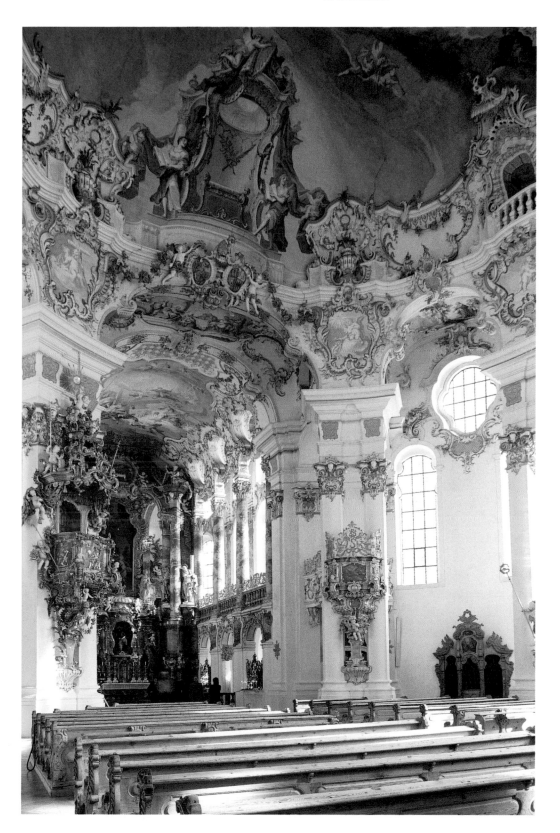

interior enlivened by large pilasters of colored stucco and by trompe-l'oeil frescoes swarming with figures. Meanwhile, the altars, pulpit, capitals, and sculpted groups (of very high quality) weave a fine "Rococo" lace along the walls, which adds a layer of minuscule, perpetual effervescence without muffling the strong volumes. Here again, the alliance between the various arts manages to transform an interior space into a musical symphony that can never be fully assimilated, one whose subtle nuances are sensitive to the quality of the light and therefore evolve during time of day and throughout the seasons.

Secular architecture

It might be objected that all the examples cited here are drawn from ecclesiastical architecture. This is a fair objection, since the art of architecture also blossomed in other spheres during these two centuries. It is impossible to ignore royal châteaux such as Versailles in France and Schönbrunn in Austria—the introduction to this chapter even discussed details drawn from two palaces. A few words of clarification and further explanation are therefore in order.

It was argued that the key role of architecture during this period entailed developing a language of persuasion. This development was highly subtle and played simultaneously on accepted conventions and bold variations. Now, the twentieth century has ultimately eliminated this type of language from modern architecture entirely, to the benefit of more brutal effects. Columns, entablatures, molding, the harmonious proportion of solids and voids—contemporary viewers tend to be blind to these features. The easiest way to help people grasp the importance and appreciate various refinements in detail is through church architecture. It goes without saying that architects employed the same language for palaces, châteaux, private mansions, and indeed simple houses. Usually this language was expressed more simply, because people felt that whereas a certain lyricism was appropriate to God, more discretion was required of secular elegance, even among princes and monarchs. That explains the soberness of non-religious architecture, especially in France. Even today historians still refuse to describe Versailles as "baroque" because the term carries heavy connotations, instead using the term "French classicism" despite inconsistencies with respect to classical antiquity.

Galleries

Secular architecture not only adopted a more sober language, it also developed its own concerns. One venerable tradition, whose origin remains unclear, called for a special space known as the gallery. This room would be very long and lit by large windows—at least on one side—and was to be easily accessible, which meant that it was rarely located deep within the main

Ambassadors' Staircase (destroyed), Château of Versailles (France), modern maquette.

building, but rather placed in a side wing. Galleries effectively replaced the main hall of medieval castles. They could serve both as a waiting space (prior to entering the private apartments) and as a reception space for parties and balls. The architectural formula was worked out in the sixteenth century, when masterpieces such as Rosso's gallery for the Château of Fontainebleau was built. But the fashion really caught on in the seventeenth century, when almost every lavish dwelling had its gallery or even galleries. Many of these rooms vanished even before the seventeenth century was out, especially in France, and once the fashion waned, people soon began dividing these vast spaces into smaller apartments. Galleries will be discussed later in terms of their decorative painting, but it should

not be forgotten that articulating a gallery with the residential parts of a mansion called on all the architect's ingenuity and often dictated the overall plan of a building.

Staircases

The main staircase represented another problem. The fifteenth and sixteenth centuries had adopted the practical solution of a spiral staircase, set in a narrow external turret, serving all floors. This approach began going out of fashion in the sixteenth century because it was hard to light, inconvenient to use, and lacked grandeur. So turrets were replaced by large towers, and the steps were widened and made less steep. But the real revolution occurred when architects decided to bring the staircase into the main

part of the building, allowing it to expand inside the entrance hall. Formerly a simple passageway that was more or less hidden, the stairway became a stately feature that would soon become officially known as a "grand staircase." But many issues henceforth required answers: should a staircase have one or several flights? Should it end on the second floor or continue up to the third? How could it be lit at a time before skylights could be made large enough to provide light from above?

At Versailles, although the entrance space offered little depth, Charles Lebrun did not hesitate to emphasize the stairway leading to Louis XIV's apartments (c. 1674–79). Lebrun's work, in which the architecture was enhanced by a series of trompe-l'oeil paintings, was highly admired throughout Europe, a fact which did not prevent it from being demolished in 1752 (reproduction, page 335). One of the most famous staircases of the period still survives, however. It was built in 1718–21 by Filippo Juvarra for the Palazzo Madama in Turin (page 336). The architect devised a high, narrow vestibule drenched in light from vast windows, with two lateral stairways, each of two flights, rising to a central partition platform that leads magnificently into the upper floor. Here again it is fascinating to study the range of variations employed, from the lavishness of the châteaux in Brühl (page 337) and Würzburg to the simplicity of private mansions in Dijon or Aix-en-Provence.

Practical ground plans

These were not the only issues facing architects of the day. Lifestyles were becoming more demanding, and soon the convenience of interior organization became a key criterion of secular architecture. The ceremonial alignment of a series of stately apartments, in which you had to cross one room to reach the next, was eventually abandoned in favor of a hallway leading to each room separately. The kitchen, with

Filippo Juvarra, staircase, Palazzo Madama, Turin (Italy), 1718–21.

Balthazar Neumann,
Staircase, Schloss
Augustusburg staircase,
Brühl (Germany),
1741–44.

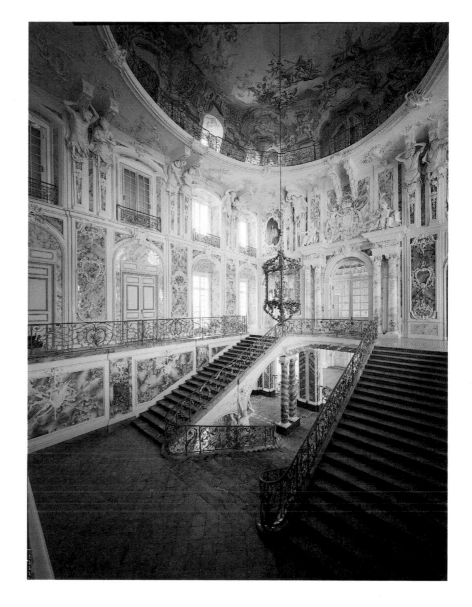

its noise and especially odors, was henceforth placed as far as possible not only from the reception rooms but also from the dining room—trying to plan the layout so that dishes would still be hot when they reached the table became a pressing issue, solutions to which became the key feature of lavish townhouses in Paris and could make the reputation of an architect (perhaps even more than his skill at employing the classical orders on the exterior façade). An effort to shelter bedrooms from street noise led to the placement of the main building at the back of a courtyard, flanked by two wings and cut off from the street by a high wall with an imposing portal (preferably with garden just behind it); this pattern became the

standard model for "distinguished" neighborhoods of Paris. This was the period, for that matter, when Paris also saw a boom in apartment buildings, many of which survive—they are simple and do not seek to ape palatial appearances, yet are of fine and honest quality. As far as country dwellings went, increasing attention was paid to the grounds with their flowerbeds, ornamental pools, fountains, and trees. Here the change in taste involved less a metamorphosis of architectural forms than a diversification of architectural responsibilities and skills.

Military fortifications

A final word will be devoted to the swift and total decline of military architecture. Wars still occurred, but fortifications wound up going more or less underground. An architect as famous as Sébastien le Prestre de Vauban, of course, composed grandiose complexes on the frontiers of France, such as Belfort and Mont-Dauphin, whose forts exalt the geometric beauty of carefully built defensive walls. Yet can it be claimed that the art of fortification still belonged to architecture? The day of the military engineer

Paris entrance gate, Lille (France), 1685-93. Simon Vollant,

City gate, Nancy (France).

had arrived. Although entrance gates to cities were still being built throughout Europe, they were less a defensive requirement than a glamorous symbol. One example is the impressive gate designed by Simon Vollant for Lille, a strategic city that came under French dominion in 1668 (page 338). Adorned with Doric columns, trophies, and statues, the imposing wall opened only onto a narrow gate with drawbridge. It still retained a defensive appearance, and even a defensive role, making it perhaps one of the last masterpieces of military architecture. But the gates erected at all the entrances to the city of Nancy on the orders of Stanslaw Leszczynski (the former Polish king who was granted sovereignty over Lorraine and Barrois in 1738), were nothing other than triumphal arches directly inspired by ancient models (page 339). They henceforth sprang from a spirit of celebration rather than from the requirements of war.

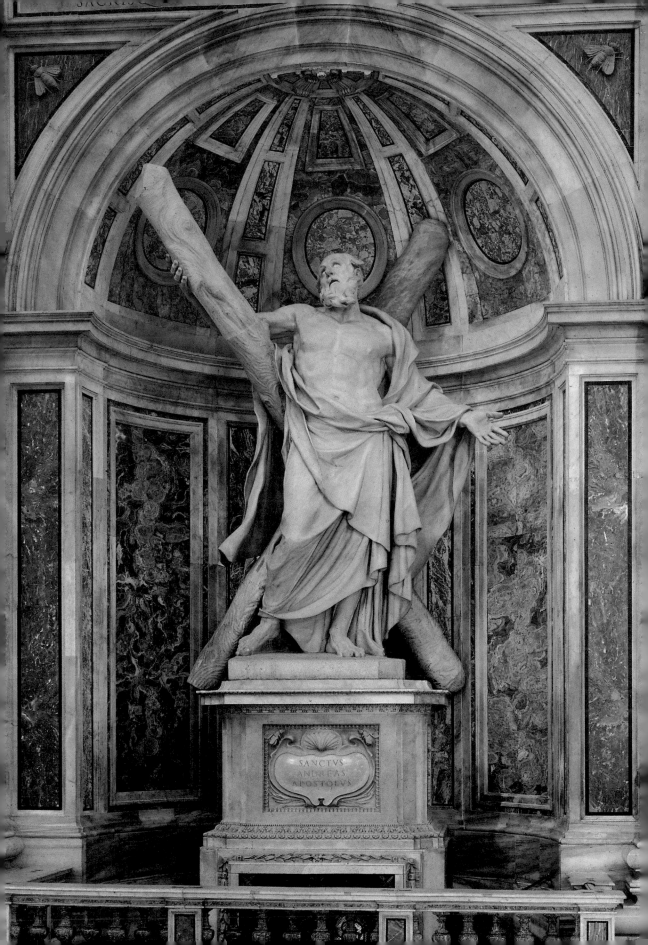

Sculpture

Sculpture is the expressive art par excellence, whether conveying facial features or one of the body's infinite poses. It was therefore ready to adapt to the rhetorical role advocated by the seventeenth and eighteenth centuries. Perhaps it sometimes did so with exaggerated confidence—when artistic virtuosity reaches perfection, sculpture runs the risk of sacrificing its poetic power for an insipid realism. This tendency must be acknowledged, but the plethora of skilled practitioners should not prevent us from recognizing true geniuses.

Spanish "verism"

The guide and model for this period was one of the greatest figures of seventeenth-century art, Gianlorenzo Bernini, the Italian architect who was first and foremost a sculptor. But first we must look at a trend that escaped Bernini's influence, namely Spanish sculpture of the early seventeenth century. Take, for example, Pedro de Mena's *Saint Peter of Alcantara* (Valladolid, Spain). It is immediately obvious that the polychrome statue belongs to a tradition distinct from Italian innovations. It can only be seen as a somewhat naïve effort to meticulously reproduce reality. The face is carefully and naturally colored, as was

long the case with cathedral statuary. The garment imitates a monk's habit to the point of illusionism. This approach might appear archaic were it not for the extreme soberness of the sculpture, for a gravity that eschews all anecdotal detail. On the contrary, it evokes the extreme severity found in paintings by Zurbarán. Far from entertaining the eye, this multicolored statue is designed to evoke a presence.

A parallel with the impact of Caravaggio's influence on painting—to be discussed below—is hard to avoid. There was the same need to reject all of art's past devices, to return to basic data, to copy nature in order to endow it with a new clarity. This realist aesthetic, so different from that of Flanders, was unhesitatingly adopted by Spanish artists, who pushed it far. Its finest masterpiece may be Padro de Mena's *Repentant Magdalen*, dated 1664 (page 342). Mary Magdalene holds a real crucifix in her hand, and her matted garment contrasts with the color of her skin as though carved from different material. Her face, although somewhat ordinary, is sober and severe. By employing "impoverished" techniques, this singular sculpture managed to reinvigorate the image of the penitent sinner, which was already being

Francois Duquesnoy, *Saint Andrew*, 1629–40. Marble, H: 14´8˝ (4.5 m). Saint Peter's Basilica, Rome (Italy).

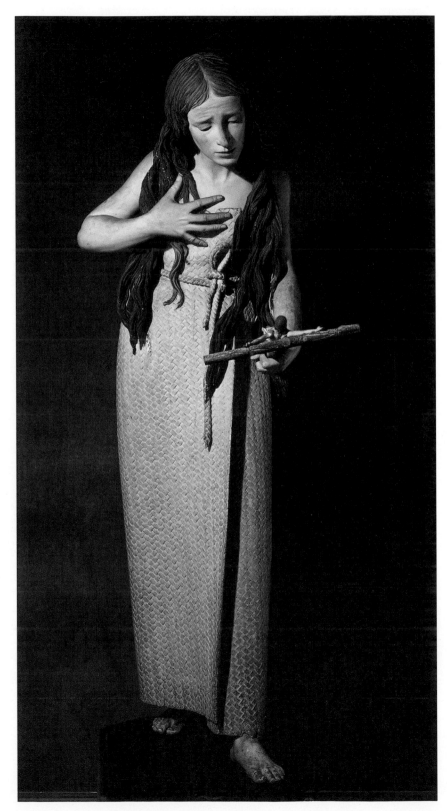

FACING PAGE
Bernini, *David*, 1623–24.
Marble, H: 7´10˝ (2.43 m).
Villa Borghese,
Rome (Italy).

LEFT
Pedro de Mena,
The Repentant Magdalen,
1664. Wood, H: 5´2˝ (1.58 m).
Museo de San Gregorio,
Valladolid (Spain).

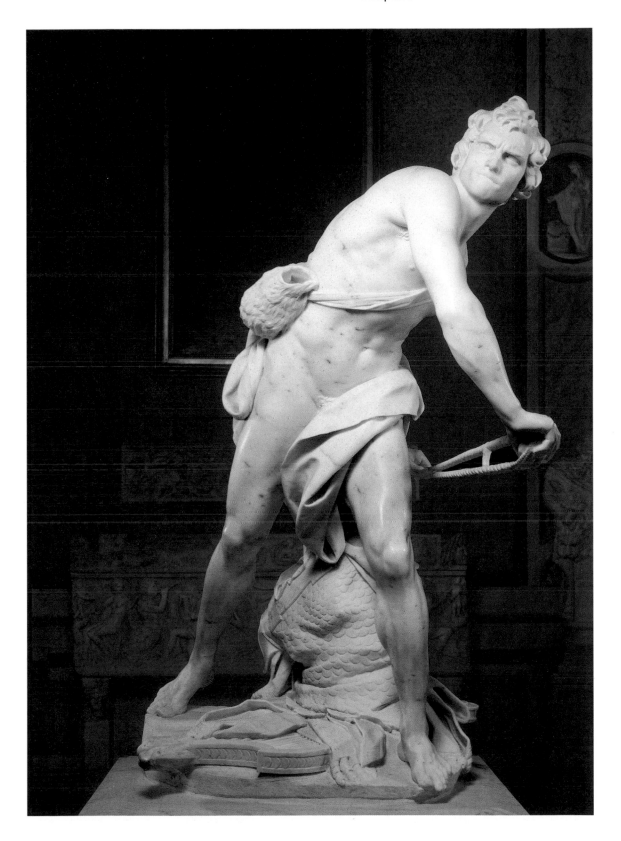

sapped by the insipidness and banality of conventional sculpture.

Italian sculpture

Realism ran the risk of leading to the dead ends of trompe l'oeil art and folk sculpture. Italian and French sculpture took a very different direction, following the lead of Bernini who adopted the avenue opened up by Michelangelo: attack marble directly in order to imbue it not with reality but with the "idea."

This is not to say that Bernini merely imitated his famous predecessor. He carefully developed his "idea" through terracotta maquettes, which eliminated the *non finito* aspect so dear to Michelangelo. Furthermore, Bernini's concern to demonstrate his virtuosity led him to pierce the marble again and again, giving it a lightness that people had thought could only be obtained in bronze. In this respect, although starting from Michelangelo's position, Bernini arrived at an opposite result: far from "making the marble tremble," he made it obediently do his bidding, including the difficult challenge of expressing movement, lightness, and transience.

Take, for example, his *David* (1623–24, page 343). Here he is still the successor to great sixteenth-century sculptors, displaying a need to suggest different directions in space through a twisting movement. David's body is not just a paean to nudity, for it twists on itself in a fleeting equilibrium and his tight, pinched face seems almost disfigured by the physical effort.

The figure's expressiveness, at a dramatic moment that will determine victory or death, hinges on David's gaze, which is barely visible beneath his furrowed eyebrows.

This rhetoric of movement is even more evident in Bernini's famous *Apollo and Daphne* (1622–25, page 345). This time the twisting motion is less pronounced, since the two running figures suffice to convey a sense of space. Sensuality is underscored by the sheen of youthful bodies, which contrasts with the fine fabrics, detailed laurel leaves, and thin bark that already begins to cover the fleeing maiden. All these elements, executed with the artist's unrivaled skill, stress the movement of the chase and the upward thrust. Once again, everything focuses on the crucial instant: at the very moment Apollo wins his race he also loses his prize. Bernini was even so bold as to depict Daphne's metamorphosis into a laurel tree. But behind this artistic feat was an idea that justified it. Pope Urban VIII himself had expressed the idea in an admirable Latin distich:

Quisquis amans sequitur fugitivae gaudia formae
Fronde manus implet bacchas seu carpit amaras.

[Who, through love, pursues the pleasures of a fleeting form
Fills his hands with bare leaves, harvesting only bitter berries.]

Was this a clever excuse to justify the sensuality of a sculpture

Bernini, *Apollo and Daphne*, 1622–25. Marble, H: 7′10″ (2.43 m). Villa Borghese, Rome (Italy).

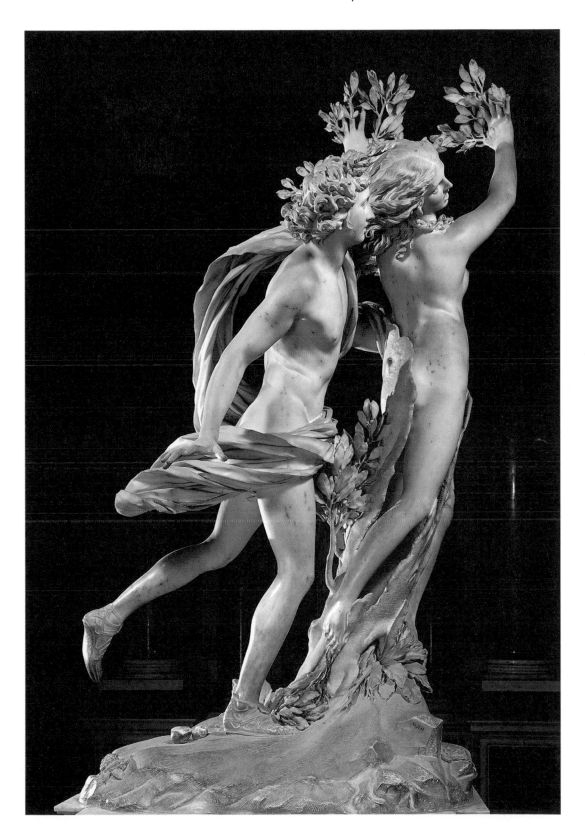

destined for the palace of a high church official? Or the real idea that inspired and guided the artist? As brilliant as Bernini may have been, it should not be forgotten that he had many rivals, even in Rome itself. His work is often contrasted, mistakenly no doubt, with that of Alessandro Algardi, who was born in Bologna in 1598 and died in Rome in 1654. We are now more familiar with Algardi's great work since Jennifer Montagu published her major study, titled *Alessandro Algardi*. There may have been a great difference of character between Bernini and Algardi, but it is unlikely that there was a doctrinal conflict. Whoever initially devised the project, it was Algardi who sculpted the two figures of the *Decapitation of Saint Paul* for the high altar of the church of San Paolo Maggiore in Bologna, which was a larger-than-lifesize representation, in marble, of a deci-sive moment of *action*. And it is hard to maintain that Algardi was any less interested than Bernini in effects of illusion when looking at his immense high-relief carving of *Pope Leo Driving Attila from Rome* (Saint Peter's Basilica, Rome), which teems with contrasting movement.

The same impression is given by a gigantic *Saint Veronica* (1646) by Francesco Mochi (1580–1654). The saint seems to be trying to flee her niche on a large pier in Saint Peter's with such urgency that many critics see the work as the very negation of the idea of statu-ary. But we should not be too hasty in drawing a contrast with its pendant piece, a more statuesque *Saint Andrew* (1640, page 340) by François Duquesnoy (1597–1643). Even here, the diagonal thrusts of the large cross suffice to disrupt the calm space of the niche as the saint turns his tearful face heavenward. Once again, a masterful lesson in visual rhetoric is being expounded.

French sculpture

It is not hard to see why Italian techniques were easily grafted onto the tradition of Goujon and Pilon, especially since it had become the custom for French sculptors and painters to complete their training with a stay in Italy. Jacques Sarazin, for example, born near Noyon in 1592, studied first with a Parisian sculptor, Nicolas Guillain, then in 1610 headed for Rome, where he would remain for almost twenty years. In Rome he worked in circles close to Domenichino and produced his early master-pieces. He was thus an experi-enced, thirty-six-year-old sculptor when he returned to Paris in 1628, where he married the niece of painter Simon Vouet, whom Sarazin had met in Rome. Both artists often worked on the same decorative projects. Sarazin's sculpture displays some of the sup-ple abundance seen in Vouet's paintings, although at other times he sought an elegant simplicity and serene composition, as seen in what is considered his finest work, the caryatids on the Louvre's Pavillon de l'Horloge (1639–42). One of Sarazin's finest figures, an

Pierre Puget, *Saint Sebastian*, 1664–68. Marble, H: 14´8˝ (4.5 m). Church of Santa Assunta de Carignano, Genoa (Italy).

allegory of *Justice* (1648–58) for the monument holding the heart of the prince of Condé, provides an excellent example. The funerary monument itself comprises a large set of bronze figures (nearly melted down during the French Revolution) in which the calm pose and elegant forms recall the art of the sixteenth century. But here Sarazin has hollowed the bronze not only with suppleness but also with strength, so that curves do not contradict volume. Whether working in metal, marble, or stucco, Sarazin was wary of virtuosity, seeking the right balance between weightiness and movement, between matter and idea.

In Paris, Sarazin headed a veritable workshop and enjoyed a wide reputation. He also had rivals, such as Simon Guillain (1589–1658), known above all for a larger-than-life bronze group of *Louis XIII, Anne of Austria, and the Young Louis XIV* (originally on the Pont au Change in Paris and now in the Louvre). Then there was François Anguier (1605–69), a good representative of "Parisian atticism" (or delicate classicism) during the early years of Louis XIV's reign, as seen in his monument for the heart of the duc de Longueville and a fine recumbent tomb figure of *Jacques de Souvré* (Louvre).

Going against this grain was sculptor Pierre Puget (1620–94), who worked above all in Marseille and Genoa, and who proclaimed Michelangelo to be his model even as he looked toward Bernini. Like them, Puget intended to be not only

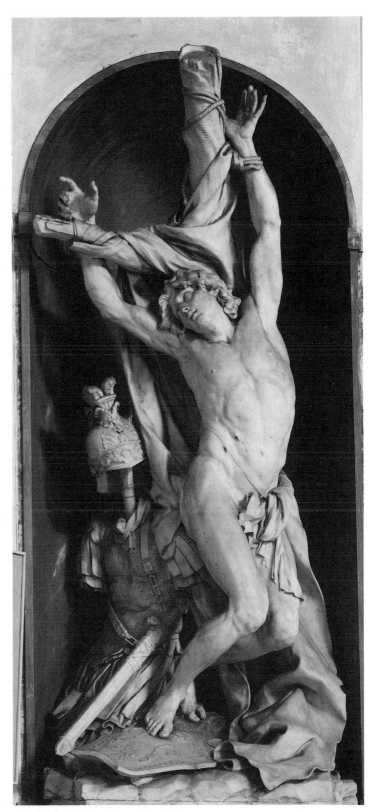

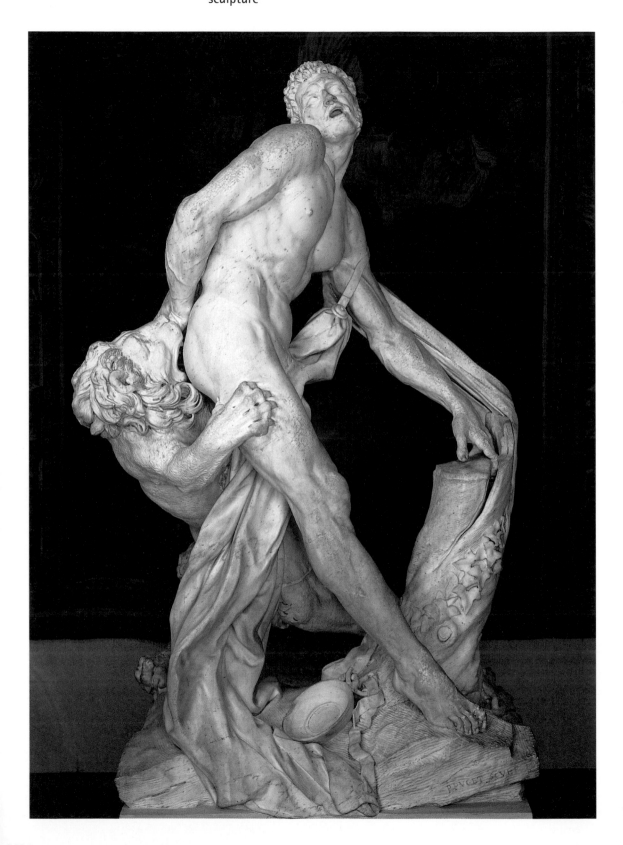

a sculptor, but also a draftsman, painter, and architect. Also like them, he wanted to grapple directly with a block of marble, and he sought to match or even outdo his predecessors in the dramatic expression of emotions. Puget's *Saint Sebastian* in the church of Santa Assunta de Carignano (page 347) no longer shows the appealing (or powerful) figure of a young Apollo triumphing over wounds that barely scar his nudity, as depicted by painters in the fifteenth and sixteenth centuries; Puget's saint, still lashed to the tree, collapses in a movement that expresses both his pain and his plea to God. Perhaps the most famous—and most tragic—of Puget's sculptures is his

Milo of Crotona (1672–82, page 348). This large and powerful nude, though not beautiful, easily rivals Bernini's *David* and the ancient *Laocoön*. The figure of Milo, attacked by a lion while his hand is trapped in a tree, arches his body in a final struggle as he howls in pain and despair. It would be difficult to find a subject more apt to express extreme emotion. Louis XIV had Puget's *Milo* brought to Versailles, where it was admired and imitated. Nearly a century later, in 1754, Étienne-Maurice Falconet would handle the same subject in a small marble (page 349). Falconet's hero, now on the ground, may seem less intensely and profoundly tragic, but his version perhaps triumphs

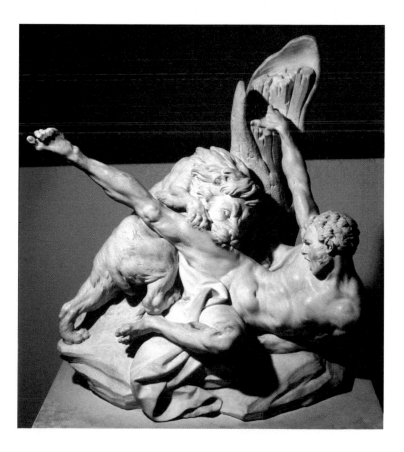

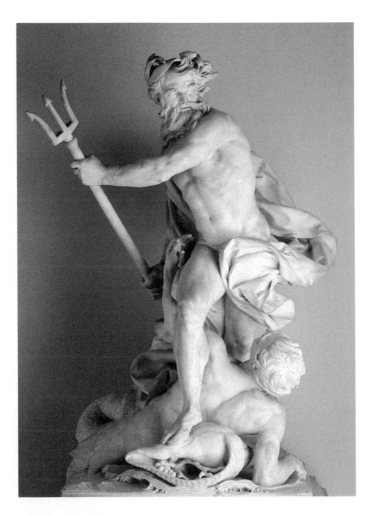

Lambert Sigisbert Adam,
*Neptune Calming the
Waves*, diploma piece
for acceptance to the
Académie Royale, 1737.
Marble, 33″ × 23″ × 19″
(85 × 59 × 48 cm).
Musée du Louvre,
Paris (France).

through the unequaled violence of Milo's scream.

French sculpture, meanwhile, had long ceased to envy Italian sculpture. Vast decorative building programs at Versailles attracted artists and served as showcases for their work. Versailles constituted a fount of skill and glamour that could legitimately claim to provide models for all of Europe.

A clear awareness of this goal had in fact induced France to organize appropriate training, offered at the Académie Royale starting in 1648. A kind of artistic tradition was thus established, one that risked ending in methodical uniformity. Such an outcome has often been deplored, but today the diploma pieces—works executed to earn membership to the academy—are on show at the Louvre. Despite the uniform size of these "smaller-than-life" marbles, their extraordinary quality must be acknowledged. A technical perfection rarely achieved in other countries is accompanied by an unusually solid visual language. It is inappropriate to use the term "academic" in a pejorative sense when studying François Dumont's

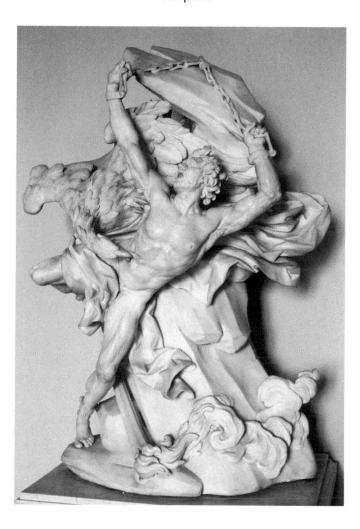

Nicolas Sébastien Adam, *Prometheus*, diploma piece for acceptance to the Académie Royale, 1762. Marble, H: 3´9˝ (1.15 m). Musée du Louvre, Paris (France).

Stricken Titan (1712), Michel-Ange Slodtz's *Fall of Icarus* (1743), Lambert-Sigisbert Adam's *Neptune Calming the Waters* (1737, page 350), Jean-Baptiste Pigalle's *Mercury Attaching his Winged Sandals* (1744), and Nicolas Sébastien Adam's *Prometheus* (1762, page 351). Once again there emerged in France, as well as in Italy, a great sculptural style—it was one of those periods when shared models and collective aesthetics teased real masterpieces out of plain talent and allowed geniuses to enjoy a public reception that spurred them to outdo one another.

It should not be assumed that this situation produced monotonous art. Ancient history and mythology offered numerous subjects conducive to the expression of emotions, not to mention the variety of saints and religious allegories. As cities grew and affluent neighborhoods sprang up, decorative sculpture enjoyed one of its finest periods. There was hardly a private townhouse in Paris that did not display a piece of high-quality carving on its gate, and the keystones of

arches generated a whole series of wittily handled motifs. The absolute masterpiece of this genre is the archway to the stables of the Hôtel de Rohan (now the Archives Nationales in Paris), adorned in 1736–37 with *Horses of the Sun* by Robert Le Lorrain (1666–1743). This decorative sculpture flaunts an elegance and dynamism that have never been surpassed.

State portraiture

Another genre—portraiture—was extensively developed in France in the latter half of the seventeenth century. Never had so many busts been modeled or carved. Here again, Bernini had shown the way. His portrait of Francesco I d'Este, duke of Modena, sculpted in 1650–51, is perhaps the portrait bust that most clearly displays Bernini's genius (page 353). Yet even after studying it carefully, do we really remember the sitter's haughty, uninteresting face? His limp cheeks are enveloped by the vibrant effect of his large, cascading wig and lace collar; in fact, every part of the marble is animated by the skillful play of varied rhythms running through it. We are now a long way from the realistic faces of the fifteenth and sixteenth centuries, with their subtle psychological insight. Do we even care whether the portrait is a good likeness or not? That was certainly not what interested Bernini. Thus he went to Paris in 1665 to execute his bust of Louis XIV, yet French courtiers claimed that they had difficulty recognizing the king. To repeat

once more, however, Bernini was less interested in imitating nature than in hewing "passion" from the marble. When it came to a portrait of Francesco I d'Este, "passion" meant presenting an image that carried the idea of pride, wealth, aloofness, and authority. And to succeed in that, Bernini had to downplay—more or less—specific features, even rejecting the public's expectations of veracity. Drapery with deep folds floats around the bust, enveloping it in an unrealistic way, as though pointing out that this is not the sitter himself but a sculpted bust with all its conventions and with all the artist's "fine ideas."

In fact, Bernini was a complex character who seems to have been much more concerned with the psychology of his sitter when he dealt with people he saw regularly, such as Cardinal Borghese (whose bust he sculpted in 1632) and Pope Urban VIII (sculpted in 1637–38). Yet it was Bernini's lyrical transpositions that primarily struck his contemporaries. Take, for example, the bust of *Henri de Bourbon* (*Le Grand Condé*), sculpted by Charles Antoine Coysevox in 1688–89 just after the prince died. Instead of working in his customary medium of marble, Coysevox produced a bronze bust. The "Grand Condé," who had once been the savior of France prior to betraying his country (although Louis XIV ultimately restored his title and property to him), was known for his great ugliness. Coysevox disguised nothing, but he lent greater majesty to the face by stressing the prince's

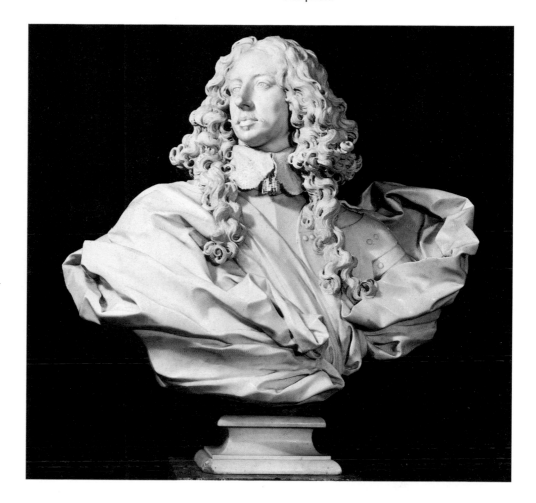

Bernini, *Francesco I d'Este, duke of Modena*, 1650–51. Marble, Galleria Estense, Modena (Italy).

calm, confident gaze and, above all, by surrounding the face with a cascade of curls. Coysevox's fine chiseling of the cloak and the antique-style breastplate also drew the eye, diverting attention from facial features. This approach was perhaps less ostentatious than Bernini's in so far as Coysevox tended to downplay his own virtuosity, but he nevertheless employed the same expressive idiom as Bernini.

It may well be that the lasting popularity of these busts derived from the fact that they substituted glamour for charm. Royal painter Pierre Mignard had neither the Grand Condé's harsh features nor the sugary grace he incorporated into his own figures. In a long panegyric devoted to Mignard, the Abbé de Monville had only this to say about the artist's appearance: "He had been handsome in his youth; in later years all that remained were noble and serious features. His eyes were blue, his gaze mild, his nose well formed." This laconic description provides food for thought. And now, turning to the marble bust sculpted by Martin Desjardins, we see that the artist indeed rendered Mignard's mild gaze and sensitive mouth (page 354). As to the rest,

FACING PAGE
Martin Desjardins,
Pierre Mignard, First Painter to the King
(detail), c. 1675.
Marble,
2′9″ × 1′10″ × 1′1″
(85 × 56 × 34 cm).
Musée du Louvre,
Paris (France).

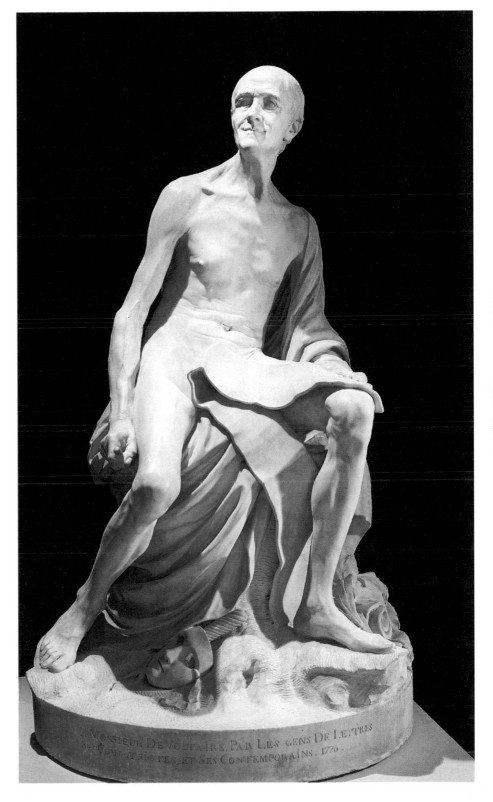

RIGHT
Jean-Baptiste Pigalle,
Nude Voltaire, 1776.
Marble,
4′10″ × 2′10″ × 2′6″
(150 × 89 × 77 cm).
Musée du Louvre,
Paris (France).

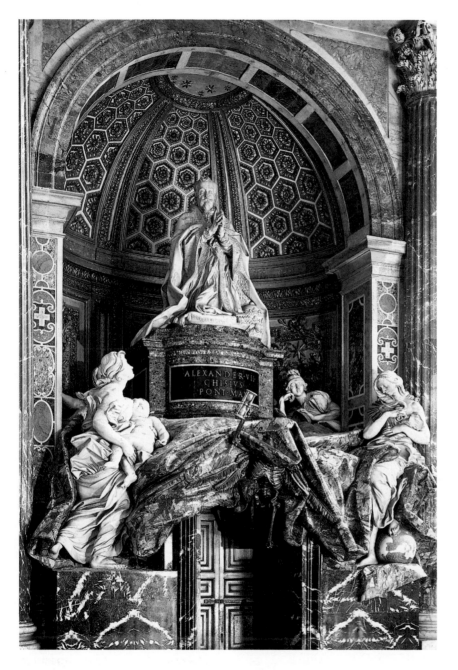

the lively curls of the heavily chis-
eled wig enliven the gaunt features
and prominent cheekbones, playing
down the stiffness of Mignard's
character, transforming him into an
image of inspired genius. This
glamorous if dangerous tradition
would survive until the arrival of

Pigalle's realism and the profound
changes that occurred in the late
eighteenth century.

Tomb sculpture

At this juncture, it is worth dis-
cussing tomb sculpture, which was

Bernini, *Tomb of Pope
Alexander VII*, 1673–74.
Marble and bronze,
Saint Peter's Basilica,
the Vatican, Rome (Italy).

directly related to portraiture and which spread throughout all of Europe, including Protestant countries, although it was especially popular in Italy and France.

Tomb sculpture was rooted in the most venerable Christian religious tradition and had already yielded masterpieces in the fifteenth and sixteenth centuries, as discussed earlier. But the seventeenth and eighteenth centuries witnessed a marked increase in the size, if not the number, of such monuments. In Saint Peter's Basilica, every papal tomb was a magnificent undertaking—or rather, a magnificent staging—in which the statue of the deceased, set above a doorway, was accompanied by monumental figures and a grand display of costly marble. Here again it was Bernini who produced masterpieces in the tombs he erected for Pope Urban VIII (1528–47) and Alexander VII (1673–74, page 356). The composition is crowned by a statue of the pope, while at his feet an allegorical subject provides an excuse for a theatrical scene.

Similar funerary monuments sprang up in churches in Rome and the rest of Italy, spurring countless artworks throughout Europe, some of which were conventional while others were highly original. In London, for example, Louis François Roubiliac (c. 1705–62) executed the tomb sculpture for the duke of Argyll (1745–49) and notably for Lady Elizabeth Nightingale (1761), in which the vivid realism of the figures sits awkwardly with the sentimental inspiration and stilted staging.

In France, where the tradition was very ancient, countless tomb monuments were produced, but the French Revolution destroyed many of them. And most of the rest were displaced, dismembered, or dispersed. However, enough of them survived to demonstrate the level of perfection attained in this realm of sculpture. It long remained associated with the traditional model of the figure kneeling in prayer, dressed in official garb. For the tomb of Richelieu (1675–77, chapel of the Sorbonne, Paris), François Girardon (1628–1715) exploited a painting by Poussin to revive the traditional figure of "the mourner." The tomb that Coysevox and Tuby executed for Mazarin as late as 1689–93 (in the chapel of what is now the Institut de France) was also limited to the most noble and monumental feature, namely a kneeling statue flanked by three allegorical figures; Mazarin is shown praying, hand on heart, a standard pose of worship that might also evoke the devotion of a man who had placed himself at the service of the realm and royalty. He is surrounded by three magnificent bronze statues, the middle one representing Peace (true enough, after a series of inevitable wars, Mazarin bequeathed Louis XIV a kingdom at peace with its neighbors), flanked by Prudence (of which Mazarin was criticized for having too much) and Loyalty (to the queen mother, to the young king, and to France). The eulogy is skillfully composed, and the calm, noble poses of the figures and the use of allegory avoid any

pathos. There is nothing here of the agitation of Bernini's tombs for Saint Peter's—here the contrast of bronze and white marble, plus the overall symmetry of the monument, place the main focus on Mazarin. Only the long fall of the carefully chiseled train of the cardinal's cloak provides some fillip to the discreetly funereal serenity.

Little by little, however, a more theatrical staging became popular. Charles Lebrun was one of the first to move in this direction—although with simplicity and moving restraint—with the tomb he designed for his mother, executed by Gaspard Collignon in 1668–90 (page 358). The artist's mother can be seen rising from her coffin on hearing the angel's trumpet on Judgment Day. The tomb of a curé named Languet de Gergy, sculpted by Michel-Ange Slodtz in 1750–57, is perhaps the most moving composition of all (page 359). The kneeling figure is here greeted by an angel who banishes Death, incorporating the deceased into the allegorical scene in a virtuoso style that still makes the most of effect. The most spectacular

Charles Lebrun and Gaspard Collignon, *Tomb of Lebrun's mother*, 1668–90. Marble. Church of Saint-Nicolas-du-Chardonnet, Paris (France).

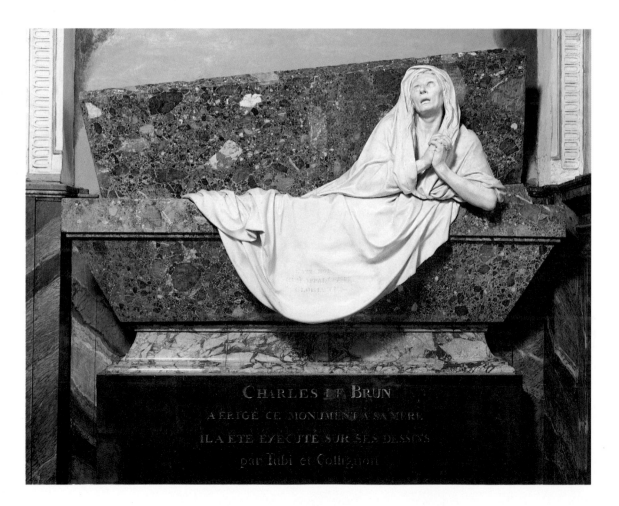

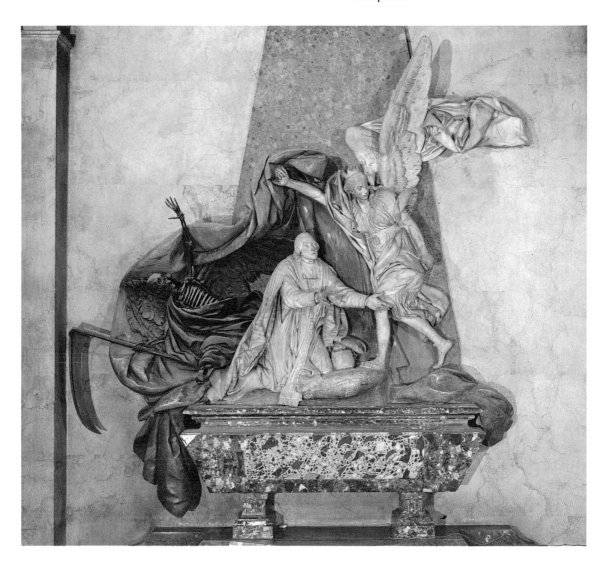

Michel-Ange Slodtz,
Tomb of Languet de Gergy,
1750–57. Marble.
Church of Saint-Sulpice,
Paris (France).

tomb is nevertheless the one that Louis XV himself commissioned from Pigalle in homage to Marshal Maurice of Saxony; since the marshal was a Lutheran, his tomb was placed in the Protestant church of Saint Thomas in Strasbourg, where it occupies an entire chapel. In a grandiose setting, Maurice of Saxony calmly descends a set of steps toward death and immortality. Each element is skillfully executed, but the decision to stage a series of allegories in a realistic space only produces a phony setting devoid of all emotion and, in short, of all sculptural feeling.

The appeal of tomb monuments in the seventeenth and eighteenth centuries represents one of the most interesting aspects of sculpture of the day. Sculptors, full of confidence, attacked the extremely complex problem of large sculptural groups, a challenge taken up only very rarely within the history

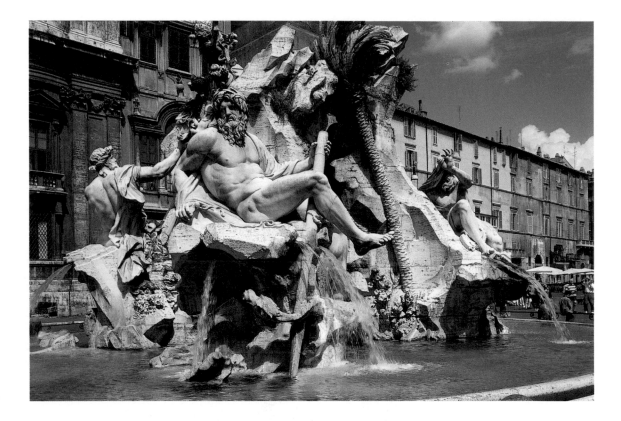

of art. True enough, Entombments in the fifteenth and sixteenth centuries had already mobilized approximately ten figures, but they did so in a limited space and they depicted a precise subject according to specific religious conventions.

Fountains

Fountains also represented complex sculptural ensembles. All over Europe in the seventeenth and eighteenth centuries, grand gardens (royal or otherwise) featured grottoes, pools, cascades, and fountains that called for harmonious groupings of statues in various poses. Statues no longer stood in darkened churches, but in an open space with foliage, ornamental waterworks, and natural light that changed with the time of day and the season.

Here again, the finest example must be credited to Bernini, with his various fountains in Rome's Piazza Navona (on occasion, this square would be deliberately flooded for nautical contests). In the middle was the Fontana dei Quattro Fiume, executed in 1648–51 (page 360). Water flows down a pile of rocks topped by a large, ancient obelisk. Four giant statues, sitting or reclining, represent the four major rivers of the world. A picturesque jumble, just emerging from the water, skillfully combines rocks, grottoes, and various animals and plants (including a

Bernini *et al.*,
Fontana dei Quattro Fiume,
1648–51. Stone,
travertine, and marble.
Rome (Italy).

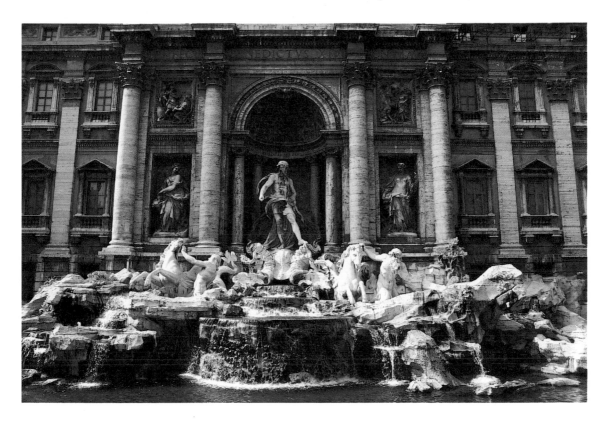

Niccolò Salvi,
Trevi Fountain, 1732–51.
Palazzo Poli, Rome (Italy).

naturalistic palm tree) into a bold chaos that contrasts with the stately structure of the obelisk. Bernini's fountain fits perfectly into the architectural setting and animates the entire square. The same effect is even more marked with Rome's other famous fountain, the Trevi, designed by Niccolò Salvi in 1732 but not completed until 1751 (page 361). This fountain was actually incorporated into the palace façade, which it uses as a theatrical backdrop. A large triumphal arch was set amid the row of windows, and water issuing from the middle runs down a pile of rocks; what would have been the door of the building harbors Neptune on his chariot, preceded by tritons and sea horses. Never

had the convergence of architecture, flowing water, and lively sculpture been pushed so far.

The idea of a rocky mass enlivened by a fountain and forming a kind of mountain inhabited by statues was often copied. It notably took the form of Mount Parnassus crowned by Pegasus and featuring the muses with their attributes, as found in German parks and gardens. But it could also be seen in certain ecclesiastical monuments such as the various "Holy Trinity columns" designed by Matthias Bernhard Braun in Bohemia, notably at Teplice (1718–19), Reichenberg (1719–20), and Waltsh (1727–28). Nor should we forget that the gardens at Versailles provided fine models, as in *Apollo's Chariot* sculpted

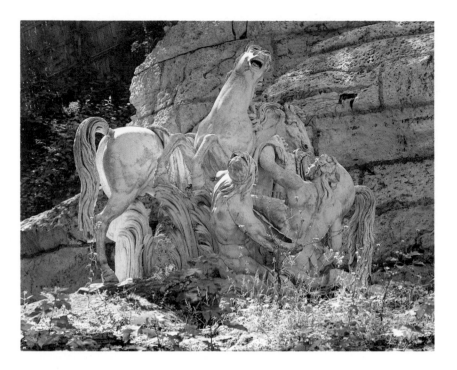

by Jean-Baptiste Tuby on designs by Lebrun; here an ancient-style chariot complete with horses rises from the waters of the Apollo Basin in a great bound under the calm gaze of the attendant god. Also worth mentioning are the sculpted groups originally assembled in the famous Grotto of Thetis (1666–72) but scattered around the grounds of the château in the eighteenth century. This was one of the few attempts of the period, outside the realm of religious sculpture, to harmoniously coordinate a series of life-size sculpted figures. The main scene showed Apollo at the end of the day, weary from driving his chariot, being pampered by nymphs in the grotto. Girardon managed to imbue Apollo's royal repose with a tone of delicate nobility quite different from the tension cherished by Bernini. In contrast, the dynamic elan of the two side groups of horses

(by Guérin and the Marsy brothers respectively) are closer in spirit to Bernini's fountain in the Piazza Navona.

"Total art"

To this diversity should be added an original approach adopted in Germanic lands. Sidelined by the catastrophic Thirty Years' War in the first half of the seventeenth century, they remained aloof from Bernini's glamorous influence. Even once the disasters had ended, Germanic artists tended to return to their own traditions, including that of the large polychrome statues that decorated churches in the fifteenth and sixteenth centuries. German sculptors usually continued to prefer wood or stucco for sculpture destined for the interior of a church or palace. The result

Gaspard and Balthazar Marsy, *Apollo's Horses,* 1666–72.
Château grounds, Versailles (France).

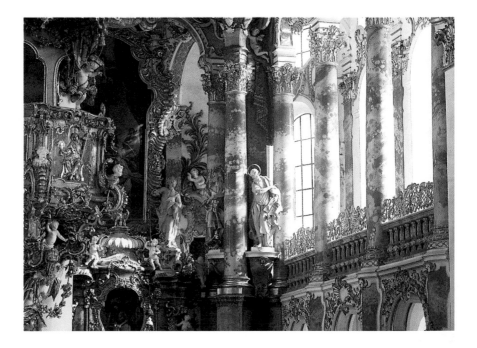

The union of all the arts: Dominikus Zimmerman, interior, Wieskirche, Steingaden (Germany), begun 1743.

was an elaborate, lively art that might sometimes appear awkward or naïve, but could often create a sense of richness, especially since the polychrome effect was employed in a spirit different from that of Spain—here color enlivened forms, providing movement. Instead of encouraging inner communion, it contributed to the overall spectacle.

A primary feature of this art was its evident concern—basically of religious inspiration—with organizing statues throughout the edifice, which was rarely the case in French or Italian churches. From one altar to another, from one plinth to another, the figures interrelate—it seems like a holy group dispersed above and around the worshipers, which again tended to confirm the shift of importance from individual statues to overall

effect. Some artists even extended this theatrical approach into the elaboration of a veritable stage set, henceforth stressing not only the use of various marbles (as in Italy) but also the illusionist potential of gilding and color.

In the monastery of Rohr, for example, Egid Quirin Asam depicted the Assumption by deploying white statues of Apostles at the back of the choir, around the empty tomb of the Virgin. The Apostles' faces are highlighted by a few touches of pink, agitated by surprised reactions that range from disbelief to adoration. Above them, meanwhile, set against a large tapestry with a gilded fringe, borne by two angels in gilded drapery, Mary rises toward heaven with outstretched arms, dressed in a gold-embroidered gown cinched by a gold belt (page 365). The bodies of

the figures are colored in subtle flesh tones that underline the lips and eyes. Of course, this piece may seem like a deflected echo—in praise of the Virgin—of earlier sixteenth-century Entombments, or more especially of Resurrections of Christ (of which some remnants survived). Some people may also feel that there is too much gold, too much theatricality. Yet we should be wary of our own taste, formed by familiarity with Michelangelo and Canova. We should learn to appreciate, unreservedly, different types of perfection. Polychrome sculpture is an age-old tradition, and it perhaps reached a level of perfection here, where forms and colors combine to create a triumphant harmony, a visual alleluia.

This accomplishment meant transcending the conventional separation of genres in search of a unified effect, which was precisely one of the major avenues explored during the seventeenth century and, above all, the eighteenth, until the knack was lost in the following century. The strongest evidence of this exploration lies in a phenomenon that could be attributed to architecture or painting but which seems closer to sculpture, namely the emergence of "Rocaille" art.

Rocaille arose from patterns based on shellwork and strapwork that, whether drawn or sculpted, conveyed to the eye an impression of depth as well as movement. The style swept Paris in the late seventeenth century with the swiftness of a fad, but once the fad settled down it delighted all of Europe, evolving into the Rococo style. Applied to furnishings, woodwork, and precious metals, Rococo wound up influencing both interior design and external architecture. It made the jump from the centerpieces of banqueting tables to church altars and walls, even governing the very design of certain churches. Not since the "Gothic" style with its gables, crockets, and pinnacles had art managed to free itself from the classical repertoire to invent a completely modern repertoire able to fulfill an artist's every need—and thereby able to impose both unity and harmony.

To appreciate all the potential and glamour of Rococo art, we need merely look at the interior of the church of Wies, decorated in 1746–56 (page 363). The church rises from fields in the midst of an undistinguished landscape. From the outside, the architecture is fairly ordinary, with a bell tower that is too narrow in relation to the double roof that masks a low dome, and with doors and windows that lack proportion and rhythm. But on entering the church, the visitor is caught up in a marvelous symphony. Benches, confessionals, pulpit, pilasters with their capitals, round windows with their ornate frames, the ceiling with its stucco-work, and even the motifs of the frescoes: everything merges together, everything is invaded by a profusion of gilded froth so lively that details escape the eye, which must let the flow of patterns wash over it without trying to disentangle them.

Egid Quirin Asam,
The Assumption, 1723.
Augustinian Abbey,
Rohr (Germany).

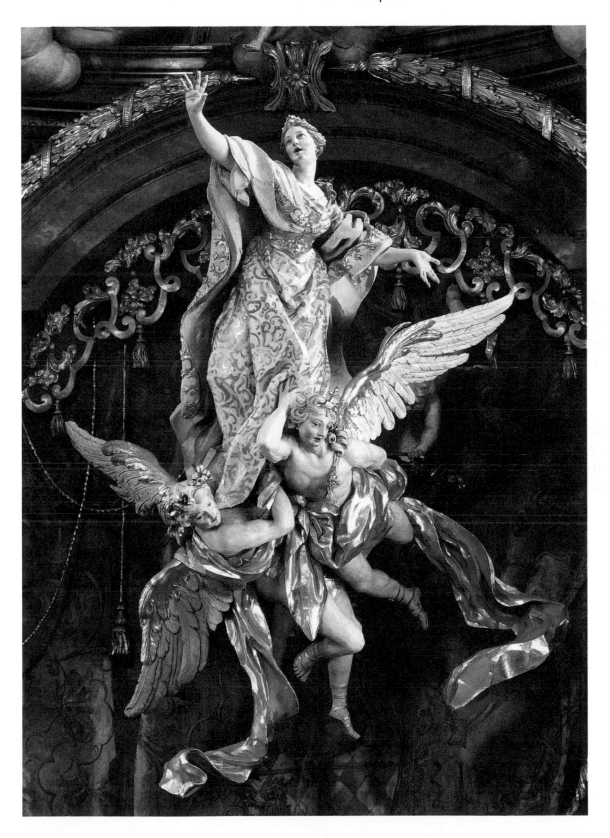

Painting

This period has often been described as the golden age of painting. The label is merited if we consider the importance of masters such as Guido Reni and Rembrandt, the diversity of artistic expression, and the simultaneous blossoming of all genres of painting. On closer inspection, however, some qualifications are called for: in Germany, struggling with the Thirty Years' War, the seventeenth century was practically barren; in England, the presence of Flemish artist van Dyck hardly compensated for the weak painting there; nor did the Spanish shine very much between the death of Velasquez (1660) and the first masterpieces of Goya (1776); in the Netherlands, the eighteenth century lacked the vitality of the previous one. So, apart from France and Italy, this "golden age" gives the impression of very uneven output that varied between specific countries and precise moments.

And yet a certain unity can be perceived. People were traveling more and more—a trip to Rome became increasingly obligatory for painters. A taste for collecting also spread, which stimulated the art market and auction rooms. Apprenticeship to a master was henceforth just one aspect of the training received by artists, who might now have access to divergent methods taught in an academy and who were more likely to come across—outside of churches—potentially influential masterpieces both old and recent. For example, a sketch by Rembrandt (Albertina, Vienna) reveals that he had seen Raphael's *Portrait of Castiglione* when it passed through an auction house in Amsterdam in 1639. This situation brought about increasingly complex developments: local traditions were weakened, while innovations had more impact and spread further. Fashions such as the taste for Rococo art and chinoiserie reached all of Europe. Engravings, which in the sixteenth century had helped so considerably to disseminate the works of Raphael and the "Mannerists," now played a more important role. As time went on, painters were increasingly confronted with countless contradictory styles that they had to learn to assimilate or reject in order to forge their own original art.

Yet when it comes to this period, art historians continue to categorize artists according to "national" schools. Was van Dyck a "Flemish" painter? Were Poussin and Claude Lorraine "French" artists? Or Ribera "Spanish"? These questions spark lengthy discussions of little merit and even less point. Henceforth the only

Pietro da Cortona,
The Age of Gold, 1637.
Fresco, Sala della Stufa,
Palazzo Pitti,
Florence (Italy).

analyses that are valid are ones that deal with each artist individually, studying his aesthetic inclinations and aversions, trying to grasp the essence of his art. Since there is not enough space here even to list all the most important artists, this chapter will merely stress some of the distinct paths that provide access into this dense period: an aesthetics of *intuition* versus an aesthetics of *ideas*, the choice between *rendering* or *executing*, and the choice between easel painting or decorative ensembles.

The aesthetics of "intuition"

It is striking that this period opened with a significant act of negation by Caravaggio (1571–1610), which had an enormous impact. Take, for example, one of his most famous works, the *Victorious Cupid* (page 369). Previously, most paintings had depicted the son of Venus as a child that incarnated the most perfect beauty. Caravaggio, however, took as his nude sitter some Roman street brat, making no attempt to modify the smirking smile, the flaccid belly, and the folds of the skin. Far from invoking allegory, far from placing his figure in an idyllic landscape, Caravaggio showed him in the studio in the midst of an affected heap of still-life objects. Caravaggio's painting, formerly on display in Marchese Giustiniani's gallery in Rome, was long accessible to the public.

A certain aesthetic was deliberately killed here, along with the perfect visual coherence of a painting.

Less than fifty years later, on seeing this work Nicolas Poussin would cry that Caravaggio had come into the world only to murder art. And yet something new was being born. Caravaggio's Cupid is no longer a character belonging solely to a fictional world; he is drawn so perfectly from everyday life that he gives the impression of existing outside of the role he plays on canvas. He seems to have a past, memories, his own psychology—an individuality that strikes the viewer and leaves a lasting impression. This is perhaps a type of realism, but it is also much more than that. The term "realism" can be applied to the old men painted by Rubens and to the drinkers depicted by van Ostade and Teniers, but here it has a different meaning. If we compare this painting with Perugino's *Saint Sebastian* (page 291) it is easy to see what has been lost—the self-contained visual coherence of the painting—and what, surprisingly, has been gained—the presence on the canvas of an individual with an intuited inner life, one who emerges from the canvas and triumphs over the alleged subject and conventionalized imagery of the painting, thereby becoming the main point of the work.

Caravaggio did not limit himself to this approach. He also enjoyed painting a David exhausted by his exploits or a troubled and weary Herodias. And toward the end of his career Caravaggio abandoned psychological analysis for grand compositions in which anonymous figures seem to emerge from the shadows.

Caravaggio, *Victorious Cupid*, 1602–03. Oil on canvas, 5′1″ × 3′8″ (1.56 × 1.13 m). Staatliche Museen, Berlin (Germany).

His contemporaries could not follow him down that path. Knowing only fragments of his oeuvre, they were struck above all by his new sensibility—profoundly at odds with the formal games then in fashion—and by his visual rhetoric, which, harking back to the fifteenth century tendency to ignore historical settings, could present biblical or mythological deeds as contemporary events.

Caravaggio's public was not simply limited to Rome and Naples, where he had painted some of his masterpieces. The Spanish were immediately impressed. By 1612–13 Juan Bautista Maino (1578–1649) was already executing a large *Adoration of the Shepherds* that is largely devoted to the realistic depiction of peasants, and in which the three angels themselves are real, barely disguised teenagers (page 370). Francisco de Zurbarán (1598–1664), too, seems to have acquired the solemn simplicity of his art from Caravaggio. His *Saint Serapion*, signed and dated 1628, depicts a terrible method of torture that dated back

to the thirteenth century: Serapion, both hands lashed to posts, was beaten to death, disemboweled, and had part of his neck cut so that his head would hang (page 371). Yet Zurbarán includes neither executioner nor spectators, nor instrument of torture, nor blood on the saint's habit. The deep folds stand out white against the black, and everything draws the eye toward the face: Serapion's mouth is half open in a final sigh, his eyes close on his private suffering and death.

The many Dutch painters who visited Italy returned home with an uncompromisingly realist vision. By 1618, Gerrit van Honthorst (1590–1656) combined this vision with effects of artificial lighting, thereby reviving the "night scenes" that had been somewhat forgotten since the fifteenth century. In contrast, Hendrick Terbrugghen (1588?–1629) was able to wed great subtlety of color to the simple pathos that is so moving in his work (page 372).

Hendrick Terbrugghen, *Saint Sebastian Tended by Irene*, 1625. Oil on canvas, 4′10″ × 3′10″ (1.49 × 1.19 m). Allen Memorial Art Museum, Oberlin (Ohio).

Valentin de Boulogne,
The Judgment of Solomon,
c. 1625. Oil on canvas,
5′9″ × 6′10″
(1.76 × 2.1 cm).
Musée du Louvre,
Paris (France).

In Italy, young painters got caught up in a kind of fad. Bartolommeo Manfredi was probably the most faithful and most skilled of Caravaggio's followers, but his cabaret scenes and groups of guards show that realism, however perfect it may be, can tend to become narrow and repetitive in inspiration. In contrast, José Ribera in Naples favored scenes of often brutal violence, which he firmly anchored in Neapolitan tradition.

French painters of this generation, most of whom spent time in Rome, could hardly fail to learn the new lesson. Valentin de Boulogne, who moved to Italy at an early age, was perhaps the most amenable to it. His figures, including children, are imbued with a kind of irremediable melancholy— there are no smiles or laughter anywhere in his oeuvre, not even in his pictures of guards or concerts. He was beginning to apply this aesthetic to biblical scenes such as *The Judgment of Solomon* (page 373), merging it with the rhetoric of passion (without, however, relinquishing his austere solemnity), when he died prematurely in 1632. Nicolas Tournier also died young, just as he was freeing himself from the conventions arbitrarily associated with Caravaggio (whose art, in fact, had been varied).

Two other examples from France nevertheless reveal an unexpected lineage. The three Le Nain brothers—Antoine, Louis, and Matthieu—were born in Laon and worked in Paris. They belonged to a generation distinctly later than Caravaggio's, and none of them seem to have traveled to Rome or anywhere else in Italy. It would be surprising if they had managed to see any of Caravaggio's important canvases. And yet, on looking at their *Family of Peasants* (page 374), it is clear that we are a long way from the genre scenes so common in northern countries, with their taste for the more or less bawdy burlesque. It is hard to comprehend the simplicity and solemnity of the Le Nains without making a link to Caravaggio or one of his followers. The figures are still, silent, turned inward. There is no trace of "Mannerism," no action to yank them out of their inner world. Their poses are frozen, their eyes turned toward the viewer. The entire weight of a life can be read in the gaze of the old lady seated on the left, silent and dignified.

The other example is Georges de La Tour. He had the great luck to spend time in Italy between 1613 and 1616 before returning to his native Lorraine. It was in Italy that he must have acquired his penchant for direct observation of lower-class people and beggars, which seems to have inspired his

Le Nain brothers, *Peasant Family*, c. 1642. Oil on canvas, 3′8″ × 5′2″ (1.13 × 1.59 m). Musée du Louvre, Paris (France).

series of *Apostles* (Albi Cathedral, France) and his series of *Hurdy-Gurdy Players*. But it was after 1636 that his psychological descriptiveness deepened and converged—through even greater austerity—with Caravaggio's late output. La Tour increasingly employed nocturnal effects, as seen in his *Saint Sebastian Tended by Irene* of 1649 (page 375). There is no movement, no speech, no inter-action between the protagonists,

who are all withdrawn into themselves; there is no indication in this painting of any period that would give it a historical meaning. And what do we see on the faces? All that remains are women leaning over an unconscious body in silent compassion. In this respect, La Tour went even further than Caravaggio, yet arrived at an opposite destination: by simplifying things, he effaced the individual psychology of his figures and simultaneously

Georges de La Tour,
Saint Sebastian Tended by Irene, 1649.
Oil on canvas, 5′5″ × 4′3″
(1.67 × 1.3 m).
Musée du Louvre,
Paris (France).

recovered two features that Caravaggism had foregone: the self-contained visual coherence of a painting and the presence of the *idea*.

It might seem absurd to situate an artist like Rembrandt in the Caravaggio tradition. Rembrandt van Rijn (1606–69) trained exclusively in northern Europe, never traveling to Italy. Yet it should nevertheless be acknowledged that his art is founded on a realism that is not so distant from Caravaggio's. He never dwelt on a mythological subject without incorporating some mocking detail. Just as Caravaggio based his *Victorious Cupid* on a Roman street brat, Rembrandt depicted *Ganymede* (page 376) as a chubby, wailing infant terrorized by the eagle carrying him to the heavens; neither Paul Scarron's *Virgil Travestied* (1648) nor Honoré Daumier's later caricatures of Olympian gods would be so scathing.

Without the precedent of Caravaggio, would Rembrandt

Rembrandt,
The Abduction of Ganymede, 1635.
Oil on canvas, 5′6″ × 4′3″
(1.71 × 1.3 m).
Musée du Louvre,
Paris (France).

Rembrandt,
Bathsheba at Her Bath,
1654. Oil on canvas,
4′7″ × 4′7″ (1.42 × 1.42 m).
Musée du Louvre,
Paris (France).

have painted biblical scenes with so little concern for historic dress? A vaguely oriental feel barely disguises his casual approach, as witnessed by one of his major masterpieces, *Bathsheba at Her Bath* (page 377). On completing her bath, Bathsheba, wife of Uriah the Hittite, holds in her hand the letter that King David has sent her. Rembrandt made no attempt to idealize her body: she is a plump, undressed Flemish lady, her blouse next to her, her feet tended by a servant. She is lost in thought, already envisaging adultery. Yet her expression is so true and the painting so powerful that there is clearly no intent to mock—here realism is not used to update the vision but to render it timeless. That was the effect usually produced by Rembrandt. Even more inclined to examine himself than

Dürer had been, his numerous self-portraits carry visual analysis to a kind of verism that, from canvas to canvas, reveals an entire inner life with its wounds, its slowly accumulating weariness, its anxiety about the future. Nothing could be much further from the sculpted busts discussed above, nor from the brilliant, picturesque portraits of Frans Hals. With Rembrandt, elegance and stateliness wane from portrait to portrait, allowing the emergence of a profound truth that slowly turns into a moving sense of resignation.

This tragic aspect of Rembrandt's realism is fully evident in his engravings, the masterwork of which is certainly *The Three Crosses*. On several occasions Rembrandt took up and reworked the same plate; illustrated here are the first state (page 378) and the fourth state (page 379). The early versions still displayed a concern to recount the Bible's most dramatic episode, but by the fourth state everything has collapsed into darkness. The paper is scarred with deep scratches, leaving only the half-open sky, the upright Christ, and the shadows

Rembrandt,
The Three Crosses,
first state, 1653.
Etching, Rijksmuseum,
Amsterdam (Netherlands).

Rembrandt,
The Three Crosses,
fourth state, c. 1660–61.
Etching, Rijksmuseum,
Amsterdam (Netherlands).

that overwhelm the scattered, frightened crowd. Here again, the quest for an inner reality triggered a reversal, culminating in a purely visionary expressionism.

Rembrandt had a strong personality, and much has been said about the misfortunes that plagued him, about a society that failed to appreciate his genius. In fact, he won recognition early and held onto it until his death (*The Syndics* was commissioned as late as 1662). Historians of Dutch art always discuss him in emotional terms—"a brilliant star

in the sky," or, "even today we feel we have lost a good, close friend"—but this devotion often blinds people to the merits of Rembrandt's contemporaries, such as Jan Lievens and Aert de Gelder. Through his paintings and engravings, Rembrandt nurtured northern Europe's realist penchant, one that rejected beauty and employed chiaroscuro or artificial lighting. His influence would long be felt, even in a period when French and Italian painters, little affected by Rembrandt's work, were heading in other directions.

An aesthetics of "ideas"

Why did Poussin claim that Caravaggio had come into the world only to kill painting? Not because he considered *Victorious Cupid* to be a poorly painted picture, but because he viewed it as a rejection of art as a *cosa mentale*, that is to say a pure conception of the mind, one that can and should refer to nature, but only to recreate its own mental world. Poussin, trained in Paris, had not experienced the glamour of Caravaggism in his youth. Instead, he made his own way through a Mannerist lyricism whose boldness he admired even if he sensed its emptiness. What might be called realism's passive spiritualism escaped Poussin, who felt that a painter should be driven by the lucid quest for an idea, for creative "generosity."

Consider one of his canvases that, although not by any means one of his most appealing, shows how Poussin forthrightly reversed Caravaggio's approach. It depicts a biblical scene, the miraculous gathering of manna that saved the starving Hebrews as they crossed the wilderness on their flight from Egypt (page 381). At first glance, we see just a jumbled crowd in a landscape of no particular interest; there is nothing distinctive about the clothing to draw the eye and hold it, just straightforward ancient-style drapery. This painting requires a more attentive look, however, as suggested by the man on the left who contemplates the scene. The left part of the picture offers an image of dereliction: a man, perhaps ill,

remains prone in despair. A woman pushes her child away, saving the last drops of milk in her breast for her mother. Already, however, hope is returning as a youth helps an old man to rise, pointing to the manna on the ground not far away. On the right side of the painting Poussin shows various reactions to God's saving grace: some people greedily eat the bread on their own, others fight over it, one young woman naïvely holds out her apron (not even wanting to bend over to pick up the manna); in contrast, another young man stops to take food to the weak, as pointed out by a woman who even overlooks her own child. In the middle ground are those people who, far from satisfying their own needs, acknowledge the miracle; grouped around Moses, their leader, and Aaron, their priest, they offer God their gratitude, submission, and prayers. Poussin thus recounts the story like a poem, stanza by stanza, linking wretchedness, despair, hope, selfish greed, charitable virtue, gratitude toward spiritual leaders, and celebration of God's gifts. The artistry that went into this painting becomes easier to appreciate if we remember that the miracle of the gathering of manna was always interpreted as a symbol of divine grace, one of the seventeenth-century's major spiritual issues, which, even outside a religious context, remained at the heart of any reflection on human fate. The picture was not just an abstract discourse illustrated with figures, but a scene that was reconceived, relived by the artist; not a

Nicolas Poussin,
The Gathering of Manna,
1637–39. Oil on canvas,
4′10″ × 6′6″ (1.49 × 2 m).
Musée du Louvre,
Paris (France).

reconstruction of a biblical event, but a meditation expressed through the analysis of human emotions. This was what the seventeenth century meant by the "ideas" behind an artist's work.

These "ideas" should not be confused with the quest for the "ideal." The latter concerned perfect beauty, but was linked to the former in so far as a painter's vocabulary was based on the human figure. Poussin himself enjoyed depicting appealin women and he often set his scenes in a world where even old age retained classical beauty (whether it was *Moses Drawing Water from*

the Rock or *The Rape of the Sabines*). Poussin thereby perpetuated the grand tradition of Annibale Carracci, whose frescoes of the *Loves of the Gods* in the Farnese Gallery in Rome were derived from Mannerism yet firmly corrected by a close study of nature. Domenichino, Guido Reni, and Pietro da Cortona had visually expounded this important lesson, which to a large extent harked back to the sixteenth-century teachings of Raphael and Titian.

France thus adopted this path. This applied not only to most of the painters who spent time in Rome—Simon Vouet,

François Perrier, Charles Errard, and Charles Lebrun—but also those who did not manage to make it there, such as Laurent de La Hyre, Eustache Le Sueur, and Jean Jouvenet. They all developed a visual language able to delight the mind even as it pleased the eye.

This perhaps explains the rise in Italy and France of a tradition of bacchanals, on land and on sea, which celebrated the beauty of bodies freed from the constraints of clothing, freed from the shackles of Christianity, free to enjoy the pleasures of life in all immodesty. The unhindered world of ideas, expressed through ancient mythology and henceforth stripped of any religious connotation, authorized daring subjects. On the ceiling of the Farnese Gallery, Carracci staged the amorous procession of Bacchus and Ariadne, an idea that Reni borrowed for his *Bacchus and Ariadne* (1637–40), a large painting with nineteen figures in which the nudes were so suggestive that the prudish heiress of the collector who acquired it had it taken to pieces in 1650 (furthermore, only in recent decades has Reni's large *Adam and Eve* been placed on public display in Dijon, France).

Nicolas Poussin,
The Triumph of Amphitrite,
c. 1634. Oil on canvas,
3'9" × 4'9" (1.14 × 1.46 m).
Philadelphia Museum
of Art, Philadelphia
(Pennsylvania).

François Boucher,
The Triumph of Venus,
1740. Oil on canvas,
4′3″ × 5′3″ (1.3 × 1.62 m).
Nationalmuseum,
Stockholm (Sweden).

Pietro da Cortona was perhaps cleverer in adopting *The Four Ages of Civilization* for his frescoes in the Palazzo Pitti. Yet his "Age of Silver" and "Age of Gold" (1637) seem all the stronger an invitation to a life without care or sin. Poussin, meanwhile, blithely painted bacchanals for Cardinal Richelieu that serve as paeans to physical beauty and happiness. Nudity is perhaps best justified when it occurs on the seashore, so Bacchus might be replaced by celebratory depictions of Amphitrite in which the pearly flesh of her nymphs gleamed against frothy blue waters (page 382). This dream of a

world rid of original sin was repeatedly taken up not only by Poussin but also by Vouet, Le Sueur, and others. Boucher produced one of the most accomplished examples in 1740 with his *Triumph of Venus* (page 383). This long-running series provided painting of this period— often so tragic—with a big ray of sunshine.

Bacchanals were largely reserved for France and Italy. It should not be thought, however, that the aesthetics of "ideas" was always associated with taking liberties (in all senses of the term). On the contrary, it often eschewed sensuality in favor of epic

lyricism, and was perfectly adapted to religious subject-matter. A perfect example was Charles Lebrun (1619–90), a distinguished, private, and earnest man who above all sought to gauge the possibilities of the art to which he had devoted his life. His major masterpiece was a set of four immense canvases of *The Story of Alexander* (c. 1665–73), now on view in the Louvre (page 384). The ambitiousness of the undertaking was justified by the powerful inspiration behind it, often decried but never equaled.

A similar attitude characterized Jean Jouvenet (1644–1717), who executed many paintings, most of them religious subjects. His finest works are probably the four large canvases illustrating the *Life of Christ*, executed in 1704–06 for the nave of the Parisian church of Saint-Martin-des-Champs (now in the Louvre and the Musée des Beaux-Arts, Lyon), although his most famous work is a *Descent from the Cross* painted in 1697 for the altar of the Capucine monastery in Paris (page 385). A fine feel for "concept"—here, the full light that falls on corpse and shroud—enabled him to rival Rubens, and it might be argued that his solemnity is in no way inferior to Rubens' verity.

"Rendering" versus "executing"

During these two centuries, another split arose among painters. This

ABOVE

Charles Lebrun,
The Battle of Arbela
(detail), c. 1668–69.
Oil on canvas,
15′3″ × 41′1″
(4.7 × 12.65 m).
Musée du Louvre,
Paris (France).

FACING PAGE

Jean Jouvenet,
Descent from the Cross,
1697. Oil on canvas,
13′9″ × 10′1″
(4.24 × 3.12 m).
Musée du Louvre,
Paris (France).

time it involved neither the rhetoric nor the subject-matter chosen, for it had much less to do with intention than with strict technique. For some unexplained reason, painters tended to divide into two types. Some were concerned to depict what they saw or imagined with a faithfulness that would fool the eye. They meticulously modeled forms, often with the aid of glazing techniques; although not going so far as van Eyck, they still wanted to "render" every detail and nuance. To other painters, however, this highly skilled "rendering" seemed petty. They wanted people to admire their fine "execution," that is to say the brilliance of their brushwork, the dazzle of their *fa presto*. They strove to make a few brushstrokes—applied with an apparent randomness that they knew connoisseurs would recognize as truly artful—cohere when viewed from a certain distance, thus creating a powerful impression of color and light. This kind of painterly *non finito* had not really existed

Peter Paul Rubens,
The Rape of the Daughters of Lucippus, c. 1618.
Oil on canvas, 7′3″ × 6′10″
(2.24 × 2.1 m).
Alte Pinakothek,
Munich (Germany).

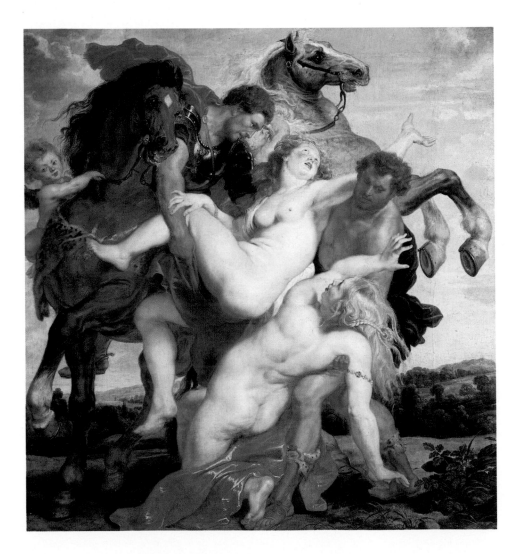

until the sixteenth century, but soon it would obsess many painters and would sometimes overshadow differences in spirit and subject-matter.

Free brushwork

As we have seen, antiquity was familiar with this painterly technique, but it is unlikely that any of it was recovered. It was perhaps an entirely personal approach that led Titian to employ loose brushwork in his late work, a technique that was immediately noted and appreciated. The main features of what would become "dashing expressiveness" thus emerged in Venice. Tintoretto's forms, for example, are more sketched than drawn, while El Greco—another heir to Titian— took free brushwork to its expressive limits in a work such as his *Adoration of the Shepherds* of 1612–14 (Prado, Madrid).

Peter Paul Rubens (1577–1640) may have been more discreet in his use of loose brushwork, but this very discretion helped to spread his influence. The brilliant Rubens has rightly been called the first distinctly European artist. Born in Cologne, Germany, he was educated in Antwerp, Flanders, but spent years in Italy (Mantua, Rome, Genoa) and worked in Paris, London, and Madrid. His works were widely seen and appreciated, the reflection of an artist who was educated, humanistic, probably devout, and extremely active. One of Rubens's prime merits was his fine brushwork: firm, colorful, with an admirable dexterity (page 386).

It is not that Rubens deliberately sought an effect of *non finito*, nor for that matter, a personal "manner": during his heyday he ran a large workshop in Antwerp where young painters worked directly on his commissions and where others painted or completed copies or variations. But in his finest pieces, Rubens's technique is supple—his swift brushstrokes often make highlights quite visible, at least when seen close up. "Execution" transposes a subject into the artist's personal, easily recognizable language, with no attempt to "render" the reality of the object. It might be added that Rubens's many drawings—well known and highly sought after—were so swift in execution as to border on the violent. They demonstrate beyond a doubt the extent to which personal inspiration guided his hand—the concern to "render" objects was only a secondary concern.

In this complex climate there arose styles that clearly defined themselves in terms of *dipingere di tocco*, or "painting in broad strokes." Examples can be seen in the oeuvres of Domenico Feti (1588–1623) and Johann Liss (1597–1631), especially the latter's Venetian period.

The most striking case of this influence, however, is probably French painter Claude Vignon (1593–1670). Sometime after arriving in Italy, Vignon began leaving obvious brushstrokes on his canvases. He was not content with a swift technique; he avoided blending colors, preferring to apply

thick, fat strokes, while in the lighter sections he left large particles of bright pigment, boldly giving a rough surface to his works. His smaller pieces thus took on the vividness of enameling, whereas his large canvases acquired striking impact, as seen in his *Adoration of the Magi* (1619, Dayton, Ohio), *Godefroy de Bouillon* (c. 1623, church of Saint-Roch, Paris), and another *Adoration of the Magi* (1625, church of Saint-Gervais-Saint-Protais, Paris).

We know that the young Rembrandt was in contact with Vignon, from whom he must have derived some of the expressive style that so struck his contemporaries. As early as 1685, French historian André Félibien des Avaux noted that Rembrandt "often made large brushstrokes and laid down thick colors, one after another, without blending and merging them together." But Félibien observed that, "with distance, these strong brushstrokes and thick colors diminish from view... producing the desired effect." Soon enough, Rembrandt's unmodeled works, especially the self-portraits composed of small, thick chaotic touches and long, shapeless strokes (though without the dripping colors so dear to Vignon) won the fervent admiration of his admirers, which passing time would only reinforce.

It was Rembrandt who lent credibility to this "broad" style. And it was portraitists such as Frans Hals who made most brilliant use of it. Hals's repertoire is picturesque but rather uniform and lacking in charm; his realism rejected any attempt to correct the coarse features of a face or self-satisfied pose. Yet his extremely free brushwork managed to transform the crudest subjects into carefree sketches. In late portraits of the regents and regentesses of an old people's alms house in Haarlem, dated 1664, Hals's loose, elliptical style is positively fascinating, but might be interpreted as the insolence or impotence of an artist who saw death approaching. Yet in fact, if we look at a painting generally dated to 1629–30, the style is already very lively if also somewhat crude (page 389). This small work has been titled *Malle Babbe* ("Witch of Haarlem") on the basis of a later document, but it translates fairly well the face of a young, half-inebriated sorceress. Ultimately, everything is transfigured by Hals's energetic, swift execution; it looks as though he improvised, not even taking the time to spread flat colors or encrust the pigment. He scars the painting with a few disordered strokes, evoking in a few touches the ruffled collar, the dull reflections in the pewter jug, and the cackling laughter of a face prepared for insult.

It is no sacrilege to compare the work of Hals to that of Diego Velasquez (1599–1660), the official painter to the court of Spain. Although somewhat short on inspiration and devoid of lyricism, Velasquez's oeuvre has been praised to the skies, yet it might seem somewhat monotonous were it not for a dozen or so major canvases such as *Los Borrachos* ("The Drinkers,"

Frans Hals, *Malle Babbe*
("Witch of Haarlem"),
c. 1629–30. Oil on canvas,
30 × 25″ (75 × 64 cm).
Staatliche Museen,
Berlin (Germany).

Prado, Madrid), *Joseph's Coat* (Escorial, Madrid), and *The Rokeby Venus* (National Gallery, London). It must be acknowledged, however, that Velasquez's palette is always successful and that his virtuoso brushwork is unsurpassed. His *Portrait of Pope Innocent X* (1650, Galleria Doria Pamphilj, Rome) may be rather pedestrian in composition, but its lightness of touch is absolutely wonderful. His series of portraits of royal children (Madrid and Vienna) displays subtle color harmonies and generates unrivaled appeal through apparently improvised brushwork that seems haughty yet casual as it produces magnificent effects of satin and silver braiding (pages 390 and 391). After seeing such brilliant brushwork, it

becomes difficult to bear all those other official portraits churned out during the seventeenth century.

Understandably, other artists such as Magnasco in Genoa and Guardi in Venice realized that the stress on "execution" could take painting in new directions. Alessandro Magnasco (1667–1749), known as Il Lissandrino—and dubbed "the Watteau of the rabble" by French art historian André Chastel—specialized in deliberately unpleasant subjects: clamorous groups of scruffy characters or alarming gatherings of tall, thin monks, sorcerers, Punchinello figures, and skeletons. Nothing very palatable—and yet everything enlivened by swift, willfully casual brushwork that left long, chaotic strokes. Magnasco almost seemed to be making fun of himself as he ventured these artistic sallies.

Quite different was the genius of Francesco Guardi (1712–93), who combined wit and finesse. In his day, nothing could be more run-of-the-mill than a view of Venice. Yet Guardi sensed this intuitively, and so he rejuvenated imagery through brushwork that was refined and surprising, thereby lending life and spice to overly familiar landscapes. Everything is precise, and yet vibrant and alive. A simple, ruined porch overgrown with weeds became, through the magic of Guardi's paintbrush, an incomparably poetic vision.

In Paris, too, there was a group of artists in the 1760s who sought above all the beauty and vivacity of brushwork. The group was

admired yet mockingly called the partisans of *Tartouillis* ("gaudy daub"). Its hero was none other than Jean-Honoré Fragonard, whose notorious "fanciful figures" were allegedly executed in an hour, start to finish—yet they appear to be not only real portraits but good likenesses (page 392). The brush was wielded with a swiftness that borders on violence. In a much smoother but equally lively manner, Fragonard also painted the famous *Bathers* in the Louvre (page 393). The jumble of foliage, clouds, and ladies is so intertwined that the eye has difficulty deciphering the scene—it can barely distinguish the uprooted tree that has fallen across the stream, around which this sensuous group clusters. All the charm resides precisely in a composition that affirms nothing and describes nothing, drenching everything—especially gleaming flesh—in a play of light.

Jean-Honoré Fragonard,
Portrait of Abbé de Saint-Non (Fanciful Figure),
1769. Oil on canvas,
32 × 26" (80 × 65 cm).
Musée du Louvre,
Paris (France).

Jean-Honoré Fragonard,
Bathers, c. 1763–64.
Oil on canvas,
25 × 32″ (64 × 80 cm).
Musée du Louvre,
Paris (France).

Enduring tradition

This art of allusion knowingly broke with what had been the grand tradition of oil painting since van Eyck, namely making the viewer forget the presence of paintbrush and painter, giving the impression of reality reproduced on canvas with the accuracy of a mirror. This tradition nevertheless retained all its prestige in the seventeenth and eighteenth centuries—no one considered it to be "backward" compared to the bravura brushwork of a Hals or a Fragonard. Despite the hierarchies and chronologies gratuitously established in the twentieth century, a meticulously fine "rendering" has remained a quality admired by art connoisseurs of all periods.

It is not surprising that almost all painters of still lifes and landscapes sought to perfect this rendering, for they were naturally inclined to convey the right volumes and tactile qualities of depicted objects, often pushing the effect to extreme trompe l'oeil. It would be difficult to outdo the freshness of the flowers painted by the likes of Osias Beert or Daniel Seghers, the

precision of the baskets of fruit by the likes of Abraham van Beyeren, the magnificence of the precious metals by Willem Kalf, the luminosity of the skies of van Goyen, and the verisimilitude of the cows and horses by Paulus Potter. The fame of Dutch painting long rested not on a bold style associated with Rembrandt but on the fabulous minutiae recreated by these artists, particularly when it came to the genre scenes that northern painters made their specialty.

Take, for example, *The Dropsical Lady* by Gerrit (or Gerard) Dou (1613–75). Dou had spent three months in Rembrandt's studio, admittedly at a very young age, and had initially imitated the master's manner. Soon enough, however, he became interested in compositional complexity and technical polish, winning great popularity with his meticulousness. His *Dropsical Lady* belongs to his last years. The overall layout, with the strong effect of dark and light, might seem appropriate to a grand history painting (page 395). Yet it is modest in size (barely 3 by 2 ft., 86 by 67 cm), if somewhat larger than Dou's usual format (rarely more than 8 to 15 by 8 to 12 in., 20 to 40 by 20 to 30 cm); and the subject is deliberately low in tone—a doctor is examining a rich lady's urine. In contrast, the composition has been elaborated down to the tiniest detail and painted with extreme care: no branch or even reflection is lacking from the brass chandelier, no pane has been left out of the window. The light is skillfully handled and the poses seem

natural. Such paintings were highly valued in Dou's own lifetime, and he enjoyed great success in Holland. The nineteenth century still considered them worthy of the finest masterpieces of painting. Nowadays, it is difficult to admire so much effort being put into such slight subject-matter. But might our connoisseur's sensibility be at fault? Perhaps we just have difficulty accepting a perfection that leaves so little room for poetic imagination.

Fascination with optics

Certainly easier to appreciate is the style of, say, Philippe de Champaigne (1602–74). That may be because he was born in Brussels, or because he went to Paris at a time when the art of Frans Pourbus the Elder was at its height. Champaigne's painting displays tightly controlled technique—the most scrupulous care is taken when reproducing the sheen of fabrics, the moiré of ecclesiastical garb, or points of lace. Perhaps the most distinctive feature of his work is his treatment of hands, which are precise, glowing, and lifelike. One look at a portrait of a man long thought to be Robert Arnauld d'Andilly reveals Champaigne's clear vision and concern for tactile reality, two qualities that date back to van Eyck (page 397). Does this make his painting archaic? No. Champaigne was fully conversant with so-called "baroque" expressiveness. Taking a longer look at his *Repentant Magdalen* (page 396), we see how

Gerrit Dou,
The Dropsical Lady, 1663.
Oil on wood,
34 × 26″ (86 × 67 cm).
Musée du Louvre,
Paris (France).

everything relates to the grand tradition of seventeenth-century painting: the tense expression of the large, pale face that wavers between previous beauty and penitential plainness, the gesture of the crossed hands in which modesty mingles with piety, and the strange harmony of blues and browns. And yet everything is minutely depicted, from the skull and the empty vase (which recalls the supper at Simon's) to the crystalline

tears running down Magdalen's cheeks. The illusionist "rendering" of the scene, far from being anecdotal, contributed to the austerity of a mystical philosophy that attains the heights of lyricism.

It would be mistaken to confuse this realism with the other, entirely different realism associated with the tradition of Caravaggio. The Caravaggesque artist sought contrasts that would tease out a deeper psychology; beautiful "rendering,"

Philippe de Champaigne, *The Repentant Magdalen*, 1657. Oil on canvas, 4′2″ × 3′1″ (128 × 96 cm). Musée des Beaux-Arts, Rennes (France).

Philippe de Champaigne,
Portrait of a Man (formerly
known as *Robert Arnauld
d'Andilly*), 1650.
Oil on canvas,
36 × 28″ (91 × 72 cm).
Musée du Louvre,
Paris (France).

meanwhile, sought only to reflect appearances, be they flowers, fruit, fabrics, or faces. It was based on the principle that painters should above all attempt to imitate nature, an old rule inherited from antiquity, which no one dared defy even if great liberties were taken in that imitation. The imitation of appearances might still represent an ideal, a true accomplishment, rather than a simple exercise in virtuosity.

Take, for example, a painting such as *The Death of the Children of Bethel*, executed in 1653 by French artist Laurent de La Hyre (page 398). It illustrates a story from the biblical Book of Kings, recounting how children who mocked the prophet Elijah were killed by two bears. La Hyre focuses on the despair of the mothers who come to identify the bodies; he did not produce a small, Flemish-size painting, but a fairly large canvas (over 3 by 4 ft., 0.97 by 1.29 m) designed to decorate a great connoisseur's study. La Hyre was familiar with Poussin's ideas, and proceeded to express the emotion in separate "episodes" set before antique ruins that were skillfully evoked and rendered in perspective. The entire scene is bathed in a crystalline light that underscores

the pure draftsmanship and subtly harmonious palette. Furthermore, in the foreground the reflection of the corpse of a young lad in the pool of water obeys all the rules of optics, as does the aerial perspective in the distance on right and left, which becomes progressively fainter until the cortege on the right is almost imperceptible. Here we do not have an attempt to deceive the eye, but rather a decision to set the subject in a new space, one that fully respected emerging scientific laws. La Hyre was applying the principles of optics as expounded by Girard Desargues, principles that were well received at the Académie Royale in Paris (founded in 1648). Only a kind of anachronism would later allow critics to declare that the free handling of a Hals or Velasquez was "modern" while the careful rendering of a La Hyre was "backward." To the contrary, mastery of the laws of optics was a decisive advance for painting in those days, and was the inspiration for many masterpieces ranging from Watteau's *Embarkation for Cythera* to Tiepolo's ceilings.

From easel painting to decorative ensembles

The discrimination between small paintings designed for "cabinets" (private studies) and large decorative ensembles may appear even more

Laurent de La Hyre,
The Death of the Children of Bethel, 1653.
Oil on canvas,
3′2″ × 4′2″ (97 × 129 cm).
Musée des Beaux-Arts,
Arras (France).

arbitrary than preceding distinctions. Not all painters who produced small pictures dared to decorate entire walls, whereas most of the major decorators also did small nudes, genre subjects, and portraits. Here it was demand that played a key role, although decorative artists had to have skills that could only be supplied by knowledge of the grand tradition. It so happened that kings and princes of the seventeenth and eighteenth centuries, more or less at peace, enjoyed substantial revenues; meanwhile, the Catholic abbeys of Germany and Austria wanted to recover their former glory once the religious wars had cooled. As to science, throughout the sixteenth century Italy had nurtured and even promoted theoretical speculation on light and geometry, making it possible to adapt painting to the scale of large edifices (thanks to scientific work by the likes of Jean-François Niceron, Girard Desargues, and Andrea Pozzo), sparking widespread enthusiasm. It was also a propitious period for collectors, who enjoyed the refinement of small Dutch and Flemish genre scenes or still lifes by the likes of Chardin. But it must be admitted that the period's chief contribution to art history lay in decorative ensembles of an scope and skill unknown beforehand and never equaled since (despite the nineteenth century's many efforts).

The fashion for small formats

Inspiration is inspiration—and quality has never been a question of size or genre. Some great artists of the day deliberately chose smaller formats. There can hardly be canvases any more perfect than those done by Jan Vermeer, and yet the *Lacemaker*, for instance, is 9 $\frac{1}{2}$ by 8 $\frac{1}{3}$ in. (24 by 21 cm, page 400). It shows only a half figure—or rather, head and shoulders—the sitter being humble, the depiction straightforward, the background plain. Yet since it was acquired by the Louvre in 1870, this little plaque of wood has been considered one of the museum's finest masterpieces. What is the source of such fascination? Is it the very simplicity of the subject and the young woman's indifferent pose, which reduces her head to a simple volume and hides her gaze, thereby avoiding any anecdotal narrative? Or is it the extremely rich coloring, set in a pale light, that juxtaposes the yellow-gold dress with the deep blue cushion and the scarlet threads of silk, everything being tempered by the neutral color of the wall, while being enlivened by a few white highlights? All of this painting's most precious secrets are contained within a surface of less than one square foot.

Moving to the eighteenth century, the canvases of Jean-Baptiste-Siméon Chardin may display less visual audacity, but his discretion masks a skillful alchemy admired by Diderot: "We understand nothing of this magic. There are thick layers of colors, applied one on top of the other, whose effect emanates from bottom to top; other times, it seems as though a vapor has been blown across the canvas." Chardin only rarely painted pictures of even

middling size (such as his diploma piece, measuring 3 ft. 8 ¾ in. by 4 ft. 9 ¾ in., 1.14 by 1.46 m), for his oeuvre was largely composed of formats that ranged from small (1 ft. 4 ½ in. by 1 ft. 1 ¼ in., 42 by 34 cm) to very small (6 ⅗ by 9 in., 17 by 23 cm). He was often content with simple still lifes (*The Copper Cauldron*, Musée Cognac-Jay, Paris; *The Copper Fountain*, Louvre, Paris), but he also enjoyed painting scenes with one, two, or at most three figures. One of his most exquisite and most admired paintings, which entered the royal

Jan Vermeer,
The Lacemaker, 1665.
Oil on canvas-backed wood, 9 × 8″
(24 × 21 cm).
Musée du Louvre,
Paris (France).

Swedish collections as early as 1749, is titled *The Morning Toilet* (page 401). There is no point in looking any further than the title: a young mother is adjusting her daughter's bonnet before they go out. Here again, the setting of the room, though small, leaves a large area of neutral ground. Here again, the light exalts a range of reds and pinks that intensify the central patch of pale blue, while the whites play a decisive role by establishing a contrast with the woman's black cape, a black all the more profound and velvety for being almost entirely composed of various shades of gray. A whole book could be written about such a painting, even though it has nothing to say. Even the loquacious Diderot realized that Chardin's art restored painting to its original nature—silent poetry.

Jean-Baptiste-Siméon Chardin, *Morning Toilette*, c. 1740. Oil on canvas, 19 × 15″ (49 × 39 cm). Nationalmuseum, Stockholm (Sweden).

The infatuation with vast ceilings

Nothing better expresses the extreme diversity of painting during this period than the fact that tiny paintings by Vermeer and Chardin can be placed alongside vast decorative ensembles by Pietro da Cortona and Gaulli (Il Baciccio) without being crushed. And in order to avoid unfair prejudices, care must be taken not to confuse things. But the fact is, when it comes to a dome or gallery, artistic sensibility and even taste no longer suffice. Working on this scale required a knowledge, inspiration, and genius that grabbed viewers, lifting them to

the level of dreams and heroism. This aspect was once outrageously forgotten, and such painting—unsuited to the art market—was long relegated to the status of "pompous art." Recently, however, tastes have changed again; true connoisseurs will continue to cherish Vermeer and Chardin, yet now they will also be able to marvel at the vast decorative ensembles of the seventeenth and eighteenth centuries.

Michelangelo had decorated the entire ceiling of the Sistine Chapel. Correggio, as discussed earlier, dared to adorn the inside of a church dome with a "fricassee of angels" flying up to heaven. These

FACING PAGE
Gaulli (Il Baciccio), *Adoration of the Name of Jesus*, decoration of nave vault, 1672–79. Fresco, church of Gesù, Rome (Italy).

BELOW
Annibale Carracci, *Triumph of Bacchus and Ariadne*, detail of gallery ceiling, 1597–1600. Fresco, Farnese Gallery, Rome (Italy).

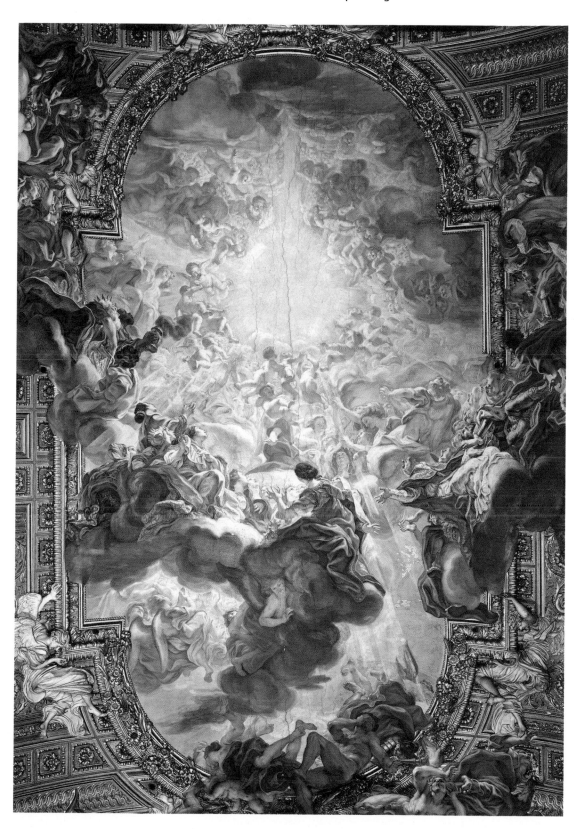

artists' approaches would be imitated in Italy, France, and Germany, in both churches and palaces, with resounding success.

Major masterpieces inspire respect. Many of these ensembles therefore survived the passing centuries, often spared disfiguring restorations. It is still possible to admire the ceilings of churches in Rome and Naples, of galleries in Florence and Milan. And mention must be made of Versailles, with its Hall of Mirrors decorated by Charles Lebrun, its chapel by Antoine Coypel (page 404), and its Hercules Salon by François Lemoyne (page 407), rivaling anything in Italy. Equally worthy of interest are Franz Anton Maulbertsch's (1724–96) dazzling series of decors, which are widely

FACING PAGE

Andrea Pozzo, *Glory of Saint Ignatius*, detail of ceiling decoration, 1691–94. Fresco, church of Sant' Ignazio, Rome (Italy).

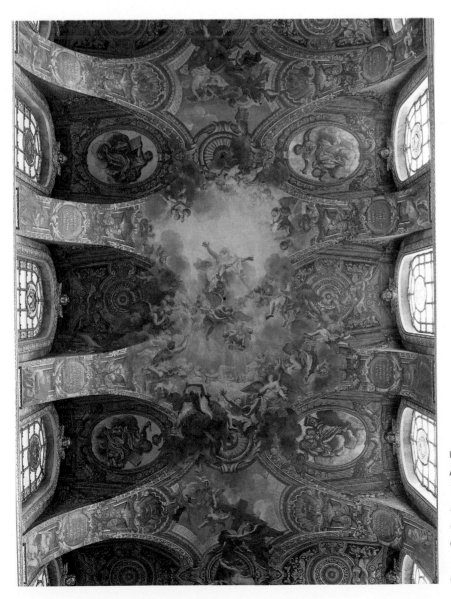

LEFT

Antoine Coypel, *The Eternal Father Promising the Coming of the Messiah on Earth*, ceiling decoration, 1709–11. Chapel, Château of Versailles (France).

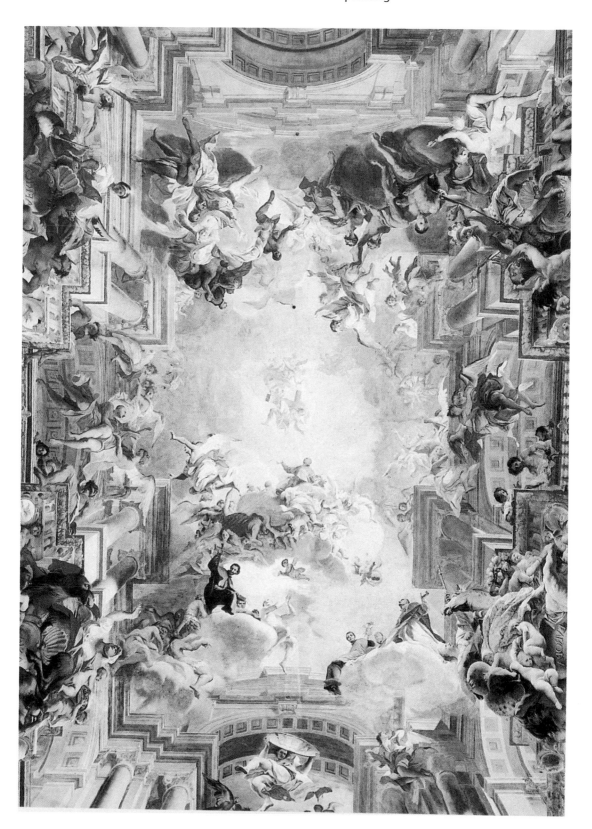

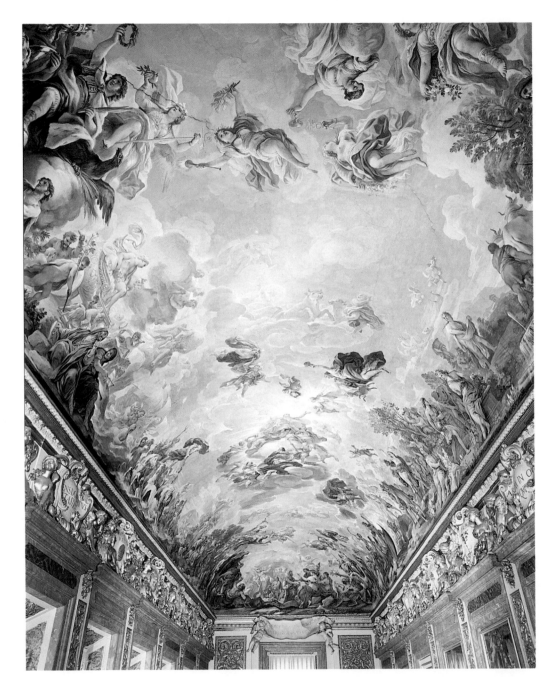

ABOVE
Luca Giordano,
*The Glorification of the
Medici Family*, gallery
ceiling, 1682. Fresco,
Palazzo Medici-Riccardi,
Florence (Italy).

FACING PAGE
François Lemoyne, *The
Apotheosis of Hercules*,
ceiling decoration,
1733–36. Hercules
Salon, Château of
Versailles (France).

dispersed—from a church in Sümeg, Hungary, to a library in Mistelbach, Austria—and therefore too often overlooked.

The great genius, however, was Tiepolo (1696–1770), a painter who was occasionally able to generate emotion in a small painting (*Agar and Ishmael*, 1732, Scuola di San Rocco, Venice), but who was more at ease on a gigantic scale (*Saint Theresa Freeing Este from the Plague,* 1758–59, Este Cathedral). He therefore accepted vast undertakings right up to his death, including the gallery of the archbishop's palace in Udine (1726–28), the gallery of the Palazzo Clerici in Milan (1740), the grand staircase and Kaisersaal of the Residenz at Würzburg (1751–53), and the royal palace in Madrid (1762–66). No one was better at foreshortening and movement than Tiepolo, and above all no one could juxtapose so wonderfully wide patches of golden yellow, sky blue, and deep red, highlighted simply with dazzling whites. The only things lacking in this glamorous art were a little gravity in the figures and a little depth to the tale—precisely those things that characterized Caravaggio-inspired art, itself incapable of the least decorative effect.

Giambattista Tiepolo, *Rachel Hiding the Idols*, side wall of gallery, 1726–28. Fresco, Bishop's Palace, Udine (Italy).

Giambattista Tiepolo,
The Glory of Spain (detail).
Fresco, Royal Palace,
Madrid (Spain).

VI
A TIME OF CONVICTIONS
(Late 18th–19th Centuries)

T he year of the French Revolution, 1789, is often taken as the start of a new period in art history. In France, this crucial, notorious date represented the end of the "ancien régime" and the launching of a new one, while in the rest of Europe it triggered a series of profound upheavals. Art, however, does not always proceed at the same pace as politics. Indeed, the crucial developments in the aesthetic sphere had already occurred some decades earlier. Should these transformations therefore be described as mere harbingers? Why should some notion of historical unity oblige us to relegate the emergence of a great creative movement, in all its exuberance and complexity, to the status of preamble or presage?

A better date, then, might be 1761, the year in which Johann Winckelmann published his *Gedanken über die Schönheit und das Geschmack in der Maleri* (*Reflections on Beauty and Taste in Painting*), and in which Anton Raffael Mengs painted his famous ceiling fresco of *Parnassus* in the Villa Albani in Rome. Yet it might seem inappropriate to adopt as landmarks a theorist's writings (even if they were widely read) and a painting always considered relatively mediocre (even if it broke with prevailing taste). Works that were immediately hailed and are *still* admired would not appear until 1780 (Jean-Antoine Houdon's marble sculpture of *Diana*) or 1785 (Jacques-Louis David's painting of *The Oath of the Horatii*). That was when the crucial mutation occurred, a major shift in formal approach that made the previous two centuries of art appear outmoded.

At the other end of the period covered by this chapter, conventional wisdom holds that "modern" art began in 1863 with the scandal created by Édouard Manet's *Déjeuner sur l'herbe*. This painting has been viewed as the one that "threw down the gauntlet." Yet similar challenges had been made, in various spheres, ever since the opening night of Victor Hugo's Romantic play *Hernani* (1830)—the scandal triggered by Gustave Courbet's painting of *Bathers* (1853), for instance, may have been more resounding and no less significant. In fact, the entire trend called "Impressionism" was merely an extension of a centuries-old tendency to depict nature in a vibrant, changing light. Impressionism was much more a culmination than a rupture. The break only came later, in 1888, the year Paul Sérusier, under Paul Gauguin's guidance, painted *The Talisman,* effectively reversing priorities: the concern to reproduce reality, which had remained the ardent quest of Manet and Monet, now began to vanish from the visual interplay of color and line. A new threshold had been reached.

During this century-long period, art flourished and evolved before everyone's eyes, ever more brilliant, ever more fertile. The era was particularly conducive to art, for the terrible crises of the French Revolution and the Napoleonic wars did not halt or even interrupt artistic creativity. Institutions survived, or quickly reformed themselves. As the press grew in importance, the influence of criticism increased, launching reputations and disseminating innovations (with, soon enough, the help of illustrations).

Meanwhile, the liberation of Greece, Hungary, and Romania pushed Islam out of Europe, while the doors of China and Japan were being forced open to Europeans. Colonization brought figurative art to lands where iconoclasm had been very strict. The West was convinced that its model of civilization was superior to all others, able to guarantee peace, abolish slavery, eliminate famine, improve transportation and communications, and introduce literacy everywhere. The spread of this model also meant the emergence, throughout the world, of European urban development and, to a certain extent, of forms of art typical of major cultural centers such as Paris, London, Munich, Düsseldorf, and Vienna.

Was this triumph unmitigated, or was expansion accompanied by a steady drop in quality? Religious faith, which had been the mainspring for the finest Western art for centuries, slowly lost its inspirational role, but could never be completely replaced by humanist or democratic ideals. Meanwhile, the lavish refinement associated with princely courts progressively vanished. In architecture, palaces gave way to houses. In sculpture, statues of saints or allegories were replaced by monuments in public squares. In painting, the skill required for vast compositions was abandoned for the ease of landscapes. A quick glance might prompt us to agree with Léon Daudet's famous quip that the nineteenth century was "stupid."

However, this period is still too recent to be judged with equanimity—we are still living in the nineteenth century. European homes, furnishings, and architectural environments tend to be nineteenth century. The paintings and precious jewelry that people own are more likely to date from the nineteenth century than the fifteenth or sixteenth, or even from the present day. Hence, we cannot see the nineteenth century. Art is so often confused with rarity that we tend to feel contempt for the overly familiar, overly abundant products of the nineteenth century. Not so long ago, the comment that "this building dates from the nineteenth century" was equivalent to a demolition permit. Châteaux and palaces have been leveled for this sin only, without anyone even bothering to remove and preserve often-intact interiors. Everyone acknowledges that Jean-Baptiste Carpeaux and François Rude were great artists, but how many people truly appreciate the sculpture of that period? During World War II, most of the bronze and cast-iron statues adorning French cities, including Paris, were melted down with little sign of regret (and sometimes even with jubilation), because they were not protected by a famous name.

Not everything was of high quality, of course. Every period produces its weak and ordinary art. Selective appreciation applies to the nineteenth century, too (perhaps especially). But first we must become cognizant of the abundance, then learn to detect quality. A good deal of groundwork still has to be done before it is too late. For it is already very late.

The period covered by this chapter has bequeathed us so many texts and theories of such complexity—in every sphere—that it is truly difficult

to encounter one assertion without immediately encountering its oppo-site. It is perhaps not too risky, however, to advance one of the era's key ideas: the profound belief—sometimes to a naïve extent—in *progress*. A double attitude came into play here, involving not only a passionate interest in the past but also the conviction that the present could rival the past. The nineteenth century was the period when Europe's great muse-ums and historic-monument commissions were founded. Everywhere people sought to save what remained of earlier centuries, studying ves-tiges in an effort to unlock their secrets. But this was more than simple curiosity; people hoped to derive a knowledge that would enable them to go further, to produce better and grander works. Ingres made no secret of the fact that he sought to imitate Raphael, nor Delacroix that he looked to Rubens and Titian, nor Manet to Velasquez. Yet they all thought—without necessarily admitting it—that they could surpass their mentors.

Mythology in the nineteenth century: Jean-Auguste-Dominique Ingres, *Jupiter and Thetis*, 1811. Oil on canvas, 10′7″ × 8′5″ (3.27 × 2.6 m). Musée Granet, Aix-en-Provence (France).

This faith in progress was diametrically opposed to the concept of the avant-garde that would emerge in the twentieth century, which led to a rejection and devaluing of all previous art. Nineteenth-century artists felt that artistic creativity should be based on past accomplishments. They did not think that earlier achievements would hinder their own inventiveness. By trying to imitate the artfulness of architects in the thirteenth or fifteenth centuries, nineteenth-century architects were soon able to exploit iron and glass to obtain greater luminosity and solidity. Similarly, inspired by the rational approach required of scientific research, painters and sculptors would steadily abandon mythological subjects for everyday imagery. For lack of distance, we may sometimes feel irritated or wearied by this ambivalent period—but pay it just a little attention, and it soon inspires boundless admiration.

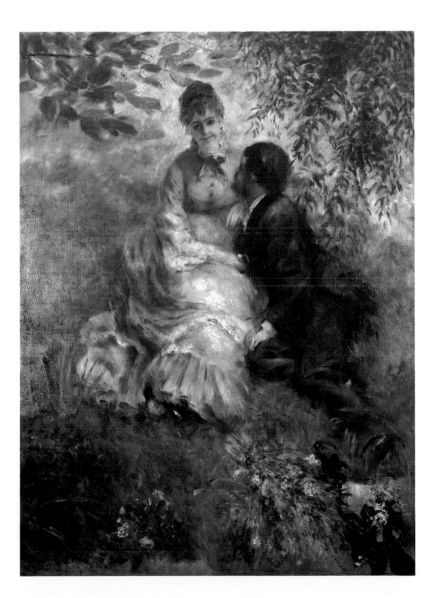

Everyday imagery in the nineteenth century: Auguste Renoir, *The Lovers*, 1875. Oil on canvas, 5′8″ × 4′3″ (1.75 × 1.30 m). National Gallery, Prague (Czech Republic).

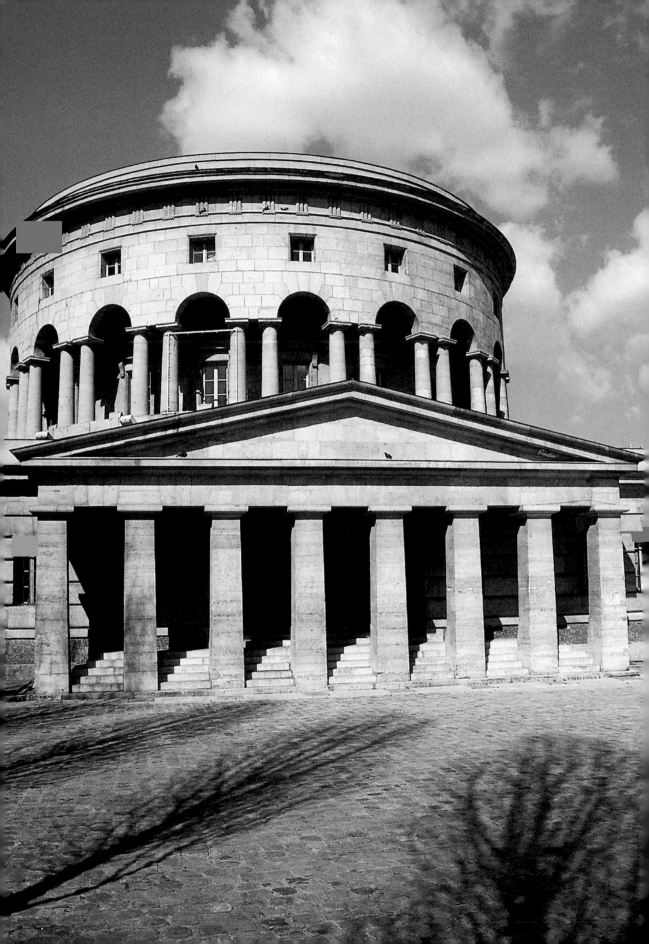

Architecture

As we have seen, the eighteenth century sometimes managed to escape the architectural language of antiquity imposed on all of Europe by fifteenth-century Italy without, however, returning to the idiom of ogival architecture. The "Rococo" trend banished columns, capitals, triangular pediments, ovolo molding, triglyphs, and even the very idea of regularity. Whimsy and asymmetry became the rule, even in ecclesiastical contexts. But very soon Rococo taste was ridiculed, and there was a sudden reversal. Architecture reverted to columns and pediments that displayed the strictest respect for antiquity. Delicate curves soon disappeared from moldings, precious metalwork, and furniture legs. Corinthian capitals seemed overly foliate and were replaced by the simple Doric order, with no base to the columns.

Return to antiquity

This precocious reaction was overtly presented as a return to the spirit of antiquity, henceforth better known thanks to the study of the temples of Greater Greece and the excavations at Pompeii. In France, these ideas were immediately taken to far extremes by the likes of Étienne-Louis Boullée (1728–99), who envisaged immense, utopian buildings based on simple volumes or even sections of simple volumes (such as his 1784 plan for a spherical monument to Newton); no one, however, actually built them, and only Boullée's remarkable drawings survive. The less visionary Claude-Nicolas Ledoux (1736–1806) developed an architecture of apparently raw forms that were nevertheless modulated with skill and care. His series of municipal customs houses, built in Paris starting in 1784, were devoid of ornamentation, although economic considerations may have played a part in this decision since the scheme to build these "tax barriers" absorbed a vast budget. The most important vestige of this program can be seen at La Villette, where interlocking volumes give an impression of strict rigor felicitously softened by the gallery around the rotunda (page 416). Both this building and Ledoux's salt works at Arc-et-Senans (1775–79) prove that an architect's fascination with antiquity could still leave plenty of room for architectural creativity.

It was perhaps in France, for that matter, that the return to antiquity seemed least striking— not because the revival was less strong—far from it—but because the architectural idiom of major buildings had changed little

Claude-Nicolas Ledoux, Rotunda of tax barrier, La Villette, Paris (France), 1784–89.

D·O·M·SVB·INVOC·S·M·MAGDALENAE

LEFT
Pierre Alexandre Vignon,
façade of the church of
La Madeleine, Paris
(France), 1807–42.

there since the sixteenth century. Perrault's 1667–68 façade for the Louvre courtyard, discussed earlier, already emphasized colonnades and pediments, and differed little from the two palaces erected nearby—on what is now the Place de la Concorde—by Ange-Jacques Gabriel in 1755. Just across the river is an antique-style temple that houses the National Assembly (by Bernard Poyet, 1806–8), which itself faces the classical church of La Madeleine (Pierre Alexandre Vignon, 1807, page 418), thereby comprising the most important "antique" ensemble in Paris. Yet few of the countless people who pass through this neighborhood every day note the elegant nuances that distinguish Gabriel's double colonnade from the two powerful, severe "temples" that face each other across the river.

It is impossible to list here all the edifices that lend a solemn, antique-inspired note to Paris. Highlights include the eight Corinthian columns on the Panthéon (Jacques-Germain Soufflot, 1755–90, page 419), the colonnaded portico of the Théâtre de l'Odéon (Charles de Wailly and Marie-Joseph Peyre, 1779–82), and the Greco-Roman temple of the Bourse (Alexandre Brogniart, 1805–15), not to mention the colossal columns bearing the pediments of churches such as Notre-Dame-de-Lorette (Louis-Hippolyte Lebas, 1823–26) and Saint-Vincent-de-Paul (Jacques-Ignace Hittorff, 1833–34). These buildings create a harmonious ensemble of varying yet sure proportions, giving a monumental feel to Parisian streets without wearying the eye.

Most major cities in France also wanted to mark their prosperity

FACING PAGE
Jacques-Germain Soufflot,
church of Sainte Geneviève
(now the Panthéon),
Paris (France), 1755–90.

with an antique-style colonnade, as typified by Bordeaux with its Grand-Théâtre (1773–80), a masterpiece by Victor Louis that features twelve large columns topped by a simple entablature rather than a pediment (page 420). Lyon, meanwhile, placed a colonnade on the courthouse erected on the banks of the Rhône (Louis-Pierre Baltard, begun 1835), while in Nîmes a theater—recently demolished, alas—was built opposite the handsome columns of the authentic Gallo-Roman temple known as the Maison Carrée. To these should be added the multistory colonnades, known as the "colossal order," that ennobled the façades of lavish provincial dwellings, such as the Ionic portico on the Château of Benouville in Normandy, an early work by Ledoux (begun in 1768) and the courtyard façade of the Hôtel de l'Intendance in Besançon by Victor Louis (1770–76).

France's classical revival may nevertheless appear modest when compared to other European capitals, notably London. England had paved the way for the vogue thanks to Neo-Palladian architects William Chambers (1723–96) and Robert Adam (1728–92). At an early date there appeared structures such as the Temple of Concord and Victory at Stowe (c. 1748) and the Temple of Theseus in Hagley Park (1758). These works, of course, may be considered simple models of Ionic or Doric temples serving as follies on the grounds of estates. But soon major buildings were flaunting Greek Revival architecture as inspired by Stuart and Revett's *Antiquities of Athens* and Wilkins's *Antiquities of Magna Graecia*.

Still in England, a country house in Grange Park, Hampshire, was built as a very sober Doric temple in 1804–09 by William Wilkins himself, who also endowed

Victor Louis, Grand Théatre, Bordeaux (France), 1773–80.

Downing College, Cambridge with a large portico and plain pediment (1807–21). Later, Harvey Lonsdale Elmes would push these convictions so far as to design a vast complex in Liverpool, Saint George's Hall (1841–54), which united a range of municipal services in one building. Of gigantic proportions, more Roman than Greek in appearance, this fortress-temple entirely surrounded by columns imposes an outsized vision of antiquity onto modern life.

It was hardly surprising that Italy, in turn, employed an idiom that had initially been its own and that it had never totally abandoned. The country re-adopted classicism discreetly, taking care to avoid overly sharp contrasts with sixteenth- and seventeenth-century traditions. It was perhaps during the Napoleonic occupation that the strictest revival buildings were erected. The church of San Francesco di Paola in Naples eschews a bell tower and boldly juxtaposes the triangle of a large, bare pediment with the vast dome and bald drum (page 422), directly inspired by the Pantheon in Rome.

William Wilkins,
Grange Park, Hampshire
(England), 1804–09.

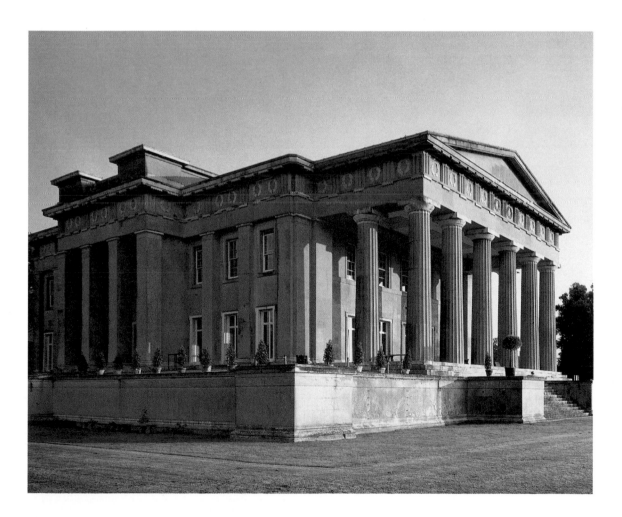

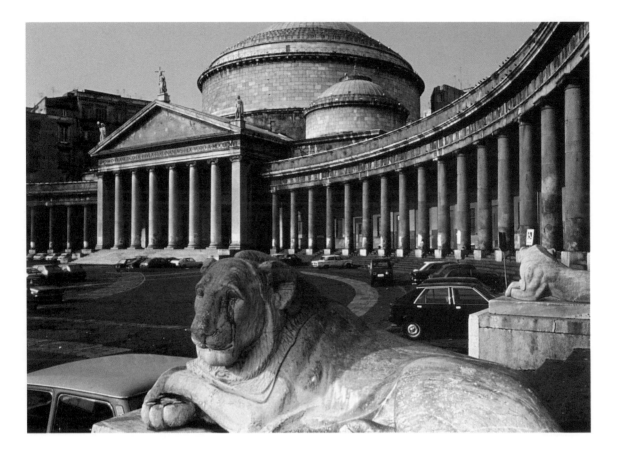

Pietro Bianchi, church of
San Francisco di Paola,
Naples (Italy), 1817–31.

But the truly successful piece—or rather, masterpiece—was the chapel that Canova built for his own tomb. White, of relatively modest size, and set alone in a gentle landscape, it features a simple Doric portico and a plain rotunda. It may appear slightly slick and cold, but it nonetheless embodies antiquity's harmonious proportions.

More surprising, in contrast, was the enthusiastic interest in the classical revival shown by Germany, where Rococo had been so popular. Perhaps nowhere else in Europe is this revival more apparent than on the Königsplatz in Munich, where Georg Friedrich Ziebland and Leo von Klenze managed to coordinate a set of buildings of varying date and function, almost making us forget the modern city all around. Even more striking is the antique spirit of two large monuments that serve as German memorials: the Walhalla (page 423), a kind of Parthenon built in 1830–42 by von Klenze on the banks of the Danube to house busts of famous Germans, and the Befreiungshalle in Kelheim (1836–44), also by von Klenze, to celebrate German national awareness. Klenze aimed to design a building whose exterior would

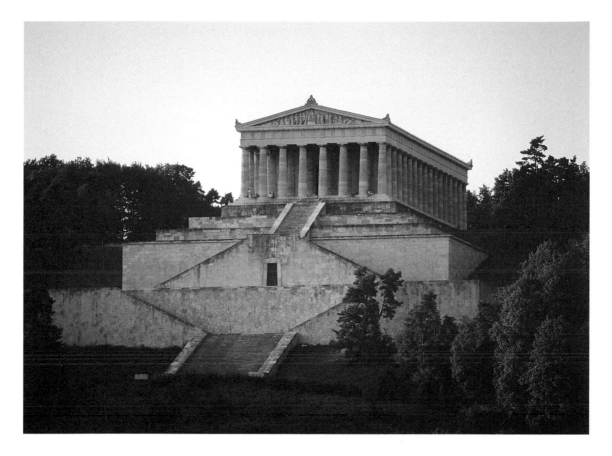

Leo von Klenze,
The Walhalla, Regensburg
(Germany), 1830–42.

evoke the tombs of Roman emperors, while the interior was more or less based on the Pantheon in Rome.

In a fine example of the varying connotations ascribed to a given aesthetic language, the revival of ancient architecture was felt to express the spirit of the French Revolution, of the Napoleonic Empire, and of France's bitterest enemies, England and Germany. Lacking intrinsic meaning, an idiom can be adopted by various ideologies. But in this case, it is important to realize that the revival phenomenon was broader—it was not only antiquity that was

resuscitated. Little by little, all styles were being rediscovered and studied, and soon they would be given new life. Remarkably, individual countries did not explore only their own heritage; every kind of architecture, independent of exacerbated nationalism, was deemed worthy of interest once it was brought to attention.

The Gothic Revival

The classical style was a tradition shared by all, and the same was true of another "former" style that eventually came to be known as "Gothic Revival." Sometime after 1870 the

Germans and French quarreled over who had launched the original style, but the revival had begun in England some time before.

As early as 1742 Betty Lengley published *Gothic Architecture Improved by Rules and Proportions* in London, and between 1750 and 1776 Horace Walpole built his "Gothic" residence at Strawberry Hill, including a library with canopied niches and a gallery with fan-vaults and pendant bosses. By 1800, the new fashion was spreading everywhere; at Little Gaddesden, outside London, a large staircase featured niches with carved canopies and was set beneath a fan-vaulted ceiling. And after the Houses of Parliament burned in 1834, the design competition of 1835 favored the "Perpendicular Gothic" style, in which the Palace of Westminster was duly rebuilt (1839–60), making it the British national style (page 425).

The French, meanwhile, were not as dismissive of Gothic architecture

Franz Christian Gau and Théodore Ballu, church of Sainte-Clotilde, Paris (France), 1839–57.

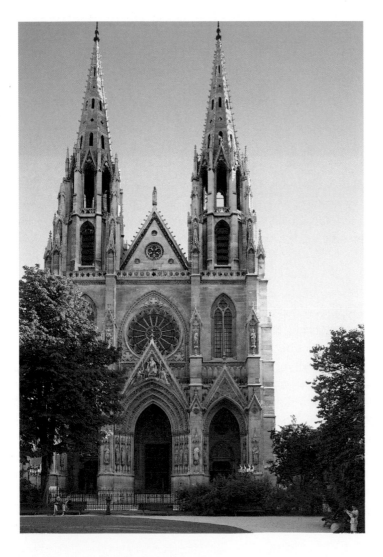

Charles Barry,
Houses of Parliament,
London (England),
1839–60.

as is so often generally supposed. André Félibien des Avaux (1619–95) had openly studied and praised Chartres Cathedral, while his son Jean François Félibien (1658–1733) declared his admiration for Strasbourg Cathedral in 1687. When the church of Sainte-Croix in Orléans was destroyed by Protestants during the Wars of Religion, local authorities insisted that it be rebuilt in its original style, which was then done throughout the seventeenth and eighteenth centuries, except for the façade, where an unusual compromise solution was found.

Despite this appreciation, French Gothic Revival architectural was long limited either to a few follies inspired by Alexandre Lenoir's exhibition of original remnants at the Musée des Monuments Français, or to the decoration of chapels in what was called the "troubadour style." Only much later were major new edifices expressly built to imitate the architecture of the great cathedrals. In Paris, the first such building was the church of Sainte-Clotilde (page 424), designed by Franz Christian Gau (1790–1853) and completed by Théodore Ballu (1817–85). The proportions are so skillful that a moment's reflection is required before it becomes apparent that the church was entirely built in the nineteenth century (1839–57). Subsequently, many major building projects were launched, some of which were brought to fruition (the churches of Saint-Léon and

Jean-Augustin Renard
(ascribed to),
Egyptian portico,
Hôtel de Beauharnais,
Paris (France), after 1803.

Saint-Epvre, Nancy) while others were never fully completed (Lille Cathedral).

Similarly, ruined castles and châteaux were often rebuilt during this period. The most famous example is the enormous one at Pierrefonds. Eugène Viollet-le-Duc completely reconstituted the château, three-quarters of which was in ruins, and endowed it with a personal decorative scheme. The attempt to render ruined buildings inhabitable by completing them and making them more finished than they ever had been epitomizes the nineteenth-century spirit. The end result should therefore be understood not as abusive restoration but as a new creation that deserves to be judged on its own merits. It is unfortunate that the term "pastiche" was employed until recently to justify, in France and abroad, the de-restoration or even demolition of these efforts.

The revival fad

The rebirth of "Gothic" art was obviously not restricted to England and France. Germany, Austria, Hungary, and northern countries also played a large part. Nor should it be forgotten that, in Italy, Milan Cathedral was completed by a façade that skillfully harmonized with the rest of the Gothic building. Such revivals were not limited to the Gothic style, however. One of the earliest trends concerned Egyptian art, triggered by Napoleon Bonaparte's expedition to Egypt. But this fashion mainly affected furnishings and decorative art, since neither the great pyramids nor the temples at Karnak brooked imitation. In Paris, the only architectural

impact survives in the portico of the Hôtel de Beauharnais (after 1803, page 426) and the Fontaine du Fellah on Rue de Sèvres (1806-9). As time went by, people also began turning to sixteenth-century styles—so highly praised in the châteaux along the Loire—when decorating their own châteaux, private mansions, or more modest residences. The brick facades in the Louis-XIII style became popular first, followed by the solemn Louis-XIV style, itself finally replaced by the rehabilitated Louis-XV style. The implementation of a true "revival" style required enthusiasm and skill, and turned into a self-conscious game.

The same phenomenon occurred in every country, including Canada and the United States. Germany, where a great many castles were built or rebuilt, was particularly affected. For the royal residence in Munich, architect Leo von Klenze drew direct inspiration from "Renaissance" architecture, namely the Palazzo Pitti and Palazzo Rucellai, as demonstrated by his use of pilasters and rustication (1823–32). Meanwhile, it was the Loire châteaux that inspired the architects of Schwerin (1840–57). In Portugal, Ferdinand of Saxe-Cobourg wanted to incorporate all styles into his Palácio da Pena in Sintra, from Moorish and Manueline to Renaissance and Baroque (page 427).

It is therefore hardly surprising that private homes in most cities, especially those built after 1840, display no specific style of their own. Does this mean that the nineteenth century was so "stupid" as to renounce individual creativity? That it was too lazy to replace borrowed idioms with a modern language, that architects had totally abdicated their responsibility? Such allegations and denunciations were indeed being made by the late nineteenth century.

Wilhelm von Eschwege, Palácio da Pena, Sintra (Portugal), 1839–85.

The time has come, however, to view this issue differently. An attentive look reveals the tact and talent that architects brought to this eclecticism. They were perhaps "playing" with various styles, occasionally adding a "Rococo" balcony to a sixteenth-century façade. But they remained sensitive to overall conception and the precise relationship of elements. They were also very attentive to exterior volumes, and took great care with interior proportions. The tiniest design of a molding, of the base of a pilaster, or the meeting of two string courses was carefully drawn. An individual architect's style can be recognized by the size of an entrance hall, the grandeur of a staircase, and the harmonious arrangement of reception rooms and bedrooms. Rarely has the art of building been more refined than during this period of apparent pastiche. It is highly regrettable that today's architects—the children of those who tore down so many admirable nineteenth-century buildings—think their consciences are clean if they retain an outer façade with its doors and windows, only to demolish the original interior arrangement.

Despite all this destruction, a stroll through the nineteenth-century neighborhood of any large city, particularly Paris—then the center of urban architecture—can be a true delight for the eye. The very mix of styles offers endless surprises: the arrangement of stories, the skillful use of columns and pilasters, the orchestration of windows and doors, the variety of balconies in wrought and cast iron, and the sculptures adorning the entrance (always different in size and shape from neighboring ones). The stroller will almost always stumble across several buildings that intrigue and delight thanks to the skill and appealing details they flaunt. There is an abundance of the figures called caryatids and atlantes, often the work of excellent artists and almost the equals of the ones on display in museums (page 429). True enough, some architects imbued their façades with a deadly dignity, while others overburdened their buildings with awkwardly "Neo-Gothic" forms. But we should not judge too swiftly. Just as in the days of the cathedrals, not everything is a masterpiece, yet even minor architects and artisans boasted skills and inspiration often not found among the best craftsmen of less refined epochs.

It should pointed out immediately that these skills were not limited to the technical and aesthetic analysis of past architectural accomplishments. When circumstances required, totally new solutions could spring from accumulated experience. Viollet-le-Duc, the restorer of Pierrefonds, also envisaged highly novel construction techniques, and he was not the only one to do so. But the nineteenth century knew how difficult it is to accustom the public eye to new forms. This cautious century took risks only in exceptional circumstances.

Decorative façade,
1, avenue de l'Observatoire,
Paris (France), 1890–97.

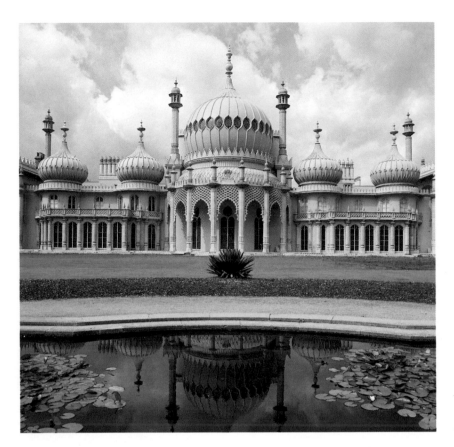

John Nash, Royal Pavillion,
Brighton, East Sussex,
(England), 1815-22.

This chapter will not dwell on bridges—more the work of engineers than of architects—which would require lengthy discussion. It should nevertheless be pointed out that the nineteenth century saw the spread of suspension bridges which, like the one at Clifton, England, adorned the landscape with structures as alien to local tradition as they were impossible to mask. Familiarity was required before iron architecture could gain acceptance.

So although the advantages of iron were understood at an early date, architects hesitated to use it. One of the most unusual instances was the Royal Pavilion in Brighton, built between 1815 and 1822 (page 430). Both inside and out, this fanciful building seems to surpass all revival fads, combining Moorish, Indian, and Chinese elements. On closer inspection, however, it transpires that the central dome rests on an iron framework, and that the outer covering is an early experiment in the use of cement.

More serious was the problem of greenhouses, for which few efficient precedents existed—the trecento-style pinnacles on the Orangery in Racconigi (1824–39) should not lead us to overlook the vast glasshouse built by Carlo Sada (1809–73) or the new

Decimus Burton and
Richard Turner,
Palm House, Kew Gardens,
London (England),
1844–48.

heating system designed by an English engineer named Taylor. Then there was the great Palm House at Kew Gardens (page 431), a vast glass-and-iron construction built in 1844–48 by Decimus Burton and Richard Turner. It was followed by Joseph Paxton's famous Crystal Palace in London (1850–51), which represented the triumph of these entirely new materials and architectural forms.

The same could be said of libraries, which required a good combination of light, space, and protection against dampness. Henri Labrouste (1801–1875) boldly built the Bibliothèque Sainte-Geneviève (1850), in Paris, in front of the Panthéon; its somewhat monotonous stone exterior encases a double hall that makes no attempt to mask its metal vault (page 432). The cast-iron arches display fine openwork and are set on tall stone bases carved with Neoclassical motifs; Labrouste was clearly attempting to produce a larger, more convenient and modern version of the original eighteenth-century library (still standing, but unused). His effort was rewarded some time later when he was commissioned to build the reading room of the Bibliothèque Nationale (1862–68, now named after Labrouste),

where he used cast-iron columns that allude to the barrel vaults and domes of the past yet in an extremely slender form that delights the eye and renders the new aesthetic appealing.

Other architects called on the same inspiration when building churches. Saint-Eugène in Paris (1854–56), designed by Louis-Auguste Boileau (1812–96), may not be a major masterpiece, but its direct transposition of Gothic structure into slender metal columns reveals how an architect could take advantage of his knowledge of earlier styles to innovate rather than copy (page 433).

ABOVE
Henri Labrouste,
interior, Bibliothèque
Sainte-Geneviève,
Paris (France), 1844–50.

FACING PAGE
Louis-Auguste Boileau,
church of Saint-Eugène,
Paris (France), 1854–56.

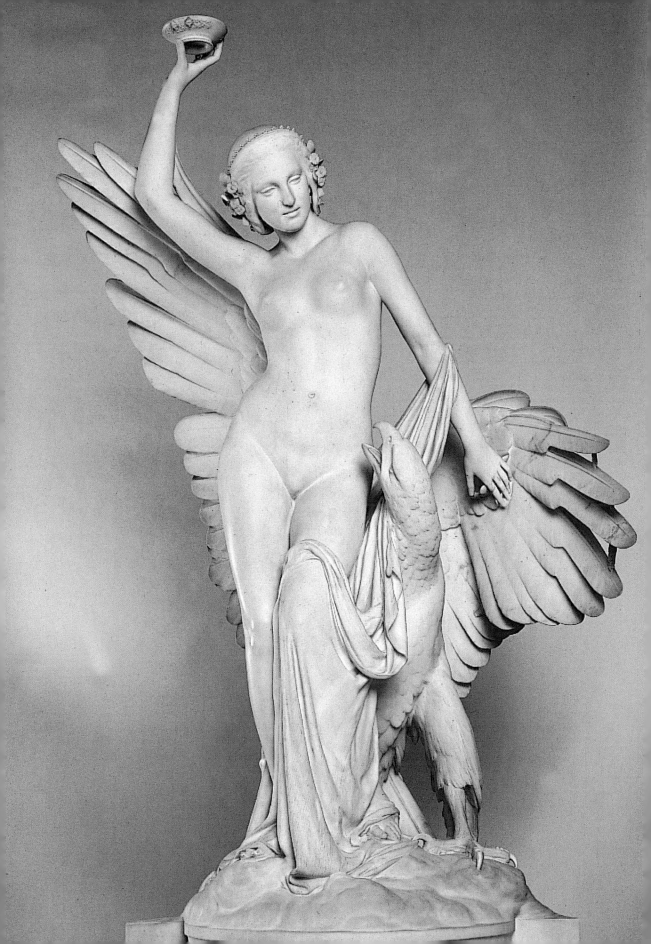

Sculpture

Nineteenth-century sculpture is scarcely better known and appreciated than architecture of the same period. It is still too recent and, despite losses from destruction, too abundant. All visitors to Paris are familiar with François Rude's *Departure of the Volunteers,* which decorates the Arc de Triomphe, and most of them do their duty by going to look at it. But how many of them could name the artists who executed the other three bas-reliefs on the arch? How many bother to examine these works, despite their obvious quality? Most European cities are veritable outdoor museums of sculpture—the least-known museums in the world.

Classical revival

Certainly, an untutored eye will have difficulty making sense of this wealth of sculpture. Yet distinct splits can be perceived. In France, a reaction soon arose to everything that smacked of Bernini's heritage—just as in architecture, a return to classicism emerged. The initial steps in this direction, discussed in the previous chapter, were taken by Jean-Baptiste Pigalle (1714–85), who boldly sculpted a life-size marble portrait of Voltaire as a naked old man nearing the end

of his life (page 355). Pigalle's defiance of propriety was only possible through his allusion to the philosophers of antiquity. This development became more marked with the oeuvre of Jean-Antoine Houdon (1741–1828). A model of his *Diana* was exhibited as early as 1777, and represented another stage in this trend, but it was only with the finished marble version of 1780 that everything became so perfectly smooth that nothing, not even the figure's hair, disturbed the purity of line. Similarly, in Houdon's sculpted portraits, wigs would soon vanish and curls would no longer modify the volume of the head, nor would lace distract attention from facial features. The sitter was usually shown naked, the bust terminating suddenly at the upper shoulders, like many Roman busts. Houdon also did a portrait of Voltaire shortly before the philosopher died. Hardly able to copy Pigalle's audacity, Houdon wrapped the old man in ample drapery, with a "ribbon of immortality" ringing Voltaire's head and thinning hair. The pose seems to anticipate the apotheosis of the man who was then Europe's most famous writer, but the mocking smile and lively eyes are rendered with a sensitivity to reality characteristic of Houdon's work.

François Rude,
*Hebe and the Eagle
of Jupiter,* 1846–57.
Marble, 8′3″ × 3′11″ × 2′7″
(253 × 120 × 80 m).
Musée des Beaux-Arts,
Dijon (France).

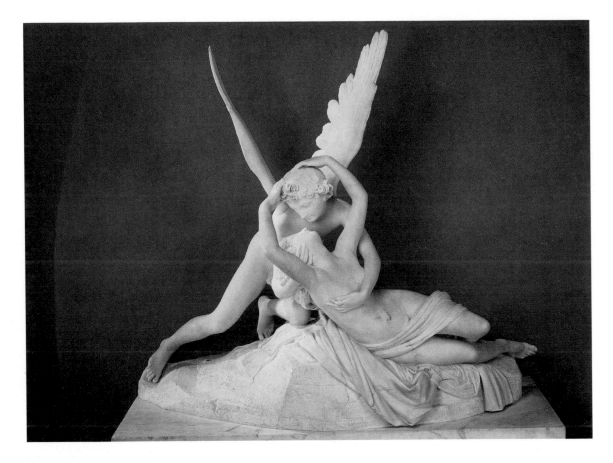

In contrast, the quest for the *idea* was what guided a sculptor from the next generation, Antonio Canova (1757–1882). His early works, at least, retain a sense of movement and sometimes even complex curves, the most accomplished example certainly being his *Cupid and Psyche*, begun in 1786 and completed in 1793 (page 436). The simplified forms and sleek marble do not efface the subtle play of curves and countercurves created by the poses of the two bodies, which are inclined along opposing axes yet united in a tender, shared embrace. Subsequently, Canova's figures would progressively abandon their final links to reality, and the quest for a pure beauty would culminate in bodies perfectly frozen in a simple pose. Paradoxically, when Canova came to sculpt a portrait of Napoleon, he wound up eliminating realistic details as being too individualized. All that remained in Canova's art was what has often been called a "cold sensuality." Even this would disappear from the oeuvre of Danish sculptor Bertel Thorvaldsen (1770–1844), who succeeded Canova as Rome's leading sculptor and took this sculptural tribute to antiquity to an extreme.

ABOVE
Antonio Canova, *Psyche Revived by Cupid's Kiss*, 1793. White marble, 5′ × 5′5″ (1.55 × 1.68 m). Musée du Louvre, Paris (France).

RIGHT
James Pradier, *Phryne*, 1845. Marble, 6′ × 1′4″ × 1′6″ (183 × 40 × 47 cm). Musée des Beaux-Arts, Grenoble (France).

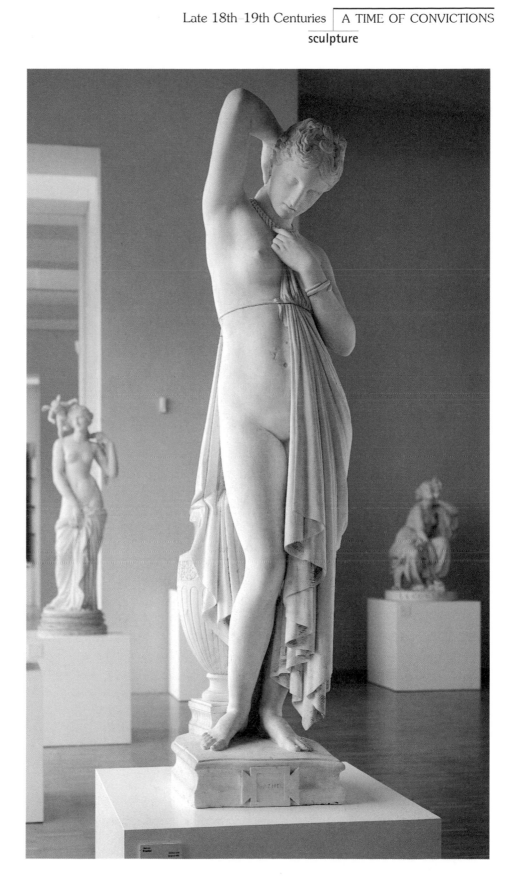

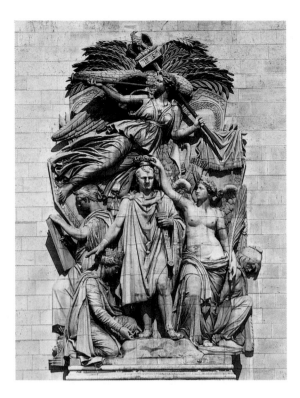

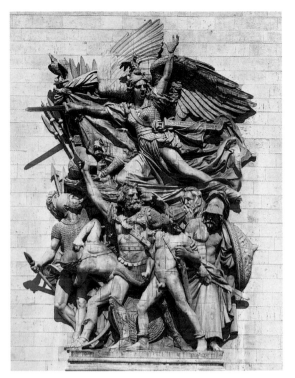

Houdon and Canova thus established a solid tradition that would take a long time to wane. The return to antique sources was perhaps less systematic among French sculptors such as Joseph Chinard (1756–1813), Pierre Cartellier (1757–1831), and Antoine-Denis Chaudet (1763–1810). A somewhat cold correctness can be seen in high reliefs by Jean-Pierre Cortot (1787–1843), whose *Apotheosis of Napoleon* on the Arc de Triomphe in Paris serves as pendant to Rude's *Departure of the Volunteers* (page 438). In contrast, Antoine Étex (1818–88), who decorated the other side of the arch with allegories of *Peace* and *The French Resisting the Coalition of 1814*, eschewed the concern for elegance by preferring somewhat squatter proportions, more energetic expressions, and fuller compositions (page 439).

The classicizing tradition continued most clearly in the work of James Pradier (1792–1852), who escaped the stiff dignity of Thorvaldsen's work and was able to draw a hint of naturalism from curves alone, although his *Odalisque* of 1841 (Musée de Lyon, France) and his *Phryne* of 1845 (page 437) underscore his concern to respect the canon of female beauty and the perfection of polished marble. This grand tradition was pursued with the same fervor by Pradier's disciple, Eugène Guillaume (1822–1905), whose fine accomplishments include his *Gracchi* of 1853.

Of course, in sculpture—as in architecture—a retrospective look

ABOVE LEFT

Jean-Pierre Cortot, *The Apotheosis of Napoleon*, 1833. H: approx. 41′ (12.7 m). Arc de Triomphe, Paris (France).

ABOVE RIGHT

François Rude, *The Departure of the Volunteers in 1792*, 1833–36. H: approx. 41′ (12.7 m). Arc de Triomphe, Paris (France).

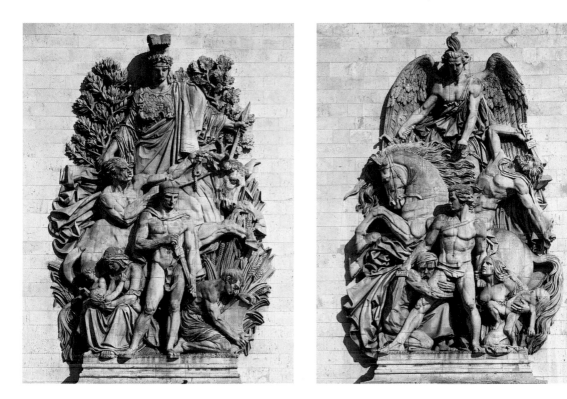

at this period should not be limited to the classicizing trend. Although this tradition continued to dominate during the French Revolution and Napoleonic Empire, reinforced by the doctrinal theories of Winckelmann and Quatremère de Quincy, the deluge of nudes it produced was never to the liking of the Church. And a Catholic revival was occurring everywhere in Europe, reclaiming ground lost during the Enlightenment. Meanwhile, historical curiosity also extended to the age of great cathedrals, which offered different spiritual inspiration and a different visual language. As the nineteenth century proceeded, artists turned their attention, respectively, to the glorious cinquecento, to the extraordinary plasticity subsequently achieved by Bernini, indeed

to the eighteenth century with its refinement and sensitivity. Soon a veritable revival of past idioms was invading sculpture in every land, notably in France. This great variety of inspiration should not be over-simplified too hastily, reducing it to a few set formulas.

Special mention should be made of François Rude (1784–1855). A native of Dijon, he was trained in the spirit of the classical revival but did not work exclusively in that tradition (perhaps due to his lack of a cultured background). Rude's *Young Neapolitan Fisherman* (1827) was composed from life, not from a Roman or Greek model. His *Departure of the Volunteers* stands out from the other reliefs on the Arc de Triomphe for its strikingly dynamic composition, even

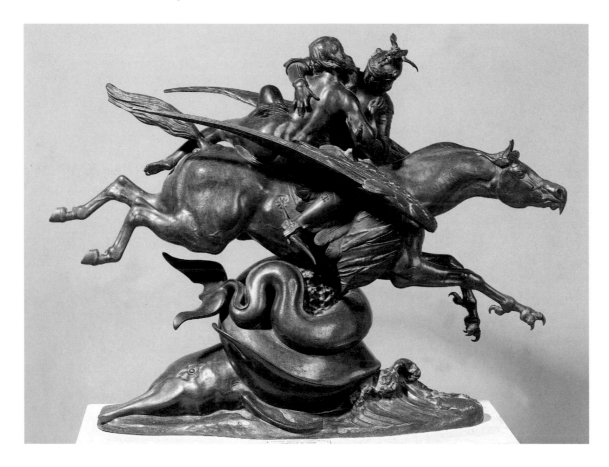

though Rude incorporated a "heroic nude" into it (perhaps recalling something from Trajan's column). Rude projected a much more modern and almost anecdotal vision with his *Awakening of Napoleon* (1845–47), whereas his final work, *Hebe and the Eagle of Jupiter* (page 434), could pass for a veritable profession of faith in antiquity.

Other sculptural revivals

In contrast, it was artistic inspiration from the age of cathedrals or the cinquecento that added some originality to work by the likes of Antonin Moine (1796–1849) and Félicie de Fauveau (1799–1886),

the latter one of the few women to have won recognition for her skill as a sculptor. Meanwhile, it was the Renaissance that influenced not only Henri de Triqueti (1804–74), who sculpted the bronze doors for the church of La Madeleine in Paris, but also Italian sculptor Carlo Marochetti (1805–67), who executed the high altar in La Madeleine as well as his famous equestrian statue of Emmanuel Philibert (1833) for the main square in Turin, Italy. Affinities with the literary movement of Romanticism, on the other hand, seem to have played a formative role for Pierre-Jean David d'Angers (1788–1856), a complex and an uneven artist who nevertheless

Antoine-Louis Barye, *Roger and Angelica on the Hippogriff*, 1824. Bronze, 20 × 27" (51 × 69 cm). Paris (France).

Jean Bernard Du Seigneur,
Orlando Furioso, 1831.
Bronze (cast in 1867),
4′3″ × 4′9″ × 2′11″
(130 × 146 × 90 cm).
Musée du Louvre,
Paris (France).

produced extraordinary medallions depicting famous people of the day in a delicate, confident style. Romanticism also inspired Jean Bernard Du Seigneur (1808–66) who, although retaining the antique-style nude, may have been thinking of Michelangelo when he sculpted *Orlando Furioso* for the Salon of 1831 (page 441).

Nor can allegiance to classicism be ascribed to an artist such as Antoine-Louis Barye (1795–1875),

who passed through a "troubadour" period but spent most of his career directly observing animals in order to depict them with an accuracy that approaches strict realism. Yet it would be a mistake to think that the sculptor of works such as the *Lion with Snake* (Salon of 1836) and the *Jaguar Devouring a Hare* (1850, Musée du Louvre, Paris) had lost any of the élan seen in early work such as *Roger and Angelica on the Hippogriff* (page 440).

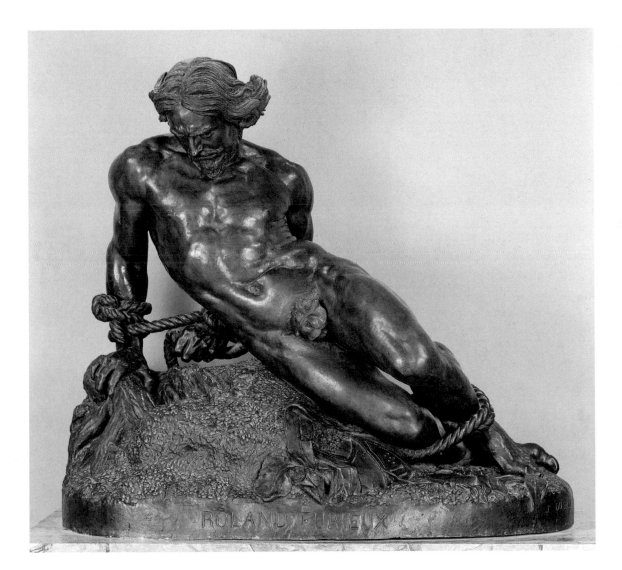

His drive was merely internalized. The tense muscles beneath the supple skin and fur of Barye's cats, and the coiled reptiles smothering their prey, still reflect the influence of early Romanticism.

More independent still was Auguste Préault (1809–79), who studied under both Moine and David d'Angers. His strange genius rejected all traditional schools and favored a violent, tormented art. Préault's imagination was equally dramatic, his *Slaughter* of 1834 being almost unbearably violent (page 442). It shows that sculpture could be even more extreme than literary forms of Romanticism.

Although not always so dramatic, Préault's art is always surprising. With no concern for classical proportions, he executed a statue of a *Gaul*, leading his horse, as though emerging from the marshes, at one end of the Pont d'Iéna in Paris. *Christ on the Cross*, carved for the church of Saint-Gervais (wood, 1840–46) shows Jesus stretching his neck in a terrible cry. *Ophelia* (1844), meanwhile, might be either a bas-relief or a tomb sculpture. At the Père-Lachaise Cemetery, Préault's medallion of *Silence* (1842) is a highly moving rendition

Antoine Augustin, known as Auguste Préault, *Slaughter*, 1834. Bronze, 3′6″ × 4′6″ (1.09 × 1.4 m), Musée des Beaux-Arts, Chartres (France).

Jean-Baptiste Carpeaux,
Flora, 1866.
Plaster (model),
4´11˝ × 5´10˝ × 1´6˝
(151 × 180 × 46 cm).
Musée d'Orsay,

of the old theme of the unutterable secret of death.

Yet another tradition inspired Jean-Baptiste Carpeaux (1827– 75). In Rome, where the French sculptor was living, his *Ugolino and His Children* (1860) was enormously popular. The dreadfulness of the subject, drawn from Dante, seemed to herald another—belated—aspect of Romanticism. Carpeaux's dynamic, tormented life indeed seems to link him to that movement, as do his far from negligible paintings, whose rapid, visionary brushwork gives them a distinctly modern feel. Yet Carpeaux's art was

in fact most closely related to the eighteenth century, almost appearing to offer a brilliant example of a "Pompadour" revival. Carpeaux apparently saw the court of Napoleon III as heir to the court of Louis XV, complete with bare-shouldered ladies and society smiles. His *Flora*, with dimple-fleshed cherubs, was clearly inspired by the sculptural idylls of eighteenth-century artist Clodion (Claude Michel). Carpeaux restored to sculpture a flickering, lively light that disrupted curves and fragmented volume; in short he rejected the entire drift of the classical revival since the days of Houdon.

Repeating a comment made in connection with architecture, it might be argued that the sculpture of this period was perhaps not marked by great geniuses yet seems to have produced, especially in Paris, a great wealth of work. These riches have not yet been fully explored. In addition to the numerous commissions for public buildings, private residences also reflected the public taste for sculpture, notably on façades that flaunted caryatids, atlantes, masks, allegorical figures, and vast decorative schemes. The money spent on following this fashion explains the proliferation of artists and craftsmen who specialized in working stone. There emerged a veritable stable of young apprentices, who would spend their entire lives carving ornaments on façades—with remarkable precision and skill—or, if talented enough, might rise to the rank of creative artist.

Once again, a stroll through nineteenth-century Paris tends to evoke the era of the great cathedrals: even if lacking individual genius, all sculptors displayed a knowledge and a know-how that contributed to the collective genius of the age.

FACING PAGE
Gabriel Davioud (architect) and Louis-Valentin-Élias Robert (sculptor), decorative façade, 8–10, place de la République, Paris (France), 1867.

LEFT
Caryatid, façade of 66, avenue Kléber, Paris (France).

Painting

Turning now to painting, it is impossible not to be struck, once again, by the feeling that this period was one of the most active and most stylistically varied in history. It was also rich in geniuses. Obviously, the fact that an enormous quantity of works have survived needs to be taken into account. The French Revolution, which destroyed so much else, not only left modern painting almost intact, it founded—or encouraged the founding of—museums that have safeguarded the names, along with often excellent works, of painters from all lands. Compared to earlier periods, relatively few paintings have been lost, and there is always hope that even these may eventually turn up.

Furthermore, neither political upheavals nor Napoleonic wars truly ruined the grand European institutions founded in the eighteenth century. In Paris itself, an official Salon continued to be held each year even during the most dire moments, and artists' workshops functioned as they always had. The French Academy in Rome, meanwhile, experienced only a short period of difficulty before once again playing a role more brilliant than ever. Social changes in the nineteenth century might have threatened artists with the loss of their patrons, but in fact the successive regimes all wanted to "encourage the arts" and artists' clientele continued to grow throughout Europe. The invention of rail travel would soon greatly enhance the mobility of artists, artworks, and art lovers. By the second half of the nineteenth century, with the flowering of the Victorian era and France's Second Empire, an international art market began to emerge, managed by enterprising dealers. Furthermore, America began to shape up as a major outlet for artists.

It is not easy to bring a sharp light to bear on such a rich and densely documented period. Geographically, however, two opposing trends can be noted: the development of a few major art centers that would dominate all European activity; and a simultaneous and deliberate move toward "provincialization."

In the late eighteenth century, Paris continued to hold great appeal, but for a few decades Rome once again became the main center that drew painters from every land. The Eternal City therefore enjoyed a third, if brief, period of brilliance, before ceding to Paris once more. Conversely— and for the first time—there arose groups that wanted to cultivate

Léon Bonnat,
The Martyrdom of Saint Denis, 1885.
Oil on canvas applied to wall,
Panthéon, Paris (France).

their specificity. They sprang from the great wave of nineteenth-century "nationalisms" that swept through Europe with the exception of long-unified countries such as England and France. In Germanic lands there was a notable attempt to ignore prevailing fashion and to rely on what was felt to be a more authentic tradition, as seen not only in the work of Caspar David Friedrich but also in the Nazarenes, the Düsseldorf landscape painters, and the Austrian Biedermeier spirit. A similar phenomenon was reflected in the Neapolitan school of Posillipo, in Belgium after 1830, in Denmark, and even in American landscape painting.

These small groups could legitimately be called "schools," a term initially avoided by this book. Almost all of them were characterized by a distinct leader—not necessarily the most talented artist—accompanied by several disciples and a small group of friends, artists, and critics. They all had their own more or less debatable doctrine, along with an expressive style that might be dainty or bold. For historians and art lovers, one of the charms of this period is certainly discovering these many fringe groups, traveling to study them on home soil (for their work rarely spread very far), and shedding light on their always fascinating if sometimes naïve ambitions.

Simply mentioning these schools in passing does them a disservice, but there is no room here to study them properly. Readers are nevertheless warned that this period should not be perceived as the simple, linear development of concepts borrowed from literature of the day, such as a steady shift from "Romanticism" to "realism," nor as the long death of "history painting" matched by the slow rise of "pure painting." No misconception is more serious—nor more common, nowadays—than the assumption that a natural, inevitable evolution took place (even admitting exceptions and countervailing incidents). There can be no more erroneous reading of the past than one that reduces everything to uniformity, overlooking the fact that each country retained its own personality and pace of development.

Adopting a less didactic attitude, this chapter will start with the facts themselves, that is to say with the works produced during the period. As just mentioned, a vast number of paintings were produced; without even seeking to cite all the major events or to establish a dialectical or hierarchical relationship between them—always open to challenge at any rate—three principal trends can be identified.

One movement pursued, throughout this period, the grand tradition of "history painting." It saw itself as heir to the past, which it wanted to rival. And it managed to do so thanks to skills and knowledge carefully handed down for three hundred years, and thanks also to the presence of connoisseurs with rigorous taste. True enough, events of the day were highly inspiring for history

painters—the French Revolution and Empire supplied epic subject-matter. Nationalist uprisings and celebrations of each country's past inspired exalting imagery. Further-more, the revival of religion that followed the Jacobin period's neglect of churches meant a new market for ecclesiastical commis-sions. One of art's least-known treasure houses consists of the frescoes and large canvases cover-ing the walls of Paris churches, which revolution had almost com-pletely stripped of their earlier trea-sures. Some fifty years ago, people began destroying these "pompous paintings," but a few enlightened minds managed to save them. How much longer, though, will we have to wait until they are cleaned and restored?

The second trend—probably the most typical of the period—explic-itly sought a return to the past. In its way, it corresponded to the revival movements already dis-cussed with regard to architecture and sculpture, yet in painting this trend went even further by making a clean break with the Age of Enlightenment, sometimes becom-ing truly mystical in inspiration. It represented a vast, often naïve, attempt to regain control over art, breaking current molds in order to return to essential issues. One paradox of this trend was that it was often at the heart of innova-tion at the very moment it claimed to be reviving the most ancient of traditions.

A third trend involved the pas-sionate study of nature, which

obviously translated into ever-greater numbers of landscapes, although it embraced the entire spectacle of everyday life—people, animals, seasons, ages, light. Everything was the object of metic-ulous inquiry, usually conducted with great empathy. This realistic perspective was obviously not completely novel, yet never before had it been taken so far, nor pro-duced so many masterpieces. In the space of a century, an entirely new inventory would be made of the scenery of Germany, Switzerland, Italy, France, Eng-land, and America, revealing poorly appreciated aspects of their landscapes. Easels invaded the countryside around Rome, the Alps, the forest near Barbizon, and Scotland. And, as in all periods of enthusiasm, even the most modest sketch conveys sensitivity and spirit.

The final, and least expected, incarnation of the realist tendency was what is called Impressionism, for in a way, Impressionism might be considered a perverse form of realism. It was no longer a ques-tion of seeing *other things*, but of seeing and painting *otherwise*. Monet had no qualms about choosing views that might seem hackneyed, such as the cliffs at Étretat and the quays in Venice. The crucial thing was his analysis of light through brushstrokes. The surprising thing was not the initial lack of comprehension, however brief, but the fact that this revolu-tion spread to painters other than landscape specialists. It profoundly

affected the work of Renoir (at least in part) and above all of Manet, Degas, and Cézanne.

History painting

Around 1775, painting's "grand manner" drifted casually toward modern subjects and genre scenes. It often drew inspiration from the stage, unmindful of the theater's artificial vision and exaggerated poses. A reaction therefore arose with the following generation, expressed most distinctly by two painters of highly different—not to say opposed—genius.

The first was Spanish artist Francisco de Goya (1746–1828). Having gained access to the court by marrying the sister of Francisco Bayeu, titular painter to the king, Goya was commissioned to execute several series of cartoons for the Santa Barbara royal tapestry manufactory, enabling him to develop simultaneously a taste for popular scenes and a harmonious palette of bright colors borrowed from Tiepolo (*The Parasol*, 1777, and *The Pottery Merchant*, 1778, both in the Prado, Madrid). Goya also painted many official portraits, the best of which evoked the

Francisco de Goya, *The Third of May, 1808*, 1814. Oil on canvas, 8′8″ × 11′3″ (2.66 × 3.45 m). Museo del Prado, Madrid (Spain).

elliptical brushwork of Velasquez. Joseph Bonaparte, installed on the Spanish throne, conferred the Royal Order of Spain on Goya, but it was only with Bonaparte's departure in 1814 that the artist produced his masterpieces, *The Second of May, 1808* and above all *The Third of May, 1808*, both intense depictions of the horrors of war (page 450). Shortly after 1819, Goya bought a residence near Madrid, known as the Quinta del Sordo (House of the Deaf Man), which he decorated with fourteen large murals that are dark, fierce, and visionary. Thus without

doctrine or guide, this "official" artist enjoyed one of the most wide-ranging careers ever open to an artist. Although plagiarized, Goya had no true successor in Spain.

Entirely different was Parisian painter Jacques-Louis David, Goya's junior by two years (1748–1825). David received solid training in the elegant, rational style of Paris yet was caught up in the trend that advocated a return to antiquity. From one painting to the next he began simplifying composition, eliminating stark foreshortening and perspective, grouping figures on the same plane, and

Jacques-Louis David,
The Oath of the Horatii,
1784. Oil on canvas,
10′9″ × 13′10″
(3.30 × 4.25 m).
Musée du Louvre,
Paris (France).

choosing architectural settings of plain columns. Everything came together in *The Oath of the Horatii*, which he wanted to complete in Rome itself, and which won instant acclaim there (page 451). It is a very austere painting with simple volumes, crisp outlines, and earnest colors; yet at the same time, David demonstrated his skill in details such as the three upraised hands and the group of women whose supple, flowing poses counteract the tense male group.

David had no hesitations about painting people of his day. And he did things in a big way, boldly painting gigantic scenes such as *Napoleon Distributing the Eagles* and *The Coronation of Napoleon*, which incorporated dozens of attentively studied portraits of his contemporaries. But he had no sense of fantasy. He preferred to populate his imaginary world with skillfully orchestrated nudes, even in wartime (*The Sabines*, 1799, and *Leonidas at Thermopylae*, 1814, both in the Louvre, Paris).

Horace Vernet,
The Battle of Friedland (1807), c. 1835–36.
Oil on canvas, 15′1″ × 17′8″ (4.65 × 5.43 m).
Battle Gallery,
Château of Versailles (France).

Pierre-Paul Prud'hon,
*Justice and Divine
Vengeance Pursuing Crime*,
1808. Oil on canvas,
7′11″ × 9′7″ (2.44 × 2.94
m). Musée du Louvre,
Paris (France).

David revived the great tradition of Poussin among the French, that of a lucidly organized universe with no room for all the monsters that emerge when reason—to use Goya's words—is put to sleep.

David had an enormous impact, and even though a painter such as Pierre-Paul Prud'hon, ten years his junior (1758–1823), escaped his influence by choosing different models, by preferring Correggio to Giulio Romano, and by favoring chiaroscuro over chiseled volumes, it could not be said that Prud'hon

rejected David's path. Rather, he proposed an elegiac version of it (page 453). But the following generation, typified by Girodet (1767–1824), Gérard (1770–1837), Gros (1771–1835), and Guérin (1774–1833), would endow imperial France with a kind of epic unity worthy of Napoleon despite their highly diverse talents. This generation consolidated a long tradition of military painting in France which only came to an end with the trench warfare of 1914. It enjoyed its heyday in the 1830s

under the pacific king Louis-Philippe, who commissioned a grand cycle of history paintings for the Battle Gallery in the Château of Versailles. Whereas Delacroix contributed a depiction of the thirteenth-century *Battle of Taillebourg* (1837), Gérard, Philippoteaux, and Horace Vernet (page 452) illustrated the Napoleonic saga through imagery as stirring as the famous painting of *The Battle of Eylau* executed by Gros back in 1808.

The grand ambitions and fascination with classical antiquity were passed on to Théodore Géricault (1791–1824), a painter who died at thirty-three after completing an ambiguous masterpiece, *The Raft of the Medusa* (page 454). Géricault's grouped masses and tragic violence could be seen as a rebuttal of David's approach even as it reinvigorates David's inspired contact with reality. Géricault's torch would be taken up by a man who, though of a different character altogether, had known and been influenced by him: Eugène Delacroix (1798–1863).

Although Delacroix was a highly cultured artist, he never made a special effort to go to Rome—his generation began to weary of the classical model. Delacroix wanted to be modern, and he looked to Titian, Veronese, and Rubens. Up to 1840,

Théodore Géricault,
The Raft of the Medusa,
second sketch for
the final painting, 1818.
Oil on canvas,
2′2″ × 2′9″ (65 × 83 cm).
Musée du Louvre,
Paris (France).

Euqène Delacroix,
The Death of Sardanapalus,
1827. Oil on canvas,
12′9″ × 16′1″
(3.92 × 4.96 m).
Musée du Louvre,
Paris (France).

he produced large-scale, lyrical imagery in big masterpieces such as *The Massacre at Chios* (1823–24), *Liberty Leading the People* (1830), and *The Entry of the Crusaders into Constantinople* (1840). Whether evoking history or current events, his painting stressed the plastic unity of the canvas, which David's analytical approach had tended to overlook. For example, in his 1827 *Death of Sardanapalus* (page 455), Delacroix adopted a high-angle view that eliminated the horizon line and, despite the angled corner of the palace seen in the upper right,

denied the eye any sense of perspective. The painting is organized around a play of diagonal lines, most of the shapes are fragmented, and the unity of the canvas is supplied by color rather than forms, mainly by the large central patch of scarlet red, underscored by a few touches of golden yellow. Subsequently, from 1850 until his death in 1863, Delacroix focused all his creative energy on large decorative projects for Parisian institutions such as the Palais-Bourbon, the Palais du Luxembourg, the Apollo Gallery in the Louvre, the Holy Angels Chapel in the

church of Saint-Sulpice, and the Salon of Peace in the Hôtel de Ville (ceiling destroyed in the 1871 fire). These enormous projects are underrated even today. Delacroix continued to paint canvases of standard format, in which he often repeated earlier compositions with new refinement, if with less spontaneity.

Delacroix's brilliance should not be allowed to overshadow other names. Horace Vernet (1789–1863), so little appreciated these days, possessed an exceptional feeling for vivid light, and he had the stamina to produce one of the largest paintings of the century, *The Capture of Abd'el Kadar's Encampment* (1845, Versailles), some 70 ft. long (21.39 m). At the same time, an artist of elegeaic sensibility such as Ary Scheffer (1795–1858) could also rise to the epic register, while Thomas Couture (1815–79), torn between his grand—and often aborted—plans and his skilled hand, has recently recovered some of his original fame

Théodore Chassériau,
The Toilet of Esther,
1841. Oil on canvas,
18 × 14″ (45 × 35 cm).
Musée du Louvre,
Paris (France).

after a period of disdain. The most appealing artist nevertheless remains Théodore Chassériau (1819–56), whose brief career yielded not only small canvases known for their delicate sensuality and resonant color (*The Toilet of Esther*, page 456), but also included large commissions (church of Saint-Roch, the interior of the former Cour des Comptes).

The abundance of artists with great qualities—which appear enhanced by the scope of the tasks undertaken—seems surprising once the works themselves—rather than books—are studied. Indeed, it is amazing that King Louis-Philippe could find twenty artists in France in 1833–35 to paint the thirty-three very large canvases that now comprise the Battle Gallery in Versailles, and that these canvases, though different in style, are perfectly harmonious. Not a single one is weak, slapdash, or boring. Even the most modest merits fame for its creator.

It is equally amazing that Philippe de Chennevières, under Napoleon III, had no trouble appointing artists able to cover entire walls of the Panthéon with veritable masterpieces that remain, alas, too little appreciated today. And a little later, after the spiteful Paris fires of 1871, there were still painters ready to decorate all the rooms of the vast Hôtel de Ville. These facts alone reveal the strength and endurance of a grand tradition of "history" painting that also aimed to be "historic."

It is certainly worth stressing the fact that, as the nineteenth century

progressed, true historical subjects claimed increasing preponderance over biblical and mythological themes. Mythology became less and less frequent as a subject, perhaps because the hospitable, contrived yet timeless corpus of Roman myths gave way to mythological scholarship that was harder to accord with interior decoration. The same was true of ecclesiastical painting, which had been revived in France by major commissions during the Restoration—too many subjects that had previously been accepted unquestioningly were becoming suspect as concern emerged for an interpretation as consistent as possible with history.

As years went by, traditional interpretations of the Bible, Gospels, and the lives of saints would give way to an art that had archaeological scruples, even when an artist such as Léon Bonnat sought to imbue these scruples with vast dramatic scope, as seen in his *Martyrdom of Saint Denis* for the Panthéon (page 446).

Paul Delaroche (1797–1856) was one of the first artists to specialize in paintings where the tragic impulse would be combined with "historical color." But the artist who, more than any other, advanced the idea of a privileged link between painting and history—or rather, the idea that painting's role was to make human history present—was Jean-Paul Laurens (1838–1921). His most admirably supple brushwork and scrupulous scholarship, discreetly wed to a visionary imagination,

won him well-merited fame followed by sudden discredit. For too long now, his works have been viewed as simple illustrations when in fact they sum up the nineteenth-century's passion for history, itself felt to be a key dimension of humanity. Laurens was as comfortable illustrating a book on Merovingian history (*Les Temps Mérovingiens* by Augustin Thierry, 1879–87) as he was depicting historical events such as *The Execution of the Duc d'Enghien* (1872, Alençon, France) or *The Final Moments of Maximilian* (1882, Hermitage, Saint Petersburg), this latter canvas being in no way inferior to Manet's overpraised version. Laurens's masterpiece is probably the vast polyptych displayed on one of the walls

Jean-Paul Laurens,
The Final Moment in the Life of Saint Geneviève,
1876–82. Oil on canvas applied to the wall,
Panthéon, Paris (France).

of the Panthéon in Paris, showing *The Final Moments in the Life of Sainte Geneviève* (1876–82). He was not concerned with celebrating his faith, but preferred instead to portray, in the most realistic way possible, the old woman who saved Paris from the barbarian hordes and who died surrounded by a crowd of people (page 458). For the fourth panel, he depicted the saint's entombment, this time handled with all the grandeur of an image straight out of Victor Hugo: by the flame of a brazier, a large, somber angel lifts Geneviève's shroud for the last time, and points a finger heavenward.

Symbolism in painting

The artists cited above were clearly taking the nineteenth century's standard route, churning out the period's main masterpieces—but not all its masterpieces. Alongside the standard route there was a winding, little-trodden path that also produced its share of treasures, which many connoisseurs today openly prefer. We are not dealing with a continuous tradition here, but rather a series of interludes, some of them very unobtrusive. Most of those interludes were closely linked to religious feelings or to a philosophy tinged with symbolism. One remarkable feature is that most of the artists working in this vein cultivated a certain archaic quality and sought, at least superficially, to forsake part of the science of painting acquired over the centuries in

order to return to "naïve" inspiration. This was not the first time that artists adopted painters of earlier centuries as models, but usually it had been in order to refine their technique. Here, however, painters were openly and knowingly rejecting acquired skills in their quest for the simplicity and sincerity of "the good old days."

An initial episode occurred at an early date, in the milieu already won over to the classical revival. Some artists were uncomfortable with David's cold, controlled figures. The literary fad for the poems of Ossian (in fact composed by James Macpherson) and the great rediscovery of Shakespeare opened up new creative realms, ones removed from the ideal of heroic clarity. Furthermore, the contempt for religion that characterized the late eighteenth century was often accompanied by a barely concealed eroticism. In a painting such as *The Ghost of Culmin Appearing to His Mother* (page 460), Danish artist Nicolai Abraham Abildgaard (1743–1809) showed that he had profited from ten years spent in Italy to adopt the ideas of Mengs and Winckelmann. The composition is simple, reduced to a single plane, and orchestrated around broad curves. But the choice of a subject drawn from Ossian completely modifies the artistic stakes. As often in Ossian's poetry, the scene takes place at night: a crescent moon appears, a shaft of light in the foreground creates a strong chiaroscuro effect, and the heroically nude

young man is just an apparition barely detectable in the half-light, while two wild dogs prowl threateningly. This strange atmosphere, a combination of night, storm, and vision, plus athletic and freakish forms, would also be exploited by Swiss-born artist Henry Fuseli (1741–1825) who, after a long stay in Italy, enjoyed a brilliant career in London. Henceforth there was nothing left of the sober antique ideal. *Thor Battling the Midgard Serpent* (page 461), which Fuseli deposited with the Royal Academy on being accepted as an associate member in 1788, might pass for his profession of faith. The subject, drawn from the Norse legends then being rediscovered, is conveyed here by a surprising play of foreshortening and contrasts that seek not to render the scene plausible but, on the

contrary, to underscore its dreamlike quality. Fuseli deliberately neglected color, relying entirely on chiaroscuro to set off the apparition of phantoms and sorcerers. When it comes to draftsmanship, Fuseli claimed he was inspired by Michelangelo, but in fact he only managed to produce a rather artificial mannerism.

Fuseli's London career was almost simultaneous with that of the poet, illustrator, and engraver William Blake (1757–1827), who also combined Michelangelo-like nudes with fantastic visions. But Blake's visions were inspired by Dante, Milton, and the Bible. Only a profoundly English culture is able to fully appreciate Blake's singular blend of awkwardness, subtlety, and religious obsession. It is probably fair to say that Fuseli and Blake founded a tradition of fantastic

painting in England not developed to the same degree elsewhere.

Returning to a more conventional idiom, the tireless imagination of John Martin (1789–1854) produced many apocalyptic scenes, but the reddish uniformity of his palette weakens the impact of his oeuvre. The same could not be said of Joseph Mallord William Turner (1775–1851), whose exploration of color, light, and substance transformed most of his canvases, notably after 1830, into tragic or grandiose visions. Works such as *Burial at Sea* and *Snow Storm* (exhibited at the Royal Academy, London, in 1842) and especially

an almost abstract *Landscape with River and a Bay in the Background* (page 462) attain great lyricism, perhaps more than the canvases where Turner felt he had to introduce religious allusions or fragments of more or less explicit subject matter.

No direct link should be drawn between this essentially Romantic artistry and the Pre-Raphaelite Brotherhood that was formed in England a little later. At best, the Pre-Raphaelites are related to the former through their determination to rejuvenate painting by giving pride of place to poetic artistry and sometimes to mysticism. Initially,

Joseph Mallord William Turner, *Landscape with a River and a Bay in the Background*, c. 1835–40. Oil on canvas, 3 × 4′ (92 × 123 cm). Musée du Louvre, Paris (France).

Edward Burne-Jones,
The Beguiling of Merlin,
1870–74. Oil on canvas,
6′ × 3′7″ (1.86 × 1.11 m).
Lady Lever Art Gallery,
Port Sunlight (England).

Pre-Raphaelite painters such as William Holman Hunt (1827–1910) and John Everett Millais (1829–96) played on a prolific accumulation of real details mobilized toward symbolic ends. It was only with the second generation that a true attempt was made to revive a vision closer to the quattrocento. The most brilliant artist of the moment was certainly Edward Burne-Jones (1833–98), who took his subjects from medieval legends and attempted to imbue them with an ethereal poetry. The eternal opposition of the sexes was thus

evoked through an image of the enchantress Nimuë (or Vivien) beguiling Merlin the magician (page 463). This composition is simultaneously simple and overburdened: two figures, a single plane (the eye barely perceives the central gap that opens onto the distance), a single color (blue against a greenish ground), yet a riot of folds and a profusion of flowers. Long curves run across the canvas likes veins in marble. The dress is deliberately timeless, and the meaning of the painting remains mysterious at first glance. More than a "Pre-Raphael" painting, this work evokes what

would be called "decadent symbolism" in poetry. This musical feeling and these languid poses were nevertheless still novel.

The idea of forming a Pre-Raphaelite Brotherhood was perhaps inspired by the earlier example of a group of young German artists who called themselves the Nazarenes. Around 1812, they found themselves in Rome and sought to reinvigorate painting through their faith and inexperience. They felt that Raphael was the evil angel of painting. Their movement can be understood from various angles, in reaction to the

Franz Pforr,
Mary and the Shulamite,
1811. Oil on canvas,
13 × 12″ (34 × 32 cm).
Georg Schäfer Museum,
Schweinfurt (Germany).

Friedrich Overbeck, *Joseph Being Sold by His Brothers*, 1816–17. Fresco (originally in Casa Bartholdy, Rome) 7'11" × 9'11" (2.43 × 3.04 m). Alte Nationalgalerie, Berlin (Germany).

triumph of French painting: as a revival of religious feeling after the age of Enlightenment (several members converted to Catholicism from Protestantism); as an artistic revival of the fifteenth and sixteenth centuries; or as a return to the days of Dürer.

For example, *Mary and the Shulamite* (1811), a famous painting by Franz Pforr (1788–1812)—who co-founded the Brotherhood of Saint Luke with Friedrich Overbeck (1789–1869) but died at age twenty-four—takes the form of a diptych and plays on a double symbolism (page 464). A sixteenth-

century German interior (on the right) is set against an Italian landscape (left), just as religious asceticism is set against the young mother's bliss. Pforr's painting is deliberately dry and linear, with flat color and little modeling, all of which suggests a "primitive" painting. A little later, Overbeck made the same symbolic comparison in a painting explicitly titled *Italia and Germania* (1811–28, Munich). It shows two friends seated in a double landscape, wearing early sixteenth-century dress. The blue sky, pale colors, and barely detectable modeling hark back to

465

Moritz Ludwig von Schwind, *The Knight of Falkenstein's Exploit*, 1843–44. Oil on canvas, 4′11″ × 3′1″ (152 × 94 cm). Museum der Bildenden Künste, Leipzig (Germany).

early Raphael or even Perugino. Overbeck displays greater skill than Pforr, but also stresses stiff drapery, sharp profiles, and distinct details (the wreath in Germania's hair, the laurel leaves against the Italian sky). A similar approach characterizes *Joseph Being Sold* *by his Brothers*, a fresco executed by Overbeck in 1816–17 (page 465). This confident composition no longer displays any awkwardness, but the stress on draftsmanship (at the expense of contrasting colors and pronounced modeling) confirms the intention to cancel

Arnold Böcklin, *The Plague*,
1898. Oil on wood,
4′10″ × 3′4″ (1.49 × 1.04 m).
Kunstmuseum, Basel
(Switzerland).

three centuries of developments in European painting.

Such works were enormously popular. Although they scarcely altered the course of painting in Rome, they marked a trend in German art. The combination of love for the fatherland and a longing for Italy ("Sehnsucht nach Italien"), spurred by a renewed interest in nature and old legends, would last a long time, often expressed in a more or less archaic visual idiom. Thus painter and decorator Moritz von Schwind (1804–71) favored highly linear

draftsmanship and a simplified palette that bordered on mere coloring (page 466). The same dream was pursued by Ludwig Richter (1803–84) and even Hans Thoma (1829–1924). Their coziness (*Gemütlichkeit*) would only be broken by the brutality of Swiss artist Arnold Böcklin (1827–1907) with his blend of realism, naïve symbolism, and strident colors (page 467). But Böcklin's extravagance hardly masks the persistence of the old, almost metaphysical dream of an alliance between Germany and Italy, between the violence of action and the contemplation of bucolic nature.

It long seemed as though France had remained aloof from these adventures. The course of French painting was thought to reflect the unity of a country that had been centralized for centuries, with a uniform taste established by the court. Only recently have we come to realize the crucial role played by certain developments and certain groups that are usually overlooked.

One of them arose from David's own studio. When he advocated a return to antiquity, some of his pupils wondered whether he might be mistaken in turning to Roman sculpture. They thought it might be better to return to the true source, Greek art, as purportedly reflected in Etruscan vases. These artists were led by a young painter named Maurice Quay (c. 1779–1804), whose talent, beauty, eloquence, and strange behavior won him a following. The group was called "les Primitifs" or "les Barbus"

("Bearded Men"). Quay died young, and his works have never been identified with certainty. Several paintings by his disciples nevertheless survived, such as *The Death of Hyacinthus* by Jean Broc (1771–c. 1850), exhibited in the Salon of 1801 (Poitiers) and *Greek Heroes Drawing Lots for Trojan Captives*, an immense canvas by Paulin Duqueylard (1771–1845), exhibited in the Salon of 1808 (Musée Granet, Aix-en-Provence). Hopefully, some day a sufficient number of paintings will resurface to do full justice to the group's ambitions.

The "Primitifs" would perhaps not merit mention here if their ideas, when combined with line engravings by English artist John Flaxman (1755–1826), had not strongly interested the young Jean-Auguste-Dominique Ingres (1780–1867). His strange *Aphrodite* [or *Venus*] *Wounded by Diomedes* (c. 1805), seems to encapsulate the lessons taught by Quay's group (page 469). Similarly, the ideas of this dissident little clan, rather than David's own, are reflected in Ingres's hieratic *Napoleon on the Imperial Throne* (1806), his admirable *Jupiter and Thetis* (dated 1811, but probably planned as early as 1806), and the initial drawing for the *Dream of Ossian* (painted in 1813, but certainly based on an earlier drawing). The *Aphrodite* provides a good example of Ingres's French-style "Nazarene" approach: the subject is taken from the part of classical antiquity that the "Primitifs" felt

Jean-Auguste-Dominique Ingres, *Aphrodite* [*Venus*] *Wounded by Diomedes*, c. 1805 [?]. Oil on canvas, 11 × 13″ (27 × 33 cm). Kunstmuseum, Basel (Switzerland).

was acceptable (in their eyes, Euripides was already corrupt); the incident is not depicted in a "classic" manner in so far as no *action* links Ares to Aphrodite, only a glance; the chariot and shield are shown in archaeological simplicity; Iris, who is taking Aphrodite to Mount Olympus, wears the austere *peplos* garment seen on Etruscan vases, completed by an Empire-style tiara; Aphrodite herself displays nothing of the canon of Greek sculpture, the curve of her body being deliberately exaggerated, as is that of Thetis in *Jupiter and Thetis* (page 414); meanwhile, the white horses betray an awkward

stiffness found only on pottery. It would be hard to push the archaic aspect any further.

Subsequently, Ingres would turn to Raphael himself. But a rereading of Ingres's oeuvre reveals persistent traces of this first interest. He rejected the use of perspective for his Louvre ceiling, *The Apotheosis of Homer* (1827); he avoided light-and-shade modeling, and favored long curves (even at the expense of forced poses or deformations). Setting aside his admirable portraits, Ingres's oeuvre displays a constant tendency toward archaism, seen as late as his ceiling of the Emperor's Hall

for the Hôtel de Ville in Paris (1853, destroyed by fire). In this respect, the opposition between "classical" Ingres and "Romantic" Delacroix seems simplistic. Although the distinction was made during the two men's lifetimes, it masks more than it reveals about the underlying aspirations of both artists.

Certain disciples of Ingres, whom critics accused of adopting a "Chinese style," also display a certain rejection of modernity. This was notably the case of Eugène Amaury-Duval (1808–85), a great admirer of Fra Angelico and a friend of the Nazarenes. For the church of Saint-Merri in Paris he painted a *Saint Philomena Borne by Two Angels* (1839) in a deliberately "primitive style," and his *Birth of Venus* (page 470) reveals a sobriety combined with a light palette that seems to achieve, if somewhat tardily, the ideal imagined by the "Primitifs."

However, another group had already emerged, once again among David's followers. They were called the "Troubadours," and their non-conformism this time concerned politics—most of them did not share David's revolutionary sympathies—and their approach to history painting. They preferred small and medium formats to their master's vast canvases, and instead of the glorious deeds of the past and the empire, they depicted anecdotal incidents usually set in the days of chivalry. In this way they could evoke tournaments, convents, everyday life,

sad or affectionate feelings. They had no ambitions other than perfecting their craft and delicately rendering their subject. The major figures in the group were Pierre Révoil (1776–1842) and Fleury-François Richard (1777–1852),

Eugène Emmanuel Pineu-Duval, known as Amaury-Duval, *The Birth of Venus*, 1862. Oil on canvas, 6′5″ × 3′6″ (1.97 × 1.09 m). Musée des Beaux-Arts, Lille (France).

Fleury-François Richard, called Fleury-Richard, *The Convent Garden* (unfinished), c. 1820s [?]. Oil on canvas, 21 × 16″ (54 × 40 cm). Musée des Beaux-Arts, Lyon (France).

both from Lyon. Révoil, a famous collector, was the more learned of the two. Richard's elegiac temperament led him to favor landscape. He liked dark gateways framing fine clumps of foliage wrapped in sunlight (page 471). His figures, almost always romantic or religious, were often mere ploys added at the last minute. This unpretentious Troubadour art sarevd as a counterpoint to large canvases depicting Napoleon's epic deeds. It participated in the "Gothic Revival," was encouraged by Empress Josephine, and enjoyed great popularity. Ingres himself painted a series of perfectly Troubadourian canvases. But its popularity was fleeting, and the movement's importance has only been recognized recently.

Not only were Richard and Révoil born in Lyon, but they also taught there. They remained devout Catholics even after joining David's workshop, and although strictly speaking they could not be called religious artists, they helped to give Lyon the image of "the capital of Catholicism" that would mark the city in the nineteenth century. During the great revival of ecclesiastical painting that began with the restoration of the monarchy, much of French painting originated in Lyon or was done by Lyon-influenced artists, as typified by the likes of Victor Orsel (1795–1850), whose large *Good and Evil* (1828–33, Musée de Lyon) is so similar to the art of the Nazarenes, Hippolyte Flandrin (1809–64), who executed a very impressive *Pietà* (c. 1842, Musée de Lyon), and above all Louis Janmot, who boldly revived the use of a gold background in 1850 for his triptych for Lyon Cathedral. Even rarer for a French artist, Janmot composed a mystic cycle of eighteen canvases, probably between 1835 and 1854, titled *The Poem of the Soul* (page 472). Janmot may not have managed to elaborate an aesthetic language equal to

Louis Janmot,
The Flight of the Soul (from the series titled *The Poem of the Soul*), 1854.
Oil on canvas, 4′7″ × 4′9″ (1.40 × 1.45 m).
Musée des Beaux-Arts, Lyon (France).

Pierre Puvis de Chavannes,
The Poor Fisherman, 1881.
Oil on canvas, 5′1″ × 6′3″
(1.55 × 1.92 m).
Musée d'Orsay,
Paris (France).

his ambitions, yet Baudelaire claimed that his paintings generated "an infinite charm, hard to describe, something of the sweetness of solitude, of the sacristy, the church, the cloister."

An interest in archaism combined with an interest in spirituality long survived in Lyon, so it is hardly surprising that this combination marked Lyon's most famous painter, Pierre Puvis de Chavannes (1824–98). At an early age, he devoted himself to grand decorative schemes. Through a long development fascinating to follow,

Puvis de Chavannes simplified line and color, stressed contours (sometimes resorting to outlining), isolated volumes, and boiled his art down to a "primitive" style without, however, claiming inspiration from past examples. His vast compositions increasingly imitated frescoes, although painted on canvas glued to the wall. His *Ancient Vision* (1886), above the grand staircase in the Musée des Beaux-Arts in Lyon, is almost free of dark values (of which there are only two or three patches). When decorating the Zodiac Salon of the

Hôtel de Ville in Paris (1887–92), his *Summer* was orchestrated around grand horizontal rhythms, while *Winter* is structured around an insistent stress on verticals. Nor did Puvis hesitate to use vast swatches of pale colors that exclude any sense of depth. One of his rare easel paintings, the famous *Poor Fisherman* (page 473), exhibited in the Salon of 1881, represents the culmination of the nineteenth century's exploration of archaism.

It is interesting to note that a painter of the same generation followed a parallel yet inverse path. Gustave Moreau (1826–98) was not interested in large decorative commissions, nor even very concerned about selling his work. He was totally absorbed in developing a distinctive style and the expression of inner feelings. During a stay in Italy from 1857 to 1859, he acquired a great admiration for artists such as Carpaccio and Benozzo Gozzoli, and he adopted elegant draftsmanship and a vivid palette not unlike that of the English Pre-Raphaelites with their archaic ambitions; like them, Moreau wanted to remain aloof from contemporary painting. Yet whereas Puvis constantly simplified his means, Moreau complicated his technique to an extreme, trying to make his colors more striking, his curves more expressive. He thus

Gustave Moreau, *Helen Before the Scaean Gate*, c. 1880. Oil on canvas, 2′4″ × 3′3″ (72 × 100 cm). Musée Gustave Moreau, Paris (France).

arrived at a point of rupture in which all that remained was the expressive power and ambiguity of his brushwork. His late canvases, such as *Helen Before the Scaean Gate* (page 474), no longer even entail overall composition or organization of figures; Moreau's once studied curves have vanished, and his thickly inscribed marks have become allusive without losing any of their visionary power.

Painting reality

Works such as Puvis de Chavannes's *Poor Fisherman* and Moreau's *Helen Before the Scaean Gate* assume their full meaning only after consideration of a third aspect of painting from this period: its passionate interest in reality, in everything surrounding the artist, independent of any idea or transposition—independent, it might almost be said, of any art. "Realism" was not invented in the nineteenth century, of course. Many painters in the past, brush or chalk in hand, had observed landscapes, plants, stones, and animals. They enjoyed depicting peasants, and even laborers, and had shown men and women at their daily tasks or in their humble nakedness. To a certain extent, the Caravaggists had entertained this ambition, although it soon proved chimerical. The nineteenth century would demonstrate greater stubbornness and consistency.

This vast quest cannot be summed up in just a few sentences. It seems unfair to list just a few names when so many countries produced so many strong, appealing works. A sensitive eye and skilled hand sufficed to produce an unforgettable sketch of the forest near Barbizon or of the countryside around Rome. Depicting the lined face of a peasant woman or the hands of a weaver was easier—and more likely to be successful—than portraying the Battle of Eylau. Despite everything that has been said over the past one hundred years, a hierarchy of genres *does* exist. It is based not on preference for one school or another, but on the skills required. Realist art can succeed with less investment than an art that attempts to change our vision of the world.

That said, the late eighteenth century's rediscovery of the real world was truly admirable. Painters suddenly developed an interest in the landscape around Rome, becoming aware of the constantly changing quality of light. The most remarkable of them was Pierre de Valenciennes (1750–1819), who left some 150 sketches, most of them painted in Italy prior to 1785–86 (120 are now in the Louvre). His straightforward, bold, and highly varied sketches greatly altered people's ideas about outdoors studies in the late eighteenth century. Then there was the wonderful sensibility displayed by Joseph Bidauld (1758–1846) during his time in Italy, as seen in his *View of the Town of Avezzano* (1789, Louvre, Paris). Later a small group would even form in

Naples centred around the Dutch painter Anton (or Antonio) Pitloo (1791–1837). Dubbed the school of Posillipo, it included painters such as Giacinto Gigante (1770–1840), Frans Vervloet (1795–1872), and Beniamino de Francesco (1807–69), who spent much of their lives analyzing Neapolitan light and its delicate alliance with sea and hills.

Landscape was usually handled with respect and simplicity, free from ulterior motives. But where does pure objectivity end? No artist was more genuine, for example, than Abbé Laurent Guétal (1841–92), whose only known passions were the priesthood and

painting the French Alps. His 1886 canvas of *Lake Eychauda* (page 476) features the lake's reflection of the peaks of the nearby Oisans range; yet the grand scale (some 6 by 9 ft., 1.82 by 2.62 m), the absolutely perfect rendering of the rocks, and the lack of any human presence lend the work a strange solemnity, a *stillness* similar to spiritual meditation.

The same could be said of works by a group of American artists often known as the Hudson River school. Albert Bierstadt (1830–1902) was born in Sollingen, Germany, went to school in the United States, then returned to Germany to train in Düsseldorf, that

Abbé Laurent Guétal,
Lake Eychauda, 1886.
Oil on canvas, 5′11″ × 8′6″
(1.82 × 2.62 m).
Musée des Beaux-Arts,
Grenoble (France).

Frederick Edwin Church,
Twilight in the Wilderness,
1860. Oil on canvas,
3'3" × 5'3" (1.01 × 1.62 m).
The Cleveland Museum
of Art, Cleveland (Ohio).

brilliant center of German landscape painting. He never forgot the refined technique he acquired there. A canvas like his *Rocky Mountains, Lander's Peak* of 1863 (Metropolitan Museum, New York) is as imposing for its size (6 by 10 ft., 1.86 by 3.06 m) as its colors. Bierstadt's work was rivaled by that of Thomas Cole (1801–48) and in particular one of Cole's pupils, Frederick Edwin Church (1826–1900), who achieved fame with his huge *Niagara Falls* of 1857. With Church, painting no longer shrank before spectacular effects—his *Twilight in the Wilderness* of 1860 projects the flames of a vast blaze into a sulfurous sky (page 477).

The revelation of American nature was a grand moment in the history of landscape painting, yet we should not overlook the enthusiasm for exotic travel that gripped artists from every land. French painter François-Auguste Biard (1798–1882) traversed Egypt, Syria, and Lapland, and spent two years in Brazil. His *Magdalena Bay* (page 479), exhibited in the Salon of 1841, serves as a pendant to the famous *Sea of Ice* (page 478) by Caspar David Friedrich (1774–1840).

Italy long remained a country that attracted landscape painters such as the German Karl Blechen (1798–1840), who exploited motifs that fueled his Romantic imagination. Other German artists, however, rejected what appeared to be a kind of betrayal; so, unlike

his contemporaries the Nazarenes, Caspar David Friedrich eschewed any Italianism, just as he rejected any relationship to French art. He insisted on painting subjects specific to northern lands—fir trees, snow, melancholy moonlight, leafless winter forests, Gothic ruins, and even Celtic vestiges. His work, which evoked the artistry of Dürer and Altdorfer and represented a Germanic variant of nature worship, enjoyed resounding popularity, if long limited to Germany.

The painter who dominated this entire period, Camille Corot (1796–1875), was one of those pure geniuses who defy all attempts at commentary. Practically self-taught, Corot adhered to no strict principles. Although highly sociable, he belonged to no group. He went to Italy three times, and always remained faithful to his memories of it, yet he could never be described as an Italianist. He executed countless landscapes, never repeating himself. Take, for example, his *Peasants under the Trees at Dawn*, probably painted 1840–45 during a stay in the Morvan region of central France (page 480). Nothing could be more

Caspar David Friedrich, *The Sea of Ice*, 1824. Oil on canvas, 3′2″ × 4′2″ (96 × 127 cm). Kunsthalle, Hamburg (Germany).

François-Auguste Biard, *Magdalena Bay as Seen from Northern Spitzbergen, Effect of Aurora Borealis,* 1841. Oil on canvas, 4′3″ × 5′4″ (1.30 × 1.63 m). Musée du Louvre, Paris (France).

simple: there is no subject, no anecdote to link the two figures in the middle, no effort to particularize the place or the dress. Just a delicate light that invades the entire painting, without brightening the colors or thickening the chiaroscuro effect. The same could be said of Corot's views of *Tivoli Cascades*, of *Lake Geneva*, and of *The Interior of Sens Cathedral*. An apparent improvisation prevents the eye from clinging to the motif, obliging it to return to essentials: light and nature.

Corot's very long career continued in a different register once observation had given way to a delicate, if somewhat uniform, lyricism. At just this point, however, another group came to the fore, one generally called the Barbizon school. It was named after a village on the edge of Fontainebleau Forest south of Paris, where many artists went to paint, drawn by the beauty of the place and by inexpensive rural life. Some artists focused on enthusiastic study of the forest and heathland as a kind of substitute for the Italian countryside. Théodore Rousseau (1812–67) and Jules Dupré (1811–89)

displayed a Romanticism quite close to Friedrich's even though they refused to incorporate any patriotic or religious symbolism. The same could not be said of the most important painter in the Barbizon school, Jean-François Millet (1814–75). His earthy realism is obvious, and it became second nature to him—he went around in wooden clogs and even found it hard to put on normal shoes when returning to Paris. Rather than painting peasants in their Sunday best, he showed real peasants in their everyday clothes and tasks, in fields devoid of any hint of the picturesque. Nor did he seek to

temper his prosaic subjects with elegant drawing or pretty touches of color. His painting is somber and his brushwork fuzzy, even muddy. But there is absolutely no sense of caricature or exaggeration. He was concerned with a truthfulness so simple and serious that it seems to border on the spiritual. Paintings such as *Peasant Grafting a Tree* (page 481), *Birth of a Calf*, and *Man with a Hoe* could not be called symbolist paintings because they contain nothing that was not directly observed, scrupulously reproduced reality. But these modern scenes have a spareness that lend them biblical

Jean-Baptiste Camille Corot, *Peasants under the Trees at Dawn*, 1840–45. Oil on canvas, 11 × 16″ (27 × 40 cm). National Gallery, London (England).

scope, offering a hint of grander ideas: life, death, fertility, labor. In this respect, Millet could be discussed in the same breath as the Nazarenes and the Pre-Raphaelites.

There is no point in seeking such humble introspection in the work of an artist just a few years younger than Corot, namely Gustave Courbet (1819–77). A wonderfully gifted painter who produced some true masterpieces, Courbet was, alas, hopelessly foolish and extraordinarily conceited. He claimed to represent "realism" all by himself, when in fact he merely fossilized one particular form of it (from which, fortunately, Monet and Degas would free French painting). He thought he could lay down its laws, as demonstrated in vast canvases that reveal his limitations more than his talent. He often handled light with striking awkwardness that destroyed the effect he was seeking, and he was unable to create a tangible atmosphere around his figures, be they stags, deer, or nude women. His *Afternoon at Ornans* (Musée de Lille, France) is a boringly dark painting, heavy with impasto.

Jean-François Millet,
Peasant Grafting a Tree,
1855. Oil on canvas,
2′8″ × 3′3″ (81 × 100 cm).
Neue Pinakothek,
Munich (Germany).

His *Bathers* (Musée Fabre, Montpellier, France), in which he depicts a body deformed by fat, can be an unpleasant experience—this attempt to "shock the middle class" cannot justify his awkward brushwork nor his dull, gray light. Yet when Courbet followed his instincts, things look quite different. His *Bonjour Monsieur Courbet* of 1854 testifies to a northerner's first encounter with the Languedoc region (page 482). Portraying himself in a flattering light (Courbet's "realism" never applied to himself), the artist is shown meeting the collector Alfred Bruyas, who invited Courbet to stay with him. Here Courbet genuinely observes the dry and simple southern landscape. The ground is dappled with light and shade, the faces appear lifelike against a pale blue sky. Courbet's *Waves* and *Cliffs at Étretat*, thickly worked with a palette knife, play on powerful contrasts between rocks, foam, and clouds. In the final years of his exile in Switzerland,

Gustave Courbet,
Bonjour Monsieur Courbet,
1854. Oil on canvas,
4′2″ × 4′10″ (1.29 × 1.49 m).
Musée Fabre,
Montpellier (France).

Wilhelm Leibl,
Three Women in Church,
1878–81. Oil on canvas,
3′8″ × 2′6″ (113 × 77 cm).
Kunsthalle, Hamburg
(Germany).

Courbet painted a few still lifes whose color almost rivals certain Cézannes, and which reveal the acuity of his vision.

Works such as these explain Courbet's vast following not only in France but also in the rest of Europe. By way of example, German artist Wilhelm Leibl (1844–1900) traveled to Paris on

Courbet's advice, yet pushed his naturalism in a different direction. The quest for realism in Leibl's *Three Women in Church* (1878–81) is inflected by the reappearance of meticulous draftsmanship that stems from a long tradition of German art (page 483).

It would a mistake, however, to overstate Courbet's importance.

After all, Millet's fame, in the final years of his life, was enormous. Then there was Rosa Bonheur (1822–99), an intelligent, bold, and determined woman who conducted her life and her art as she saw fit. After initially deciding to devote herself to painting animals, she was soon producing naturalist canvases, and her paintings won Salon prizes and were sought after as far away as the United States. Regularly cited are her *Plowing in Nivernais* (page 484), shown in the 1848 Salon, and her *Horse Fair*, exhibited at the Salon of 1853 (Metropolitan Museum of Art, New York); both are indeed masterpieces. *Plowing* is much more than just a painting by an animal specialist. The composition is fresh, the landscape faithfully reflects the Nivernais region (with no addition of decorative trees), the plow is totally authentic, and never before have furrows been so

perfectly painted "from life," so glowing and moist. All this skill does not, however, constitute a plea for the condition of peasants nor a celebration of the harmony between nature and people. The more we look at this painting—the more we become aware of its sincerity—the easier it becomes to perceive the Romanticism that always animated Courbet's art, despite his claims. It was artists such as Rosa Bonheur and, in the next generation, Léon Augustin Lhermitte (1844–1925) and Jules Bastien-Lepage (1848–84), who perpetuated in France the tradition of a truthful and realistic art. Lhermitte's *Paying the Harvesters* (1882, page 485) and Lepage's *Hay* (1877, Musée d'Orsay, Paris) represent an art still poorly known today, whose democratic convictions often overshadowed, in the twentieth century, its genuine qualities.

Rosa Bonheur,
Plowing in Nivernais, 1849.
Oil on canvas,
4'4" × 8'5" (1.34 × 2.6 m).
Musée d'Orsay,
Paris (France).

Claude Monet and the Impressionist movement

Meanwhile, another movement had taken shape, one also based on a sharper observation of nature, although not one concerned with either forms or meanings. Instead, emphasis was placed entirely on light. The vagaries of an exhibition review dubbed this approach "Impressionism," a name that spread throughout the world even though the label corresponded to neither the movement's goals nor its output. Initially, there was indeed a small group of painters more or less linked through friendship, but they never adopted a joint doctrine, and their careers diverged early on. Admittedly, in only a matter of years they managed to impose a new way of seeing and painting, which is rare for any period. And success came relatively quickly, despite all that has been said or written. Throughout the twentieth century, their popularity never flagged. Even today, it is "Impressionist" paintings that command the highest prices in the salerooms. The history of the movement is therefore sometimes made to glitter like a religious icon,

Léon-Augustin Lhermitte, *Paying the Harvesters*, 1882. Oil on canvas, 7′ × 8′10″ (2.15 × 2.72 m). Musée d'Orsay, Paris (France).

and sometimes is thoroughly muddled.

Whatever the changes in taste and vagaries of fashion, one name deserves to maintain its precedence, that of Claude Monet (1840–1926). This is not because no other painters before him had ever studied how light changes during the day, modifying colors and decomposing forms only to recompose them—Eugène Boudin (1824–98), for example, spent his entire life exploring the subtle light of changing skies and distant seas. Nor because Monet's output was free from weaknesses—some of his canvases lack inventiveness or a true sensitivity. No, Monet deserves precedence because, ultimately, he was the artist who most clearly conceptualized this quest for light, who stubbornly pursued it to his dying day, and who wrought outstanding masterpieces from it.

Take one of those masterpieces, *The Magpie* (page 486). Nothing could be simpler: a snowy rural landscape. And nothing could be subtler: a few tree trunks stand in opposition to the shaded slope, creating a kind of geometric grid that lends solidity to the painting, while a peaceful balance is established by the line of the fence that divides the surface into two equal parts. On top of this, a symphony of whites glitter in such a way beneath the sun that shadows become blue, imperceptibly gilding luminous spots. The magpie is not there merely to introduce a dark,

Claude Monet,
The Magpie,
1869. Oil on canvas,
2′11″ × 4′3″ (89 × 130 cm).
Musée d'Orsay,
Paris (France).

blue note amid all this shimmer; it also provides a presence that wards off the idea of stillness and death inherent in any snow-shrouded landscape. France and Flanders had long been producing snowy landscapes—starting with the first such masterpiece, the Limbourg brothers' illumination for February in *Les Très Riches Heures* (page 201)—but Monet's canvas puts them all in the shade.

Painted at Étretat during the winter of 1868–69, this painting illustrates the mastery achieved by the twenty-nine-year-old Monet. It also pointed to what would be one of the main quests of the Impressionist group, which would not hold its first exhibition until April 1874. It does not encapsulate, however, every aspect of Monet's work. One of his key qualities was his endless explorations, his refusal to stick to a single theme or manner. Even in a relatively early painting such as *Impression, Sunrise* (which lent its name to the group), it is possible to see Monet exploiting the wonderful resources offered to landscape artists by the vivid, rapid brushwork used by Velasquez and Frans Hals in their portraits (which also appealed to Manet). This *brevitas* made it possible to accentuate

Claude Monet,
Green Reflections
(detail of left section),
1920–26. Oil on canvas,
H: 6′5″ (1.97 m).
Musée de l'Orangerie,
Paris (France).

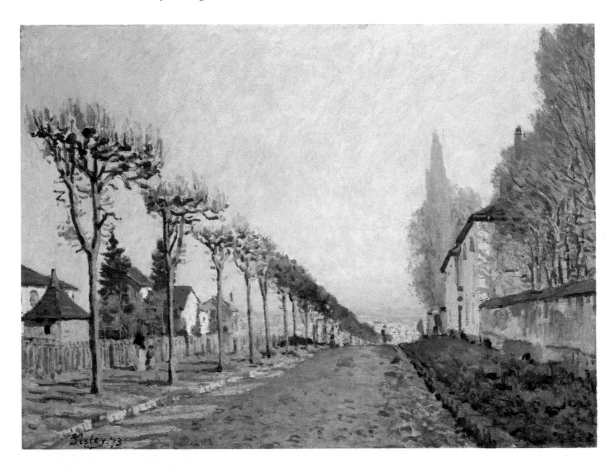

highlights rather than melding them into the overall picture, to simplify the orchestration of values. In each of his major cycles, Monet would adopt a specific type of brushwork: coarse for the *Rouen Cathedrals,* fuzzy for the *Views of London*, slashing for the *Water-Lilies*. From this latter series, we can still relish, in addition to many bold sketches, the vast decorative ensemble in the Orangerie in Paris (page 487). These two rooms of *Water-Lilies* represent the culmination of a long life, the invention of an entirely personal language, and testify to a profound communion with nature that embraces vegetation, water, and the changing reflections of the sky during the day; this haven of meditation is perhaps Western art's most accomplished response to landscape painting from China and Japan.

Monet's lead, reinforced by the exhibitions held from 1874 onward, would strongly impress a group of landscape painters with similar tastes and sensibilities. His influence is particularly easy to recognize in the likes of Armand Guillaumin (1841–1927), who unfortunately soon seemed to lose his refined vision and palette (*Low Path, Effect of Snow*, 1869,

Alfred Sisley, *Machinery Path, Louveciennes*, 1873. Oil on canvas, 21 × 29" (54 × 73 cm). Musée d'Orsay, Paris (France).

Musée d'Orsay, Paris), Alfred Sisley (1839–99), who painted canvases of discreet finesse in the 1870s, such as *Machinery Path, Louveciennes* (page 488) and *The Flooding of Port-Marly* (1876, Musée d'Orsay), and Camille Pissarro (1830–1903). Pissarro, the eldest of the group, had followed Corot's example before being drawn to Monet's innovation and never abandoned a certain rustic realism inspired by Millet. It was Pissarro who, in the 1870s again, produced some of the truest and most honest images of the French countryside: *Harvest at Montfoucault* (1876, Musée d'Orsay) and *Red Rooftops* (page 489).

Above all, Monet had drawn a friend in his wake, namely Pierre-Auguste Renoir (1841–1919). In 1869 Renoir painted *Barges on the Seine* (Musée d'Orsay) in vivid, pearly colors, and later, around 1876–77, he produced the famous *Path in High Grass* (Musée d'Orsay). Perhaps never before had a painter so skillfully decomposed his subject into shimmering colors and then, by alternating cool

Camille Pissarro,
Red Rooftops, Corner of the Village, Winter, 1877.
Oil on canvas,
21" × 26" (54 × 65 cm).
Musée d'Orsay,
Paris (France).

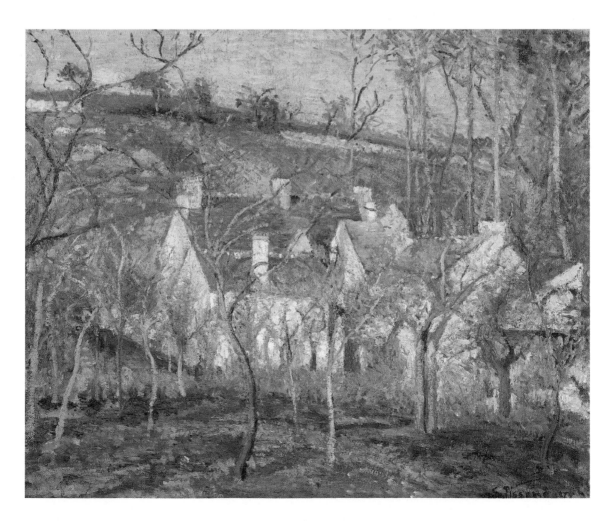

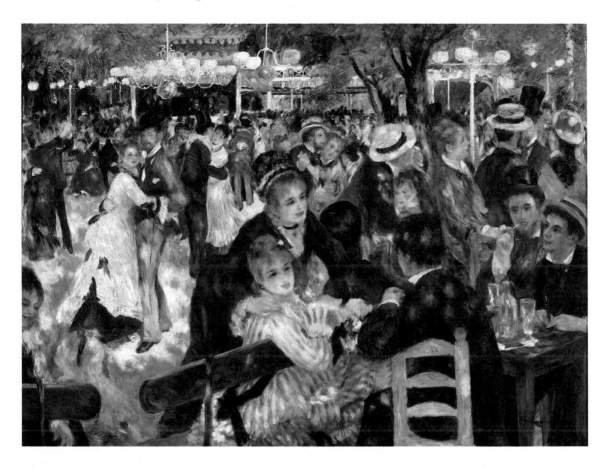

and warm tones and a series of small vertical lines, recomposed a subtle structure that delights the eye.

Renoir, however, was drawn more to nudes and genre scenes than to landscape. In 1876 he completed the large *Ball at the Moulin de la Galette*, which presents a complex scene (page 490). Adopting a slightly raised angle of view, the composition is artfully off-balanced; above all, however, this image is drenched in sunlight filtered through foliage, dynamically dappling drinkers, dancers, and ground. That same year, Renoir's *Torso, Effect of Sunlight* (Musée d'Orsay) cast the female nude in a light that shifts from orange and pink to hues of deep purple, dissolving the solidity of forms in a delightful visual effect. Renoir thus took a stage further the experimentation carried out by Monet in his *Women in the Garden* (1867, Musée d'Orsay), and in so doing displayed an understanding of light expressed through bold and agile brushwork that still dazzles the viewer today.

Unfortunately though, from *The Luncheon of the Boating Party* (Phillips Collection, Washington, D.C.), Renoir's compositions became muddled, his backgrounds sloppy. He was the first to sense

August Renoir, *Ball at the Moulin de la Galette*, 1876. Oil on canvas, 5′8″ × 4′3″ (1.31 × 1.75 m). Musée d'Orsay, Paris (France).

the danger, as he later acknowledged in a letter to art dealer Ambroise Vollard: "I had gone as far as Impressionism could take me, and I arrived at the realization that I did not know how to paint or draw." Renoir thus embarked on his "sharp period," producing several more masterpieces such as the 1885 *Bather* (Clark Art Institute, Williamstown, Massachusetts) and the 1886 *Motherhood* (Musée d'Orsay). Alas, Renoir's art would soon fall into the fluffy style that did him such a disservice.

Impressionism's three major "allies"

Monet's explorations and discoveries also had a decisive influence on three artists who, while not joining his movement, were to a certain extent transformed by his work: Manet, Degas, and Cézanne—three great geniuses of French painting.

Édouard Manet (1832–83) won early admiration for the virtuosity of his brushwork. He even won considerable notoriety thanks to the scandal surrounding his *Bath*, later called *Déjeuner sur l'herbe* (1863), a painting that merited neither the considerable scorn nor the great praise heaped upon it. Manet sought inspiration from Spanish painting, but he did not know where to take his own art, and he misconstrued both his gifts and his faults to the extent of venturing into history painting and religious subjects. The novelty of the new Impressionist movement seems to have allowed Manet to gradually

discover his true self. He never entirely abandoned velvety contrasts of gray and black, but henceforth his finest works would resonate like startling symphonies of color, as seen in the dazzling *Reading*, about 1868, in which Madame Manet, all dressed in white, is seated on a white sofa in front of white curtains that set off her pale Dutch complexion (page 492). All the skilled brushwork that Manet developed in his early canvases bursts forth here in a peerless effect of light. In 1873, with *The Railroad* (National Gallery, Washington, D.C.), a little girl dressed in blue and white stands out against a cloud of steam left by a passing locomotive. During this period Manet executed many outdoor studies—*Boating* (1874, Metropolitan Museum of Art, New York), *Argenteuil* (1874, Musée des Beaux-Arts, Tournai, Belgium)—and a small group of canvases by the canals of Venice featuring white and blue striped mooring posts and the reflection of sunny palaces in the waters of the lagoon (1875, Provident Securities Company, San Francisco). The *Café-Concert* paintings (1878, National Gallery, London, and Musée d'Orsay, Paris), with their beer waitresses, display a bright light and sharp draftsmanship, but it was *A Bar at the Folies-Bergère* (1881–82, page 493) that pursued, in its way, the issues raised by Renoir's *Ball at the Moulin de la Galette*. This time artificial light was involved, and the problem was complicated by the mirror behind

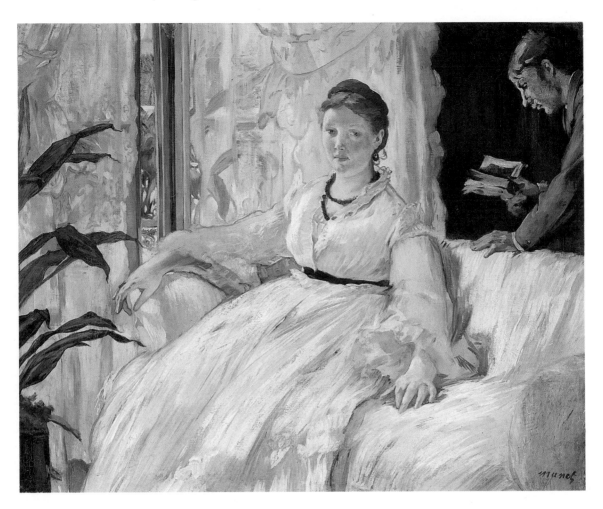

the barmaid, endlessly multiplying the spots of color and light. Perhaps never in the history of art had an artist appeared so sensitive, so brilliant, so close to attaining the pure joy of painting. It would probably be unfair to discuss Manet without mentioning Berthe Morisot—despite being related by marriage, she was more than just a mere pupil of his. Her art may lack power, but her gay, bright, vivid brushwork brought her into Manet's sphere at an early date (*Butterfly Hunting*, 1874, Musée d'Orsay).

It is somewhat paradoxical that a society figure like Edgar Degas (1834–1917) became friendly with the Impressionists. Everything should have kept him apart: his classical training at the École des Beaux-Arts, his repeated trips to Italy, his conservative opinions (which later led him to join the anti-Semitic campaign against Dreyfus), and above all his lack of interest in landscape. He never seems to have painted out of doors. "*You* need a natural life," he said to Pissarro, "but *me*, a contrived one." It was the ballet,

Édouard Manet, *Reading*, c. 1868. Oil on canvas, 24 × 29″ (60 × 73 cm). Musée d'Orsay, Paris (France).

the racetrack, portraits, and nudes that always appealed to Degas. Far from imitating the brushwork developed by Monet and Renoir, Degas long retained a smooth, meticulous technique until age obliged him to adopt the magnificent fluency of pastels.

Yet friendship was not the only reason Degas faithfully participated in the Impressionist exhibitions. He was profoundly interested in the play of light, natural and artificial. His contrasts of vivid hues and bold compositions could border on provocation. He initially turned his hand to historical subjects such as *Spartan Girls Challenging Boys*

(1860, National Gallery, London) and *Semiramis Building Babylon* (1861, Musée d'Orsay, Paris). He also executed admirable portraits, his masterpiece probably being the *Bellini Family* (1860–62, Musée d'Orsay), a large canvas (6 by 8 ft., 2 by 2.50 m) that is sober and serious, with subtle coloring that masterfully acknowledges the painterly tradition. True enough, at an early date Degas also showed enthusiasm for effects of light—more artificial than natural—for contrasts of bright hues, and for audacious composition. And he would continue to examine reality right into old age. All of this was more than enough to

Édouard Manet,
A Bar at the Folies-Bergère,
1881–82. Oil on canvas,
3′1″ × 4′3″ (96 × 130 cm).
Courtauld Galleries,
London (England).

establish affinities not only with Manet, but also with Pissarro and Sisley. A painting like Degas's *Race Horses* (c. 1896–72, page 494) was extremely bold in its handling of the shadows of horses and riders on a ground tinged with pale colors. The subject here gives way to effects of light, or rather it is the effect of light that becomes the subject of the painting. Light also explained the paradoxical pose of the famous *Ballerina Holding a Bouquet* (c. 1877, Musée d'Orsay), a kind of dazzling firework display around a lemon-yellow bodice enlivened by the dancer's strawberry-pink mouth and, at the bottom, by another spot of pink on her slipper. Already Degas was adding a few strokes of pastel to his oil painting, and as his sight failed with advancing age, he devoted himself entirely to pastel when depicting his dancers and nudes, as typified by *The Tub* (page 495) and *Woman Doing Her Hair* (Musée d'Orsay). His palette was reduced to a few colors and his drawing abandoned its sharpness, but the poses retained their boldness and the overall effect attained unmatched plenitude and solemnity.

Despite appearances, the paradox may be even greater when Paul Cézanne is linked to the Impressionists. At first, his taste favored a

Edgar Degas, *Race Horses*, 1869–72. Oil on canvas, 18 × 24″ (46 × 61 cm). Musée d'Orsay, Paris (France).

Edgar Degas, *The Tub*, c. 1885–86. Pastel, 28 × 28″ (70 × 70 cm). Hillstead Museum, Farmington (Connecticut).

painting that was oily and dark—or highlighted with strident colors—and went against the grain of the group's explorations. And if he later became the "great Cézanne," it was precisely in so far as he was able to reject and transcend the paths proposed by Monet.

It is better to draw a veil over Cézanne's early experiments. Although it is still fashionable to praise them highly, these exercises in mythological subjects and portraiture should be recognized for the remarkably awkward paintings they are. It was his friendship with Pissarro that allowed Cézanne to find his way. Impressionism tended

to weaken his interest in grand subject matter (even though he continued to paint the likes of *The Temptation of Saint Anthony* and *Bathsheba* until around 1877) and nudes (even though he continued to paint *Bathers* until the end of his life). It pushed him closer to landscape, still lifes, and portraiture. But his *House of the Hanged Man* (1872–73, Musée d'Orsay) demonstrates that Cézanne, accustomed as he was to thick impasto, could not match the light touch of his friends. He became increasingly fascinated by light, but rather than diffusing it in dynamic strokes, he sought to restore forms in all their

density. Not that he imprisoned his forms in black outlines; on the contrary, he took care to increase the "transitional passages" that gave life to light. For instance, in the *Boy with a Red Waistcoat* (c. 1894–95), the central contrast of the three primary colors—red, yellow, blue—is lit by large white patches tinged with green, and resolutely framed by dark hues of varying degrees of warmth or coolness (page 497).

In still lifes such as the *Apples and Oranges* (1895–1900), the fruit stands out distinctly from the white tablecloth, and is strongly modeled through a play of light and shade (page 496). Instead of being decomposed by multiple reflections or vibrant brushstrokes, they take shape as spheres—indeed, colored spheres that acquire their precise quality of color thanks to a scattering of green passages in the background.

As a truly luminist painter, Cézanne attached great importance to the arrangement of warm and cool tones. His landscapes thereby became pitched battles between ochers and greens, as witnessed by *Mount Sainte-Victoire* (c. 1904–06, Kunsthaus, Zurich).

ABOVE
Paul Cézanne,
Apples and Oranges,
1895–1900. Oil on canvas,
2′5″ × 3′ (74 × 91 cm).
Musée d'Orsay,
Paris (France).

FACING PAGE
Paul Cézanne,
Boy in a Red Waistcoat,
c. 1894–95. Oil on canvas,
2′8″ × 2′1″ (80 × 64 cm).
Bührle Collection,
Zurich (Switzerland).

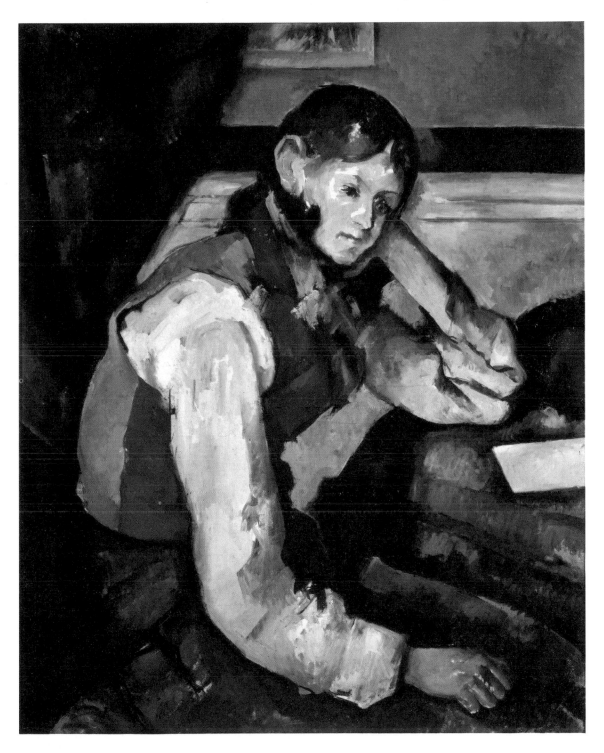

Sometimes the ocher turns to brick red, and clouds may become green, if necessary, against the blue ground, but everything is always most meticulously organized and arranged.

It might be regretted that Cézanne's isolation in the years he spent in Aix-en-Provence did not give him the opportunity to produce more of his nearly perfect portraits. The Musée d'Orsay in Paris nevertheless boasts two of the finest, namely *Woman with Coffee Pot* (c. 1890–94) and *Portrait of Gustave Geoffroy* (1895), whose solidity and skill allow them to outshine all the paintings in neighboring rooms. It is even sadder that this same isolation prevented Cézanne from focusing on the great problem of how to render nude bodies moving in a landscape. He left many small studies of male and female *Bathers*, as well as two large sketches, which indicate how interested he was in this problem. Although he seemed to be nearing a solution, he died before resolving it.

Seurat's Neo-Impressionism

A young painter decided to take up this challenge in the year 1883–84. His name was Georges Seurat (1859–91). This Parisian artist had received a solid education before enrolling at the École des Beaux-Arts and immediately became interested in scientific theories of color, optics, and aesthetics. He was only twenty-three when he undertook his *Bathers at Asnières*, a large canvas some 6 by 9 ft.

(2 by 3 m, page 499). Given the subject—the banks of the Seine in summer—it appears to be a perfectly Impressionist work, especially since it attempts to convey the greatest possible sense of light and color. Yet there is nothing "Impressionist" about it. The light resonates, but does not move. The figures, detached from one another, are motionless, their outlines being carefully defined and stylized like statues. The masses of the riverbank, the grassy slope, and the distant buildings are simplified to an extreme, and the brushwork—obviously slow and careful—does nothing to animate them. How removed this painting is from Renoir's *Ball at the Moulin de la Galette*! We know, for that matter, that Seurat did not paint this work outdoors; he studied each of the motifs, then reworked them, simplifying them, harmonizing them. All are henceforth locked in a form simultaneously geometrical and luminous.

Like Cézanne but in a very different way, the young Seurat felt a need to return to the solidity of volumes, which had been undermined by the Impressionist approach. A little later, he would exploit the optical theories of physicist Eugène Chevreul to develop his famous "divisionist" technique that makes colors resonate even more strongly without dissolving shapes. But *Sunday Afternoon on the Island of La Grande Jatte*, painted in 1885 and exhibited in the Salon des Indépendants in 1886 (Art Institute, Chicago) no longer displays the same sensitivity as the

Bathers: theoretical concerns had led Seurat to harden forms to the point where his figures begin to seem like cardboard cutouts.

Seurat was dead by Easter 1891. His methods had already influenced a small group of friends, but his early death meant that divisionism would never be more than a passing fashion. Artists of great merit, such as Pissarro, Signac, Cross, and van Rysselberghe—not forgetting Achille Laugé, whose delicate, serene art is only now receiving recognition—would show an interest that was more or less enthusiastic, more or less faithful. Yet already other trends were emerging, relegating Impressionism itself to the status of an outmoded theory.

Georges Seurat,
Bathers at Asnières,
1883–84. Oil on canvas,
6′6″ × 9′9″ (2.01 × 3.01 m).
National Gallery,
London (England).

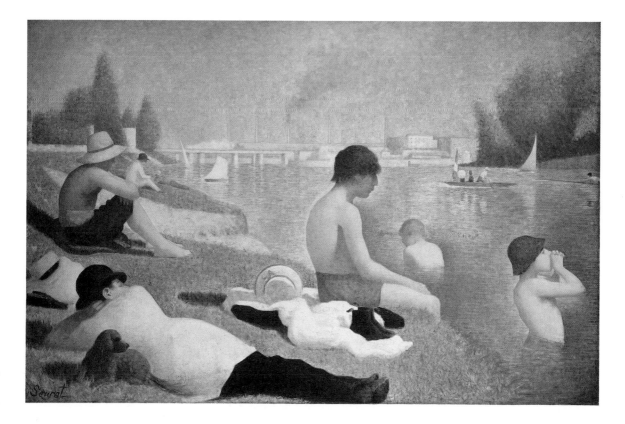

VII
A TIME OF CONTRADICTIONS
(Late 19th–20th Centuries)

The years 1880 to 1970, whether disparaged or enthusiastically hailed, were some of the most fertile in the entire history of art. In architecture, new techniques were mastered as iron and, in particular, reinforced concrete offered novel possibilities. In sculpture, the human figure remained the focal point of creativity and permitted an expressive freedom not restricted by ecclesiastical commissions or official allegories. Painters also became fully aware of their liberty, pushing that freedom to extremes. These were also the days when European art was most widely disseminated abroad, being accepted and admired in Latin America, the Far East, Australia, and Africa. Names such as Matisse and Picasso became famous worldwide, and French architect Le Corbusier was hired to build in places as far away as Argentina, Tokyo, and India.

Yet this period was in no way a time of perfection and culmination— it was a time of ferment when everything was shifting and was constantly called into question. Every single doctrine, as soon as it was formulated, found itself contradicted. Artists themselves often repudiated their own works, moving on to new experiments. Furthermore, events hardly allowed people the time to catch their breath. Two devastating world wars were separated by only twenty years of respite, from 1919 to 1939. Even as Christianity's role in financing and inspiring artists continually diminished in importance, there suddenly arose ideologies with which art would never manage to create a fertile relationship, such as Communism in the Soviet Union and Nazism in Germany.

Two further factors cannot be overstressed. The first concerned greater ease of travel: rail networks crisscrossed every civilized country, and speeds constantly increased; in the 1930s, highways began making car travel much simpler; and sometime around the 1950s, air travel became common. Except during times of war, then, all kinds of contact were feasible. Secondly, and above all, around 1880 photographic reproduction boomed in all its forms, especially in the printing industry, where it quickly displaced wood engraving. Thus, in a relatively short time, vast segments of our civilization's architectural and artistic heritage, past and present, became available to all.

It is therefore hardly surprising if many artists of the day were gripped by an intoxicating fever. The eclecticism of the preceding period, which had enjoyed rediscovering its own rich traditions, was steadily replaced by a heady quest for novelty at all cost. Indeed, less confident artists felt a certain nausea when suddenly confronted with all the masterpieces of the past; they thus tended to reject everything that smacked of tradition. Movements ending in "ism" proliferated, canceling each other out. Artists became increasingly isolated and had to assume individual responsibility for both inspiration and career.

These individualistic careers make the art historian's task difficult. How can they be categorized and organized? Who should be included

and who excluded? Most books that deal with art since 1880 take the simplest route: more or less openly, they reintroduce the idea of linear progress and then strive to identify its various stages. Art history thus becomes a series of discoveries—whose authorship and priority are no less hotly disputed than scientific discoveries—with a list of dates that resembles a record of athletic exploits. Applying the idea of progress to the arts is all the more reductive during this period in so far as it hardly accounts for the contradictory paths followed by each country or each group; and the idea of dates becomes all the more dangerous because it makes us overlook the fact that, in art, it is not the initial transgression that counts but the value of the work that follows.

Not that the nature of the period and the sequence of dates are insignificant. On the contrary, it must be stressed again that the period from 1880 to 1970 was wracked by two dreadful wars (1914–18 and 1939–45), both of which more or less paralyzed artistic creativity in Europe, abolishing certain institutions and triggering unexpected developments. Never before had art changed so brutally, something that would be difficult to understand if we overlook the complex play of *time-frames*.

Two examples drawn from painting, which underwent even greater effervescence than the other two arts, will perhaps illustrate this idea. Take a canvas by Roger de La Fresnaye, *The Conquest of the Air* (page 504). It was painted in 1913, just when this young artist had finally forged his own artistic personality by combining the tradition of the Nabis with the experiments of the Cubists. *The Conquest of the Air* is apparently modest in impact, a long way from creating the shock of *Les Demoiselles d'Avignon*, which Picasso painted in 1907 after his discovery of African masks. La Fresnaye's outdoor scene is simple, peaceful, brightly lit. Yet there is nothing Impressionist about it—the light is static and no longer defines objects, which are rendered as simple, geometric patches of color. Nor do the clouds move. Everything seems frozen, distilled to its essence. Furthermore, in what must have seemed the worst possible mistake to many artists of the day—and which some people still consider a reason for dismissing this work— La Fresnaye's painting has an explicit subject. Not unlike the meditations of Puvis de Chavannes, La Fresnaye's subject might even be seen as his profession of faith: faith in science, faith in humanity, faith in the effort to accomplish the age-old dream of conquering the skies. Hence the title that La Fresnaye gave to this canvas.

His painting employs no antique-style allegory, no Grecian theme evoking Icarus and Daedalus. The figures wear contemporary dress and La Fresnaye even added a timely note of patriotic pride via the distinctive French flag (the first flight across the English Channel, by French aviator Louis Blériot, had taken place in 1909). This content is matched by the artistic feat of simultaneously pushing to their limits both the

intensity of the colors and the interplay of forms. In the wake of Gauguin, La Fresnaye managed to reunite, after an apparent divorce, two grand pictorial traditions.

Quite different is a painting done in 1962 by Alfred Manessier (page 505). Produced after World War II, the work no longer displays such fine, straightforward confidence. Although titled *Offering to the Earth*, it contains no allegory and no figurative image. Artists had achieved their wish of no longer being obliged to depict reality. Manessier did not pursue this goal by pushing an image beyond the point of recognition, nor by using geometric forms (always more or less dry and impoverished). With great ease, he simply *created* a painting by combining colors and patterns according to an interiorized plan. Of course, once all links with reality are broken, once an artist's freedom becomes total, his

Roger de La Fresnaye, *La Conquête de l'air*, 1913. Oil on canvas. Museum of Modern Art, New York (New York).

Alfred Manessier, *Offering to the Earth*, 1962. Oil on canvas, 9'10" × 3'11" (3 × 1.20 m). Musée des Beaux-Arts, Dijon (France).

work may become just an arbitrary riddle—no analytical framework exists. The issue, then, becomes the painter's confidence: he must be so completely gripped by the feeling to be expressed that his vision captivates the viewer's eye. What are we seeing here? Darkness descending on a sleeping world? A vague glimmer of dawn? A deep root from which sprouts, like a promise of light, a sheaf of passionate, blood-red color? Such a painting possesses all the ambiguity—and all the persuasive power—of music. Like music, it stirs feelings that are hard to define yet universally acknowledged. Manessier's achievement would not have been possible prior to Sérusier's *Talisman*, prior to Matisse and Braque, but it crowns the spiritual meditation pursued by European painting throughout this period.

Architecture

During most of this period, architecture followed its nineteenth-century impetus. The growth of industry and increased speed of travel were accompanied by ever vaster, ever more populous cities.

Europe built extensively, respecting models developed first during the Napoleonic period and then, in the 1860s, by Baron Haussmann in Paris. Europe also exported to distant lands its vision of urban planning—straight avenues, buildings flush with the sidewalk, façades with columns and pediments. All these features can be found, with surprisingly few local variations, in Africa, India, Brazil, Mexico, and even Japan. Most cities in the world have at least one neighborhood, or major set of buildings, that reflect the period and style of France's Third Republic and the late Victorian era. Meanwhile, countless palatial residences from one continent to another were more or less inspired by French classical châteaux such as Balleroy and the Petit Trianon.

Many of these buildings have now been demolished or disfigured. They were long accused of being "eclectic," and only in the past twenty years have people begun to study them, admiring the skill with which various styles incorporated modern conveniences while maintaining a respect for elegant lines and volumes. The international popularity of this style might seem to be a reward for its tastefulness and its trusty techniques. In fact, it conveniently masked major revolutions, and by 1930 the truth would rear its head—two different approaches to architecture were heading for a clash. The first, traditional, intended to respect the heritage of the past, while the second awarded itself the label of "modern" and unscrupulously tried to impose its views everywhere.

American skyscrapers

One early novelty concerned the growing number of skyscrapers built in the United States. These were not residential buildings. Even today, America, heir to its colonial past, retains its penchant for private homes set in a patch of greenery, even at the cost of suburbs that stretch for miles and miles. These sprawling areas nevertheless always have a central core of administrative facilities to house local government, businesses, and offices. This downtown zone is often very limited, so even tiny plots are subject to intense real-estate speculation, which has encouraged contractors to build ever higher. Rivalries have inevitably developed, like the one

Skidmore, Owings and Merrill, Lever House, New York (New York), 1950-52.

between New York and Chicago. These strange clusters of disparate buildings, each more striking than the last, represent a veritable challenge to urban planning. Yet they stir the imagination through their gigantic scale, their technical prowess, and their very anarchy. In a way, they reflect the same urge to amaze that characterized colossal barbarian feats, they share the outsized appetite that gave birth the great pyramids of Egypt and the palaces of Asia Minor. Harmony of overall design and detailing, which were major concerns of European architecture, soon went by the board. Instead, repetition became the rule: infinite repetition of the same details, vertically as well as horizontally. Architects were more inclined to accept this dictate once it became impossible to view an entire building at a single glance.

Initially, skyscrapers were little more than fairly large and fairly tall buildings—eight to ten floors—designed in a lavish way. For instance, the Wainwright Building in Saint Louis (1890–91), designed by Louis H. Sullivan and Dankmar Adler, was an elegant edifice topped by a heavily carved cornice (page 509). The lower floors were treated like a plinth on top of which tall pilasters rise seven floors, between the windows, with carved bases and capitals. This decorative approach would already be less pronounced on Sullivan and Adler's Guaranty Building, a much larger and taller skyscraper erected in Buffalo in 1894–95 (page 510). Meanwhile, Sullivan's Carson, Pirie, Scott & Co.

Department Store, built in Chicago in two phases (1899–1901 and 1903–04) plays instead on broad horizontal bays; only the rounded corner displays any vertical thrust (page 511). Leaping ahead to the Lever House in New York, built in 1950–52, the metamorphosis was complete: all decorative effect was eliminated, as was all rhythmic patterning of the walls. Apart from the lower two floors, which occupy the entire plot of land, the overall design represents one single volume obtained by repeating a module that offers the eye no discernible reference point.

This development occurred, in fact, because architects soon required a partner: the engineer. Only an engineer could determine whether the architect's plans were feasible by calculating the stress placed on building materials, the choice of which had become decisive: metal, reinforced concrete, and of course glass. Weight-bearing walls gave way to a rigid internal structural skeleton onto which partitions and outer walls could be hung. Glass therefore triumphed, while brick was slowly replaced by granite or marble cladding—such facings, long criticized when it came to discussing ancient Roman buildings, thus found themselves quietly rehabilitated.

The revival and rejection of decoration

Just as they borrowed every technique, skyscrapers initially accepted architecture's traditional decorative idiom. At first they even copied the

FACING PAGE
Adler and Sullivan,
Wainwright Building,
Saint Louis (Missouri),
1890–91.

PAGE 510
Adler and Sullivan,
Guaranty Building,
Buffalo (New York),
1894–95.

PAGE 511
Louis H. Sullivan, Carson, Pirie, Scott & Co. Department Store, Chicago (Illinois), 1899–1901 and 1903–04.

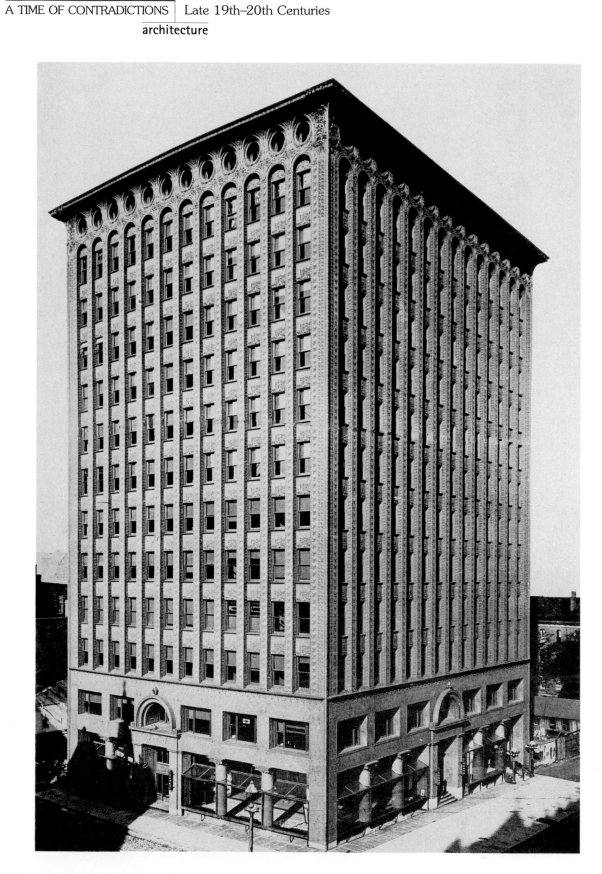

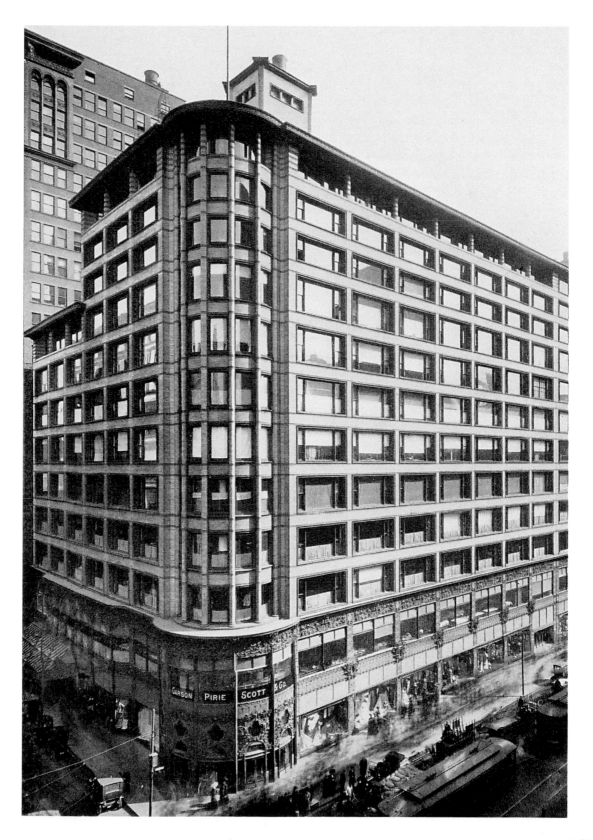

"Gothic Revival" so typical of Anglo-American architecture ever since the Houses of Parliament were rebuilt in London. Or else they might employ motifs derived from the Italian Renaissance and the "Adam style." Extreme modernism thus sought to justify itself by making an alliance with the distant past—a tactic that produced visual treats which can still be seen on a stroll through late-nineteenth century neighborhoods in Chicago, New York, and Saint Louis.

The turn of the century was nevertheless the very moment when Europe began questioning the architectural value of ornamentation. Columns, pilasters, and pediments had become so common that they lost the power of novelty, so indispensable to art. Details such as triglyphs, ovolo molding, and acanthus leaves no longer appealed to the eye. Thus at the turn of the twentieth century, almost everywhere in Europe and even in America, there arose movements that challenged these traditions and advocated "modernism" in all the decorative arts. This trend was variously known as Jugendstil, Art Nouveau, Liberty Style, and so on. Intriguingly, the revolt did not originate in the major capitals, but in smaller cities such as Brussels, Darmstadt, Glasgow, Barcelona, and Nancy.

The "Nancy school," for example, was perhaps the first to frankly address the issue and to offer a no less frank response in the form of a return to nature. Every plant, every leaf, every flower displayed wonderful architecture, so why not study nature's architecture and transpose it onto buildings? The Greeks had done the same thing with acanthus leaf capitals, and architects in the twelfth and fifteenth centuries had also explored this path. Now the fossilized grammar of the past had to be shed so that the secret of vital, dynamic thrust could be fully recovered.

This revolution spread to all spheres of decorative art—glasswork, stained glass, furniture, bookbindings, and even painting (Victor Prouvé)—but was especially pronounced in architecture. Right angles were almost completely banished, since they are absent from nature: doors and windows therefore took on flowing lines, while swelling veins of sap rounded sharp angles. Young sprouts of ferns and oval clusters of fuschia provided artful patterns as the city of Nancy became dotted with private residences that displayed refined decoration (page 513). This "naturalist" revival, based on principles that were better defined than those that informed the Glasgow school or the peerless, highly personal art of Antoni Gaudí in Barcelona, soon spread to Paris, where Hector Guimard adopted it for the Castel Béranger (1897) prior to designing his famous entrances for the Métro (1900).

The attempt to profoundly modify architectural decoration (usually accompanied by similar efforts concerning interior decoration) produced highly varied buildings, all of which are interesting and many of

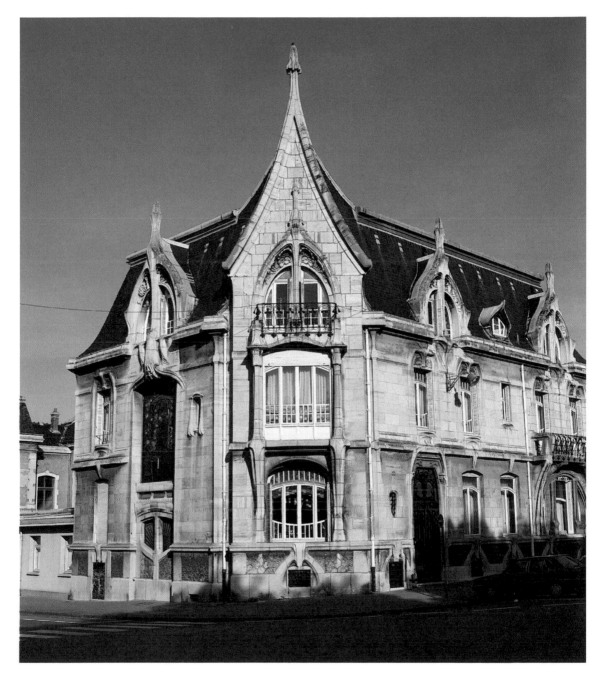

Lucien Weissenburger,
Villa Bergeret,
Nancy (France), 1904.

which are masterpieces. Even today, lovers of architecture can stroll through many cities—not only Nancy and Prague—and discover façades never featured in books yet ingeniously organized around carefully designed grillwork, carvings in sandstone or other material, and skillful mosaic-work.

In 1925, the "Exposition Internationale des Arts Décoratifs et Industriels Modernes" held in Paris tried to sustain the general enthusiasm for architectural decoration, which was beginning to fade. But merely challenging the traditional decorative idiom of architecture ultimately raised the fundamental question: "What is the point of ornamentation?" As early as 1908, in an essay titled *Ornament and Crime*, Viennese architect Adolf Loos (1870–1933) drew up a veritable indictment—with all the intensity of those dogmatic years and their constant calls for socialism and modernism—against the use of any architectural ornament whatsoever. He felt that it was a waste of effort and therefore a drain on health and wealth. "It has always been thus, but these days there is more waste of material, which therefore means a waste of capital. . . . Modern man, a man with modern nerves, needs no ornament. He despises it."

This rhetoric alone would not have sufficed to change things— indeed, Loos fell out with the architects who headed the Vienna Secession. And yet architecture, at its profoundest level, was evolving in this direction. Walls were less and less required to support the roof; an inner skeleton entirely of metal or reinforced concrete, set on a concrete base, constituted the framework. The roof could be replaced by a simple terrace, and walls reduced to a simple facing, usually of brick, that could be freely pierced with windows. Without really noticing, architecture was reverting to conditions that recalled Gothic cathedrals, and so a similar response occurred: much of the wall surface was given over to windows separated by simple partitions made of light materials.

These responses were explored right from the first half of the twentieth century, usually on expensive, private houses where architects could let their imagination run free. Such houses can still be found in many countries, although not always in good condition, because they have not always withstood the test of time. Without a doubt, the most famous of these experiments is Fallingwater, built in 1935–39 at Bear Run, Pennsylvania, by Frank Lloyd Wright (page 515). Wright's house does not necessarily live up to its reputation—there is no architectural *gesture* here, nor any original discovery. The choice of the site was highly eccentric, and the solution is elegant, but a whim cannot serve as a model. There is no ornamentation, of course, at Fallingwater; the entire building is conceived as a kind of sculpture set among the trees and cascading water. These circumstances and this success have rarely been reproduced. The glass and cement combination does not always produce housing that is

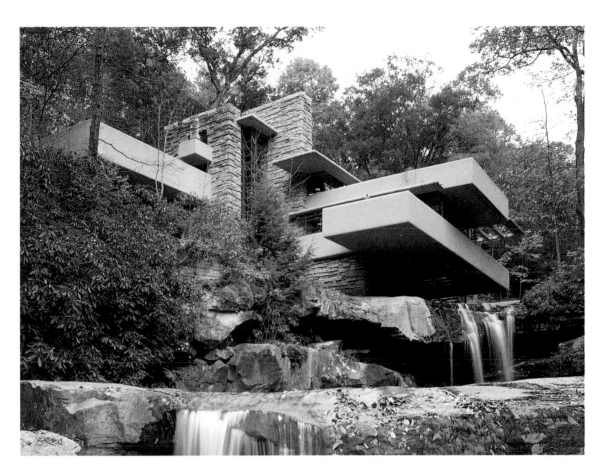

Frank Lloyd Wright,
Fallingwater, Bear Run
(Pennsylvania), 1935–39.

comfortable or practical, as Europeans have realized during tough times produced by war shortages. In cities, the exaggerated use of glass, combined with the abolition of ornamentation, creates unsightly "holes" that are perhaps faithful to the doctrine of "modernism" but violate all logic of urban planning. Even worse, the indictment lodged by Loos resulted in the swift extinction of crafts that had flourished for centuries—all across the world, balconies were denied the wrought or cast iron railings that lend Paris so much of its charm. Ornamental carving also died. Both losses were

as irreparable as they were unforgivable. To appreciate the effect of the elimination of all ornament, we need merely look at the emblematic edifice designed by Walter Gropius to house the famous Bauhaus school in Dessau, Germany, in 1925–26. If we ignore its legendary status, what we see is a building of such strict harmony that it is almost as grim as a prison.

Housing projects

If Europe let itself be convinced by Loos's argument, that was probably because architecture had other,

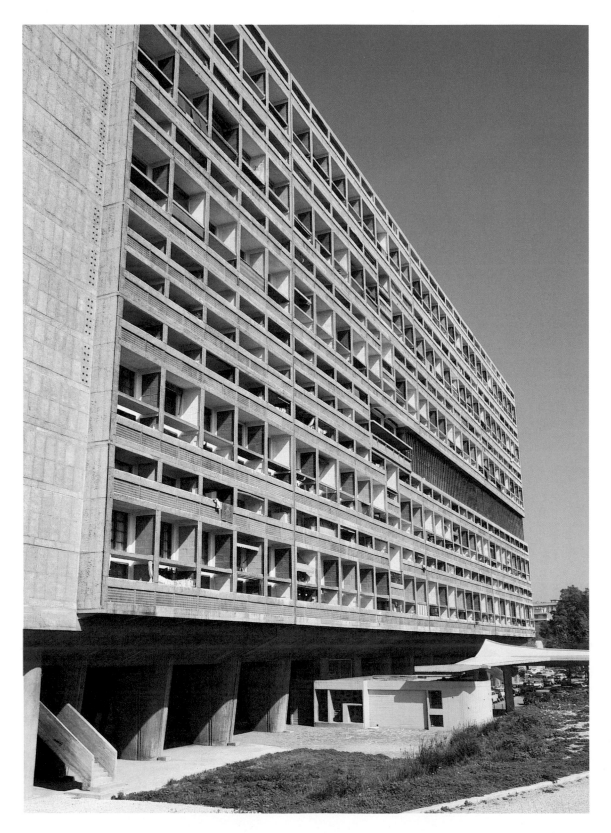

more urgent matters at hand. After each of the two wars a great deal of reconstruction was required, demanding enormous sums of money. Each time, over a ten- or fifteen-year period, all architects had to obey the two constraints of speed and cost-cutting, thereby eliminating any "extras." Furthermore, a cruelly and durably impoverished Europe had to deal with the nonstop growth of its urban populations.

At the end of World War I, architects were faced with the new problem of building large quantities of low-cost housing, especially in Vienna. The decision to create workers' villages made up of tiny individual houses was ill adapted at a time when few people owned automobiles, and the solutions adopted by Viennese architects were not considered very successful. In France, just outside of Lyon, an initial high-rise housing project was built in 1932–35. It comprised a group of buildings from nine to eleven stories, plus two skyscrapers of eighteen storeys. Other housing projects were then built in the greater Paris region. World War II, however, would bring all these efforts to a halt.

The issue resurfaced, more urgently than ever, at the end of World War II. It was the well-known architect Charles-Édouard Jeanneret, known as Le Corbusier, who claimed to have analyzed and solved the problem. His famous Unité d'Habitation, or "Housing Unit," built in Marseille in 1945–52, provided housing space equivalent to 327 small bungalows.

Le Corbusier, Unité d'Habitation, Marseille (France), 1945–52.

Some 180 ft. high (56 m), 450 ft. long (137 m), and 80 ft. wide (24 m), it was entirely built of reinforced concrete—and immediately dubbed "the crackpot's place" (page 516). In design terms, it demonstrates Le Corbusier's genius better than any of his lesser buildings. Especially when viewed close up, it displays powerful volumes and harmonious proportions never matched by any other designer of apartment buildings. Unfortunately, the poor quality of the reinforced concrete has meant that the building has not aged well and has already required restoration.

Le Corbusier's success—which no one in France dared question in the 1950s—combined with a severe housing shortage in those days, meant that France and rest of Europe adopted the idea of housing units in the form of slab blocks, which were built in large clusters. Along with schools, such buildings represented Europe's primary investment in architecture during this period. Although they fulfilled a pressing need, most of them have no architectural merit, and often enough they actually disfigure sites that merit protection. And they have had an even worse effect: although Le Corbusier, with a sincerity and naïveté reminiscent of Jean-Jacques Rousseau, thought his buildings would make a real contribution to society by generating human happiness and harmony, we now know that he was cruelly wrong. Slab blocks have led to the worst kinds of social behavior. At last, some of them are now being demolished.

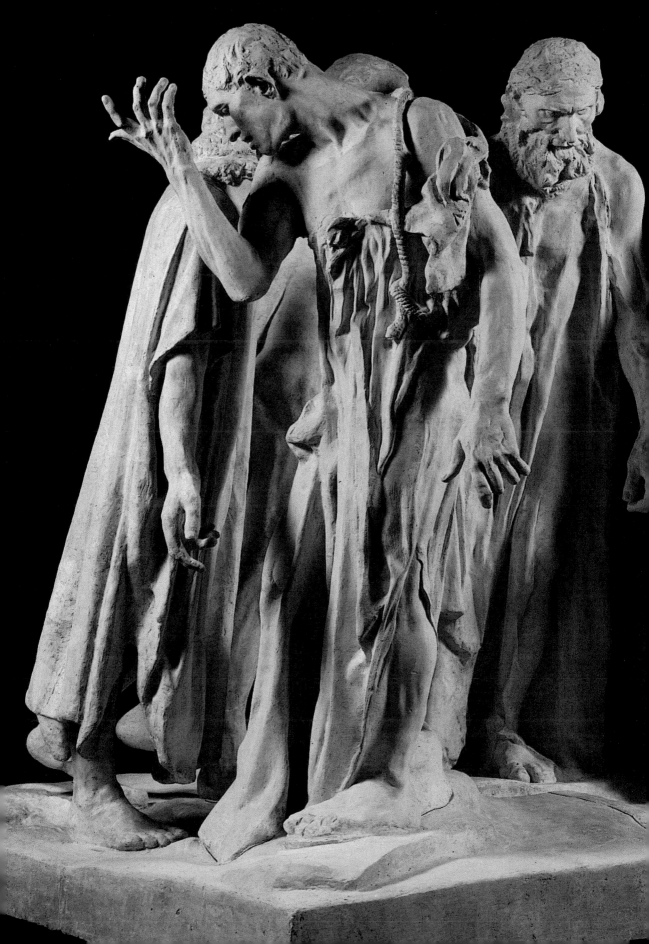

Sculpture

Sculpture underwent a highly specific and, on reflection, rather surprising evolution. At work, apparently, was a factor that modern criticism normally refuses to take into consideration: the determining presence of a towering genius. The genius in question was Auguste Rodin (1840–1917), who by the end of his long career had acquired international fame. His prestigious example set sculpture on a confident path that avoided all the vacillations and contradictions that affected painting during this period.

The primacy of Rodin

Rodin's career got off to a slow start. The first of his works to attract notice was *The Age of Bronze*, completed in 1877 and purchased by the French government at the Salon of 1880. This statue of a nude male created a scandal not because of its subject matter, but because of Rodin's handling. Rejecting the old principle which held that sculpture is an art of heavy materials and monumental simplification, Rodin—aware of exploratory efforts by Carpeaux and Carrier-Belleuse—stressed effects of light breaking on the surface, analyzed with virtuoso skill. Meanwhile, he was accused of having relied on life casts to produce the statue. He was exonorated, but he became famous. Rodin thus realized that a scandal was no longer a hindrance to fame. He later provoked other scandals, but above all he became more self-aware and assumed full creative liberty.

There are a number of reasons underlying Rodin's extraordinary artistic career: his ability to combine powerful inspiration with a practical sense of organization; his literary sensibility that, without being highly cultivated, enabled him to exploit both symbolic themes and historical subjects; his sensuality that quickened right into old age; an ambitiousness that scorned neither money nor official honors; and a robust physical and mental health. Rodin therefore had no need to follow a doctrine. He challenged the very idea of a statue as an isolated work even as he exploited that idea for some of his most famous pieces—*John the Baptist Preaching* (1879) and *Balzac* (1898). He also liked to sculpt groups of several full-length figures (*The Burghers of Calais*, 1884–95), organizing them in space (*Monument to Victor Hugo*, 1896; *Monument to Claude Lorrain*, 1889). At the opposite extreme, he could be content with fragments (*The Caryatid*, 1908),

Auguste Rodin, *The Burghers of Calais*, 1884–85. Plaster, 7'2" × 8'7" (2.19 × 2.11 m), Musée Rodin, Paris (France).

transforming two clasped hands into masterworks (*Cathedral*, 1908; *The Secret*, 1910). Rodin revived, in his own way, Michelangelo's aesthetic of *non finito*, allowing a head to emerge from a raw block (*The Thought*, 1886) or barely sketching two faces in marble (*Mother with Her Dying Daughter*). He not only created marvelous effects from flickering light that fragmented volumes, but he also enjoyed playing with the almost transparent sheen of marble.

This is not to say that Rodin's art had no limits. In a way, *The Gates of Hell*, which he began in 1880 and worked on for long afterward, could be considered a failure despite the admiration it has won. Perhaps it failed because it never escaped the banality of an architectural context that was half-Renaissance, half-eighteenth century, and perhaps because Rodin never managed to execute it on the vast scale it required. But the failure was above all due to the fact that he wanted, in paradoxical fashion, to create a decorative role for relief carving so deep that it practically became freestanding sculpture. *The Gates of Hell* may therefore seem disappointing, but it provided a mine of treasures that Rodin drew on endlessly. Rodin's triumph resided in a fertile imagination that drove him to discover an apparently infinite world of forms within the human body.

Rodin's strength also lay in the poetical world he created, one that impressed all his contemporaries, whether they favored realism or symbolism. The somewhat literary titles he gave to his sculptures do not cloud Rodin's constant, intense observation of the visible world; he thereby reinvigorated Romanticism at the very moment it was banished from both poetry and prose. Take, for example, *The Burghers of Calais* (page 518). The city of Calais wanted to pay tribute to the memory of citizens who, in 1347, tried to save their city—under siege by King Edward III of England—by sacrificing their own lives. Rodin eliminated all historical color, all details that might evoke the fourteenth century. Nor did he include an allegory. Instead, the sculptor—who so relished depicting women—decided to imbue each of these not-very-youthful male figures with a different quality (resolute, meditative, exemplary, etc.), not unlike seventeenth-century art's aim of portraying a "range of passions." The heads of the burghers are as individualized as real portraits would be. Arms and feet—the only visible parts of the body—are crudely realistic, while the deeply hollowed, varied folds of the garments exclude any idea of transparence. This work might be labeled "expressionist" if the term did not mean, in sculpture as in painting, a decision to heighten intensity by deforming things; although Rodin sought a certain vehemence, he did not disfigure forms. Contrasting poses, trembling muscles, and facial features are all Rodin needed to convey inner feelings, thereby creating a universal appeal that allowed him to fulfill all kinds of commissions

and to make sculpture an intimate art of personal emotion.

The grand humanist tradition

Few sculptors escaped Rodin's influence, even though he never really had any direct disciples nor launched a "school of Rodin."

Among the generation that followed, Antoine Bourdelle (1861–1929) sought to infuse sculpture with greater tension. By deliberately playing on vast dimensions (*Monument to General Alvear*, 1920–25; *Madonna and Child*, 1922), Bourdelle—who was Rodin's friend and colleague, and hoped to achieve similar expressive power—was led to reintroduce a certain simplicity of plane, from which he drew a deliberately archaic feel (*Hercules the Archer*, 1910; *Dying Centaur*, page 521). More importantly, Bourdelle sharpened the linear aspect of his work, which led him to work extensively in bas-relief and to take up the paintbrush. In decorating the Théâtre des Champs-Elysées in Paris, he even revived the old wet-plaster technique of fresco painting, although he failed to

Antoine Bourdelle, *Dying Centaur*, 1913. Bronze, 28 × 9″ (71 × 22 cm), Musée Bourdelle, Paris (France).

induce other artists to follow his example.

Aristide Maillol (1861–1944) belonged to the same generation, but initially considered himself a painter. He was associated with the Nabis, and produced some fine paintings before turning to sculpture. From his painterly work he retained a taste for simple curves and for smooth, firm volumes with balanced outlines; in this respect, Maillol's oeuvre represents the most direct riposte to Rodin. It is not very imaginative, being composed primarily of female nudes with young, full bodies, sculpted in a limited range of poses (page 523). Even the rebellious figure in a *Monument to Auguste Blanqui*, a statue now in Puget-Theniers, France, is shown devoid of anger and violence, and is not fundamentally different from Maillol's *Pomona* (1912) or from the tranquil prone figure of the *Monument to Cézanne* (1913–25). Maillol rarely attacked the male nude (his *Young Cyclist* would remain a rare example, despite the praise it received), and showed practically no interest in depicting childhood, old age, illness, or portraiture. Whereas Rodin alluded to the tormented world of Dante's *Inferno*, Maillol looked to antiquity, which earned him commissions to illustrate Ovid's *Ars Amatoria*, Virgil's *Eclogues*, and Longus's *Daphne and Chloe*, ultimately making him one of the twentieth century's finest engravers. Maillol's antiquity, however, did not entail copies of Roman works, but rather inspired a

sculpture rooted in the sunny lands of Roussillon in southern France (where Maillol was born and died, and where he maintained a workshop even though most of his life was spent in Paris and nearby Marly-le-Roy). His was an aesthetic of the nude, reinvigorated by familiarity with antique models; his art instinctively revived the Latin taste for "full, round forms" and for a serene sensuality. Such harmony was reassuring in an era marked by wars and excesses of all kinds. Even more than Rodin, Maillol—who lived to be over eighty—demonstrated that sculpture was right to continue to depict human beings, and even to endow humanity with an image of beauty and happiness.

The work of Rodin and Bourdelle influenced sculptors in every land. The international importance of Parisian sculpture is clearly demonstrated by a visit to the museum in Split, Croatia, devoted to the Yugoslav sculptor Ivan Mestrovic (1883–1962). Other artists, on the contrary, deliberately sought a different path. Belgian sculptor George Minne (1866–1941) displayed a Symbolist sensitivity made famous through his lanky, meditative adolescents (*Fountain with Kneeling Youths*, 1898, several versions). German sculptor Wilhelm Lehmbruck (1881–1919) also indulged in a mannered idiom of thin, often outsized figures (*Female Torso*, 1910; *Seated Youth*, 1918). And, starting from local Italian tradition, Milanese sculptor Arturo Martini (1889–1947) was able to establish—after a phase of

Aristide Maillol, *Venus*, 1919–28. Bronze, H: 5′9″ (1.76 m), Tuileries Gardens, Paris (France).

excessive verism—a more sober, synthetic art.

French sculpture, meanwhile, enjoyed one of its most brilliant periods. In vain have critics sought to denigrate it by describing it as "a throwback to figurative art" as distinct from "Modernism" and the "avant-garde." That attitude is an arbitrary rewriting of history based on infatuations that, it might be thought, should now be over. The truth is that there were many artists at work whose passion and skill were matched by sensitivity, and many of their masterpieces have survived despite more or less deliberate destructions.

This is the place to mention—despite the discordance in dates—Burgundian artist François Pompon (1855–1933), who offered a deliberate and total contrast to Rodin. Having served as assistant to Rodin for some fifteen years, Pompon was privy to the secrets of his master's craft. He nevertheless developed his own manner—very slowly—in an opposite direction, made all the easier by the fact that he sculpted only animals. Instead of following examples from the past, instead of playing on variations in furs and hides, Pompon focused his effects on smooth, straightforward volumes that encourage the light to dance across carefully polished surfaces. Pompon was more interested in subtle details that intuitively revealed the psychology of the animal than in movement. He earned lasting success with his famous *Polar Bear*, exhibited at the Salon d'Automne in Paris in 1922.

Joseph Bernard (1866–1931) discovered his own taste for smooth bronze and marble figures at an early date, but differed from Maillol in his sense of movement. He conveyed motion through supple, elegant lines that guaranteed the popularity of sculptures such as *Woman and Child* and *Woman with Jug* (page 525), which had something of the feel of sixteenth-century bronzes by Giambologna and Barthélemy Prieur and, much earlier, of the "Alexandrian" period. Bernard's attentiveness to the play of curves would lead him, like Bourdelle, to indulge in the musical pleasure of composing bas-reliefs (*The Dance*, 1925).

The long career of Paul Landowski (1875–1961) is more complex. A passionate artist, Landowski dreamed of vast projects but was always ready to adapt his style to the dimensions and requirements of commissions, and especially to the quality of the light in which the work would be seen. He has been compared to his contemporary and friend Henri Bouchard (1875–1960), who sometimes also displayed a spare, firm realism (*Claus Sluter*, 1911, Dijon) and sometimes evoked a grand, antique-style lyricism: his *Apollo Musagetes* (1937), showing Apollo as "leader of the muses" looking down from the heights of the Palais de Chaillot, copes comfortably with the colossal dimensions and changing light of Parisian skies (page 531).

Perhaps less idealistic and less inventive were Charles Despiau

Joseph Bernard, *Young Woman with Jug*, 1910. Original plaster, 6'1" × 1'7" × 1'7" (188 × 48 × 48 cm), Musée des Beaux-Arts, Lyon (France).

Emmanuel Frémiet,
Pylon of the Pont Alexande III,
1900. Gilded bronze,
Paris (France).

(1874–1946) and the younger Robert Wlérick (1882–1944). They refocused attention on accurate observation of face and body, though with a spare precision in form and rhythm that rescued their work from triviality and elevated it to the grand style.

The role of major commissions

In fact, during the first half of the twentieth century sculpture recovered its full decorative role. Just when it seemed in danger of being reduced to a simple statue erected in a public square, it managed to reestablish a fundamental link with architecture and with the overall decoration of a building. Sculpture was aided in this task by the world fairs held in Paris in those days, such as the Exposition Universelle of 1900, the "Exposition Internationale des Arts Décoratifs et Industriels Modernes" in 1925, and the Exposition Universelle of 1937. The 1900 exposition endowed Paris with major sculptures such as the allegorical figures taming winged horses, placed on the four large piers of the Pont Alexandre III spanning the Seine (page 526).

Georges Recipon, *Harmony Overcoming Discord*, 1900. Hammered copper, Grand Palais, Paris (France).

These late works by Emmanuel Frémiet (1824–1910) provide a good idea of his lyricism, too often ignored to the benefit of his work as an animal sculptor. The same exposition enabled Georges Recipon to execute two of the finest quadrigas—or four-horse chariots—of modern sculpture: *Immortality Outrunning Time* and *Harmony Overcoming Discord* (page 527). These two allegorical groups, set on the corners of the exhibition hall, known as the Grand Palais, display a skillful choice of proportions, a clever arrangement of superb figures against the sky, and a most

extraordinarily powerful sense of movement. The "Exposition Internationale des Arts Décoratifs et Industriels Modernes" exhibition, meanwhile, successfully attempted to counter Adolf Loos's indictment of ornamentation by reconciling French sculpture with architecture. France's attachment to the age-old—and still vibrant—tradition of decorative sculpture was then confirmed by the Exposition Universelle of 1937. Never before had sculpture appeared so brilliant. The exhibition committee commissioned work from some five hundred sculptors. For the Palais de Chaillot alone, fifty-seven sculptors

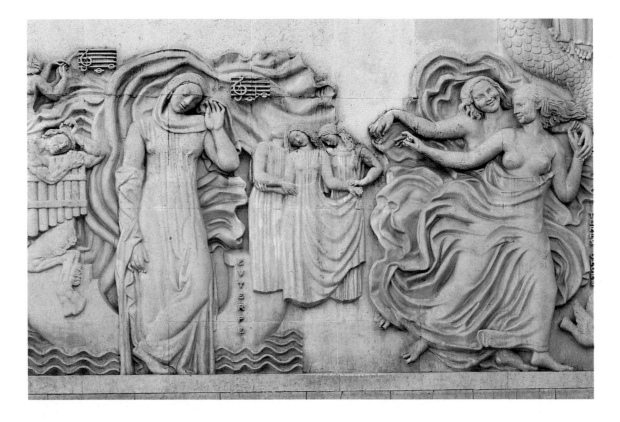

were hired. In terms of expenditure, the national and municipal governments spent five million francs on sculpture for the Palais de Chaillot and the nearby Palais de Tokyo. Most of these works have survived. The exterior decoration of the Palais de Chaillot, for example, remains intact. Based on current evidence, all the work was of high quality and some of it could be called masterful.

At the Palais de Tokyo, one of Bourdelle's pupils, Alfred Janniot (1889–1969), covered the sides of the monumental staircase leading down to the Seine with bas-relief carvings that illustrate the themes of land and water (page 528). This work was even more skillful than

Janniot's earlier decoration of the Musée des Colonies in 1931. The Trocadero esplanade of the Palais de Chaillot, meanwhile, hosted ten gilded bronze statues, still in situ, that were commissioned from Marcel Gimond, Paul Niclausse, Paul Cornet, Robert Couturier, and other young sculptors of the day. This gallery of statues demonstrates the variety and quality of their talent (page 529). At the foot of the ornamental pool are two large groups carved in stone by Léon Drivier (1878–1951) and Pierre Marie Poisson (1876–1953); titled *Joie de Vivre* and *Youth*, these works go beyond Neoclassicism in an attempt to connect with ancient Roman sculpture. Crowning the street

Alfred Janniot, *Allegory to the Glory of the Arts* (detail), 1937. Bas-relief, Palais de Tokyo, Paris (France).

façade of the Palais de Chaillot are two groups of triple allegories by Raymond Delamarre (1890–1986) and Carlo Sarrabezolles (1888–1971) representing, respectively, *Mind* (an allegory of Philosophy flanked by the Visual Arts and the Liberal Arts) and *Matter* (Earth flanked by Air and Fire). These elegant bronze figures, over 11 ft. (3.5 m) tall, seem simultaneously hieratic and supple. However, the sculptures that are most popular among the crowds that visit the Chaillot site are Bouchard's *Apollo Musagetes*, mentioned earlier, and

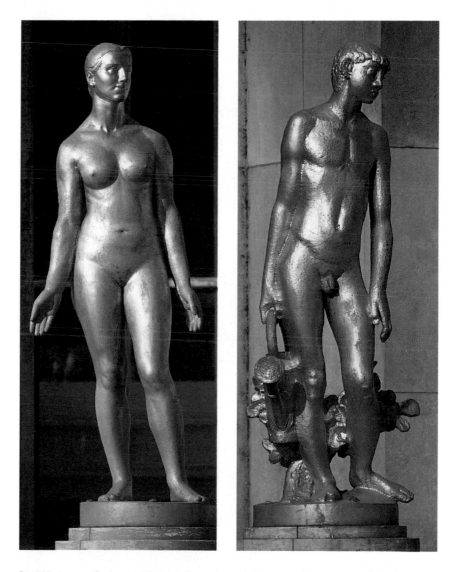

Paul Niclausse, *Spring*, and Robert Couturier, *The Young Gardener*, 1937. Gilded bronze, Trocadero Esplanade, Palais de Chaillot, Paris (France).

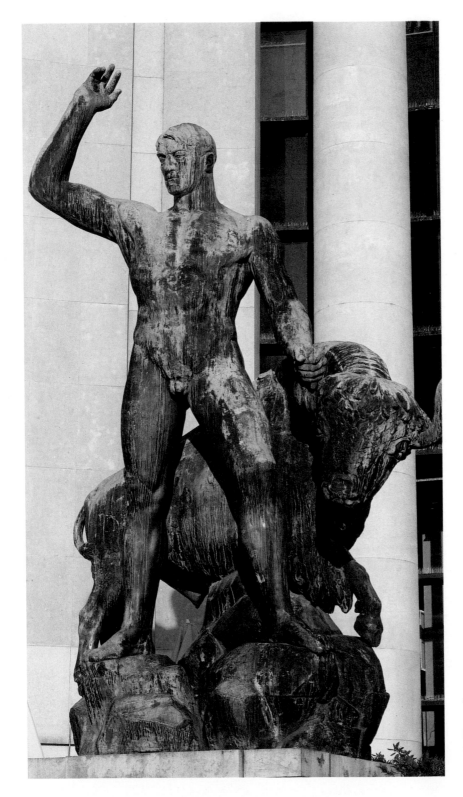

Albert Pommier, *Hercules Taming a Bison*, 1937. Bronze, Trocadero Gardens, Palais de Chaillot, Paris (France).

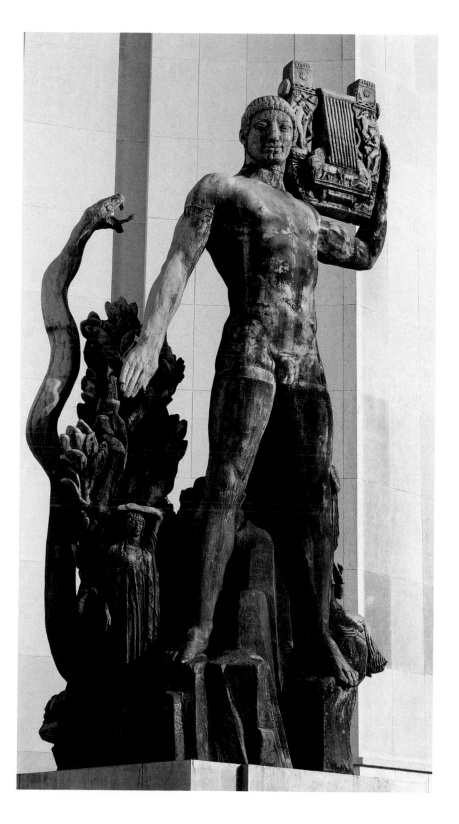

Henri Bouchard, *Apollo Musagetes*, 1937. Bronze, Trocadero Gardens, Palais de Chaillot, Paris (France).

Hercules Taming a Bison (page 530) by Albert Pommier (1880–1944). These two statues are set in front of the two main wings of the exhibition building; their colossal dimensions in no way detract from their handling, from the power and clarity of the symbolism (referring to the Arts in the former case, and to Intelligence Mastering Brute Force in the latter case). Their harmonious lines show that, even seventy-five years on, such sculpture remains thoroughly effective.

Explorations bold and timid

This great tradition of "humanist" sculpture survived into the early years of the twenty-first century only by going underground: around 1970–80, it was permanently forsaken by public authorities, who condemned it to extinction by ceasing to commission major works. True enough, even prior to Rodin's death another kind of sculpture had emerged, one that attempted to follow the vagaries of painting. Most of this work was produced, for that matter, by painters— Renoir, Degas, Gauguin, Matisse, Picasso, Max Ernst, Boccioni, Modigliani, and others—seeking to extend their experimentation into a related realm. All these experiments are worthy of consideration within the context of the artist's own oeuvre, and vary in quality depending on the commitment the artist made to them. But such works were not widely known in their day, nor is it certain they will ever play a major role in the history

of sculpture, a discipline that does not open its arms to every suitor.

Similarly, novelty and boldness are not sufficient to transform an "avant-garde" experiment into a masterpiece. It might initially arouse curiosity, but once the first impression has passed it often inspires little more than indifference (perhaps because sculpture is a material art by nature, easily reverting to its initial inertia). That was the fate, for example, of abstract constructions by Anton Pevsner (1886–1932) and his brother Naum Gabo (1890–1977), both of whom were part of the

Henri Laurens, *Winged Mermaid*, 1948. Bronze, 1'11" × 1'2" (60 × 34 cm). Musée National d'Art Moderne, Centre Georges Pompidou, Paris (France).

Ossip Zadkine, *The Birth of Forms*, 1958. Bronze, 6′9″ × 4′6″ (2.05 × 1.4 m). Musée Zadkine, Paris (France).

Russia's "avant-garde" prior to 1922–23. As ingenious as these works may have seemed, they are now forgotten.

Only three such artists managed to retain their eminence. The first was Henri Laurens (1885–1954). Through a subtle play of details taken from reality and artfully arranged in space, Laurens's best works succesfully retain a kind of sensuality while evacuating any immediate relationship to representation (page 532).

The second was Ossip Zadkine (1890–1967), who always maintained close links with the Cubists and who, like them, rarely severed his ties to reality completely. He would simplify volumes, play skillfully with luminous planes and ridges. He sometimes lapsed into a certain dryness, or was overly influenced by the rage for African art; but his *Female Musicians* (1924), *Maenads* (1934), *Clementius, Three Beauties* (1955), and *Birth of Forms* (1958, page 533)

incontrovertibly reveal him to be one of the most intelligent sculptors of his day.

The work of Étienne Hajdu (1907–96), meanwhile, is closer to lyrical abstraction. It rarely suggests any resemblance to natural forms, yet it almost always retains an essence of reality that, like a whiff of perfume, grabs the attention. Hajdu's sources of inspiration were both varied and subtle. Among his finest pieces are the bronzes that artfully play on voids and solids, occupying space like the firm if whimsical shoots of some succulent plant (page 534). Hajdu did not need to follow a more or less artificial theory; his work conveys a strong yet discreet sensibility that simultaneously reveals and masks itself, a type of miracle that has become all too rare in sculpture.

Far from merely producing "gallery sculpture," these artists retained a sense of monumentality. It might be feared that the knowledge and sensibility necessary to produce such art died with them, but that may not be the case. An artist

Étienne Hajdu, *Rhythms*, 1970. Zinc, 1' 7"× 2' 5" (49 × 74 cm). Private collection.

like Georges Jeanclos (1933–97) unhesitatingly pursued the tradition. Dismissed by the "media," he nevertheless won commissions and honors, but died too young to have international fame, that—barring scandal or publicity blitz—is today granted only in the last years of life. Jeanclos executed major commissions in France, including the doors to the new Finance Ministry in Paris (1989), the portal of the church of Saint-Ayoul in Provins (1989), the fountain of Saint-Julien-Le-Pauvre in Paris (1995), and the bronze grille in Lille Cathedral (2000). More than just an original style, these works convey a personal sensitivity to materials, an emotion unique to Jeanclos. He has sometimes been criticized for a mannerism derived from both Japanese and "Gothic" art. Yet these influences never overwhelm the originality of Jeanclos's sometimes ragged, sometimes pure and refined forms. What emerges is an affectionate, troubled spirit haunted by a strange mixture of charity and wisdom. Once again, sculpture has naturally reverted to its original role.

Georges Jeanclos, *Boat*, 1988. Terracotta, 1′ × 1′6″ × 9″ (32 × 48 × 24 cm). Albert Loeb Gallery, Paris (France).

Painting

From the years 1880 to 1970, painting offered a panorama entirely different from sculpture. Rodin, with all the confidence of his creative genius, confirmed sculpture's place within the grand tradition. Among painters, the success of the Impressionists produced the opposite effect: a ferment of initiatives followed and overlapped one another, creating obvious confusion and unresolvable contradictions.

What kind of sifting and selection should be done for a period that is still so recent? Despite the wars, most paintings have survived. And despite appearances, this plethora makes inquiry more difficult. Many works are secluded in private collections, while the vagaries of fashion arbitrarily consign others to museum storerooms, leaving scholars to study a few black and white photographs, at best. We can never be too wary of what art historians call the "purgatory effect": once an artist dies, an often exaggerated chorus of praise is followed by a more or less deep, more or less lengthy oblivion during the next generation. Many painters are never resurrected from this purgatory. The past forty years have seen many reputations collapse entirely, while other reputations recover their initial glory.

Another obstacle that may raise scruples is the fact that artists became totally scattered across the world. For a long time, painters were trained in a few major European capitals, and more or less pursued their careers in one of its large cities. After 1880, however, the situation changed rapidly. Training henceforth played only a secondary role, and was no longer thought to be necessary or even desirable. The greatest painters of this period, Gauguin and van Gogh, were practically amateur artists who reached adulthood before following their calling, acquiring their craft themselves and then leading a more or less wandering existence. Ever since the Impressionist period, the few existing centers of gravity have taken the form of exhibitions, certain galleries, and private events. Even the notion of "career" has tended to fade.

Swift travel and communications often abolish borders. Some painters are truly international, to the extent that their land of birth has been more or less forgotten. Others, on the contrary, like Mexican artist Rufino Tamayo, born in Oaxaca in 1899, imbued the very meaning of their art with a profound sense of roots. Some artists felt they were responsible for creating their own

Paul Sérusier, *The Talisman*, 1888. Oil on canvas, 11 × 9″ (27 × 22 cm). Musée d'Orsay, Paris (France).

fame, which they would attempt to sustain by periodically drawing public attention to themselves through scandals and publicity stunts. But many artists were like Giorgio Morandi (1890–1964), who won international recognition without ever leaving his studio on a modest street in Bologna, Italy. Here we have to confront not only a diversity of places and attitudes, but also an inextricable weave of styles. Between the brilliant Anders Zorn (Sweden, 1860–1920) and the highly fertile Joaquin Sorolla y Bastida (Spain, 1863–1923) there exist major visual similarities that can perhaps be explained by the influence of Paris. And yet what links could be made between the genius of Viennese artist Gustav Klimt (1862–1918) and that of the Danish painter Vilhelm Hammershoi (1864–1916)? As the decades went by and the world of painting expanded, experiments diversified. So today there is a growing temptation to try to cite everything.

But mentioning every painter I have ever admired, from Venezuela to Finland, would only add to the confusion. After some hesitation, I thought it important to return to the rule I initially set myself: not to include everything, but to point to navigable paths that encourage further exploration.

Two great mediators: Gauguin and van Gogh

The start of this period was marked by two peerless figures, Paul Gauguin and Vincent van Gogh.

Most unusually, the singularity of their lives caught the public's imagination at the very moment that their art profoundly influenced other painters.

Indeed, the life of Gauguin (1848–1903) reads like novel— a novel of a man gripped by painting, a man who sacrifices his job, his wealth, his family, and finally his health, dying before he obtained full recognition for his genius. This tragedy is not a myth, and it should be added that it is impossible to separate Gauguin's painting from his personality, which was bold, coarse, accustomed to a seafaring life, and yet simultaneously delicate, refined, and inclined to constant self-interrogation.

As to Gauguin's pictorial exploits, they led from a highly talented Sunday-painter's Impressionism—his *Seine at the Pont d'Iéna*, signed and dated 1875, is perfectly worthy of the collection in the Musée d'Orsay—to an extreme experimentation in color that would take painting into unexplored realms. Gauguin's discoveries did not stem from the systematic application of a method, as was the case with Seurat's divisionism and even Monet's studies of light. His findings emerged, after a long search, in the strange painting titled *The Vision After the Sermon* (also known as *Jacob Wrestling with the Angel*, National Gallery, Edinburgh). What first strikes us about this work, painted in 1888, is the composition directly inspired by Japanese prints, with its high-angle view and the

Paul Gauguin,
The Meal (The Bananas),
1891. Oil on canvas-
backed paper,
29 × 36″ (73 × 92 cm).
Musée d'Orsay,
Paris (France).

decorative play on the Breton women's traditional hats. The entire meadow, however, is painted bright red, very slightly modulated to intensify the color still further. What little modeling there is appears in the secondary parts, as though Gauguin was still somewhat frightened by the simple juxtaposition of flat areas of pure color.

Indeed, Gauguin was aware that while flat areas of paint could lend color its highest resonance, they could also drain it of life. His finest works entail a perpetual tension between bright color and pure color. A painting such as *The Meal* (or *The Bananas*, 1891) justifiably ranks as one of his finest accomplishments (page 539). And yet

pure color only appears in one small rectangle on the right, painted in the finest yellow. Gauguin apparently wanted to give this scene a kind of quietly hieratic feel. At some point he may even have thought of alluding to Christ's supper at Emmaus, for the painting was done in the same year as *Orana Maria*. The three figures are distinctly separate from one another, and the canvas is structured by large, parallel zones of color. The colors tend to be sober—two burnt siennas and a light blue. They are accompanied by shadows, including inner shading for the faces and the large bowl in the middle. A modeling very similar to that of Cézanne's is used for the fruit, achieving a simultaneous

plenitude of form and color. Although one of the bananas attains a pure red, this red is prepared by a gamut of hues ranging from Prussian blue to ocher and orange. The three pieces of fruit in the middle attain all the luminosity of a Manet.

The White Horse (1898) reveals the extent to which Gauguin acquired a mastery of color (page 540). He seems to use it in an entirely musical way, for it no longer serves to reproduce reality. The white horse, in fact, is painted green over a vague pink, while the second horse is brick red. Color is no longer used to lend fullness to the forms: the two riders are mere patches of pigment, and the apparently casual brushwork prevents the white horse from destroying the overall unity of the painting by taking on an overly heavy mass. Here it is vision that commands color. The contrast of orange spots against the dark—almost black—blue of the water where the horse drinks, the pale green meadow shot with yellow in the pink path, and the ocher patches of the two naked riders, combined with the curving rhythm of the trees, suffice to evoke the beauty of antiquity rediscovered.

It has been suggested that this painting is a direct reference to the carving on the Parthenon, which is not absurd. Gauguin always wanted to put meaning into his paintings, sometimes even by inscribing words on them. His triumph is to have succeeded where Cézanne failed, namely in combining the most extreme artistic experimentation

with a celebration of the sensual world, halfway between primitive innocence and metaphysical angst. Most of Gauguin's paintings are dominated by a questioning gaze. We should not forget that the artist primarily vaunted himself as a "painter of stories." This comment, coming as it did after Impressionism, was a reaffirmation that painting did not have to abandon its earlier prerogatives nor its profound links to literature. It was symbolist poet Stéphane Mallarmé, after all, who presided in person over the banquet given on March 23, 1891 in honor of Gauguin's imminent departure for Tahiti.

On two occasions—in 1886 and 1888—Gauguin's complicated path crossed that of Vincent van Gogh (1853–90). Van Gogh, that other great painter of the day, died very young, at the age of thirty-seven (the large number of works he left behind—over nine hundred—plus the self-portraits that make him look like an old man, sometimes give the impression of a long career). His own life also read like a novel, although more interiorized and more tragic than Gauguin's. It was not until 1881 that van Gogh dared to pick up a paintbrush, at which point he began producing works of a somewhat naïve realism, handled in a dark impasto. On arriving in Paris in March 1886, he discovered both Impressionism and Post-Impressionism, made friends with Gauguin and Émile Bernard, and took an interest in Japanese prints. His palette swiftly became lighter, his colors more intense. But it was

Paul Gauguin,
The White Horse,
1898. Oil on canvas,
4′7″ × 3′ (140 × 91 cm).
Musée d'Orsay,
Paris (France).

only when he moved to Arles that color became the crucial issue for van Gogh. Unfortunately, he only had three years to live.

It had been with some reluctance that van Gogh attempted a light Impressionist touch and divisionist effects. Very rapidly he returned to a heavy impasto technique, creating a tormented surface modeled, so to speak, by a brush that gave meaning to every stroke. He could thereby lay down entire areas of bright color without producing the inertia of flat washes. This can be seen in the *Wheat Fields* that occupy two

thirds of the canvas and carry yellows to the height of intensity— the brushstrokes embody the wavy stalks, the mown path, and the bundled sheaves, never allowing the eye to rest (page 542). "Flat colors, coarsely applied," is how van Gogh himself described a painting of his room in Arles in which, trapped between very light blues and a full range of ochers extending into pale yellow, a startling patch of red explodes. The dynamism of the brushstroke carries the dynamism of the color.

The effects that van Gogh would draw from this alliance can

Vincent van Gogh, *Wheat Fields*, 1889. Oil on canvas, 2′5″ × 3′ (74 × 92 cm). Rijksmuseum Vincent van Gogh, Amsterdam (Netherlands).

Vincent van Gogh,
Starry Night,
1888. Oil on canvas,
28 × 36″ (72 × 92 cm).
Musée d'Orsay,
Paris (France).

be easily appreciated in *Starry Night* (page 543). He was certainly not the first artist to paint a night scene, but here he managed to paint one with bright colors that avoid sinking into gaudiness. Brushstrokes divided into segments that are horizontal—or, on the ground, slightly diagonal—allowed him to express the peacefulness of a southern sky at night, with blues intensified by pale highlights and the orange reflections of light on the still waters. "It seems to me that the night is much more lively and richly colored than the day," he wrote to his brother in September 1888, just a few days after having explained: "Instead of trying to accurately render what is before my eyes, I use color more arbitrarily, to express myself more powerfully."

Indeed, beneath the painter there still lurked the Protestant preacher that van Gogh nearly became. He would not divorce a painting's visual technique from its meaning. "What I think of my own work," he wrote in 1887, "is that the scenes of peasants eating potatoes, which I painted when I was in Neunen, are still, after all, the best thing I've done." Van Gogh wanted his color to be "suggestive," to stir the "emotions"

of the person looking at it. In June 1890, just a few days before he died, he spoke to his sister of his passion for portraiture, repeating once again: "I would like to do portraits that will look like apparitions to people a hundred years from now. I'm not trying to do this through a photographic likeness, but through passionate expressiveness, using our modern taste and skill in coloring as a means of expressing and exalting character." Van Gogh thereby indicated the path that would be taken fifteen years later by the group called the Fauves ("wild beasts").

The Talisman

In October 1888, the young artist Paul Sérusier returned from Pont-Aven, where he had been working alongside Gauguin, with a painting of a landscape executed on a very small plaque of wood. He showed it to an eighteen-year-old student at the Académie Jullian named Maurice Denis, as well as to several friends, explaining that he had painted it under Gauguin's guidance (page 536). Denis later reported that Gauguin had said to Sérusier: "How does that tree look

Maurice Denis,
Patches of Sunlight on the Terrace, 1890.
Oil on cardboard,
9 × 8″ (24 × 20 cm).
Musée d'Orsay,
Paris (France).

Maurice Denis,
The Catholic Mystery,
1889. Oil on canvas,
3′2″ × 4′8″ (97 × 143 cm).
Musée Départemental
Maurice-Denis,
Saint-Germain-en-Laye
(France).

to you? It's quite green. So make it green, the finest green in your palette. And that shadow, rather blue, isn't it? Don't hesitate to paint it as blue as possible." This comment accords with the ones made by van Gogh in his letters—which obviously had not yet been published—and probably inspired Denis to forge his own, now famous, dictum: "Remember that a picture—before being a war horse or a nude woman or any other anecdote—is essentially a flat surface covered with colors assembled in a certain order." Denis was explicitly ranking visual impact above the imitation of nature, which was still the avowed ideal of all painters.

The Nabis

Nevertheless, Denis apparently did not follow Gauguin's advice when it came to intensifying his colors. It was long thought that, as a good theorist and devout Christian, he lacked the boldness to do so. In the past thirty years, however, renewed interest in his work has revealed that he has been misunderstood. A few small paintings such as *Patches of Sunlight on the Terrace* (page 544) show that he could go further than anyone else in this respect: the reds are aflame, intensified by a patch of green, while the shadows are replaced by a pure black. But Denis did not want aesthetic impact to supplant meaning, which for him primarily meant a combination of

amorous sentiments and religious emotion—these feelings were the very basis of Denis's artistic calling. So rather than remaining content with perfunctory drawing, he soon returned to the pleasure of a flowing draftsmanship that allowed him to express his ideas in the subtlest way possible. The same play of red and black hues can be seen in his *Catholic Mystery*, but here they surface within a lively, golden light that delicately frames the adoration of the Virgin (page 545). Denis seems to be harking back to the art of Fra Angelico. Later, commissions for large secular and ecclesiastical decorative schemes—including the famous "cardinal's construction projects," which incited him to accept his Catholic faith—confronted Denis with the particular problems associated with monumental compositions. It might be argued that he did not always resolve such problems, but at least he did more than merely follow the path pioneered by Puvis de Chavannes. And Denis thus launched a new school of painting, one whose value and quality will be properly assessed only once it has been seriously studied.

Édouard Vuillard,
Woman in a Striped Dress,
1895. Oil on canvas,
26 × 23″ (65 × 58 cm).
National Gallery of Art,
Washington, D.C.

Pierre Bonnard,
The French Window or
Morning in Le Cannet,
1933. Oil on canvas,
2′10″ × 3′8″ (86 × 112 cm).
Private collection.

The early works of Édouard Vuillard (1868–1940) display a similar taste for flowing lines, although accompanied by a more discreet sense of color and often by an affectionate, childlike spirit. These paintings were often views of bourgeois interiors, where lyrical bursts of intense color would have seemed totally inappropriate. Vuillard liked to paint private scenes with a limited palette, even if that meant wittily playing on the stripes of a dress, the checks of a tablecloth, or the patterns of wallpaper. Nothing approaches Pre-Raphaelite art more closely than his *Woman in a Striped Dress* of

1895, which features two women set among the subdued colors of autumnal bouquets (page 546). Yet at the same time, nothing could be more different, both in terms of the deceptively casual brushwork and the absence of that passion, ecstasy, and repressed Romanticism that so often rings a little hollow in the work of Dante Gabriel Rossetti and Edward Burne-Jones.

Closely linked to Vuillard was Pierre Bonnard (1867–1947), who began painting in a similar vein although with a very knowing boldness and a calculated naïveté. It sometimes seems as though he used a touch of humor to protect himself

from the sensuality that threatens to invade his work. His sensuality was similar to the kind found in the novels of French author Colette, finding expression in details such as a face in shadow, the reflection of sunlight on a balcony, a door opening onto a garden, or cakes set on a table (page 547). Bonnard's sensuality is also evident in his paintings of some of the finest female nudes in all of French art. Everything is handled in small strokes, seemingly applied randomly. An apparent casualness allowed Bonnard to place mimosa yellow on top of an orange ground, or to array an entire range of blues from violet to Veronese green. No one played with the contrast of warm and cool tones better—or with more pleasure—than Bonnard. He forces the eye to embrace the overall resonance almost instantly, then induces it to caress local tonalities throughout the canvas thanks to delightfully intricate passages and unexpected yet artfully designed dissonances. "As Delacroix noted in his *Journal*," wrote Bonnard just before he died, "you can never paint too violently. In painting, there's only one obligation: raise the tone."

The Fauves

Although the aging Bonnard referred to the "violence" of color, he was never counted among the artists known as the "wild beasts," or Fauves. Given his friends and the generation he belonged to, he is better described as one of the main representatives of the Nabis, or "prophets." Above all, like Vuillard,

Valloton, and Lacombe, Bonnard lived and was happy to exist in a world where color and forms intensified one another, constantly mingling, to the artist's ever greater delight. But what the Fauves were trying to do, around 1905, was to draw pure color from this everchanging clutter, to seize upon the sharpest hue, to simplify it and thereby render it directly accessible—so to speak—to the mind. By so doing, they completely broke with Impressionism even within Monet's lifetime, whereas painters such as Denis, Vuillard, and Bonnard appeared instead to be exploring an intensely lyrical variant of Impressionism.

There is a story that one day Bonnard paid a visit to Matisse while the latter's *La Danse* (1910–11) was still in his studio. Bonnard asked Matisse why he used just one single color for the figures. Matisse allegedly replied that, "I know that the sky casts blue reflections on figures, and grass green reflections. Maybe I should provide some indication of shadow and light, but why complicate the issue? It doesn't matter to the canvas, and it only interferes with what I'm trying to express." Bonnard never wanted to separate color from light. Matisse wanted color on its own.

The term "Fauves" was coined by art critic Louis Vauxcelles in his review of the 1905 Salon in Paris. In fact, it applies neither to a clearly defined group nor to a clearly expressed doctrine. Unfortunately, the term all too often overshadows a parallel movement

Henri Matisse,
*Interior (Still-Life with
Eggplants)*, c. 1911–12.
Distemper and mixed
media on canvas,
6′10″ × 8′ (2.12 × 2.46 m).
Musée des Beaux-Arts,

that was emerging at the same in Germany, with ever greater expressive violence. Furthermore, it is surprising that fully fifteen years had elapsed since Sérusier painted *The Talisman* and Denis produced his *Patches of Sunlight*. But a law of painting holds that the various aesthetic resources available to artists can never be pushed to extremes all at the same time. And since the Nabis were primarily attempting to explore the possibilities of flowing patterns, they had to downplay color intensity. In fact, it was the Neo-Impressionists who, after having tried to convey

atmosphere by an accumulation of tiny dots, began to "raise the tone" by employing large strokes of pure color. Henri-Edmond Cross (1856–1910) and Paul Signac (1863–1935) thus managed to break the constraint of "division-ism" and to produce works richer and bolder—if less subtle—than Seurat's. They thereby paved the way for new young artists such as Henri Matisse (1869–1954), André Derain (1880–1954), Maurice de Vlaminck (1876–1958), Raoul Dufy (1877–1953), and Robert Delaunay (1885–1941), who by 1905–06 were painting

landscapes and portraits by juxtaposing pure colors and keeping draftsmanship to a minimum. Nothing could be riskier for a painter than to give color free rein. Rare were the artists who managed to sustain their initial verve.

In a kind of paradox, the most convinced and most intellectual of all the Fauves was Henri Matisse. He did not hesitate to push his experiments to extremes. Consider, for example, one of his most accomplished works, painted in 1911–12 and titled *Interior* but often known as *Still Life with Eggplants* (page 549). Everything here is reduced to color—the draftsmanship is very basic. No forms are modeled, and only a few diagonal lines on the left forestall an impression of complete flatness by suggesting depth. Only two or three reflections on the vase, in the middle, and a few shaded tones in the brown ground hint at a sense of space, which is immediately contradicted and demolished by the perfunctory pattern of five-petaled blue flowers that float everywhere and obsess the eye. Deep values are concentrated in just a few points (including the three eggplants in the middle) and allow the hues—yellow, orange-red, periwinkle blue, green—to intensify one another, while broad swirls contrast with the blue flowers and thereby allay potential boredom. *Still-Life with Eggplants* displays surprising skill and sensitivity, although expressed in a kind of subtle equation that deliberately excludes all passion.

It might appear that Matisse's *Interior, Goldfish Bowl* of 1914 (Musée National d'Art Moderne, Paris) is a more austere work, one in which he reconstructs the space that he had previously endeavored to demolish. Here Matisse laid down broad planes of colors in simple shapes, merely enlivening the rectangles with a few curves—the fishbowl, the plant, the balcony, and what seems to be a mirror on the right. The dark walls are painted in a most conventional "tobacco" brown, and the overall effect would be dull were it not for a sunny patch of yellow wall, for the two soft blue rectangles separated by a more subtle shade of blue, and for the sharp notes of red provided by the window ledge and the two goldfish (the red being notably intensified by a green patch in the foreground). Here again, it is hard to imagine a painting that could be further from Impressionism—even though light drenches the window, fishbowl, and landscape, Matisse was primarily seeking to reduce objects to basic shapes and give priority to the play of color.

Not every work in Matisse's abundant oeuvre attained this level of quality. His friends often accused him of being too dogmatic, of taking on professorial airs. On the contrary, he demonstrated on many occasions that he did not know where to go or when to stop. Most of his much-vaunted drawings are empty, while his portraits—unlike those of Picasso, to whom he is often twinned—remain fairly inexpressive. In the 1920s, Matisse

produced many tritely picturesque figures of female odalisques, and around the same time he often attempted to reintroduce a realistic modeling of flesh and fabrics amid boldly flattened washes, which only made the works seem garish. By the late 1930s, however, Matisse had returned to a spare manner that yielded notably successful canvases, and at the end of his life he enjoyed doing large collages of paper cutouts that produced a fine decorative effect even if, when viewed close up, the material quality of the paper dampens visual pleasure.

Draftsmanship was one of the issues that Matisse constantly addressed. He fully understood the law holding that a detectable line ringing areas of saturated color produces an unpleasant impression of redundancy. The more the colors are expressive in themselves, the more brushstrokes should be thick, indeed coarse. But this technique excludes all detail, and notably all indulgence in rendering the beauty of bodies and faces. Raoul Dufy, a born storyteller, seems to have had even more difficulty than Matisse in remaining content with perfunctory draftsmanship, and he ultimately discovered a solution by completely divorcing line from color.

By the mid 1920s, Dufy was applying pure color to the canvas, often choosing the brightest hue, spread in broad washes to create

Raoul Dufy,
Black Cargo Ship,
1952. Oil on canvas,
2´8˝ × 3´3˝ (81 × 100 cm).
Musée des Beaux-Arts,
Lyon (France).

the general atmosphere, or alternatively in small touches to create a contrast. On top of this ground he would then draw freely, making the drawing as complex as he liked. The results could be very intense, as seen for example in a painting of 1952 titled *Black Cargo Ship* (page 551). In the middle is a deep patch of black, flanked by the blues and greens of the sea. There are also two bright zones of yellow and pink, plus three or four additional spots of color that echo these hues. Once

this color scheme was established, a brush laden with green was used to draw the ship, while a brush with black pigment drew the fisherman with net, the tourist reading a newspaper, the woman in a white dress with parasol, the houses on the quay, the waves, and so on. This original compositional technique allowed Dufy to recount things in his own humorous fashion, with the same freedom as Bonnard. He perhaps lacked Bonnard's sensuality and tenderness, but he displayed a similar

Pablo Picasso,
Seated Nude,
1909. Oil on canvas,
36 × 29″ (92 × 73 cm).
Tate Gallery,
London (England).

lightness and wit, and made the most of his casual approach to create intense contrasts or to blend colors so as to form the subtlest harmonies.

The "Cubist" interlude

At this point we must discuss "Cubism," to use the time-honored label. It would be unpardonable to overlook what passes for the most important trend in early twentieth-

century painting. Although I have no wish to ignore the trend itself, I would have preferred to avoid using the term, which merely creates a knot of contradictions and confusion.

Defined most strictly, the term refers to the artistic output of two young friends, Pablo Picasso and Georges Braque, during the brief period of 1907 to 1917. Yet even this restricted output does not reflect one single approach. Starting from

Georges Braque,
*The Château of
La Roche-Guyon,*
1909. Oil on canvas,
31 × 23″ (80 × 59 cm).
Moderna Museet,
Stockholm (Sweden).

a hesitant style—which, when it came to Picasso, often entailed literary or even anecdotal subject matter—in the years 1907 to 1909, the two painters swiftly evolved toward a series of austere works that rejected the more facile appeal of Nabis and Fauvist color and draftsmanship. They painted spare landscapes, constructed around the contrast of warm and cool tones, based on a highly restrained palette of emerald greens and brown ochers. At the time, rather than employing a system of "cubes," they seemed concerned to endow their paintings with an openly geometric structure; that is to say, they were responding to art's recurring need to restore form by abandoning a glibly arbitrary descriptiveness, as already discussed in terms of Cézanne and Seurat.

This exploration came to an end fairly soon. By 1909 it gave way to works that greatly increased the number of tiny individual planes, completely dissolving volumes and making the subject difficult to discern. There was no more depth to the picture, and in 1912 paper was even glued onto the surface of the canvas. And yet tradition still employs the label "Cubism" for these works, which is simply meaningless. The output of these years covered a wide range of experiments by these young artists. But it did not go unnoticed. Two painters, Albert Gleizes (1881–1953) and Jean Metzinger (1883–1956) wrote a book titled *Du Cubisme* in 1912, while the poet Guillaume Apollinaire published his study of *Peintres cubistes* in 1913. From that

moment onward, the term was applied to many artists who rejected not only the "soft" vision increasingly cultivated by Monet and the Impressionists, but also the complex swirls made popular by Art Nouveau. This third application of the term still embodies nothing that justifies the word "cube," except perhaps for a certain geometric rendering of forms, notably by the group dubbed the Section d'Or. It was this development, however, tha t probably marked painting more than the fleeting experiments of 1907–09.

Picasso has become a legend. Even twenty years after his death it is still impossible to judge him with equanimity. We must discard, successively, the image of the revolutionary artist (he was far from the boldest of his generation), the aura of his turbulent love life (which does him little honor), his reputation for political commitment (the Communist Party long took advantage of him, just as he took advantage of Communism), and above all the blind veneration sustained by commercial speculation. Not everything that left Picasso's hands was a masterpiece, and many of his sculptures, for instance, are of little interest. Behind the various masks—which are beginning to fall, one by one—there nevertheless remains a painter of striking genius and a draftsman of first rank, endowed with an extravagant pride and cleverness that enabled him to remain in the public spotlight right to the end, never experiencing the indifference that normally overcomes artists in their

Pablo Picasso,
Two Brothers,
1905–6. Oil on canvas,
4′7″ × 3′2″ (142 × 97 cm).
Kunstmuseum, Basel
(Switzerland).

old age. It is hard to know what judgment the future holds for Picasso—perhaps he will suffer the discredit that eventually fell upon another painter who once dazzled the world with his conceit and his highly valued works, Jean-Louis-Ernest Meissonier.

That, however, would be unfair to Picasso. He was, I repeat, an authentic genius, and he merits the greatest admiration. Yet he nevertheless took a long time to find his own personal path. His first style, called the "Blue Period," was based on a sordid realism that was

highly literary in the pejorative sense of the term. Only when he abandoned that approach in search of a more complex idiom based on circus figures (another literary motif then fashionable) did Picasso produce his first masterpieces. This was called his "Rose Period," as typified by the *Portrait of Benedetta Canals* (1905, Musée Picasso, Paris), a female figure executed with all the rigor of a Degas in the sole desire to convey her beauty. Another notable example is the *Boy with Wreath of Roses* (1905, private collection, New York), probably inspired by some work by Gauguin, in which the normally plain background is animated by a wallpaper pattern. Then there is the canvas titled *Two Brothers*, where Picasso shifts away from circus figures in order to focus on the nude and move closer to antiquity (page 555).

Despite a few experiments, Picasso showed little interest in problems of color; indeed, his wariness of them long made him favor monochrome, even at a time when Fauvism was blossoming. His interest in African masks (then just coming into fashion) and the explorations he conducted jointly with his close friend Braque—who was personally seeking to free himself from Fauvism—led to the idea of a pictorial approach that would be as removed as possible from both Impressionism and Fauvism. Nature thus was frozen into simple geometric volumes, while color was neutralized by being limited to a contrast of warm and cool grays. Forms were reduced to a kind of maquette, while lines, whether curved or rectilinear, were stripped of all sensibility, as exemplified by Picasso's *Nude in the Forest* (1908, Hermitage, Saint Petersburg) and *Factory at Horta de Ebro* (1909, Hermitage), as well as by Braque's *Houses at Estaque* (1908, Musée de Berne, Switzerland) and *Château of La Roche-Guyon* (page 553). Right from its first public exhibition at the Salon of 1908, this drastic simplification of representation sparked a scandal. Over the previous fifty years, however, creating a scandal had become a sign of success.

This approach was too austere to be sustained for long. By 1909, the contrast between warm and cool tones vanished and the subject was decomposed into multiple facets (page 552). Disintegration soon became so total that it was hard to identify the subject. At this point, both painters felt that they could introduce printed lettering, more or less cryptic, into a painting without destroying its visual unity. Then, around 1912–13, these fragments of words became fragments from a newspaper, a handbill, a music score, wallpaper, or fabric glued directly to the canvas, thereby transforming the painting into one the first "collages."

The works spanning this period, already unsettling in themselves, were energetically defended by some critics, who employed pseudo-philosophical arguments of some interest in so far as they were among the first to hold that artistic creativity no longer need

Pablo Picasso,
Mandolin and Guitar,
1924. Oil with sand
on canvas,
4′8″ × 6′7″ (1.43 × 2.02 m).
Solomon R. Guggenheim
Museum, New York
(New York).

show the least concern for the viewer's interest or pleasure. And the artistic output was considerable—Picasso alone produced some seven hundred works between 1908 and 1916. Success was international and the richest collectors and museums fought over these pieces, which were presented as sacred works even though of little appeal to the public. Around 1970, the revival of artistic experiments testing the limits of art placed the works of the period 1908 to 1916 in a historical perspective, showing the intrinsic quality of some of them even as it demonstrated that, with time, such experiments have lost much of their interest.

Furthermore, the war of 1914 had dispersed the group. Picasso steadily restored color to his painting with a series of *Harlequins* (1915), followed by a sequence featuring *Punchinello* (1920). He returned to a more direct interpretation of his subject matter, and during the 1920s his color became lighter and brighter in tone. A still life titled *Mandolin and Guitar*, painted in 1924 at Juan-les-Pins on the French Riviera, is composed solely of flat washes of color devoid of all modeling (page 557). Depth is merely suggested by a few diagonal lines. And yet a gay, sparkling light—created by the contrast of colors and the play of values carefully arranged around a

few areas—floods the entire paint-
ing. In terms of both technique
and spirit, nothing could be further
from Picasso's earlier works, which
suddenly fade from memory.

This was the moment when
Picasso produced some of his finest
masterpieces. Later, they became
fewer and farther between. For the
many remaining years of his life,
true inventiveness was replaced by
mere chatter. His inspiration would
steadily lose its vigor and he wasted
his genius on paintings done
"after" a given master, feebly com-
menting on the likes of Cranach,
Velasquez, and Delacroix. His
highly praised *Guernica* is, after
all, little more than a rather facile,
pompously grand painting, while
his composition for the UNESCO
headquarters in Paris is even less
successful (official commissions
were not Picasso's strong point).
On the other hand, whenever it
seemed as though his work was
becoming repetitious, Picasso was
suddenly able to get a grip on him-
self and produce some true master-
pieces, executed independently of
any doctrine or preconceived ideas,
sometimes harking back to the
great myths and sometimes draw-
ing inspiration directly from reality.

Braque, meanwhile, once he had
recovered from the tribulations of
war (which had been a terrible trial
for him), also reintroduced more
legible images and color into his
work. His palette would neverthe-
less remain dominated by somber
harmonies of grays, dark browns,
and cool greens. The large *Marble
Table* of 1925 (Musée National

Georges Braque,
Bird and its Nest,
1955. Oil on canvas,
4′3″ × 5′7″ (1.30 × 1.73 m).
Musée National d'Art
Moderne, Centre Georges
Pompidou, Paris (France).

d'Art Moderne, Paris) is notable for a varied, supple handling that appeals strongly to the eye. Braque always kept reality at a distance—he refused to put a glass in perspective or to round off a fruit bowl. Light existed for Braque, but never moved. Even though he sometimes painted flowers, he imbued them with a kind of weight and silence that made them seem timeless.

Braque failed completely when it came to a large ceiling commissioned by the Louvre in 1953. He also had little success at portraiture and landscape. Yet it would be mistaken to see him solely as a painter of still lifes. In the 1920s he was able to attack the problem of the female nude without imitating Picasso—or anyone else—in any way. In the 1922 canvas of a *Canephora* (or *Basket-Carrier*, page 558) or the *Nude Woman with Basket of Fruit* (1926, National Gallery,

Washington, D.C.), Braque made a nod in the direction of the revived fashion for antiquity, but he avoided banal naturalism. These paintings feature sensitive, curving lines that construct even as they decompose the monumental, solemn shapes of the picture. By the late 1930s, Braque was painting large interiors with still lifes and figures that represented an attempt to sum up his art. He was now a long way from Picasso. He painted a world that was alien to reality, whose shapes and colors were entirely governed by the artist's inspiration and visual requirements. These canvases are neither simple nor easily accessible, and yet their own internal necessity lends them nobility and solemnity.

Toward the end of his life, Braque went even further. In an unexpected move, he seized upon the visual theme of the bird, producing several masterpieces that

Georges Braque,
Canephora or *The Basket-Carrier*, 1922. Oil on canvas, 5′10″ × 2′4″ (180 × 72 cm). Musée National d'Art Moderne, Centre Georges Pompidou, Paris (France).

include a *Bird and its Nest* (page 559): its "static flight" represents a surprising accomplishment for an aging genius, a silent return to the primal enigma—the need for a sense of eternity that haunted Braque's entire oeuvre.

The "Cubist" group

An entire group of highly talented painters were influenced by Cubism. Some of them remained faithful to the movement, such as Juan Gris who continued to exploit the same techniques and subject matter—often with great finesse—until his dying day. Others, in contrast, soon took other paths, such as Fernand Léger who, after having produced a few canvases of subtle artistry, lost his way in a decorative style that was weak and cold.

The same fate befell Robert Delaunay (1885–1941). His natural inclination led him toward color, which Cubism increasingly eschewed. So, with the backing of the poet Apollinaire, in 1913 Delaunay founded his own movement, Orphism. Whereas Léger wound up using only the three primary colors, Delaunay employed the entire color wheel with all its shades, finally arriving at an entirely geometric idiom composed not of lines and areas but of colors that interact through a play of juxtaposition, isolation, and interpenetration. In his decorative schemes for the Exposition Universelle of 1937, however, this rainbow approach would ossify into inert ornamentation.

Delaunay had achieved his finest effects when his colors were still wedded to a sense of light. This magical period was rather short, but it yielded works of great sensitivity, such as a series on *The Church of Saint-Séverin* (1909–10), another on *Laon Cathedral* (1910–12), and especially a very delicate series featuring a *Window* (1912) that overlooked the Eiffel Tower, that symbol of modernity. Two other masterpieces also stand out. The first is *The City of Paris* (1912, Musée National d'Art Moderne, Paris), in which Delaunay boldly analyzed three large female nudes in a landscape, conveying a light in which each plane has its own value and color. The second is *The Cardiff Team* (page 561), which sums up what might be called Delaunay's personal catechism: the glorification of movement, handled through a juxtaposition of colors (extending to the frankest of reds); the use of lettering on the canvas (reflecting Delaunay's love of posters, which he called "the finery of twentieth-century cities"); and the celebration of modernism and especially its latest marvel, aviation (hence not only the Eiffel Tower and Ferris wheel, but also an homage to the aviator Blériot and a boldly lettered poster alluding to the Astra airplane manufacturing firm). Executed on the eve of World War I, this painting displays an audacity, optimism, and youthful abundance surpassing anything that Picasso was doing at the time. Delaunay himself would never match it again.

Robert Delaunay,
The Cardiff Team,
1913. Oil on canvas,
10'7" × 6'9" (3.26 × 2.08 m).
Musée d'Art Moderne
de la Ville, Paris (France).

A similar sparkle and optimism, if somewhat more contemplative, would nevertheless be found in the work of Roger de La Fresnaye (1885–1925), as mentioned above. His early canvases revealed the influence of the Nabis, picked up at the Académie Ranson where Maurice Denis and Paul Sérusier taught. There La Fresnaye learned that painting is not simply a reproduction of reality. His contact with Cubism seems to have been rather brief and fairly superficial, but it sufficed to transform his art. The swirls of the Nabis were replaced by strict geometry, although one that contained no "cubes." Instead, La Fresnaye used flat patches of color to reduce his composition to the basics. The inspiration behind most of his major paintings reflects a vision that governs and justifies their composition. His *Draftsman* could be considered one of great masterpieces of French art (page 562). He skillfully orchestrated the three primary colors, tempered by large patches of white, black, and gray, into a rigorous but sensitive play of shapes that transforms this seated figure into a philosophical

Roger de La Fresnaye, *The Draftsman*, 1913–14. Oil on canvas, 4′3″ × 5′3″ (1.31 × 1.62 m). Musée National d'Art Moderne, Centre Georges Pompidou, Paris (France).

Jacques Villon,
Self-Portrait,
1949. Oil on canvas,
3´3″ × 2´4″ (100 × 73 cm).
Musée des Beaux-Arts,
Rouen (France).

allegory worthy of writer Paul Valéry.

The "Cubist" connection is too often overlooked when discussing an artist who finally won true fame in France and the United States at the end of his life, namely Jacques Villon (1875–1963). His reputation is fully merited. Villon's real name, however, was Gaston Duchamp, and the provocative art of his younger brother—Marcel Duchamp—has somewhat overshadowed Villon's difficult masterpieces, at least in America. His *Self-Portrait* of 1949 does not have the powerful harmony of La Fresnaye's *Draftsman*, but it reintroduces a delicate sense of ambient space (page 563). His unusual

palette of apple greens and blue-grays, his touches of warm and cool tones that bring the shadows to life, and his very resonant effects of light all show that Cubism could lead to profoundly different, if equally perfect, accomplishments.

Current fashion would have us ignore André Lhote (1885–1962), usually dismissed as a theorist devoid of all artistry. But Lhote was in no way just an intellectual who dabbled with a paintbrush. On the contrary, born into a modest family, he was placed as an apprentice with an ornamental sculptor, and turned to painting without having had a true master. His taste was profoundly shaped by his discovery of the collection of a Bordeaux art lover named Dr. Frizeau, especially the famous canvas by Gauguin titled *Where Do We Come From? What Are We? Where Are We Going?* Lhote then became an art critic at the *Nouvelle Revue Française*, where he explained difficult ideas in clear, straightforward French, even though he never went to high school, much less college. His contact with Cubism was rather tangential, and he felt closest to the Section d'Or group. He was always careful not to sacrifice legibility when it came to subject, color, and light.

Nor should his role as theorist be underestimated. Even in the context of today's extensive literature on art, his criticism remains outstanding. Unlike most artists who wrote on painting—with the exception of Eugène Fromentin—Lhote never tried to preach a doctrine,

not even that of Cubism (as Gleizes and Metzinger did). He always sought to elevate practical, concrete advice into more general principles. Even though he sometimes displayed a lack of understanding for certain seventeenth- and eighteenth-century painters—and perhaps too much indulgence for certain artists of his own day—Lhote's comments were accurate and profound. His concept of "visual constants" sheds useful light on the history of painting, and while the radical movements of the day may have ignored these constants, they have never refuted them. Lhote's two treatises—on landscape painting and figure painting—perhaps remain the best thing any young painter—or art lover—could read.

Despite his various activities—he opened his own art school in Paris's Montparnasse in 1922, he was often invited to teach abroad, and he wrote a number of articles and books—Lhote still managed to paint a good deal. Too much perhaps, which is why some of his work may seem a little vacuous. But his confident technique lends consistent freshness to his paintings. He painted simple little landscapes that are sensitive and luminous, as well as larger canvases with rich yet clear compositions. His work may lack mystery, but as the years go by their clarity seems increasingly commendable. For instance, his *Port of Call* (page 565), painted in 1913, may lack the lyricism of Delaunay's *Cardiff Team,* but it remains a fine, skillfully orchestrated canvas that,

André Lhote, *Port of Call*,
1913. Oil on canvas,
6′10″ × 6′ (2.1 × 1.85 m).
Musée d'Art Moderne
de la Ville, Paris (France).

like Delaunay's, rejects traditional subject matter and draws inspiration from modern life. By achieving the right balance between realism and stylization, this painting points toward the grand decorative art that would emerge in the postwar period.

World War I and Painting: 1914–39

The extraordinary burst of activity between 1900 and 1914 gave wings to great painters who were soon competing for attention with the masters of preceding generations. We should not forget that Degas only died in 1917, that Monet lived until 1926, and that Renoir's late works came after Picasso's entire "Cubist" period and after the earliest "abstract" works. The multiplicity of concurrent styles, accompanied by polemical writings, created what can only be described as an incredible commotion. (In order to endow these years with a more or less artificial coherence, some unfair omissions have been made here.)

Suddenly, however, silence fell when war broke out. Most artists were called up, major museums closed, and aesthetic disputes hardly seemed proper while Reims Cathedral was burning. One curious after-effect, however, is the lack of research that has been undertaken into the impact of the years 1914 to 1918 on artistic creativity. At any rate, it is remarkable that the horrors and tragedy of war inspired so few artists.

Once peace returned, it transpired that only a few of the already accomplished artists had died: Germany, alas, lost August Macke (aged twenty-seven) and Franz Marc (thirty-six), while France's La Fresnaye, who was gassed, remained a bedridden patient unable to work seriously again. He finally died in 1925.

The tragedy nevertheless seems to have left a profound mark on the next generation, the one born after 1895. The complex experiments of Fauvism and the various Cubisms now seemed to belong to a different age. The younger generation was not very inclined to follow them up, especially since the boldest participants of the 1900 to 1914 years often renounced this part of their past. Picasso himself, as already mentioned, not only abandoned collages but also the radical fragmentation of forms, returning to a more synthetic approach (and sometimes even disconcerting friends and foes alike by suddenly, masterfully, adopting a highly traditional style).

This period has been described as a "return to order" in the pejorative sense of the expression—the "return" often appeared to be linked to the rise of totalitarian regimes such as Communism in the East, Nazism in Germany, and Fascism in Italy. In fact, artists were soon fleeing Russia without having developed a new "order" there. In Germany, prior to 1933 painters indulged in an extreme form of Expressionism. Although France and Italy did generate a reaction favorable to a more considered art, this reaction cut across all generations and was perhaps

more common among French-born artists than among the foreign artists who comprised most of what was then called the "Paris school."

It must nevertheless be admitted that the twenty years between the two world wars constitute a slump. The boom of the previous decades had come to an end. Fame too often fell to artists whose casual technique was acclaimed as "modern" when in fact it was weak or sloppy. A thirst for novelty meant that uninteresting and naïve works by Dadaists and Surrealists were hailed as masterpieces. Praise was heaped on painters such as Kandinsky (who soon betrayed his lack of vigorous inspiration), Klee (all in all, a fine minor master), and Mondrian (a painter as gifted as he was sensitive, but who locked himself into an asceticism from which he could not or would not escape, unlike Picasso who several years earlier had broken out of his own "abstract" manner). Fortunately, the vacuum was masked by the brilliant careers of the earlier generation, who gave the impression that never before had painting been so rich and varied.

Our view of these years may perhaps be skewed by conventional hierarchies that have yet to be challenged. De Chirico's frankly

Piet Mondrian, *Gray*, 1911. *Oil on canvas*, 2′6″ × 3′6″ (78 × 107 cm). Gemeentemuseum, The Hague (Netherlands).

mediocre works and Dalí's relentless clowning have blinded us to the true value of paintings by Italian artists such as Carlo Carrà (1881–1966) and Felice Casorati (1883–1963). In France, critics have recently begun to reconsider the period of the 1930s. The high quality of sculpture, as discussed above, makes it hard to continue to overlook the heyday of the group that gravitated around Jean Théodore Dupas (1882–1964). Such artists, including Dupas himself and Robert Poughéon (1886–1995), developed a skilled, sensitive style that remained deliberately cool (representing an explicit rejection of German Expressionism). Furthermore, it is hard to admire the likes of Balthus while still remaining contemptuous

of large decorative canvases by Jean Souverbie (1891–1981), such as his *Earth* of 1935 (page 568). Surely Souverbie's discreet palette, enlivened by a few chalky whites and salmon pinks, and his hieratic style imbued with a certain sensuality, convey more than just the blandness of an official commission.

The years 1934 to 1937 were marked by two important exhibitions in Paris. In the first, "Peintres de la Réalité" ("Painters of Reality"), Charles Sterling presented a still little-known aspect of seventeenth-century French art, notably the work of Georges de La Tour. Meanwhile, the Exposition Universelle of 1937 allotted painting a role equal to that of sculpture. Such exposure to the grand

Jean Souverbie, *The Earth*, 1935. Oil on canvas, 6′10″ × 11′5″ (2.1 × 3.5 m). Musée des Années Trente, Boulogne-Billancourt (France).

tradition encouraged young artists who hoped, once again, to relaunch painting on a new basis. In 1935 they formed a group called Forces Nouvelles. These "new forces" included Robert Humblot (1907–1962) and Georges Rohner (1913–2000), but they would soon be dispersed by the outbreak of World War II.

Not all these artists had the courage to continue defending their art in the face of all the criticism heaped on it. That fact should not, however, detract from the value of the courageous paintings they produced in the 1930s—honest, straightforward, discreet, often marked by anguish or occa-

sionally by a somewhat tense serenity. Take, for example, Roger Chapelain–Midy, born in Paris in 1904. He soon acquired a certain reputation, even international (having received a Carnegie Prize in 1938), but became the object of growing disdain after the 1950s. As a teenager during World War I, he was one of those who felt a need to return to a clear visual language, accessible to all, and to a subject-matter that celebrated peace, nature, and the delight of sunny mornings (page 569).

Just two decades after the war ended, though, another war came along, bringing with it more paralysis, horror, and ruin.

Roger Chapelain-Midy,
Summer Symphony,
1936. Oil on canvas,
4′8″ × 6′4″ (1.44 × 1.95 m).
Musée National d'Art Moderne, Centre Georges Pompidou, Paris (France).

The other post-war period: 1945–75

The "return to order" that followed World War II was less marked than the one that occurred in 1918. The most distinctive phenomenon of 1945 was the glorification of masters from the Nabis, Fauve, and Cubist periods—Bonnard, Matisse, Picasso, and Braque were practically deified in their own lifetimes. They seemed to embody bold creativity—partly because of their past excesses—in distinct contrast to everything else: the tense, ultimately conventionalized violence of German Expressionism; the feeble orthodoxy of the Nazi period; the weakness of Italian, English, and Spanish painting; the vain efforts of Surrealism to regain its public; and the political imperatives imposed by Communism on artists in Russia and other countries behind the Iron Curtain.

Up until the 1970s, Paris represented the most lively center and haven for painting. To appreciate this situation, one has to have experienced the period firsthand, traveling through Europe and North America (which was not yet easy to do). Although an abundant literature on this period exists, it was subsequently obscured. Unlike the generation that emerged in the interwar period, the one that surfaced after 1945—born between 1905 and 1914, trained in the 1920s and 1930s—was highly brilliant and inventive. It was fully aware of the experiments conducted in the early twentieth century, but most of its painters replaced the aggressive and fractious attitude of that period with an art that matured in a time of difficulty and reconstruction. All of them rejected purely intellectual speculations and gratuitous provocation in search of an artistry that combined tangible sensitivity with a crucial sense of vision.

Lyrical abstraction and after

Lyrical abstraction became the major stylistic trend. Most painters became fascinated with it. Some adopted this approach right away, others shied away before finally accepting it. French painting displayed the strongest attraction to this movement, through artists such as Roger Bissière (1886–1964), Jean Bazaine (1904–2001), Alfred Manessier (1911–93), and Jean Le Moal (1909–85). Yet at the same time, various parallel developments were pursued by Dutch, Swiss, and German painters following the rigorous path of geometric abstraction pioneered by Mondrian (notably incarnated by Richard Paul Lohse, 1902–88). American experimentation in this realm was represented by the likes of Mark Tobey (1890–1976) and Mark Rothko (1903–70).

Bazaine displayed the same intuitive approach as Manessier (discussed above), based on the play of shapes and color, and on more or less direct allusions to the time of day, the seasons, or the elements. Somewhat older than Manessier, Bazaine had already made a name for himself before World War II,

Jean Bazaine,
Snowy Evening,
1963. Oil on canvas,
4′3″ × 2′8″ (130 × 81 m).
Musée National d'Art
Moderne, Centre Georges
Pompidou, Paris (France).

and in 1941, during the German occupation of Paris, he organized an exhibition titled "Vingt Jeunes Peintres de Tradition Française" ("Twenty Young Painters in the French Tradition"), thereby assuming the leadership of his generation of artists. Bazaine's love of the sea, of cold, turbulent waters, and of sunlight on rocks and sandy beaches is expressed through a range of colors both bright and muted. Linear structure often disappears, because he relied primarily on subtly calculated brushstrokes that dissolve into one another,

suggesting reality without ever reproducing it (page 571).

One of the most famous artists of the immediate postwar period was André Marchand (1907–98). But he subsequently left Paris for the South of France and was forgotten by the fashion-conscious art world, dying in semi-obscurity, bitter and proud. He had made his start prior to 1939, painting troubling works with large, solitary figures that were forerunners of the sordid realism that gripped literature and the visual arts after 1945. The arrival of war and the French military rout drove him back to his southern roots, where he found a different source of inspiration: landscapes dotted with rocks and flowers, nude bathers in the sunshine. In order to convey the intensity of light and shadow, Marchand boldly set black figures or bright patches of pure color against an intensely red sky. Later, his style changed and his vision became more complex. In the *Pink Flamingos* series, for example, he employed linear drawing similar to that of Dufy and, less subtly, but with greater authority, deployed large, significant areas of color. Marchand's isolation in the

André Marchand,
Bather at Sunset,
1945. Oil on canvas,
2′8″ × 3′3″ (81 × 100 cm).
Private collection.

provinces enabled him to remain in touch with nature and to resist the vogue that demanded a complete break with figurative representation.

Quite different was the work of Portuguese artist Maria Elena Vieira da Silva (1908–92). Born in Lisbon, she moved to Paris in 1928 and married, in 1930, Hungarian painter Arpad Szenes (a sensitive artist who also merits discussion here), abandoning her earlier interest in sculpture. Her experience of sculpture nevertheless explains her need to construct her paintings in space—a deep, shifting, often limitless space (page 573). But she was moving against the grain of her times. With entirely feminine skill and stubbornness, she persisted and managed to win admiration for her exploration of the third dimension. During the war she spent a long time in Rio de Janeiro, and afterward her works approached abstraction, the last links to reality

Maria Elena Vieira da Silva,
Red Interior,
1951. Oil on canvas,
32 × 24″ (81 × 60 cm).
Granville Collection,
Musée des Beaux-Arts,
Dijon (France).

often being replaced by a highly poetic weave. Veira da Silva's delicate, tenacious art consistently garnered admiration in France and, naturally, Portugal.

Nicolas de Staël, born in Saint Petersburg in 1914, emigrated from Russia in 1919 and spent his youth in Brussels. Caught up in the whirlwind of World War II, he only began showing his work in 1945. His early paintings were abstract but handled very roughly, in a style markedly different from the more or less geometric abstraction so widespread at the time. Starting in 1952, he returned to figurative art, not in a desire to depict but rather

to suggest lively scenes, nudes, and above all landscapes, which he did through the attentive arrangement of small areas of color. In the end, this meant pursuing the path of Sérusier's *Talisman*, though with greater simplification, freedom, and variety in harmonies of line and color. These works had instant appeal, and de Staël's suicide in March 1955 brought a brutal end to an oeuvre that many people already considered first-rate. Taking a landscape titled *Sicily*, painted in 1954, we immediately note that the sky is green and the sea is black, while purple and red patches occupy the canvas in an

Nicolas de Staël, *Sicily*, 1954. Oil on canvas, 3′9″ × 4′9″ (1.14 × 1.46 m). Musée des Beaux-Arts, Grenoble (France).

Sergio de Castro,
*Landscape and Still Life
in Studio*, 1958.
Oil on canvas,
2′8″ × 3′9″ (81 × 115 cm).
Private collection.

apparently arbitrary way (page 574). Everything seems straightforward. On a second look, however, everything seems askew, or rather is skillfully skewed to create a new, powerful impression. These efficient inversions and careful simplifications imitate—without copying—the miracle of van Gogh's *Wheat Fields*.

Quite different miracles lurk in the work of Sergio de Castro, who has too often been compared to de Staël. Whereas the latter was born in Saint Petersburg, Castro was born in Buenos Aires, Argentina, in 1922, and is indebted to his Spanish heritage

for his taste in muted, gently harmonious colors. He was initially drawn to music, but the death of Manuel de Falla (whose assistant he was) in late 1946, his encounter with artist Joaquim Torres-Garcia, and his move to Paris in 1949 (the year Torres-Garcia died), all finally led him toward painting, which is concerned with the subtle orchestration of shapes and colors (page 575). Whether a landscape (Italy, Greece, Spain), a still life, or one of his *Studio* series, each of de Castro's paintings comes across as a visual poem—solemn or affectionate—that reflects the artist's sensitivity and skill.

Reviving the grand tradition

Count Balthasar Klossowski de Rola, often known as Balthus (1908–2001), had an eventful childhood. He was introduced to artists at an early age, but never had any formal training. Apparently he initially thought that if he added a few more or less Surrealist elements to his paintings, he could eliminate all that was anecdotal from them and simultaneously endow them with an authentically poetic feel. This literary element long did a disservice to his work, but it also shielded him from the many speculative movements of the day. Balthus thereby retained a fresh eye that was open to the lessons of the old masters.

His early works have been overly praised, for they are rather painfully characterized by a more or less deliberate awkwardness and facile eroticism. It was only in 1953, when he withdrew to the Château de Chassy in central France, that he managed to find renewed inspiration. He painted a few very austere portraits of females, such as *Young Girl with White Blouse* (1955, private collection), and he reinvented landscape independently of all the theories that had held sway since Impressionism, Neo-Impressionism, and Fauvism (*Farmyard at Chassy*, Musée National d'Art Moderne, Paris). He discovered a balance between color, value, geometry, and line. Above all, in 1961 Balthus was named director of the French Academy in Rome,

making him the successor, one hundred years later, to Ingres. Confronted with all the masterpieces of Italian art, Balthus slowly pared down the psychoanalytical and potentially scandalous side of his work, retaining only his deep instinct for simplified forms. His 1973 *Nude in Profile* offers a new image of feminine grace that is timeless and independent of any school (page 577). Similarly, his *Studio* (1980–81, Musée National d'Art Moderne, Paris) is bathed in a light that, rather than annihilating forms, gives them fullness and determines their organization on the canvas. Light does not diffuse color, but condenses it into rare harmonies of blue and yellow. The miracle is that his huge, single-handed effort—potentially plagued by too many private memories and meanings—has culminated in these profoundly original works. A further miracle is that these paintings, executed with a disdain for every prevailing fashion, were highly admired and coveted even during the artist's own lifetime.

Balthus was not the only artist to chose a solitary path, aloof from—or even counter to—his times. Without intending to compare the two artists, it is worth recalling that Lucian Freud, born in Germany in 1922 and a refugee in England in 1933, only decided to teach himself to paint after finishing his education. He was somewhat influenced by the Neue Sachlichkeit ("New Objectivity") movement, led by Otto Dix and George Grosz, but was able to free

Balthasar Klossowski
de Rola, known as Balthus,
Nude in Profile, 1973.
Oil on canvas,
7´4˝ × 6´6˝ (2.25 × 2 m).
Private collection,
New York (New York).

himself of their penchant for caricature while remaining faithful to figurative art, which has contributed to his current renown. His thick, heavy impasto, his emphatic forms, and his powerful realism leave little room for poetry.

It would be equally risky to compare Balthus to Avigdor Arikha, born in Bukovina, Romania, in 1929, if both artists had not shown the same stubbornness in following their own paths, far from the mainstream. Arikha experienced the full tragedy of World War II and Israel's war of independence. He was first enamored of abstract painting, but in spite of early success he completely abandoned it, putting down his brush for eight years. He began painting again in 1973, after vowing to paint only from nature. This meant not only denying himself an entire realm of art—that most noble realm of imagination—but also meant rejecting one of the apparently major advances made by "modernism" from Redon to Braque. Such limitations might seem absurd on the part of a painter who was also an art historian and knew the work of Poussin and Ingres better than anyone. In fact, however, it reflected an amazing ambition: to reinvent painting from scratch, beyond all received ideas. Its full significance is perhaps best revealed by the fact that Arikha was able to produce a masterpiece from a few bottles on a table as easily as through a portrait of Queen Elizabeth.

This return to reality was not a return to straightforward naturalism, but to visual truth. With their inventive compositions and exquisite play of colors, Arikha's paintings "from life" convey both the sensibility and spiritual depth of the artist. Whether producing his *Portrait of Anne,* the *Portrait of Lord Home* (page 579), a *Red Cup and Silver Vase,* or a *Chinese Bowl and Fruit* (page 578), Arikha's modesty and pride yields a thoroughly new vision. He rejects, as a purely intellectual myth, the idea that art moves in a certain direction, and his example proves that we can always start over again. The crucial thing is to follow the path of inspiration.

Yesterday and Today

Trying to judge things without sufficient distance is asking for trouble. When it comes to art, everyone is familiar with this risk—during Gauguin's own lifetime no one would have cited his work as important, apart from a few friends. And during van Gogh's lifetime, no one except his brother believed in his genius; in fact, when he was living in Arles, far from Paris, few knew he even existed. Today we might feel that we are better informed, thanks to exhibitions, the press, and other media. But the hubbub can drown the music—of all today's fleeting celebrities, which ones merit discussion? It is not a question of keeping informed, but of keeping well informed. Can any historian assume, in all good conscience, that he is able to judge the art of his day?

My summary of the art of recent years will therefore be limited to a few general remarks on developments obvious to all. Yet even the most conspicuous developments may be misleading. In the past twenty or thirty years there has emerged a multitude of small groups, all of whom claim to embody "modernity," to represent the "contemporary art" of the day. This proliferation began very early, even prior to the social upheaval of 1968. Not all of these movements can be listed here.

There were the days of Minimal Art, which favored simple, spare volumes stripped of all discursive appeal. And there was Pop Art, born in London in 1956 and naturalized American in 1961, which took as its subject matter advertising images, comic books, and elements of everyday life inflated to a monumental scale. Then there was Nouveau Réalisme, which replaced painting with detritus and garbage, followed by Hyperrealism, which viewed reality—or photography—through a magnifying glass. Nevertheless, all these groups still produced art in the traditional sense of the term.

At the same time, more or less original activities were invented: "happenings" were no longer concerned with producing a work, but with triggering an event. The Fluxus group, founded in Cologne, Germany, in 1962, turned happenings into social criticism and occasionally into strident activism. In contrast, Conceptual Art, which emerged around 1965, eliminated all action. It asserted that the "idea of art" was the same as art itself, and that words alone sufficed—definitions and equations devoid of all aesthetic quest—with no need for any form of expression other than a sheet of paper.

Meanwhile, various other "fields" emerged. Happenings evolved into Body Art, which played on the deliberate mutilation of the body during bloody ceremonies sometimes accompanied by sacrilegious acts.

Other trends were not so much scandalous as burdensome, notably installations that, invoking Surrealism or vaunting personal memories, began occupying entire galleries of museums where it seemed as though time had been brought to a halt. On an even larger scale, Land Art claimed to take nature itself—or the cityscape—as an object of "work," obviously conceived as ephemeral. At which point, around 1978–80, Transavantgardia advocated a return to pictorial values and even to narrative—although always brandished with deliberate awkwardness and violence.

Many of these minuscule groups justified their claims by citing Marcel Duchamp and his famous precedents, such as the ready-made *Bicycle Wheel* of 1913 and especially the *Fountain* of 1916, which was simply a mass-produced urinal that Duchamp claimed was a work of art merely because he declared it so. Duchamp lived until 1968, and his calculated taunting of intellectuals won him surprising prestige in the United States. In practical terms, Duchamp's mockery opened the door to the most eclectic activities.

In 1999, an international publisher produced a catalogue—printed in Italy and written in French and English—titled *Art at the Turn of the Millennium.* The publication illustrated the work of 137 "artists" who had emerged since 1980. Oil painting was almost entirely absent, and the few paintings included were clearly impoverished. A great many "installations" of all kinds were featured, but the lion's share of the catalogue was devoted to photography and video, almost always pornographic.

Indeed, one of the characteristic features of this period is the abrupt repudiation of traditional techniques. Only architecture still calls for skills that, in fact, it would be hard to abandon. In other fields, all the experience acquired since the Carolingian period has vanished in less than thirty years. These days, sculptors are no longer able to model a knee or hand, painters are unable to draw a shoulder or torso. Almost no institutions still teach these things. The phenomenon has occurred with stunning swiftness, and has now reached Japan and China, where only a small fraction of artists maintain their own tradition—the others copy Western models.

I am not saying that the repudiation is total. I personally know young artists still able to wield a paintbrush with all the skill of their predecessors a century ago. Nor would I hazard a comparison with the sudden decline of Roman art, which was the result of killing, looting, and burning. That is hardly the case today. Never before has scientific study of former techniques been so sophisticated, and today's restorers are fully conversant in theory and practice. No, the real change concerns mentalities: the mentality of the public, who has been taught to like crude work, and the mentality of artists, who no longer have the patience for a long apprenticeship. The fashion for *art brut*, or "raw" art, openly encouraged by the art market, certainly contributed to this development.

Another point needs stressing: the market for contemporary art has profoundly changed in recent years.

Throughout much of history, artists could only make their work known by showing it on their own premises or briefly displaying it in contexts that varied from one place to another. Starting in the late seventeenth century, the organization of a regular exhibition in Paris, called the Salon, provided artists with a point of contact for potential clients. Then, in the second half of the nineteenth century, galleries adopted the role of go-between, attempting to undermine the prestige of official Salons. These latter lost all importance in the twenty years following World War II, although during this same period the reign of galleries also came to an end.

A new situation arose. Beginning in 1970, New York's quest to assert its importance in relation to Paris and other European centers led to the emergence of a small, informal group of well-known American critics, major gallery owners, and powerful collectors (including the curators of wealthy museums). This group, backed by the main auction houses and represented at international contemporary art shows, has influenced both reputations and market values.

This highly centralized system increasingly tends to treat artists like bank certificates and their works like shares worthy of speculation. The situation is not very favorable to the development of the arts, and it is damaging to museums, which all wind up resembling each other all over the world. How long it can last is not at all clear.

Am I being pessimistic? Yes. I cannot even bring myself to mention or illustrate those living—or lately deceased—artists made famous by recent auctions in the U.S. or the latest biennial in Venice. Even the press has had trouble finding things to praise during the vast open-air exhibitions of sculpture recently held on the Champs-Elysées in Paris.

Is this pessimism totally justified? No. Art always springs up where it is least expected. Nothing is sadder than seeing young people abandon art due to the difficulty of finding essential training and encouragement. But those who persist will find the path wide open and the expectations great.

APPENDICES

List of Illustrations

A

B

D

P

S

PROPER NAME INDEX

The italicized page numbers refer to illustrations.

Topographical Index

Acknowledgments

Addressing a subject that has no real boundaries is always a bold undertaking. A lot of material is written, much of which must then be cut (even when worthy of greater development), and one's entourage inevitably becomes impatient. So I would like to express my warm gratitude to the entire team that accompanied me down this difficult path: Muriel Rausch, Audrey Gregorczyk, Sophie Chambonnière, and the extremely patient Dominique Grosmangin. My thanks also go to Antoine du Payrat who designed the cover, to Murielle Vaux who supervised production, and to Colette Malandin who copyedited the original French text. Finally, I would like to thank Catherine Laulhère-Vigneau, former head of Éditions Flammarion's illustrated books department.

As for any errors and mistakes that may emerge, they should all be attributed to the author, who failed to pay sufficient heed to the old saying, "Grasp all, lose all."

Editor: Muriel Rausch, with the help of
Jean-François Colau, Laëtitia Moukouri, and Amélie Renault
Translated from the French by Deke Dusinberre
Copyediting: Bernard Wooding
Design: Dominique Grosmangin
Typesetting: Thomas Gravemaker
Proofreading: Joshua Parker
Color Separation: Dupont, Paris

Previously published in French as *Histoire de l'Art* © Éditions Flammarion, 2002.
English-language edition © Éditions Flammarion, 2003
26, rue Racine
75006 Paris

03 04 05 4 3 2 1

FC0411-03-X
ISBN: 2-0801-0875-1
Dépôt légal: 10/2003

Printed in Spain by JCG